Transatlantic Encounters

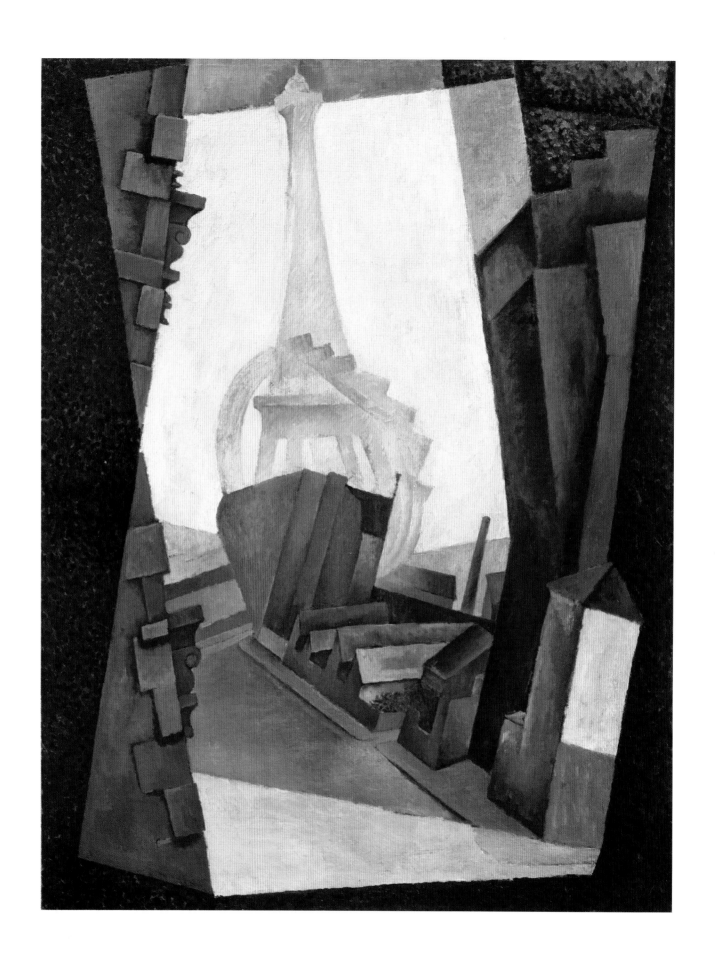

Transatlantic Encounters

Latin American Artists in Paris Between the Wars

Michele Greet

Yale University Press New Haven and London

Publication of this book has been aided by a grant from the Millard Meiss Publication Fund of the College Art Association.

The George Mason University Art History Program also aided in the publication of this book by providing funds for production costs.

yalebooks.com/art

Designed by Leslie Fitch and Tina Henderson

Printed in China by 1010 Printing International Limited

Library of Congress Control Number: 2017939208

ISBN 978-0-300-22842-7

A catalogue record for this book is available from the British Library.

This paper meets the requirements of ANSI/NISO Z39.48-1992 (Permanence of Paper).

10 9 8 7 6 5 4 3 2 1

Jacket illustrations: (front) Tarsila do Amaral, *Carnival in Madureira*, 1924. Oil on canvas, 30 × 25 in. (76 × 63 cm). Fundação José e Paulina Nemirovsky, São Paulo; (back) *L'Atlantique,* 1931. Lithographic poster (fig. 27).
Frontispiece: Diego Rivera, *Eiffel Tower*, 1914. Oil on canvas, 45¼ in. x 36¼ in. (115 x 92 cm). Private collection, courtesy of Mary-Anne Martin Fine Art, New York. © 2017 Banco de México Diego Rivera Frida Kahlo Museums Trust, Mexico, D.F./Artists Rights Society (ARS), New York.

Contents

Acknowledgments

Researching and writing *Transatlantic Encounters* would not have been possible without the assistance and generous support of numerous individuals and institutions. A Post-Doctoral Research Fellowship at the Center for the Study of Modern Art, the Phillips Collection, funded the initial research for this book from 2008 to 2009. In addition to giving me access to the Phillips Collection Library, the fellowship allowed me to take advantage of many resources in the Washington, D.C., area, including the Library of Congress, the Art Research Library at the National Gallery of Art, and the Art Museum of the Americas archives; to take several research trips to New York to visit the Frick Collection Library, which has a wonderful collection of catalogues of Latin American artists in Paris, and the Thomas J. Watson Library at the Metropolitan Museum of Art; and to take trips to Los Angeles, where I consulted the César Moro Archives at the Getty Research Library. While at the Phillips Collection, I taught a seminar on the topic of my research to a wonderful group of students from the University of Illinois. Our discussions in that class helped direct my investigation.

In the summer of 2011 I was awarded a Creative Award Grant by George Mason University for a research trip to Paris, where I consulted archives at the Bibliothèque Nationale, the Palais Galliera, the Bibliothèque Kandinsky at the Centre Pompidou, and the Archives Nationales. I would especially like to thank Dominique Bermann Martin for inviting me into her home and sharing André Lhote's archives with me. From 2012 to 2013 a National Endowment for the Humanities Fellowship supported my writing of the book manuscript, and a 2016 Millard Meiss Publication Grant funded, in part, book production costs. I am extremely grateful for the support these grants provided.

Additionally, I would like to thank the institutions where I presented iterations of this research: American University; the Art Museum of the Americas; George Washington University; the Institut National d'Histoire de l'Art, Paris; the Institute of Fine Arts, New York University; the Phillips Collection; Purdue University; Rice University; the Universidad de los Andes, Bogotá; the University of Essex (UK); as well as College Art Association and Latin American Studies Association conferences.

I would also like to thank the following individuals for their assistance: the interlibrary loan staff at GMU, who went out of their way to assist me with my many obscure requests; GMU's visual resources curator, Sherrie Rook, who meticulously processed many of my images; my colleague Ben Cowen for assisting me with Portuguese translations; and Leonard Folgarait, Anna Indych-López, and Robert DeCaroli for writing letters of recommendation for my various grant applications. For sharing their knowledge and scholarship I'd like to thank Michel Bastarache, Lori Cole, Dafne Cruz Porcini, Ingrid Elliott, Tatiana Flores, Claudia Garay, Georgina Gluzman, Rodrigo Gutiérrez Viñuales, Béatrice Joyeux-Prunel, Rachel Kaplan, Lynda Klich, Jay Oles, Fernando Saavedra, Gloria Santos, Ana Paula Cavalcanti Simoni, Edward Sullivan, Susana Temkin, Gerardo Traeger, Edgard Vidal, Fernando Villegas, and Adriana Zavala.

I would especially like to thank the American Federation of Arts, specifically Margery King, Pauline Willis, Katrina London, and Abigail Lapin Dardashti, for

recognizing the potential of this project and inviting me to guest-curate an exhibition based on my research. The AFA facilitated research trips to Brazil, Argentina, and Cuba, where I visited museums and private collections. I would like to thank the following individuals who welcomed Margery and me during our travels: Fernanda Pitta, Ivo Mesquita, and Teodora Carneiro at the Pinacoteca do Estado de São Paulo; Katia Canton at the Museu de Arte Contemporânea da Universidade de São Paulo; Jorge Schwartz at the Museu Lasar Segall, São Paulo; Ana Cristina Carvalho at the Governmental Palaces, São Paulo; Carlos Alberto Gouvêa Chateaubriand, Luiz Camillo Osorio, and Claudia Calaça at the Museu de Arte Moderna do Rio de Janeiro (MAM); Paulo Herkenhoff and Tiago Cacique at the Museu de Arte do Rio; Victoria Giraudo at the Museo de Arte Latinoamericano de Buenos Aires (MALBA); Sonia Ubeira at the Fundación Pettoruti, Buenos Aires; Patricia Artundo and Elena Montero Lacasa de Povarché at the Museo Xul Solar, Buenos Aires; and Ana Cristina Perera Escalona and Roberto Cobas at the Museo Nacional de Bellas Artes, Havana. Additional thanks go to the collectors who allowed me to visit their homes and galleries: José Darío Gutiérrez (Bogotá), Ignacio Gutiérrez Zaldívar (Buenos Aires), Norma Beatriz Quarrato (Buenos Aires), Gustavo Tuffano (Buenos Aires), Pierre Moos (Paris), Marta Fadel Lobão (Rio de Janeiro), Cidô Brecheret (São Paulo), Sandra Brecheret Pellegrini (São Paulo), Isabella Hutchinson (New York), Mary-Anne Martin (New York), Alberto Minujin (New York), and Cecilia de Torres (New York).

Finally, thank you to my fantastic graduate students—Adriana Ospina, Beth Shook, Melissa Derecola, and Suzanne Gilbert—for their help with the website that accompanies this project, and to all the GMU students who have taken the various iterations of my "Transatlantic Encounters" class. Last but not least I'd like to thank my mother, Dorothy Greet, for reading the entire manuscript and providing feedback, and my wonderful husband and partner, Robb Williams, and our two daughters, Sienna and Kaylee, for their love and support. In addition to being wonderful travel partners, you have been so understanding and tolerant of the enormous amount of time that goes into a project such as this. Thank you for being there for me from beginning to end!

Introduction

In 1925 Brazilian artist Vicente do Rego Monteiro (1899–1970) published three hundred copies of his book of prints, *Quelques visages de Paris* (Some views of Paris), in Paris (fig. 1). The book, intended for a French audience, takes the format of the travel diary of an Amazon Indian chief who describes Paris's main tourist attractions. Rego Monteiro writes in his introduction about this fictional character: "One day a chief of the savages left the virgin forests and went to Paris incognito, [and] after a short stay, unmoved by all the grandeur he returned to his home. On one of my last trips to the interior of the Amazon, I had the fortune of meeting him. He confided to me his impressions of Paris, and gave me some drawings he made while there that I have compiled here under the title *Quelques visages de Paris.*"[1] Through his graphic images and accompanying texts (in French), Rego Monteiro, now recognized as a foundational modernist, parodies cultural misunderstandings and satirizes expectations of primitivism by his Parisian audience in an attempt to undermine stereotypes of Latin American culture, which paralleled views the French held of their colonies in Asia and North Africa.[2]

Quelques visages de Paris begins with a key to the graphic imagery contained therein. Rego Monteiro

V. DE REGO MONTEIRO

QUELQUES VISAGES DE PARIS

IMPRIMERIE JUAN DURA
54, AVENUE DU MAINE, 54
PARIS
MCMXXV

PRIX 20 FRANCS

FIG. 1. Vicente do Rego Monteiro (1899–1970), Cover of *Quelques visages de Paris* (Some views of Paris) (Paris: Imprimerie Juan Dura, 1925). Estate of Vicente do Rego Monteiro.

devised a set of pictograms to denote frequently occurring objects in the subsequent images, employing these symbols as a sort of hieroglyphic code that unifies the imagery and suggests that it derives from an ancient form of symbolic writing. European intellectuals conceived of hieroglyphics as a crude alphabet, a primitive writing system whose continued reliance on visual resemblance to the signified object rendered meaning transparent; therefore, it was not fully evolved.[3] Whereas alphabetic writing was a sign of civilization, pictograms were the opposite, a marker of an underdeveloped society founded on mystical belief systems. By inventing his own hieroglyphics or pictograms in *Quelques visages de Paris*, Rego Monteiro created images in a recognizably archaic visual language, one associated in the French imagination with "primitive" societies whose vision of the world was simplistic, immediate, and in need of civilizing. Yet, by assuming the point of view of an Amazon Indian chief in his presentation of the imagery, Rego Monteiro reversed these cultural judgments, deeming Parisian monuments and architecture baffling and illogical rather than highly developed.

In the caption accompanying his depiction of the Pont de Passy (fig. 2), for example, Rego Monteiro, in the voice of the fictitious Indian chief, writes: "Two bridges, one on

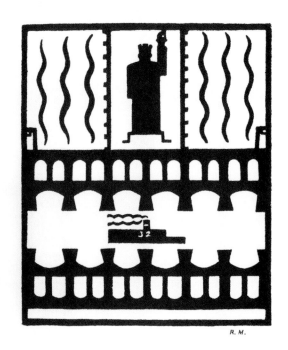

FIG. 2. Vicente do Rego Monteiro, *Pont de Passy*, in *Quelques visages de Paris*, n.p.

top of the other, as if there weren't enough space to put them next to each other. That must be very embarrassing for the little boats that pass under the arches, if they ever make a mistake. Luckily a great lady illuminates them, but what I never understood is why the fire never burns."[4] The image reiterates this sense of confusion. The Pont de Passy, now known as the Pont de Bir-Hakeim, has two levels, one for vehicles and pedestrians, and a second for a railway viaduct supported by metal colonnades. The bridge passes over the Île aux Cygnes, an artificial island in the middle of the Seine, where a one-fifth-scale replica of the Statue of Liberty stands. In the print, Rego Monteiro flattened out the perspective, rendering the two halves of the bridge as mirror images of one another. In their center is a barge that looks as if it is being consumed by the tooth-like columns supporting the bridge. Pictograms throughout the image indicate water, buildings, and smaller bridges without having to render them in full visual detail. And in the top center is a schematic rendering of the Statue of Liberty that resembles a tribal idol in its simplified design. Taken as a whole, the image has an anthropomorphic quality, complete with eyes, nose, and a toothy mouth. Thus, to the Indian chief, Paris appears threatening and perplexing, not unlike how European travelers to the Brazilian Amazon described the region.

Like the Pont de Passy print, Rego Monteiro's *Tour Eiffel* also has an anthropomorphic quality, seemingly winking at the viewer, as if letting him or her in on a private joke (fig. 3). But the joke is on the viewer who does not recognize the fallacy of his or her own vision of the "other." In text accompanying the print of the Eiffel Tower, Rego Monteiro writes (as the chief): "A large fireplace or combat tower: it seems as if it isn't very solid or well balanced: for fear that it would fall, it is attached to the ground on all sides with numerous taut ropes. Is this the remains of the Tower of Babel!"[5] The Indian chief's reference to the Tower of Babel suggests the impossibility of translinguistic and transcultural communication, something frequently problematic in colonial explorations and conquests. Lacking an understanding of modern construction techniques, the Eiffel Tower would appear to the Indian chief to be a precarious construction without an obvious purpose. While to Europeans the cultural significance of the Eiffel Tower is self-evident, the Indian chief attempts to interpret it according to his own cultural codes. Just as ethnographers and European travelers misinterpreted and consequently deemed illogical,

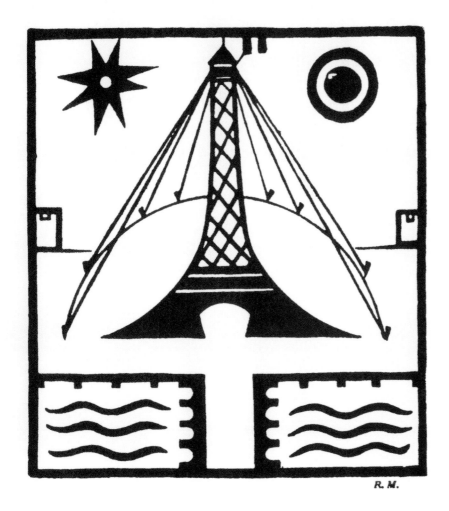

R. M.

FIG. 3. Vicente do Rego Monteiro, *Tour Eiffel*, in *Quelques visages de Paris*, n.p.

unsophisticated, or "primitive" the culture of Brazil's ethnic groups (or any other non-European society, for that matter), the fictional Indian chief renders inconsequential Paris's most emblematic monument, calling into question the notion of cultural hierarchy—a premise often presented as a justification for colonial expansion. This obvious misconception highlights the incorrect assumptions Europeans made about other cultural groups.

In his images of the Trocadero, the Place de la Concorde, and the Jardin des Plantes, Rego Monteiro identifies in France those aspects of indigenous culture that Europeans tended to emphasize in ethnographic studies: ancestral warrior cults, archeological monuments, and exotic plants and animals. About the Jardin des Plantes (fig. 4), for example, the chief asks: "Did plants grow here long ago, we could never really say. Perhaps the poor animals ate them all. I ask myself how they came to nest there. Is it Noah's ark where the animals lived in

harmony; but one thing bothers me! Why have they put bars between them?"[6] The Indian chief does not understand the artificial separation between plant, animal, and human life—a classificatory schema specific to Western civilization. In his graphic rendering of the zoological park, flat, stylized animals, isolated in space by areas of white, occupy cages arranged on the surface to create a decorative motif. The image emulates textile design in its non-vertical orientation of the animals in the center, a technique that contests the hierarchical orientation of academic and most modernist painting. Thus both visually and verbally, the chief questions the logic of European civilization. Rego Monteiro's project was an attempt to parody and therefore challenge the stereotypes and misconceptions of Latin American culture that he encountered in France. While the Indian chief's repeated misinterpretations of France's key monuments in *Quelques visages de Paris* would have been humorous to French

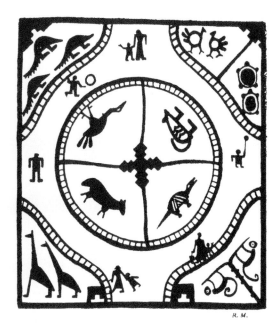

FIG. 4. Vicente do Rego Monteiro, *Jardin des Plantes,* in *Quelques visages de Paris,* n.p.

audiences, Rego Monteiro employed humor to reveal just how absurd erroneous cultural assumptions can be.

Responses to *Quelques visages de Paris* demonstrate how this French desire for an authentic primitivism affected Rego Monteiro, and other Latin American artists living in Paris. As French writer Fernand Divoire asserts in his preface to the book: "This man from the virgin forest that Rego Monteiro found among the trees, the enormous flowers and the snakes, I am not quite sure that it is not the artist himself. . . . His tradition, is not our tradition, nor that of the Mediterranean Peninsulas."[7] And French critic André Warnod writes, "The fantasy is in a sense a very precise rendition of reality. Mr. Rego Monteiro is a man from the virgin forest."[8] But expatriate Brazilian poet Sérgio Milliet counters this assessment, stating: "His art, which relates to indigenous tradition through its color and design, is agreeable and intelligent. I would even reproach Rego Monteiro for being too intelligent. I would like to see in him a bit more naïveté."[9] Milliet's tone here is of course ironic. In the face of consistent French demand for "naïve" art from non-European artists, Milliet recognized that Rego Monteiro had employed the trope of the naïve in an intelligent social commentary, a commentary so insightful that it may have even been lost on his French audience.

This study of Latin American artists in Paris commences with a discussion of Rego Monteiro's *Quelques visages de Paris* because not only are these prints beautifully rendered, but they also brilliantly encapsulate in visual form one of the primary issues these artists confronted when they arrived in France: expectations of primitivism. Rego Monteiro's use of parody in *Quelques visages de Paris* was an attempt to compel his readers to recognize the fallacy of their unidirectional determination of cultural value. For him, satire was a form of resistance, a cultural strategy that challenged prevailing notions of the "primitive" roused by France's colonial expansion, which in turn affected the reception of Latin American art. His prints paralleled other Latin American artists' attempts to develop different strategies of cultural contestation and negotiation of place in Paris. These expectations and subsequent negotiations will be a primary theme throughout this volume.

In the years between World War I and World War II, Paris was at the center of the art world. But that "center" was much more global and multicultural than historical accounts would have us believe. While the very essence of twentieth-century art history, as it is currently written, stems from the movements and avant-garde experiments that emerged in Paris in the early years of the century, the artists who contributed to these movements comprised a multitude of international voices. These artists in turn articulated distinct interpretations of European modernism in distant locations as they returned home or moved on to other cities. While numerous scholars have written about the arts in Paris during this period, almost none examine the participation of Latin American artists in the Parisian art scene, even though these artists both contributed to and reinterpreted nearly every major modernist trend between the wars, including cubism (Manuel Ortiz de Zárate, Emilio Pettoruti, Diego Rivera, Angel Zárraga), surrealism (Tarsila do Amaral, Antonio Berni, Wifredo Lam, Agustín Lazo, Roberto Matta, César Moro, Nina Negri, Ismael Nery, Raquel Forner), constructivism (Jaime Colson, Germán Cueto, Amelia Peláez, Juan del Prete, Joaquín Torres García), and the more figural modes associated with the School of Paris.[10] *Transatlantic Encounters: Latin American Artists in Paris Between the Wars* will examine Latin American artists' intense interaction with European artists and critics as well as their major contributions to the international art scene in Paris between the two world wars.

Artists from around the world embraced the myth of Paris as a legendary site of bohemian life, creativity, artistic transformation, and coming of age. While Paris was a destination for cultural travelers and exiles from the far reaches of the globe, it held a special appeal for Latin American artists because of the city's deep-seated Latin heritage and cultural history. Latin American artists had been traveling to Paris to study and exhibit since the nineteenth century, but the sheer numbers of artists who arrived after World War I, coupled with the increased allocation of government grants from Latin American nations, distinguish the influx of artists between the wars from previous migrations. Indeed, more than three hundred Latin American artists were living and working in Paris between 1918 and 1939, staying anywhere from several months to several decades.

Since it took a number of years for art markets to recover after World War I, artists began traveling to Paris in significant numbers around 1923, with more arriving every year until around 1930. This great influx of Latin American artists was curtailed by the Great Depression and the accompanying xenophobia of the period; most artists returned to their home countries by 1933. By 1937 Latin American artists began returning to Paris, only to be compelled to leave with the onset of World War II. At their height, however, these numbers demonstrate a critical mass that rivaled or even surpassed other groups of foreigners such as Russian Jewish artists in the School of Paris. Nevertheless, the presence of Latin American artists has been overlooked in the art historical literature on the period.

Whereas many of the Central and Eastern European artists who arrived in Paris in the late 1910s came as refugees to escape devastating government pogroms and social duress, other artists traveling in the 1920s, including those from Japan, Scandinavia, the United States, and Latin America, came by choice, establishing a distinction between those who could return and those in permanent exile. For the most part these artists left their home country voluntarily and temporarily for their own personal and professional gain, undertaking travel abroad as an elective strategy of creative replenishment.[11] With the recent academic focus on globalization and multiculturalism, discussions of exile, travel, and migration have come to the fore as experiences worthy of intense historical and theoretical study. James Clifford, for example, proposes reimagining the Paris of the 1920s and 1930s as a series of "travel encounters," a place of constant "departures, arrivals, transits."[12] *Transatlantic Encounters* draws on recent studies in the humanities that focus on cultural contact, colonialism, transnationalism, globalization, and ethnic diasporas to illuminate the relationship between displacement and artistic production, and to provide a framework for analyzing the intellectual formation of Latin American artists during their time in Paris.

Living abroad allowed artists a new perspective on their homeland, while also enabling them to observe the life and customs of the foreign country from a point of view that was distinct from that of local residents.[13] Not only did travel alter the outlook of the traveler, but it also diversified the metropolis, and as Kobena Mercer points out, this foreign presence casts into doubt the "assumption that the nation-state is merely a neutral 'container' of artistic and cultural production."[14] In other words, the presence of Latin American artists in Paris in significant numbers, and indeed that of any other group of foreigners, altered the very nature of the city, making it into what Mary Louise Pratt deems a "contact zone."[15] This considerable presence of foreign nationals began to blur the imagined boundaries between Europe and the rest of the world, creating anxiety that European nations were losing their distinctive character and prompting calls for the classification and categorization of art along regional, national, or what was often referred to as "racial" lines in the 1920s and 1930s.[16] These calls for differentiation spurred an acute focus on defining national and regional identities.

Understandably, the highest concentration of Latin American artists in Paris came from the largest countries in Latin America, such as Brazil, Argentina, and Chile. (Mexico is a different case because of the intensified artistic activity there after the revolution, which incited many artists to return or to remain in the country.) Once in Paris, these artists often socialized, exhibited, and sometimes shared a studio with their compatriots. Yet citizens from countries as distinct as Cuba and Chile did not necessarily share a sense of solidarity as a group. They cannot therefore be considered a Latin American diaspora—a group of displaced peoples of common heritage without a country. While framing these artists as "Latin American" imposes a sense of overriding unity on individuals with very different allegiances, I have chosen to examine Latin American artists as a group in this study rather than tracing national alliances because, I argue, it

was precisely their time in Paris that allowed for a broader notion of "Latin American art" to take shape. The idea of "Latin America" as a geopolitical construct has existed since the days of Simón Bolívar (1783–1830).[17] Yet art academies primarily emerged after independence, in the late nineteenth or early twentieth centuries, with the formation of nation-states. Consequently their agendas were decidedly nationalistic. Indeed, national governments often sponsored artists' studies abroad, since a European education was still envisioned as a sign of cultural status. Ironically, it was during their time abroad that these art students came into contact with artists from other Latin American countries and began to form alliances that would complicate a purely national construction of identity. In the open academies of Montparnasse such as the Académie Colarossi, the Académie Julian, the Académie de la Grande Chaumière, and later the Académie André Lhote and Fernand Léger's Académie Moderne—where art students could pay a daily or monthly registration fee and draw from a live model—those who shared a common language, expatriate status, and cultural heritage as citizens of former Spanish or Portuguese colonies began to band together to increase the possibility of recognition in a highly competitive art market already inundated with foreigners, thereby establishing a Latin American artistic identity abroad.

Since many of the artists who came to Paris from Latin America were students, their time abroad was a formative period in their development. In the context of French art schools, copying was a means of learning from and venerating admired or canonical artists, styles, or movements. Experimenting with various European modernisms and seeking an artistic identity shaped much of their early work. Questions of influence are thus paramount to understanding Latin American artistic production in Paris.[18] Traditionally, art historians have focused on tracing influence, seeking to determine a particular artist's sources, the degree to which these sources were modified, and just how they were transformed to create something new. When the original source has been manipulated in a particularly inventive way, the artist is often lauded for having transcended influence to become an innovator in his or her own right.

Influence is problematic in discussions of art produced by citizens of former colonies, however. Whereas all artists borrow and engage with the work of their contemporaries or of the past to a greater or lesser extent, this borrowing signifies differently in the context of uneven power relations. As Gerardo Mosquera points out: "All cultures 'steal' from one another, be it from situations of domination or subordination. Such is their behavior as living organisms, whose health depends on their dynamism, their capacity for renovation, and their positive interaction with their context. These appropriations may often be 'incorrect' according to their usage in the culture of origin, but they are nevertheless put to work in an original manner that, especially in communities of subordination, reinvents the language of dominance."[19] When the foreigner emulates the production of French artists, or when the citizen of a former colony borrows from the culture of imperial power centers, for example, the resulting creation is often dismissed as incorrect, derivative, or a substandard copy. The concept of influence means the power to affect another person's actions or ideas by example or argument. In the context of uneven power relations, influence from the top down may entail coerced assimilation or, on the contrary, a perverse and unquestioned desire on the part of the artist to mimic the dominant culture in order to become part of that culture of privilege. In either case, power structures play a greater role than independent agency in the determination of source material and how it is manipulated. And meaning is primarily determined and evaluated according to the codes of those in power.

When influence is from the bottom up, as in the case of European primitivism, the modern artist from the imperial center is seen as actively selecting and interpreting the most stimulating formal sources from a wide range of objects from distant countries or colonized regions. The power is in the hands of the European artist who chooses and manipulates at will without regard for how the object originally functioned culturally or signified visually. This "influence" is understood as making the European artist more original and creative, rather than plagiaristic. Or, as Mercer contends: "Modernist formalism was entirely complicit with the colonial gaze, for the cross-cultural could only be admitted into its visual order when it was sequestered within the primitive, the folkloric, or the ethnographic."[20]

The Latin American artist occupies a space in between. Whereas France had very few holdings in Latin America,[21] and by the early years of the twentieth century most Latin American countries were celebrating nearly a century of independence from Spain or Portugal, these

countries' status as former colonies and France's continued quest for colonial acquisitions in Asia and Africa established a cultural hierarchy that was difficult to transcend.[22] This mindset permeated the art market as well as artists' conceptions of self. As Cuban correspondent and writer Ramón Vasconcelos (1890–1965) pointed out in 1938: "America in general distrusts its artists; everything European exerts an irresistible draw in the native imagination and buyers would rather commission any unknown French or Spanish sculptor before giving the opportunity to earn fame and fortune to a native artist. Yesterday a European colony politically, today we continue to be one intellectually and artistically."[23] Or as Brazilian artist Emiliano di Cavalcanti (1897–1976) asserted: "When he comes to Paris, the Brazilian has always had the attitude of someone from the colonies faced with the metropolis. It is natural. We have all had instruction in Brazil, through literature that has had an impression on us, that we are men linked to Europe."[24]

Whereas the encounters set in motion by colonial expansion were key factors in modernization and globalization throughout the world, the West laid claim to modernism as its own circumscribed invention, an account that is perpetuated rather than contested in mainstream Western art history.[25] According to the standard narrative, the very notion of modernism is based on the idea of originality and rupture with the past. Once that rupture has occurred and an original model has been created, no appropriation or reformulation of its forms or precepts can supersede it, making it almost impossible for foreign artists to succeed in the constant quest for novelty.[26]

Formal experimentation signified differently in diverse contexts, however. As Cuban novelist Alejo Carpentier (1905–1980) notes in his review of Cuban artist Carlos Enríquez (1901–1957): "On the banks of the Seine, the work of Carlos Enríquez is stripped of the potential for scandal that it had in Havana."[27] This variance was not because his work was not sufficiently original, but because in Paris it existed in close proximity to so many other artists who were engaging in similar processes. In other words, audiences in Havana perceived his work to be much more radical than those in Paris because of the context in which it was presented. Rather than understanding the foreign artist as constantly behind the curve, Saloni Mathur argues that "metropolitan encounters and associations between immigrants were crucial to both the formal innovations, breaks from tradition, and kinds of radical consciousness

that led to the formation of the avant-garde." Mathur envisions the avant-garde not as primarily formal, but rather as "an intricate global network of arrivals and departures, thefts and exchanges, influences and rejections, circulations and still points."[28] It is this notion of the avant-garde, one that credits the experience of the global metropolis as the primary impetus for innovation, that allows for a new understanding of Latin American artists' contributions to these movements.

The expectations of audiences and critics further complicate interpretations of Latin American artistic production in Paris. Analyzing influence is both culturally and historically relative. Whereas emulating European styles was often perceived as an indicator of an artist's modernism and lent validity to his or her work upon return home, in Paris critics often viewed this emulation as merely a dilution of a European creation, rather than an original contribution to artistic dialogues. Parisian critics therefore often lauded those artists whose output they considered "authentic." Yet the manner in which the French understood Latin American peoples to be "authentic" often paralleled their view of their own colonies. By envisioning these peoples as primitive, exotic, and barbaric, in contrast to France's modernity, civility, and erudition, they reinforced cultural and ethnic hierarchies. Consequently, French critics frequently denied Latin American artists' agency in the artistic process by perpetuating the idea that, through race and culture, these artists had an inherent connection to the primitive or the exotic, which they could, and, according to French critics, should tap into.[29] This European expectation and preference for works with "native" content persisted for decades and continues to affect art historical scholarship on the period.

Since many Latin American artists and intellectuals of Spanish, Portuguese, or mestizo descent conceived of themselves as part of a shared Latin culture, however, they were often taken by surprise by the expectations of primitivism imposed on their work, and by assumptions that they somehow had inherent knowledge of an indigenous "other." Latin American artists developed various strategies to confront these biased perceptions, ranging from a complete embrace of European tendencies to bold assertions of their cultural difference. They realized that their transformation of source material had to be far greater than that of their European contemporaries in order to achieve recognition. One way of doing so was to employ modernist techniques to depict national or regional subjects,

portraying heritage as a source of originality. Other artists, however, chose to engage and contribute to European modernist dialogues without foregrounding difference, as a means to position themselves as universal or international artists. The choice was always strategic and depended on how an artist wished to position him or herself in relation to contemporary arguments about nationalism and universalism. Yet either end of this spectrum had its challenges. By seeking admittance to the dominant culture, artists risked erasing cultural distinction; but by foregrounding difference, they reinforced their marginality and the notion of Latin American countries as places of specificity disconnected from Europe's historical trajectory.[30] Some of the most interesting artistic production in Paris, such as that of Rego Monteiro, engaged these expectations while simultaneously challenging their erroneous assumptions. By appropriating and transforming European constructs of the primitive, Latin American artists regained their agency by constructing an "account of the modern/primitive encounter from the 'other' side."[31]

Another barrier to recognizing Latin American artists' contributions to transatlantic dialogues is historiography. As Latin American art history gained prominence in European and North and South American academia in the second half of the twentieth century, art historians and critics often continued to embrace the notion of national difference and authenticity as a means to validate the field. The more an artist's work resembled European sources, the less it served this narrative. Until the turn of the twenty-first century, the literature on Latin American art took a predominantly nationalistic focus, with numerous studies on Mexican muralism and national movements, to the exclusion of investigations of transnational circulations and global interchange. The strategy was to deny or downplay influence and interaction, as a means to highlight the originality of Latin American art. For this reason, these artists' sojourns abroad were often dismissed as provisional or inconsequential rather than seen as a major contribution to transnational dialogues. But as Mosquera points out, recently the notion of "cultural hybridity" has displaced that of authenticity and national identity.[32] This displacement simply replaced one category of difference with another, but continued to serve as a means to categorize and contain the "other" without fully interrogating the nuances of cultural mixing.

This project attempts to unravel the complicated issues of influence, emulation, and appropriation in the context of uneven cultural exchange. By determining which sources artists chose to engage and which aspects of these sources they chose to manipulate, reject, or co-opt, this study will examine just how Latin American artists expanded and transformed modernist dialogues. Cuban artist Marcelo Pogolotti (1902–1988) elaborates on how he went about the process: "From the vast range of aesthetic tendencies that presented themselves before my astonished and frequently perplexed eyes, I selected the nuances that would gradually reveal my own essence."[33] The way artists manipulated sources, while often not following European codes of aesthetic engagement, reveals unique cultural responses to this material. Moreover, the meanings conveyed in their work shifted according to contexts of display; images signified differently as they crossed national and ethnic boundaries from Europe to Latin America, or vice versa. By examining the specific context of the art schools these artists attended, the salons and galleries where they exhibited, their relationships with Parisian artists, and reviews of Latin American art exhibitions written by French and Latin American critics (and subsequent responses by the artists), *Transatlantic Encounters* will reveal the complicated cultural strategies these artists adopted to participate in and, at times, critique and transform the international art scene in Paris.

The artists discussed here hail from a variety of backgrounds and differ in reputation and stature. Some, such as Mexicans Diego Rivera (1886–1957) and Frida Kahlo (1910–1954), Uruguayan Joaquín Torres García (1874–1949), Cuban Wifredo Lam (1902–1982), and Chilean Roberto Matta (1911–2002), are well known as canonical international modernists and need little introduction; many others are recognized as foundational figures in their country of origin but are virtually unknown elsewhere; while still others have fallen through the cracks even in local art histories and merit rediscovery. Primary source accounts of the period guided the choice of artists to include in this study. An individual exhibition, repeated reviews in the press, or a work featured in a salon catalogue suggest that an artist captured the attention of Parisian audiences between the wars and that his or her work deserves consideration, even if he or she is unknown today. Indeed, there are many reasons for the differences in the current artistic standing of some of the artists discussed here. Some remained abroad so long that they were forgotten in national art historical narratives, while others were from countries that to this day have not established the

academic infrastructure to write such accounts. In still other cases, artists, especially women artists, while successful abroad, lacked the social or financial support to continue in their chosen field upon their return home and are therefore not well known. Yet none of these reasons negate these artists' contributions to artistic developments in Paris between the wars. Thus, this study does not rely on current reputation, but rather attempts to reconstruct the debates, interests, and contributions of Latin American artists who were active and recognized in Paris between the wars. While examining the impact of artists' Parisian sojourns back in Latin America is extremely important, due to space and time limitations, this project does not attempt to trace these artists' critical reception at home. Instead this study provides the groundwork for future investigations of these transnational dialogues in Latin American cultural capitals.

The book is organized around Paris's artistic infrastructure (art schools, salons, galleries, and press) and modernist movements, detailing Latin American artists' presence in and contributions to these institutions. Chapter 1, a prelude of sorts, deals with the years during and just following World War I, when very few Latin American artists were living and working in Paris. This period was nevertheless significant because several key Latin American artists, working with the influential French art dealer Léonce Rosenberg (1879–1947), became deeply involved with cubism, making important contributions to the movement and setting the stage for much greater participation over the next decade.

The next several chapters focus primarily on the 1920s, when the greatest influx of artists arrived in the city. Chapter 2 examines the conditions of transatlantic travel and artists' integration into the Parisian art world, analyzing how and where these artists obtained studio space, where they socialized, their sources of funding, and the art schools they attended. Since conditions of production and availability of resources had a significant impact on artists' ability to contribute meaningfully to the Parisian art scene, locating these artists in a broader social context reveals some of the challenges they faced.

Chapter 3 is a case study of the first ever survey exhibition of Latin American art at the Musée Galliera in 1924, a defining moment in the formation of a Latin American artistic identity on the world stage. Rather than showcasing a particular stylistic tendency, for the first time organizers conceived of Latin American heritage as the unifying factor behind the show, giving rise to an exhibition format that would persist for the rest of the twentieth century: the survey of Latin American art.[34] The stylistic eclecticism of the show, which many critics found disconcerting, compelled them to ponder the existence of a Latin American aesthetic. This quest to pin down characteristic traits common to the region marked much of the criticism in the years to come.

Chapters 4 through 7 address Parisian institutions involved in the display, sale, and criticism of both national and international art. Chapter 4 is an investigation of Latin American participation in the official and independent salons of Paris, examining where these artists chose to exhibit, the consequences of their choices, reviews of their work, and strategies of resistance to salon politics.

Chapter 5 looks at Latin American artists within the Parisian gallery system. After the show at the Musée Galliera, Parisian galleries took a significantly greater interest in exhibiting and selling Latin American art. Nearly fifty galleries held at least one exhibition that featured Latin American art, including prominent galleries such as the Galerie Bernheim-Jeune, the Galerie Pierre, the Galerie Percier, and the Galerie Zak. Additionally, more than thirty artists held individual exhibitions during this period, and many held more than one. These artists went on to have distinguished careers in their home countries, but their presence in Europe has been essentially forgotten in the scholarship on the period.

Chapter 6 analyzes the individual exhibitions held in Paris of four Latin American women artists working in experimental modes between the two world wars: Brazilians Tarsila do Amaral (1886–1973) and Anita Malfatti (1889–1964) in 1926, Mexican Lola Velásquez Cueto (1897–1978) in 1929, and Cuban Amelia Peláez (1897–1968) in 1933. When an artist entered the modern art milieu, she faced decisions about subject matter and technique—about whether to portray national themes or avoid them and how to negotiate the gendered implications of style. All four of these artists joined the vibrant artistic environment in Paris and strategically positioned themselves, via their artistic choices, in relation to aesthetic debates about the role of the decorative in modern art.

The topic of Chapter 7 is the presentation of Latin American art in the Parisian press. By analyzing journals dedicated specifically to Latin American culture, such as the *Revue de l'Amérique latine,* as well as the coverage of Latin American art in French art journals (for example,

L'amour de l'art, L'art vivant, Beaux-arts, Bulletin de l'effort moderne, Cahiers d'art, and *Renaissance de l'art français et des industries de luxe*), this chapter looks at how the print media shaped perceptions of Latin American art. The final section considers the role Latin American critics living in Paris played in disseminating knowledge about both European and Latin American art across the Atlantic.

By 1930 Latin American artists began to conceive of themselves as a cohesive group, not to the exclusion of their national identity or European collaborations, but as an additional alliance within the international artistic community in Paris. That year Joaquín Torres García organized the *Première exposition du Groupe Latino-Américain* at the Galerie Zak, which showcased the work of twenty-one artists who were experimenting with vanguard tendencies. In the history of Latin American modernism, Torres García is widely acknowledged as a formative figure in the introduction and promotion of constructivism and abstraction in Latin American art, but the full implications of his presence in Paris in the interwar years have yet to be examined. Chapter 8 details Torres García's many contributions to Parisian avant-garde art circles as an artist, innovator, organizer, and theoretician.

Chapter 9 considers the myriad ways Latin American artists engaged with surrealism in the late 1920s and throughout the 1930s. Whereas some artists became members of the surrealist group, others appropriated the movement's aesthetic and theoretical approaches from a critical distance, selectively incorporating those aspects of surrealism that suited their needs. Still other artists were designated as surrealists by their European counterparts, despite having little or no direct contact with the movement. Through a series of case studies, this chapter unravels the numerous contributions to and manipulations of surrealism by Latin American artists in Paris.

Finally, Chapter 10 focuses on the years just preceding World War II and the brief resurgence of interest in Latin American art during this period. Starting with a discussion of the 1937 *Exposition internationale des arts décoratifs et industriels modernes,* the chapter examines in detail several exhibitions at Parisian galleries and the types of artwork chosen for display in the late 1930s. While much of the art made during these tumultuous years foregrounded cultural nationalism, there were several voices of resistance and distinction that provided a counterpoint to the dominant aesthetic preferences of the moment.

Contact with and participation in an international avant-garde community in Paris fundamentally shaped the direction of modern Latin American art, whether it provoked a rejection or embrace or selective reinterpretation of European tendencies. It was the experience of living and working in Paris that facilitated this self-identification as a group, which in turn allowed for an expanded sense of kinship among Latin American artists once they returned home. The critical mass of Latin American artists working in Paris also expanded the worldview of European artists and intellectuals in more subtle ways, however. Without contact with these artists, for example, it seems unlikely that the surrealist poet André Breton (1896–1966) would have organized an exhibition of surrealist art in Mexico in 1940. Hence, without the intense transnational dialogues that occurred in Paris between the wars, neither Latin American nor European modernism would have taken the forms they did. Accounting for these artists' contributions to the Parisian art scene between the wars greatly enhances our understanding of the artistic landscape during this period as well as those that followed.

1 Among the Cubists

Cubism was one of the most influential and innovative avant-garde movements to emerge in the early years of the twentieth century. Many Latin American artists experimented with cubist techniques in the 1920s, but only a select few were directly involved in its development in the years surrounding World War I. While artists often proudly mentioned contact or friendship with Pablo Picasso in letters or autobiographies, since Picasso did not take pupils, he was rarely the source of direct knowledge of the movement. Rather, the few Latin American artists who engaged and exhibited with the cubists did so in the context of Léonce Rosenberg's art gallery. This chapter will examine the work, patronage, and exhibition history of three (and, later, four) Latin American artists who made significant contributions to cubism, tracing their embrace and eventual rejection of the movement.

CHEZ LÉONCE ROSENBERG

At a moment when many French artists were absent from Paris, either abroad or on the war front, art dealer Léonce Rosenberg created new opportunities for foreign artists who remained in the city. While there were very few Latin American artists residing in Paris during World

War I, three artists working in a cubist mode—Chilean Manuel Ortiz de Zárate (1887–1946) and Mexicans Diego Rivera and Angel Zárraga (1886–1946)—gained important exposure and artistic contacts through their affiliation with the dealer.[1] For Rosenberg, the structural and aesthetic lessons of cubism were the essential expression of modernism, and he selected the artists whom he endorsed accordingly. While Ortiz de Zárate, Rivera, and Zárraga interacted with Rosenberg in different capacities, they all benefited, at least temporarily, from his patronage and contributed unique interpretations of cubism to Rosenberg's gallery. These artists set the stage for a decade of intense Latin American engagement with European modernist movements.

Léonce Rosenberg and his brother Paul inherited their profession from their father, Alexandre. In 1906 they took over his gallery on 38, Avenue de l'Opéra, Paris, but soon split ways. In 1910 Léonce opened his own gallery, Haute Époque, at 19, rue de la Baume, which he would rename the Galerie de L'Effort Moderne in 1918. There he began cultivating his interest in contemporary art while continuing to deal in antiquities from Egypt, Asia, and Africa. During the war Léonce, unlike his brother, served in the 15th Wing

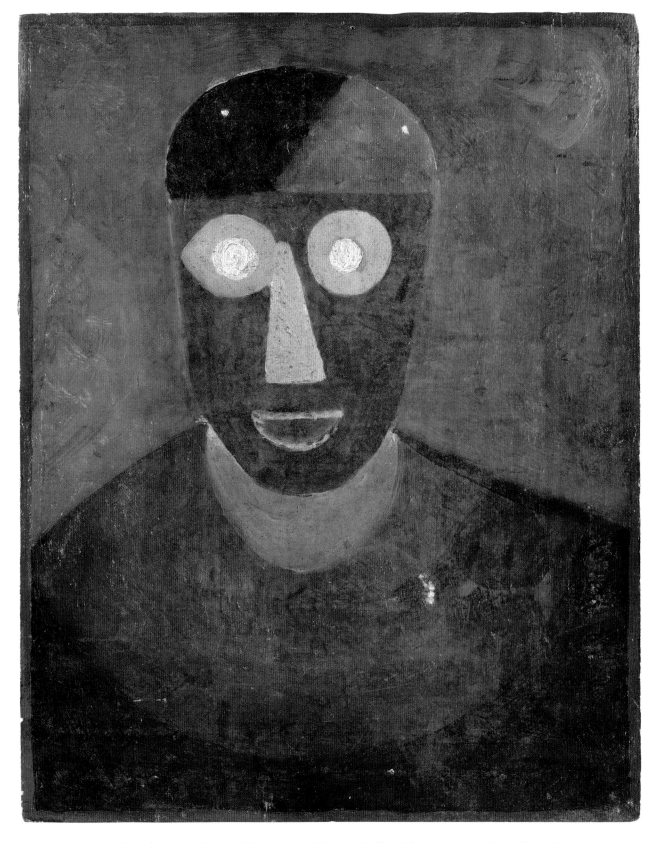

FIG. 5. Manuel Ortiz de Zárate (1886–1946), *Portrait of Picasso*, 1920–25. Oil on wood, 14⅔ × 16⅛ in. (37.2 × 41 cm). Musée Picasso, Paris.

of the Royal Flying Corps with the British Expeditionary Force; but it seems that by 1916 he was back in Paris to regain his health, and at the urging of Picasso, he began positioning himself as the champion of cubism.[2] Since Daniel-Henry Kahnweiler had been forced to leave Paris and close his gallery during the war, Léonce Rosenberg emerged as a dominant force in the contemporary art market. Indeed, Rosenberg may very well have taken advantage of artists whose sources of support had disappeared during the war in order to build up his stock of paintings.[3] With virtually no competition, he signed Diego Rivera, Juan Gris, Jacques Lipchitz, and Henri Laurens to exclusive contracts in April 1916, Georges Braque in November of that same year, and Fernand Léger as soon as he returned home from the front in December 1917, gaining unprecedented control over the presentation and sale of their work.[4] On January 1, 1919, he added Gino Severini to his clientele with a three-year contract. While Picasso never signed an exclusive contract with Rosenberg, he did work with him briefly before he left to work with Paul Rosenberg in 1918.[5] Similarly, André Lhote consigned art to Rosenberg without a binding contract after his return from the front in 1917, as did two other Latin American artists, Angel Zárraga and Manuel Ortiz de Zárate.

It is tempting to speculate that Ortiz de Zárate and Zárraga were not offered contracts because they were less well known than the other artists under Rosenberg's charge, but this was most likely not the case. Rivera's subsequent fame in Mexico has tended to skew accounts of his popularity in relation to other Latin American artists living in Paris with whom he was actually on similar ground. Both Zárraga and Ortiz de Zárate were well established in Paris before beginning their association with Rosenberg. They were regular contributors to the Paris salons and their work was often reviewed in the French press.[6] As Ramón Favela points out: "Although the same age as Rivera, Zárraga was well-entrenched in the artistic and social landscape of Paris and Madrid before Rivera's arrival. . . . Rivera walked in Zárraga's shadow in Paris and Spain until 1914 and was again overtaken by Zárraga's popularity among Parisian critics after 1918."[7] In 1928, for example, Zárraga sold a still life for 6,000 francs, whereas Rivera's *Tour Eiffel* sold for only 850 francs that same year.[8] Ortiz de Zárate, who had arrived in Paris in 1904, was also a fixture in the Montparnasse art and social scene. He lived directly below Amedeo Modigliani and formed a close bond with the Italian and was also friendly

with Tsuguharu Foujita and Picasso.[9] He often participated in group shows with the most advanced artists of the day, and it was he who introduced Rivera to Picasso in 1914.[10] In June 1916, just after Rivera signed with Rosenberg, Ortiz de Zárate took part in a group exhibition at the Galerie des Indépendants that included works by André Derain, Fernand Léger, André Lhote, Henri Matisse, Jean Metzinger, and Pablo Picasso; in November of that year he co-organized and contributed to the first exhibition at the new Montparnasse gallery Lyre et Palette, with works by Moïse Kisling, Modigliani, and Picasso displayed alongside African sculptures. Ortiz de Zárate's *Portrait of Picasso* is a humorous tribute to Picasso and his exploration of African art that demonstrates Ortiz de Zárate's involvement with the movement and its key proponents (fig. 5).[11] Thus, Zárraga and Ortiz de Zárate may have followed the lead of Picasso and Lhote, who opted not to commit themselves exclusively to Rosenberg, in order to maintain more autonomy over the distribution and sale of their work; Rivera was most likely in greater need of support and had more to gain from the stability of a contract with Rosenberg in 1916, since he had recently lost his scholarship from the Mexican government.[12]

Although they maintained a more informal relationship with the dealer, Angel Zárraga and Manuel Ortiz de Zárate consigned many of their cubist paintings to Rosenberg to sell between 1916 and 1918.[13] *Still Life with Lemons and Tapioca,* a painting by Zárraga that can be traced back to Rosenberg's gallery, is typically cubist in its flattened forms and faceted shapes (fig. 6). The bottle of dietary tapioca, which could be a subtle reference to Zárraga's Latin American origins, is a peculiar subject for a still life. Tapioca is a starch extracted from the cassava plant, a plant native to South America. But since the writing on the bottle is in French, the tapioca, like the lemons (a ubiquitous still-life motif), suggests cross-cultural trade and travel rather than specific cultural origins. Rather, the items in the still life may simply serve as motifs upon which to experiment. In this painting Zárraga employs cubism as a framework for an exploration of color relationships by dividing the canvas into green and blue halves united by the bright forms of the yellow lemons rendered from three different vantage points. Within each color half, Zárraga investigates variations in tone and hue, punctuated with rectangular planes of pink and red.

Another cubist painting that Zárraga made around the same time, *Coffee Jar,* also demonstrates his mastery

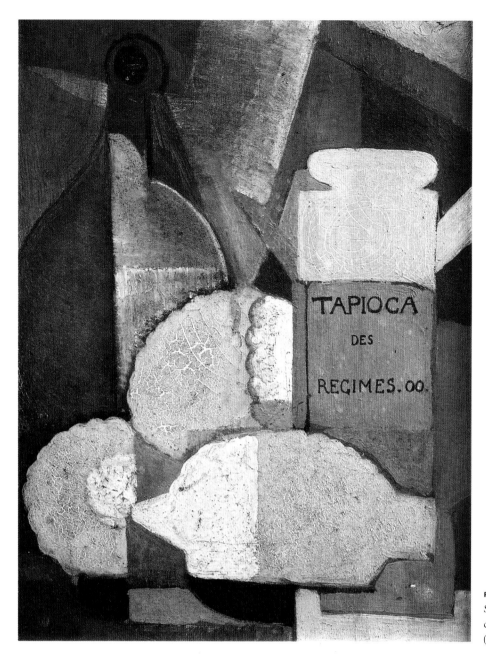

FIG. 6. Angel Zárraga (1886–1946), *Still Life with Lemons and Tapioca*, ca. 1916. Oil on canvas, 13¾ × 10⅔ in. (35 × 27 cm). Private collection.

of characteristic cubist techniques, while simultaneously foregrounding his subtle play with color (fig. 7). The inclusion of areas of stippling and multiple perspectives engages the vocabulary developed collectively by the cubists under Rosenberg's patronage. The painting depicts a coffee jar with a conical lid surrounded by other vessels, perhaps a sugar bowl and a bottle. In the foreground is a fan, spread open to reveal its segments, which are decorated with miniature Orientalizing motifs. While Zárraga depicted the coffee jar and the vessels from the front, he also rendered the surface of the table and the fan parallel to the picture plane, thereby combining several different vantage points in the same composition. The

core geometries of the vessels beget similar shapes in the surrounding space. The arc of the fan mirrors the curve of the sugar bowl, whose trajectory continues into the space beyond it, for example. And the curve recurs again in the lip of the coffee jar. These curvilinear forms intersect with the surrounding flattened cubist space, creating a dynamic interplay between lines and curves. Zárraga's most interesting choice here, as with *Still Life with Lemons and Tapioca,* is his subtle manipulation of color. His juxtaposition of different hues of blue, orange, green, red, and pink, sometimes saturated, sometimes subdued, takes cubism beyond an exploration of space into the realm of color theory. Texture adds to the complexity of these

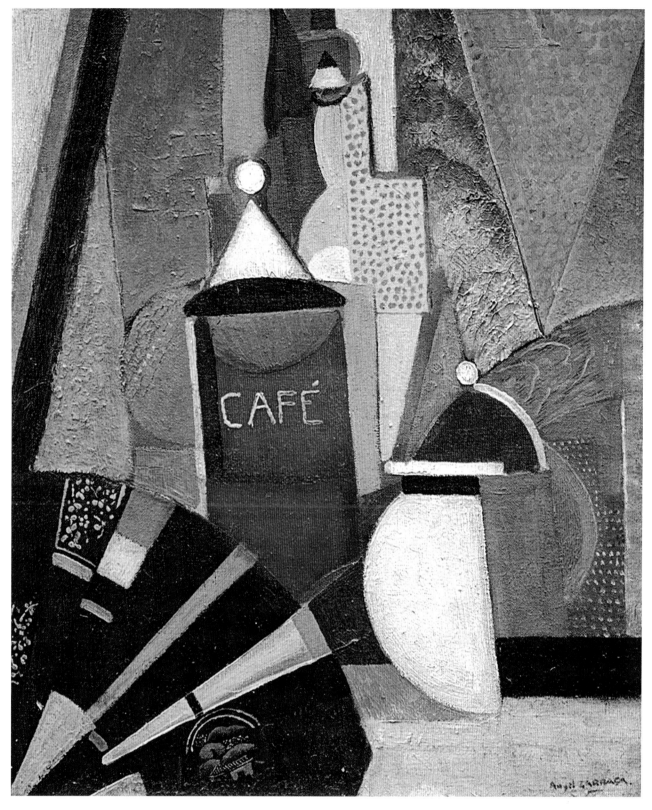

FIG. 7. Angel Zárraga, *Coffee Jar*, 1916. Oil on canvas, 21¼ × 17¾ in. (54 × 45 cm). Collection of Pierre Moos, Paris.

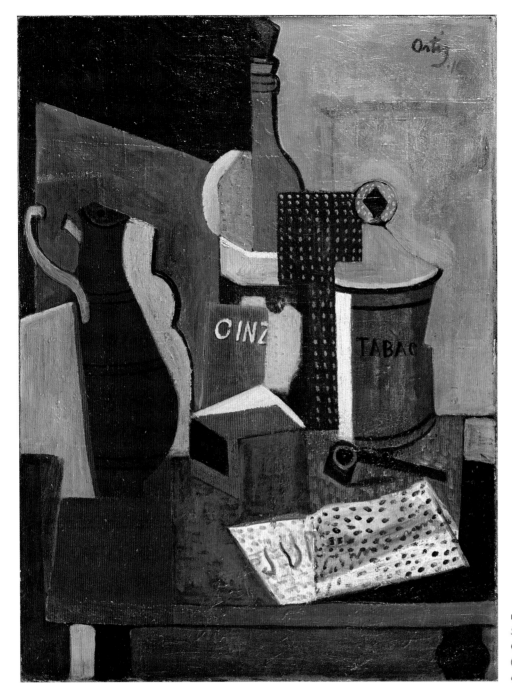

FIG. 8. Manuel Ortiz de Zárate, *Still Life with Tobacco Pot,* 1916. Oil on canvas, 28⅞ × 21½ in. (73.5 × 54.5 cm). Private collection.

color combinations, with some areas rendered in pure smooth hues, others stippled in complementary colors, and still others built up into a thick, multicolored impasto. In a 1919 letter to his family in Mexico, he writes: "I don't see why cubism has to be puritanical concerning color. . . . Should a painter deny himself the pleasure of rich pigments, of the attractiveness of the subject, of the play of light on landscapes and figures?"[14] This reflection reveals one of Zárraga's primary contributions to cubism: an investigation of the role of color in determining a cubist construction of space.

Like Zárraga, Ortiz de Zárate almost never revealed his Chilean heritage in his work. It was not until 1924, when he participated in the survey of Latin American art at the Musée Galliera, that French critic Jean-Gabriel Lemoine remarked in his review of the show: "It took this exhibition for us to learn that Ortiz de Zárate, the loyal participant in the Indépendant and Automne salons, was Chilean. Neither his art nor his person reveal anything particularly national."[15] While it is more difficult to pin down exactly which paintings by Ortiz de Zárate passed through Rosenberg's gallery, a work such as *Still Life with*

FIG. 9. Diego Rivera (1886–1957), *Zapatista Landscape*, 1915. Oil on canvas, 56⅔ × 48⅜ in. (144 × 123 cm). Museo Nacional de Arte, CONACULTA, INBA, Mexico City.

Tobacco Pot of 1916 is representative of this time period (fig. 8). This work shows a sophisticated play between flatness and volume, incorporating the characteristic cubist stippling initiated by Picasso around 1914, amidst forms painted in a limited palette of earth tones offset by cool grays and blues. This painting focuses on the leisure activity of pipe smoking, with the pipe, tobacco pot, and ash container (the letters *cinz* are most likely a truncated portion of the Portuguese word *cinza*, which means ash) clearly visible, along with a bottle of wine and a newspaper. Like Rosenberg's other protégés of the period, the painting evidences a clarity of design and structure that stems from the cut-out shapes of synthetic cubism. The artists Rosenberg supported were, for the most part, proponents of what French critic Maurice Raynal deemed "crystal" or "classical" cubism because of the severe quality of their edges, their clarity of color and line, and their intellectual approach to painting and sculpture.[16] Ortiz de Zárate's works fell directly in line with these criteria.

Unlike Zárraga and Ortiz de Zárate, Rivera maintained a much more extensive relationship with Rosenberg because of the exclusive contract he signed with the dealer. Rosenberg's wartime patronage of the artist sustained him

during a difficult period and resulted in the presentation and circulation of many of his cubist paintings in Paris. The details of Rosenberg's contracts varied according to the renown of the artist, however. Braque's contract, for example, provided Rosenberg first choice of the works the artist produced and required a minimum purchase of 1,000 francs per month, whereas other contracts stipulated much lower rates and maximum rather than minimum purchase arrangements.[17] Rivera's contract was similar to that of Gris and Laurens, requiring that he deliver "about five major pictures a month, not counting the sketches, pastels, watercolors, etc." for payment ranging between 250 and 280 francs.[18] Rosenberg's first purchase from Rivera was the now-famous *Zapatista Landscape* (fig. 9), most likely referred to at the time simply as *Paysage*, and from then on much of Rivera's cubist production passed through Rosenberg's hands.[19] One painting specifically identified in the letters exchanged between Rivera and Rosenberg in 1916, *Bouquet of Flowers* (now known as *Still Life with Vase of Flowers*), exemplifies the types of painting Rosenberg acquired (fig. 10).[20]

In *Still Life with Vase of Flowers*, Rivera employs highly textured paint to emphasize the tactility of the surface, and consequently the notion of the painting as an object in its own right. Rivera does not simply render the vase in multiple perspectives, but rather transforms it into a guitar with his subtle modification of the vase's silhouette and the addition of a black semicircle and L-shaped neck. As a result, the pink and mauve blooms striated with green stems suggest the rhythm of musical notes, and the white silhouettes of flowers against the black background approximate the color of sheet music. The form thus vacillates between a bouquet of flowers and guitar and sheet music, moving away from a direct analysis of form to hint at the profound creativity Rivera developed in the years to come.

Since there is an extensive body of literature on Rivera's cubist period, a comprehensive overview of his work is not necessary here; rather, his cubist practice will be examined within the larger spectrum of Rosenberg's gallery.[21] With the work of the leading cubists under his charge, Rosenberg set out to corner the market and shape the future direction of the movement. His patronage established a network of like-minded artists who could exchange cubist theories and aesthetic approaches. As Lipchitz would later describe: "We were all working so intimately together that we could not help taking motifs from one another."[22] It was in the context of Rosenberg's

FIG. 10. Diego Rivera, *Still Life with Vase of Flowers*, 1916. Oil on canvas, 32⅛ × 25⅞ in. (81.6 × 65.7 cm). Private collection.

gallery that Rivera, Ortiz de Zárate, and Zárraga solidified artistic alliances and participated in the intellectual exchanges and debates over cubism's potential course. While Rosenberg's contracts offered a limited source of income for artists whose livelihood had dried up during the war years, the dealer took advantage of the situation to strictly monitor those artists under his patronage. What at first seemed to be a uniting of like-minded artists soon degenerated as many of the artists under Rosenberg's patronage chaffed under the strict control he asserted over the sale and exhibition of their work.

When André Lhote joined Rosenberg's gallery after he returned from the front, he renewed his friendship with Rivera, whom he had met in 1913. Lhote and Rivera shared a desire to maintain readability in their cubist compositions, constructing their pictures out of planes of solid color.[23] Both envisioned cubism as an outgrowth of traditional pictorial conventions rather than a radical break with the past. In a letter from Lhote to his friend G. Pauli dated July 26, 1917, Lhote asserts: "I've made some sensational discoveries with my friend Rivera concerning the laws of construction of a picture. They have been the same ever since the Greeks and up to Cézanne (who zealously kept the secret) via Rembrandt, El Greco, Velázquez."[24] These discussions took concrete form in an exploration of cubist portraiture by the two artists in 1917.

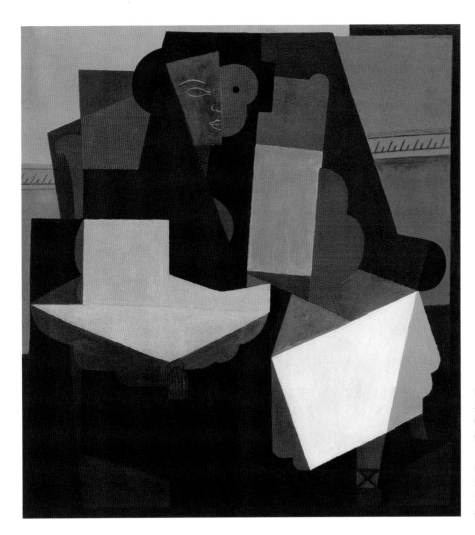

FIG. 11. Diego Rivera, *Portrait of Madame Marguerite Lhote*, 1917. Oil on triplay (plywood with pine veneer), 47¼ × 43⅓ in. (120 × 110 cm). Private collection.

FIG. 12. André Lhote (1885–1962), *Woman with Striped Apron*, 1917. Oil on canvas, 13¾ × 10⅜ in. (34.9 × 26.5 cm). Private collection.

During one of his visits to the Lhote household in 1917, Rivera executed *Portrait of Madame Marguerite Lhote* (fig. 11). Following the premise of synthetic cubism, Rivera constructs his subject out of a series of flat geometric shapes. While each shape is entirely abstract and bears no visual resemblance to the sitter on its own, through its positioning in the composition and relationship to other shapes, it starts to take on meaning. The placement of a small black circle on a bulbous salmon-colored shape located in the upper center of the composition becomes an eye on a face. Similar curvilinear shapes suggest hands or the ruffles of a dress, and right angles become the angle of a chair or an elbow. André Lhote's painting *Woman with Striped Apron*, which also may have been a portrait of Marguerite, made the same year, indicates many points of convergence between the two artists (fig. 12). While Lhote's portrait remains much more readable according to the traditional conventions of portraiture than Rivera's, the artists' shared exploration of form is evident in several areas. In both paintings, the artists have rendered the

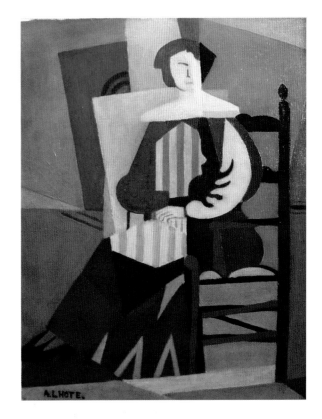

face in two segments. Whereas the segment on the right remains essentially abstract, Lhote and Rivera superimposed a linear outline of facial features on the left portion, ensuring that the viewer undeniably identifies the accumulation of shapes as a figure. To further solidify this reading, each figure reveals a shoe reduced to simple, bold forms, defining the limits of the body in space. Finally, both artists have employed similar methods of rendering the interior space of the room, including decorative wall molding to identify the setting as a conventional interior, while simultaneously disrupting the academic rendition of deep space through the inclusion of multiple perspectives, indicated by the angles of the molding.[25] This visual dialogue between Rivera and Lhote regarding the cubist portrait provoked Rosenberg's collaborator, the French poet Pierre Reverdy, to proclaim that portraiture and cubism were essentially antithetical practices that could not be reconciled.

In his essay "Sur le cubism," published in March 1917, Reverdy attempts to define the parameters of cubism, insisting that a portrait cannot be rightly called cubist, because it requires a visual likeness: "We will not admit that a cubist painter can execute a portrait.... What he has managed to create is a work, a composition in this case, and not a head or an object constructed according to the new laws, which, when they are successful, do not allow for resemblance."[26] Rivera and Lhote, like Picasso before them, found the figure, be it generic or specific, to be a versatile and fitting point of departure for experimentation with cubist structures. While their so-called "portraits" clearly depart from visual resemblance, for Reverdy the mere fact of an identified sitter negates the authenticity of the artist's dedication to cubist technique. Because of the implied insult to Rivera and Lhote, the article resulted in the now notorious altercation between Rivera and Reverdy at Lhote's home after a party hosted by Rosenberg. While Rosenberg made various attempts at reconciliation between those who sided with Reverdy and those who supported Rivera, this conflict marked the beginning of a dispute that would eventually split the gallery into cubist and anti-cubist camps.

REJECTING CUBISM

Rivera renewed his contract with Rosenberg on November 15, 1917, but tensions continued to mount between the artist and his dealer over the limitations of cubism and artistic freedom. During the summer of 1918, Rivera and his wife, Angelina Beloff, traveled with

FIG. 13. Diego Rivera, *Portrait of Jean Cocteau,* 1918. Pencil on paper, 18⅛ × 11¾ in. (46 × 30 cm). Carlton Lake Art Collection, Harry Ransom Humanities Research Center, University of Texas at Austin.

the Danish couple Adam and Ellen Fischer to the Bay of Arcachon on the Atlantic coast of France. Lhote and French writer Jean Cocteau were staying nearby, and the group often spent afternoons together.[27] There, Rivera made a pencil portrait of Cocteau that evidences an almost Ingres-like classicism, in explicit defiance of Rosenberg's continued advocacy of a narrowly defined cubism (fig. 13). While he did not intend the portrait for Rosenberg's gallery, his contract was so binding that Rivera had to write to his dealer to request permission to offer the drawing to the poet.[28] This degree of control over artistic output did not sit well with Rivera.

During the summer of 1918, Rivera continued exploring new aesthetic directions, chafing more and more under Rosenberg's oversight. Together Rivera and Lhote embarked on a rediscovery of Cézanne as a means to redeploy the lessons of cubism as the foundation for a more traditionally readable composition.[29] One of Rivera's

paintings of that period was *Landscape at Arcachon,* which clearly indicates his close study of Cézanne in its structuring of the surface with patches of pigment, its areas of *passage,* and its muted palette of greens and warm earth tones (fig. 14). Lhote, too, explored Cézanne with works such as *Village by the Sea* (fig. 15). Together with Adam Fischer, Rivera and Lhote began preparing a group exhibition of their work (along with that of the younger artists Eugène Corneau, André Favory, and Gabriel Fournier) at the Galerie Blot in Paris.[30] Their plans to exhibit non-cubist paintings based on the precepts of Cézanne heightened the rift between them and Rosenberg, instigating what French critic André Salmon deemed the Rivera Affair.[31] To express his discontent, Rosenberg published a letter in art critic Louis Vauxcelles's column "Carnet des ateliers" for the journal *Carnet de la semaine,* calling Rivera and Lhote to task for straying from the cubist framework. Vauxcelles, who felt the movement was too restrictive and was actively encouraging artists to leave Rosenberg, was all too happy to print Lhote's and Rivera's responses in the next issue.[32] Indeed, his introduction practically revels in Lhote's and Rivera's vehement defense of their right to evolve as artists and move beyond cubism.[33] Lhote begins:

> I noted in the letter that M. Léonce Rosenberg asked you to print in the last *Carnets des ateliers* a passage that concerns me since the content could be misinterpreted by the reader. Mr. Léonce Rosenberg speaks of "the cubist aspect that my paintings possessed during a certain period." One might think that he was tricked into

being interested in my efforts when this "cubist aspect" appeared and that he was right to lose interest in them the day that my paintings possessed less of a "modern effort," and represented forbidden subjects such as nudes and portraits. While during the year that M. L. R bought my paintings, I was brought fatally close . . . to working parallel to the so-called cubists. . . . During that same year, never did I hide the fact that I distanced myself from all formulas that allow logic to encroach on sensitivity, or my taste to be guided by instinct.[34]

Rivera followed up with a defense of his own, asserting: "My most essential endeavor was always to follow Cézanne's teachings. Instinct directed me to search for a foundation, a structure. Once that base was established, that same instinct pushed me to decorate the structure, which cannot be humanized if it remains a scaffolding. Hence, the necessity to paint fully. . . . And if because of this we are no longer cubists, oh well, all the better."[35] Rivera's nonchalant dismissal of cubism suggests that his choice to abandon the movement's precepts was definitive and that he would not attempt a compromise with his dealer. For both artists, cubism had become formulaic, and they would not comply with Rosenberg's desire to establish a set of norms for what constituted modern art. Whereas Rosenberg felt he was within his rights to demand a certain aesthetic from his artists, Lhote and Rivera believed that he should accept their evolution as artists without shaping it.

Unfortunately for Rivera, Rosenberg turned out to be quite vindictive in his efforts to control and define the

FIG. 14. Diego Rivera, *Landscape at Arcachon,* 1918. Oil on canvas, 21¼ × 25⅔ in. (54 × 65 cm). Private collection.

FIG. 15. André Lhote, *Village by the Sea,* 1918. Oil on canvas, 18 × 25½ in. (45.7 × 64.8 cm). Private collection.

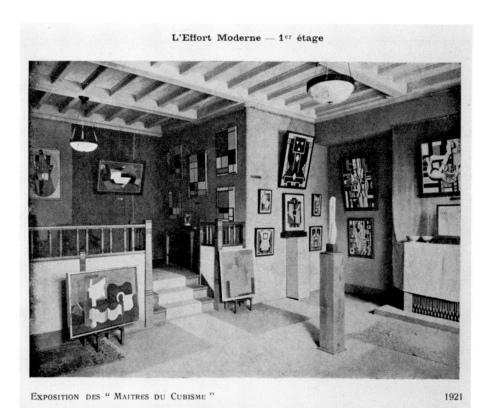

L'Effort Moderne — 1ᵉʳ étage

EXPOSITION DES " MAITRES DU CUBISME " 1921

FIG. 16. *Exposition des "Maitres du Cubisme,"* Galerie de L'Effort Moderne, 1921. Photograph in the *Bulletin de l'effort moderne,* no. 1 (January 1924): 9–10.

market, essentially hoarding Rivera's works and keeping them from circulation in the months prior to and after canceling his contract. As Adam Fischer relates: "For the past half year a powerful press campaign has been carried on against a certain art dealer who is sitting on a large stock of Cubist art, and who, in order not to damage his business, has made use of a contract he had with a young painter to take his entire production in order to, by hiding his pictures, conceal the fact that he was on the point of abandoning Cubism."[36] Rosenberg finally relented and released Rivera from his contract, just in time for him to open his show at the Galerie Blot, which Vauxcelles conveniently stepped in to co-organize.

The exhibition at the Galerie Blot marked Rivera's ultimate departure from Rosenberg and cubism. In his review of the exhibition, however, André Salmon suggests that Rivera's outright rejection of cubism was a ploy to position himself as a leader rather than a follower of the likes of Braque and Picasso. By positing cubism as a means rather than an end in itself, he argues, Rivera constructed cubism as a "blocked passageway" that, in order to be escaped, must be renounced.[37] In renouncing it, he would be moving modern art in a new direction. But Rosenberg remained a significant controlling force in the Parisian art market, impeding Rivera from making the mark he had hoped. He continued to hold all of Rivera's paintings in

his possession for nearly three years, until 1921, when he finally put them up for sale at public auction along with works by Lhote, Lipchitz, María Blanchard, and Zárraga, all of whom were no longer working with the dealer.[38] Moreover, Rivera's enthusiasm for continuing to forge ahead in Paris may have been dampened by his decision to return to Mexico at the invitation of the secretary of education, José Vasconcelos, as well as difficulties in his personal life. Thus, while Rosenberg served as an important force in promoting Latin American cubists during the war, he also had the power to curtail, at least temporarily, their careers in Paris.

After Rivera split with him in late 1918, Rosenberg inaugurated the Galerie de L'Effort Moderne with an ambitious series of exhibitions intended to assert a cubist aesthetic as the essential means forward after World War I (fig. 16). Rosenberg coined the term "L'effort modern," or "modern effort," as his professional trademark, employing it as the name for both the gallery and the art journal he founded in 1924, which will be discussed in Chapter 7. The phrase "modern effort" implies a deliberate and focused determination to promote the most up-to-date trends. The exhibition series comprised solo shows of the wartime paintings and sculptures of Braque, Picasso, Gris, and Lipchitz. Just as Rosenberg's aesthetic and commercial vision began to crystallize, however, many of the original

artists under his charge, dissatisfied with Rosenberg's strict control over their production and continued advocacy of a narrowly defined cubist style, began leaving the ranks. By 1920 Braque, Gris, Laurens, and Lipchitz, along with Picasso, Lhote, Zárraga, and Ortiz de Zárate (who had informal relationships with the dealer), had all defected. Only Léger, Severini, Auguste Herbin, and Metzinger continued to work with Rosenberg for several more years. Rosenberg maintained a wartime monopoly, but as soon as the war was over and new opportunities emerged for the sale and presentation of modern art, he was unable to sustain his position.

Like Rivera, Ortiz de Zárate and Zárraga were among the first to turn their back on cubism, choosing instead to embrace the more classicizing aesthetic that came to be known as the return-to-order. The exact trajectory of Ortiz de Zárate's transition away from cubism is difficult

FIG. 17. Manuel Ortiz de Zárate, *Nude*, ca. 1927. Location unknown. Reproduced in Manuel Ortiz de Zárate and Galerie Bernheim Jeune, *Exposition Ortiz de Zárate* (Paris: Bernheim Jeune, 1927), n.p.

to pin down because he often did not date his paintings, but in 1920 André Salmon wrote that he renounced cubism with "more pride and civility" than Rivera.[39] And the following year another critic described Ortiz de Zárate's contribution to a group exhibition at the Café du Parnasse as a "richly modeled voluptuous nude" that celebrated "the monumental power of a beautiful woman's body."[40] In 1927 Ortiz de Zárate held a major solo exhibition at the Galerie Bernheim-Jeune that consisted of sixty-four paintings of still lifes, floral arrangements, and monumental female nudes (fig. 17), with no hint of his foray into cubism.[41] He does not seem to have interacted with Rosenberg at all during the 1920s and instead turned to the French salons as his primary exhibition venue.

Zárraga, like Rivera, was forthcoming about his departure from cubism, contributing frequently to discussions in French journals on the topic. While he spoke with reverence of cubism as a foundational phase in his artistic development, he felt that cubism's moment had passed and that it had degenerated into a decorative motif that no longer maintained its former level of visual provocation. Writing in 1924, in response to an "inquiry" into cubism in the *Bulletin de la vie artistique* entitled "Chez les cubistes," Zárraga explains:

> Cubism, which was born from brilliant hypotheses, from an anguished search, from chaotic demolitions, cannot be regulated in five seconds; nevertheless that is exactly what they want us to do: haste of the pedants, unbridled ramblings of incontinent men, sickly fever of women who want to understand immediately and who demand explanations. In brief, they want us to make a pretty amusement park for women of leisure to stroll through from what was once a magnificent virgin forest. And from what was the obscure and tremendous (the word is not too strong) contribution of the elite of one generation, they made into a trivial pastime for the latecomers to the avant-garde or a pretty decorative motif for department stores yearning for novelty. It was and still is much more than that: more than a decorative pastime, more than gossip at five o'clock tea, more than theatrical or choreographic entertainment, more than a *business*.[42]

There is no evidence of an actual rift between Rosenberg and Zárraga, but Zárraga's reference to regulating cubism and the mention of business at the end of this passage may very well be an expression of frustration with Rosenberg's

FIG. 18. Toño Salazar (1897–1986), *Caricature of Blaise Cendrars.* Reproduced in Toño Salazar, *Caricatures* (Paris: L'Agence Technique de la Presse, 1930), n.p.

the tail, and the incendiary orchid clusters of architectures that fall on top of them and kill them."[46] His words express his simultaneous awe and disgust with the modern moment in which new technologies have taken over, replacing the natural world with their cold, mechanical efficiency. His poems are marked by an emphasis on speed, simultaneity, motion, and increasing disorientation.

Zárraga's drawings are not meant to illustrate specific imagery evoked in the poems, but rather to parallel the sentiments Cendrars conjures. Made just as Zárraga was on the cusp of abandoning cubism, these drawings suggest a return to a more figural mode of illustration while simultaneously maintaining the emphasis on geometry and angular form associated with cubism. Two of the drawings allude directly to the extreme bodily maiming of soldiers as a result of the destructive new technologies of World War I: trench warfare, armored tanks, and poisonous gas. One depicts a figure whose legs have been amputated at the knee, pulling himself along with a crutch (fig. 19). His upturned face has been grotesquely distorted so that it no longer resembles a human being, but rather becomes a nightmarish machine age automaton. What looks like the spout of an oilcan projects from his shoulder, further dehumanizing the figure. In another drawing, the figure has become completely robotic, with a square head and a claw-like appendage replacing the arm; two crutches keep the figure from toppling over. Oddly, Zárraga's other illustration in the series draws on Mesoamerican iconography (fig. 20). A masked figure on bent knee, the water and fertility god Tlaloc, holds a writhing serpent that appears to be about to bite his thumb. Wings protrude from his shoulders like an angel, but he is dressed in armor and wears a warrior's helmet. Depicted in profile, the figure's hooked nose, schematized features, and "speech scroll" suggest Zárraga's knowledge of sixteenth-century codices such as the Codex Borbonicus in French collections. Yet Zárraga seems to have deliberately combined iconographic traditions here: pre-Columbian, Christian, and cubist elements mingle in an image that alternates between archaic and modern, in which schematic design alludes to both a mechanized futuristic world and the warriors of Mexico's past.

These drawings were some of Zárraga's few forays into illustration and quite an anomaly in terms of subject matter. His paintings of this period, such as *Still Life with Fruit and Necklace* (fig. 21), also exemplify his return to a more naturalist mode of picture-making in 1918, but

attempts to normalize and package cubism for the market, thereby undermining the creative intensity that marked early cubist explorations.

While Zárraga's esteem for cubism's historical significance remained intact, like Rivera, he made no explicitly cubist pictures after 1917.[43] That year he began to explore new pictorial possibilities in collaboration with the Swiss poet Blaise Cendrars. Back in Paris to recover from the amputation of his arm on the Western Front (fig. 18), Cendrars asked Zárraga to illustrate his book of poems *Profond aujourd'hui*.[44] Cendrars referred to *Profond aujourd'hui* as an "elegy to the futurist moment."[45] The cynical tone of the poems, however, reflected his personal experience with the destructive nature of "futurist" technologies on the Western Front. In his opening "ode" to technology, he writes of "Extravagant signboards over the multicolored city, with the ribbon of streetcars climbing the avenue, howling monkeys holding one another by

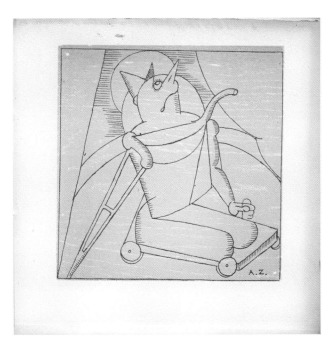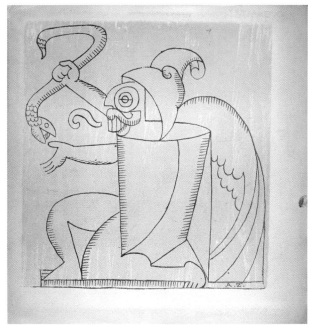

FIGS. 19 AND 20. Angel Zárraga, Illustrations for Blaise Cendrars, *Profond aujourd'hui* (Paris: La Belle, 1917), n.p.

have none of the references to war and national identity evident in his drawings for Cendrars. *Still Life with Fruit and Necklace* evidences the current zeal for Cézanne in Zárraga's pure volumes of bold color: the spheres of the persimmon and oranges, the rectangular box on which they sit, and the ellipse of the white bowl.[47] Each shape embodies a simplicity of form and color that simultaneously maintains a strong visual resemblance to the object represented. Zárraga essentially reduces the objects to their formal essence without passing into abstraction. The background, however, consists of almost entirely

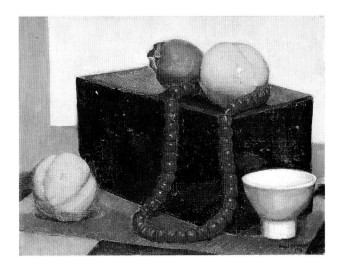

FIG. 21. Angel Zárraga, *Still Life with Fruit and Necklace*, 1918. Oil on canvas, 10⅜ × 13¾ in. (26.5 × 35 cm). Private collection.

abstract geometric forms, stacked and layered to deny the perception of spatial depth, thereby subverting the illusionary solidity of the objects in the still life. Thus, while the painting is not overtly cubist, the lessons of cubism remain apparent in its structure.

Like Rivera, Zárraga had been recruited by Mexican Secretary of Education José Vasconcelos to return to Mexico to paint public murals. Whereas Rivera accepted the offer after taking a trip to Italy to study mural technique, Zárraga opted to remain in Paris, a decision that would set him on a very different path from his compatriot. Once Rivera left the city, Zárraga began to construct an artistic trajectory that located his work within a grand French tradition rather than that of a foreigner abroad. In June 1920 Zárraga held a solo exhibition at the Galerie Bernheim-Jeune of recent paintings, none of which was from his cubist period. As with Rivera, it was Vauxcelles who stepped in to provide support and write the essay in the catalogue, helping Zárraga establish independence from Rosenberg's patronage. Vauxcelles even purchased a number of paintings for a private collector for the amount of 7,000 francs.[48] In the preface to the catalogue, Vauxcelles acknowledges the artist's great debt to cubism in his approach to composition, but argues that for Zárraga, too, cubism served as a means, not an end: "[Zárraga] only saw in cubism a means, a constraint, a method of perfecting his technique. . . . To his time with

the aestheticians, Zárraga owes two sorts of investigation, first that of the relationships between volumes, and second that of identifying the placement of color in space, in other words the integral organization of a painting and its construction of depth."[49] For Vauxcelles, Zárraga's work should be compared to the likes of Courbet, Cézanne, Matisse, Renoir, and Bonnard; in fact, Zárraga painted portraits of Renoir and Bonnard that were shown in the exhibition.[50] He even goes so far as to claim Zárraga as a *French* colorist, asking in a hypothetical dialogue, "Why are you talking about 'our tradition' here? Zárraga is a foreigner, Mexican, 'métèque,' but if we follow that line of thinking, Sisley is English? Van Gogh is Dutch? Pissarro is from the Dutch Antilles? I claim Angel Zárraga as a great French colorist."[51] According to Vauxcelles's logic, Zárraga had passed some sort of aesthetic test and, because of his talent as a colorist, now deserved to be considered French rather than *métèque*—a common derogatory term for foreigners living in France. Thus, Zárraga's foray into cubism not only earned him aesthetic experience, it earned him honorary French citizenship.

The 1920 exhibition established Zárraga's financial independence from his former dealer—fourteen of the forty paintings were sold during the show—and his aesthetic divergence from cubism. In 1921 Zárraga held a second exhibition at Galerie Bernheim-Jeune that included a retrospective section of twenty cubist paintings executed between 1914 and 1917.[52] More than half of the works exhibited were already in private collections, indicating Zárraga's freedom to access his work without the intervention of Rosenberg that so hindered Rivera, and perhaps also that his work had sold more readily than Rivera's. By including both cubist and post-cubist works in the same exhibition, Zárraga positioned himself as having benefited from but subsequently surpassed cubism, a course that Rosenberg felt undermined the so-called "modern effort." The critics, however, supported Zárraga's move. In a review for *Excelsior,* French critic René Delange proclaims: "Those who deny cubism might nevertheless perceive in it the rapport that connects experimentation with abstraction to painting. They will realize that the stabilization of studied volumes 'in the hall of representation' have permitted an exceptionally gifted artist to become a rare master of composition, to achieve a perfect equilibrium, as Félix Fénéon said, between sensitivity and logic. Zárraga, angel of cubism—as Guillaume Apollinaire called him—possesses absolute visual logic that has made

him a pure painter, where a subtle sensitivity is ordered by prodigious technique."[53] Perhaps because of differences in personality or because of his more shrewd or sustained alliances with French critics, it seems that Zárraga was able to disengage from cubism, constructing it as a foundational but outmoded practice, without the controversy that haunted Rivera.

Like the other cubists under Rosenberg's charge, Ortiz de Zárate, Rivera, and Zárraga contributed to a collective dialogue about the nature and direction of cubism between the years 1916 and 1918. Their works were certainly on par with those of their French colleagues, yet their contributions—even though Raynal mentioned both Ortiz de Zárate and Zárraga in his book *Modern French Painters,* published in 1928—have been frequently ignored or downplayed in more recent histories of cubism, which discuss the circle of artists Rosenberg assembled during the early years of his "modern effort."[54] Whereas Rivera returned to Mexico, after they separated from Rosenberg, Zárraga and Ortiz de Zárate both maintained significant careers in Paris. Ortiz de Zárate held a solo show in 1927 at the Galerie Bernheim-Jeune and remained a regular participant in the Paris salons. Zárraga became a sought-after artist in the 1920s and 1930s, participating in numerous group and individual shows, receiving important secular and religious commissions in and around Paris, as well as maintaining a presence at the salons.[55] Association with Rosenberg's gallery during the war years significantly shaped their artistic formation and served as a launching pad for these artists' careers.

Following the defection of the majority of his cubist protégés, Rosenberg attempted to regain control of the cubist market. In 1920 he published a treatise on cubism entitled "Le cubisme et tradition"—which echoed in many ways Jean Metzinger and Albert Gleizes's 1912 essay "Du 'Cubisme'"—in an effort to frame cubism as integrally related to the French artistic tradition of clarity, discipline, and order, and to position his gallery as the linchpin of the movement's commercial success.[56] For Rosenberg, modernity incorporated the lessons of the past to construct new artistic forms that were integrally linked to tradition, but were relevant to the contemporary moment. Ironically, his argument paralleled the rationalizations by Rivera, Lhote, and Vauxcelles for departing from cubism. But his essay appeared at the moment when he was losing many of the artists whose work could substantiate his proclamations. In 1921 he made a decision that most likely

damaged his commercial position further: he agreed to be the expert advisor for the liquidation of the holdings of Kahnweiler's gallery, which had been confiscated by the French government during World War I, in four auctions held between 1921 and 1923. It may very well have been at these auctions where he rid himself of his unwanted stock of paintings by Rivera, Zárraga, and Lhote as well.

ROSENBERG'S NEW RECRUIT: EMILIO PETTORUTI

By 1923 Rosenberg had reached a crossroads. His gallery was floundering and he needed to broaden and redefine his vision in order for it to survive. Between 1919 and 1924 no Latin American artists were associated with his gallery, but in 1924 an artist whose aesthetic was very much in line with Rosenberg's, Argentinean artist Emilio Pettoruti (1892–1971), came to his attention. For Rosenberg, who had begun to focus his attention on purism as a natural outgrowth of cubism, the paintings Pettoruti brought to his gallery coincided with his aesthetic preference for clean, hard-edged forms, flat areas of color, and a constructive approach to space. While this relationship never came to fruition, the initial transactions between the artist and the dealer reveal a great deal about the persistence of Rosenberg's aesthetic vision, as well as about the functioning of the gallery and the importance of gallery representation for foreign artists in Paris.

Since Pettoruti had only recently arrived in Paris, his futurist colleague Filippo Tommaso Marinetti, who was also in Paris at the time and had contributed to Rosenberg's journal in May 1924, took the lead in setting up the meeting with Rosenberg. Marinetti even accompanied Petorutti to the appointment and made sure that Rosenberg knew about Pettoruti's recent exhibition at Der Sturm in Berlin.[57] As a result of Marinetti's savvy introduction, Rosenberg asked to see Pettoruti's work, and the two made arrangements for Pettoruti to return to the gallery with some selections. Pettoruti's memory of that meeting provides a vivid picture of Rosenberg's gallery and his interactions with potential clients:

> Rosenberg brought me into a lovely room upholstered in gray, with a carpet of the same color in which one's feet sank agreeably. In the back I saw three easels and in front of them, closer to me, at a distance of about three meters, two overstuffed armchairs and a low table on which there were ashtrays, cigars and cigarettes of different brands. He invited me to take a seat,

sat down, and gave precise orders to an employee. The employee appeared with two paintings for the side easels. With another rapid order, one of my paintings occupied the central position. Rosenberg looked over all three, then two, then one, in silent inquisition, as if waiting for the pictures to speak to him. He switched out the two paintings on the sides and continued to scrutinize them; later he changed the one in the center, replacing it for a different one of my paintings.[58]

The details Pettoruti remembers highlight the sumptuousness of the gallery, which served as a tool to differentiate the dealer from the often poverty-stricken artist. Pettoruti even indicates in his memoirs that he arranged to meet at the gallery rather than his studio because he was ashamed of the shabby conditions in which he worked. This juxtaposition of wealth and poverty worked to Rosenberg's advantage, allowing him to set the terms of his interactions with artists. Pettoruti's description of just how Rosenberg scrutinized works of art also reveals a choreographed display of power over the artist in which Rosenberg positioned the already-chosen against the new recruit. The silent evaluation forced the artist to ponder: Do I measure up? Can I compete? Does my work equal that of my peers?

Pettoruti recognized that in order to acquire representation, his paintings had to correspond to the dealer's aesthetic. He therefore carefully selected the works he presented to Rosenberg, opting only to show him paintings executed between 1918 and 1920, rather than the more classicizing works he was making around 1922 such as *Girl* (fig. 22), even though Rosenberg had begun publishing similar works by February 1924 in the *Bulletin de l'effort moderne*. This decision suggests that Pettoruti may have been aware of the conflicts that plagued Rosenberg's gallery and therefore strategically chose paintings that he felt would appeal to the dealer.

Among the paintings Pettoruti presented to Rosenberg was *The Blue Grotto of Capri* of 1918 (fig. 23). Since most artists working with Rosenberg maintained a certain level of readability in their work, *The Blue Grotto of Capri* was a bold choice because at first glance it appears almost completely abstract. Cleanly defined geometric shapes painted in shades of blue, green, yellow, and gray converge on a central point of light. By reducing the size of the forms as the eye moves from the exterior edges of the canvas to the center, Pettoruti sets up a centripetal composition

FIG. 22. Emilio Pettoruti (1892–1971), *Girl*, 1922. Oil on wood, 9 × 10⅔ in. (23 × 27 cm). Private collection.

that is punctuated at times by jagged zigzags and snakelike ripples. The diagonal vectors and swirling composition reflect his contact with futurism during his time in Italy. Familiarity with the site referenced in the title, however, transforms the painting from an abstract configuration of shapes into a representational image. The Blue Grotto is a cave on the island of Capri that can only be accessed by swimming or rowing a small boat through a narrow passageway (fig. 24). The orientation and small size of the opening serve to refract and magnify the sunlight as it hits the turquoise Mediterranean waters and lights the interior of the cave. Once inside, the space opens up to reveal an enormous cavern with a pinpoint of light at its center. Pettorutti's image captures the angularity of the rocky grotto as well as the ever-shifting light as it fluctuates and moves with the waves. But it is only with a specific knowledge of this location that the image coalesces into

a recognizable representation of the place. In presenting this image, Pettoruti took the risk that Rosenberg would recognize his subtle play between abstraction and representation.

The other images he showed to Rosenberg were primarily figural and included works such as *Self-Portrait*, *Pensive,* and *The Blind Flutist. The Blind Flutist* is an early version of a motif that would become Pettoruti's trademark: the urban street musician (fig. 25). The painting depicts a three-quarter-length figure directly parallel to the picture plane playing a simple tubular flute. He is set against a background of urban apartment buildings; the lack of trees or greenery and palette of browns and beiges gives the scene a desolate, industrial feel. Like *The Blue Grotto of Capri,* Pettoruti has clustered the more intricately rendered motifs—the fingers of the hand, the striped vest with scalloped edges echoed in the undulating line of the

FIG. 23. Emilio Pettoruti, *The Blue Grotto of Capri*, 1918. Oil on canvas, 24¾ × 34¼ in. (63 × 87 cm). Private collection, Buenos Aires.

hair, and the dark glasses set over a two-tone mustache—toward the center of the composition, with larger blocks of color toward the exterior edges. Pettoruti also plays with depth and flatness in the hands framed by the space of the building in the background, and the brim of the bright yellow hat that forms the roofline of the apartment complex. Through the use of dark-brown tones, Pettoruti suggests a sense of volume in the arms, but this perception of depth is contradicted by the collapsed space in other parts of the composition.

Despite a certain visual affinity, Pettoruti did not consider himself a cubist. As he would later write, "If my painting coincides more with what is called cubism than with futurism, it is because in my youth I studied the Italian quattrocento, in which 'construction' dominates, and in addition it fits with my temperament."[59] Pettoruti also insisted that the first time he saw the work of Picasso and Gris was upon his arrival in Paris in 1924. Since it is very possible that he saw reproductions of their work in journals or magazines while in Italy, however, his

insistence on the purity of his artistic inventions could be taken as a deliberate attempt to present himself as a unique artistic voice and to position himself outside the fray of the arguments among the cubists. Moreover, since seven years had passed since the conflict at Rosenberg's gallery, Rosenberg's acceptance of these paintings may

FIG. 24. Blue Grotto in Capri. Photograph.

FIG. 25. Emilio Pettoruti, *The Blind Flutist*, 1919–22. Oil on wood, 22¼ × 17½ in. (56.5 × 44.4 cm). Private collection, New York.

indicate a slight broadening of his vision to incorporate ideas outside his originally very narrow construction of cubism.

After close examination of Pettoruti's work, Rosenberg offered to represent him. Since Pettoruti had scheduled a trip to Argentina in July 1924 for an exhibition, Rosenberg asked him, in the meantime, for some photographs of his work to include in his new journal, the *Bulletin de l'effort moderne.* According to Pettoruti's memoirs, he did not have the money to have photographs made of his work, so he promised to send some from Italy, where he had to return before his trip.[60] The photographs never arrived, and once Pettoruti landed in Buenos Aires, he decided not to return to Paris, thereby ending his relationship with Rosenberg before it had really begun. Although Pettoruti opted to remain in Argentina, with Rosenberg's patronage he could very well have established a prominent career in Paris.

While Rosenberg never considered national identity as a determinant of style, he was one of just a few dealers to support Latin American artists during this period, and continued to do so throughout the 1920s. He backed artists solely based on the affinity of their aesthetic with that of the gallery. Rosenberg's offer to represent Pettoruti in 1924 reveals the dealer's persistent assertion of a cubist aesthetic as an archetype of modernity. While many artists had abandoned cubism by this point, for him, it still represented a viable alternative to the figurative trends that had come to dominate Parisian galleries and salons. As more and more art students arrived in Paris, cubism, while no longer considered an end in itself, became a necessary vehicle through which artists could study composition and structure. Cubism informed much of the instruction at the open art academies in Montparnasse, as will be discussed in the next chapter, and became a foundational aesthetic for many of the students who passed through their doors. Rosenberg's support of the movement and the artists who contributed to it facilitated an aesthetic dialogue, or at times dispute, that shaped artistic production throughout the decade.

2 Latin American Artists in Montparnasse

MONTPARNASSE! Mecca for artists! Now that the days of light have returned, and the sun shines once again over Paris, whose trees are recovering their leaves, the strength of this neighborhood is felt now more than ever, from this Babel of art, of which one dreams from far away, and to which they come from all corners of the globe.

—Alejo Carpentier, 1928

Writing in 1928, Cuban journalist, art critic, and writer Alejo Carpentier recognized the global character and irresistible draw for artists and intellectuals of Montparnasse, the historic French neighborhood on the Left Bank of the Seine. By the 1920s Montparnasse had replaced Montmartre, where artists such as Picasso and Modigliani had congregated before the war, as the center of artistic and intellectual activity in Paris. While few Latin American artists traveled to France during World War I, after the situation began to stabilize, artists surged into the country. Cubism had begun to lose its edge as the preeminent modernist movement after the war, giving rise to a plethora of derivative, reactionary, and experimental styles. Amid this eclecticism, hundreds of Latin American artists flooded into Paris in the 1920s, with the majority converging on Montparnasse. In Montparnasse they found an artistic environment like no other, with vibrant artistic spaces such as studios, cafés, and art schools that allowed artists to intermingle and exchange ideas in a way that was inconceivable in any other city. As Cuban journalist and writer Ramón Vasconcelos writes: "Legend gave it [Montparnasse] a magnetic prestige. . . . Some imagined it to be a classical bohemian paradise, where one only had

to grow one's hair, light a pipe, and wear baggy corduroy pants to become a celebrity," whereas others imagined it as a place of "pure intellectualism" or as an "unending party."[1] Latin American artists took advantage of this environment at every level, absorbing its dynamism and gleaning ideas that could be transferred and reconfigured back home.

While Latin American artists had been traveling to Paris since the nineteenth century, the surge of Latin American artists who arrived in the 1920s was distinct in scale, intensity, and class differentiation. In the nineteenth century, a sojourn in Paris was an expected class privilege and a sign of cultivation, unobtainable for those without means.[2] Parisians for the most part took very little interest in learning about Latin America during this period.[3] This indifference began to dissipate around 1895 with the foundation of the Société des Américanistes de Paris, whose goal was "the historical and scientific study of the American continent and its inhabitants from the ancient to the contemporary period."[4] In the early years of the twentieth century, as France began to compete with Germany for Latin American markets, the French government sponsored various initiatives to provoke interest

in and knowledge about Latin America, creating the Groupement des Universités et Grandes Écoles de France pour les Rapports avec l'Amérique Latine (Consortium of French Universities and Institutions of Higher Learning for Relations with Latin America) in 1908, which focused on educating a new generation about the region as well as sponsoring intellectual exchange between France and the Americas.[5] Soon thereafter, the French state, in coordination with diplomats and industrialists, founded the Comité France-Amérique, which hosted dinners, dances, and conferences and published a monthly magazine for those with business aspirations in the region. The committee's activities were curtailed with the onset of World War I, but after the war ended, it resumed its mission with renewed intensity.[6] In the 1920s more new journals emerged such as *Hispania* (1918), the *Revue de l'Amérique latine* (1922), and *Paris, Sud et Centre Amérique* (1920s), and organizations such as the Association Paris-Amérique Latine (1925), creating an environment much more receptive to a Latin American presence.[7]

FIG. 26. Postcard of an ocean liner sent from Tarsila do Amaral to Mario de Andrade, September 8, 1924.

In addition to this new French interest in Latin American culture, other factors promoted the surge in Latin American travel to Paris. After World War I, the French franc went into rapid decline, creating favorable exchange rates for many countries in the Americas. The low cost of living in Paris mitigated the class divide, allowing students and lower-income artists from Latin America to make a journey that was previously unfeasible. The range of economic backgrounds of the Latin American artists who arrived in Paris in the 1920s led to vastly different experiences of the city, from a meager existence with little food and no heat to living in the lap of luxury, as did the Brazilian artist Tarsila do Amaral or the Uruguayan Pedro Figari (1861–1938). Most, however, were middle-class artists with a government pension or family funds to support them. As Carpentier observes, "In general, the world of writers, musicians and artists in Montparnasse, exudes a sense of economic well-being, contrary to what is commonly believed."[8] The myth of the starving bohemian artist was left behind in Montmartre.

Immigration policy also encouraged travel and residency in France. After 1917 all that was needed for entry into the country was a *carte de séjour* for foreigners over the age of fifteen, and there were few restrictions put in place until 1932, when jobs became scarce and foreign residents had reached 9.2 percent of the population.[9] This openness, which was meant to recruit foreigners to work in the mines, factories, and farms that were shorthanded after the war, benefited cultural travelers as well.[10] These cultural immigrants flocked to Montparnasse, making the foreign population there even higher than the rest of the city.

Before the advent of air travel in the mid-twentieth century, the only way to cross the Atlantic was by ocean liner. The opening of the Panama Canal in 1914 allowed those from western cities in South and Central America new possibilities for travel that had not existed previously (fig. 26). Wealthy passengers traveled in great style, partaking in sports and games (bridge, tennis, swimming, billiards) as well as costume balls and dances throughout the voyage.[11] An art deco–style poster advertising passage to and from South America aboard *L'Atlantique* exaggerates the massive size of the ship, which literally towers over a small tugboat below (fig. 27). The size and solidity of the ship's black hull suggest that this ship can dominate tumultuous seas, guaranteeing safe, smooth passage.

As France and Britain introduced new ships to replace those operated by the Germans in the 1920s, transatlantic

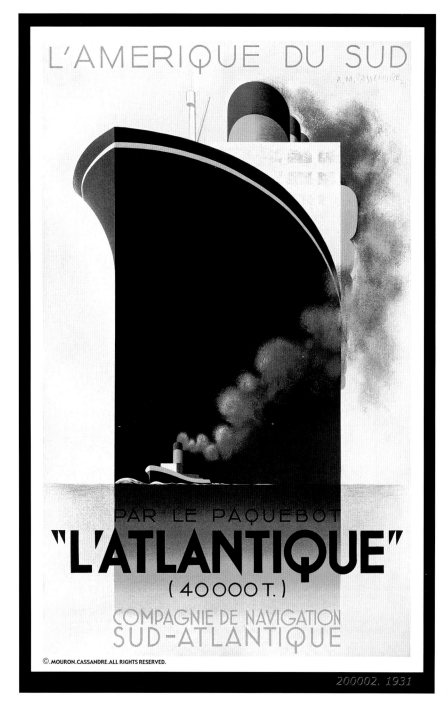

FIG. 27. *L'Atlantique*, 1931. Lithographic poster.

travel also became more accessible to the middle and lower classes.[12] As Lorraine Coons and Alexander Varias write: "In search of a new audience, steamship companies focused on the middle classes, who were eager candidates for affordable travel. Steerage was replaced by a new class of passage, 'tourist third cabin.' . . . Dreary quarters were upgraded to accommodate teachers, students, and tourists on tight budgets who were lured by company advertisements inviting Americans to explore Europe and other exotic parts of the globe. There was something very

bohemian about the whole experience, and tourist third cabin soon came to be christened the 'Left-Bank' class."[13] While Coons and Varias's study focuses on the United States, ships crossing from Buenos Aires, Rio de Janeiro, São Paulo, and Havana to Le Havre also recruited new types of passengers. Whereas those with means traveled in great luxury, third-class passage permitted many artists a way to cross the Atlantic. Describing his trip to Paris in 1927, Cuban artist Domingo Ravenet (1905–1969) writes: "Third class was completely full. We were like sardines in

a can. I had a bunk in a small cabin for eight people, but there were entire families with children who slept on deck. They covered themselves with blankets and you could barely walk around at night because of it."[14] Despite the discomfort of the trip, Ravenet made it to Montparnasse, where he spent the next five years taking classes, painting, and absorbing the artistic life of Paris.

LES ATELIERS

Upon arrival in Paris, the first thing an artist had to do was secure housing and studio space. Many artists opted to stay in the cheap hotels in Montparnasse such as the Hôtel du Maine, while others shared space with compatriots to save funds. Ecuadorian Manuel Rendón Seminario (1894–1980), Brazilian Domingos Viegas Toledo Piza (1887–1945), and Colombian Marco Tobón Mejía (1876–1933) all list the same address in 1924, for example.[15] Interestingly, these artists never exhibited together, painted in very different styles, and are never mentioned in connection to one another in reviews. Their shared address was therefore most likely a financial arrangement or a matter of convenience. These temporary or shared arrangements may have hampered productivity, but they also demonstrate the transnational networking that began to link many of these artists outside their home countries.

Despite the need for inexpensive housing, there is no evidence that Latin American artists ever took up residence in the artists' residence known as La Ruche. Instead they rented private studios with less than optimal conditions (fig. 28). As Cuban artist Armando Maribona (1894–1964) ascertained, foreign artists had a difficult time finding studio space because clandestine subletting forced prices up or because studios were left vacant for years

FIG. 29. Manuel Rendón Seminario (1894–1980), *Manuel Rendón in His Studio on the Rue Notre-Dame des Champs in Paris,* 1916. Oil on canvas, 36 × 28¾ in. (91.4 × 73 cm). Private collection.

FIG. 28. Agustín Lazo in his Paris studio, ca. 1927. Photograph. Agustín Lazo archive, Mexico City, collection of Andrés Blaisten.

while the artists who owned them were away from the city.[16] Only modern buildings were equipped with heat, and "in all the rest you have to buy the fuel to light the coal or gas stove every day, and heat water on the stove to take a bath."[17] Rendón experienced this situation in the small courtyard studio he rented on Notre-Dame des Champs (fig. 29). It had no running water, gas, or electricity and, as Miguel de Ycaza Gómez writes, "In winter a furious gale penetrated through the roof's glass window, while water froze in a bucket nearby. He cooked on a small coal stove. Each week he had to take it apart and clean off the soot deposited in the twenty-seven feet of pipes which served as a chimney. If he were careless about this chore, the room would be filled with smoke."[18] Indeed, there were daily reports in the papers of people dying of carbon monoxide poisoning from the use of these stoves in the home.[19] Paraguayan artist Jaime Bestard (1898–1965) complained that his studio was so cold that he could not get a model to pose nude for him.[20] While some solved the problem by finding space outside of the city—such as Venezuelan artist Francisco Narváez (1905–1982), who rented a studio in the Paris suburb of Arcueil—many

preferred to endure harsh conditions in order to live in Montparnasse, where they could mingle with the likes of Marc Chagall, Max Ernst, Tsuguharu Foujita, Othon Friesz, Alberto Giacometti, Vassily Kandinsky, Moïse Kisling, Fernand Léger, Henri Matisse, Joan Miró, Picasso, and Jules Pascin, among many others.[21]

Although Montparnasse was a proving ground for numerous young artists, especially those who wished to attend art school, not all foreign artists opted to live there. Perhaps because he was older and had his family in tow, now-renowned Uruguayan artist Joaquín Torres García lived only briefly in Montparnasse in 1926, but soon left the Montparnasse area to rent an apartment on the northern outskirts of Paris on 3, rue Marcel Sembat. He transformed the garage into a studio and lived there with his family for six years (fig. 30).[22] Despite his distance from the cultural heart of Paris, he managed to position himself as a major organizer among international artists in Paris, as will be discussed in Chapter 8. Others with more lucrative means also opted not to reside in Montparnasse. Tarsila do Amaral's studio on Hégésippe Moreau near Montmartre became a gathering place for artists and intellectuals,[23] and Figari had a luxurious apartment in front of the Jardin du Luxembourg, with a light-filled studio overlooking the Pantheon (fig. 31).[24] Mature artists or those with means tended to live in other areas of the city, whereas newly arrived art students valued the edginess of Montparnasse. As Maribona observes: "An abundance of Latin Americans in Paris kept increasing their colonies of twenty flags. They formed two distinct sectors divided by the Seine: the rich, on the Right Bank, and the students and the studious on the Left."[25]

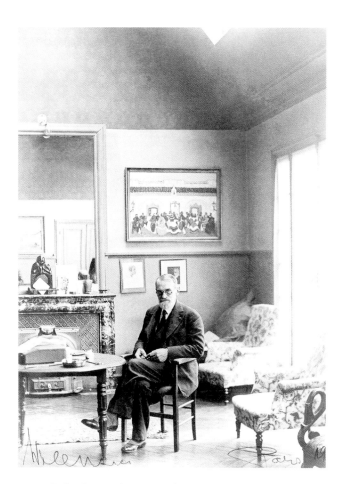

FIG. 31. Pedro Figari in his Paris studio, Rue du Panthéon, no. 13, n.d. Photograph.

LES CAFÉS

While Montparnasse had begun to attract artists prior to World War I, it became a central haven for cultural travelers of all types after the war. Montparnasse was legendary for its openness and freedom, both in terms of artistic experimentation and acceptance of unconventional social mores. As French critic André Warnod writes in 1925, Montparnasse allowed artists "freedom to paint the way they wish and to expose their works as they see fit, to live in their own way, without regard for morals and conventions, to hang around with whom they please, to develop a style that suits them, to drink when they are thirsty, and even more than that."[26] He goes on, "Women are numerous in Montparnasse, but they are liberated women. Some have come to Paris to study painting, they take classes assiduously at the academies, and live among boys like students, they smoke, they discuss painting, they drink alcohol like men."[27] For women artists, homosexuals, or those just wishing to escape the strictures of a conservative Catholic society, Montparnasse offered a place

FIG. 30. Joaquín Torres García in his Paris studio, 1932. Photograph.

FIG. 32. Enrique Riverón (1902–1998), *La Rotonde, Montparnasse*, 1925. Ink on paper, 8 × 11 in. (20.3 × 27.9 cm). Private collection.

of social and cultural freedom, and a place to create in new ways.

By the time most Latin American artists began arriving in Paris in the early 1920s, the cafés of Montparnasse in the Carrefour Vavin had become legendary gathering places for artists and intellectuals. Brazilian artist Emiliano di Cavalcanti expresses his impression of the scene: "The fugitive Russians, the fugitive Italians and Spaniards, a thousand and one fugitives from who knows how many countries knocking elbows in Le Dôme, La Rotonde, at La Coupole, all with a thousand and one political and social doctrines."[28] The mere existence of such locales where like-minded individuals could assemble to discuss new aesthetic theories and techniques, contemplate the state of the arts, or just relax distinguished Montparnasse from the environments these artists had left behind. La Rotonde and Le Dôme, located right across the street from one another, became favorite meeting grounds for Latin American artists in Paris.[29]

Victor Libion, who opened La Rotonde in 1911, allowed his patrons to sit and converse all day and provided a large selection of foreign newspapers for his international clientele. After the war, Libion expanded the café to include a luxurious dance hall, which Carpentier describes for the journal *Carteles:* "The owner of the establishment had a rare weakness for painters. He let them pay their bills with cubist paintings. He lent them money. He established interminable credit. . . . And it must have been that providence favored him because with such an unhealthy diet . . . he became rich. When the war ended, he enlarged his establishment. And today he has transformed it into a

luxurious café, whose walls boast hundreds of paintings, and on whose second level is a dance floor with a famous jazz band."[30] By depicting cafés in their work, artists documented their presence in these cafés as a means of inserting themselves into Montparnasse culture. In Cuban artist Enrique Riverón's (1902–1998) caricature of La Rotonde (1925), women in modern dress sit alone or intermingle in groups, and a man in a turban huddles in the corner (fig. 32). Two tables over, Foujita draws his topless model, Kiki de Montparnasse, who gazes at him admiringly. The cropped faces of a couple in the foreground create the impression that the energy and activity of the café extends beyond the limits of the composition in all directions. A glimpse of the lower section of a canvas that hangs on the wall identifies the café as La Rotonde—the café "whose walls boast hundreds of paintings." For Riverón, depicting La Rotonde confirms that he was there amidst the café's diverse and animated clientele.

Chilean artist Oscar Fabrés (1894–1960) also represented the famous "hangouts" of Montparnasse in his book of prints *Montparnasse: Bars, Cafés, Dancings* of 1929. His rendition of La Rotonde (fig. 33) is the only image left without a label; like Riverón, he chose to use the proliferation of paintings on the wall as a marker of place, highlighting the variety of styles and subject matter rendered by the artists of Montparnasse. Also like Riverón, Fabrés emphasizes the diversity of the café's clientele, with long-bearded bohemians drinking alongside fashionable young women in cloche hats. A woman of African descent sits by herself next to a Jewish couple whom Fabrés has distinguished by exaggerating the man's hooked nose.[31] Through the center of the scene, two artists with portfolios under their arms head toward an empty table in the corner. For Fabrés, the artist is the figure of central importance, whose presence lends the café its renown.

In both Riverón's and Fabrés's rendition of La Rotonde, the diversity and animation of the crowd are the focus of the image. Patrons are not grouped according to ethnicity or vocation, but rather mix in an unprecedented manner. This depiction contradicts the account written by Warnod in 1925 in *Les berceaux de la jeune peinture: Montmartre, Montparnasse* (The cradles of young painting: Montmartre, Montparnasse), in which he describes the division of Montparnasse by nationality. For Warnod the "Latins" (meaning most likely Italians and Spanish people, rather than Latin Americans) and Scandinavians claimed La Rotonde, while Germans and Americans occupied

FIG. 33. Oscar Fabrés (1894–1960), *La Rotonde*. Illustration for André Salmon and Oscar Fabrés, *Montparnasse: Bars, Cafés, Dancings* (Paris: Bonamour, 1929), n.p.

Le Dôme.[32] What he calls the "Brazilian colony" gathered instead at Chez Gismondi, where they took their meals.[33] His rather disparaging reassignment of Brazil from colonized to colonizer suggests, from the point of view of the native Parisian, that the city is being overrun by foreigners, whose intent is not to assimilate, but rather to impose their culture and foreign ideas on the city's inhabitants. The reality seems to have been somewhere between these two poles, neither idyllic cultural mixing (the vision of Montparnasse imagined from afar) nor complete nationalistic segregation. Latin American artists patronized both La Rotonde and Le Dôme, sometimes with their compatriots and sometimes meeting new colleagues from other European or Latin American countries.

While the conversations held among these artists are lost, the photographic and artistic documentation of their presence remains. In addition to depicting La Rotonde, artists also captured photographic images of themselves at the café (fig. 34). In 1926 Argentinean artists Héctor Basaldúa (1895–1978), Horacio Butler (1897–1983), and Aquiles Badi (1894–1976), who referred to themselves (and others) as the Grupo de París, were photographed at Le Dôme with friends.[34] This group of fashionably dressed young men and women crowds around a small table on the sidewalk, drinking wine, socializing, and inserting themselves into the Montparnasse scene. They may perhaps be celebrating the recent exhibition of Argentine art held in April 1926 at the Jeu de Paume, in which Basaldúa and Butler had participated.[35] Yet for Butler, these cafés had developed such a reputation that it was difficult for foreigners to carve out a presence there:

> At the intersection of Boulevard Raspail and Montparnasse was a true assembly of artists and students who arrived from every country to attempt their first and last steps along the problematic path of the arts. In the geographic center, two famous cafés, Le Dôme and La Rotonde, serve watered down café-crème, with which a tightly packed crowd adds to the on-going discussion of the theories that have started to break art down. Of course, neither Picasso nor Lenin

FIG. 34. Horacio Butler, Héctor Basaldúa, and Aquiles Badi on the terrace of Le Dôme, Paris, 1926. Photograph.

FIG. 35. Postcard of Le Dôme, Paris, sent from Agustín Lazo to his mother in Mexico, 1927.

dwarfed by oversized wine glasses. A stack of dishes sits on the table as well as what appears to be the bill, suggesting that the men have been at the café for a long time. Emulating a state of drunkenness, the columns in the background tilt at odd angles, while the man on the right, Nicaraguan poet and journalist Eduardo Avilés Ramírez (1895–1989), grasps the stem of a wineglass. The central figure, Cuban poet Félix Pita Rodríguez (1909–1990), stares directly ahead with a glazed expression; a cat sitting on the ledge above his head winds its tail playfully around him. To Rodríguez's right, Enríquez depicts himself with his head in his hands, as if mentally or physically exhausted. Enríquez captured the quintessential café experience: long hours of drinking and discussion, aimed at fueling artistic creativity. Moreover, the caricature reveals another important aspect of the Paris experience. It was here, not at home, that artists came in contact with Latin American artists of other nationalities. Nicaraguan

visit these terraces anymore, but numerous artists whose contribution to the field of art would renovate the world of images still circulate. In the midst of this jungle, it is not easy for the newly arrived to discover a good path.[36]

In 1927 Mexican artist Agustín Lazo (1897–1971) chose a postcard of Le Dôme on which to write home to his mother, inquiring about her health and complaining about the constant rain in Paris (fig. 35). He calls Le Dôme a *café de artistas,* which is confirmed in the advertisement for the seventeenth Salon des Artistes Décorateurs in the upper-left-hand corner of the photograph. Unlike Basaldúa's photograph, the postcard presents a sprawling view, capturing the numerous tables crowded with patrons that cover the sidewalk on both sides of the café, rather than focusing in on an intimate group. But with his personal note, Lazo asserts his presence in this legendary artists' space.

Cuban artist Carlos Enríquez chose to render Le Dôme in caricature when he visited the city in 1930 (fig. 36). He depicts three men seated behind a café table,

FIG. 36. Carlos Enríquez (1901–1957), *Caricature,* ca. 1930. From left: Enríquez, Félix Pita Rodríguez, and Eduardo Avilés Ramírez. Reproduced in Juan Sánchez, *Vida de Carlos Enríquez* (Havana: Letras Cubanas, 2005), 42.

and Cuban, artist and writer, these friendships were forged in the cafés of Paris.

The legends that rose up around Montparnasse cafés encouraged artists to construct images to insert themselves into those legends. Participating in café culture lent an air of authenticity to their Paris experience. Montparnasse was an environment where the arts were accepted, debated, and incorporated into life and leisure, not ignored or dismissed as inconsequential. These sites validated artistic pursuits. The café was an informal meeting place, a place of ideas and freedom outside the domain of official institutions. Cafés defined the Montparnasse experience as much as, if not more so than, the artistic education acquired there.

AN ARTIST'S PENSION (*LES BOURSES*)

More than a spirit of freedom and a place to have a drink, what Paris offered that was not available in most Latin American cities was infrastructure. With its numerous art schools, studios, galleries, salons, dealers, journals, art critics, and relatively cheap rents, the city had everything artists needed to establish their careers. While most Latin American countries had national art schools, which were founded after independence in the late nineteenth or early twentieth centuries with the formation of nation-states, there were almost no alternatives to these official institutions. In fact, national governments often sponsored artists' studies abroad, as a European education was still envisioned as a sign of cultural status. Long-term government grants for study in Europe proliferated in the 1920s because of favorable conditions abroad. Whereas prior to World War I, Latin American artists usually headed to Rome or Madrid to obtain an artistic education, Paris was the destination of choice after the war. As Alejo Carpentier points out, these grants also served to differentiate Latin American artists in Paris from other groups of foreigners: "Furthermore, everyone knows that contrary to what befalls students from the poor countries of central Europe, [Latin American students] constitute neither a threat nor competition for French natives. The Latin American is supported by his country, and almost always ends up returning there. He is, of all the métèques, the only one who is cordially accepted in the face of French xenophobia."[37]

At least forty-five artists from various countries received grants to study in Paris between the wars, and it is likely that many more were distributed.[38] These grants came from both state institutions such as the Pensionato Artístico do Estado de São Paulo, Secretaría de Educación Pública (Mexico), Consejo Nacional de Administración (Uruguay), and the Premio Chile del Ministerio de Educación, as well as private groups such as the Amigos del Arte or the Jockey Club de Rosario (Argentina). Upon winning a travel grant, artists would receive a modest pension to support a specified period of study abroad. Unfortunately, as many artists noted in letters home or in memoirs, these funds were often insufficient, did not always arrive on time, and were sometimes terminated because of changes in leadership, leaving artists stranded in Paris with no means of support. As Argentinean artist Pablo Curatella Manes (1891–1962) writes in a letter to Pettoruti: "We are considered as the last, the very last workers, our work is insignificant for them; and I could say it bothers them."[39] Another Argentinean artist, Héctor Basaldúa, lost his scholarship because the paintings, such as *Still Life* (fig. 37), that he sent back to Buenos Aires were not well received, despite their minimal challenge to artistic conventions.[40] He resorted to doing illustrations for *Vogue* magazine in order to remain in Paris. With or without grants, artists often took on extra work to make ends meet. For example, Brazilian Antonio Gomide (1895–1965) did textile design for Tissus Rodier, the House of Drécoll, and La Maîtrise at the Galeries Lafayette, which most likely influenced his approach to painting;[41] Rendón made copper repoussé at night;[42] and Ravenet acted as a tour guide and interpreter for rich Cubans.[43]

FIG. 37. Héctor Basaldúa (1895–1978), *Still Life,* ca. 1930. Oil on canvas, 25¼ × 31⅓ in. (64.1 × 80 cm). Private collection.

Government grants often laid out very specific requirements for the assessment of a student's progress. While each institution likely had different stipulations, a document from Cuba entitled "Reglamento de pensiones para estudios artísticos" (published in 1926) details the conditions set forth by the Secretaría de Instrucción Pública y Bellas Artes for students given pensions, and suggests what such requirements may have been like in other countries.[44] According to this document, students would receive 100 pesos per month for a period of six years as well as an amount of 300 pesos each way for travel expenses. During their time abroad, students had to check in with Cuban diplomats every three months in order to confirm progress in their studies.

The document goes on to outline the different requirements for each area of study: figure painting, landscape, sculpture, and music. In the category of figure painting, for example, year one would be spent at the Academia Nacional de Bellas Artes San Alejandro in Cuba, and years two through five would be spent abroad. In year two, the first year abroad, the student would be required to submit two copies of notable paintings in the approximate size of the originals and four studies drawn from nature. In year three, three original painted sketches of mythological, biblical, or historical themes, of which one must be of a history of Cuba, or related to Cuba's history such as a life of Christopher Columbus, had to be submitted, as well as five studies drawn from nature. Year four required the execution of a completed painting from one of the previous sketches selected by the commission, and in year five the student could submit an original painting, of any subject, in which the figure or figures in the foreground were life-size. Finally, in the sixth year, the student would return to Cuba. There he or she would create an original painting, of a Cuban theme, in which the figure or figures in the foreground are no less than life-size.[45]

These extremely explicit instructions indicate the degree to which national government institutions attempted to exercise control over grantees. It also allowed them to rescind grants if these instructions were not followed. The requirements are extremely conservative, aligned explicitly with the artistic hierarchy of the official French salons, in which the ultimate expression of an artist's ability was the execution of a large-scale history painting. In this case, however, the painting must exalt the history of Cuba rather than that of France, although the suggestion that Christopher Columbus is an appropriate

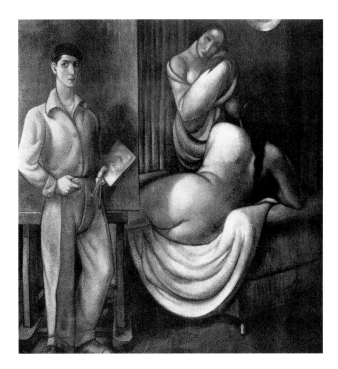

FIG. 38. Antonio Gattorno (1904–1980), *The Artist and His Models*, 1926. Oil on linen, 75 × 90 in. (190.5 × 228.6 cm). Location unknown, formerly Museo Nacional de Bellas Artes, Havana.

subject indicates the degree to which a colonial mindset still dominated the national imagination. There is no room here for artistic experimentation, nor for deviation from the pre-selected specialization in figure painting.

One artist who received such a scholarship from the Cuban government was Antonio Gattorno (1904–1980). While Gattorno spent his first few years abroad in Madrid, by 1926 he was living and working in Paris.[46] When Gattorno began introducing modern features into his submissions in 1924, his professors at the Academía "San Alejandro" were scandalized. According to Carpentier, "The most laudatory aesthetic insults were lavished on him; there was even talk of withdrawing his grant." In Paris he was therefore forced to maintain a tempered approach.[47] *The Artist and His Models,* for example, adheres, at least provisionally, to academic technique (fig. 38). The classicizing aesthetic that characterizes this picture may have served a dual purpose, however; it was sufficiently academic to appease his patrons in Cuba, while simultaneously incorporating the modernist practice of simplifying forms and subtly distorting them to reveal underlying geometries. Further exploration of avant-garde tendencies would certainly have provoked the cancellation of his grant.

Cuba's grant requirements may have corresponded well with the curriculum at France's École Nationale

Supérieure des Beaux-Arts, but in reality very few Latin American artists were able to gain entrance to this exclusive and traditional institution. Due to its nationalistic outlook, stringent entrance exams, and age requirement, foreign enrollment at the school was kept to a minimum. Around eleven Latin American artists were enrolled at the École Nationale Supérieure des Beaux-Arts during this period (although there were most likely more), but some of those studied there before World War I, such as Colombian sculptor Marco Tobón Mejía (see figs. 67 and 81) and Brazilian painter Túlio Mugnaini (1895–1975), who both trained under the famous Jean-Paul Laurens.[48] Others only remained at the school for a short time, leaving to attend classes at the more liberal academies in Montparnasse. Indeed, many artists who aspired to vanguardism did not want to be associated with the École des Beaux-Arts at all because they perceived it to be retrograde. As Horacio Butler proclaims: "I know the environment in almost all the studios. It seems untrue, but the worst of them all is the École des Beaux-Arts. It is enough to say that one is a student there to become known as an ass. The Academy serves a filial role. The professors are ancient fossils and the students are just as bad."[49]

One of the most extreme cases of veneration for the Parisian system occurred in Chile, where a trip to Paris had become essential to artistic education. When Chilean artist Camilo Mori (1896–1973) returned to Santiago in 1923 after a two-year sojourn in Paris, he gathered a group of artists around him who dubbed themselves the Grupo Montparnasse, to evoke the vibrant art scene in the Parisian neighborhood. Some of these artists had already traveled to Paris, such as Julio Ortiz de Zárate (1885–1946), José Perotti (1898–1956), and Luis Vargas Rosas (1897–1977), and others still had a trip on the horizon, but they all shared a common attraction to Parisian trends. In 1925 the group founded the first art salon in Chile, the Salón de Junio, modeled after Paris's salon system. Since the Chilean public was accustomed to highly academic art and resistant to new styles, the salon quickly became polemical because of the modernist bent of most of the paintings exhibited. Chilean art critic Juan (or Jean) Emar (1893–1964; pseudonym for Álvaro Yáñez Bianchi and a play on the French term "J'en ai marre" [I'm fed up]) supported their cause, however, writing numerous reviews of the Grupo Montparnasse's work, and encouraging the reform of Chile's art schools and attitude toward artistic production.[50]

Perhaps in response to this press coverage, the progressive minister of public education, Pablo Ramírez, embraced these new artistic currents and proposed a radical renovation of artistic education in Chile. In 1928 he shut down the Escuela de Bellas Artes and sent twenty-six of the best students to Paris on a government scholarship to study in the open academies of Montparnasse. Most remained there until 1931, and some for much longer.[51] The students were expected to study new artistic currents, while specializing in the applied arts. The only other requirement was that each student had to submit a copy of a famous painting each year to the Chilean government, because originals were hard to come by. Among the art teachers accompanying the group were founders of the Grupo Montparnasse—Camilo Mori, Isaías Cabezón (1891–1963), and Julio Ortiz de Zárate—who were appointed Jefes de Inspección de Estudios Artísticas en Europa (Chief Inspectors of Artistic Studies in Europe).[52] Whereas previous scholarship students such as José Perotti, who was in Paris with Mori in the early 1920s, resented the "paternal vigilance of the academy," this new group of Chilean art students experienced a degree of freedom that was often lacking in government grant programs.[53]

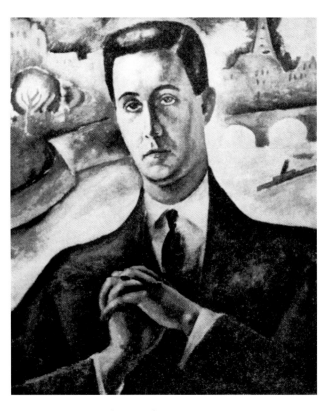

FIG. 39. Isaías Cabezón (1891–1963), *Portrait of Victor Valdés Alfonso*, 1927. Oil on canvas, 18⅛ × 21¼ in. (46 × 54 cm). Private collection.

The relatively lax structure did not result in particularly radical art-making, however, and none of the students aligned themselves with avant-garde movements. For the most part they emulated the anti-academic style of the School of Paris, painting primarily still lifes and nudes. Cabezón's portrait of Víctor Valdés Alfonso, for example, is an eminently readable portrait (fig. 39). The figure is depicted in bust length, with his hands folded in front of his chest. His face is strongly modeled, but the torso has a flatter, more geometric feel. Behind him is a view of a bridge over the Seine and the Eiffel Tower, locating the image definitively in Paris. While the figure is quite naturalistic, Cabezón has taken greater artistic license with the background, referencing a cubist flattening and stacking of space and the loose gestural brushwork of the fauves.

Mori, too, made paintings in Paris that demonstrate this moderate approach to modernism. His *Still Life* from 1929 depicts a bowl of fruit and two fish laid out on a French newspaper with the title *L'intransigeant* clearly visible at the top (fig. 40). *L'intransigeant* was, of course, a prominent venue for art reviews by the renowned critics Maurice Raynal and E. Tériade; a positive review in this paper could establish an artist's reputation. Like Cabezón, Mori adopted the tilting space and loose, gestural brushwork generally indicative of modernism between the wars, but avoided any radical distortion of form. This combining of European modernist techniques with a more academic approach was commonplace in the art schools of Montparnasse, but when exhibited in Santiago these images represented a fundamental break with the previous generation of artists who had studied under Fernando Álvarez de Sotomayor, the staunchly conservative former director of the Escuela de Bellas Artes.[54] The audacity of these works was in their resistance to the status quo in Chile, not in the breaking of new ground in Europe.

Indeed, the atmosphere in most Latin American capitals was often so conservative that there was little room for radical art or experimental practice. The director of the Museo Nacional de Bellas Artes in Buenos Aires asserted in the 1920s: "As long as I direct this museum, there shall never be a Cézanne on its walls!"[55] Similarly, in a letter to his mother, who entreated him to return home, Colombian artist Eladio Vélez (1897–1967) expresses his abhorrence with the environment in Bogotá: "What the devil am I going to do there [in Bogotá] where people are dying of hunger, where art even in times of plenty has never served as a means of earning a living, where there

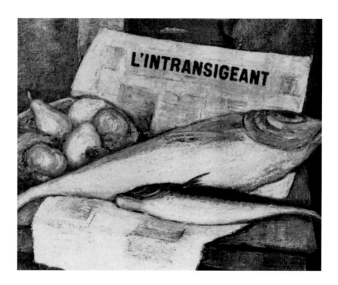

FIG. 40. Camilo Mori (1896–1973), *Still Life*, 1929. Oil on canvas, 23⅔ × 28¼ in. (60 × 73 cm). Location unknown.

is no hope except to teach classes for unmarried women or women who can't have children at the wretched Escuela de Bellas Artes."[56] And writing in 1926, French critic Maurice Raynal rails against the "ridiculous academic tutoring [in Latin America] which has, with great self-confidence, succeeded in annihilating the noblest personalities."[57] Because this conservatism affected the awarding and maintaining of grants as well as the job prospects of artists upon their return home, it is therefore quite comprehensible that many Latin American artists embraced Paris but simultaneously took moderate steps toward reform.

LES ACADÉMIES LIBRES

Since the nineteenth century, independent art academies had been opening in Montparnasse as an alternative to the École Nationale Supérieure des Beaux-Arts. By the mid-1920s artists could choose from a variety of schools, including the Académie Julian, the Académie Colarossi, the Académie de la Grande Chaumière, the Académie Ranson, the Académie Moderne, the Académie Montparnasse, and the Académie André Lhote, as well as private lessons in artists' studios. These schools were unique because they did not require entrance exams and accepted artists of different gender, ethnicity, and national background. Fees were reasonable and classes flexible; students could often simply pay a daily or monthly fee to draw from a live model and pay an additional fee to receive weekly feedback from the professor of record. For some, these schools were the only alternative because

they could not afford to pay a model to come to a private studio.[58] Often artists did not follow a curriculum at one school, but rather took a sampling of classes with different teachers at several of the academies, sometimes following a favored teacher from one location to another. The flexibility of the system has led to incomplete records, but with the addition of artists' accounts it is possible to sketch out a general picture of where many of the Latin American artists in Paris were pursuing their training.

The two oldest of the independent academies were the Académie Julian and the Académie Colarossi. Established in 1868 by the painter Rodolphe Julian at the Passages des Panoramas to prepare male students for the entrance exams at the École des Beaux-Arts, the Académie Julian grew to have numerous branches across Paris, including two in Montparnasse, the most popular of which was located at 31, rue du Dragon, where Paul Albert Laurens, Jean-Pierre Laurens, and Paul Landowski taught.[59] By the late nineteenth century it had evolved from a preparatory school into a center of modernism.[60] In 1919 Gilbert Dupuis assumed responsibility for running the academy, making the school a truly international endeavor. According to Martine Hérold, Dupuis "was a man of great culture and profound humanity. He spoke seven languages and he thrived in this world renowned tower of Babel that each year attracted more and more foreigners."[61] In the 1920s there were students, male and female, from all over Europe, the United States, Russia, Japan, China, Lithuania, Egypt, and most Latin American countries enrolled at the Académie Julian. Between 1920 and 1933, the names of fifty-three Latin American artists appeared in the school records, and an additional twenty-four noted having studied there (but no records were found), most registering for just a few months.[62] The school explicitly catered to this sort of short-term study, with tuition available for one-, three-, six-, or twelve-month periods for half- or full-day study.[63]

The Académie Colarossi opened its doors in Montparnasse in 1879 when Filippo Colarossi, a former model at the Académie Suisse on the Quai des Orfèvres, took over the school and moved it to 10, rue de la Grande Chaumière. There he rented out studios to a small group of artists and hired two salon painters, Raphael Collin and Gustave Courtois, to give classes in figure drawing and painting. As John Crombie contends, like the Académie Julian, "From the start, Colarossi's academy was highly cosmopolitan, with American, English, German

and Scandinavian artists forming the bulk of students—a number of whom also lived in rented studios in the court-yard—soon leavened by a sprinkling of Latin Americans and Japanese."[64] Although the school's archives burned in the 1930s, at least sixteen Latin American artists studied at the Académie Colarossi, and it is likely that many more took classes there.[65]

For the most part, the artists studying at the Colarossi and Julian worked in academic or impressionist modes, with little evidence of interest in the avant-garde movements of the early twentieth century. They were there to perfect their technique, and it was only after leaving the school that some artists explored more cutting-edge styles, while others, such as Julio Fossa Calderón (1874–1946), Dina Mongay-Munoz (1910–?), and Rómulo Rozo (1899–1964), went on to have significant success in the French salons. A brooding *Self-Portrait* by Colombian artist Roberto Pizano (1896–1929), most likely made during his time at the Académie Julian in 1927, displays the sort of academic accuracy promoted at the school (fig. 41). Several sketches by Colombian artist Eladio Vélez made at the Colorossi also survive. One is a figure study of a female nude in three different poses, the type of study done in quick succession as a means for an artist to practice depicting the figure in space. In another, Vélez decided to do a close study of the model's face next to a nude rendering of the female form (fig. 42). The model is neither young nor classically beautiful; her breasts sag and her belly bulges, indicting previous childbirths, and her tightly curled hair and thick lips suggest African descent. Rather than downplaying these characteristics, Vélez seems to have been fascinated with them, looking closely at the realities of aging and ethnic difference. While the use of nude models had started to take hold in the Americas in the late nineteenth and early twentieth centuries, the access to different types of models on a daily basis made the experience of Paris quite different from that in Latin America. As Maribona describes: "On Mondays the vestibule or hallway of the schools of painting and sculpture presented a picturesque spectacle of male and female models gathered there to look for work. Those who posed in the nude were covered only by a coat or blanket, ready to show their bodies and the color of their skin to the artists from the schools or to those from outside; those who posed in costumes, wore something appropriate to their role: a Napolitano, a torero, a shawl or mantilla with a Spanish comb, an Alsatian, Malakoff, powdered wigs,

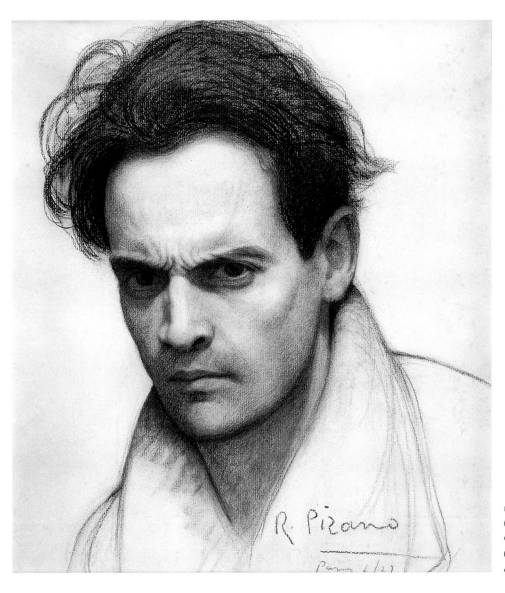

crinoline dresses, short trousers; elderly by themselves or accompanied by children, also models."[66]

The next two academies to arrive in Montparnasse were the Académie de la Grande Chaumière and the Académie Ranson. When the Académie Colarossi began to flounder because Colarossi's sons were stealing funds, the Grande Chaumière opened its doors to fill the gap in 1904.[67] A few years later, in 1911, the Académie Ranson, founded by the Nabi painters Pierre Bonnard, Édouard Vuillard, and Paul Sérusier, moved from Montmartre to rue Joseph-Bara in Montparnasse. Although the Académie Colarossi was thriving again by the 1920s, the Grande Chaumière was by far one of the most popular schools among students. In addition to electric lights and "conversation rooms" for socializing, according to Crombie: "The new Academy at no. 14 was custom-designed, and superior in every respect to Colarossi's now ramshackle

courtyard studios. . . . The three-story premises extended into the large courtyard which itself occupied half the back garden of the next door property. Over the portals of its street-front entrance, the Academy's title and twin functions—PEINTURE & SCULPTURE—were boldly proclaimed in gilt letters. Cool and airy in summer, its half dozen spacious ateliers were, as the publicity brochure boasted, 'heated to perfection' during winter."[68] Heat was a major factor for artists in choosing to spend time at the Grande Chaumière. Rendón commented that after spending the morning working in his own studio, he would pay two francs for the nude drawing classes at the Grande Chaumière just because there was heat.[69] And Jaime Bestard also viewed heat as a mitigating factor, observing: "When winter was coming and it was getting dark early, I liked to attend sessions [at the academies on the rue de la Grande Chaumière] when I had enough disposable

FIG. 42. Eladio Vélez (1897–1967), *Nude Figure and Head*, ca. 1930. Pencil on paper. Jorge Cárdenas Collection, Medellín.

means. Preferably, I chose cold afternoons and there in the sketching studio, I drew, forgetting the outside world for four or five hours in a row in the shelter of the big pot-bellied stove, that not far from the model, radiated its delightfully cozy and uniform heat."[70]

Others were drawn to the internationalism at the Grande Chaumière. As Pettoruti contends: "I had heard so much about the Académie de la Grande Chaumière (it owes its name to the street where it is located) that I went to see what it was like; there I encountered an academy where hordes of foreigners gather, especially from Nordic countries."[71] For Horacio Butler, the Grande Chaumière provided entertainment and a view of global culture: "It is completely cosmopolitan there. The sketching classes are a spectacle: The English in golf clothes, elegant Americans, Japanese in kimonos and the average French woman, whose open-mindedness is rather doubtful."[72] The diversity of the students is notable in a photograph of the Grande Chaumière in which men and women of different ethnic and racial backgrounds draw from a live model (fig. 43). This intermixing sometimes led to

romance—Argentinean artist Antonio Berni (1905–1981) met his first wife, French sculptor Paule Cazenave, there—and facilitated transnational friendships and collaborations that would never have occurred in a more circumscribed environment.

While students could opt to simply attend the open *croquis* or life-drawing classes at the Académie de la Grande Chaumière in the evenings without receiving corrections, they could also pay an extra 60 to 80 francs a month to work with a professor.[73] Pettoruti viewed the choice to take life-drawing classes as a waste of time, however: "I noticed that some artists, after having studied at the Academy in Buenos Aires, wasted their Paris afternoons practicing nude drawing at the Académie de la Grande Chaumière or others of that nature."[74] For him, these sessions without feedback prevented artists from taking advantage of what Paris had to offer because they did not push them to explore new directions.

For those who took regular classes, the Académie de la Grande Chaumière did not promote a particular style, but rather a general anti-academic modernism tempered with cubism.[75] Among those who taught there were Othon Friesz, Fernand Léger, and André Lhote, before they founded their own schools or private workshops.[76] The most prominent and long-standing teacher was the sculptor Antoine Bourdelle, who taught there from 1909 until 1929. Known for monumentality, Bourdelle's style is often located between romanticism and cubism. While he came from an older generation than some of the more cutting-edge sculptors of the 1920s such as Constantin Brancusi or Jacques Lipchitz, numerous Latin American artists praised his tutelage, and he was noted for pushing

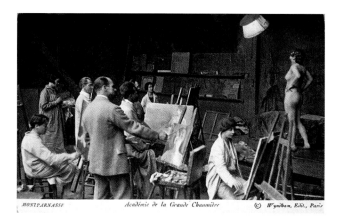

FIG. 43. A mixed life-drawing class at the Académie de la Grande Chaumière, 1920s. Postcard.

FIG. 44. Antoine Bourdelle (1861–1929), Monument to General Carlos María de Alvear, 1912–23. Bronze, pink granite base, base 45 ft. 11 in. (14 m) high; statue 12 ft. 2 in. (3.7 m) high. Plaza Julio de Caro, Buenos Aires.

students to "forget naturalism a bit and INTERPRET."[77] But Bourdelle was also guilty of "primitivist" expectations. Chilean artist Marco Aurelio Bontá Costa (1899–1974) notes that he overheard the instructor criticizing a South American woman sculptor for working in the style of her European peers: "You are from there [South America] . . . that exotic and marvelous land and you made this garbage. I don't understand."[78] This type of pressure often pushed artists to represent their cultural heritage, even if they had no previous inclination to do so.

Nevertheless, Bourdelle's students continued to hold him in high regard, and it may have been through his contact with these students at the academy that he obtained a commission to sculpt a monument to General Carlos María de Alvear that was unveiled in Buenos Aires in 1926 (fig. 44). Rather than a means to enter the rank of the avant-garde, the Académie de la Grande Chaumière provided exposure to a moderate anti-academic modernism

and an international meeting ground. Audiences in Latin America perceived this modernist aesthetic as much more radical than did those in Europe, making the notion of vanguardism relative to the challenge of reception. Contacts made at the schools did lead some artists to explore new directions; but often it was only after they left the academic environment that they began to forge their own path and push the notion of vanguardism further.

ACADÉMIE ANDRÉ LHOTE

While Latin American artists show up on the rosters of most of the schools in Montparnasse, André Lhote's academy held special appeal for students from Latin America, and his unique approach to teaching had a significant impact on the development of modernism in the region. What distinguished Lhote's academy from the other independent schools in Montparnasse was that he was a prolific theoretician in addition to being a renowned artist. Extremely well known and respected during his own time, Lhote's work declined in popularity after World War II, and his importance as a teacher and theoretician is often ignored in writings on European modernism. With the recent scholarly attention being paid to the so-called "call to order"—a movement in European art after World War I that promoted traditional approaches to art-making and rejected the radical practices of the avant-garde— Lhote is starting to be repositioned as an influential figure between the wars.[79] Beginning in 1919, his essays appeared frequently in French and British journals, and he based his teaching soundly on the application of the theories he articulated there.[80] Students were drawn to his teaching because it was grounded in a specific set of ideas about art-making that were at once modern and rooted in tradition. Because Lhote promoted a specific set of principles for structuring a composition, many artists struggled to regain autonomy after studying with the master, however.

While, as discussed in the previous chapter, Lhote had experimented with cubism in the 1910s, he did not consider himself a cubist, and by the 1920s he was attempting to distance himself from the movement.[81] In his essays Lhote downplayed his engagement with cubism and the artists of Léonce Rosenberg's gallery by relegating cubism to a previous historical moment and deeming it only useful in the present as a formal exercise. For him, cubist techniques were a means to structure the pictorial surface, but not an end in themselves. Lhote advanced the idea

FIG. 45. Académie André Lhote, n.d. Photograph. André Lhote archive, Raincy, France.

of a great French tradition and greatly admired artists such as David, Ingres, Seurat, and especially Cézanne. Yet he abhorred artists who simply aimed to imitate nature (that is, the impressionists); rather, he felt that artists should strive to find the underlying rhythm and structure of a composition based on an intuitive and emotional response to nature. Artists should not paint what they see, but rather compose and organize the canvas based on notions of balance and order. As Lhote asserts: "I distrust working from formulas so much that never would I permit myself to draw a figure or a landscape 'by heart,' like I could do if I wanted. In drawing or painting, I try to follow the deformations of objects as accurately as possible, for which I cannot assume responsibility. It is this subconscious operation that gives my work soul, if it must have one, which is later reviewed and 'put in order.' Creating is always organizing chaos."[82]

In his teaching, Lhote encouraged students to analyze a visual source, reorganizing it to coincide with the structural logic of the flat surface of the canvas. Artists should strive to establish a coherent organization for the entire composition, not to replicate individual elements of the natural world. For Lhote, that organization should be based on essential geometries rather than light or color.[83] When using chiaroscuro "we must be careful to distribute (according to the rhythms that we will discuss later), an equal amount of light and shadow."[84] Since this technique did not proscribe a specific visual result, it appealed to myriad students as a means to arrive at their own artistic vision. Lhote's approach most likely was a great draw for art students from Latin America because it represented a middle ground. It was not a radical rejection of tradition,

which Latin American art students were only just discovering, but rather a means to build upon and update that classical tradition without disavowing a link to the past.

While Lhote had been teaching at various Montparnasse academies since 1915, he opened his own art school in 1925 at 18, rue d'Odessa, which he ran until 1962.[85] André Warnod describes Lhote's new accommodations (fig. 45): "The light pink walls are decorated with some paintings and photographs of masterpieces; two models pose at the same time to permit the students to learn composition, the portrait class is held in an addition, and in a special small room [Demetrios] Galanis comes to teach the art of engraving twice a week."[86] The school offered classes in the nude, portraiture, and still-life painting, and every three months there was a special course in composition that lasted for two weeks. Like the other schools in Montparnasse, admission was open, and students paid a monthly fee. Typically, on Mondays, Lhote

FIG. 46. Letter from Manuel Rodríguez Lozano and Julio Castellanos to André Lhote, December 17, 1925. André Lhote archive, Raincy, France.

would offer a demonstration and set the model's pose for the week. Students were then free to depict the model however they pleased in whichever medium they wished, and could even set up their own still lifes.[87] Despite his emphasis on freedom of interpretation, however, Lhote insisted that his students work from a model rather than simply inventing scenes. But he did not advocate naturalistic representation: "You want to reproduce the model which is wrong. The model is absolutely in the wrong. It is only there for you to react to."[88] Lhote would return to the classroom on Thursday mornings and Friday afternoons to offer corrections, which he would tailor to each individual student.[89]

Through his teaching, Lhote developed strong connections with Latin American artists from all over the region, and correspondence from several of these artists is preserved in his archives (fig. 46). In addition to his early friendship with Diego Rivera, at least twenty-seven Latin American artists studied with Lhote between the wars, many of whom took his teachings as the basis for modernist production in the Americas. His methods were particularly influential with Brazilian and Argentinean artists. Through his connections with Tarsila do Amaral and other Brazilian artists and intellectuals, Lhote's paintings were exhibited in Brazil several times between the wars.[90] And many of the artists of the Grupo de París in Buenos Aires arrived at their particular vision of modernism via study with Lhote.[91] Lhote reviewed Uruguayan artist Pedro Figari's 1923 exhibition, and Ecuadorian artist Pedro Léon (1894–1956) disseminated Lhote's ideas in his book on modern art in which he cited Lhote extensively.[92] Lhote's work was also included in an exhibition of modern French art in Colombia in 1922 and in Uruguay in 1935, and in 1939 Carmen de las Casas brought a selection of his paintings to Venezuela for sale and exhibition.[93] Even after World War II, Lhote maintained his ties to Latin America, founding an academy in Rio de Janeiro in 1952 and hosting numerous Brazilian artists at his French school.

One of Lhote's first Latin American students and greatest supporters was Tarsila do Amaral. While Amaral studied with Lhote at L'Académie de la rue du Départ from March to June 1923, before he established his own academy, she maintained contact with the French artist for many years.[94] During her studies with Lhote, Amaral absorbed his methodology, which is clearly evident in paintings done under his tutelage such as *Two Models* (fig. 47). In this painting Amaral has reduced the figures to

their essential geometries, employing cubist facets to create an overall rhythm that unites figure and ground. The diagonal of the roof on the left echoes the diagonals in the drapery and the figure's arm, establishing a geometric order to the composition. She has emphasized figural distortion, allowing a flattened breast, curved torso, or angular knee to create its own geometric form that stretches the limits of naturalistic representation. Color is clearly superfluous, reduced to muted tones that are secondary to formal arrangement. Whereas Amaral quickly diverged from such a literal interpretation of Lhote's teaching, she employed his ideas about establishing equilibrium and stability in a composition as the basis for creating her own unique style.[95] Writing in 1952, Amaral still remembers with awe the impact Lhote's teachings had on her and explains his approach:

> In December of this same year of 1922, I returned to Paris contaminated with revolutionary ideas. I ran to Lhote and found him in the big wooden shed in Montparnasse where he gave his painting class. There he was, surrounded by students—one big, happy family. Everything seemed mysterious to me. I remember

FIG. 47. Tarsila do Amaral (1886–1973), *Two Models*, 1923. Oil on canvas, 18⅛ × 15 in. (46 × 38 cm). Private collection.

how keenly I listened to his lessons. I can still see the Michelangelo reproductions glued to the walls as examples of good drawing: Lhote became the link between Classicism and Modernism. Small in stature, with intelligent eyes, always agreeable, he explained in his southern accent how we could adapt the technique and compositional methods of the old masters to the demands of contemporary art.[96]

Not only did Amaral respect Lhote as a teacher, she also viewed him as a leading modernist, collecting his paintings along with those of Picasso, Miró, Picabia, and Delaunay. Her first acquisition by Lhote was *Three Female Nudes* (ca. 1920), and in 1924 she purchased *Soccer* for 2,500 francs for the São Paulo home of her friend the Brazilian poet and novelist Mario de Andrade (fig. 48).[97] The painting is modern in both technique and subject matter. Sports had emerged as a popular subject of artistic exploration in conjunction with the 1924 Olympic Games in Paris. Soccer, in particular, had strong contemporary relevance because Uruguay, the only South American participant in the tournament, had won the gold medal. In *Soccer,* Lhote employs flat geometric planes and vibrant color to highlight the modernity of the subject. In a letter

to Lhote about this purchase, Amaral mentions that she had been promoting Lhote's work in the Brazilian press, but expresses her frustration with the pace at which the "modern movement" is taking hold in Brazil.[98] For her, Lhote's work epitomized modernity and should serve as an archetype for artists there. Amaral wrote the letter in a familiar tone and alluded to her camaraderie with Madame Lhote, which suggests that she shared a genuine friendship with the family beyond that of student and teacher. Amaral's acquisition of Lhote's paintings and promotion of his work in Brazil indicates that she viewed him as a leading figure in modernism.

Indeed, Amaral consistently supported Lhote, even when the continued controversy regarding the relevance of cubism and the debates over whether artists should adhere to a classical French tradition or adopt a new universalizing abstract aesthetic had begun to take their toll on Lhote's reputation in the 1930s.[99] Amaral defended the artist's stance and importance as a teacher in a 1936 article on Lhote for the *Diário de São Paulo:* "He has created a school of conciliation very much his own. There has been much discussion about his art. Supporters of cubist expression, the sincere and the snobbish, simply see in his painting modernized archaism and as they can no longer accept artistic realism, they immediately include him among the mediocre painters. However, Lhote is a conscientious artist who contributed to modernity with his interesting, solid, vigorous and pleasing compositions—if lacking in genius—and in his lessons on the art of drawing, which his pupils have spread throughout the world."[100] Her characterization of Lhote as "lacking in genius" suggests that Amaral followed artistic debates in Europe closely and adjusted her assessment of the artist accordingly. But she also notes the global impact of his methods.

Artists from the Argentinean Grupo de París also felt the profound influence of Lhote's teachings. Basaldúa and Butler took classes with Lhote at the Académie de Montparnasse in 1923; Antonio Berni (fig. 49) and Lino Spilimbergo (1896–1964) enrolled at Lhote's new academy in 1926; and Aquiles Badi (fig. 50) and Pedro Domínguez Neira (1894–1970) followed their lead in 1927 and 1929, respectively. Basaldúa seemed to have been ambivalent about Lhote's methods, however: "I went to André Lhote's studio (ex cubist, theoretician, terrible painter and excellent though dangerous teacher). . . . Lhote, invoking the great deformers: Tintoretto, Ingres, Greco, Rodin, etc. made me reduce all my forms to geometric elements.

FIG. 49. Antonio Berni (1905–1981), *Landscape at Marcesine,* 1927. Oil on canvas, 40⅔ × 35⅜ in. (103.2 × 90 cm). Private collection.

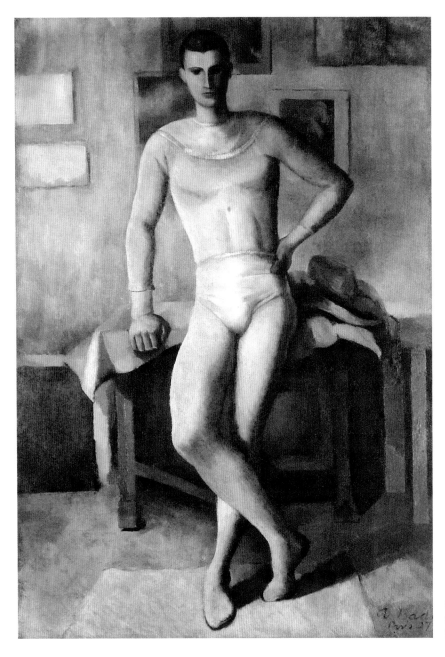

FIG. 50. Aquiles Badi (1894–1976), *Blue Acrobat,*
1927. Oil on canvas, 45⅔ × 31⅞ in. (116 × 81 cm).
Private collection.

There I spent two months making cubes and now I have
to return from the expedition, desperately fighting to
reunite everything without achieving anything but trash
and more trash. In the end, surely with hard work and
perseverance I will stop floundering some day."[101] But in
1926 Basaldúa's paintings still showed strong evidence of
Lhote's approach.[102] In *Nude* of 1926 (fig. 51), for example,
the characteristic faceting and diagonal structure of
Lhote's compositions appear in the background, but the
figure is set apart, more monumental and naturalistic
than Amaral's rendition of the nude from Lhote's studio.
This shift evidences a change in Lhote's own approach to
painting as he moved toward greater monumentality, as

can be seen in *Seated Nude in Landscape* of 1928 (fig. 52).[103]
Horacio Butler also recognized Lhote as one of the lead-
ing teachers in Montparnasse, but was wary about becom-
ing too entrenched in the artist's methods: "I'm still at
the Académie Montparnasse, that, without a doubt, is the
most interesting at the moment. During the three weeks
that I have been there, I have benefited tremendously. The
professor, André Lhote, is a much discussed painter. I
think that he is a better teacher than artist. His corrections
are very interesting but they are something to undergo for
at most two months. The technique that is taught there is
based in cubism and a group of principles that should be
taken as a means not an end."[104]

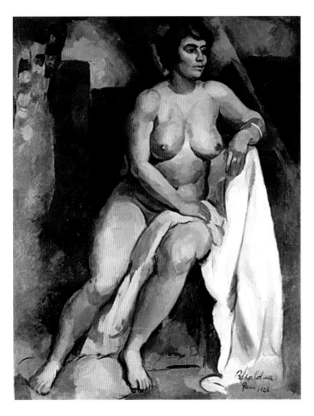

FIG. 51. Héctor Basaldúa, *Nude,* 1926. Oil on canvas, 46 × 35 in. (117 × 89 cm). Private collection.

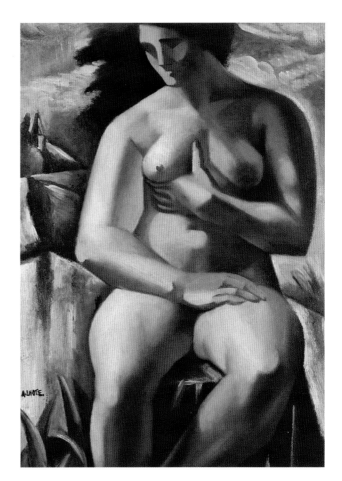

FIG. 52. André Lhote, *Seated Nude in Landscape,* 1928. Oil on canvas, 37⅞ × 24⅜ in. (96 × 62 cm). Private collection.

A sketch by Spilimbergo made in Lhote's studio provides one of the best insights into Lhote's approach to teaching (fig. 53). On the side of the paper, Spilimbergo summarizes Lhote's lesson: "The richness of the color and [undecipherable word] lines is determined through the study of objects that break apart the discrete parts of the canvas." This notation refers to Lhote's directive to find the underlying structure of a composition through observation and extrapolation of the essential forms of the model. In the sketch, Spilimbergo has organized the composition with a diagonal grid, aligning trees, torsos, and the bend of knees and elbows with the surface structure of the grid, a lesson Lhote almost certainly derived from Cézanne's *Bathers* (1889–1905). This approach to composition allowed the artist to expand or exaggerate the shapes that stemmed from observation of a model according to a specific structure. While based on nature, the forms no longer conform to naturalistic resemblance, but rather shift to accommodate the structure of the canvas, taking shape according to their relationship with the overlaying

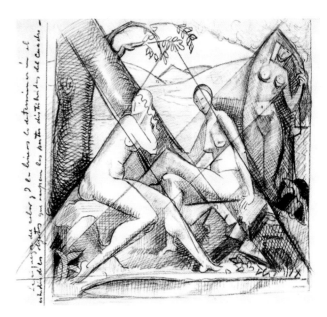

FIG. 53. Lino Spilimbergo (1896–1964), Study composition, 1928. Pencil on paper, 9¼ × 12 in. (23.5 × 30.5 cm). Private collection.

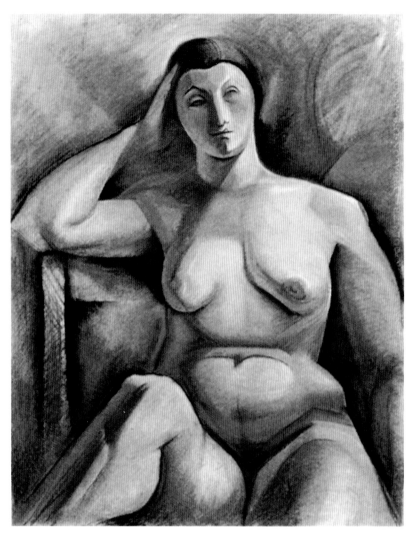

grid. A tree balances the vertical figure on the right, a distant mountain echoes the meeting point of the diagonal grid, and branches arch to conform to the curve of shoulders and heads.

Drawings from the same period such as Spilimbergo's *Nude* of 1927 (fig. 54) indicate a similar experimentation with form. Here the model has been simplified, while retaining a solid form, to reveal clean planes and an underlying geometry. Angles have become harsher, curves rounder, and the face is devoid of individuality. Shapes in the background echo those in the figure, creating a pattern over the entire surface. This common foundation in Lhote's methods unified the early work of Argentinean artists of the Grupo de París and gave it a modernist edge in the conservative context of Argentina. Yet Pettoruti argues that Lhote's teachings prevented these artists from breaking into the ranks of the avant-garde: "At that time the Académie Lhote was famous, frequented by numerous aspiring artists from all over the world; however, this

great theoretician of vanguard art, who did not know how to apply his brilliant propositions that made him famous to his painting, also did not know how to create disciples that would advance the system. There were legions of Lhote's students, but none who distinguished themselves."[105] His evaluation of Lhote's students most likely reflects his frustration that more artists, such as those of the Grupo de París, did not push artistic boundaries further upon their return to Argentina.

Despite Pettoruti's proclamation, Lhote's teachings did not hinder the majority of his students; rather, they established a firm foundation on which to build. Most of the works discussed above represent an early or experimental phase in an artist's career from which he or she later diverged. Many of the Latin American artists who experimented with cubist techniques in the 1920s did so via Lhote's teachings, not through a study of Picasso, who did not teach or exhibit at the salons. They did so not to become belated cubists, forever behind in a Eurocentric

modernist trajectory, but rather because they, like Lhote, saw cubist technique as a valuable tool for developing new approaches to composition. Indeed, Lhote's importance for Latin American artists continued well beyond the 1920s. When Cuban artist Marcelo Pogolotti met him in the context of the Association des Écrivains et Artistes Révolutionnaires (AEAR), which will be discussed in Chapter 10, he proclaimed that Lhote possessed an "exceptionally well-nourished intelligence." He went on to say: "His conversation, accompanied by refined critical sense, was lively and agile, being the fruit of slow, painstaking consideration."[106]

Despite the reticence expressed by several Latin American students toward Lhote's approach, he provided one of the few opportunities for artists to study with an instructor who embraced a specific theoretical vision of modernism. Unlike the other academies in Montparnasse that hired a range of different teachers, united only in their anti-academicism, Lhote's school imparted a reasoned and structured means to achieve modernism. Lhote established a method to build on the past without entirely rejecting tradition. While many Latin American artists eventually broke free from Lhote's method, it served as an archetype of theory-based teaching. Thus, not only did the Académie Lhote provide a contact zone for Latin American artists from different countries, it compelled artists to contemplate the very notion of method and its implications in relation to past, present, and future artistic production.

3 Paris

Capital of Latin America

By the mid-1920s numerous artists from almost every country in Latin America lived and worked in Paris, but this presence did not automatically result in a cohesive Latin American artistic community.[1] While the notion of Latin America as a geopolitical construct had existed since the days of Simón Bolívar a century earlier, art schools and the governments that founded them were decidedly nationalistic, and artists were expected to exalt that national identity. As more artists, intellectuals, and diplomats—who often had strong cultural connections or leanings themselves—converged on Paris, transnational liaisons assumed greater importance. These liaisons led to the formation of two important cultural centers: the Académie Internationale des Beaux-Arts and the Maison de l'Amérique Latine. As their inaugural endeavor, these organizations hosted a small exhibition of modern Latin American art followed the next year by an extensive survey of Latin American art from the pre-Columbian to modern era, the first such exhibition to be held anywhere in the world. The conception of such an exhibition, framed by geopolitical identity rather than by movement or style, forced audiences and critics to contemplate which characteristics should distinguish Latin American from European art, and whether a Latin American aesthetic identity could or even should exist. Establishing these cultural centers in Paris set up a new dynamic between Latin American artists and their European colleagues, compelling them to contemplate the role of art in shaping notions of place.

LA MAISON DE L'AMÉRIQUE LATINE

On December 29, 1922, Argentinean economist Alejandro de Olazabal and Brazilian intellectual Pedro Luis Osorio presented a proposal to the French government for the formation of an Académie Internationale des Beaux-Arts to be housed in a building donated by Olazabal at 9, rue de Presbourg, which would include a music conservatory as well as sections for painting, sculpture, architecture, printmaking, and the philosophy of art. The school would focus on training artists from Latin America and would be run in conjunction with a newly formed Maison de l'Amérique Latine.[2] Whereas the academy's mission was education, the *maison* would serve as a cultural center and a showcase for Latin American art, music, and literature, with the objective of "attracting [Latin] American artists to Paris for the great benefit of their culture."[3] The assumption

here is that Paris would serve as an archetype of cultural advancement for Latin American cities. In February 1923 Olazabal and Osorio convened a meeting to discuss these proposals and plan their implementation.

Plans proceeded quickly for both the academy and the maison. Over the summer of 1923 directional committees for the Académie Internationale des Beaux-Arts were appointed and convened to define the school's mission. Members of the committee on painting included such noteworthy French artists as Maurice Denis, Roger de La Fresnay, Albert Gleizes, Paul Albert Laurens, Jacques Mathey, Lucien Simon, and André Dunoyer de Segonzac. Latin American artists living in Paris were also chosen as delegates for select Latin American countries.[4] Given his connection with Latin American art students at the Académie de la Grande Chaumière, Antoine Bourdelle hosted the first meeting of the sculpture section at his home, which included delegates from Argentina (Pablo Curatella Manes), Brazil (Victor Brecheret), Colombia (Marco Tobón Mejía), and Uruguay (José Luis Zorrilla de San Martín and Pablo Mañé). It was also decided that committees should be formed in each large city of Latin America, with the mission of:

1. Making known the resources and facilities that the Académie Internationale des Beaux-Arts has to offer the artists and students of Latin America
2. Choosing works to be shown in the large exhibitions that the Academy will organize in Paris
3. Preparing and organizing exhibitions of French art in Latin America.[5]

As their mission statement indicates, Olazabel and Osorio envisioned a widespread transatlantic exchange of art, education, and resources.

That same summer the Maison de l'Amérique Latine was also launched—although it did not yet have a permanent address—with a musical concert and an exhibition of Latin American art.[6] This exhibition, while not nearly as extensive as the official exhibition that would take place the following year, marked the first time works by contemporary Latin American artists living in Paris were assembled for display as a unified group.[7] These artists represented eleven countries, including Argentina, Brazil, Chile, Colombia, Costa Rica, Cuba, Ecuador, Peru, El Salvador, Venezuela, and, oddly, Spain (with the work of Servando del Pilar). Most of the artists selected exhibited regularly in the Paris salons and worked in relatively

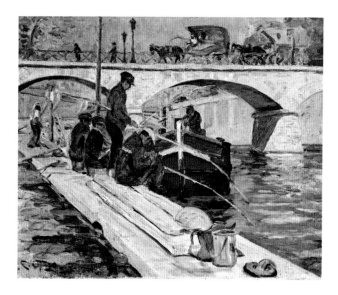

FIG. 55. Carlos Otero (1886–1977), *Fishermen on the Seine*, 1923. Oil on canvas, 13⅓ × 16⅛ in. (34 × 41 cm). Private collection.

conservative styles. Paintings such as Juan Manuel Gavazzo Buchardo's (1888–1965) *The Bridge, Meudon, France* or Carlos Otero's (1886–1977) *Fishermen on the Seine* of 1923 (fig. 55), with their sketchy impressionist brush-work painted *en plein-air,* most likely represent the types of paintings on display.

While titles of most of the works were not mentioned in the press, the *Revue de l'Amérique latine* identified two outstanding paintings by now-renowned female artists: Anita Malfatti's *Woman with Fruit Basket,* now known as *Tropical* (fig. 56), and Tarsila do Amaral's *Portrait of Mário de Andrade* (fig. 57).[8] As the only two women artists in the exhibition, both made bold and different choices in their submissions. Malfatti, who had just arrived in Paris, chose to submit a work made six years earlier. The painting, *Woman with Fruit Basket,* depicts a dark-skinned young woman carrying a basket of tropical fruit. Malfatti distorted and flattened the woman's proportions in an expressionist mode and reduced the fruit to essential geometric shapes. The warm browns, yellows, and greens of the fruit and foliage give the periphery of the canvas a vibrancy that is lacking in the simple figure clad in white, and create a decorative border around the central image. Similarly, the dramatic V-shape of the woman's neckline, which is reversed in her hairline, creates a frame around her face and draws attention to her distant expression. She is not an idyllic peasant, content in her simple life; rather, her thoughts and dreams are elsewhere, perhaps far removed from the imagined paradise of Brazil. The painting thus simultaneously re-creates and subtly

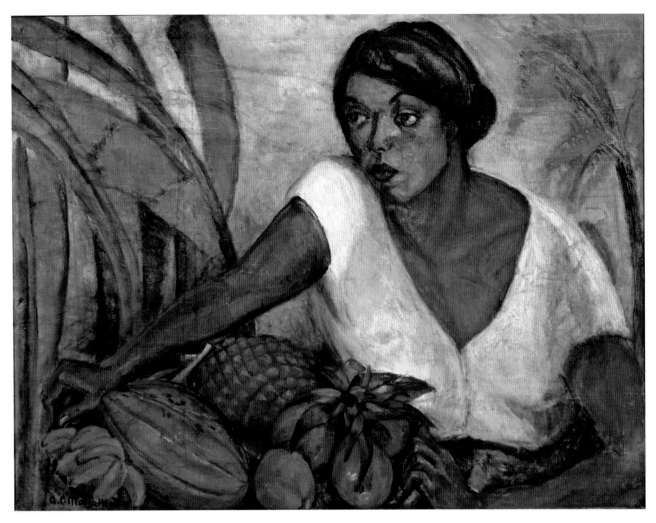

FIG. 56. Anita Malfatti (1889–1964), *Tropical,* 1917. Oil on canvas, 30⅓ × 40⅛ in. (77 × 102 cm). Pinacoteca do Estado de São Paulo.

undermines visions of arcadia projected on the Brazilian countryside. Malfatti's experimentation with color and form reflect her knowledge of modernist developments in Germany and the United States, where she had spent time prior to her sojourn in Paris. Yet this painting was somewhat of an anomaly in Malfatti's oeuvre, since it is one of only a few of her paintings to reference Brazilian identity. And it may have been precisely for this reason that she chose to submit it to this exhibition of Latin American art: it fulfilled the foreign audience's expectation of exotic motifs, while simultaneously highlighting her facility with European modernist techniques.

Amaral, on the contrary, chose to submit a portrait of her good friend, the avant-garde writer Mário de Andrade. In a reduced palette of mostly shades of blue, Amaral paints a bust-length portrait of Andrade as a dignified gentleman in a suit and glasses. His body is clearly delineated and set against a flat, textured teal background punctuated with overlapping blue and yellow circles,

which are echoed in the blue and yellow shadows on Andrade's face. Despite the rather loose, impressionistic brushwork, the portrait remains eminently readable. Her image therefore combines the conventions of portraiture with the simplification of form and overall surface patterning and color distribution that she had learned under André Lhote's tutelage. Unlike Malfatti, Amaral chose a subject that emphasized Brazil's intellectual modernism, rather than exploring notions of the tropical and the exotic. Interestingly, however, these two artists would swap tactics in the next few years, as will be discussed in Chapter 6. Significantly, the submissions by these two women seem to have been among the only works that proposed modernist formal explorations as an appropriate presentation of Latin American art.

This inaugural exhibition at the Maison de l'Amérique Latine was a relatively small and rapidly assembled endeavor that attracted little critical attention. It was, however, a prelude to the much more extensive exhibition

that would take place the following year. French critic Raymond Cogniat, who was just starting to write a regular column on Latin American art for the recently launched *Revue de l'Amérique latine,* wrote the only known review of the show. His review introduced the matter that would come to define debates about Latin American art over the next decades: the existence or lack of a Latin American aesthetic. For Cogniat, such an aesthetic was nascent, but underdeveloped, still dominated by European ideas and influences: "What remains is for us to hope that these exhibitions will now recur often to permit us to follow the evolutionary efforts of the artist who, though very influenced by our formulas, maintains a certain independence that may perhaps allow their character to emerge."[9] While he does not delineate exactly what he was looking for, Cogniat suggests in this passage that Latin American artists should differentiate themselves from their European peers by foregrounding their innate character.

On January 1, 1924, the office of the Direction des Beaux-Arts et des Musées of the city of Paris announced that it would make the Musée Galliera available to the Maison de l'Amérique Latine and the Académie Internationale des Beaux-Arts from March 14 until April 15, for a much larger official exhibition of Latin American art that would showcase the full range of what the continent had to offer and "make Latin American art known in France in its most original manifestations . . . without differentiating by tendency or school."[10] By renouncing a "tendency or school" as an organizational mechanism, the organizers set the parameters for a new category of art exhibition, one determined by geopolitical rather than aesthetic identity. This decision paralleled that of the French Salon des Indépendants, whose hanging committee decided that same year to abandon its tradition of presenting works by tendency (or alphabetically, which it had done for the past two years) and instead organized

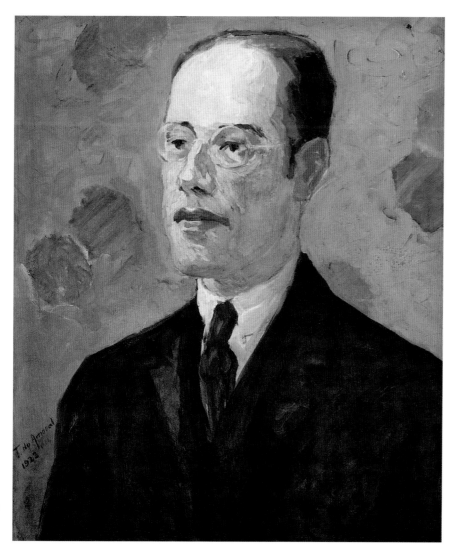

FIG. 57. Tarsila do Amaral, *Portrait of Mário de Andrade,* 1922. Oil on canvas, 21¼ × 18⅛ in. (54 × 46 cm). Acervo Artístico-Cultural dos Palácios do Governo do Estado de São Paulo.

the galleries according to national identity. This shift toward a national or regional presentation of art emerged in response to the increasing presence of foreigners in Paris between the wars, and fears that this presence would dilute "French art."[11] Thus, while the exhibition provided a unique opportunity for Latin American artists to exhibit in Paris, it also segregated and classified their work as "other."

The exhibition press release served as a call for participation, inviting Latin American artists living in Paris as well as collectors of Latin American art of all periods to submit works for inclusion. Perhaps in deference to their host country, a selection committee, made up of an eclectic range of French artists—including cubist Albert Gleizes, the academic painter and teacher at the Académie Julian Paul Albert Laurens, fashion designer and illustrator Georges Lepape, and art deco illustrator and printmaker Pierre Brissaud—assessed the paintings submitted, and in coordination with Bourdelle and Charles Despiau, who were in charge of the sculpture section, defined the scope of the show.[12] In the years between the world wars, there was a move to professionalize museum staff and separate education departments from curatorial departments, but many museums continued to organize exhibitions on an ad-hoc basis, which appears to be the case here. Given the range of style and quality of the final exhibition, it appears as if most if not all submissions were accepted. Organizers also planned an extensive concert and lecture series to accompany the exhibition throughout its month-long run. Conceived as a grand affair aimed at showing off the very best of Latin America's artistic talent, the exhibition strove to present a vision of the region as sophisticated and culturally relevant.

Osorio, who had assumed a leadership role in organizing the show, appealed directly to the cultural elite of Paris, inviting all the diplomatic corps from Latin America, as well as elite foreigners associated with the art, political, and literary worlds of Parisian society, to an elegant reception and concert at the Hôtel de Ville on February 15 to promote the exhibition. At the reception he made an impassioned speech about his hopes for the project and reasons for creating these cultural institutions:

> There are nearly one hundred million men there [in Latin America] who inherited at birth a culture thousands of years old. . . . It is up to our race, whose path has not destroyed our faith and whose misery has

not shrunken our heart, to legitimate our historical fate, by creating for the world the liberating solutions of tomorrow. There are nearly one hundred million men there whose similar ethnicity, religion, historical tradition, customs, and democratic ideals will intensify in a world of common aspirations. . . . However, we are still just numbers, dispersed by the four winds to follow our individual dreams. . . . Why can these people, despite the efforts they make daily in this regard, not build "the central organs of a nervous system" of continental life that has been so powerfully drafted? It cannot be a question of choosing the capital of one of the countries in Latin America to be the capital of the "Continent-Nation." We will never allow any form of continental union that confers to one of us the international preeminence that this privilege would in fact imply. Some propose to build a new capital located in a neutral zone. . . . What we need is not a capital, it is a Latin American "brain," that proclaims and that exerts in the world our supreme continental will to take an active and personal part in the historical task of humanity's future. . . . Where to found the institution that will embody all these aspirations? Paris is at the head of the bridge that reaches everywhere. Paris is for Latin Americans the uncontested ancestor of our democracies. . . . So that is why we have crossed the Atlantic Ocean to come, to your country, to found our Latin American foyer.[13]

In his speech Osorio made explicit this notion of a cultural community of Latin Americans in Paris. He even proposed Paris as the cultural capital of Latin America, a capital that could not be established in Latin America because it would privilege one country over the rest.[14] While this concept of a unified Latin American culture stems from a long history of ideological pan-Americanism, Osorio's explicit proposition of Paris as the quasi-capital of this region sets up a unique transnational alliance between France and the individual nations of South and Central America. France would not exert any political authority over Latin America, but rather would serve as a neutral ground as well as a cultural archetype for the formation and promotion of the arts of Latin America.

Osorio offered an additional justification for his selection of Paris as the Latin American capital of the arts, asserting: "It is necessary, however, that we soon be able to say Latin American as we have always said North

American."[15] By focusing on Latin America exclusively in this endeavor, the southern region could distinguish itself from the United States, whose increasing cultural and political hegemony was a growing source of strife. The United States' occupation of Cuba in 1898, followed by the invasions of Panama in 1903 and Nicaragua in 1912, had caused Latin Americans to regard their northern neighbor as an imperialist threat rather than as a model to emulate. By the 1920s U.S. companies dominated much of the oil industry in Latin America, leading to increased anti-U.S. sentiment and a continued emphasis on self-definition. Having experienced the power of the United States to enforce its will on the divided republics to its south, Latin American intellectuals began to focus on creating a cohesive pan-Latin American identity, emphasizing common race and culture as a means of unifying the bond between individual nations and differentiating themselves from Anglo-Saxon–based societies. By choosing Paris as a base of operations, Osorio aligned Latin America's Mediterranean heritage—its Latin-based language and culture—with Old World society as a means of rejecting North American imperialism. This was the first cohesive proposal of its kind to present Latin American art as a means of conveying this culture to the world.

THE FIRST SURVEY EXHIBITION OF LATIN AMERICAN ART

The *Exposition d'Art Américain-Latin* opened with great fanfare on March 15, 1924, at the Musée Galliera on 10, avenue Pierre 1er de Serbie (fig. 58). Among the distinguished guests at the opening were the ambassadors of Chile, Venezuela, Bolivia, Ecuador, and Peru, and Luis Martins de Souza Dantas, the ambassador of Brazil, as well as the Princesse d'Orléans-Bragance, the daughter of the former emperor of Brazil. Over 260 works of contemporary art by forty-two Latin American artists residing in Paris, whole art collections owned by important Parisian and Latin American collectors, as well as a retrospective section of pre-Columbian and folk art filled the galleries and garnered significant attention in the press.[16] Weekly cultural programs brought in new visitors throughout the month-long event, including presentations on Latin American literature, poetry readings, musical performances, and a lecture on Latin American art by École des Beaux-Arts professor Louis Hourticq.[17] Given the expansive geographic, chronological, and stylistic scope of the exhibition, the show simultaneously dazzled audiences and left them perplexed.

The retrospective section, drawn primarily from private collections, included tapestries and funerary vases from the Peruvian coast belonging to Raoul D'Harcourt; Cuban cigars owned by a Mr. Alvarez; tapestries, ponchos, indigenous garments, and musical instruments from Ecuador and Colombia belonging to the Ecuadorian artist Camilo Egas (1889–1962); feathered and ornamental objects from the Andes in the collection of Timoleon Flores, Ecuadorian consul; and a collection of paintings of Mexico by the nineteenth-century French artist Édouard Pingret belonging to a Mr. and Mrs. Chapsal. The submissions were thus heavily weighted to favor the indigenous traditions of the Andes. This juxtaposition of indigenous artifacts with the contemporary art in adjacent galleries tended to construe the past as a pure, original force and the present as tainted by European influence. As Henri Clouzot, the Musée Galliera's conservator, observes: "Evidently, the vicinity [of the pre-Columbian art to the contemporary art] is not without danger. When we see the purity of style, the perfection of technique and materials of the ceramics and textiles from the Peruvian coast before the arrival of the Spanish, and which are now just a memory, when we admire the sense of decoration and color, which in rare cases persist among indigenous tribes and can still today withstand comparison with the best European creations, we realize that the conquest did not always have fortuitous results for native art."[18] With this assessment

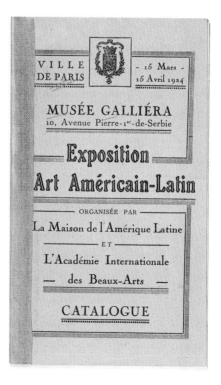

FIG. 58. Cover of *Exposition d'Art Américain-Latin* (Paris: Musée Galliera, 1924).

of pre-Columbian art as highly innovative and therefore worthy of comparison with the European tradition, critics were hard-pressed to find a means to evaluate positively the contributions of contemporary Latin American artists.

The contemporary art section included paintings, sculptures, architectural designs, and decorative arts in various media submitted by Latin American artists from fourteen different countries, with the greatest concentration from Argentina, Brazil, and Cuba.[19] Each artist submitted from one to eight works for inclusion, and paintings represented by far the largest category. Executed in a broad range of styles, the paintings presented an eclectic vision of Latin American art. On one end of the spectrum were the cubist works by Emilio Pettoruti and Alejandro Xul Solar (1887–1963), and on the other the impressionist landscapes and cityscapes of Manuel Cabré (1890–1984; fig. 59) and the Cézannesque compositions by Manuel Ortiz de Zárate. Only a handful of paintings depicted explicitly Latin American subject matter, such as those by Camilo Egas and Pedro Figari, whereas a much greater number portrayed the French, Spanish, or Italian countryside, generic still lifes, portraits, or genre scenes. It is difficult to determine by titles alone exactly what the subject of the paintings were, since many were listed simply as "landscape," "still life," or "portrait."

But of those that were more explicit, many more referenced place-names in Europe than in Latin America, and critical reviews of the show came to the same consensus. Unfortunately, there are no installation photographs of the exhibition in the Musée Galliera's archives, and no photographs by individual artists have surfaced.

One of Pettoruti's submissions, *Governess* of 1918 (fig. 60), was a cubist rendition of a woman inscribed in an oval on a rectangular canvas. While the composition bears close resemblance to Gino Severini's *Woman with Green Plant* of 1917 (fig. 61) and suggests knowledge of the artist's work from his time in Italy, Pettoruti's rendition differs in its crisp delineation of forms and uniform blocks of solid color. Sharp, angular forms dominate the composition and disrupt the illusionary distinction between figure and ground. Pettoruti also added checkerboards, dots, or wavy lines to some of the shapes to create dynamic patterns, which simultaneously suggest flooring, clothing, or hair. A door to the left of the figure indicates spatial recession because of its relative size, but also appears to be directly next to the figure, further collapsing the pictorial space. The picture thus plays with perceptions of solid and void in typical cubist fashion. Whereas Pettoruti employs similar pictorial tactics to Severini, Pettoruti distributes form and color more evenly and highlights clarity of design.

FIG. 59. Manuel Cabré (1890–1984), *The Seine*, 1923. Oil on canvas, 22 × 29½ in. (56 × 75 cm). Private collection.

FIG. 60. Emilio Pettoruti, *Governess,* 1918. Oil on board, 28¾ × 22⅔ in. (73 × 57.5 cm). Private collection, Buenos Aires.

FIG. 61. Gino Severini (1883–1966), *Woman with Green Plant,* 1917. Oil on canvas, 39⅓ × 31⅞ in. (100 × 81 cm). Private collection.

Pettoruti therefore extrapolates Severini's model, bringing it more in line with the new penchant for purist forms after the war. There is nothing here that suggests Pettoruti is invoking his Argentine heritage; rather, he is engaging and enhancing Severini's approach to cubism.

Since cubist pictures appeared regularly in the French salons, Pettoruti's painting would not have been particularly surprising for the French audience. Cogniat criticizes it on its merits as a cubist composition, stating, "Mr. Pettoruti submitted two curious cubist paintings in which values are well rendered and colored volumes well organized, but that remain a bit cold like all paintings of this type."[20] Others questioned the relevance of cubism in an exhibition of Latin American art, however. The critic for the *Journal des débats* asks: "Does an Argentinean cubist like Mr. Pettoruti think he justifies himself by calling on the example of his ancestors?"[21] The assumption here is that Pettoruti's cubism somehow recalled the blocky forms of

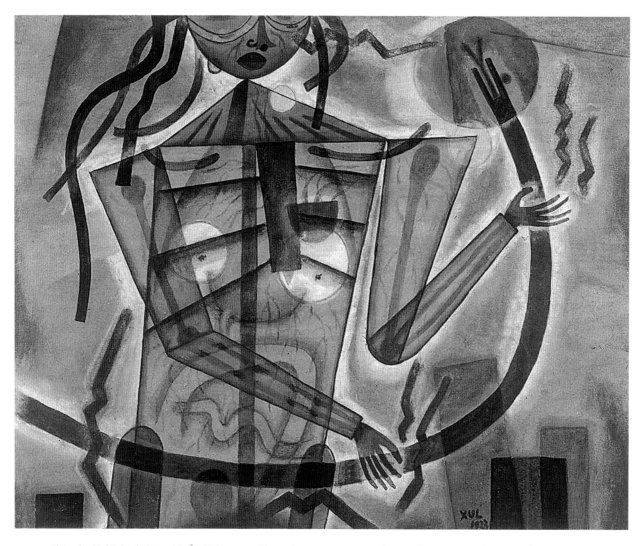

FIG. 62. Alejandro Xul Solar (1887–1963), *Ña diáfana*, 1923. Watercolor on paper mounted on card, 10¼ × 12½ in. (26 × 32 cm). Museo Xul Solar, Buenos Aires.

pre-Columbian art, and that in invoking this art, Pettoruti is claiming cubism as a legitimate expression of "Latin American" culture. The critic then goes on to call for more local or folkloric art, since in his eyes, cubism was a dubious expression of this culture. This desire on the part of French critics to identify "Latin Americanness" in works of art whose format and content indicate no such connection reveal the dilemma posed by the exhibition's imposition of a geopolitical construct on aesthetic production.

The Mexican critic José Frías took a different stance. Writing for the Mexican journal *Revista de revistas,* he calls Pettoruti a "vanguard artist" and likened Pettoruti's approach to that of the dadaists, expressionists, cubists, and futurists, proclaiming his art personal and sincere.[22] French critics pronounced the artist derivative, failing to examine the nuances of his contribution to European

movements. Latin American critics, on the contrary, felt the need to assert his originality. These divergent interpretations of the artist reveal an important divide among critics in their assessment of artists who, in the context of this exhibition, suddenly represented a regional identity. It was the premise of the show, envisioned under the umbrella of Latin American identity, that set up this dichotomy between center and periphery and compelled critics to judge artists by a new set of criteria.

The other artist deemed a cubist in the exhibition was Argentinean Alejandro Xul Solar, but his identification with cubism was tangential at best. Rather, his modernist explorations resulted from a fascination with the work of Paul Klee and Vassily Kandinsky, which he developed during his 1921–23 residency in Munich. Of the three watercolors by Xul Solar that appeared in the show, only one

can be identified decisively. *Ña diáfana*, exhibited in Paris simply as *Femme au serpent*, depicts a woman holding a long, writhing snake, whose head seems to be engulfed in the blue and yellow orb of the waning moon (fig. 62). The mysterious woman's face has been cut off by the upper edge of the frame, leaving only her chin, lips, nose, and the blue semicircles under her eyes visible. Xul Solar painted her body in translucent washes of scintillating color, which change hue at the intersection between forms. Her bones and internal organs are visible beneath the surface, creating intersecting layers of overlapping shapes, and crimson zigzags emanate from her fingers and mouth like electrical energy. The arc of the snake's body echoes the strands of hair on the diaphanous woman's head, suggesting that the two figures are in the midst of some sort of mystical communion. The snake, a recurring motif in Xul Solar's paintings, may signify various religious traditions such as the Judeo-Christian creation myth or the Toltec legend of the feathered serpent, since Xul Solar sought to reveal universal truths by drawing parallels between religious, linguistic, and artistic traditions.[23] As one of the most progressive and experimental artists in the exhibition, Xul Solar seems to have been overlooked or misunderstood completely by critics, with one dismissing him as a "rather false" cubist,[24] and another essentially equating his work with that of Pettoruti.[25] It seems that avant-garde explorations had little place in this survey of Latin American art.

Work by artists who frequently contributed to the French salons dominated the exhibition. In the many reviews of the show, the names Manuel Ortiz de Zárate, Domingos Viegas Toledo Piza, Manuel Rendón Seminario, Marcial Plaza Ferrand, and Manuel Cabré appeared over and over, with the highest praise often heaped on Ortiz de Zárate. Phil Sawyer calls Ortiz de Zárate's work "bold and rugged in form and interpretation";[26] Frías proclaims him "one of the most serious pictorial talents in Latin America";[27] and many others list his work as among the best in the show. Since Ortiz de Zárate rarely dated his paintings and very little scholarly work has been done on his oeuvre, it is difficult to pinpoint which paintings he submitted to the exhibition. It seems likely, however, that a painting such as *Still Life with Guitar* was among his submissions (fig. 63). This painting demonstrates Ortiz de Zárate's shift away from cubism to explore the essential geometries of Cézanne in the 1920s. This type of painting

FIG. 63. Manuel Ortiz de Zárate, *Still Life with Guitar*, ca. 1920s. Oil on canvas, 28¾ × 45⅔ in. (73 × 116 cm). Musée National d'Art Moderne, Centre Georges Pompidou, Paris.

FIG. 64. Pedro Figari (1861–1938), *Assassination of Quiroga*, ca. 1924. Oil on cardboard, 19⅔ × 27½ in. (50 × 70 cm). Private collection.

would have appeared modernist in its brushwork, but remained accessible to a general audience unaccustomed to the experimental forms of the avant-garde. It also aligns with the general tendency to paint in a readable and often classicizing manner known as the "call to order" after the war. Since the aim of the exhibition was to extol Latin American art to French audiences, showcasing those artists whose work was on the cutting edge of innovation was probably deliberately avoided. This tactic led critics to lament that the exhibition did not reveal any singular talent, and that many of the paintings were banal and sentimental.[28]

Two artists whose work seemed to fulfill French critics' desire for "native" subject matter were Pedro Figari and Camilo Egas. The Uruguayan Figari, while not in Paris at the time, had seven paintings in the exhibition submitted by the Franco-Uruguayan poet and writer Jules Supervielle. All of Figari's paintings were scenes of Uruguay and included two *Candombe* paintings, *Pericón, Toucans, Fiesta in the Village, The Visit,* and *Assassination of Quiroga.*[29] Executed in Figari's characteristically loose brushwork, *Assassination of Quiroga* depicts a chaotic scene

(fig. 64). Riders on horses wielding swords and guns surround a stagecoach from which they have dragged and executed the federalist leader Juan Facundo Quiroga. Quiroga was an Argentinean *caudillo* who, after leading several attacks in the Cisplatine War, was appointed governor of Buenos Aires in 1834. He was executed the following year on a return trip from Salta, where he had been attempting to mediate a dispute between governors. His assassination led to a crisis in the confederation, the establishment of the government of Juan Manuel de Rosas, and calls for a return to civility in Argentine political life. In choosing to depict an historical event that took place nearly a century prior, Figari romanticized the wild, unruly ways of the formative days of the Argentine state. In his painting, Figari depicts Quiroga's body as merely a black smudge in the lower-right-hand corner of the canvas. A group of assassins crowd around his head as if confirming whether or not he is really dead. Men on horseback whirl around the space, and the two horses pulling the coach rear up on their hind legs, heightening the drama of the scene. The undulating forms of the trees and clouds in the clear blue sky echo the movement of the scene unfolding below. This

type of imagery, with its reference to a real historical event, would have reinforced the French vision of the Argentine pampas as a wild, uncivilized place.

Whereas Figari appropriated the loose brushwork of the impressionists, unlike these artists Figari did not paint scenes of modern leisure observed from life. Whether painted in Paris, Uruguay, or Argentina, Figari's scenes were nostalgic imaginings of disappearing customs. Yet by co-opting impressionist brushwork, he lends an air of authenticity to these scenes through an association with the nineteenth-century penchant for capturing modern life. These paintings seem to represent fleeting moments, captured quickly by an artist who observed the scene. Impressionism, while still a prominent technique in the Parisian salons half a century after its inception, was no longer disruptive nor cutting edge. Figari was not simply a late impressionist, however; he redeployed impressionist technique as a means of representing the fuzzy edges of memory, a past reconstructed according to the desires of the present, taking into account the tastes and expectations of a Parisian audience.

In combination, Figari's paintings prompted critics to assert that his work "separates itself right away from the rest of the group."[30] Many commented on the local emphasis of his subject matter, calling his compositions "very animated scenes of Uruguay,"[31] "full of local color,"[32] or "quaint pictures of Uruguayan life."[33] None commented on Figari's technique; rather, it was his focus on the local that drew attention to his submissions. Critics found in them an exotic world of afro-Uruguayan life, folk dances, celebrations, and violent political upheaval, an image of Latin America that confirmed rather than challenged that which existed in the European imagination.

Although the catalogue lists Camilo Egas's submissions as a self-portrait and two still lifes, it appears that he added several drawings of indigenous Ecuadorians after the catalogue went to press. According to the *Chicago Tribune* review, Egas submitted "some very fine works in red chalk of heads of Indians."[34] Of the known works by Egas, it is likely that the drawing in the exhibition was (or was very similar to) *Head of an Indian* of 1922 (fig. 65). The drawing is extremely naturalistic in its proportions and shading and appears to have been drawn from life. It depicts the face of a young indigenous woman with downcast eyes, looking off to the left. She does not engage the viewer, but rather subverts her gaze, allowing the artist to capture her form without actively acknowledging

his presence. Egas has rendered the figure without any of the characteristic clothing or ornaments that would have identified her as Native American, and instead focused on creating a realistic portrait of an individual, perhaps made as a preparatory drawing for the series of murals he would execute for the Jijón y Caamaño library in Quito in 1922. If this was one of the works in the exhibition, it is perplexing that two reviewers identified Egas's drawings as "indigenous types," however, with one calling them "curious" and another "savory."[35]

It is also possible that the work in the exhibition was more like *Head of an Indian*, made in Paris in 1924 (fig. 66). In Paris, Egas would no longer have been able to work from an indigenous model and would have had to draw from memory. The transformation in his rendering of the indigenous female over this two-year period indicates more than just a lack of a model, however. In the 1924 drawing, Egas has distorted and exaggerated the figure's lips and jawline. She now also wears beads and a headdress, marking her indigenous status. She has become a caricature or a parody of Indianness rather than a unique individual. Since we do not know exactly which drawings were in the 1924 exhibition, it is impossible to determine which came first—the reviews that referred to the images as "types" or the images that inspired the characterization. In either case, it was in Paris that Egas shifted his approach to the indigenous subject, moving from academic and naturalistic to exaggerated and almost comedic. As I have discussed elsewhere, this shift was perhaps a response to the distorted expectations of the Parisian audience, who did not want reality, but rather stereotypes of the exotic and native. By employing the technique of caricature, these images satirize the "primitive" qualities of Native Americans, thereby calling attention to the constructed nature of this trope.[36]

Works such as those by Figari and Egas were the exception and not the rule, however, and caused critics to decry Latin American artists' lack of originality. In his extensive review of the exhibition, Cogniat proclaims: "Several times in this review we have remarked on the lack of personality of many American artists. We have noticed, however, that the nations which have a distinctive folklore, characteristic origins, and a climate, vegetation, and countryside, often very different from that which we are familiar with in Europe, that those who have such a past and such examples before their eyes, cannot possibly totally lack originality and it would probably take very

FIG. 65. Camilo Egas (1889–1962), *Head of an Indian*, 1922. Drawing in red chalk, 11⅜ × 8⅞ in. (29 × 22.5 cm). Célia Zaldumbide Collection, Quito.

little to awaken in them more instinctive tastes, more spontaneous and less encumbered by foreign influences."[37] For Cogniat, originality does not refer to an artist's unique vision, but rather to that artist's willingness to represent "native" characteristics in his or her work. The less a work of art resembles European models, the more "original" he considers it. Moreover, the condescending tone of Cogniat's remarks and suggestion that artists need merely to tap into their instinctive (as opposed to cultivated or learned) response to their environment relegates Latin American artists to the role of unschooled children in need of informed guidance from a discerning critic. Latin American artists did not passively accept this criticism, however. Cuban artist Armando Maribona, for example,

writes disparagingly about the prejudices inherent in French critics' assumptions: "Regarding [Latin American] painters and sculptors, more than a few arrived knowing how to execute works to perfection; but for French critics they lacked 'personality' in their concept of forms, colors, and composition. Did they or did they not present something NEW? It was NOVELTY that was demanded of them."[38]

The sculpture section was even more devoid of stereotypical references to Latin American identity. The only piece that referenced this heritage was Marco Tobón Mejía's medallion *Profile of the Andes* (fig. 67). For the most part, the works submitted by the twelve sculptors living and working in Paris were portrait busts or allegorical

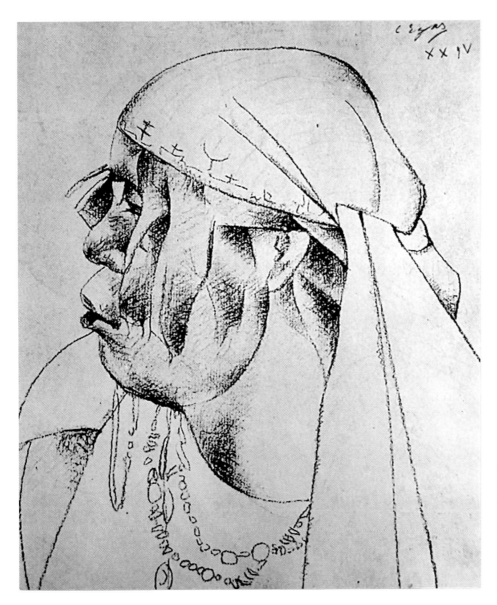

FIG. 66. Camilo Egas, *Head of an Indian,* 1924. Drawing on paper. Private collection.

FIG. 67. Marco Tobón Mejía (1876–1933), *Profile of the Andes,* 1923. Medallion, bronze, 9 in. (23 cm) diameter. Museo de Arte Moderno de Medellín.

scenes. One of these submissions, a bronze head by Argentinean Alberto Lagos (1885–1960), was even acquired by the French government.[39] Several sculptures received critical acclaim in the press, including works by Brazilian Victor Brecheret (1894–1955), Argentinean Pablo Curatella Manes, and Costa Rican Max Jiménez (1900–1947), despite their "European" subjects and techniques. Brecheret submitted two sculptures: *Sentinel* (silver plate) and *Rhythm* (bronze; fig. 68). *Rhythm* is a small-scale bronze sculpture of a female nude crouching on one knee. As suggested by the title, Brecheret did not try to capture a likeness of his model, but rather the essence of her movement. Reduced to simple geometric shapes, the woman's back forms a C-curve that has been elongated and distorted to create

FIG. 68. Victor Brecheret (1894–1955), *Rhythm,* ca. 1924. Bronze, 10⅛ × 7⅛ × 3⅛ in. (25.8 × 18.2 × 8 cm). Private collection.

a rhythmic pattern. Her bent knee fits perfectly under the curve of her arm, and a straight line delineates her profile. Her breasts have been reduced to small mounds so as not to interfere with the linear rhythm of the bends and curves of the body. The sculpture is a study in form and energy guided by the shape of the female body. Reviewers commended Brecheret's "progressive talent," and Frías even referred to his work as the salvation of Latin American sculpture.[40] Cogniat, despite his call for nativist themes, lavished praise on Brecheret's submissions, asserting that his sculptures "were conceived in the most interesting decorative spirit. The lines are simple and beautiful, supple and harmonious, the ensemble lacks

neither strength nor balance and has a well established architectural character that is unfortunately too rare in sculpture."[41]

Curatella Manes submitted four sculptures, including a work in bronze called *Woman in a Heavy Overcoat* of 1921 (fig. 69). While not orthodox cubism, the sculpture reveals Curatella Manes's engagement with the movement and aptitude with reducing and simplifying forms to derive essential geometries. As compared to Brecheret's *Rhythm, Woman in a Heavy Overcoat* is all angles and planes. Curatella Manes has almost completely eliminated curvilinear forms, yet the sculpture shares an interest in overall linear patterning and rhythm. Neither sculpture

FIG. 69. Pablo Curatella Manes (1891–1962), *Woman in a Heavy Overcoat*, 1921. Bronze, 14½ × 7⅞ × 10¼ in. (37 × 20 × 26 cm). Museo Nacional de Bellas Artes, Buenos Aires.

represents a recognizable individual; rather, the female form has become a motif upon which to perform geometric simplifications, a technique with which reviewers were familiar. Cogniat calls the piece a "good example of simplification of volumes;"[42] the reviewer for *L'oeuvre* comments on Curatella Manes's architectural approach to human anatomy;[43] and Sawyer praises his "love of blocking out his figures in big angular forms."[44]

Among the most disputed sculptures were Max Jiménez's submissions. Cogniat decries that Jiménez's sculptures "were not of first rank; without a doubt we find harmonious lines in the granite, but in the silver plate works by the same artist we find an accumulation

of unformed volumes, with a weak silhouette, that do not succeed in creating an ensemble."[45] But Frías retorted that people laughed at Jiménez's sculpture (he is referring specifically to his sculpture *Intersection*, fig. 70, here) because they did not understand it. According to Frías, the piece represented a couple embracing and was marked by strength, simplicity, and synthesis, which for Frías, made it among one of the most avant-garde works in the show.[46] Frías even chose to reproduce the work alongside his review, in which he only discussed nontraditional works. In fact, one of Frías's chief complaints about the exhibition was that the organizers "weren't excessively keen on Latin Americans who were working with

advanced tendencies," which for Frías was an unfortunate representation of the true vanguard potential of Latin American art.[47]

Jiménez's sculpture *Intersection* was one of the most abstract works in the show. Whereas both Brecheret and Curatella Manes simplified their forms, Jiménez pared his figures down until they straddled the boundary between abstraction and representation. His granite sculpture, which measured nearly a meter high, melds two figures together to form an intertwined unit. An undulating biomorphic form, which seems to have a life of its own, stands in for female hair. While it is nearly impossible to cull any further description from the photograph reproduced with Frías's article (the only known reproduction of the sculpture), the confusion that it provoked reveals a bit about its reception and the audience at the Musée Galliera exhibition. Although artists such as Constantin Brancusi had been experimenting with extreme simplification in sculpture in the years during and after World War I, in the context of an exhibition of Latin American art, Jiménez's vanguard experiments with sculptural form seemed out of place to reviewers seeking an aesthetic derived from regional identity. In an attempt to make sense of its inclusion, Sawyer compares it to pre-Columbian art, a tactic that would soon become commonplace in interpretations of modern Latin American production: "Here is something of the primitiveness of the Astecs [sic] and the hidden meaning of his civilization. Coming from a country

FIG. 70. Max Jiménez (1900–1947), *Intersection,* ca. 1923. Location unknown. Reproduced in José D. Frías, "La exposición latinoamericana en el Museo Galliera," *Revista de revistas* (Mexico) 15, no. 733 (May 25, 1924): 35–36.

where the government has changed often, one is not surprised at a certain revolutionary tendency which may be interpreted in different fashions, but certainly is an attempt to have a perfectly free expression in Art which promises to evolve into something very personal and interesting."[48] Sawyer at least recognizes the experimental quality of the sculpture, but attributes it to Jiménez's exposure to political upheaval and the resultant desire for freedom. By explaining the sculpture's formal qualities in regionalist terms, Sawyer attempts to make them coincide with his limited knowledge of Latin American culture. Critics frequently could not reconcile styles bordering on abstraction with expectations of tropical, primitive, or politically radical content, and therefore dismissed artists such as Jiménez.

Reviewers found a bit more of what they were seeking in the decorative arts sections of the exhibition. Uruguayan artist Carlos Alberto Castellanos (1881–1945) submitted two decorative panels, two landscapes of tropical America, and a set design for a new ballet, *Amancay.* One of the decorative panels was *Spaniards Surprised by Indians,* a lush landscape swirling with color and rhythm (fig. 71).[49] Trees burgeoning with foliage in vibrant shades of red, orange, gold, and blue surround two small figures on horseback—conquistadors in full armor—upon whom branches swoop down from above like claws. At first glance the scene seems to be simply a decorative rendition of a dense tropical forest, but upon closer examination birds and figures start to appear. The conquistadors are not alone, but rather are surrounded on all sides by scantily clad Native Americans with their bows drawn. The density of the forest and its hidden dangers exacerbate the feeling of exposure that early explorers must have felt. Castellanos employed the symbolist tropes of untamed nature and non-natural color to create an appealing yet fear-inducing fantasy of discovery and conquest. While Castellanos renders the Spanish vulnerable through his formal choices, his presentation of extreme circumstances implies that the resulting conquest was a courageous fight. Even the decorative background of undulating clouds and light suggests enlightenment and new beginnings. Thus Castellanos's image allowed the viewer to indulge in a tropical fantasy complete with vicious natives, without contemplating the brutality of the conquest.

Other contributions to the decorative arts section were Argentinean artist Alfredo Guido's submission of set and costume designs based on Peruvian colonial dress for

FIG. 71. Carlos Alberto Castellanos (1881–1945), *Spaniards Surprised by Indians,* n.d. Oil on canvas, 47¼ × 55⅛ in. (120 × 140 cm). Musée Municipal de la Coutellerie, Thiers, France.

the opera *La cruz del sud* by Uruguayan composer Alfonso Broqua, and a dining room set by Brazilian designer José de Andrada. While reproductions of these designs are no longer extant, critics' responses reveal yet again the extent to which the parameters of the exhibition dictated interpretation of the works. Whereas Jean-Gabriel Lemoine comments that Andrada's designs were not particularly Brazilian, he praises the style and lyricism of Guido's work.[50] And Henri Clouzot makes a similar observation, praising Guido's taste for the picturesque, yet searching for a means to understand Andrada: "José de Andrada, who is Brazilian, is the only representative of the applied arts with a dining room table in coral and black wood, of an excellent model. I would not say that he was inspired

by indigenous art, nor the colonial art of Quito. His handsome piece of furniture is defined by its 'mastery.' That is to say that it is French and Parisian."[51] Ironically, it was the "mastery" with which Andrada executed the table that precluded its identification as Latin American, which in the minds of critics should have made it crude and primitive. Revealing his extremely limited knowledge of Latin American artistic tradition, Clouzot makes a failed attempt to link Andrada's design with indigenous art or, rather oddly, the art of colonial Quito, in an effort to match his imagined construct of Latin America with the art at hand.

The exhibition garnered a great deal of attention in the press, with at least nine different newspapers printing

reviews of the show. While the comments were positive overall, the general consensus was that the art on display was an "echo of French art," and that a Latin American tradition was still in the process of formation.[52] As Cogniat proclaims, "It is evident that the great majority of the inhabitants of South America have Latin origins and without a doubt are in need of several more years, more polish, before these transplanted races manage to find for themselves a formula or a means of expression of their own."[53] Since his review of the preliminary exhibition of Latin American art in 1923, Cogniat had contemplated how this might be done. He contends that pre-Columbian art should serve as a model for this sought-after originality and regional expression. Clouzot makes a similar assessment: "To tell the truth, we have the impression, as we tour the exhibition hall, that this contact [between France and Latin America] has been established for a long time. This is because this time the committee could only request works by artists and collectors living in Paris. Another year, they will present to us works born from the Latin American soil and will permit us to judge the characteristics and tendencies of an autochthonous art. That which is presented to us at the Galliera is a bit too much 'de chez nous.' . . . Therefore we cannot say that there is an Argentine art, a Brazilian art, an Uruguayan art. It is all art of French influence."[54] For Clouzot, the problem was not that artists needed more time to develop an original voice, but rather that the organizers selected artists who had too much European exposure. This was the grand conundrum for Latin American artists: to prove their modernity and universality at home they had to be conversant in European visual idioms, but in Europe evidence of this knowledge and training was judged to somehow impede the possibility of a unique or native perspective.

The Mexican critic José Frías begins his review with the question "Can Spanish America have its own art?" He then goes on to observe, like his European counterparts, that what the show reveals, with only a few exceptions, is "a sufficient ability, and a constant dedication by artists to copy European art."[55] But Frías draws a different conclusion than the European critics, asserting, "I prefer to highlight that which can be defined as modern art and which can be later converted into 'our art.'"[56] The fundamental difference here is that Frías believes that artists should first learn modernist technique and then transform what they have learned into something uniquely Latin American. For him, the artists who were more interesting,

and whom he chose to review—Jiménez, Pettoruti, Ortiz de Zárate, Rendón, and Brecheret—were those who could bring new impulses and revolutionary ideas to Latin American art.

The organization of the exhibition at the Musée Galliera around the geopolitical construct of Latin America compelled both artists and critics to ponder the existence of a Latin American aesthetic. Critics on both sides of the Atlantic tended to agree that such an aesthetic did not yet exist, and found the future possibility of defining characteristics that unified the art of the region a desirable goal. They differed, however, in how that goal should be obtained. Whereas Latin American artists and critics lauded European training as a path toward regional innovation, European critics pushed for isolationism, a return to pre-conquest roots, and a rejection of European techniques. This, of course, was an impossible goal that coincided more with European fantasies of an authentic, unadulterated primitivism than with the reality of a culture that stemmed from several hundred years of Spanish colonial rule. Despite the implausibility of European critics' propositions, this notion of the primitive and the authentic set the tone for future debates and exhibitions of Latin American art and led artists, critics, and exhibition organizers to begin to respond, often in diametrically opposed ways, to what they thought Latin American art, as a regional construct, should be.

ASSOCIATION PARIS-AMÉRIQUE LATINE

The exhibition at the Musée Galliera put Latin American art on the map and prompted numerous individual and group exhibitions in Paris over the next decade. It also brought serious attention to Osorio's efforts to organize the Latin American community in Paris, marking this community as a cultured and sophisticated group. Osorio's original proposal had included the formation of a Maison de l'Amérique Latine, but just prior to the exhibition Osorio revised his proposition, calling for two different organizations to be formed: the Bureau des Nations de l'Amérique Latine, which would handle intellectual and artistic action in the nineteen member countries, and the Cercle de l'Amérique Latine, soon renamed the Association Paris-Amérique Latine, which would serve as the French cultural liaison.[57] It appears as if this proposal was meant to replace the name Maison de l'Amérique Latine, since that nomenclature does not appear in the press again until the 1940s.

On June 3, 1925, the Association Paris-Amérique Latine (often referred to interchangeably as the Cercle Paris-Amérique Latine) was officially inaugurated at its new headquarters at 14, boulevarde de la Madeleine, with more fanfare. Diplomats, ministers, police, members of the French academy, Princess Galitzine of Russia, the marquise of Crussol, and the ambassador of Brazil, Luis Martins de Souza Dantas, were all in attendance and listened to a series of speeches by Osario, the Duchesse Douairière D'Uzès, and the president of the association, Pierre Dupuy, among others.[58] Argentina, Bolivia, Brazil, Chile, Colombia, Costa Rica, Cuba, Guatemala, Haiti, Mexico, Paraguay, Peru, El Salvador, Uruguay, and Venezuela all officially became member states.[59] Over the next several years the association implemented an extensive cultural program, featuring lectures, concerts, and art exhibitions, as well as receiving important visitors. They published the *Bulletin provisoire du Bureau d'études et de propagande,* which included articles on literature, local and world politics, the arts, sciences, sports, economics, and financial and commercial issues. And Latin Americans living in Paris met in the building's immense art deco–style halls for weekly dinners.[60]

The exhibition program seems to have been shaped by the debates and criticisms surrounding the survey exhibition of Latin American art at the Musée Galliera. Of the nine shows reviewed in the press between 1925 and

1928, five featured works by artists from the Andes whose paintings and sculptures depicted indigenous motifs.[61] The exhibition facilities were most likely bare bones, since most of the artists who exhibited there submitted works on paper or small-scale oil on canvas compositions, and at least one review mentioned that drawings were simply pinned on the wall without frames.[62] As can be seen in this installation view of Armando Maribona's exhibition at the Association Paris-Amérique Latine in 1925, the paintings were hung rather haphazardly from temporary partitions (fig. 72). The informality of the exhibition space and the recurring emphasis on specific regions suggests that artists were selected according to the national interests of those with close ties to the association, rather than a clear curatorial vision. Nevertheless, featuring artists whose work foregrounded native motifs was a means to satisfy expectations of primitivism from Parisian audiences and critics.

The first of these shows hosted by the Association Paris-Amérique Latine was an exhibition of three sculptures and thirty drawings by the Peruvian sculptor Carmen Saco (1882–1948) displayed alongside Inca and folk art. Although the show featured her sculpture *Project for a Fountain,* a tableau of reclining female nudes in an Arcadian landscape, it was the inclusion of several works with Inca themes—*Manco Capac and Mama Oclla, The Priestess of the Sun,* and *The Last Inca Chief* (current

FIG. 72. Armando Maribona's exhibition at the Association Paris-Amérique Latine, Paris, 1925. Photograph.

FIG. 73. Carmen Saco (1882–1948), *Repenting*, ca. 1920s. Location unknown. Reproduced in Gustave Kahn, "Quelques sculpteurs de l'Amérique latine," *La renaissance de l'art français et des industries de luxe* 9, no. 8 (special issue on Latin America) (August 1926): 478–87.

location of all three works unknown)—that reviewers commented on the most. Cogniat extolls *Manco Capac and Mama Oclla* for its "glorification of the [Inca] civilization and the race."[63] Another reviewer lauds the artist's adoration of Peruvian culture: "The drawings reveal Mme. Carmen Saco's charming fantasy, whose spirit reflects all the poetry of her country. The Peruvian art that inspired her, she considers it a testimony to a race that she loves profoundly."[64] Although most likely intended as praise, the sentimental tone and interpretation of her work as an emotional response to the decorative motifs found in indigenous art had a condescending note to it, as if love of country somehow spontaneously allowed Saco to produce pleasing designs, rather than training and active aesthetic judgment. From a review of her work published the following year, we know that Saco did not focus on Inca themes exclusively, and had submitted allegorical

sculptures such as *Repenting* (fig. 73), *The Beggar, The Defeated Boxer,* and *Adolescent* to the Paris salons; according to French poet and art critic Gustave Kahn, these works possessed "a fortitude and authority not very common in women."[65] Significantly, Kahn ascribes masculine qualities to Saco's sculptures that were not native-themed, whereas the reviewer of her show at the association employs language associated with femininity to describe works with indigenous subjects, establishing, through gendered equivalency, a hierarchy of value from Western to non-Western. In the context of the Association Paris-Amérique Latine, reviewers specifically sought native motifs, defining Latin America in terms of its pre-Spanish past, rather than its modern post-colonial present.

Significantly, just following Saco's exhibition, in December 1926 the association hosted an exhibition of works by Gauguin entitled *Exposition rétrospective: Hommage au génial artiste Franco-Péruvien Gauguin* (fig. 74). Even though Gauguin moved to Paris from Peru when he was only eight years old, claiming Gauguin (one of France's most lauded modernists) for Peru served as a means of asserting the primacy of Latin America, and the Andes in particular, as a source of creative inspiration and proven birthplace of great art. In his introduction, Peruvian artist and intellectual Felipe Cossío del Pomar (1889–1991) reinforces this narrative: "One cannot follow the counsel of an artist while ignoring his heritage. It explains a great deal about his art and his life, it gives us the key to his preoccupations and the genesis of the originality of his art. It was in the land of his ancestors where he first saw the bronze race with which he identified much later; it was Inka art objects that inspired his fantasy of the decorative, from his childhood he acquired a taste for symbolic decorations from quechua ceramic artifacts; the kataris, the huacas, the keros."[66] For Cossío del Pomar, it was Peru, not France, that inspired Gauguin's primitivism. And since Peru played a significant role in shaping Gauguin's artistic vision, Peruvian origin should consequently produce other great artists.

In March 1927 another Peruvian artist, César Moro (1903–1956), who will be discussed further in chapters 7 and 8, held a joint exhibition with Dominican artist Jaime Colson (1901–1975), who will be discussed in chapters 9 and 10, at the association's galleries, with a selection of Peruvian scenes.[67] These artists were faced with the double bind of identifying as Latin American for greater recognition, while simultaneously having to confront the

prejudiced notions of what belonging to that group meant. In an article published in the Peruvian newspaper *Mundial* in 1927, the Peruvian philosopher and journalist José Carlos Mariátegui identifies explicitly the assumptions and prejudices these artists were facing, disparaging their Parisian audience and their demand for native themes: "From César Moro, Jorge Seoane, and the rest of the artists who have recently emigrated to Paris, native themes and indigenous motifs are requested. Our sculptor Carmen Saco brought the most valid kind of artistic passport in her sculptures and drawings of Indians."[68] Perhaps in reaction to these expectations, Moro ceased painting Peruvian scenes and instead began experimenting with surrealism. Whereas many foreign artists in Paris intensified their expression of cultural nationalism in their work in response to Parisian expectations, Moro took the opposite tack from this point forward, emphatically rejecting any expression of "Peruvianness."

In late 1927 the Association Paris-Amérique Latine held two more exhibitions of Andean art, a joint

exhibition of Peruvian art by Manuel Domingo Pantigoso (1901–2001; fig. 75) and Francisco Olazo (1904–1948), which will be discussed here, and a solo exhibition by Bolivian Elena del Carpio. Pantigoso's portion of the joint exhibition with Olazo featured ninety paintings brought from Peru: twenty-two oils, thirty-three gouaches, and thirty-five watercolors.[69] Among the oil paintings was *The Shepherdess* (1927), which depicts a young indigenous woman in traditional costume and jewelry attending two llamas (fig. 76). Pantigoso executed the image in a loose painterly style, but maintains academic proportions in the figures and animals. The scene is set in the high sierra with the stark, treeless Andean range in the background, framing and dominating the figures of the girl and the llamas beside her. The vibrant reds of the girl's costume make her stand out against the drab background, while the blue thread she is spinning links her to the traditionally female occupation of weaving, for which the Inca were renowned. Painted in profile, the heads of the two llamas and the girl form a sort of trinity, as if they are

FIG. 74. Cover of Association Paris-Amérique Latine, *Hommage au génial artiste Franco-Péruvien Gauguin* (Paris: Association Paris-Amérique Latine, 1926).

FIG. 75. Manuel Domingo Pantigoso (1901–2001), *Exposition d'art Péruvien Domingo Pantigoso* (Paris: Association Paris-Amérique Latine, 1927).

spiritually linked to one another as well as the land. There is no indication here of social strife or the advances of modern life that afflicted Peru during Augusto B. Leguía's presidency in the 1920s. Rather, the image presents a picturesque vision of an idyllic past that continued unchanged into the present, exactly the sort of Peru conjured in the European imagination, and which critics were all too willing to accept as "authentic." As one reviewer writes: "They [Pantigoso and Olazo] have given us a marvelous vision of Peru, of the beauty of her natural landscape and of the picturesque quality of life."[70] And another comments: "Without frames and hung in a disorderly manner, the gouaches and watercolors are nevertheless a marvelous picturesque evocation of Peru and of Andean life. . . . The exhibition by Mr. Pantigoso and Olzao is one of the most original of the season."[71]

Although these exhibitions of Andean art were interspersed with two exhibitions of Cuban art and a group show of works by Argentinean artists living in Paris, the emphasis on Andean artists and their picturesque renditions of native motifs—by an organization that set out to define and present Latin American culture to a Parisian audience—did little to challenge existing stereotypes, and instead upheld the Native American as a symbol for an entire region. By the mid-1920s indigenism was emerging as an avant-garde trend in Mexico and the Andes, as a means to denounce the social and political repression of the indigenous masses. But this trend did not manifest fully in pictorial form until the 1930s, so Parisian audiences got only picturesque decorative scenes, timeless images of traditional cultures unaffected by political upheaval. The Association Paris-Amérique Latine was by no means the only exhibition venue available to Latin American artists in Paris, however; many resisted this quaint and circumscribed presentation of Latin American identity. The next few chapters will examine the presentation and reception of Latin American art at the salons, at independent galleries, in the press, and in conjunction with avant-garde movements.

The Association Paris-Amérique Latine does not seem to have remained in existence much past the late 1920s.[72] The last exhibitions reviewed there were held in 1928, and by 1932 the primary source for these reviews, the *Revue de l'Amérique latine,* also folded in the wake of the worldwide economic depression. A new Maison de l'Amérique Latine, established under the initiative of Charles de Gaulle and the minister of foreign affairs, opened in 1946 and is still

FIG. 76. Manuel Domigo Pantigoso, *Shepherdess,* 1927. Location unknown. Reproduced in *Manuel Domigo Pantigoso: Fundador de los independientes* (Lima: IKONO, 2007), 175.

in existence today.[73] Although the current Maison de l'Amérique Latine claims to have had no connection with the organization that functioned in the 1920s, the former ambassador of Brazil, Luis Martins de Souza Dantas, was involved in both endeavors and was most likely instrumental in founding a new maison after the war.

4 At the Salons

The Paris salons provided infrastructure for many Latin American artists who simply did not have regular exhibition opportunities in their country of origin. By the early 1920s, when Latin American artists began to arrive in Paris in large numbers, there were five annual salons from which to choose: the official salons organized by the Société des Artistes Français (1881) and the Société Nationale des Beaux-Arts (1890), the Salon des Indépendants (1884), the Salon d'Automne (1903), and the recently founded Salon des Tuileries (1923).[1] Whereas many of the national art schools in Latin America (for example, Mexico's Academía de Bellas Artes de San Carlos, Cuba's Academia Nacional de Bellas Artes San Alejandro, Venezuela's Instituto Nacional de Bellas Artes, and Brazil's Escola Nacional de Belas Artes) held annual exhibitions of student work, these exhibitions did not confer the same degree of prestige or subsequent sales as did success abroad. Initiatives outside the art schools were often short-lived and inconsistent in their exhibition schedules. In Venezuela, for example, the independent Círculo de Bellas Artes, established in 1912, hosted only three salons in its six years of existence. The one exception was Argentina's Salón Nacional de Bellas Artes (now

known as the Salón Nacional de Artes Visuales), which has run uninterrupted since 1911. The mere fact that Paris offered consistent and multiple exhibition opportunities was a major draw for artists. By examining which salons attracted Latin American artists, the implications of these artists' alignment with specific salons, reviews of their work, and their strategies of resistance to salon politics, this chapter will demonstrate the significance of Paris's salon system in establishing an artist's career and reputation.

Equally important was the regular press coverage of these salons by professional art critics. Throughout the 1920s André Salmon wrote a column for the *Revue de France,* Waldemar George wrote for *L'amour de l'art,* Maurice Raynal wrote for *L'intransigeant,* and Raymond Cogniat specifically covered Latin American involvement in all the salons for the *Revue de l'Amérique latine.*[2] Participation in the salons of Paris, especially with accompanying notices in the press, allowed foreign artists to make a name for themselves both abroad and in the eyes of their compatriots at home, without the organizational challenges of an individual exhibition. By participating in these salons, however, Latin American artists contributed

to the immense foreign presence that inundated these exhibitions in the 1920s, and were consequently subject to the emerging anti-foreign sentiment that this onslaught provoked. These exhibitions were thus both a source of prestige and of controversy.

THE SOCIÉTÉ DES ARTISTES FRANÇAIS AND THE SOCIÉTÉ NATIONALE DES BEAUX-ARTS

Since foreigners were often excluded from the inner sanctum of the French academy, it would seem logical that they exhibited more frequently in those salons that were more accepting of non-academic techniques. This was not the case, however. Since academic technique was entrenched in the conservative academies in Latin American capitals, artists seemed to exhibit in almost equal numbers in the traditional salons and at the Salon des Indépendants and Salon d'Automne.[3] Yet artists greatly favored the salon organized by the Société des Artistes Français over that sponsored by the Société Nationale des Beaux-Arts, most likely because of the latter's more stringent entry requirements. While no longer run by the state in the twentieth century, these two salons still aimed to provide an official marketplace for art as well as to promote a positive and regulated representation of national culture. Given these salons' previous ties to the academy and the state, modernist or experimental art was rarely sanctioned, but Latin American artists working in academic modes found recognition there. Paris salons were a place of official affirmation, and for those who

FIG. 77. Felipe Cossío del Pomar (1889–1981), *Descendants of the Incas,* ca. 1930. Oil on canvas. Location unknown. Reproduced in F.-G. Dumas and Société des artistes français, *Catalogue illustré du salon, Collection de catalogues illustrés* (Paris: Baschet, 1930), 76.

only remained in Paris for a short period, positive reviews lent credibility to the artist's work at home. For longtime residents of Paris, frequent recognition at the salons could lead to the ultimate accolade, the French Legion of Honor, for significant contribution to French culture.[4]

French art critic Raymond Cogniat began reviewing Latin American artists' contributions to the salons regularly in his column "La vie artistique" for the *Revue de l'Amérique latine* beginning in 1923. Very quickly his low opinion of the two national salons became clear. He frequently commented on the banality and monotony of the work on display and the boredom the whole experience provoked, calling these salons a place "where the banal competes with the pretentious,"[5] and asserting that they "provided the annual occasion to discover artists that can only be encountered there—fortunately, one time a year is enough!"[6] Despite his overt disdain for the official salons, Cogniat dutifully reviewed the works by Latin American artists shown there, but often did not have much good to say. In his view these salons were obsolete, only useful as a showcase for academic art and as a point of comparison with the more forward-looking Indépendant, Automne, and Tuileries salons.

While few Latin American artists won top prizes at the national salons, artists such as Peruvian Felipe Cossío del Pomar and Chilean Julio Fossa Calderón had their work featured in the official catalogue of the Société des Artistes Français. Cossío del Pomar's painting was a surprising choice because of its rather bland organization and unrefined technique. Cossío del Pomar was more of a scholar than a painter, only exhibiting three times in the Société des Artistes Français and twice in the Salon d'Automne during his entire time in Paris between 1911 and 1932. His painting *Descendants of the Incas* (ca. 1930) depicts an indigenous man and woman in traditional dress in an Andean landscape (fig. 77). The composition is straightforward, with little attempt to structure the space in a dynamic manner. Its most remarkable feature is the attention to detail in the costumes and textiles. As Cogniat notes, the painting was most likely singled out as an anthropological curiosity rather than for its technical skill: " The work by Cossío del Pomar makes one stop a moment because the characters he has chosen (descendants of Incas) are curious types, and are wearing very original costumes, but the technique of the artist is lacking."[7] This choice on the part of salon organizers to feature the artist's work in the catalogue thus once again speaks

FIG. 78. Julio Fossa Calderón (1874–1946), *The White Dress*, ca. 1929. Oil on canvas. Location unknown. Reproduced in F.-G. Dumas and Société des artistes français, *Catalogue illustré du salon, Collection de catalogues illustrés* (Paris: Baschet, 1929), 128.

to the tendency to value Latin American art for its presentation of the exotic rather than its aesthetic quality. Fossa Calderon's featured painting, *The White Dress,* on the contrary, is a traditional full-length portrait of a woman in a long white gown (fig. 78). The painting has no ethnic overtones, and would therefore have been indistinguishable from paintings by French artists. It was precisely this parity that provoked calls for segregation or separation and classification of non-French artists in the 1920s, however.

The salons also provided an outlet for sculptors, who would not have had a regular forum in which to exhibit their work otherwise. Female sculptors, in particular, found Paris to be a more accepting environment. Argentinean Carmen Mazilier was a regular exhibitor at the national salons between 1924 and 1931, and in 1928 her sculpture *Gaucho on the Pampa* was featured in the Société des Artistes Français catalogue (fig. 79). Not surprisingly, her earlier submissions—sculptures of a mother and child, a bust of a young woman, or a nude huntress executed in an academic style—received little critical attention. Cogniat even commented disparagingly that her

sculptures would have been just as successful at the salons of 1900.[8] But once she changed her subject matter to a nostalgic national motif, an Argentinean cowboy, her work appeared in the catalogue and critics took note. According to Cogniat, "*Gaucho on the Pampa* by M. Mazillier [*sic*] is also good, a work in plaster of small size in which the author knew to avoid insipidness. Clearly, the type of figure, in itself, has a lot of character, but in addition, he is handled with a view toward the whole so that technique does not diminish the ensemble with too much meticulous detail."[9] Suddenly, now that the subject is a gaucho, the work has character, and even Cogniat's assessment of the artist's technique has improved.

Other sculptors such as Uruguayan José Luis Zorrilla de San Martín (1891–1975) and Colombian Marco Tobón Mejía used the salons as a place to vet, in stages, ideas for monumental sculptures commissioned by their national governments; they exhibited small-scale clay or plaster models to receive feedback before executing the final versions in marble or bronze.[10] In 1926 Zorrilla de San Martín won a silver medal at the Société des Artistes Français for his life-size equestrian statue the *Gaucho* (fig. 80), which

FIG. 79. Carmen Mazilier, *Gaucho on the Pampa,* ca. 1928. Plaster. Location unknown. Reproduced in F.-G. Dumas and Société des artistes français, *Catalogue illustré du salon, Collection de catalogues illustrés* (Paris: Baschet, 1928), 200.

FIG. 80. José Luis Zorrilla de San Martín (1891–1975), *Gaucho.* Plaster. Photograph, taken in the artist's studio in Paris, ca. 1925.

was to form part of the *Monument to the Gaucho* inaugu-rated the following year in Montevideo on the Avenida 18 de Julio, in the Plazuela Lorenzo Justiniano Pérez. Praised by Cogniat as "a classic work of beautiful allure," Zorrilla de San Martín's muscular gaucho, who sits with regal bearing on his stead, follows the tradition of the Roman equestrian monument. Receiving a medal at the French salon and recognition in the press served as validation and promotion for his Montevideo commission, which paid homage to the anonymous heroes who died in Uruguay's fight for independence.[11]

Tobón Mejía, who received the Legion of Honor from the French government in 1928, submitted vari-ous manifestations of his sculpture *Anguished Solitude: For the Monument to the Poet José Asunción Silva* to the salon beginning around 1923 (fig. 81). When it was finally exhibited in its finished form—a two-meter-tall marble sculpture of a voluptuous nude sitting on a rock—in 1930 at the Société des Artistes Français, it was nominated for a gold medal and reproduced in the July issue of the *Revue de l'Amérique latin* in its *supplément illustré.*[12] Cogniat describes the evolution of the sculpture: "We have already had the opportunity to see this work in several stages and materials, but, only this time, executed in its full dimen-sions and definitive material (marble), does it achieve its full value; it now seems more moving than it was previ-ously, beautiful combination of forms and expressive atti-tudes."[13] When French president Paul Doumer visited the salon and was told the piece was by a Colombian artist, he proclaimed: "The Latin Sister to France, South America.

It's the same. The talent of our race; the same culture, eternal throughout all time and space."[14] This comment reveals an interesting conundrum: when Latin American artists worked in European visual languages and attained results on par or superior to their French colleagues, their success was attributed to an all-encompassing "Latinity" rather than individual talent or the spirit of a nation. But this ability to assimilate simultaneously disturbed French critics, who worried that these artists would surpass the French at their own game. These critics therefore began to demand differentiation and authenticity in both subject matter and style.

THE SALON D'AUTOMNE AND THE SALON DES TUILERIES

The more forward-looking Salon d'Automne and Salon des Tuileries attracted a different coalition of artists with more modernist, yet not generally radical or avant-garde, leanings.[15] Peruvian poet and critic César Vallejo (1892–1938) describes the Salon des Tuileries as promoting "a new type of beauty" and allowing viewers to discover "unexpected visual horizons."[16] Founded in 1903, the Salon

FIG. 82. Domingos Viegas Toledo Piza (1887–1945), *Still Life,* n.d. Oil on canvas, 18⅛ × 21⅔ in. (46 × 55 cm). Private collection.

d'Automne retained a highly selective jury, which lent a degree of prestige to exhibiting there as compared to the Salon des Indépendants. As with the national salons, at least sixty Latin American artists exhibited at the Salon d'Automne between the wars.[17] Some artists used the salon as a regular exhibition venue, such as Manuel Ortiz de Zárate (see fig. 63), who exhibited at the Salon d'Automne nearly every year from 1920 to 1940, as did Brazilian artist Domingos Viegas Toledo Piza (1887–1945) until 1936 (fig. 82). Others just submitted to the salons occasionally because of their shorter stays in Paris or because they had representation elsewhere. The roster of artists who exhibited at the Tuileries was similar to that of the Salon d'Automne, but a bit more limited given its smaller size, with Brecheret, Curatella Manes, Ortiz de Zárate, Toledo Piza, and many others exhibiting there regularly.[18] More so than a positive review at the national salons, receiving critical acclaim at the Salon d'Automne or the Salon des Tuileries helped many artists secure an individual exhibition at one of Paris's many art galleries.

Just after the war, in 1919, the Salon d'Automne featured eleven paintings by Uruguayan artist Carlos Alberto Castellanos from his *Tropical South America* series. Significantly, the artist deliberately chose to foreground Latin American identity in his Paris debut as a means to distinguish himself from his French colleagues.[19] And it seems to have worked. The French government acquired three of these paintings, including *Water Carrier* (fig. 83), *Indian Hunters,* and *Bird Seller,* for the Musée du Luxembourg. This exposure thus served to establish

FIG. 81. Marco Tobón Mejía, *Anguished Solitude: For the Monument to the Poet José Asunción Silva,* ca. 1929. Plaster. Location of plaster version unknown. Reproduced in F.-G. Dumas and Société des artistes français, *Catalogue illustré du salon, Collection de catalogues illustrés* (Paris: Baschet, 1929), 215.

FIG. 83. Carlos Alberto Castellanos, *Water Carrier,* n.d. Oil on canvas, 49¼ × 43⅓ in. (125 × 110 cm). Hotel de Ville de la Mairie de Sées, France.

the artist's reputation in Paris, where he would exhibit numerous times at the salons as well as in group and individual exhibitions over the next decade. By 1927, when he held an individual exhibition at the Galerie Durand-Ruel, his paintings were selling for as much as 30,000 francs.[20]

One of the paintings acquired by the Musée du Luxembourg, *Water Carrier,* demonstrates Castellanos's adherence to symbolist notions of the decorative, which he most likely derived from his training with Joaquín Sorolla in Spain before the war. Drawn in sinuous art nouveau lines, the clouds, landscape, foliage, and drapery create a dynamic pattern over the picture surface. Wrapped in a colorful striped shawl, the water carrier balances a jug on her head as she strides placidly through the landscape. The decorative patterning, paired with the figure's bare feet and dark skin, suggest a timeless exoticism that aligned with European notions of an imaginary tropical paradise. The Salon d'Automne featured another

five works from Castellanos's series *Tropical South America* the following year, which prompted the following praise in the *New York Herald* (Paris edition): "It was from the start a success—a legitimate success, since Mr. Carlos A. Castellanos is a marvelously gifted painter, whose palette reveals all the splendor of the tropical landscapes, all the originality of exotic types. No one has captured better than him the poetry of the light, the blue skies and the luxuriant vegetation of certain regions of Latin America."[21] Exoticism was clearly a formula for success in Paris, and the Salon d'Automne served as a launching pad for Castellanos's career.

The range of subjects and styles accepted at the Salon d'Automne was greater than at the national salons. Another noteworthy Latin American painter to exhibit there was Anita Malfatti, who used the salon as a sounding board during her three years in Paris. In 1924 Malfatti submitted her first two paintings, *Little Canal* and *Church Interior*

(fig. 84), to the Salon d'Automne. While *Le crapouillot* reproduced the latter with no commentary, Cogniat proclaimed that he felt a "particular aversion" to the types of paintings Malfatti submitted.[22] Although Cogniat does not specify what he disliked about the paintings, he may have found them to be a rather quaint and common rendition of European sights. Most likely as a result of this negative commentary, the following year Malfatti decided to submit *Tropical*, which had been exhibited previously as *Woman with Fruit Basket*, at the preliminary exhibition of Latin American art at the Maison de l'Amérique Latine in 1923. This time, Cogniat wrote a positive review, calling it "colorful and agreeable."[23] Malfatti thus understood the clear pressure for Latin American artists to submit a certain type of painting to the salons.[24] Cogniat's endorsement was sufficient for her to secure an individual exhibit at the Galerie André in 1926, which will be discussed in Chapter 6.

Malfatti again returned to the Salon d'Automne in 1927 with *Woman from Para* (fig. 85) and *Villa d'Este*. *Woman from Para*, in particular, exemplifies her evolution as an artist in response to the critical environment in Paris. After severely criticizing the portrait she submitted to

the Salon des Tuileries in the spring of 1927, Cogniat dedicated two paragraphs in his review of the Salon d'Automne to Malfatti's *Woman from Para*:

> Miss Malfatti, whom we feared at the last exhibition to have been losing her personality and disappearing into academic mediocrity, gives us this time a new aspect of her originality and one could not deny the definitively modern character of certain influences which one recognizes in her work, in particular the ways in which *Woman from Para* is treated, picturesque silhouette—(but picturesque painting not picturesque in essence)—which is detached by a white curtain, with designs in very light gray.
>
> One finds, especially if one remembers certain paintings by Miss Malfatti, from several years ago, the path traveled since her last submission and the works so strongly influenced by Matisse. And this is not a reproach because under this influence, Miss Malfatti had shown us paintings which were far from being unimportant.[25]

In *Woman from Para*, Malfatti has achieved a synthesis between her recent exploration of Matisse and her assertion of national identity, moving from influence to re-appropriation and re-invention. Unlike *Tropical*, *Woman of Para* does not equate the Brazilian woman with tropical bounty and peasant primitivism; rather, indicators of place are subtler, appearing in the colonial ironwork on the balcony rail and in the woman's lush black hair combed into a rather eccentric style that resembles wings. Moreover, whereas Pará was the second-largest state in Brazil, it would not have been immediately familiar to a Parisian audience. The place-name thus lends specificity to the image that the generic regionalism of *Tropical* lacked.

The painting also evidences her growth as an artist. In it, Malfatti undertakes a subtle play with muted colors and textures. Patterns in white cover most of the painted surface: on the gauzy curtains that frame the figure, on the delicate fabric of her long white dress, on the tiny flowers against her jet-black hair, and on the flat surface of the balcony floor. These variations in white are offset with equally ornate patterns in black on the balcony's iron grillwork and the window shutters. The only points of vivid color appear in the woman's bright shoes that peek out from beneath her dress and the cushion under her elbow. This foregrounding of the decorative emphasizes the flatness of the picture plane in a manner similar

FIG. 84. Anita Malfatti, *Church Interior*, 1924. Oil on canvas, 25½ × 21¼ in. (65 × 54 cm). Private collection.

FIG. 85. Anita Malfatti, *Woman from Para,* ca. 1927. Oil on canvas, 31½ × 25½ in. (80 × 65 cm). Private collection.

to recent works by Matisse such as *Decorative Figure on an Ornamental Background* of 1925. But unlike Matisse, Malfatti has avoided vibrant color in her evocation of the decorative, eliminating a common signifier of the tropical. While deploying the decorative in her paintings could be dangerous, easily dismissed as innately feminine rather than modern, Malfatti controls her presentation by limiting her color palette, thereby differentiating herself from Matisse and facile associations with the tropical, and claiming her place as a modernist.[26]

More importantly, however, Malfatti refuses to allow the painting's formal qualities to be its only significant feature. The painting's subject conveys meaning in a way that Matisse's decorative figure simply does not. In Matisse's painting, the nude is merely a motif, a body to distort, flatten, and surround with colors and patterns, and the

composition is an exercise in formal virtuosity. The nude's facial features have been reduced to simple geometries, leaving her devoid of character. Under the equalizing spell of the ornamental, the figure is no more important than the floral wallpaper or the potted plant that surround her. Malfatti's figure, on the contrary, exudes individuality; her inverted hand gesture, her unusual hairstyle, and her clothing choices all suggest a unique personality, whether real or imagined. Yet the iron railing and black shutters create a confined space, isolating her from the world, as if she were trapped, unable to achieve her creative potential. Is this painting perhaps a statement on the status of women in Brazil? Or a more personal expression of frustration at the limitations placed on women artists? Could Paris be Malfatti's way out, her ultimate validation as a modernist? Through the critical feedback Malfatti

received for her submissions to the Salon d'Automne, she was able to refine her approach and find a voice as an artist that was both Brazilian and modern.

Angel Zárraga, too, used the Salon d'Automne as a place to evaluate new ideas. As a longtime resident of Paris, Zárraga had a history with the Salon d'Automne and had even served on its jury in 1912. While Zárraga had held several individual exhibitions in the early 1920s, by the mid-1920s his primary sources of income were private, civic, and religious commissions for mural paintings.[27] The salons continued to serve as a source of critical feedback and personal promotion, however. In 1925 he exhibited several painted panels destined for church commissions in Rethel and Minimes at the Salon d'Automne before determining their final form on the church walls. In 1931, however, he reversed the process, submitting a painting of three soccer players, a theme he had been exploring for almost a decade. The Salon d'Automne thus served as a final showcase for his paintings of athletes rather than as a first step.

After his divergence from cubism, the athletic body, a theme that was simultaneously classicizing and modern, became one of Zárraga's preferred subjects. In the years leading up to the summer Olympic Games that were held in Paris in 1924, sports dominated the media and the public imagination. The Popular Front government even set up a ministry department specifically dedicated to sports, leisure, and physical education.[28] A quintessentially modern subject, athletes were the ultimate symbol of a healthy, vital nation intent on resuming its role as the cultural leader of the world. But the Olympic committee had refused to allow female athletes to participate in the games, provoking athlete and sports advocate Alice Milliat to found the Fédération Sportive Féminine Internationale in 1921 and to organize the first Women's World Games (originally called the Women's Olympic Games) as an alternative to the Olympics in 1922.[29] Zárraga's wife, Jeannette Ivanoff, played for the French soccer team that won the championship match at the Women's World Games, inspiring Zárraga to commemorate the victory in paint in a work entitled *Soccer Players,* one of his first paintings of athletes (fig. 86).[30]

Although Zárraga emphasized the highly developed muscles in the soccer players' legs, his depiction is not a caricature of the masculine woman that detractors often upheld as an argument against women's rights in the 1920s. Rather, Zárraga's women exude a calm confidence and physical prowess, while still maintaining their femininity.

He has depicted them in the format of three graces, with each body viewed from a different angle. The three figures' clasped hands suggest the synchronicity and cooperation necessary for a successful match. While more monumental and naturalistic than his earlier cubist canvases, *Soccer Players* retains the acute attention to the organization of space and distribution of color derived from cubism. The three white rails behind the figures serve as a structuring mechanism, and the bright green grass in the sunny field offsets the boldness of the vivid red jerseys and black shorts. By painting the subject in a dignified yet modernist manner, Zárraga makes a public statement of support for women's competitive sports as a serious and worthwhile endeavor. While *Soccer Players* was never shown in the salons, it was reproduced twice in the press, suggesting that the subject held significance for both the artist and the public.[31] It may also have been featured in one of Zárraga's group or individual exhibitions in the mid-1920s.[32]

Throughout the 1920s, Zárraga painted numerous images of athletes, establishing himself as a leading authority on the subject. As the critic for the *Miroir des sports* proclaims: "Angel Zárraga, Mexican of Paris . . . has sacrificed everything to the painting of sports. . . . In a moment of rest, in the way they hold the ball . . . Zárraga establishes the difference between the male and female athlete, between man and woman. Him, with clenched jaw, gripping the leather sphere as if to throw it with maximum force; her, holding it, maternally, against her chest, as if nursing a child. The eternal masculine and the eternal feminine are as such, opposed in the realm of sport. . . . Angel Zárraga is, without a doubt, the first great painter of soccer."[33] Ironically, while the author adopts a laudatory tone, this review reveals an underlying anxiety regarding the increasing prominence of female athletes and their demand for equal opportunities. Because the author endeavors to maintain a culturally defined distinction between male and female athletes, he reads into Zárraga's pictures a gendered distinction regarding the pose and handling of the ball that simply is not there. In *Soccer Players,* there is nothing maternal in the handling of the ball—or symbolic baby—that Zárraga has placed on the ground at the women's feet. And in other renditions of individual male and female athletes Zárraga paints the figures, both men and women, holding the ball in very similar ways, taking his poses from classical and religious compositions rather than from life. Thus, Zárraga's paintings tend to collapse gendered categories in a way that promotes athleticism over traditional

FIG. 86. Angel Zárraga, *Soccer Players*, 1922. Oil on canvas, 57½ × 45 in. (146 × 114.5 cm). Museo de Arte Moderno, Mexico City.

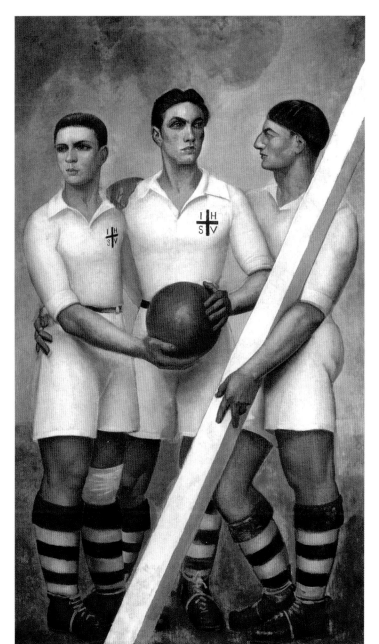

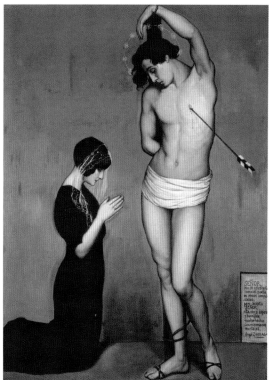

FIG. 87. Angel Zárraga, *Three Soccer Players*, ca. 1921. Oil on canvas, 84⅓ × 49 in. (214.3 × 124.5 cm). Private collection.

FIG. 88. Angel Zárraga, *Martyrdom of Saint Sebastian*, 1911. Oil on canvas, 72⅞ × 53 in. (185 × 134.5 cm). Museo Nacional de Arte, Mexico City.

signifiers of masculinity and femininity, rather than emphasizing an imagined difference.

For his debut of the theme at the Salon d'Automne in 1931, Zárraga submitted a work he had painted a decade earlier of three male athletes entitled *Three Soccer Players* (fig. 87). Interestingly, his rendition of male soccer players has a much more overtly erotic quality than that of the female soccer players. The three men stand in close proximity, with their arms intertwined. One grasps another's hip as they cradle the soccer ball between them. The soccer player on the left gazes intently at the rugged features of the more somber central figure, who stares fixedly ahead. Yet their crisp white uniforms with a red-cross insignia recall Christian imagery and a purity of purpose.

The manner in which the figure on the right holds the angled goalpost also parallels the iconography of Christ bearing the cross on the road to Calvary. The superimposition of religious symbolism on his male athletes may have been a way of deflecting the sensuality of these images, but from our twenty-first-century viewpoint it is difficult not to perceive these figures as homoerotic.[34]

Zárraga's exposure to Mexico's (and Spain's) baroque heritage and his exploration of symbolism in his early years offer the artistic precedent to his pairing of religious iconography and the idealized athletic body. In *Martyrdom of Saint Sebastian* of 1911, for example, Zárraga portrays transcendence and religious ecstasy through the idealized erotic male body (fig. 88). When it was exhibited at the

Salon d'Automne in 1912, the overt sensuality of this work caused a scandal because it was considered "too beautiful and too powerful, and seemed to inspire something more than pious compassion."[35] Transposing this tradition on to the contemporary sports arena provided a new modernist vision of the ecstatic body, which aligned with the classicizing tendency in art between the wars.[36] By sculpting the muscles and exerting the body beyond its limits, the athlete achieved transcendence. For Zárraga, sports were like a new religion, the ultimate expression of sublime poetic beauty:

> Stadium sports, foot races, soccer, basketball, revealed to me once again the mechanics of the human body. To my colleagues who do not paint nudes, saying that no one walks around nude in contemporary life, I would reply by taking them to the stadiums to admire the long muscles and fine rhythm of the speed races, the thick bodies of the long distance runners, the efficient balance of the discus throwers, the solid back muscles of the soccer players, whose knees articulated in bone from the muscles and from the two leg bones, are the most beautiful architecture that one could imagine. And the ancient beauty, new, old, and young of the swimmers and the angelic gesture of these swimmers when as they leave the trampolines to jump propelled by the spring of their calves and submerge themselves like living spindles in the water's laughter.[37]

In his rendition of the athletic body, he attempted to capture the ideal form of these men and women in motion or in moments of repose. While Zárraga certainly was not the only artist to paint athletes during this period, his unique interpretation of the subject helped fit images of modern athletes into an established art historical trajectory. Louis Vauxcelles, Zárraga's longtime supporter, recognized the originality of *Three Soccer Players* and reproduced it in conjunction with his review of the Salon d'Automne in *Excelsior*, giving Zárraga even greater exposure.[38] Zárraga was therefore able to use the 1931 Salon d'Automne to bring his images of soccer players to a wider audience and remind his patrons of his artistic range.

For sculptors, the Salon d'Automne and the Salon des Tuileries were often their primary exhibition venue. Argentinean sculptor Pablo Curatella Manes exhibited at the Salon d'Automne nearly every year from 1919 to 1934, as did Brazilian Victor Brecheret from 1912 to 1929. Their presence at the Salon des Tuileries was almost as

great. Commenting on their submissions to the Salon d'Automne in 1925, Cogniat proclaims: "And here are two artists who are very modern yet very different from one another, but who know how to show evidence of their talent and their originality."[39] That year Curatella Manes had shown his low-relief sculpture *Lancelot of the Lake and Queen Guinevere* at both venues (fig. 89). The sculpture was intended as part of a collaborative monument entitled *La douce France* (Gentle France) designed for the esplanade of Les Invalides at the 1925 *Exposition internationale des arts décoratifs et industriels modernes*. In response to art critic Emmanuel de Thubert's call for sculptures of heroes of the Middle Ages and Celtic mythology, Curatella Manes created a low relief of Lancelot and Guinevere's tearful reunion after a long separation.[40] Lancelot embraces Guinevere on bent knee, while she stands above him, engulfing her beloved with her entire body. By distorting and flattening the figures, Curatella Manes fills the pictorial space in a dynamic manner, reflecting his training with André Lhote. The grid pattern on Lancelot's chain mail armor creates a counterpoint to the smooth surface of Guinevere's gown, and the arrangement of hands in both high and low relief makes the scene seem to fluctuate between illusion and reality. Perhaps because of its emphasis on narrative, which fell outside Curatella Manes's usual focus on single figures or motifs, the artist used the French salons as a means of both vetting and publicizing the sculpture that he would submit to the *Exposition internationale*. His repeated presentation of the sculpture had its desired effect: Waldemar George reproduced it with his review of the Salon des Tuileries in *L'amour de l'art*, Maurice Raynal praised it in *L'intransigeant*, and Curatella Manes eventually won a silver medal for the sculpture at the *Exposition internationale des arts décoratifs et industriels modernes*.[41]

His success at the *Exposition internationale* also brought Curatella Manes recognition in Argentina. On January 15, 1926, the Buenos Aires–based journal *El hogar* published a full-page spread on Curatella Manes's recent work with illustrations of *Lancelot of the Lake and Queen Guinevere*, *The Guitarist*, and *The Accordionist*. The accompanying text, written by André Lhote, served as a guide for viewers, instructing them how to appreciate modern art. In it, Lhote rails against those who expect art to look like nature, and instead asserts that the art world is distinct and should follow its own rules.[42] The combination of Curatella Manes's recognition at important Paris

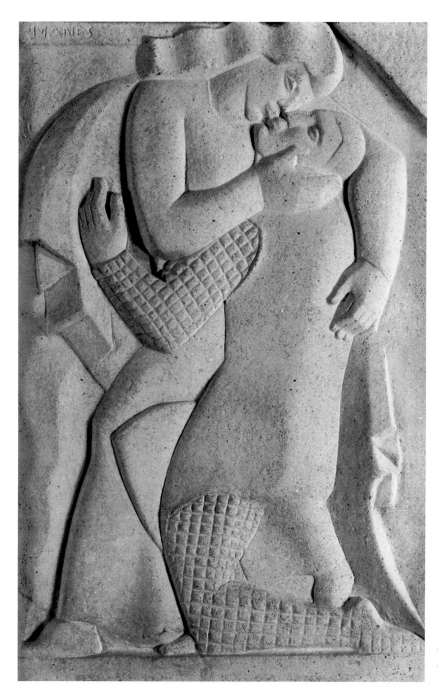

FIG. 89. Pablo Curatella Manes, *Lancelot of the Lake and Queen Guinevere,* 1925. Terracotta, 25½ × 17 in. (65 × 43 cm). Private collection.

exhibitions and his endorsement by Lhote paved the way for audiences in Buenos Aires to expand and shift their criteria for understanding modernist artistic production.

Victor Brecheret first began to attract the attention of critics with his sculpture *Entombment,* which he submitted to the Salon d'Automne in 1923, but it was the art deco–inspired sculptures that he submitted in 1924 and 1925 that truly cemented his reputation in Paris.[43] For the 1924 salon, Brecheret created a sculpture entitled *Perfume Bearer,* a representation of Mary Magdalene carrying an alabastron of perfume to anoint the dead Christ (fig. 90).[44] Sinuous

organic lines define the Magdalene's body, creating their own internal rhythms, with complete disregard for naturalistic proportion. Her elongated torso swells into curvaceous hips that continue into the curve of a gracefully bent knee. Facial features are simplified and breasts become small orbs with more emphasis on geometry than proportion. On her shoulder is an oblong alabastron, whose vertical shape is echoed by an arched foot below and balanced by the horizontal arm and thigh. The counterbalance of forms determines the Magdalene's graceful pose rather than observation of the body in space. Brecheret's

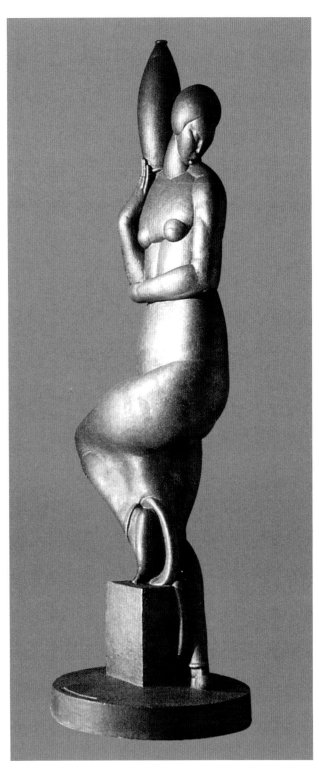

facility with art deco design brought him significant attention in the press. *Montparnasse* magazine reproduced the sculpture, and noted critics such as Maurice Raynal, Géo-Charles (a pseudonym for Charles Guyot), Louis Hautecoeur, and of course Raymond Cogniat reviewed it.[45] Writing for the *Gazette des beaux-arts,* Hautecouer expresses most eloquently the quality that appealed to critics: "The great statue by M. Brecheret, *The Perfume Bearer* is made of spherical, ovoid volumes that are fit inside each other. Little does the author care about their existing relations; the hips are enormous, the breasts minute. M. Brecheret has decided to portray a spindled composition with the feminine forms; submitting nature to all the necessary operations, for he has substituted each member for geometric volumes. This does not evidently portray an imitation of reality, but a variation of this real subject, which is a woman."[46]

Following his success in 1924, Brecheret again showed at the Salon d'Automne in 1925, prompting André Warnod to write a full article on his sculpture *Dancer,* entitled "La danseuse de Brecheret" (fig. 91).[47] The importance of this press coverage for Latin American artists cannot be overstated. Many artists collected these reviews as verification of their success abroad and quoted or reprinted them in their entirety in publications and exhibition catalogues in their home countries (and many can still be found in artists' archives). Given the absence of a developed system of art criticism and the public's general lack of understanding of modernist tendencies in Latin American capitals, obtaining reviews abroad was the only means of forwarding one's career as an artist and demonstrating that these new approaches to art-making were indeed legitimate. After many years exhibiting at the French salons, Brecheret was awarded the ultimate honor, the Cross of the Legion of Honor for Fine Arts, in 1933, and the French government purchased *Group* for the Musée du Jeu de Paume the following year.[48]

For Colombian sculptor Rómulo Rozo, the more modernist Salon d'Automne was a place where he could push the limits of his classical training and experiment with new ideas. Rozo had arrived in Paris in 1925, after having spent four years in Spain studying with sculptor Victorio Macho. In Paris he enrolled at the École des Beaux-Arts and participated in the *Exposition internationale des arts décoratifs et industriels modernes,* where he won a silver medal for an ornate bronze door knocker that depicted a stylized Adam and Eve and the tree of knowledge (fig. 92). In the

FIG. 91. Victor Brecheret, *Dancer,* 1925. Marble, 28¾ × 4½ × 13⅞ in. (73 × 11.5 × 35.2 cm). Private collection.

offspring. When the Chibcha later saw two serpents in the lake, they believed them to be a reincarnation of these primogenitors.[49] Rozo represented the two stages of the myth as a hybrid figure, with the upper half of the body representing the goddess holding a stylized infant above her head, and the lower half depicting the intertwined bodies of the two serpents rising from the water. Both mother and child wear identical masks with stylized rectilinear features, and the goddess's headdress is adorned with snail shells, which represent fertility.[50]

Rozo's submission caught the attention of the critic for the *Revue moderne des arts et de la vie,* who compliments his "richness of decoration" and "absolute originality." He goes on: "One finds there a modern expression of movement united magnificently in its ornamentation and archaic mysticism."[51] For this critic, it was precisely Rozo's turn to archaic traditions that defined his modernity. If the modern incorporated the constant quest for originality, then Rozo's introduction of indigenous myth to the Parisian audience was the ultimate expression of modernity. While Rozo would return to the official salons after this exhibition, he chose to use the Salon d'Automne as an experimental space in which to present native subject matter for the first time.

FIG. 92. Rómulo Rozo (1899–1964), Door knocker, 1925. Bronze, 26 × 13 × 4 in. (66 × 33 × 10 cm). Museo Nacional de Colombia, Bogotá.

spring of 1926 he submitted an academic *Head of a Woman* to the Société Nationale des Beaux-Arts. His submission to the Salon d'Automne—a small bronze statuette (32 centimeters) of the Chibcha divinity Bachué—was completely different, however. Perhaps as a means of distinguishing himself from the themes associated with the European tradition in the face of calls for national art in the mid-1920s, Rozo turned to Colombia's indigenous past for inspiration. According to Chibcha legend, the life-giving goddess Bachué emerged from a lake with a baby in her arms. She took this child as a husband, populating the earth with her

The positive feedback he received in the press, and the French fascination with all things primitive, most likely reinforced his decision to continue working in this vein.

The following year, in 1927, Rozo submitted a much larger version (170 centimeters) of *Bachué* (fig. 93) in black granite to the Salon des Indépendants, which resulted in an extensive review in the journal *Revue du vrai et du beau*. Once again, it was Rozo's exoticism that appealed to the reviewer: "The Latin-American artist Rómulo Rozo takes an increasingly dominant place in the Parisian art scene. His style and means of expression continue to evolve there, and his technique becomes even more refined, without losing, because of this, its very striking originality derived from its ancestral atavism—that he seems to consider as a kind of protective talisman—a superb black granite statue. This morsel is one of the most sensational pieces in the exhibition. . . . He appears to work in a state of a constant hallucination. Occultism seems to reveal itself in his creations."[52] The reviewer even attributes Rozo's achievement to working in a hallucinatory state. This conflation of the artist with notions of shamanism ascribes creativity to the magical and intuitive rather than the intellectual, and aligns Latin American artistic production with that of an imagined primitive. Paradoxically, the review is illustrated with a photograph of Rozo carving the final details into his sculpture *Bachué* with a hammer and chisel (fig. 94). While most likely posed, the photograph emphasizes craft and workmanship rather than trance-induced inspiration.

While style and subject matter differed greatly among the Latin American artists who exhibited at the Salon d'Automne and the Salon des Tuileries, these salons provided a consistent and legitimate exhibition venue for artists attempting to establish a name for themselves. Many artists used these modernist-leaning salons as a proving ground or a venue in which to test and develop new ideas before facing the weightier consequences of an individual exhibition. By exposing their work to professional critics in the salon context, artists were able to receive critical feedback and hopefully amass positive reviews of their work, which in some cases was their primary ticket to success upon return home. As Mexican critic José Frías writes: "Despite how much it is affirmed that the salons serve little purpose, they are, unquestionably, powerful stimuli for many young people. . . . The salons ignite many enthusiasms, and allow some unknown artists to escape from anonymity."[53]

FIG. 93. Rómulo Rozo, *Bachué*, 1925. Black granite, 67 × 15 × 17 in. (170 × 38 × 43 cm). Private collection, Bogotá.

FIG. 94. Rómulo Rozo carving *Bachué*, ca. 1925. Photograph.

THE SALON DES INDÉPENDANTS

Established in 1884 with no jury, prizes, or entry crite-
ria, the Salon des Indépendants attracted many foreign
entrants. After being closed during the war from 1915 to
1919, the Salon des Indépendants reopened in 1920 at the
Grand Palais des Champs-Élysées. As more and more
foreign artists arrived in Paris in the 1920s, the salon grew
larger each year, accepting up to two thousand submis-
sions and causing some critics to accuse foreign artists of
diluting so-called "French art."[54] Consequently, in 1924 the
hanging committee decided to abandon its tradition of
presenting works alphabetically by artist's last name and
instead organized the galleries according to national iden-
tity. (Organizing works by artists' last names started in
1922; before that, from 1911, it was organized by tendency.)
Defining national identity was a fraught project, however,
and many artists who had established French residency
exhibited in the French section, although most Latin
American artists seem to have exhibited under their coun-
try of origin.[55] While this organizational mechanism did

little to re-establish the "purity" of French art, many art-
ists, both French and foreign, were outraged at the blatant
xenophobia of the move, sparking the so-called "quarrel
of the independents" in the press. In his review of the 1924
salon, Cogniat comments on the "violent polemics" that
surrounded the show, and the little good it did in inter-
preting the artwork.[56] For Latin American artists, many
of whom believed in the notion of their shared Latinity
with their French colleagues, the reorganization felt
outright discriminatory. Chilean poet Vicente Huidobro
protested outside the salon, passing out copies of his jour-
nal *Creation* at the opening and shouting, "Down with the
Salon des Indépendents,"[57] while José Frías proclaimed,
"The separation of artists by nationality goes against the
statutes of the Independent Salon, since one of its articles
establishes that 'there will be no distinction by age, sex, or
nationality.'"[58] Cuban artist Armando Maribona protested
that French paranoia about the infiltration of foreign
influence was misplaced because so many foreign artists
emulated French styles: "What do you think of the xeno-
phobia of those men? . . . What leaves me with a feeling
of painful melancholy is confirming that foreigners are
quickly losing their originality. And this, which is serious,
should be enough so that they do not need to declare these
absurd classifications by nationality. What greater proof
do the French want of their influence than this, sad, of the
abolition of the personalities of the foreigners who come
to Paris?"[59] Rather than diluting or corrupting French art,
Maribona felt that foreign artists were losing their iden-
tity because of their exaggerated reverence for the French
tradition. Thus for Maribona, the situation was far worse
for the foreigner than for the French artist. Yet the French
still feared the impact of this growing foreign presence.

While some French and foreign artists boycotted the
1924 exhibition, the organization of the salon seems to
have had more impact on the debates and perception of
non-French artists than on actual participation. In 1924 at
least thirteen Latin American artists participated in the
Salon des Indépendants, and their presence continued
to increase until the late 1920s, with the roster of art-
ists very similar to that at the Salon d'Automne and the
Salon des Tuileries.[60] Yet this segregation by national
identity caused French critics to impose primitivist
assumptions on art by foreigners. As Maribona points
out: "The Northern Europeans continue to believe that
Africa starts in the Pyrenees, and that America is a semi-
savage continent."[61] The review in *Comoedia,* for example,

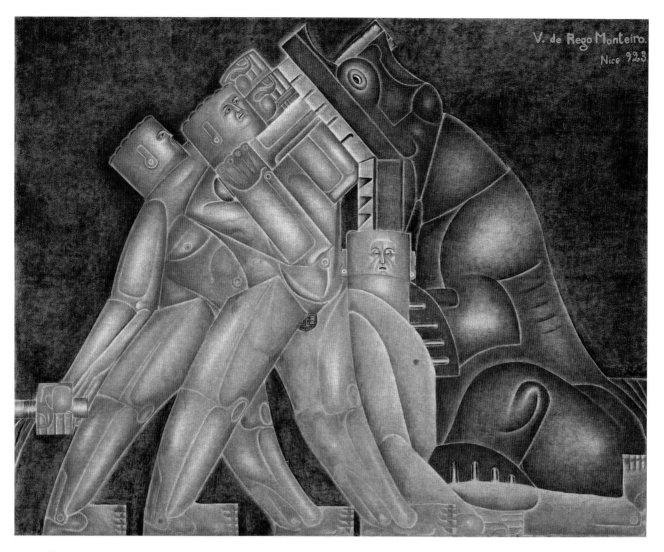

FIG. 95. Vicente do Rego Monteiro, *The Hunt*, 1923. Oil on canvas, 70½ × 102 in. (202 × 259.2 cm). Musée National d'Art Moderne, Centre Georges Pompidou, Paris.

divides the assessment of the salon into "French Painters" and "Foreign Painters," and interprets each artist's work according to his or her country of origin: "Mrs. Manes inclines the Argentine flag toward André Lhote's method, and Mr. Rego Monteiro wants us to believe that in Brazil one expresses oneself in the same way with oil painting as with the hardest stone."[62] Ironically, Germaine Manes was Pablo Curatella Manes's French wife, whom he met in Paris, and Vicente do Rego Monteiro, who was Brazilian, now represented an entire nation. The critic perceives Rego Monteiro's transferal of the quality of stone to paint as unsophisticated, and relates this quality not to the artist's training and creative decisions, but rather to his Brazilian origin, despite the fact that he was bilingual and bicultural—he spent his career alternating between Paris and Brazil, living in Paris from 1911–14, 1921–38, and 1946–57. This association of style with national identity

allows the critic to disparage an entire nation with the stroke of a pen.

As the negative review perhaps indicates, the painting Rego Monteiro submitted to the Salon des Indépendants, *The Hunt* (1923), was a rather daring transitional work and quite unique in the context of the salon (fig. 95). In the early 1920s Rego Monteiro had experimented with cubism in works such as *Woman before a Mirror* (fig. 96) of 1922, with its fractured flattened space, blocks of solid color, and tilting perspective; but in 1923, working in Nice, he began to develop a signature style that used paint to emulate low-relief stone carvings.[63] His submission of *The Hunt* to the Salon des Indépendants was the first time Rego Monteiro combined his new style with implicitly Brazilian subject matter. He seems to have been the only Latin American artist to submit a piece that addressed national identity in any way at all to the 1924 salon. While

the painting was most likely completed before the controversy erupted, by submitting it to the salon, Rego Monteiro was positioning himself in future debates as an artist who was willing to confront, exploit, and reconstrue French expectations of primitivism and exoticism.

In *The Hunt*, Rego Monteiro depicts three blocky figures engaged in a primordial struggle with some sort of mythical beast, perhaps a pre-Columbian were-jaguar.[64] While the hunters have managed to stab the beast through the upper jaw with a sword or machete, one man sits prone, impaled by the beast's schematized claws, suggesting that nature is a deadly force in this primitive world. Set against a flat, charcoal-gray background, the bodies of the three men and the beast form a pyramidal composition, with the tension mounting as the bodies merge at the apex. The heads are cylinders and the tubular limbs are schematized, making the figures appear almost robotic or mechanical, but the muted palette of browns and copper tones gives the image an ancient, earthy feel.

FIG. 96. Vicente do Rego Monteiro, *Woman before a Mirror,* 1922. Oil on canvas, 38½ × 27⅛ in. (98 × 69 cm). Private collection.

The crisp outlines and carefully modeled shadows create the illusion that the image has been carved in stone in low relief. The scene therefore alternates between a futuristic, mechanized world, where people are machines of war, and an ancient, primitive one in which the forces of nature present a perpetual threat. The allusions to World War I and mechanized warfare in *The Hunt* firmly associate Rego Monteiro's deployment of primitivism with modernist processes or, as Edith Wolfe contends, the painting defies "academic constructions of the Indian as modernity's antagonist."[65]

Cogniat, who was familiar with the artistic development of Latin American artists in Paris and had first reviewed Rego Monteiro's work the previous year, wrote a more nuanced review of the piece than that printed in *Comoedia*, comparing Rego Monteiro's emphasis on precision to that of Tsuguharu Foujita, rather than equating it to some sort of national style: "It remains for us to speak about Mr. Rego-Monteiro who is one of the most curious personalities among the South American artists that we have in France. We have pointed out many times the precision with which he renders and reproduces certain details, a precision that does not reduce the importance of the subject and offers a great analogy with the process of the Japanese painter Foujita. We said also how much attention he has paid to organization, how much his compositions seem to have been ordered almost architecturally. One finds in this painting all these qualities, but pushed almost too far. This *Hunt*, very stylized, is a little too massive all the same and the heaviness that results contrasts oddly with certain details of its execution."[66] Whereas Cogniat was certainly capable of simplistic and prejudiced assessments of Latin American art, he was at heart a formalist, and when an artist presented a unique artistic vision, Cogniat paid close attention. He avoided canned references to pre-Columbian architecture and instead critiqued the painting on its ability to balance detail and architectural structure. His comparison with Foujita nevertheless equated Rego Monteiro's work with a generic "other" rather than a specific Brazilian or Latin American foreigner, and it was to this "othering" that Rego Monteiro began to respond in works such as *Quelques visages de Paris,* discussed in the Introduction. Rego Monteiro's contributions to the Salon des Indépendants sparked Cogniat's interest, and Cogniat continued to cover the artist's development throughout the 1920s. During that period Rego Monteiro would become much

more sophisticated at engaging and redeploying the primitive in a critique of European colonialist attitudes.[67]

THE SCHOOL OF PARIS AND THE SALON DE FRANCE

While the debates about national identity and the arts surrounding the 1924 Salon des Indépendants did not curtail Latin American participation in the salon, they did lead to the reconceptualization of the artistic environment in Paris. In 1925 French critic André Warnod attempted to define and circumscribe the perceived foreign invasion with his invention of the School of Paris: "The School of Paris exists. . . . We can confirm its existence and its attractive force that makes artists from all over the world come here. . . . There are among them great artists, creators who give back more than they take. They pay for the others, the followers, the makers of pastiche, the secondhand merchants, so others can remain in place and content themselves with coming to France to study the fine arts, returning home right away to exploit the goods they just have acquired and loyally spread throughout the world the sovereignty of French art."[68] For Warnod, there were two categories of artist: creators and followers. Foreign creators were an acceptable presence because they contributed to French culture, but the followers, despite the fact that they perpetuated the French tradition in their home countries, offered nothing in return for their participation in the schools, salons, and galleries of Paris. What seemed to be at stake for Warnod was that France was losing control of the parameters of artistic exchange. Modernists could borrow ideas and forms from the pure "primitive" tribal artifacts acquired through colonial expansion because the maker was distant, anonymous, and unable to affect the terms of exchange; but when the foreign artist was living in France and exhibiting in the salons, the inability to distinguish the work of the French artist from the foreign was disconcerting for critics and audiences. By organizing the salon by national identity and relegating foreign artists to the School of Paris, France regained control of the terms of exchange because the label allowed the art of anyone who was not French to be construed as derivative.[69] Warnod's terminology thus defined the parameters of the debate for decades to come and positioned foreign artists against their French counterparts. Moreover, his proclamation established a perception of debt and obligation on the part of foreign artists, demanding that they pay France back for the boost in reputation the mere fact of living and working in the country provided.

At its inception the School of Paris did not denote a particular style, nor was it associated with a self-consciously avant-garde stance; rather, it denoted a generally figurative modernism and anti-academicism. While the term has since come to refer primarily to the Jewish artists living in Montparnasse around World War I, in the 1920s it was much more broadly defined, incorporating various Latin American artists, as well as artists from North America, Asia, Northern and Eastern Europe, and Australia. One of the first concrete responses to Warnod's pronouncement of the School of Paris was the organization in October 1926 of the Salon de France. The Salon de France was a one-time event sponsored by the journal *Paris-midi* and held at the Musée Galliera. In a gesture of solidarity toward the nation that had just isolated and segregated their work at the Salon des Indépendants and proclaimed them freeloaders of French goodwill, 142 artists from thirty-six different nations banded together to support their benefactor, voluntarily giving up the proceeds from the sale of their work at public auction to a fund for the stabilization of the French franc. Among the participants were such well-known artists as Chagall, Foujita, Kees van Dongen, and Juan Gris, as well as Latin Americans Luis Alberto Acuña (1904–1993), Tarsila do Amaral, Carlos Alberto Castellanos, Pedro Figari, Anita Malfatti, Carmen Saco, Domingos Viegas Toledo Piza, and Angel Zárraga.

FIG. 97. Luis Alberto Acuña (1904–1993), *Nessus Seducing Deianira*, 1926. Oil on canvas. Location unknown, formerly Musée du Jeu de Paume, Paris.

Of the few works by Latin American artists reviewed in the press was Colombian artist Acuña's painting *Nessus Seducing Deianira* (fig. 97), about which the *Paris-midi* newspaper, the sponsor of the exhibition, proclaims: "There are other perfectly moderated canvases that demonstrate a sureness of technique; one is the painting by the Colombian Acuña, *Nessus Seducing Deianira.*"[70] The painting depicts the Greek centaur Nessus, whose blood eventually killed Heracles after he tried to abduct his wife, Deianira. Next to Deianira is a peacock, a symbol of beauty, vanity, and immortality because of its ability to eat poisonous snakes without harm. In Acuña's version, Deianira does not resist seduction, but rather seems beguiled by the centaur's charms. She stands nude, in the pose of a Greek goddess, leaning seductively against the centaur's haunches. Acuña's combination of the mythological subject matter and decorative approach to the composition aligned the painting with the classical French tradition, with no hint whatsoever of the artist's cultural identity. The singling out of this painting therefore begs the question as to what exactly organizers wished to accomplish with this exhibition. Was it enough to segregate foreign artists so that their emulation of French art could not be confused with the "real thing"? Was the danger now eliminated because critics would no longer mistake a foreigner as French? Since the Musée du Luxembourg bought the painting a few months later for 3,500 francs, for its annex at the Jeu de Paume, it appears that separation was enough to satisfy the French need for classification and categorization for the time being.[71] Indeed, the annex had been established in 1922 for just this purpose, to divide contemporary art by foreigners from that of their French colleagues. Acuña was among many Latin American artists whose work the museum acquired between the wars.[72]

This segregation of foreign artists reinforced the notion of debt established by Warnod. As a writer for the *New York Herald* points out: "In an effort to aid France, to which they feel they owe much, foreign artists living in France arranged the benefit and contributed some of their most precious works."[73] And an author for the *Petit Parisien* comments that these artists "owe their reputation to the great, unique city that is Paris."[74] Rather than review the art, the article in the *New York Herald* instead reports on the astronomical prices received for some of the works, commenting that Latin American art obtained among the highest bids. According to the article, the record went

to Pedro Figari's *Creole Woman,* which sold for 67,000 francs (although this amount was perhaps a typo) and was only beaten by Van Dongen's portrait of *Anatole France.* Malfatti's *Figure* went to the French state for 2,000 francs, and Amaral's *Composition* was sold to a French collector for 3,300 francs.[75] This emphasis on sales, without so much as a comment on the quality of the work, served to perpetuate this notion of a debt owed to France by foreign artists.

Not all reviews of the show supported this notion of debt, however. Writing for *L'art vivant,* Georges Charensol points out the chauvinism inherent in the premise of the exhibition: "The Salon de France raises one more time the question of the School of Paris. Is it appropriate to make a distinction between our artists and foreigners who are working here? The committee of the Salon de France answers in the affirmative, but their point of view is too particular to be adopted by an art critic whose mission is to understand the works and not the men who make them. . . . The organizers of the Salon de France estimate that the foreign artists that live among us have contracted a debt to France—a debt that they have been asked to pay back with a painting or a sculpture. Did they not prefer our country to theirs? For me this reason is judgmental, in any case, one will not find demonstrations of xenophobia penned by me."[76] This exhibition put foreign artists in a bit of a bind. To protest or to not participate would have been to shun a perceived debt, but to partake was in a sense a self-othering, an acceptance of foreignness as a defining characteristic of artistic production.

Latin American artists adopted various strategies for negotiating the xenophobia unleashed at the 1924 Salon des Indépendants and in the subsequent debates in the press. One tactic that artists employed was to appropriate the rhetoric used against them—in particular, the notion of the School of Paris. In 1930 Rego Monteiro and French poet and writer Géo-Charles, under the auspices of *Montparnasse* magazine, presented a major exhibition in Brazil, the *Grande exposition d'art moderne, L'École de Paris.* The exhibition opened in Rego Monteiro's hometown of Pernambuco at the state museum and then traveled to São Paulo and Rio de Janeiro. *Montparnasse* published a special issue that served as an exhibition catalogue, and Géo-Charles presented a lecture series on the School of Paris at the various venues, where he proclaimed that the exhibition reunited "the majority of the talents symptomatic of the School of Paris."[77] Significantly, young Brazilian artists

in Rio criticized the exhibition as out of date because it focused on Picasso and Braque rather than surrealism, the most current artistic trend in Paris.[78] This appraisal indicates just how closely urban Latin American artists followed Parisian developments.

The exhibition, which included sixty paintings, watercolors, and drawings by forty-nine artists, did not conceptualize the School of Paris as a divisive mechanism deployed to label foreign artists who gained their reputation in Paris and therefore owed a debt to France. Rather, the exhibition presented the School of Paris as a global exchange between French artists and artists from all over the world that invigorated Montparnasse between the wars. Hence the Brazilian exhibition included the work of numerous French artists such as Braque, André Derain, Raoul Dufy, Albert Gleizes, Marcel Gromaire, Auguste Herbin, Henri Le Fauconnier, Léger, Lhote, André Masson, Matisse, and Maurice de Vlaminck, alongside works by artists from all over the world, including Foujita, Gris, Picasso, and Severini and Latin Americans Rego Monteiro and Rendón. Many of these works were lent to the exhibition by none other than Léonce Rosenberg.[79] While Latin American artists and the Brazilian exhibition are now almost never mentioned in discussions of the School of Paris, this exhibition demonstrates that artists claimed a degree of agency and awareness in trying to redefine the terms of the debate.

The debates about the place of foreign artists in Paris raged in the press throughout the second half of the 1920s and into the 1930s, and as xenophobia mounted throughout Europe, more and more critics such as Waldemar George and André Salmon revoked their support of the School of Paris, even as a separate but valid entity, instead promoting the purification of the French tradition in the arts.[80] For George, the School of Paris allowed "any artist to pretend he is French," and this emulation of the French tradition actually served to dilute it.[81] Throughout this period exhibitions organized around national identity proliferated, framed on either end by two exhibitions of Latin American art: the *Exposition d'Art Américain-Latin* at the Musée Galliera in 1924, discussed previously, and the *Première exposition du Groupe Latino-Américain de Paris* in 1930, which will be discussed in Chapter 8.[82] In this context artists could not just create art without considering how their choices of style and subject matter positioned them. Artists thus had to make a choice to strategically align themselves with nationalism, regionalism, or

universalism, and to carefully consider the implications of the organizational principles of group exhibitions. Whereas many chose to perform their foreignness to exploit French fascination with the exotic, others disavowed any connection to regional identities, instead exploring theories of universalism.[83]

THE SALON DES SURINDÉPENDANTS AND THE SALON DES VRAIS INDÉPENDANTS

Another survival mechanism, which dated back to the French Salon des Refusés of 1863, was to defect. If artists did not agree with the terms put forth by the Salon des Indépendants, they could create their own alternative salons with their own standards. In fall 1928 two new salons were inaugurated that explicitly challenged in their titles the restrictions imposed at the 1924 Salon des Indépendants: the Salon des Vrais Indépendants (Salon of the True Independents) and the Salon des Surindépendants (Salon of the Over-Independents) (fig. 98). These new salons took place simultaneously at the Parc des Expositions at the Porte de Versailles each year until 1930, when the Surindépendants, which had distinguished itself as the more progressive of the two, moved to Montparnasse on the Boulevard Raspail. Like the original Salon des Indépendants, these salons were open and not juried; their only criteria was that organizers expected members to exhibit there exclusively and not participate in any other juried or invitational salons.

What distinguished these salons, however, was that organizers returned to hanging artwork by style, not by national identity. Not only did these salons disavow

FIG. 98. E. Tériade, "A travers des salons—Tendances de les Surindépendants," *L'intransigeant,* October 26, 1931, 5.

national identity as an organizational mechanism, but, as André Fage writes, they also served as a protest against the averageness of the Salon des Indépendants, which had been "invaded by cosmopolitan mediocrity which confuses painting with mystification and hides its impotence behind a pretentious eccentricity."[84] The first exhibition of the Vrai Indépendants included 593 paintings and drawings that were displayed in three rooms: one that focused on avant-garde works, described in *Paris-soir* as primarily post-cubist and surrealist in style, one of works inspired by impressionism, and a final room of more traditional paintings.[85] In his review, André Warnod calls the formation of these salons a "war cry," commenting on their deliberate affront to the original Salon des Indépendants.[86] And Cogniat complains: "Perhaps Latin American artists were numerous; unfortunately the absence of an indication of nationality in the catalogue did not permit us to know exactly."[87] Whereas this lack of labels made Cogniat's job of reviewing Latin American art more difficult, it served the very deliberate purpose of confounding distinctions between French and foreign artists. Organized in this way, the art could be judged only on its aesthetic merits, not on the national identity of its maker. Extensive press coverage—reviews appeared in *Comoedia, Paris-soir, Petit Parisien, Journal des débats, Eve,* and the *Revue de l'Amérique latine*—soon made these salons a viable alternative for artists.

While certainly not all the works exhibited there were avant-garde, these salons quickly became a new space for experimental art, and the battle between surrealism and constructivism played out in their halls. As Warnod writes: "We have found that many of the exhibitors have a taste for adventure and risk. . . . The Salon des Surindépendants owes much of its interest to being a sort of laboratory and not at all a painting fair,"[88] and Cogniat calls them a "refuge of the extreme avant-garde."[89] The most progressive Latin American artists soon recognized the merit of exhibiting there. Tarsila do Amaral was the only Latin American artist to exhibit in the avant-garde room at the Vrai Indépendants in 1928, with a painting that one critic calls an "amusing fantasy."[90] The following year, however, Vicente do Rego Monteiro, Eduardo Abela (1889–1965), and Joaquín Torres García showed at the Salon des Surindépendants (while Amaral stuck with the Vrai Indépendants for one more year before switching to the Surindépendants), and in 1930 they were joined by Manuel Rendón Seminario and Pablo Curatella Manes,

who showed his *Group of Acrobats,* which Cogniat called the best in the exhibition (fig. 99).[91]

Among Rendón's submissions was a painting of an imaginary map that dealt with globalism and transatlantic contact, which most likely resembled works such as *The Geography Map* of 1928 (fig. 100). Here, Rendón deploys the uncanny quality of surrealism to question the accepted logic of cartographic techniques. Positioned in the center is a shape resembling the outline of a country on a modern map, but framed within that implied country is a cropped world map, with South and Central America, Europe, and Africa clearly labeled. By inscribing the continents within the imaginary nation, Rendón reverses traditional geographic hierarchies of space and scale. Superimposed on the map is what appears to be a blue leaf covered with a network of linear veins. A comparable blue shape next to it can perhaps be read as a shadow. The leaf and its shadow simultaneously connect and obscure the continents below as if suggesting the interconnected, yet never fully translatable nature of transnationalism. Rendón also endows the imagined nation with an anthropomorphic quality, painting hair like protuberances on top and nestling it in a hilly landscape like a head on shoulders. The nation thus takes on a bizarrely exaggerated importance in relation to the world and the individual.

These maps caught the attention of Paul Fierens, who comments: "Rendón dreams of beautiful voyages by copying geographic maps that he animates with schematized figures."[92] But for Cogniat, who knew of Rendón's Ecuadorian origin, Rendón's maps conjure notions of the exotic. He seems to have mistaken the artist's experiments with surrealism for a fantastic quality presumably stemming from his "foreignness." He therefore misses Rendón's critique of cartography's imposition of hierarchies of value and instead employs a rhetoric of the "other" to describe the artist's paintings, commenting on their "ardent coloration," "idiosyncrasy," "strange atmosphere," and "hot tonalities."[93] By using this language, Cogniat effectively relegates these images to the realm of the exotic without taking seriously their critical inversion of cartographic categories.

Whereas in 1929 more than half the Salon des Surindépendants was dedicated to surrealism, the tide began to shift by 1931. That year Torres García and several other constructivists, after their debut at Cercle et Carré in 1930, exhibited there en masse. (These artists will be

discussed in Chapter 8.) Torres García and Rendón were among the most experimental artists of the late 1920s and represent the two poles in the debate between surrealism and constructivism, which took place in part at the Salon des Surindépendants. Its organization by style rather than national identity focused on visual parity and common aims rather than cultural difference. Artists sharing a regional identity were therefore not awkwardly forced into the same aesthetic category and could instead represent diametrically opposed approaches. While the Salon des

Vrais Indépendants diminished in importance, the Salon des Surindépendants continued to be a place of aesthetic experimentation until at least the mid-1930s, when new artists such as Argentinean Nina Negri (1909–1981), who will be discussed in Chapter 9, entered the playing field.

The various Paris salons were an important proving ground for Latin American artists. In addition to providing an infrastructure that simply did not exist at home, these salons allowed artists to test new ideas and garner reviews that would help establish their reputations at

FIG. 99. Pablo Curatella Manes, *Group of Acrobats,* ca. 1923. Bronze. Location of this casting unknown (several versions exist). Reproduced in Maurice Raynal, *Pablo Curatella Manés* (Oslo: Merkur Boktrykkeri Nyt, 1948), 32.

FIG. 100. Manuel Rendón Seminario, *The Geography Map*, 1928. Oil on canvas, 39⅓ × 31⅞ in. (100 × 81 cm). Private collection, Paris.

home and abroad. Moreover, these artists understood the implications and parameters of exhibiting at the different salons and often selected their venue accordingly, strategically positioning themselves as traditional, anti-academic, or avant-garde. Latin American artists were not immune to the conflicts that plagued the Salon des Indépendants in the 1920s, however; many took a stand in the face of increasing xenophobia by exhibiting elsewhere or creating their own exhibition opportunities. As the decade progressed, the sway of the traditional salons in the sale of artwork decreased, and artists began to depend more and more on dealers and galleries for the sale and display of their work. Yet these venues continued to function in tandem, with a positive review at the salon often leading to a gallery show, or simply additional exposure for established artists. The following chapter will examine the role of galleries in presenting Latin American art to Parisian audiences.

5 At the Galleries

The Paris salons provided a consistent and relatively accessible place for Latin American artists to exhibit their work in Paris. Yet by the 1920s the importance and prestige of the salons, both traditional and modernist, was in decline. Many critics bemoaned the lack of originality of the artists who exhibited there and began to look elsewhere for new talent. While anti-academic and generally modernist art now dominated the Salon d'Automne, Salon des Tuileries, and Salon des Indépendants, truly avant-garde artists sought out alternative spaces to gather and display their work. More mainstream artists, too, often avoided the salons altogether in favor of working directly with a dealer. By the mid-1920s private galleries were the primary venue for the display and sale of works of art in Paris. For many Latin American artists, for whom an art market was still virtually nonexistent in their home countries, the Paris art scene represented a unique opportunity. More than thirty Latin American artists held individual exhibitions during this period at some of the most prestigious galleries in Paris. This chapter will examine a selection of some of the most notable individual exhibitions of Latin American art held on both sides of the Seine between the wars.

The individual exhibition at a Paris gallery was the ultimate rite of passage for a Latin American artist, evidence that an artist's work warranted recognition both at home and abroad. As Louis Vauxcelles observes: "Foreign painters multiply their efforts in order to receive Parisian consecration; it would seem that success in their native land does not have weight in their eyes, unless it is harshly corroborated on our premises."[1] With reviews in hand, an artist could return home assured of an official post at the national school or at the very least recognition for his or her work. But Peruvian poet César Vallejo was more cynical about the process: "They bring in their suitcases a few books or canvases made in America and, as soon as they arrive in Paris, nothing else motivates them except 'success.' Their hope is that newspapers will feature them so that they can return to their native land as soon as possible to tell their friends and supporters that they 'triumphed' in Europe." He goes on to say that artists come to collect "an album of newspaper clippings. They don't come to learn or to live, but rather to be astounding upon their return."[2] While Vallejo derided some artists' goal-oriented approach to the Paris exhibition, his comments nonetheless reveal the prevalent belief that recognition

in Paris was the only means to achieve success in one's native land.

Exhibition reviews were an essential part of the process. The individual gallery show meant little if it was not reviewed in the press, and artists often gave a painting to critics who wrote a positive review.[3] For foreign artists, these reviews were particularly important because they were often the only tangible evidence of success in Paris. While the press will be discussed in much more detail in Chapter 7, the press and the gallery system functioned in tandem, with each depending on the other for professional and commercial advancement. By the mid-1920s Paris had a network of professional critics who wrote regular columns for daily and weekly newspapers including *L'excelsior, Gil-blas, L'intransigeant, Paris-journal, Comoedia, Paris-midi, L'ère nouvelle,* and *Carnet de la semaine,* and contributed to journals and magazines dedicated specifically to art and art history.[4] Reviews of Latin American art appeared in almost all of these papers and helped establish artists' careers. Critics also took an active role in organizing exhibitions and writing the text for exhibition catalogues. Establishing a relationship with art critics was thus paramount for achieving recognition in Paris.

The gallery system in Paris also grew exponentially in the 1920s. In 1923 there were 130 dealers in the city, and by 1930 that number had reached two hundred, with 113 of them specifically focusing on modern art.[5] While there was a great emphasis on modernism, the styles favored by gallerists were not generally radical or non-conformist. Instead, dealers preferred artists who adopted an anti-academic approach to figuration.[6] The numerous Latin American artists who held individual exhibitions in Paris during this period for the most part fell into this category. Very few galleries catered to the avant-garde, but those that did began to shift the parameters of the term to incorporate cultural difference as a marker of avant-garde status. Being deemed avant-garde in the 1920s thus did not necessarily imply radical formal experimentation, but could also allude to the use of original source material.

As the number of galleries increased, the length of artists' contracts decreased, and many artists simply sold their work on commission without a binding agreement with a dealer.[7] This was the case for most Latin American artists in Paris, with the exception of a few who worked with Léonce Rosenberg. Most artists who held individual exhibitions rented out a gallery space for a fee, usually for a period of about two to three weeks, but did not obtain

exclusive gallery representation. The artist was also in charge of publicity and marketing, which often meant that attendance waned after the opening. Armando Maribona describes a hypothetical exhibition at the Galerie Zak for which an artist paid a fee of 2,000 francs for the space. Members of the Latin American community flocked to the opening, but the gallery remained nearly vacant in the days that followed.[8] This lack of the sustained publicity that a dealer could provide limited the impact of these short shows organized by artists.

The growth in new galleries also led to an intensified commercialization of art. Maribona called dealers "traffickers of paintings," but at the same time acknowledged that "having a dealer is the ideal situation for a painter and a sculptor because artists are known to be terrible businessmen."[9] The influx of wealthy foreigners into Paris in the 1920s, while expanding the market for contemporary art, also led to speculation and price inflation.[10] Wealthy Latin Americans with an interest in art often bought it on a trip to Europe, rather than purchasing works from local artists. Indeed, many of the works sold by Latin American artists in Paris were to compatriots, usually cultural travelers or diplomats, who felt that Paris gave credence to their artistic purchases. While the art market fell into sharp decline along with the stock market in 1929, and many of the newly established galleries closed by the early 1930s, some struggled on and remained the primary exhibition venue for those Latin American artists who remained in Paris until World War II.

ON THE RIGHT BANK

All Paris galleries were not created equal. The Seine created a great divide, with more luxurious and established galleries on the Right Bank and more modest galleries popping up every day on the Left Bank and into Montparnasse. But this divide did not necessarily dictate the type of art exhibited. Right Bank galleries presented new art almost as frequently as their Left Bank counterparts in the 1920s and 1930s. In describing the formality of Right Bank galleries, André Fage writes in 1930: "We are far here from the good-natured hospitality of the rue de la Seine and the very modern but somewhat whimsical comfort of Montparnasse. The atmosphere of rue La Boétie is very different: less intimate and more solemn, a little stiff, a little haughty, with charming saleswomen, but too stylized, an army of secretaries and accountants. . . . The 'owner' lives in an ivory tower, protected by offices and

FIG. 101. Carlos Mérida (1891–1984), Plate from *Images de Guatemala* (Paris: Quatre-Chemins, 1927), n.p. Ten mounted color plates, each 20½ × 15⅓ in. (52 × 39 cm).

galleries."[11] While one might assume that Latin American artists more frequently exhibited at the smaller galleries on the Left Bank, this was not the case. In fact, they exhibited in almost equal numbers on both sides of the Seine, with a bit greater presence on the Right Bank. And some of the most prominent galleries, such as the well-established Galerie Bernheim-Jeune, featured numerous Latin American artists, including Angel Zárraga (1920, 1921, and 1926), Manuel Ortiz de Zárate (group shows in 1925 and 1927), Rosario Cabrera (1925), José Clemente Orozco (1925),[12] Vicente do Rego Monteiro (1928), Jaime Colson (1939), Mario Carreño (1939), and Max Jiménez (1939).

Other galleries on or near the famous rue de la Boétie that exhibited Latin American art were the Galerie Percier (Max Jiménez, 1924; Tarsila do Amaral, 1926 and 1928; and Joaquín Torres García, 1931), the Galerie de L'Effort Moderne (which represented Vicente do Rego Monteiro and Manuel Rendón Seminario and showed work by Emilio Pettoruti and Tarsila do Amaral, which will be discussed in Chapter 7), and the Galerie A.-G. Fabre (Vicente do Rego Monteiro, 1925; Joaquín Torres García, 1926; and Gustavo Cochet, 1926). The Galerie 23, where Torres García mounted the Cercle et Carré exhibition in 1930, and the Galerie Renou et Colle, where André Breton presented *Mexique*, were also in the area.

Many well-established old-school galleries expanded their repertoire in the 1920s to include contemporary anti-academic art (mostly in a fauve or cubist vein) in response to market demands.[13] Near the Place de la Madeleine were other prestigious Right Bank galleries that featured Latin American art, including the Galerie Druet, which held three exhibitions of Pedro Figari's work in 1923, 1925, and 1927, and the Galerie Durand-Ruel, which presented Carlos Alberto Castellanos's paintings and tapestries in 1927. Carlos Mérida (1891–1984) showed his book of prints *Images de Guatemala* (fig. 101) at the Galerie de Quatre-Chemins in 1927, and in 1937 Nina Negri and Luis Vargas Rosas exhibited there with the Atelier 17 group.[14] Germán Cueto (1893–1975) and Lola Velásquez Cueto held an exhibition at the Salle de la Renaissance in 1929, and many more conservative artists also found representation at Right Bank galleries.

PEDRO FIGARI: A CASE STUDY IN RIGHT BANK SUCCESS

Pedro Figari was one of the most well regarded and sought after Latin American artists in Paris during the 1920s. An important intellectual and literary figure, Figari held more individual exhibitions than any other Latin American in Paris between the wars except his compatriot Joaquín Torres García, who will be discussed in Chapter 8,

and garnered the attention of several prominent French critics, including Louis Vauxcelles, André Salmon, André Warnod, André Lhote, and Jean Cassou. Figari's enormous critical appeal and financial success stemmed from his combination of accessible yet anti-academic technique with regionally specific subject matter, a synthesis that perfectly suited his French audience. Despite having exhibited in Buenos Aires and Montevideo before showing in Paris, Figari did not achieve critical recognition there, except among a small circle of colleagues, until after he proved himself many times over abroad. Figari's experience demonstrates the extent to which Latin American artists were hamstrung due to lack of infrastructure and being assessed according to antiquated academic standards in their home countries. It took years, numerous exhibitions, positive reviews, French accolades, and ultimately a French book on the artist for Figari to achieve a modicum of recognition in Uruguay. Success in Paris was the ultimate rite of passage.

Figari, a lawyer and public intellectual, began painting as a hobby around the turn of the century. At the time of his first Paris exhibition, Figari was already sixty-two years old and had visited the city several times before, first in 1886 and a second time in 1913. His objective during his 1913 trip was not to secure an exhibition, but rather to publish a French translation of his recent book, *Arte, estética, ideal* (1912), a sweeping philosophical text on aesthetics, creativity, science, and religion. In it he argued that the artist must create with emotion, not just virtuosity and academic precision, and that he (or she) should re-instill humanity into art-making. These ideas significantly shaped his own artistic production. During his 1913 visit he attended an exhibition of impressionist paintings at the Galerie Durand-Ruel that included works by Monet, Renoir, Sisley, Pissarro, Degas, and Cézanne. Figari's choice to employ certain aspects of impressionist technique—loose, visible brushwork, bold color, and an emphasis on rhythm and motion rather than minute detail—in his own work most likely stemmed from this exposure.[15] He did not hold his first one-man show until 1921 in Buenos Aires, where he only sold one painting and received little attention in the press.[16] In the meantime, his book, translated by Charles Lesca and with a prologue by Henri Delacroix, came out in Paris in 1920; his debut on the Paris art scene was as an intellectual rather than an artist.

In May 1923 the *Revue de l'Amérique latine* published the first essay on Figari's artwork to appear in France,

quoting French artist Fernand Laroche, who had recently toured Latin America and given a lecture in Montevideo: "I was in Chile, Peru, Argentina, Brazil, Uruguay and nowhere did I find a truly national or American art. In all these countries I saw capable painters, passable masters in the art of rendering whatever subject they chose, but nowhere did I find a painter who, asking himself the source of his inspiration, translated it into a specifically Chilean, Argentine, Uruguayan, or Brazilian language. Pedro Figari is the one fortunate exception. We can say of him that he is the only American painter who paints in American, and that is one of the best indicators that he has our admiration."[17] Laroche's assessment set the tone for the many French reviews of Figari's work, and reviews of Latin American art in general, to follow. French audiences did not want to see a reflection of themselves in Latin American art; rather, they wanted to see "national character," a display of difference that would codify cultural distinctions between regions. Figari's scenes of life and culture in the Río de la Plata region under the Rosas regime did just that.

With the help and encouragement of his friend the French-Uruguayan poet Jules Supervielle, Figari held his first solo exhibition in Paris in November 1923 in absentia at the Galerie Druet. While the Galerie Druet was one of the Right Bank galleries that emphasized "advanced currents in painting," it presented a measure of stability in a constantly shifting market.[18] Supervielle wrote the preface for the catalogue, establishing a framework for visitors to understand the artist's work.[19] According to Supervielle, Figari's paintings were nostalgic renditions of disappearing customs painted by memory and executed with a "tender and quizzical" brush. He painted with a "partial exactitude," highlighting the essential while ignoring superfluous detail.[20]

Figari sent sixty paintings to Paris with his friend Raúl Monsegur for the exhibition; these paintings occupied the entire first floor of the gallery. Among the works on display were a painting of the Afro-Uruguayan dance Candombe; a series of paintings depicting Three Kings Day celebrations; another series representing folk dances that included the Pericón (fig. 102, for example), Media-Caña, El Palito, and El Gato; as well as numerous genre scenes and landscapes of the Río de la Plata region. Since Figari painted multiple versions of the Candombe, it is impossible to determine exactly which paintings hung on the walls of the Galerie Druet in 1923. One example,

however, incorporates many of the qualities that caught the attention of French critics (fig. 103). The Candombe was an annual ceremony (usually performed during Carnival) in which members of the freed slave population would dress up in secondhand party dresses and formal attire donated by upper-class whites. In the guise of a different social and racial group, these "kings and their entourage" would visit the governor and chief of police to demand justice, in a confrontation that could never be enacted without theatrical pretense and the ritual inversion of social status. After the visit, the king would preside over a celebratory collective dance, a fusion of African traditions known as the Candombe.[21] Since the Candombe was at its height in the 1870s, Figari most likely did not observe this tradition, but rather reconstructed it from local legend and pure imagination. In this work, Figari represents seven male and female dancers in the midst of a highly animated dance. Painted in a summary style, the women, wearing brightly colored dresses, dance in close proximity to the men, two of whom are robed in formal attire, complete with top hats, dress shirts, and coats. Painted in front of a white wall, the figures are flattened and condensed to emulate a crowded space. Framed by a central doorway, a *tamboril* (drum) player keeps the beat for the dancers. Figari has indicated the rhythms

of the dance with undulating outlines and a scarcity of detail. None of the figures is an identifiable individual; instead, Figari has exaggerated stereotypical markers of Africanness—prominent lips, protruding jawlines, beady eyes, dark brown skin—as indicators of ethnic identity.

French critics immediately latched on to Figari's paintings of Afro-Uruguayans as the highlight of the exhibition. Whereas Supervielle emphasizes Figari's nostalgia for disappearing customs, many French critics, while they highly admired the show, had a rather different take on the artist. Louis Vauxcelles, who reviewed the 1923 exhibition for *L'ère nouvelle,* interprets Figari's rendition of blacks as comedic, an amusing parody rather than a quaint memory: "He is gifted with a good deal of talent. . . . Mr. Figari possesses a sense of movement, or rather of swarming, of the frenzy of the dance, his good natured and quizzical observations are as lively as they are acute. We are witness to stories of negroes in the middle of Lent who are unutterably comic; there are men of color wearing the commander in chief's *kepi* [type of military cap], ladies in leather (in black leather), whose forehead is surmounted by a plume like those one sees on the horses that pull hearses. . . . It is charming. Go see them."[22] What Vauxcelles found so funny was the blacks' inversion of social hierarchies through the act of donning the attire

FIG. 102. Pedro Figari, *Pericón beneath the Orange Trees,* n.d. Oil on cardboard, 27½ × 39⅜ in. (70 × 100 cm). Museo Nacional de Bellas Artes, Buenos Aires.

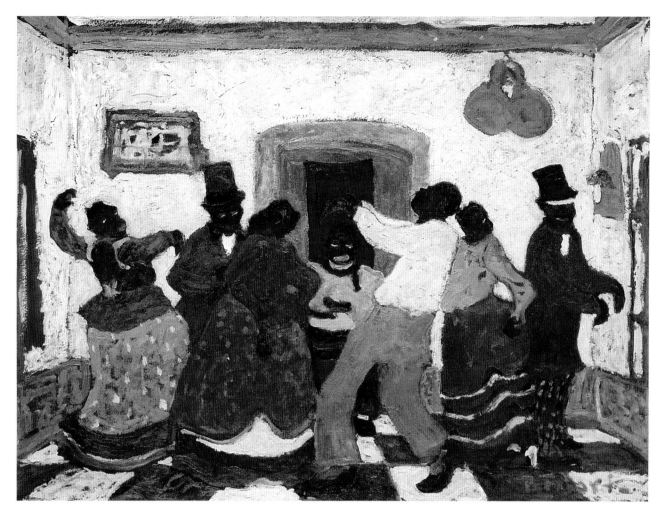

FIG. 103. Pedro Figari, *Candombe*, n.d. Oil on cardboard, 23⅔ × 31½ in. (60 × 80 cm). Private collection.

of a different social class. This ritualized act of defiance had a long history among Afro-Uruguayans and other former slave populations in Latin America, but was most likely unfamiliar and therefore disconcerting to French audiences. Vauxcelles underscores his assessment of this ritual as primitive, humorous, and unsophisticated by comparing the women's plumes to those on "horses that pull hearses," a gaudy display of pomp out of place in civil society.

Raymond Cogniat, too, writing for the *Revue de l'Amérique latine,* noted that Figari's renditions were not real, but rather caricatures of a certain class of society, a class from which the artist was far removed. Cogniat comments on the "burlesque allure" of Figari's figures and the caricaturesque quality of their physiognomies. He even goes so far as to classify the artist as a humorist.[23] Significantly, only the French critics identified in Figari a sense of mockery and racial condescension, which they found humorous. (There is no evidence that anyone found

these racial stereotypes offensive.) Indeed, it was precisely the familiarity of these stereotypes and Figari's infantilizing presentation of blacks that seemed to appeal to French audiences. Although Figari did not regard himself as a humorist or caricature artist at all, but rather a savior of the beautiful legends of the Río de la Plata, his paintings do not proffer an alternative vision or critique of the French obsession with all things African, but rather take advantage of this propensity as a point of entry into the Parisian art world.[24]

Unlike his exhibition in Buenos Aires, the Paris show was an enormous financial success. Figari sold fifty of the sixty paintings exhibited, earning a sum of just over 38,000 francs, and began to establish a coterie of collectors interested in his work.[25] While Paris certainly had a more developed art market than Buenos Aires and Montevideo, this difference also says a great deal about the audiences and the cultural environment in Paris. Paris was in the midst of a craze for negrophilia, and all things

perceived as exotic or primitive held a certain allure; Figari's pictures fit the bill. His critical and financial triumph in 1923 brought Figari to Paris two years later, and he remained there for nearly a decade.

For his second Paris exhibition, which took place in October 1925, also at the Galerie Druet, Figari solicited the preeminent French critic André Salmon to write an essay for the catalogue.[26] Salmon begins by commenting on France's general indifference to Latin America, but claims that thanks in part to Figari, a new appreciation for the region was beginning to emerge: "Uruguay! Argentina! Lands of epic enthusiasm, towards which we were ungrateful for so long! We are fortunately starting to make amends, without penitence."[27] He then raises a topic that dominated considerations of Latin American art of the period: whether artists should embrace or deny expressions of national identity. According to Salmon, the French perceived Latin American artists' frequent choice to highlight European aspects of their cultural identity and negate stereotypical symbols of their "Latin Americanness" as a sort of inferiority complex. Since Figari decided to embrace these symbols and endow them with regional specificity, he gained the respect of French critics: "We said, not without reason, that Latin America, at least in Europe, fretted about its gauchos, even denying them, that is to say disavowing them to foreigners. . . . Thanks to Figari[,] painter of the gauchos, Latin America does not have to fear anymore, nor to disavow. We will not confuse its gauchos with some Tom Mix of the cinema or an adventure novel anymore."[28] The qualities that appealed to French audiences and critics were just the sorts of themes that embarrassed delegates of official culture in Latin America, who preferred to ignore expressions of popular culture and emphasize the refinement of Latin America's cultural elite. Salmon's preface was reprinted in *Le crapouillot* and also sent to Buenos Aires, where it was printed in translation in the Argentine literary magazine *Martín Fierro,* to promote Figari's reputation and the relevance of his subjects. The wide dissemination of this essay served to spread the notion that French critics expected and valued cultural nationalism over and above emulation of French trends, and paved the way for other artists to follow in Figari's footsteps. The challenge for so many Latin American artists who exhibited in Paris in the 1920s, however, was how to exploit cultural difference as a symbol of modernity without falling into facile constructs of the picturesque, the exotic, and the

stereotypical. Figari seems to have walked a fine line, with some critics claiming he achieved this goal, while others were not entirely convinced.

Figari's second Paris exhibition included a total of sixty-four new works and attracted even more hype than the first. Three successive articles appeared in the *Revue de l'Amérique latine,* singing the artist's praises, and André Warnod reviewed the exhibition for *Comoedia,* as did Waldemar George for *L'amour de l'art.* Significantly, Latin American and European critics continued to interpret the artist's work very differently. Whereas the reviews written by Latin American critics focused primarily on Figari's rendition of lost traditions and a nostalgia for the past,[29] the French critics, for the most part, found his work to be comical and seemed to have been obsessively fascinated with his rendition of blacks.[30] Moreover, whereas the Latin American critics attributed intellectual and artistic agency to the artist, French critics described his approach as spontaneous and his talent as innate, tied directly to his cultural origin. So-called "primitive" subjects, in their eyes, were more authentic if an artist unencumbered by academic standards and hierarchies painted them. Although Figari was a self-trained artist, this distinction emphasized the degree to which French critics formed their cultural assumptions according to entrenched stereotypes of primitivism.

For example, Uruguayan writer Gervasio Guillot Muñoz—whose article on the artist was written in response to Figari's 1924 exhibition in Montevideo at the Salón Witcomb and later sent to the *Revue* as publicity for Figari's 1925 show in Paris—praises the sophistication of Figari's technique and his "malicious wisdom."[31] For Guillot Muñoz, Figari "contemplated and experienced his subjects for a long time."[32] But for French critic Raymond Cogniat, who also highly praised Figari's work, there was nothing cerebral about his paintings; they were "spontaneous," "intense," and "ardent."[33] Or as Warnod writes: "That which gives pictorial value to Pedro Figari's canvases, it could not have been acquired in any school of Fine Arts in the world; it was inherent to him."[34] Despite Figari's known status as an intellectual, French critics were reluctant to understand his creativity as a rational pursuit; rather, they contended that his inspiration came from an instinctual rather than a cerebral place.

There were also persistent distinctions in how critics dealt with the topic of Figari's rendition of blacks. Guillot Muñoz's brief mention of the Afro-Uruguayans

in Figari's paintings positions them against a backdrop of slavery and repression, explaining the figures' joviality as an expression of vengeance: "The negroes in Figari's paintings are avenged, by a crushing joviality, of the misfortunes of their ancestors who did not even have the Black Code of Colbert to defend themselves against the abuses of the treaty and the atrocities of the traffickers."[35] For Guillot Muñoz, therefore, there is a historical explanation for their actions and appearance. But for Warnod, Figari's "negroes and negresses dressed in party clothes . . . the negresses dressed up like tropical birds, like gardens" are "very buffoonish."[36] And for Jean Cassou they are "monkeys dressed in obsolete tinsels, in simple and romantic comedic marionette shows."[37] For the French critics they were simply a source of amusement, one that fed on entrenched racism.

Additionally, Guillot Muñoz notes that Figari's paintings served as a reaction against Orientalism, which had become banal in its repetition of worn-out exotic motifs: "His work does not fall into a narrow minded regionalism, that is part of a superficial and gaudy folklore, it avoids the blatant exoticism that permits certain paradoxes of bad taste under the dubious pretext of old fashioned local color."[38] Waldemar George, however, did not like Figari's work for the exact reasons others praised it: "I do not like Figari. Everything good that our colleagues Salmon and Louis Vauxcelles say cannot modify my opinion. . . . As picturesque as his subjects are, as gaudy as his colors are, as burlesque as his drawings are, I find that he paints and draws 'on the surface.' We can agree however that this expression of modern Latin American folklore is not deprived of an exotic flavor that would appeal to my erudite friend P.-L. Duchartre, who is currently preparing a book on exoticism through the ages."[39] This conflict of opinion regarding the difference between expressions of cultural difference and sheer exoticism reveals the contested terrain Latin American artists had to negotiate, a terrain that shifted constantly according to the viewer's cultural perspective.

Despite two successful exhibitions in Paris, Figari still lacked recognition and support from Uruguayan authorities. In a 1927 letter to Federico Fleurquin, a member of the Uruguayan Consejo Nacional de Administración, Figari laments: "I know that there [in Montevideo] they say that my work is not serious or useful, but since you are open minded, you will have to smile when you think that here, in this great land, the most selective and sanctioned

FIG. 104. Cover of Georges Pillement, *Pedro Figari* (Paris: Crès, 1930). Collection Les Artistes Nouveaux.

experts all think the opposite, they show it publically and celebrate my work as something very serious."[40] That same year, sixty-five Latin American artists and intellectuals living in Paris signed a petition to the public authorities of Uruguay asking that they support Figari while he finished his group of paintings on the historic past of the Río de la Plata.[41] This request was ignored, however, and it took a monograph on the artist and several more individual and group exhibitions in Paris for Figari to finally achieve recognition at home.

In 1930 George Pillement wrote *Pedro Figari*, the only monograph on a Latin American artist to be published in Paris between the wars (fig. 104). The book was part of a series of thirty short volumes on modern art entitled *Les artistes nouveaux* and included volumes on Renoir, Courbet, Maurice Denis, Marcel Gromaire, Maurice Utrillo, Monet, and Pissarro. Pillement's argument was nothing new, however. He regarded Figari's presentation of cultural difference as a form of aesthetic originality, a viewpoint that had become ubiquitous in assessments of Latin American art. He calls Figari's work "absolutely new" and goes on to say: "Pedro Figari is, without contest, the

first Hispano-American painter who will have succeeded in affirming his personality. Others can, as of now, claim to express certain aspects of their continent, he will have been the first to release its artistic conscience, to give it form and color."[42]

Also, like the French critics who preceded him, Pillement's praise of Figari stemmed from the artist's rendition of blacks. Yet what he found in Figari's blacks was a reinforcement of prevalent stereotypes circulating in France. It was his familiarity with condensations of Africanness in the figure of Josephine Baker, North American jazz musicians, and even African masks that resonated with Pillement. He saw the artist's presentation of these, by today's standards, offensive stereotypes as proof of his authenticity: "Some touches put down carelessly, it seems to us, create the swaying walk of the negroes, their loose gait of large indolent monkeys with swinging arms. And this is what persuades us of the authenticity of Figari's art."[43] Pillement even chose to illustrate the cover of the book with one of Figari's most exaggerated and caricaturesque renditions of a man of African descent. The aspect of Figari's work that most appealed to French audiences was that which was most deeply rooted in racist European categories.

With the publication of Pillement's monograph, Figari was declared a resounding success in Paris. French historian Raymond Ronze describes Figari as: "The artist admired today in Europe, the greatest painter of Uruguay, and perhaps of all America. . . . He sold everything that he wanted to, palpable and very agreeable proof of triumph. The French government bought a painting from him, supreme honor, seldom granted to a foreign artist. The detractors in Montevideo were deaf to it. But the Uruguayan government understood at this point that this man, represented a few months earlier as a slanderer of his country, served to glorify Uruguay."[44] With this, Figari finally turned a corner in Montevideo. In a letter to his friend Manuel Güiraldes, Figari writes: "I can tell you, my dear friend, that every day my reputation as a painter becomes stronger here. What Pillement wrote in the book, which I hope has arrived in due time in your hands, is what people think and believe on this subject, manifested in diverse ways, from diverse sources, and coming from diverse channels, so that even in my own country they will start to believe it."[45] Finally in 1931, Figari received the accolade he had been hoping for, the ultimate recognition in Montevideo: the Uruguayan government awarded him

the Premio Centenario.[46] Two years later he returned to Montevideo, where he held an individual exhibition at the Sociedad Amigos del Arte in October 1933. Rather than an essay, the catalogue reprinted quotes from French reviews by Warnod, Lhote, Pillement, Salmon, and Fierens, further proof of Paris's considerable sway over local opinion.[47]

Paris thus served as the ultimate rite of passage for Figari. Although he was almost immediately accepted in Paris, holding three highly praised exhibitions at the prominent Right Bank Galerie Druet, this recognition took years to manifest at home. Indeed, it was precisely his focus on popular subjects and Afro-Uruguayan customs that was the cause of this divide. Whereas these subjects resonated with the general penchant for primitivism and cultural nationalism in Paris (especially since they represented an exotic "other," rather than a Parisian counterculture), these themes were only gradually beginning to lose their stigma as a threat to official culture and become a source of national pride in Latin America. Figari's paintings, and Paris's validation of them, thus played a significant role in this shift in Latin America toward an appreciation of folk culture and disappearing local customs. Simultaneously, however, Figari's presentation of these motifs, perhaps unconsciously, relied on racial stereotypes prevalent in both France and Latin America, thereby reinforcing rather than challenging constructs of racial difference. As one of the most prominent Latin American artists to exhibit in Paris, Figari's exhibitions set the stage for other artists to make their debut on both sides of the Seine, and to continue to explore just how to render cultural difference.

ON THE LEFT BANK

While often newer and more precarious, the galleries on the Left Bank were also generally more open to the risk inherent in presenting experimental art. One of the first Left Bank galleries to feature Latin American artists was the Galerie Carmine, which, according to André Fage, presented new painters who could not be found anywhere else and who worked in "very different tendencies."[48] The gallery hosted exhibitions of paintings of Native Americans by Ecuadorian Camilo Egas and Guatemalan Humberto Garavito (1897–1970) in 1925, Brazilian landscapes by Domingos Viegas Toledo Piza in 1926, and paintings by Joaquín Torres García in 1927.

The gallery's first venture into exhibiting the work of Latin American artists adhered to Parisian expectations.

FIG. 105. Camilo Egas, *The Indian Race*, ca. 1924. Oil on canvas, 31⅞ × 25⅔ in. (81 × 65 cm). Private collection, Quito.

This emphasis on native themes may have been inspired in part by the exhibition of Latin American art at the Musée Galliera in 1924 and the opening of the Association de l'Amérique Latine galleries in 1925. It also corresponded with the general fascination with African art and primitivism that took Paris by storm after the war. More importantly, however, these were some of the first solo exhibitions after Figari's to feature Latin American subjects in a space not specifically designated as "Latin American," introducing new thematic possibilities at the modern Paris gallery.

Egas's one-man exhibition at the Galerie Carmine in 1925 included sixteen drawings and eighteen paintings, whose titles indicate an emphasis on indigenous themes.[49] Having been subject to expectations of primitivism at the 1924 exhibition at the Musée Galliera, Egas, known today as the founder of indigenism in Ecuador, transformed his approach to indigenous subjects for his solo show to incorporate a mocking critique of Parisians' distorted perceptions of the Native Americans. In *The Indian Race*, for example, four enormous indigenous figures crowd the composition, extending beyond the limits of the frame (fig. 105).[50] Their bodies are swollen to grotesque proportions and they are clothed in oversized garments that bunch and fold in a manner that accentuates their inflated torsos. Their heads are disproportionately small, with exaggerated facial features and expressions that convey a deep sense of emptiness and suffering. Their bare feet are distorted and seem to be rooted in the earth on which they stand. Egas's images disconcert the viewer by disfiguring and aggrandizing native subjects. In this image, Egas seems to have combined caricature with the

monumental figures prevalent in France in the 1920s and applied this hybrid style to an indigenous figure. Whereas the monumentality of the figures in most French paintings of the period emphasized the gravity of the subject matter, Egas subverted this reading by enlarging and distorting the indigenous body, making his monumentality comic. By employing the technique of caricature, these images exaggerate and satirize the "primitive" qualities of Native Americans, thereby calling attention to the constructed nature of this trope.

Reviews of Egas's one-man exhibition indicate that critics embraced the artist's new vision of indigenous subject matter. Nevertheless, whereas responses written by Latin Americans living in Paris focused on the artist's audacious rejection of beauty and bold departure from the types of images other Latin American artists were producing in Paris, those written by Parisians fixated on the primitive quality of Egas's imagery and do not seem to have recognized his subtle critique of this trope. The Peruvian indigenist writer Ventura García Calderón—whose collection of short stories entitled *La venganza del condór* came out in 1924—writes in the preface to Egas's exhibition catalogue: "I would like to publicly congratulate Mr. Camilo Egas because he has not, like so many other Americans, shown the European public a tender nymph from Versailles or the satyrs that police the forests. He exhibits Indians, scandalously and with cynical impudence, when we are used to a more subtle approach."[51] García Calderon also wrote an extensive review of Egas's show in the *Paris Times:* "The sewing machine and Cubism, we heard about all that through the mail. But we made our own monkey skin drum and wild-reed flute. It is this inventory of American life that you have established, Camilo Egas, with your exquisite innate talent as a painter."[52] Both of these reviews highlight the idea that Egas was breaking new ground by embracing his native culture and presenting it in a manner that opposed European as well as Latin American tradition. In effect, his stance was avant-garde in its rejection of established norms.

It is unclear whether Egas presented Native Americans in this manner out of sympathy or bias, however. On the one hand, these images, which combined monumentality with a caricatured version of the fear-inducing primitive, revealed the degradation and suffering of the indigenous population and highlighted their inability to escape a life of ignorance, filth, and misery rather than concealing it

behind the mask of the picturesque. On the other hand, by negotiating in European stereotypes of the primitive (despite his use of satire), Egas's paintings perpetuated the conception of Native Americans as inherently ignorant and uncivilized and thus undermined these images' ability to denounce this condition. This paradox reveals the contradiction in Egas's own situation. In Ecuador, his middle-class upbringing distanced him from the life, language, and culture of the native population, allowing him to imagine an idyllic vision of the indigenous population in his paintings. In Paris, however, his outsider status caused Parisians to define him by his national origin, which they associated with indigenous culture. This expectation of primitivizing native themes may have caused him to attempt to emphasize the gulf between himself and Native Americans. The aimless, degraded native could also have served as a symbol of Egas's own alienation from European society.

The numerous reviews of Egas's exhibition published in French journals articulate the primitivist assumptions about the Americas held by the French, and emphasize the French audience's taste for what they perceived to be exotic.[53] Breaj calls Egas's figures "a human fauna of terrible beauty," and Yves Mar states: "We have discovered a complete race of almost animal humanity in the paintings that Camilo Egas is exhibiting at the Carmine Gallery. These are the Indians of Ecuador. At first they are shocking, but later one finds in them a strength and simplicity, not devoid of magnificence." Egas's show was also reviewed by Vauxcelles, who comments: "In some of his paintings, simple, solid and beautifully colored, the artist has evoked with force and without empty words the ancient nobility and the unknown beauty of one of the oldest races of the world: The Indians of Central America [*sic*]."[54] All of the critics found in the paintings an animal quality that they related to the ancient and primitive culture of an unknown land. (Vauxcelles even goes so far as to mistakenly refer to the figures as Indians from Central America.) These images were found disturbingly beautiful because they conformed to a certain perception of the primitive that was deeply rooted in French society. They did not see this animal nature as satirical, but rather interpreted it as an exaggeration of a primal quality they believed characterized primitive societies.

This distinction between French and Latin American perceptions reveals the conflicting pressures Latin American artists often faced while in Paris. These artists

often had to negotiate between a desire to produce something bold and new and Parisians' expectation of nativist imagery. Egas found a way to deal with this paradox through the use of caricaturized forms and the subtle mocking of Parisian primitivism. By refusing to paint indigenous peoples as happy peasants living an idyllic rural life, Egas initiated a reevaluation of Native Americans in art that would give rise to the socially critical indigenism of the 1930s. The contradictions inherent in these images reflect the artist's constantly shifting position in the social power structure and his attempts to negotiate a place in the international art world.

In contrast, Guatemalan artist Humberto Garavito—whose show opened just one month after Egas's, on November 16, 1925—rendered indigenous Guatemalans as picturesque and nostalgic, without the challenge to expectations present in Egas's pictures. His exhibition *Quelques types du Guatemala* included twenty-three paintings of Guatemalan subjects and seven of Spanish themes. The paintings in the show, such as an untitled image from the exhibition catalogue, most likely adhered to the conventions of *costumbrismo*, the depiction of regional types and local customs (fig. 106). Painted in a loose, gestural style,

FIG. 106. Humberto Garavito (1897–1970), *Untitled* (*Indigenous Figures and Parrot*), ca. 1925. Location unknown. Reproduced in *Exposition H. Garavito (Quelques types du Guatemala)* (Paris: Galerie Carmine, 1925), n.p.

this image depicts three indigenous figures, one man and two women, engaged in some sort of trade or interaction. A woman kneels on the ground, gesturing toward a parrot on a pedestal. Her head is bowed and her eyes averted from the couple standing above her, as if to indicate her lower social standing. The two standing figures gaze down at the bird, contemplating its worth. All three are barefoot and dressed in simple, traditional clothing, but their postures and relationship to one another suggest a certain social hierarchy. In the background are several small whitewashed houses set against a mountainous terrain. Garavito embraced the picturesque, presenting to the French audience an idyllic scene of timeless peasants without hinting at the changes wrought by the beginnings of modernization.

In the exhibition catalogue René-Jean praises that very quality: "He evokes the picturesque quality of Guatemala's inhabitants, its Indians dressed in harmonious colors, which juxtapose with audacity the glare of the red with the flatness of the deep blacks. . . . It is a far away life which emerges and is offered to us to observe."[55] There was nothing challenging or provocative about Garavito's paintings; instead, they conformed to a long-standing Parisian taste for the exotic and the picturesque. But since Latin America was rarely the subject of these "pictorial voyages" before the 1920s, for René-Jean, Garavito's exhibition attested to Parisian galleries' global turn: "The artistic richness of Paris has become global, it is a spiritual beam where rays from all over the globe are linked."[56]

The review in *Paris, Sud et Centre Amérique* attributes Garavito's success to his ability to produce a vision of the tropical that matched French fantasies: "Success was very quick and the many art critics and amateurs who came to the Galerie Carmine, addressed their most cordial praise to Mr. Garavito, who knew how to render on the canvas the enchanting qualities of the landscapes of Central America, all the magic of the hot colors and the vibrations of the tropical light."[57] Success for Garavito was not measured as avant-garde status, or challenging the status quo, but rather in popular appeal and press attention. Because the subject matter was unique and the style accessible, Garavito's work found an audience in Paris, and that was enough to sanction his work at home in Guatemala. As Guatemalan writer Miguel Ángel Asturias, who also lived in Paris at that time, proclaims: "Garavito has been successful in Paris. This piece of news has to be propagated the same way fire spreads on dry straw, into houses

and temples and plazas."[58] The "exotic" subject matter and focus on native themes rather than cutting-edge technique distinguished these early exhibitions of Latin American art at the Galerie Carmine from mainstream artistic production.

Accordingly, in the catalogue for Toledo Piza's exhibition at the Galerie Carmine the following year, French critic Louis Vauxcelles unabashedly proclaims his surprise at not having his expectations of exoticism met: "The Brazil of Toledo Piza offers none of the lush vegetation that our imagination dreams up; none of the unreal flora, no tangled forests where resin trees and the giant Araucaria grow in one night; no sugar-cane fields, cassava or fragrant coffee plantations."[59] Prevailing expectations such as these clearly affected the types of exhibitions hosted at this and other galleries. Toledo Piza rarely painted Latin American subjects, but he managed to secure his first one-man exhibition in Paris only after a summer trip to Brazil, where he painted the landscapes displayed. While they did not correspond to Parisian desires, the promise of such themes alone may have been enough to land the show.

Some Left Bank galleries adopted a more comprehensive vision of Latin American art, supporting artists whose output did not necessarily correspond to French expectations of primitivism as well as those whose did. One of the most important and audacious galleries to support Latin American art was the Galerie Zak. According to Alejo Carpentier, "The Galerie Zak is one of the most famous of the progressive art galleries of Paris. Like the shops on the rue La Boétie, it maintains rigid criteria for acceptance of a painter; those who aim to hang paintings there must undergo careful examination by a house expert who determines whether or not they are liable to let down a selective clientele."[60] While Carpentier may have exaggerated somewhat the gallery's selectivity in order to highlight the odds Eduardo Abela (the artist he was reviewing) had overcome, his comment suggests that the Galerie Zak was at very least competitive with the high standards set by the rue de La Boétie galleries. The gallery was founded by Jadwiga Kon, wife of a Russian artist of Polish descent, Eugène Zak, on 16, rue de l'Abbaye, in Saint Germain des Prés in 1928; it featured artists such as Chagall, Derain, Dufy, Modigliani, Utrillo, and Vlaminck as well as many other artists of Polish and Jewish heritage. Kandinsky's first one-man show in Paris was held there in 1929. Significantly, the Galerie Zak also took a major

interest in Latin American art, hosting individual exhibitions by Torres García (1928), Abela (1928), Juan del Prete (1930), Amelia Peláez (1933), Ricardo Grau (1935), a joint show of works by José Cuneo and Barnabé Michelena (1930), and in 1930 a group exhibition of Latin American art organized by Torres-García, the *Première exposition du Groupe Latino-Americain de Paris,* which will be discussed in Chapter 8.[61] Unfortunately, gallery records were lost during World War II, when Jadwiga and her son were taken to Auschwitz, where they died in 1944.

One of the first Latin American artists to exhibit at the Galerie Zak was Cuban modernist Eduardo Abela, who called himself "Abela of Cuba" in publicity for the show. Paris at the time was in the throes of its latest fad: Cuban music. Rumba singer Rita Montaner made a sensational debut at the Cabaret Le Palace in 1928, and Cuban bands played almost nightly at dance halls and the most important social venues in Montparnasse: La Coupole, Le Dôme, and La Rotonde.[62] Abela had only been in Paris for one year at the time of his exhibition, but he took advantage of the rage for all things Cuban as well as the networks and contacts of his friend Alejo Carpentier, a Cuban novelist and critic, to publicize his show. The exhibition featured a series of fourteen paintings, almost all depicting Afro-Cuban themes. Whereas the distance and self-reflection gained by traveling to Paris compelled Abela to probe his Cuban identity, like many other Latin American artists who exhibited in Paris, he constructed a vision of his national identity that was shaped by European notions of primitivism and a fascination with the exotic. Moreover, European expectations focused on one aspect of Cuban identity, Afro-Cuban culture, positioning it to stand in for a broader heterogeneous society. Like Figari, Abela had little contact with or knowledge of this particular facet of Cuban identity and therefore invented it to appeal to his new audience. This invention earned him the designation of avant-garde artist, not because of his formal radicalism, but rather because of his use of what Parisian critics deemed original sources—his exploitation of markers of difference as an avant-garde strategy. In many ways, therefore, galleries such as the Galerie Zak helped expand the parameters of the avant-garde in the 1920s in new directions.

Carpentier encouraged Abela to paint scenes of Afro-Cuban music and dance, subjects with which he was not entirely comfortable, but that definitely resonated with French tastes at the moment. In 1928 Carpentier had left

Cuba for Paris for political reasons and was working on his novel *Ecué-yamba-O,* which explored Cuba's Afro-Cuban traditions as the basis for a new national identity. But to Abela these themes were entirely foreign; he would later explain: "I didn't know anything about African things, that I had never been to see the traditional carnival dances in Havana . . . that I didn't feel any affinity with the Black."[63] The paintings he made in Paris were therefore based entirely on Carpentier's suggestions and his own imagination.[64] Carpentier was savvy; he knew exactly what would appeal to Parisian audiences and bring fame to his compatriot. As is apparent in the tone of Abela's reflections, the artist was troubled by the inauthenticity of his vision, however. The craze for negrophilia in Paris, in which Abela found himself subsumed, was two-sided.[65] On the one hand, the European avant-garde envisioned all things non-European—be they African, Native American, or Asian—as providing the raw material or a primitive energy in their quest for new modernist forms. These unknown cultures also became signifiers of difference, a means of overturning the staid decadence of bourgeois society. But these primitivist constructs bore little relation to the lived reality of peoples from these regions. Abela knew his paintings represented an imaginary world and that he was feeding the European taste for the exotic, but these paintings were his ticket to a Paris show.

In his review of Abela's show for the Cuban journal *Social,* Carpentier argues, however, that it was not necessary for artists and writers to aspire to anthropological authenticity. For him, "Abela wasn't interested in emulating the *American Photo,* but rather in determining the spirit of things. . . . He doesn't work with documents, nor does he intend to copy the seven bells of a *diablito.* . . . His creatures occupy an ultramodern dream atmosphere, in which sometimes there are symbols. . . . What is certain is that he has succeeded in translating the poetry of the tropics in a profound way in his paintings executed with extremely advanced technique."[66] For Carpentier, it was enough to capture the spirit or essence of a place, a spirit that differentiated Abela from the pack: "His paintings are unmistakable, and they don't look like anything else that can be seen in Paris until now."[67] Nor did the Parisian audience care about accuracy so long as they perceived the source of inspiration to be unique or "other"; artists from Latin America, they believed, benefited from privileged access to these sources. This presumption of "privileged access" to heterogeneous aspects of their national

culture troubled many artists, however. Despite his reservations, Abela decided to follow Carpentier's advice and give his Parisian audience an Afro-Cuban exhibition.

Paintings in Abela's exhibition included works such as *Path to Regla* (fig. 107) and *The Mystical Rooster* (fig. 108). Painted in dark tones of mostly black and gray, *Path to Regla* depicts a night crossing to a borough of Havana located at the bottom of Havana Bay. Regla was formerly an African slave settlement where the syncretic religion Santería dominated. Given its location, to get back and forth from central Havana to Regla one would have to go by boat. In Abela's rendition, six female revelers dance in a small boat behind an oarsman. On the left is the round surface of a drum, evoking the rhythm of music, and several of the women hold sashes that billow with their movement. Red and yellow lanterns illuminate the group and reflect on the water. The small rowboat seems to project up into the pictorial space from the lower-right-hand corner, as if the viewer were along for the ride. The figures are stacked and flattened in space and the brushwork is sketchy, leaving detail to the imagination. We imagine that the boat is en route to a nighttime festival to take place in a mysterious place across the water, but Abela provides few clues as to the exact nature of the event. The figures remain anonymous, in transit through the dark to an unknown ritual space. It was this sense of mystery and perhaps even danger that appealed to Parisian audiences.

In another painting, *The Mystical Rooster,* Abela continues this theme of ritual activity. Here, two men and a woman dance around a central male figure who holds up a rooster—a sacred animal, frequently used in rituals in the Santería tradition—toward the heavens. Figures swirl around a central axis, creating a circular rhythm on the surface of the canvas; but the setting is ambiguous and faces are generalized and nondescript, creating a sense of mystery. Again the palette is dark, with charcoal gray, black, and blue predominating. This choice of color was most likely a deliberate disavowal of the prototypical tropical landscape rendered in vibrant tones, but the dark colors reference a different stereotype surrounding ritual, sacrifice, primitivism, and fear of the dark continent.

In terms of style, Abela seems to have taken his cues from French artist Jules Pascin, who lived in the United States from 1914 to 1920 and traveled to Cuba several times during his stay. His renditions of Cuba in paintings such as *Cuban People* (fig. 109) of 1917 reveal a similar spatial ambiguity, fluidity of line, and hazy quality to works by

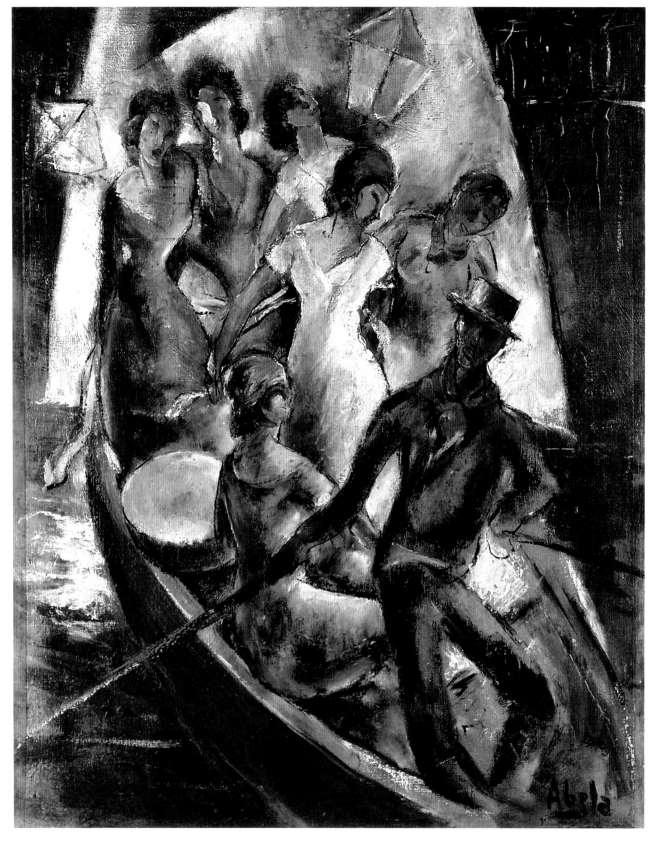

FIG. 107. Eduardo Abela (1889–1965), *Path to Regla,* ca. 1928. Oil on canvas, 21⅞ × 18⅓ in. (55.5 × 46.5 cm). Museo Nacional de Bellas Artes, Havana.

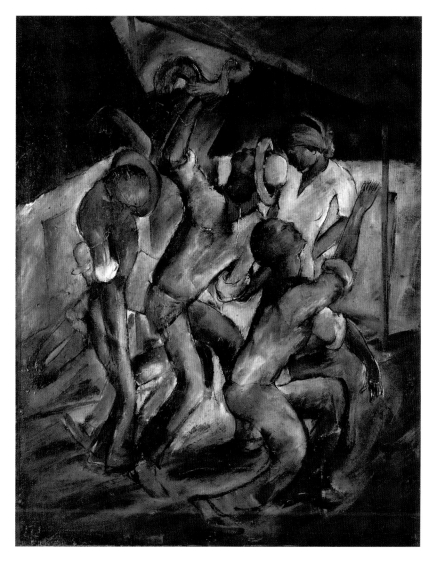

FIG. 108. Eduardo Abela, *The Mystical Rooster,* ca. 1928. Oil on canvas, 25⅜ × 21½ in. (64.5 × 54.5 cm). Museo Nacional de Bellas Artes, Havana.

FIG. 109. Jules Pascin (1885–1930), *Cuban People,* 1917. Oil on canvas, 25⅔ × 21¼ in. (65 × 54 cm). Private collection.

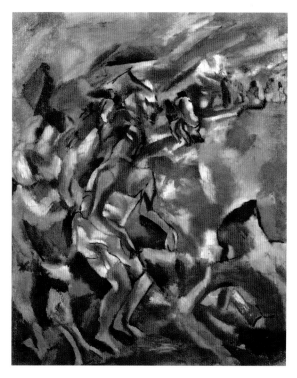

Abela. Abela looked to Pascin, who was well established in Paris at the time, as a guide to determine an appropriate style in which to present Cuban themes to a Parisian audience. Abela differentiated himself from Pascin in several ways, however. His titles and themes are more specific to the Afro-Cuban cultural tradition, most likely because of his alliance with Carpentier, and his palette is much darker, creating a sense of mystery and anxiety around his images that was not present in Pascin's work.

Carpentier was Abela's constant advocate, bringing visitors to the artist's studio almost daily and helping him to organize his exhibition at the Galerie Zak. Thanks to Carpentier's literary contacts the exhibition was extensively reviewed, including mentions in the *Semaine à Paris, Montparnasse, L'intransigeant, L'art vivant, Chantecler, Journal des débats,* the *New York Herald, Renaissance de l'art français et des industries de luxe, Le figaro,* and the *Revue de L'Amérique latine.* These reviews generally praised Abela's work and expressed fascination with the unknown world

he presented. Critics were enthralled with his images of musicians, popular dances, and festivals, commenting on his ability to translate musical rhythm and movement onto the canvas. The critic for *Chantecler* went so far as to deem him the "Gauguin of the Antilles," and others compared him to Pascin and Goya. Given the atmosphere in Paris, where all things African inspired a combination of fear and fascination, these critics quickly fell into facile stereotypes, commenting on the unbridled sexuality released through the rhythm of dance, and calling the images seductive and even diabolical. In *Montparnasse,* the reviewer compares Abela's dancers to Josephine Baker, whom he envisions as an archetypal African dancer: "Like the dances of Josephine Baker, these canvases radiate a persistent anxiety, an atmosphere of terror and passion." For others the scenes were nostalgic, evoking "old Havana, the lazy and enchanting colonial existence, whose last vestiges are preventing progress."[68] Abela's paintings brought to life an imagined Havana, steeped in mysticism and archaic traditions on the edges of the civilized world.

Abela's exhibition also received transatlantic publicity, a coveted mark of recognition for Latin American artists in Paris. Cuban writer Adolfo Zamora, who was in Paris for the show, sent a review of Abela's exhibition back to Cuba to be published in the avant-garde journal *Revista de avance,* writing: "Abela has discovered this suggestive characteristic of the Cuban blacks: how else to explain the existence of the rumba or any other dance, in which the dancer delegates emotional content to movement, in which the soul not only dances, but is the dance itself?"[69] Ironically, Zamora does not remark on the fact that Abela "discovered" the essential characteristics of the Cuban black while in Paris; rather, he confirms Abela's constructed vision of the primal nature of Afro-Cuban dance and the predominance of physical and sensual expression (as opposed to intellectual) in blacks as being a fitting representation of Cuban culture.

In a surprisingly self-conscious reflection on Abela's exhibition and the state of Latin American art in Paris in 1928, however, Raymond Cogniat admits to his awareness of the pressure on artists to produce nativist work: "Artists from Latin America who can honestly figure among the avant-garde groups are becoming more and more numerous and this fact is extremely important, since it marks a rapid evolution which has recently been accentuated. . . . The turn toward original sources of inspiration, the prevalent taste in Paris for African sculptures and for

primitive arts in general, have facilitated this blossoming of South American artists. They have the great advantage of finding their sensibility close at hand and even perhaps in their unconscious memories are formulas that are very new for us and deeply original. One has to wonder how artists could hesitate for such a long time to draw from such a rich heritage and instead prefer our quite out of date theories."[70] Cogniat makes several significant points in his review. His assessment of Abela's work as avant-garde and acknowledgment of the increasing presence of Latin American artists among the ranks of the avant-garde indicates the changing parameters of the term. Cogniat does not define avant-garde practice as formal radicalism or even as the creation of new and innovative styles; rather, for him avant-garde art is that which employs "original sources of inspiration." As the African became a more and more ubiquitous reference in modern art, other "unexplored" world regions gained appeal. (Carpentier, too, makes note of the shift: "Now, the vogue for African art is at the point of being supplanted by the vogue for pre-Columbian art."[71]) The problem, however, was Cogniat's assumption that the Latin American artists who traveled to Paris felt any greater affinity with the indigenous or African American inhabitants of their country than they did with Europeans. For Cogniat, Abela succeeded in Paris where other artists had not because he found "in these traditions a powerful stimulant, a new and peculiarly expressive inspiration." He goes on to comment on the savage, hallucinogenic quality of his pictures and "the mystery of ancestral incantations."[72] Artists like Abela who chose to explore so-called "heritage" sources often started doing so in Europe according to European expectations. Moreover, they did so as a means of self-differentiation and to enter the ranks of the avant-garde, not to express "unconscious memories." Consequently, because of their alignment with European constructs of the primitive, reviewers like Cogniat found their work to be new and original, yet comprehensible because it remained within the parameters of the European modernist paradigm.

Despite critical acclaim and numerous visitors—according to the *New York Herald* the most elegant and eligible members of the young literary and artistic avant-garde attended the opening—Abela did not sell a single painting at his Galerie Zak exhibition and was forced to return to Cuba penniless.[73] Thus, unlike the art of Figari, while his works were a critical success, they were a commercial failure. Indeed, achieving avant-garde status may

very well have been a negative indicator of financial reward. Did Abela push aesthetic boundaries just enough farther than Figari to deter buyers? Or was the difference between the sales of Abela and Figari due to Abela's show being located in a Left Bank rather than a Right Bank gallery? The question for many Latin American artists was whether they could translate this avant-garde standing abroad into a subsequent exhibition in Paris or into employment, sales, or even just recognition once they returned home.

While there is a common perception that as artists acquired a reputation they moved from exhibiting in Left Bank galleries to the more prestigious Right Bank galleries, very few Latin American artists followed this pattern of crossing the Seine. The only known instance is that of Ecuadorian Manuel Rendón Seminario, who held two exhibitions in Left Bank galleries, at the Galerie Vildrac in 1918 and the Galerie Zborowski in 1926, but crossed the Seine when he signed a contract with Léonce Rosenberg's Galerie de L'Effort Moderne in 1927, staying with the dealer until 1932, as will be discussed in Chapter 7. Some artists held their first and only exhibitions in Paris at Right Bank galleries, whereas others crossed the Seine the other way,

such as Figari, who after having three successful exhibitions at the Right Bank Galerie Druet went on to exhibit in Montparnasse at the Galerie Castelucho-Diana in 1931. Torres García went back and forth across the Seine. His first Paris show, in June 1926, took place at the Galerie A.-G. Fabre in the prestigious rue de la Boétie sector (fig. 110). But this exhibition was a retrospective of sorts, and while it included some of his more experimental New York paintings, it highlighted the neoclassical-style works he had produced in Barcelona, including "frescos, fragments from larger decorative works, sketches of architectural decoration, still lifes and figures."[74] Once he began to experiment with more radical techniques in Paris, he returned to Left Bank galleries to test his new approach on more open-minded audiences, holding exhibitions in 1927 at the Galerie d'Art du Montparnasse and the Galerie Carmine, in 1928 at the Galerie Zak and the Galerie Marck (group exhibition), in 1929 at the Galerie des Éditions Bonaparte (group show), in 1930 at the Galerie Castelucho-Diana (group show), and in 1931 at the Galerie Jeanne Bucher. It was not until 1931 that he secured an individual exhibition at the prestigious Right Bank Galerie Percier and another that same year at the Galerie Jean Charpentier on the rue Faubourg-Saint-Honoré—although the famous Cercle et Carré exhibition he helped organized took place on the Right Bank at the Galerie 23, named for its prime location at 23, rue de la Boétie. In the 1930s artists experimenting with abstract tendencies continued to find representation in Left Bank galleries, with Juan del Prete's (1897–1987) second exhibition at the Galerie Vavin-Raspail in 1931 and exhibitions of Torres García's and Wifredo Lam's work at the Galerie Pierre in 1932 and 1939, respectively.

Paris galleries on both the Right and Left Banks were thus essential to establishing the reputation of Latin American artists at home and abroad. These exhibitions, in combination with published reviews, served as a rite of passage for those artists trying to work against the grain of academicism and antiquated standards in their home countries. Throughout Paris, Latin American artists also had to contend with the primitivist expectations of their Parisian audiences, who anticipated and rewarded expressions of cultural difference often more so than art that disavowed national or regional identity. Nevertheless, artists who worked in a wide range of styles and subjects exhibited in Paris, and this diversity constantly challenged critics' quest to identify an overriding Latin American aesthetic.

FIG. 110. Cover of Joaquín Torres García and Juan de Gary, *Exposition Torrès Garcia* (Paris: Galerie A.-G. Fabre, 1926).

6 "Exhilarating Exile"

Four Latin American Women Exhibit in Paris

In her essay "Art and the Conditions of Exile," Linda Nochlin proposes the notion of "exhilarating exile," a heightened awareness of cultural difference that inspires creativity, as a framework for understanding the work of women artists living and exhibiting abroad.[1] In Paris, far removed from the conservative Catholic society of their home countries and the traditional boundaries of feminine identity, women artists from Latin America experienced new freedoms that inspired novel approaches to art-making. Funded by family money or government grants, a sojourn in Paris was not an involuntary exile embarked on to escape political or economic peril but rather a deliberate distancing undertaken to gain further training, exposure to new ideas and colleagues, and career advancement. Paris provided infrastructure in the form of networks of dealers, critics, and exhibition opportunities that simply were not available elsewhere, and an environment that, while still marked by misogynistic assumptions, was much more accepting of women as serious artists. For these women, holding an individual exhibition in Paris was a rite of passage, a means to establish their reputation abroad in order to validate their work at home. Temporal and spatial distance from their country of origin allowed

these artists to envision the world from a different perspective, and to develop diverse strategies to present, transform, or deny their cultural and gender identity for Parisian audiences. This chapter will analyze the individual exhibitions of four Latin American women artists held in Paris between the two world wars: Brazilians Tarsila do Amaral and Anita Malfatti in 1926, Mexican Lola Velásquez Cueto in 1929, and Cuban Amelia Peláez in 1933.[2]

While there were at least sixty-five Latin American women artists living, working, and exhibiting in Paris between the wars, most exhibited at the more conservative Paris salons and only a select few managed to secure individual exhibitions.[3] Among those who did, only the four discussed here could be considered avant-garde, with the exception of those associated with surrealism (María Izquierdo, Frida Kahlo, and Nina Negri), who will be considered in Chapter 9. Three of the women discussed here are quite well known, but Lola Velásquez Cueto has not received the same scholarly attention. The decision to include this little-known textile artist stems from three factors. First, the renowned Right Bank gallery La Renaissance hosted her individual exhibition in Paris, and second, the influential critic André Salmon promoted her

work, indicating that her textiles caught the attention of Paris's artistic elite. Third, while prominent Mexican male artists have overshadowed her career, Velásquez Cueto's innovations in textile arts and her combination of folk traditions with avant-garde tactics merits further attention.

The artists under consideration here all encountered the Parisian art scene at a moment when notions of the decorative and the clean lines of purism were vying for supremacy. Writing in 1925 in an essay entitled "L'art décoratif d'aujourd'hui" (The decorative art of today), Le Corbusier asserts: "Previously, decorative objects were rare and costly. Today they are commonplace and cheap. Previously, plain objects were commonplace and cheap; today they are rare end expensive. . . . Today decorative objects flood the shelves of the department stores; they sell cheaply to shop girls."[4] The implication here is that the decorative, which had previously been associated with finely crafted luxury goods, had become tainted through mass production and its subsequent appeal to women and the popular masses. Thus, according to Le Corbusier, artists should employ the clean lines and pure geometric forms that stem from industrial design and machine aesthetics to counter the vulgarity of the decorative. This aesthetic assessment established a dichotomy between the arabesque and the straight line, the handcrafted and the industrial, and luxury and utility. Nevertheless, artists such as Matisse, who reveled in lavish ornamentation and all-over surface patterning, resisted Le Corbusier's aesthetic hierarchy, embracing the decorative as an expression of modernism. Nor was the act of creating a decorative composition entirely opposed to the process proposed by Le Corbusier. Artists on both sides of the divide were concerned with the structure and organization of surface, the flatness of the picture plane, and the rhythm and placement of compositional elements. And critics often employed the term "decorative" broadly to describe any of these traits. Le Corbusier's (and others') association of the decorative with the feminine affected the interpretation of women artists' work, however. The stylistic and formal choices of Amaral, Malfatti, Velásquez Cueto, and Peláez thus positioned them within the modernist aesthetic debate surrounding the decorative.

Whereas Amaral and Velásquez Cueto directly acknowledged their national identity, playing into while subtly challenging Parisian expectations, Malfatti and Peláez chose to avoid explicitly national subject matter and instead to foreground stylistic experimentation in

their Paris exhibitions. All four grappled with notions of the decorative in different ways, embracing or rejecting its popularity and associations with the feminine. Amaral and Malfatti, who both held exhibitions in Paris in 1926, seem to have deliberately adopted opposite pictorial strategies in a sort of rivalry and play for recognition in the Parisian environment. Three years later Velásquez Cueto exhibited tapestries inspired by Mexico's indigenous craft tradition, whereas Peláez took the lessons of cubism and an emerging constructivism as a point of departure. The diversity of these exhibitions suggests that attempting to identify an overriding feminine or Latin American aesthetic is a futile endeavor. Rather, what united these women was their common experience of "exhilarating exile."

TARSILA DO AMARAL

In June 1926 Brazilian artist Tarsila do Amaral held her first solo exhibition at the Galerie Percier on the famous rue de la Boétie (fig. 111).[5] According to Malcolm Gee, the

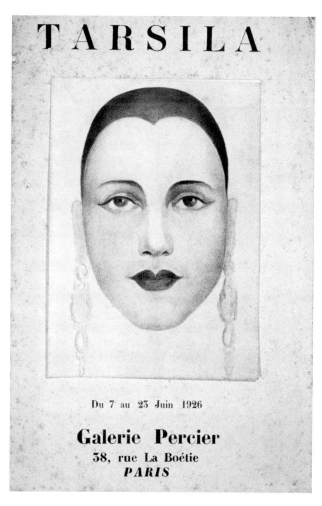

FIG. 111. Cover of Tarsilo do Amaral, *Tarsila* (Paris: Galerie Percier, 1926).

Galerie Percier "maintained one of the more pro-avant-garde policies on the right bank during this period."[6] In addition to receiving significant critical acclaim, it was one of the first exhibitions in a prominent Right Bank gallery to foreground national identity without falling into conventions of the picturesque.[7] What differentiated Amaral from many of her Latin American contemporaries was her ability to combine modernist aesthetics with local subject matter. Moreover, it was the first solo exhibition in Paris by a Latin American woman artist to be considered avant-garde by many critics. Not only did Amaral parlay national identity into avant-garde status, her choice of style also served to challenge common assumptions about the aesthetic properties of women's paintings and these artists' inferior status as draftspeople.

Amaral's 1926 exhibition was a long time coming. Amaral had lived in Paris at various intervals during the 1920s, studying, as discussed previously, first at the Académie Julian and later with André Lhote and Fernand Léger, who had a major impact on her work.[8] For several years she maintained a studio in Montmartre that became a gathering place for the Brazilian intelligentsia and European avant-garde alike.[9] By the fall of 1924 she was eager to show her work and began to explore possible exhibition venues. She considered exhibiting in the galleries run by the journal *Paris-midi,* but her friend and mentor, Swiss novelist and poet Blaise Cendrars, insisted on the importance of strategic self-presentation and discouraged her from exhibiting there: "Me, I advise you not to exhibit right now. Take your time. Good things take time. You must have a good dozen paintings, in addition to *Shantytown Hill* [fig. 112], before considering an exhibition. But if you are absolutely in a hurry, do it now; but not in the galleries of the *Journal* where no one but the nouveau riches attachés of the embassies—amateurs exhibit. Proceed carefully, into the middle of the gallery sector, on the rue la Boétie. Everyone will take care of you, you won't need a protector, you will be surrounded by friends."[10] In a letter to Oswald de Andrade, Amaral's partner, Cendrars elaborates further: "If for whatever reason she must absolutely exhibit right away, she should exhibit in any gallery on the rue de la Boétie, Galerie Percier, for example, and she should have Rosenberg organize her exhibition and Léger write the preface to the catalogue. But be careful not to run into trouble like Chagall. You could talk to Picasso, Cocteau who all can be useful to her if she does an exhibition right away."[11] Cendrars's

suggestions indicate the importance of artistic contacts as well as a gallery's reputation and location in furthering an artist's career. The wrong venue could institute entirely undesirable perceptions of an artist's work. Amaral decided to take Cendrars's advice and wait until she could secure an exhibition at a gallery on la rue la Boétie.

Cendrars's knowledge of the artistic milieu in Paris as well as his intellectual engagement with notions of the modernist primitive had a major impact on Amaral. The two first met in May 1923, and Cendrars introduced Amaral and her partner, Andrade, to many of the most prominent members of the Parisian avant-garde, including the artists Picasso, Léger, Brancusi, Delaunay, Chagall, and the poets and authors Ambroise Vollard, Jean Cocteau, Jules Supervielle, Valery Larbaud, and Jules Romains. Before his acquaintance with the fashionable Brazilian couple, Cendrars had already demonstrated a fascination with non-European cultures, publishing *L'anthologie nègre,* a collection of African stories, in 1921.[12] His friendship with Amaral and Andrade motivated him to explore new destinations; he traveled with them to Brazil in February 1924.[13] For Cendrars, procuring an exhibition for Amaral served the dual purpose of highlighting his own connections to Brazil and situating the country as a rich source of primitivist modernism.

In 1926 Amaral finally secured an individual exhibition at a venue recommended by Cendrars, the Galerie Percier. Amaral recalls: "I first had to take an exam. In spite of Cendrars's introduction, M. Level, the director of the gallery, could not commit himself to showing the work of an unknown artist. The excuse was that he had no space. He would, however, go to my studio to see my work. When I showed him *Shantytown Hill*—black people, black children, animals, clothes drying in the sun, among tropical colors, a painting that today belongs to Francisco da Silva Teles—he asked me: 'When would you like to exhibit?' I had passed. I was going to be shown on Paris's street of avant-garde art."[14] In recommending that Amaral feature *Shantytown Hill* as a centerpiece of her Paris exhibition, Cendrars understood the appeal it would hold for Parisian audiences. While the title refers to the relatively recent construction of the shantytowns in the outskirts of São Paulo or Rio, the scene appears to be a quaint Afro-Brazilian village, complete with brightly colored houses and tropical vegetation. The houses are modest; there is no sign of the poverty, overcrowding, crime, or pollution that later came to characterize shantytowns. Instead, Amaral used the houses and people as motifs, reducing

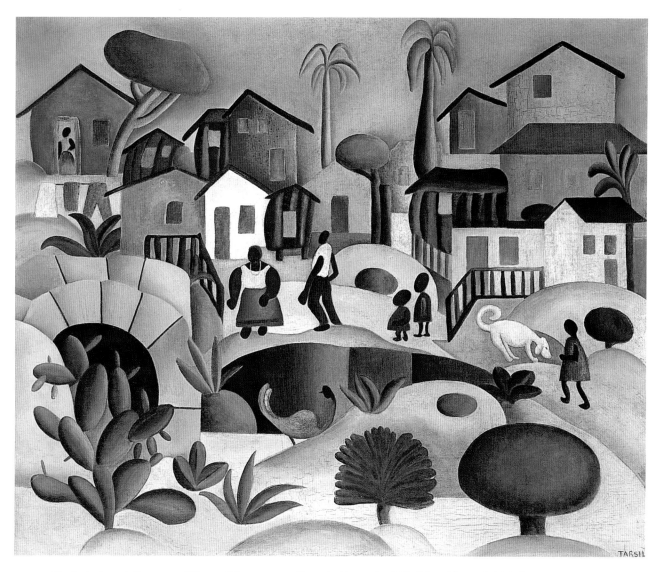

FIG. 112. Tarsila do Amaral, *Shantytown Hill*, 1924. Oil on canvas, 25⅜ × 30 in. (64.5 × 76 cm). Hecilda and Sergio Fadel Collection, Rio de Janeiro.

each form to its essential geometry and stacking these forms throughout the pictorial space. Eccentric bulbous plants are dispersed throughout the space and a smattering of small dark-skinned figures—a couple and their two children, a woman in a doorway, and a child with a dog—occupy the landscape and create a dynamic pattern over the surface. This image offers no social critique—to be fair, social realism had not yet taken hold in the Americas and was not yet part of the modernist repertoire; rather, it presents a new vision of Brazil, a population and landscape ignored by official culture, as valid subject matter for contemporary painting. It was Amaral's combination of modernist technique and new subject matter that enticed Level and led him to grant her an exhibition.

While Cendrars understood the appeal of *Shantytown Hill*, he was still concerned about the overall

conceptualization of the show. He wrote to Andrade from Brazil about the exhibition: "Do a FRENCH, PARISIAN exhibition and not a South American demonstration. The danger to you is to be understood as official [representatives of Brazilian culture]. . . . It is a matter of tact. This time use your Indian character and do not forget all that I already told you on this subject."[15] What Cendrars most likely meant by this comment was that national identity was in demand, but it had to be presented with savvy. Parisians did not want to see picturesque renditions of official culture; they wanted "Indian character." He may also be referring to her audience here, suggesting that the invitees should be members of the avant-garde, not solely from the South American diplomatic corps, which was often the case at exhibitions hosted by the Association de l'Amérique Latine. Being associated with the culture

endorsed by public officials, which Amaral and Andrade denigrated but in which they nonetheless participated in Paris, was a deathblow to avant-garde status.

Amaral's 1926 exhibition (fig. 113) ultimately included seventeen paintings as well as a selection of drawings and watercolors made on her trip to Minas Gerais in 1924, now known as her Pau-Brasil (Brazil wood) paintings. An illustrated catalogue with her self-portrait on the cover, and with reproductions of three paintings (a landscape, *São Paulo*, and *Angels*) and an excerpt from Cendrars's book of poems *Feuilles de route* within, accompanied the exhibition. The paintings exhibited fall into several broad categories. Whereas four paintings focused on Afro-Brazilian types (*Negress, Adoration, Fruit Vender, Shantytown Hill*), other works represented religious piety (*Angels, Children in the Sanctuary; Adoration* could also fall into this category), tropical landscapes (three untitled landscapes, *Lagoa Santa, The Market*), a self-portrait, or pure fantasy (*Boogeyman*).[16] A final group of paintings highlighted the modernity of São Paulo (*São Paulo, Level Crossing, Barra do Pirahy*, and *The Railway Station*).

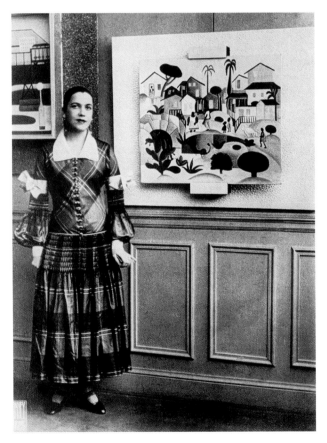

FIG. 113. Tarsila do Amaral in the Galerie Percier at her first individual exhibition in Paris, June 1926. Photograph. Mario de Andrade Archive, Instituto de Estudos Brasileiros, Universidade de São Paulo.

All of the paintings in the exhibition demonstrate a strong affinity with Léger's machine aesthetic: his crisp, clean edges, bold color, and systematic organization of the pictorial space. Rather than simply emulating the style of an esteemed mentor, Amaral's co-opting of Léger's style was a strategic means of positioning herself as a serious artist. She deliberately avoided painting in a stereotypically feminine manner, and embraced those qualities in Léger's work often deemed masculine—boldness, clarity, hard edges, and urban motifs.

But Amaral challenged the primacy of a purist aesthetic by commissioning Pierre-Émile Legrain, a cutting-edge designer working in an art deco style, to make the highly decorative frames for her oil paintings in the exhibition. Legrain, who was known for his innovative work as a bookbinder and furniture designer, designed for two wealthy Parisian patrons—Jacques Doucet, a couturier, and Jeanne Tachard, a milliner—who both owned extensive collections of African objects that frequently inspired Legrain's creations.[17] The frames he made for Amaral's paintings, most of which are now lost, incorporated an eclectic range of unconventional materials including lizard skin, parchment paper, shards of mirrored glass, corrugated cardboard, and leather.[18] Legrain's art deco frames, in their use of materials such as lizard skin, heightened the "exotic" content of the pictures, while their whimsy and materiality added an element of "decorative boldness" to the clean lines in the paintings.[19] Amaral's choice of frames and attention to composition bridge the supposed gap between purism and the decorative.

At Cendrars's urging, Amaral included several paintings of Afro-Brazilians in the exhibition to appeal to Parisians' fascination with the exotic and the primitive. She was acutely aware that this vision of Brazil was exactly what her audience desired. Writing to her family in 1923, she proclaims: "You should not assume that this Brazilian tendency in art is considered bad here. On the contrary, what we want here is that everyone brings a contribution from his or her own country. This explains the success of the Ballets Russes, Japanese prints, black music. Paris is tired of Parisian art."[20] Primitivism is what gave her legitimacy in Paris, but hers was a strategic primitivism that stemmed primarily from an exploration of forms used by members of the European avant-garde such as Léger, Brancusi, Picasso, and Henri Rousseau, rather than some sort of lived or even intellectual connection to native cultures indigenous to Brazil.[21] She nevertheless

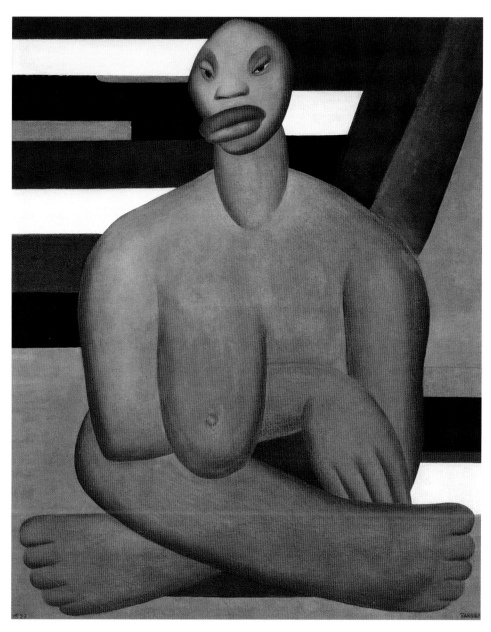

FIG. 114. Tarsila do Amaral, *The Negress*, 1923. Oil on canvas, 39⅜ × 31½ in. (100 × 80 cm). Museu de Arte Contemporânea da Universidade de São Paulo.

claimed (and critics willingly conceded) a certain privileged access to these cultures—despite her upper-class upbringing—because of her national identity, positioning herself as an authority on the subject.

Her 1923 painting *The Negress* was her first attempt to tap into this enthrallment with the "other" (fig. 114). As has been mentioned by various scholars, *The Negress* exhibits a strong link to Brancusi's *White Negress,* made in the same year as Amaral's painting. In her reduction of form to essential elements, smoothness of texture, and condensation of "Africanness" to prominent lips and a single exaggerated breast—a symbol of sexuality, fertility, and a primitive libidinous nature—Amaral is clearly emulating Brancusi. Ironically, her now-iconic painting was barely acknowledged in reviews of her 1926 exhibition. The

Journal des débats refers to it in passing as "the derriere and the lips," but that was essentially it.[22] No one was shocked or offended or even particularly interested in this exaggerated representation of the Afro-Brazilian woman. By the time it was exhibited in 1926, this construct of the African woman, dating back to the display of the Hottentot Venus in 1815, had saturated Paris to such an extent that it did not even elicit comment.[23]

Instead, *Adoration* (see fig. 144), a painting of a subdued Christianized black man, was the first work to sell as well as the image Léonce Rosenberg chose to publish in his journal *Bulletin de l'effort moderne* a few months later.[24] Whereas *The Negress* presents the Afro-Brazilian woman as a sort of primordial Amazon fertility figure defined by her sexual attributes, showing the formidable

FIG. 115. Tarsila do Amaral, *São Paulo*, 1924. Oil on canvas, 26⅜ × 35½ in. (67 × 90 cm). Pinacoteca do Estado de São Paulo.

primitivism conjured in the French imagination, such qualities have been subdued in *Adoration*. Here, the praying figure appears simple, almost childlike. Christianity has tamed his supposed savage instincts and made him nonthreatening. As Amaral herself describes, *Adoration* depicts a "thick-lipped black man with his hands pressed together before an image of the Holy Ghost, surrounded by blue, pink and white flowers, and a frame by Pierre Legrain. The colored wax pigeon, bought in a little town in the countryside, which Cendrars had given me as a present, served as a model."[25] Her description evokes an imagined simplicity of time and place, where craft was spontaneous and intuitive, and religious devotion was based on innocent mysticism. The painting depicts a bust-length view of a dark-skinned man in profile. His lips and facial features are exaggerated and distorted to reflect prevalent stereotypes of African peoples. Along the central axis of the composition his folded hands, which clasp three white flowers, direct the viewer's gaze to the white dove on a decorative pedestal. Through color Amaral sets up a dichotomy between the purity of the white dove, representative of the Holy Spirit, and the devout black man

raised by religion from a state of darkness. Amaral has surrounded the scene with a decorative floral border reminiscent of colonial altarpieces, causing the eye to focus on surface detail rather than penetrate into deep space. It was this image, not *The Negress*, that presented a unique vision of the Afro-Brazilian to the Parisian audience.

In contrast to her paintings of Afro-Brazilians, Amaral's four city paintings included no people, but instead glorified modern technological advancements such as railway tracks, gas pumps, steel girders, lampposts, bridges, and billboards. In the face of constant demands for Brazilian themes, construed in the Parisian imagination as indigenous or primitive peoples and exotic landscapes, these paintings act as a counterpoint to the Afro-Brazilian works and the pristine tropical landscapes. They broadcast the modernity and progressive atmosphere of Brazil's major cities, suggesting that the country had more to offer than its native character, and that São Paulo was equal to or perhaps even surpassed Paris in its modernity.

In *São Paulo*, for example, Amaral presents the city as a pristine modernist utopia (fig. 115). The entire cityscape has been reduced to basic geometries. The tree in the

foreground, with its perfectly circular foliage, echoes the circular forms of the gasoline pump and electric lamp. A billboard with oversized numbers hangs on one of the buildings in the upper left, advertising the new age of information and science. The modern apartment buildings in the background all stand at right angles, and a railway bridge on steel girders and concrete supports bisects the center of the composition. Even the grassy areas are perfectly manicured and tamed by the city's overriding geometry. The only indication of São Paulo's tropical location is the lone palm tree that divides the buildings in the background. While her original impetus to paint in this manner certainly stemmed from her training with Léger and knowledge of works such as his *Steam Boat* of 1923 (fig. 116), the choice to employ this aesthetic to represent the Brazilian city complicated expectations of primitivism from her Parisian audience. By refusing to subscribe fully to this reductive primitivism, Amaral highlights Brazil's "hybrid culture," its simultaneous modernity and ethnic difference.

The numerous reviews of the exhibition were exceedingly positive, treating Amaral as a trained and respected artist. A few, however, resorted to her feminine identity as a means to interpret her paintings. The review in *Paris, Sud et Centre Amérique,* for example, calls attention to her physical appearance: "Mrs. Tarsila is a painting herself: her hairstyle, her physiognomy, her general expression makes one think of her paintings, enigmatic and troubling."[26] By equating her paintings with her "enigmatic and troubling" appearance, the reviewer suggests, by extension, that the country she represents must also embody these qualities.

In his article on Latin American art written for the *Renaissance de l'art française et des industries de luxe,*

FIG. 116. Fernand Léger (1881–1955), *Steam Boat,* 1923. Oil on canvas, 74¾ × 49¼ in. (190 × 125 cm). Musée National Fernand Léger, Biot, France.

Raymond Cogniat also describes Amaral's interpretation of Léger's style in terms of gender. She is "very often influenced by Fernand Léger, but a more sensitive less cerebral Fernand Léger. It is not necessary to look long to discover in Miss Tarsila, under that stylization, an elegance, a very feminine delicacy. We can expect a lot from this artist."[27] While Cogniat intended his assessment of Amaral as praise, the terms of comparison between the male and the female artist are inherently belittling. He never explains how being "less cerebral" and more "sensitive" actually manifests in her work; rather, Cogniat's stereotypes of femininity color his review. It seems, on the contrary, that it was precisely the cerebral, logical quality of Léger's work, his hard edges and pure colors, that appealed to Amaral, and that by appropriating his style she was actually deliberately countering expectations that women's art be "delicate" and "elegant."

While some reviews were vaguely patronizing, calling her work "charming," "exotic," and full of "local color," others note that her paintings transcend the picturesque and resist "cheap exoticism."[28] These reviewers praise Amaral for not attempting to capture ethnographic authenticity and instead finding creative inspiration in the Brazilian people and landscape. What mattered was the stimulus these original sources provided, the artist's interpretation of these sources, and the fact that the resulting paintings were highly innovative. As the critic for *Paris-midi* proclaims, Amaral "did not bother to put her easel on the bank of the Tamanduatchy River," but rather worked in a bright studio.[29] And Raynal notes, "Here are purely Brazilian scenes be they native or purely imaginary."[30] For these reviewers, Amaral's constructed vision of Brazil struck just the right balance between fantasy and reality.

Many of the critics measured Amaral's work against their own biased expectations of Latin American art, an art they assumed would be unsophisticated and primitive. The critic for *Paris-midi* asserts that Amaral's works are "much less naïve than one would expect,"[31] and Georges Charensol notes—incorrectly—that her paintings "owe more to popular imagery, such as that practiced by the naïve craftsmen of Brazil [than to French painters of the extreme-left]."[32] While Raynal proclaims that Amaral's exhibition "mark[ed] a moment of new autonomy in Brazilian art," an art that according to him, had been hampered by academicism and lack of personality, he argues that she achieved this effect by employing "international technique" to "discipline" the "primitive sensibility" that

he associated with Brazil.[33] Raynal's language suggests a latent colonialist attitude. It was only through discipline and logic, products of European enlightenment philosophy, that the primitive can be subdued—the exact argument used to justify colonial expansion. For him, Amaral's paintings tame an inherent primitive and present it in an ordered manner acceptable to Parisian audiences.

For Gaston de Pawlowski, however, the process was reversed: the discipline came first and then "extravagance" followed. Amaral was not asserting control over an inherent primitive, but rather deploying acquired artistic training to deliberately construct a primitive world: "In the same way that we demand a licence to drive a car, we should demand a 'fauve membership card' of all avant-garde painters, certifying that the artist has provided proof that he knows his medium, is authorized, from that point on, to give in to all eccentricities. . . . I am grateful that Tarsila, in the exhibition she offers us, has slipped in a few small studies in pencil in a purely classical style, some reasonable sketches, to prove to us that she has the right to her 'fauve membership card' and that her extravagances are voluntary and well thought out."[34] Pawlowski was among the few critics who accorded Amaral artistic agency, and for him that agency positioned her among the avant-garde.

Amaral's exhibition presented a new twist on the primitivism that had long since been a marker of avant-garde status in Paris. She co-opted the discipline of Léger's purism and used it to interpret in new ways Brazilian sources outside the realm of official culture. This combination had the effect of being readable to her Parisian audience as modernist, yet unique in its source material. Although Amaral perpetuated prevalent stereotypes in her rendering of Afro-Brazilians, her presentation of this source material moved Brazilian art in a new direction. Moreover, her inclusion of several modernist cityscapes complicated perceptions of Brazilian culture as inherently primitive. Through her time in Paris, Amaral learned to negotiate the specific demands of Parisian gallery culture, creating a vision that at once subscribed to those criteria, but also challenged biased expectations.

ANITA MALFATTI

Amaral's compatriot Anita Malfatti employed a distinct artistic strategy to establish her reputation in Paris. While both Amaral and Malfatti came from upper-class backgrounds, Malfatti had traveled more widely than Amaral,

spending time in the United States and Germany with her family before arriving in Paris in 1923, while Amaral had more connections among the avant-garde and diplomatic community in Paris. The two most likely met at the inaugural exhibition at the Maison de l'Amérique Latine, where they both exhibited in 1923 and where they both caught the attention of critics, but they did not frequent the same circles. While Amaral opted to return to Brazil nearly every year to explore her country's colonial and folk heritage, Malfatti traveled around Europe, taking a trip to Italy in the summer of 1924, and to Spain and the Pyrenees in the summer of 1926. Amaral embraced the Parisian penchant for the primitive and the national, but Malfatti almost exclusively avoided it. And while both artists co-opted the styles of established French modernists—Léger and Matisse, respectively—these artists arguably represent two ends of the formalist spectrum, with Léger emphasizing clarity and order and Matisse expressionist brushwork and decorative abundance. Moreover, both women adopted different strategies to present themselves to the Parisian public: Malfatti used the salons as a proving ground and a means to gain critical attention, while Amaral avoided them almost entirely. The choices these two artists made could not have been more divergent, leading to a rivalry between the two. Malfatti's negative reaction to Amaral's 1926 exhibition made explicit this rift and troubled their mutual friend, Brazilian writer Mario de Andrade, who wrote to Malfatti on July 24, 1926: "It is a profound shame that you have not been able come to a friendly understanding after having diverged in your aesthetic orientation."[35]

Malfatti's Paris exhibition at the Galerie André, on the Left Bank of the Seine, which took place only five months after Amaral's, in November 1926, reveals her aesthetic differentiation from her compatriot.[36] Prior to her exhibition, Malfatti had already established her reputation in Paris as a modernist. She had exhibited every year since her arrival at the Salon d'Automne or the Salon des Indépendants, and by the time of her individual exhibition at the Galerie André, she had gained a favorable reputation among French critics. Her exhibition was more extensive than Amaral's and consisted of twenty-two oil paintings, fourteen watercolors, and eleven drawings. Many of the paintings in the show were made during her travels around Europe and included scenes of Italy (*The Small Canal* and *Church Interior* [see fig. 84]), Monaco (*Interior [Monaco]* and *Port of Monaco*), and the Pyrenees

(*Pyrenees Landscape*). Also exhibited were several still lifes (*Dolly, Lemons, Apples*) and nudes (*The Blue Room, Bather, Small Nude*) executed in the monumental style that dominated the School of Paris between the wars.[37] One of the few, if only, paintings in the exhibition to reference her Brazilian identity was the oft-exhibited *Tropical* (see fig. 56). Her decision to emphasize themes and landscapes immediately familiar to a European audience, rather than Brazilian subjects, signifies that her strategy was completely the opposite to that of Amaral.

Tropical was the anomaly, the one picture that suggested difference. Since she had already exhibited *Tropical* twice in Paris, once in 1923 at the Maison de l'Amérique Latine and again in 1925, at the Salon d'Automne, Malfatti knew the work had a receptive audience and would set her apart in the minds of critics. Her decision to take advantage of the painting's appeal, while not repeating its motifs in any other compositions while in Paris, indicates that she was struggling with how to negotiate between Parisian critics' expectations of nationalistic modernism and her own desire to disavow these themes. In the end, Malfatti chose to engage current trends emerging in Paris, rather than to construct a vision of Brazil for her Parisian audience.

In Paris, Malfatti took an interest in Matisse's highly decorative surfaces, painting several works that took his approach in a new direction. She exhibited one of those paintings, *Interior (Monaco)*, in the 1926 Salon des Indépendants, where it received significant positive feedback, and included it again in her individual exhibition at the Galerie André (fig. 117). The painting depicts an interior space: a dining room with an open doorway leading into an adjacent room. A figure with short dark hair can be seen through the door, with her back to the viewer. The entire pictorial surface is animated with ornate patterns: a floral motif unites the tablecloth and doorway curtain, swirling leaves decorate the dining room wallpaper, a dot pattern adorns the wallpaper in the connecting room, and the floor is a checkerboard design. No one object or motif in the painting takes precedence over any other because of the overall imposition of ornament. The only rest for the eye is the bright white door in the center of the composition that leads the gaze toward the figure, who in contrast to everything around her, wears only a simple white wrap. Even the two portraits on the wall are more animated than the figure. The painting overwhelms the eye with its ebullient patterns and surfaces

and subsumes the viewer into this overly decorative space. Malfatti heightened this effect further by eschewing traditional perspective, tilting the table and floor up to create more surface area to endow with pattern.

This direct engagement with Matisse's approach presented interpretive challenges. On the one hand, emulating an older, more established male artist could provide a point of entry for viewers of Malfatti's work, but, on the other hand, following him too closely could relegate her work to the derivative. Moreover, the decorative often signified differently for male and female artists. Matisse's application of bold, vivacious color (which began during his fauve period) and extravagant patterning could be interpreted as an exaggeration required in the constant quest for the new that marked interwar art; in contrast, a woman artist using these same techniques could easily be dismissed as insubstantial and concerned only with the surface of things. Malfatti seems to have avoided these pitfalls by diverging from Matisse in several significant ways. While *Interior (Monaco)* shares quite a bit with works such as the *Pianist and Checker Players* by Matisse of 1924 (fig. 118), Malfatti evades Matisse's use of vibrant color, instead choosing a palette of browns and earth tones. Her choice to work in more drab colors may stem from a desire to avoid the associations with the tropical that Amaral's work evoked. Whereas Matisse constructs an intimate family scene, whose elaborate patterning conjures the rhythm of piano music or the playfulness of leisure activity, Malfatti's room is oddly disconcerting. Who is the figure? What is she doing? Do the portraits on the wall depict family members? Or is she a visitor in this space? The title, *Interior (Monaco)*, suggests travel and time spent in hotels or guest apartments. This sense of alienation or disconcertedness most likely derived from occupying unfamiliar spaces, and the ever-present sense of not entirely belonging as a Brazilian woman abroad.

While reviewers immediately recognized Malfatti's exploration of Matisse, *Interior (Monaco)* was generally well received. It was reproduced in conjunction with reviews of the Salon des Indépendants in the *Revue moderne des arts et de la vie* and *Artistes d'aujourd'hui* as well as in *Paris, Sud et Centre Amérique* as an advertisement for her exhibition.[38] M. Molé comments that the painting was "well composed" and, more importantly, that Malfatti "remained true to herself in the originality she possessed." While Molé does not specifically mention Matisse, he does acknowledge Malfatti's familiarity with "all forms of

FIG. 117. Anita Malfatti, *Interior (Monaco)*, ca. 1925. Oil on canvas, 28 2/4× 23⅔ in. (73 × 60 cm). BM&F Collection, São Paulo.

modern art," and hence his proclamation of her originality suggests that she had achieved distinction without resorting to subject matter as a differentiating mechanism.[39] The critic for the *Paris Times* remarks that while he could identify her sources, this influence quickly dissipated and Malfatti distinguished herself as a unique artist. He also notes, however, that she was "so French in skills and in temperament."[40] This comment equates skill and originality with French culture, and on the flip side, implies that these traits are not inherent to Latin American artists.

In an interview with Malfatti for his review of the 1926 Salon des Indépendants, André Warnod ponders the artist's national identity in relation to her artistic output. His assessment of her responses reveals the contradiction Malfatti confronted in Paris. While there is almost nothing in her work that reveals an interest in Brazilian

FIG. 118. Henri Matisse (1869–1954), *Pianist and Checker Players,* 1924. Oil on canvas, 29 × 36⅜ in. (73.7 × 92.4 cm). National Gallery of Art, Washington, D.C.

folk culture, Malfatti felt compelled to suggest that her ultimate goal was to create local or Brazilian paintings. In Warnod's words:

> We have been surprised to find in the discourse of most young American artists who have come to study painting in Paris, proof of a sincere patriotism.... They are our guests, but they know that they will return home and will build a house made of materials acquired here. A young Brazilian, Miss Anita Malfatti who is showing at the Salon des Indépendants an interior and a portrait painted in a very delicate spectrum, told us how she had toured the United States and Germany before coming to France, without attaching herself to one master or another, but rather being enriched by everything she encountered, attempting to present as well as she could the French spirit, the French culture, in order to later create local paintings in Brazil and to benefit from folklore and the Brazilian picturesque. Is there not more elevated language here than the language that so many young women painters employ who are at present plagued by a demoralizing concern for "schemes."[41]

For Warnod, women painters are easily distracted by "schemes," so focusing on the national was a way for an artist to "elevate" herself above the fray. But since Malfatti was not actually doing so yet, one has to wonder, therefore, if it were not Warnod who put those words in her mouth in an attempt to understand her almost complete lack of reference to Brazil in her work.

Another work in Malfatti's exhibition that elicited special praise was a still life entitled *Dolly* (fig. 119). Since the painting was featured in the exhibition catalogue and Malfatti chose it as one of her two submissions to the Salon des Indépendants the following year, it most likely held particular significance for her. The painting depicts an overtly feminine subject, a doll in an elaborate ruffled dress and crinolines. The doll sits in an ornate floral box with her bonnet removed to reveal blond hair and large, expressive eyes. Like *Interior (Monaco)*, every surface of the painting is highly decorated, with an emphasis on rhythm and pattern. Malfatti established a close vantage point, cropping out the surrounding room and creating an unusually intimate rendering of the doll. When it was exhibited at the Salon des Indépendants, one critic commented it was a "still life perhaps in theme, but alive, and such a beautiful life, because of the color and composition,"[42] and another called it a "little fantasy doll."[43]

Ironically, this focus on *Dolly* did not earn Malfatti the designation of "lady painter." Rather, the critic for the *Paris Times,* in a review of her individual exhibition, remarks that there was "nothing feminine nothing insipid" about her work.[44] For this critic, her compositions were logical and solidly composed and revealed her skill as a colorist.

Although Malfatti's exhibition received significantly less attention in the press than did Amaral's—perhaps because of its location on the Left Bank or perhaps because Malfatti did not do as much self-promotion—reviews of the show were exceedingly positive. Critics considered her a serious modernist with special skill as a colorist and did not resort to interpreting her work in accordance with stereotypes of femininity. These reviews indicate that, through her exploration of the decorative, Malfatti had succeeded in positioning herself within current modernist debates, with her affinity with Matisse a point of departure rather than a crippling influence. Moreover, Malfatti made a conscious choice, in spite of critical acclaim for her painting *Tropical*, to avoid cultural nationalism as a modernist strategy. She understood the reductive and often stereotypical responses that this type of painting evoked and chose instead to take a different path than Amaral.

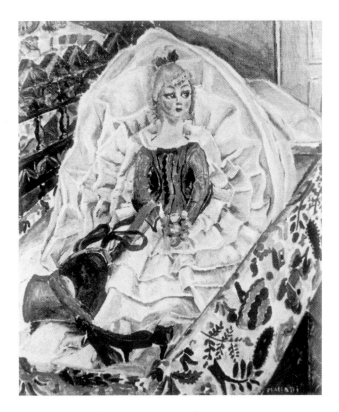

FIG. 119. Anita Malfatti, *Dolly*, ca. 1926. Oil on canvas. Location unknown. Reproduced in Marta Rossetti Batista, *Anita Malfatti: no tempo e no espaço* (São Paulo: Editora 34, EDUSP, 2006), 343.

LOLA VELÁSQUEZ CUETO

Three years later, in 1929, Mexican artist Lola Velásquez Cueto held an exhibition of sixty tapestries at the prestigious Right Bank Galerie de la Renaissance. As a textile artist, Cueto's medium immediately distinguished her from artists working in oil on canvas. The 1925 *Exposition internationale des arts décoratifs et industriels modernes* had brought the decorative arts to the forefront of the public imagination, and throughout the 1920s various avant-garde artists, frequently women such as Sophie Taeuber-Arp and Sonia Delaunay, employed the textile medium to create daring new designs. As a traditionally feminine endeavor, embroidering also held cultural associations with indigenous craft traditions in Mexico. Velásquez Cueto's work as a textile artist thus bridged the gap between the traditional and modern; it drew on aspects of the local while simultaneously coinciding with an avant-garde sensibility and penchant for the primitive. Like Amaral, Velásquez Cueto took advantage of Parisians' taste for the primitive to launch her career in Paris and to open up new opportunities elsewhere.

Velásquez Cueto had arrived in Paris with her husband, artist Germán Cueto, and two children in 1927, and they rented an apartment in Montparnasse. As their daughter Mireya Cueto would later relate, a parade of Mexicans and Latin Americans passed through the Paris apartment, converting the house into "a sort of second Mexican Consulate."[45] Germán's cousin the Spanish painter María Blanchard introduced the couple to the artistic avant-garde of Paris, including Juan Gris, Jacques Lipchitz, Julio González, and André Salmon. Thus, like Amaral, Velásquez Cueto gained inside access to Paris's avant-garde and expatriate community. The pair had brought with them to Paris a large quantity of Mexican crafts as well as fifty tapestries woven by Lola in Mexico. In Paris she purchased "an excellent modern machine" to make more works for her 1929 exhibition.[46] Salmon describes his impression of her process: "Under the magical fingers of Mrs. Lola Velásquez Cueto, it is not really a machine, but rather a tool, that she operates and controls at will, according to her own science and whim, as if it were a paintbrush or a burin."[47] Salmon's justification suggests that Velásquez Cueto was deliberately modernizing her process, and in so doing challenging the belief that the use of a machine would adulterate the perceived purity of the craft process.

Almost immediately upon her arrival, the art critic for the Mexican journal the *Universal ilustrado* began promoting Velásquez Cueto's "triumph" in Paris: "Soon we will applaud an exhibition in one of the most selective galleries of Paris and, surely, the global success of tapestries 'Made in Mexico,' because they don't care that they were made in Europe with European machines, if they are made by a Mexican."[48] Ortega points out a major paradox of exhibiting in Paris: Parisians demanded an aura of authenticity or cultural difference, but were not going to look too closely to verify it.

Through her Paris connections, Velásquez Cueto and her husband secured the luxurious Galerie de la Renaissance for a joint exhibition in 1929 (fig. 120). The galleries encompassed several rooms and had plush leather couches and ample lighting. The exhibition featured sixty tapestries by Velásquez Cueto and a selection of sculptures and masks by Germán. Pre-Columbian, folkloric, and colonial motifs inspired some of Velásquez Cueto's tapestries, while others replicated European and Mexican paintings. Diego Rivera had provided Velásquez Cueto with a cartoon for his mural *Corn Festival* that she converted into a tapestry for the show, and she also replicated Rousseau's *Scout Attacked by a Tiger.*

Her style varied greatly among the tapestries on display, from richly colored and illusionistic to flat and monochromatic. In *Indian,* for example, Cueto depicts an indigenous woman in traditional dress holding a bowl in which she seems to be collecting a substance from the leaves of a plant (fig. 121). A black bird dives down to investigate, and below a small black dog rests among the flowers. The entire composition is rendered in rich browns and greens, the colors of the Mexican earth. While Cueto has flattened and stacked the forms in the pictorial

FIG. 120. Installation view of the Galerie de la Renaissance, *Tapisseries Mexicaines de Lola Velásquez Cueto,* Paris, 1929. Photograph.

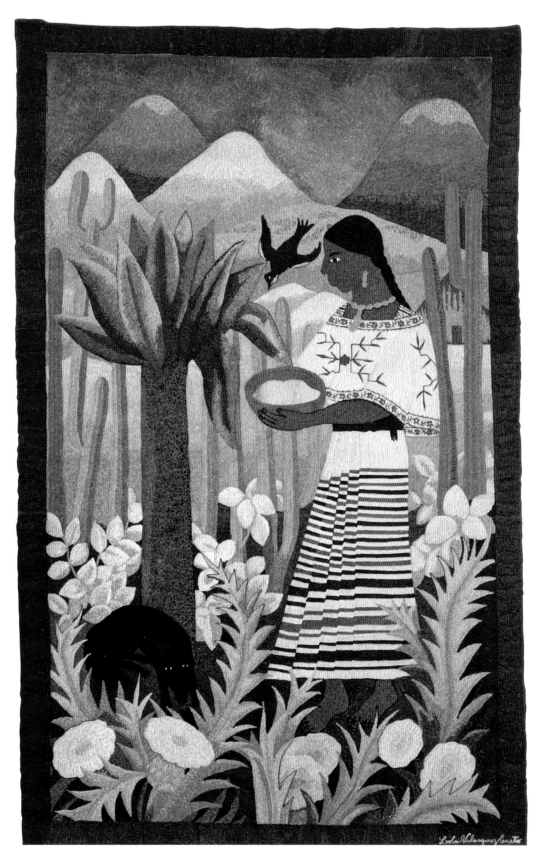

FIG. 121. Lola Velásquez Cueto (1897–1978), *Indian,* ca. 1920–27. Tapestry, 46.5 × 29⅛ in. (118 × 74 cm). Private collection.

space, there is still a clear sense of foreground, covered with abundant white flowers, and background, marked by the characteristic snow-covered peaks of Mexico. She contrasts the undulating flowers with the vertical energy of the cacti in the middle ground. The horizontal stripes on the woman's skirt add another motif to the patterned surface.

Whereas *Indian* follows the compositional structure of a painting, woven entirely in deep purple and ivory, *Patron Saint of Mexico* (ca. 1920) is completely flat and symmetrical (fig. 122). Surrounded by ivory floral patterns, the silhouette of the iconic Virgin of Guadalupe, with her characteristic rays of light, occupies the center of the tapestry; among the flowers, birds emerge as dark silhouettes. Other tapestries such as *Turkeys* adopt a nonhierarchical orientation, one more aligned with traditional weaving techniques. And still others, such as *Dancer,* straddle the fence between symmetrical patterning and illusionistic picture (fig. 123).

In his review of the exhibition, André Salmon discusses Velásquez Cueto's work at length in relation to the notion of the decorative in modern art. For Salmon, the decorative can be "fatal" and does not allow for a "high level of invention." But, he contends, "Mrs. Lola Velázquez Cueto disciplines it with rare tact, which makes her a great decorator, free from everything that modern art has taught us to detest of a certain 'decorative spirit.'"[49] For Salmon, there is a difference between the showy yet

confining decorative, in which pattern supersedes design, and that which inspires invention. By drawing on her cultural tradition—source material that was unfamiliar to her Parisian audience—Velásquez Cueto rose above the restraints of mere ornament to create a new vision. According to Salmon, pre-Columbian art, which he situates as a direct precursor to Velásquez Cueto's tapestries, was "the last great hope for those who have tired of African Art."[50] Thus, one manifestation of the primitive replaced another in the constant quest for novelty in Paris.

This praise of Velásquez Cueto's ability to "discipline" the decorative parallels reviews of Amaral's show, which lauded her regulation, through her precise, controlled style, of the perceived "primitivism" of her subjects. Parisian audiences wanted access to the exotic, the folkloric, and the primitive, yet they simultaneously feared that these imagined primal forces would explode forth in uncontrolled mayhem, or that a popular propensity for ornament would contaminate modern art. Those artists who could harness the essence of these sources, yet present them in a disciplined manner, were the ultimate modernists.

Like Amaral's exhibition, Velásquez Cueto's was widely reviewed, perhaps because of its comparable location in a Right Bank gallery and the artist's many art world connections. Having the support of André Salmon also certainly worked in her favor. Others who reviewed her show included Maurice Raynal, Arthur Rimbaud, and

FIG. 122. Lola Velásquez Cueto, *Patron Saint of Mexico,* ca. 1920. Tapestry, 19.5 × 30⅓ in. (49.5 × 77 cm). Collection of Mireya Cueto, Mexico.

FIG. 123. Lola Velásquez Cueto, *Dancer*, 1924. Tapestry, 20 × 29⅛ in. (51 × 74 cm). Collection of Mireya Cueto, Mexico.

Jean Cassou.[51] Writing for the French art journal *L'art vivant,* Cassou embedded his discussion of Velásquez Cueto into a larger article entitled "La renaissance de l'art mexicain."[52] Cassou attributes Velásquez Cueto's success to sudden inspiration stemming from a Mexican "awakening" to "ancestral forces," rather than to learning an intellectual pursuit: "We imagine that inspiration struck out of the blue and emerged in an immediate and direct way for a tapestry to surpass all the qualities of the highest, most accomplished work of art. The least bit of labor with which a Mexican artist applies his ingenuity becomes a pretext to release all the powers of art."[53] In other words, a Mexican artist need only apply him or herself in a minimal way as long as he or she is drawing on an inherent connection to the Mexican past.

Like Amaral and Malfatti, Velásquez Cueto experienced little direct comment or bias in regards to her gender. Even Salmon's discussion of the decorative did not revert to tropes of femininity, but rather exalted her ability to elevate the decorative to the realm of high art. What she did experience, however, like so many Latin American artists in Paris, was an alignment of her work with notions of the primitive. But her ability to combine local sources with modernist aesthetic principles won her critical acclaim. Paris thus provided Velásquez Cueto a vital opportunity to establish herself in the art world and to contribute, through her work, to the most current debates about the role of the decorative in modern art. After her Paris show, Velásquez Cueto secured exhibitions in Barcelona and Rotterdam, and her success abroad opened the door for several exhibition opportunities in Mexico upon her return home.[54]

AMELIA PELÁEZ

While most Latin American artists left Paris by the early 1930s because of deteriorating economic and political conditions, a few stayed on as long as they could. Cuban artist Amelia Peláez was among those who remained in Paris, waiting out Gerardo Machado's dictatorship. Despite these difficult times, in 1933, after six years in Paris, Peláez held her first individual exhibition at the Galerie Zak on the Left Bank of the Seine, following a prestigious lineup

of Latin American and European artists who had exhibited there since the gallery opened nearly a decade earlier.

Peláez, like Malfatti, almost entirely avoided reference to her national identity in her work, focusing instead on painting still lifes, landscapes, and portraits. Still lifes, in particular, dominated her artistic production, with floral arrangements being a preferred motif, allowing her to explore the graphic possibilities and color combinations these bouquets inspired. Similar to the three artists discussed above, Peláez paid close attention to the decorative arrangement of compositional elements. Her approach to design drew extensively on the theories of constructivism purported by Torres García and his circle, which called for artists to abandon the imitation of nature and instead impose structure on the entire canvas. While there is no evidence that Peláez was directly involved with Torres García's Cercle et Carré group, her teacher and mentor, Alexandra Exter, was.[55] Moreover, her choice of exhibition venue, the Galerie Zak, suggests her knowledge of the recent exhibition organized there by Torres García that will be discussed in Chapter 8. Combining a constructivist approach with an emphasis on decorative motifs, Peláez, too, engaged directly with the most current aesthetic experiments of the day.

Peláez had arrived in Paris in 1927 on a grant from the Cuban government to study the operation of European museums and art schools. With her friend the poet and artist Lydia Cabrera and Cabrera's mother, Peláez took an apartment in Montmartre, far from the experimental art scene and wild nightlife in Montparnasse. In Paris, Peláez took art history courses at the École du Louvre and painting classes at the École Nationale Supérieure des Beaux-Arts as well as at the Académie de la Grande Chaumière. Unlike Velásquez Cueto and Amaral, Peláez did not bring a stockpile of paintings with her from Cuba for exhibition. Rather, like Malfatti, she created most if not all the works for her Paris show in Europe. Also, like Malfatti, she did not return to Cuba during her period abroad, but rather took the opportunity to travel extensively in Europe, visiting Spain, Germany, Italy, Czechoslovakia, and Hungary. This fact alone may explain these artists' differing emphasis, or lack thereof, on national content.

One of her earliest known Paris paintings, which she would later include in her 1933 exhibition, is *The Hare* of 1929 (fig. 124). In the manner of a seventeenth-century Dutch still life, Peláez rendered the prone body of a dead hare beside a simple dish and teacup. Rather than a display of lavish abundance, the scene conveys scarcity

FIG. 124. Amelia Peláez (1897–1968), *The Hare*, 1929. Oil on canvas, 28 × 35½ in. (71 × 90 cm). Museo Nacional de Bellas Artes, Havana.

FIG. 125. Amelia Peláez, *Still Life in Ochre*, 1931. Oil on canvas, 30⅔ × 38½ in. (78 × 98 cm). Museo Nacional de Bellas Artes, Havana.

and simplicity. The body of the hare has been elongated beyond natural proportions and is therefore too lean to have any nutritional value. Its ear and hind leg extend beyond the limits of the frame, slicing the composition in two with the arc of the body. The dish is a perfect circle as if rendered from above, whereas the cup presents a side view. The combination of vantage points, while reminiscent of cubism, is greatly simplified, with each form reduced to its essential attributes, more in line with the newer developments of purism and constructivism. The palette is drab, consisting of mostly variations of gray and brown, and the paint is applied in thick ridges. This roughness and lack of color suggest the poverty of a peasant table, where there is no room for superfluous detail. Peláez let the shapes of the objects determine the structure of the composition, manipulating each until it creates a graphic pattern on the surface, but still

retains a connection to its original form. While almost entirely devoid of ornament, Peláez's composition foregrounds rhythm and pattern as a means of "disciplining" the decorative.

In *Still Life in Ochre* (1931) Peláez further emphasizes geometry and structure (fig. 125). The central motif is a vase of flowers, which Peláez renders in an extremely restricted palette. Only four leaves painted in dark and light shades of blue break up the entirely ochre color scheme. By limiting the range of color, Peláez is able to focus on form: the twists and turns of the stems as they emerge from the vase, the curious blooms that explore the pictorial space, forming asymmetrical patterns, and the minimalist vase that contains them. The background is entirely abstract, made up of a series of rectangular shapes in variations of brown and ochre, which do not relate to any visual reality, but rather offset the colors and forms of

FIG. 126. Amelia Peláez, *Gundinga*, 1931. Oil on canvas, 29 × 24 in. (73.5 × 61 cm). Museo Nacional de Bellas Artes, Havana.

the bouquet. This manipulation of color and form to create a decorative surface became Peláez's modus operandi in Paris.

Around 1931 she began to focus more intently on her artistic development, enrolling in Léger's Académie d'Art Contemporain, where she took courses in set design and color dynamics with Russian artist Alexandra Exter.[56] She continued to study composition, abstraction, and color theory with Exter, most likely at her teacher's private studio, until she returned to Cuba in 1934. Peláez's time with Exter was pivotal in her growth as an artist. According to Peláez: "Exter was a magnificent teacher, her specialty was set design and she had a weakness for illuminated manuscripts. . . . The Russian insisted on what one could call the multiplicity of teaching, that is to say, in learning, on the part of the student, from all the techniques and fields of design and visual arts, in such a way that at the

end of one's studies, the graduate could manage any of these fields and apply the most convenient technique."[57] And Exter thought equally highly of her pupil, writing in a letter of recommendation in 1936: "In my long and extensive practice of teaching, Mlle. Amelia Peláez y del Casal was one of the most individual and talented students that I have ever encountered." She goes on: "The forms in her painting are well synthesized and her search for the broad lines in a composition is always sharp and beautiful."[58]

While Peláez had begun simplifying her forms prior to working with Exter, this inclination seems to have intensified under her tutelage. Painted in 1931, *Gundinga* (fig. 126) exemplifies the extremely pared-down style Peláez developed under Exter, and bears considerable resemblance to costume designs by her mentor (fig. 127). *Gundinga* depicts a young woman in full frontal view, staring out at the viewer. Painted in dark brown, the

background is entirely flat and uniform. Against this solid block of color, Peláez creates a subtle play of hue, painting the woman's hair a shade darker and her skin a shade lighter than the background, making her form appear to simultaneously emerge and recede. Her dress is a simple cream-colored shape that resembles a piece of cut paper, echoed by the white flower petals in her hair. Both her body and facial features are reduced to the most basic geometric forms. This simplicity disavows individual resemblance, making the woman a type rather than a portrait. Whereas some scholars have assumed this painting to represent a mixed-race woman from Cuba, "Gundinga" is actually the name of a small town in Nigeria.[59] Nigeria had become a French colony in 1922, causing an influx of immigrants to France from the region. Since Peláez did not create any other paintings that referenced her Cuban identity during her Paris period, but did paint a portrait of a Hindu woman—which like *Gundinga* was shown in her 1933 exhibition—it seems likely that *Gundinga* does not represent a Cuban woman at all, but rather forms part of

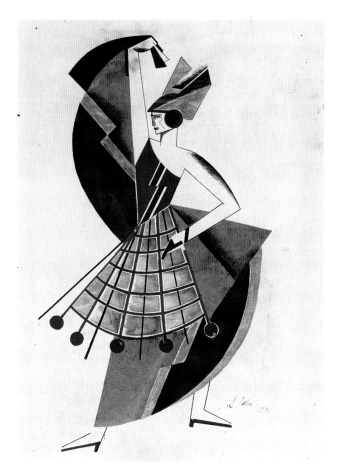

FIG. 127. Alexandra Exter (1882–1949), Costume design for *La dama duende* by Pedro Calderón de la Barca, 1925–26. Gouache on paper, 22⅔ × 16½ in. (57.5 × 42 cm). Private collection.

a general trend in Paris to paint foreign types.[60] Malfatti, for example, painted a Japanese woman in traditional garb, as did many other artists of the period. For Peláez, the woman most likely served as a motif upon which to experiment with extreme simplicity and pictorial flatness, in a manner similar to her floral still lifes, rather than an assertion of her national identity.

In June 1932 Peláez's grant ran out, but she remained in Paris with financial support from her mother. She continued to study with Exter, with whom she explored aspects of the collage practice of synthetic cubism. Peláez did not, however, include these quasi-cubist experiments in her 1933 exhibition, which suggests that these compositions were most likely academic exercises, rather than ends in themselves. *Composition with Glasses* of ca. 1933 hints at her profound debt to Exter and the benefits of cross-cultural exchange (fig. 128). Peláez pastes a clipping from a Cuban newspaper in the center of the composition, which announces the arrival of the first boat from Saint Petersburg in Havana. She also includes a circular postmark from Havana, dated May 9, 1933, suggesting epistolary exchange. If *Gundinga* does indeed refer to a Nigerian woman, the inclusion of these items within this cubist exercise is Peláez's only direct reference to Cuba in the work she completed in Paris. And significantly, she presents Cuba as the hub of transcultural exchange rather than an exotic locale offered up for the curious eyes of the Parisian public.

It was not until April 1933, after six years in Paris, that Peláez had amassed enough work to hold an exhibition. The exhibition was extensive, comprising more than forty works. Still lifes dominated, but several portraits of women and landscapes were also exhibited (including *Gundinga, Hindu Woman, The Hare,* and possibly *Still Life in Ochre,* discussed above).[61] French novelist Francis de Miomandre wrote the preface to the exhibition catalogue. In the mid-1920s Miomandre had begun to take an interest in Latin American art and culture, reviewing exhibitions and translating the work of several important Latin American writers living in Paris, including Miguel Angel Asturias's *Légendes de Guatemala* in 1932 and Peláez's friend Lydia Cabrera's *Contes Cubains* in 1935. Miomandre, like so many other Parisian critics, attempts to connect the artist's work with his perception of her heritage. While he does not mention Peláez's national identity in his presentation of the artist, Miomandre links her choice of subject matter with the tropical and the exotic: "Isolated in their

FIG. 128. Amelia Peláez, *Composition with Glasses,* ca. 1933. Pencil and collage on paper, 19⅔ × 14⅓ in. (50 × 36.5 cm). Private collection.

own dream, objects, flowers, landscapes, strange figures, at once powerfully natural and evanescent. . . . Flowers petrified at the moment of their sunniest bloom; forests seen from the sky and reduced to green undulations; gardens of limbo, somnolent with heat and half hidden by the overabundance of vegetation . . . a closed, complete enigmatic world haunted by an enigmatic silence."[62] With his poetic language, Miomandre evokes a timeless, dreamlike atmosphere, steamy and replete with overabundant vegetation. Even though most of Peláez's floral still lifes represent interior scenes, with cut flowers contained in

simple geometric vases, Miomandre conjures an exotic Caribbean world—a mysterious tropical jungle—to satisfy the European imagination.

Taking their cue from Miomandre's preface, most of the reviews of Peláez's exhibition, while overwhelmingly positive, emphasize the exotic in Peláez's work. The critic for *Germinal,* for example, writes that her paintings were "heavy with dreams" like "an echo that comes to us from the depths of time"[63] and M. Gros, writing for the *Journal des beaux-arts,* refers to her images as "closed," while labeling her use of color "violent" and tone "savage."[64] While the

terms "violent" and "savage" could link her use of vibrant color to fauvism, "savage" also suggests a certain primitivism and rawness. Interpreting her work slightly differently, the critic for *Le rempart* reads Peláez's compositions as an expression of her "sensuality" and of "a very unusual inner life."[65] While this psychoanalytic interpretation may, in part, suggest the recent influence of Freud on art criticism, this reference to sensuality posits a connection between the artist's gender and the manner in which she paints.

The only review to diverge from this tendency to interpret Peláez's work as inherently tropical, exotic, and dreamlike was an extensive feature article on the artist published in *Mobilier et décoration* by Simon Lissim.[66] The article reproduced eight paintings from the show, including works such as *Boats in Mallorca* (1930) (fig. 129), which evidences a pared-down color palette and exploration of geometry, texture, and composition similar to *Still Life in Ochre*. Although Lissim does refer to her "mystical soul," his emphasis is on technique: "The subject is of no importance—they [her pictures] are forms, volumes, they are colors, and harmonies, it is rather the immaterial souls of the objects that attracts one. . . . Her ocean scenes where the water and the sky are but one, where the yellow, red

and orange islands seem to be there only for decorative effect."[67] Lissim does not employ the term "decorative" to mean ornate, but rather to refer to the process of constructing a harmonious composition with color and form. By shifting the reading of her work from mysterious and otherworldly to a deliberately constructed decorative effect, Lissim locates Peláez within the central debates about the constructive and the decorative taking place in Paris, rather than attributing her compositions to some sort of mystical inspiration.

Although her exhibition at the Galerie Zak was widely reviewed, Peláez sold few works, bringing most of them back to Cuba with her the following year. But more than sales, the positive reviews served to cement her reputation in Cuba. News of her success appeared in at least two Havana papers in reviews entitled "Triunfo de una Cubana en Francia" and "Triunfa una Cubana."[68] One of the reviewers even mentioned that her exhibition received "applause from people who matter." This sense of cultural hierarchy, of Paris as the tastemaker and measure of worth, made it difficult for artists to achieve recognition without this experience abroad. "Triumph" in Paris was a means to validation at home.

FIG. 129. Amelia Peláez, *Boats in Mallorca*, 1930. Oil on canvas, 25 × 31¼ in. (63.5 × 79.5 cm). Museo Nacional de Bellas Artes, Havana.

The positive reviews of the show and endorsement from Cuba encouraged Peláez to participate in other artistic forums in Paris. She submitted works to the Salon des Tuileries in 1933 and to the Salon des Indépendants in 1934 and contributed illustrations to the group show *Exposition de livres manuscrits par Guido* at the Galerie Myrbor in 1934.[69] But the overthrow of Cuban president Gerardo Machado and the persistence of a difficult economic and political climate in Paris caused her to return home that year.

CONCLUSION

At a moment when debates surrounding notions of the decorative and the constructive were colliding in Paris, four women artists from Latin America held major individual exhibitions in important Paris galleries. During periods of "exhilarating exile" all four of these artists entered the vibrant artistic environment in Paris and strategically positioned themselves, via their artistic choices, within this world. Entering the modern art milieu involved decisions about subject matter and technique, about whether to portray national themes or avoid them, and about how to negotiate the gendered implications of style.

While certain biases against the artists' gender crept into reviews of their exhibitions, for the most part these women were highly regarded and treated as serious artists. The freedom and vitality of Paris allowed them to assume new professional roles that would have been limited by the traditional boundaries of feminine identity in their home country. Their work, too, challenged conventions of femininity by establishing a specifically modernist take on the decorative. Amaral and Peláez eschewed excessive ornamentation, instead employing the clean lines of purism and constructivism, thereby disavowing the derogatory associations of the decorative with the cheap and vulgar, and by extension the feminine. Malfatti and Velásquez Cueto, on the contrary, embraced arabesques and elaborate surface patterns, but were consistently aware of underlying structure. Malfatti employed color strategically to distance herself from Matisse and notions of the tropical, and Velásquez Cueto drew on such a myriad of sources that she never fell into the mundane and repetitive.

Expectations of primitivism and exoticism significantly influenced critics' perceptions of their work. Whereas Amaral and Velásquez Cueto embraced national themes, Malfatti and Amaral deliberately eschewed them. Amaral and Velásquez Cueto did not simply acquiesce to Parisians' fascination with the exotic and the tropical, however. Amaral deployed her purist aesthetic to present a new vision of Brazil, one that countered official culture with her depiction of Afro-Brazilians and favelas, and simultaneously presented Brazil's cities as the ultimate modernist destination. Velásquez Cueto took her inspiration from Mexico's textile tradition and folk culture to create a unique interpretation of the decorative. While her tapestries appealed to Parisians' desire for new sources of primitivism, her visual language contributed to modernist explorations of form. Malfatti and Peláez chose a different tack for engaging with the modern without resorting to the national, instead focusing exclusively on technique. All four made strategic choices about the image they wanted to convey to their Parisian audience, and created their own unique visual languages that contributed to modernist discourse in Paris.

7 In the Press

The press played a significant role in creating a conceptual framework for understanding Latin American art in Paris. Coverage of the arts in the French press grew considerably in the 1920s with the founding of various new illustrated art magazines and the increasing professionalization of art criticism.[1] As Latin American artists gained recognition in the 1920s, several art magazines moved beyond the occasional exhibition review to run articles on Latin American art as an emerging aesthetic category. While the journal dedicated to the region, the *Revue de l'Amérique latine* (1922), was most instrumental in this regard, interest began to cross over to the many art magazines that were established in Paris between the wars, such as *Montparnasse* (1914), *Renaissance de l'art français et des industries de luxe* (1918), *Bulletin de la vie artistique* (1919), *L'art vivant* (1925), and *Cahiers d'art* (1926).[2] While a few more forward-looking journals such as the *Bulletin de l'effort modern* (1924) rejected cultural nationalism as a qualifier and featured Latin American art on purely aesthetic grounds, the views expressed in the more mainstream press often reflected French prejudices and primitivist assumptions, as well as the intense desire to pinpoint national characteristics between the wars. Those who painted exotic lands and native motifs found recognition in the press, and those who did not were often deemed derivative. Thus, while these reviews provided unprecedented exposure for Latin American artists, they often reinforced perceptions of this art as spontaneous, primal, and rooted more in instinct than intellect.

REVUE DE L'AMÉRIQUE LATINE

The most consistent and comprehensive venue for the review of Latin American art was the journal the *Revue de l'Amérique latine,* edited by Charles Lesca (translator of Figari's book) and Peruvian writer Ventura García Calderón (fig. 130).[3] Established in January 1922 to replace the Groupement des Universités et Grandes Écoles de France's *Bulletin de l'Amérique latine,* this monthly journal published essays by writers and intellectuals from France and Latin America on intellectual, artistic, economic, and social life in Latin American countries, as well as translations of significant literary works by Latin American writers. Printed in French, the journal sought to expose the Parisian intelligentsia to Latin American culture as well as to contribute "to a more intimate communion among the countries that make up the Latin New World," which

according to the editors, tended to look to Europe rather than to one another as a model to emulate.[4] The journal promoted the notion of not only a Latin American community, but also of a Latin American aesthetic.

During its first year, coverage of the visual arts was limited to exhibition announcements, but in January 1923 French art critic Raymond Cogniat initiated a regular monthly column on Latin American artists in Paris: "La vie artistique." That year the journal also implemented an illustrated supplement that reproduced black and white photographs of artworks exhibited in the city. Lauded as one of the "greatest critics of contemporary art," Cogniat was an important promoter of Latin American art.[5] He had started out as a journalist for *Comoedia* in 1920 and later became editor-in-chief for *Monde illustré* and *Beaux-arts*. Throughout his career, he organized numerous exhibitions in France and abroad and published

FIG. 130. Table of contents of the *Revue de l'Amérique latine* (Paris) 16, no. 79 (July 1, 1928).

various art books, including *Au temps des Impressionnistes* (1950), *Histoire de la peinture* (1954), and *Le siècle des Impressionnistes* (1959), as well as volumes on Rouault, Cézanne, Gauguin, Dufy, and Soutine. After World War II he was named general commissary of the Biennale di Venice and the Bienal de São Paulo. While he joined the *Revue de l'Amérique latine* early in his career, he stayed with the journal until it began to founder in 1931 and the arts section was discontinued, becoming a foremost authority on Latin American artists in Paris along the way.

Since he wrote a monthly column on Latin American art, his opinions shaped perceptions of this art in Paris. While he reviewed all styles of art, he demonstrated a definite preference for moderate anti-academic modernism. He often criticized the excesses of the extreme avant-garde, but was equally critical of the highly academic works that dominated official salons. He attended all the salons in Paris, reporting on the contributions of Latin American artists, and wrote reviews of most of the individual exhibitions in Paris galleries, including those of Tarsila do Amaral, Vicente do Rego Monteiro, Manuel Rendón Seminario, Eduardo Abela, José Clemente Orozco (1883–1949), Carlos Alberto Castellanos, Rómulo Rozo, and many others. (These reviews have been incorporated throughout this text in discussions of individual artists.) His assessments therefore served as important guidelines for less informed viewers and critics and had a major impact on the interpretation and evaluation of Latin American art.

One of the most frequently reviewed and highly lauded artists in the journal was Uruguayan Pedro Figari (fig. 131). Nineteen articles on the artist appeared between 1923 and 1931 in the *Revue de l'Amérique latine,* at least five of which were by Cogniat. About Figari he writes: "Of all the South American artists that we have seen up to now, there is but one who has found a truly individual means of national expression ... without borrowing anything from European artists."[6] Ironically, the novelty of Figari's themes seem to have superseded, in Cogniat's mind, the artist's loose brushwork that was so akin to that of the impressionists. For Cogniat, national themes rendered in an original manner were the gold standard for Latin American art; artistic interchange, appropriation, or the emulation of European styles was not. He therefore tended to ignore or downplay connections and affinities with European art and emphasize difference.

Oddly, whereas most of the artists Cogniat reviewed in the *Revue de l'Amérique latine* self-identified as Latin

FIG. 131. Armando Maribona (1894–1964), *Caricature of Pedro Figari in the Revue de l'Amérique latine,* October 1, 1928, lxi.

American or exhibited under the auspices of their nation of origin, Cogniat also decided to claim Francis Picabia as a Latin American artist. Picabia was born in France, his mother was French, and his father was a Spanish-Cuban who served as a cultural attaché for the Cuban legation in Paris. Picabia, however, had never set foot in Cuba and refused to claim that heritage.[7] In a satirical letter to "Madame Rachilde, writer and good patriot," published in his dada journal, *Cannibale,* Picabia writes: "Madame, you set out alone, with your single French nationality, I congratulate you. I am of several nationalities and Dada is like me. I was born in Paris, to a Cuban, Spanish, French, Italian, American family, and the most surprising thing is that I have a very clear sense of being all these nationalities at the same time."[8] During his dada period, Picabia set out to confound national identity and to undermine the xenophobic nationalism that fueled World War I. Although Picabia abandoned his dada stance and adopted an aesthetic of figurative pastiche in the mid-1920s, he did not suddenly seek to align himself with his Cuban heritage.[9] Rather, it was Cogniat who classified him in this manner, publishing two reviews of his new work in 1927 and 1928 in the *Revue de L'Amérique latine* in which he labeled him "an American in Paris" and foregrounded

his Cuban heritage.[10] While, by featuring him in this manner, Cogniat's reviews could be attempts to claim for Latin America one of the most nonconformist members of the Parisian avant-garde, his assessment of the artist was critical, suggesting that Picabia had lost his edge and that he was suffering a "crisis of originality." Cogniat even accuses him of confusing "simplicity with banality."[11] Cogniat's purpose therefore seems to have been to assert his authority over a formerly radical artist and, in relegating him to Latin America, undermine Picabia's project of transnationalism.

Others, however, embraced Picabia's connection to Cuba with pride. As Alejo Carpentier would assert in 1933 in an article sent from Paris: "We all know, however, that Picabia is Cuban. Even though it is not by birth or ancestry, it doesn't cost us anything to put him in the family tree that has its roots in the soil of Latin America, to observe the richness of his lyricism, the caustic attitude of his spirit, the abundance of arbitrary gestures that he has produced in large quantities throughout his tormented existence. Independence, violence, verbal fortune, mockery: four attributes that are inseparable and that alone are enough to attach him to our continent with solid links."[12] Carpentier seems to have ignored Picabia's shift in style in the late 1920s and instead claims him as Cuban because of his radicalism and association with an extreme avant-garde. What is interesting here is not so much the "truth" of Picabia's ancestry, but rather the desire on the part of critics from both sides of the Atlantic to classify artists according to national identity and to lay claims to Picabia for their own purposes. As the foreign presence in Paris increased, this maneuvering to claim or relegate artists to a national or racial category according to their aesthetic traits marked much of the criticism of the period, and was a major characteristic of the reviews in the *Revue de L'Amérique latine.*

Picabia's disputed status as a Latin American artist reveals one of the central questions of the time, a question that continues to concern scholars today: Who and what does the category of "Latin American art" include? Does this category simply imply that the artist had Latin American origins, no matter how distant, or does it refer to the content of the work or deliberate identification with the label in some way? What happens when an artist becomes a naturalized French citizen or if he or she is a second-generation immigrant? What about dual citizenship or artists who reject the very notion of "national

identity"? The French press, through discussions of artistic production, had a major voice in shaping notions of national and Latin American identity. Indeed, the assignment of individuals to this new classification of "Latin American artist" began to establish a perceptual divide between center and periphery, cementing a category that in actuality was quite malleable or, to quote Benedict Anderson, entirely "imagined."

FRENCH ART JOURNALS

One of the first French art journals to prominently feature Latin American art was the *Renaissance de l'art français et des industries de luxe.* Established in 1918, the *Renaissance*

had paid no attention at all to Latin American art until 1926. Yet with the survey exhibition of Latin American art in 1924 at the Musée Galliera a recent memory, and the significant presence of Latin American artists at the annual salons and the 1926 Salon de France, the journal began to take notice of this vibrant presence, asserting that it did not wish to "remain a stranger to this large and fertile movement" and that the *Renaissance* would therefore strive to "give an account to their readers of the most outstanding artistic and literary events of the Latin New-World."[13]

In fall 1926 the *Renaissance* ran a special issue focusing entirely on Latin America, with articles on painting,

9ᵉ ANNÉE, Nᵒ 8 DIRECTION·HENRY·LAPAUZE AOUT 1926

LA RENAISSANCE
DE L'ART FRANÇAIS
ET DES INDUSTRIES DE LUXE

VASE DE NAZCA — PÉROU — COLLECTION BERTHON — COMMUNIQUÉ PAR LE DOCTEUR CAPITAN

NUMÉRO SPÉCIAL SUR L'AMÉRIQUE LATINE
NÚMERO ESPECIAL SOBRE LA AMÉRICA LATINA

10. Rue Royale, Paris
Téléph.: Louvre 33-63

FIG. 132. Cover of the *Renaissance de l'art français et des industries de luxe* 9, no. 8 (special issue on Latin America) (August 1926).

sculpture, and education.[14] The cover of the issue featured a pre-Columbian vessel from Nazca Peru decorated with two schematized figures (fig. 132). This use of the pre-Columbian as an archetype of Latin American artistic production forced a connection between the pre-Columbian and the modern that often simply was not there, but satisfied a deep-seated desire on the part of the French to identify regional characteristics that established cultural difference. Indeed, pre-Columbian art often became the measure against which modern Latin American art was judged and interpreted.

The editors, of course, turned to Raymond Cogniat to write the article on "Les peintres de l'Amérique latine." Organized in alphabetical order by country and published in two parallel columns in French and Spanish, the article presented contemporary Latin American art, for the first time, as a viable aesthetic category and subject for consideration in a mainstream French art journal (fig. 133). Cogniat states up front that he is not interested in presenting a general overview of Latin American art, but rather will focus on artists who "have succeeded or have attracted attention at the annual salons or at individual

FIG. 133. Raymond Cogniat, "Les peintres de l'Amérique latine," *Renaissance de l'art français et des industries de luxe* 9, no. 8 (August 1926): 473.

exhibitions in France."[15] Thus, for Cogniat, "success" in Paris was the deciding factor as to whether an artist was among the "Painters of Latin America." He goes on to remark that although these artists work in a wide range of techniques, they are united by the considerable influence of French art. He also notes that very few artists embraced the most advanced modernist tendencies because, according to him, the innovations of the avant-garde were so eccentric that they "inspired mistrust" in Latin American artists.[16] While it is true that there were few Latin American artists engaging in radical formal experimentation between the wars, his selection of artists to highlight reflects Cogniat's own preference for moderate anti-academic modernism, and the general trend toward classicism between the wars.

Cogniat's presentation of Latin American art relies on a Hegelian definition of progress, which conceived of modernism as the product of linear development from past to present. Consequently, the present is always more advanced than the past, and his conceptual center—Europe—always more forward-looking than the periphery. For Cogniat, modernism is the result of research and exploration, and whereas European artists already had an established notion of aesthetic modernism, "modern art in South America is still in the research phase, that we have already surpassed."[17] He then adopts a tone of reproach, claiming that Latin American artists should not seek direction from Europe, but rather they should turn to their own traditions for inspiration: "From these new, audacious countries, some of which have a very rich artistic tradition [he is referring to pre-Columbian and folk art here] that is so different from our own past, we would expect an extraordinary renewal of artistic formulas, or simply a serious adaptation of European concepts. This has not yet been produced."[18]

Cogniat claims formal innovation and figural distortion as European inventions that arose from a long trajectory of artistic research. For him, European modernism was a product of race and location, and artists from elsewhere could therefore never claim to be the originators of these properties; the modernist hierarchy would always favor Europe. Rather than accept that Latin American artists could contribute to and participate in this process of invention, he felt that these artists should establish a separate trajectory. For him, other modernisms had to look different and must reflect the regional character of their producers. The problem, however, was how he imagined

the regional character of Latin America. The majority of the artists who arrived in Paris were urban middle-class intellectuals of Spanish or mestizo descent. They were the products of more than three hundred years of colonial rule and the subsequent nation-states founded on the French model. Rejecting the European prototype, for early twentieth-century Latin American artists, was the equivalent of rejecting a substantial portion of their heritage.

The rest of the article proceeds to discuss distinguished artists from each country. Cogniat singles out Brazil as particularly advanced, reproducing works by Rego Monteiro and Amaral; he highlights Picabia as an important Cuban artist who fell victim to the excesses of the extreme avant-garde; and he maintains his strong preference for Figari. In his discussion of Mexico, Cogniat's desire to align artistic traits with national identity is most evident: "Whereas Mr. Zárraga is a painter who is one of us, because of his process as well as his choice of subject, Miss Cabrera brings us types very much from her country or very characteristic landscapes."[19] The contradiction here is that European artists are never assigned to different countries because of their technique or approach. Paris lays claim to stylistic innovation, so if an artist embraces any of the techniques developed there or even invents his or her own, critics consider him or her French, or, which is often the case, a French derivative. Only typical or regional subjects serve as a marker for national artistic production outside Europe.

After 1926 the *Renaissance* continued to highlight Latin American art, covering exhibitions by Carlos Alberto Castellanos (1927) and Joaquín Torres García (1931) and reprinting in 1928 an essay by Mexican-born Latvian-American historian and art critic Anita Brenner, "Une renaissance mexicaine," that had originally appeared in the United States in 1925 (fig. 134).[20] The images accompanying Brenner's essay—which included Diego Rivera's *Market Day* at the Secretariat of Public Education, José Clemente Orozco's *Franciscan and the Indian* at the National Preparatory School, and an untitled mural by David Alfaro Siqueiros (1896–1974)—mark the first time photographs of their murals were circulated in France, and was most likely the means by which many Latin American artists living in Paris became acquainted with Mexican muralism.[21] Brenner's essay introduced the notion of a "Mexican Renaissance" to French readers, suggesting that artistic innovation could take place outside the confines of Europe. While this comparison of

Mexico's burgeoning art scene to the Italian Renaissance dates back to at least 1922 in the writings of Mexican intellectuals, the inclusion of Brenner's essay in a French journal initiated a shift in the perception of Latin American art, or at the very least Mexican art, in the French press.[22] For the first time, contemporary Latin American art not produced in Europe, and not made for exhibition there, received critical attention in an important European art magazine.

Following Brenner's lead, in 1929 Jean Cassou wrote an article entitled "La renaissance de l'art mexicain" for *L'art vivant*, accompanied by reproductions of several works by Carlos Mérida, Lola Velásquez Cueto, and Agustín Lazo, and highlighted the importance of Rivera, Orozco, and Rufino Tamayo (fig. 135).[23] Although Cassou could claim a special connection to Mexico because his paternal grandmother was Mexican, he still falls into rather facile stereotypes. He speaks of France's "discovery" of Mexico's cultural richness and the recent "awakening" to the "strong ancestral forces" that Mexicans themselves have experienced.[24]

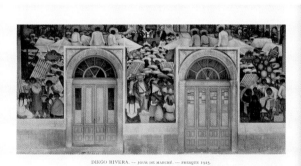

DIEGO RIVERA. — JOUR DE MARCHÉ. — FRESQUE 1925.

UNE RENAISSANCE MEXICAINE

Les peintres contemporains mexicains, possèdent une qualité qui frappe dès l'abord ; cette qualité c'est l'épique. Ils surgissent d'hors la longue chaîne des révolutions comme une affirmation qu'en nul autre lieu, l'art n'a été si intimement lié au sort d'un peuple. Le fait qu'un groupe d'artistes de personnalités, étrangement semblables à celles des artistes de la Renaissance, se soit volontairement retranchés derrière le nom de « syndicat révolutionnaire de peintres » résume, en soi, l'histoire tragique de leur pays.

Toute création indigène n'est qu'un tissu serré de satire et de douleur : La nation mexicaine a été créée, sevrée et éduquée aux mains de dictateurs étrangers. Ses terres et sa richesse étaient à eux. Leur culture et leur religion lui furent imposées. Le Mexique, dans son effort pour s'affirmer soi-même, a vaincu l'Espagne, l'Église, Napoléon au travers de Maximilien. Il s'est débattu entre les mâchoires du capital américain et celles de ses propres politiciens véreux qui déprécient et dénigrent, comme le firent les « conquistadores », la race indienne, quoiqu'elle forme encore aujourd'hui les trois-quarts de la population.

Cette même attitude d'affirmation du moi court comme un refrain révolutionnaire au travers de l'œuvre des meilleurs peintres mexicains. Diego Rivera, une dynamo dans une masse statique de chair, assis sur la poutre d'un échafaudage, près du toit d'un haut édifice, produit sans hâte fresque sur fresque. Un chapeau géant de cow-boy ombre ses yeux somnolents et son sourire bénin. Une cartouchière gonflée et l'étui sombre

Contemporary Mexican painters possess an epic quality which strikes us from the very first. They arise out of a long chain of revolutions, thus affirming that in no other country has art been so intimately linked with the national destiny. The fact that a group of artists, strangely similar in personality to those of the Renaissance, should have chosen to fall back upon the title of " revolutionary syndicate of painters " — this alone sums up the tragic history of their country.

Every native creation is but a closely woven tissue of satire and suffering. The Mexican nation has been created, weaned and educated at the hands of foreign dictators. Its land and its riches belonged to them — and they in turn imposed upon the country their culture and religion. Mexico, in its effort toward self-assertion, has conquered Spain, the Church, even Napoleon through Maximilian. It has been torn between the jaws of American capital and those of its own doubtful politicians — who depreciate and discredit the country, just as the *Conquistadores* did the Indian race which nevertheless still forms three quarters of the population.

The same spirit of self-assertion runs like a revolutionary refrain through the work of the best Mexican painters. Diego Rivera, a dynamo in a static mass of flesh, perched on the beam of a scaffolding near the roof of a tall building, produces fresco after fresco without the least haste. A gigantic cow-boy's hat shades his sleepy eyes and good-natured smile. A stuffed cartridge-belt and the dark case of a Colt 45 encircles

FIG. 134. Anita Brenner, "Une renaissance Mexicaine," *Renaissance de l'art français et des industries de luxe* 11, no. 2 (February 1928): 60.

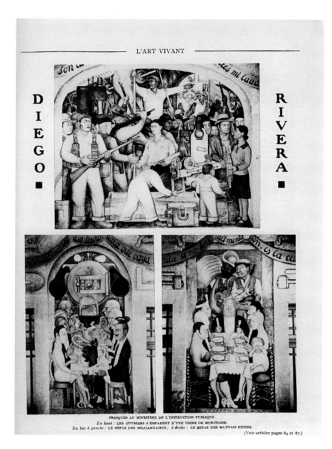

DIEGO ∎ RIVERA ∎

FRESQUES AU MINISTÈRE DE L'INSTRUCTION PUBLIQUE.
En haut : LES OUVRIERS S'EMPARENT D'UNE USINE DE MUNITIONS.
En bas à gauche : LE REPAS DES MILLIARDAIRES ; *à droite :* LE REPAS DES MAUVAIS RICHES.
(Voir articles pages 84 et 87.)

FIG. 135. Jean Cassou, "La renaissance de l'art mexicain," *L'art vivant* 5 (1929): 759.

The following year, 1930, the entire January issue of *L'art vivant* was dedicated to Mexico, with articles on pre-Columbian civilizations, archaeology, Zapotec art, reproductions of objects from the Museo Nacional de México, photographs of landscapes, colonial churches, volcanoes, popular art, an article by Dr. Atl (1897–1964) on "L'ultra baroque," an essay on "L'école à l'air libre," and a section on contemporary art and the "L'Esthétique mexicaine" by E. Gomez Maillefert and José G. Zuno, respectively.

In his essay "La peinture mexicaine contemporaine: Ses caractéristiques," Maillefert also follows Brenner's example, proclaiming that Mexico is undergoing an artistic renaissance. But whereas Brenner proclaims that the innovative character of Mexican art, which paralleled the experimental ethos of the Italian Renaissance, stemmed from the country's revolutionary context, for Maillefert this renaissance was inspired by artists' travels to Europe and exposure to impressionism, divisionism, and the art of the Italian Renaissance in European museums. While both factors were most likely at play, the difference here is one of agency. Brenner credits context, but Maillefert still traces the root of all innovation back to Europe. He

nevertheless concludes that Mexican art is "one of the strongest visual expressions of our time."[25] In his discussion Maillefert highlights the work of Dr. Atl, Fermín Revueltas (1901–1935), Diego Rivera, Fernando Leal (1896–1964), David Alfaro Siqueiros, and José Clemente Orozco, deeming Orozco "an essentially Mexican painter, violent, tragic," thereby transposing Orozco's subjects onto the artist's personality.[26] *L'art vivant*'s "Mexique" issue was particularly noteworthy because, in addition to reproducing easel paintings by Dr. Atl and Roberto Montenegro (1886–1968), it included for the French public an extensive spread of photographs by Tina Modotti (1896–1942) of Orozco's National Preparatory School murals and Rivera's Ministry of Public Education and Chapingo murals, thereby significantly expanding on the imagery made available by Brenner.

Around 1926 other French art journals also began to take an interest in Latin American art. In addition to reviewing the work of Angel Zárraga, Pedro Figari, and Manuel Ortiz de Zárate, the *Bulletin de la vie artistique*, the mouthpiece of the Galerie Bernheim-Jeune, published a review of a group exhibition, *Quelques peintres de l'Amérique Latine*, at the Cabinet Maldoror in Brussels in 1926 that reinforced prevailing stereotypes about Latin American art. The exhibition included works by Mexican artist Santos Balmori (1899–1992), Dominican Jaime Colson, Chilean Isaías Cabezón, and Peruvian César Moro, but French novelist Francis de Miomandre decided to entitle his essay "On demande de la peinture de sauvages" (We demand paintings of savages) (fig. 136). Although Miomandre would later become much more involved with Latin American culture, this exhibition review marks one of his first interactions with Latin American artists. His assessment reveals the prevalent desire to define and circumscribe this new aesthetic category of Latin American art and to impose upon it European primitivist fantasies. Miomandre writes: "What characterizes the youngest of the painters from there [Latin America], is a need to renew contact with the Indian soul and the art forms that it generated, all while remaining up to date with the most audacious and new ideas in Europe."[27] While images entirely unrelated to indigenous culture illustrate the essay, Miomandre forces a connection, remarking on the stone-like quality of Balmori's nudes (as a means to draw a parallel with pre-Columbian stonework), singling out the painting *Araucana Indian* by Isaías Cabezón for comment, calling Colson's decorative

sensibility "Aztec," and declaring of Moro's submissions: "But it's all of Peru that sings out in the watercolors and paintings by the delicious César Moro, beautiful colonial Peru of the vice-roys and of the *'Carrosse du Saint-Sacrement,'*[28] Peru of the ancient kings dressed in feathers, Peru of the Indians of the interior, mourning their dissolution with the sounds of the heart wrenching *quena.*"[29]

Moro's submissions to the exhibition included paintings such as *The "Cholos"* reproduced in Miomandre's review, but whose current location is unknown. *The "Cholos"* can be compared to a painting made around the same time, *Señora, Give It to Me!* (fig. 137).[30] Painted in translucent washes of vibrant color, *Señora, Give It to Me!* depicts the racial diversity of the streets of Lima. Vast incongruities of scale simulate the social disparity between the two elegant señoras on the left and the street vendors selling *anticuchos* (grilled meat on skewers) squeezed into the lower-right corner. Moro fills the space surrounding the figures with angular geometric forms that deny the perception of deep space and emulate the spatial fragmentation of cubism. The words "¡Señora deme a mí!," while reminiscent of cubist collage or stenciled letters, are more literal than cubist practice and instead evoke the language of bargaining common in the marketplace. While Miomandre recognizes the modernity of Moro's technique, calling his forms "flowering

geometry" born of the "cult of Picasso," what strikes him as most original is Moro's Peruvian subject matter, which appears "savage" to the European viewer.[31]

Perhaps in reaction to this review, or the general expectation of such scenes in Paris, Moro ceased painting Peruvian scenes and instead began experimenting with rather orthodox cubist technique in 1926, employing the precise clean lines and intersecting planes of Juan Gris or Fernand Léger. Like many Latin American artists recently arrived in Paris, he appropriates different styles in search of an artistic identity. While his cubist endeavor did not last long because he came in contact with the surrealists (see Chapter 9), the significance of these pictures by Moro is their complete lack of reference to his Peruvian identity. Many foreign artists in Paris intensified their expression of cultural nationalism in their work in response to Parisian expectations; Moro takes the opposite tack from this point forward, emphatically rejecting any explicit expression of Peruvian themes, motifs, or forms in his work as a means to position himself as an international artist and head off essentializing readings of his artistic identity.

Journals that touted an avant-garde outlook took a distinct approach to Latin American art. With their focus on formal innovation, these journals tended to downplay or ignore national or regional identity as an aesthetic determinant. *Cahiers d'art,* for example, only featured those

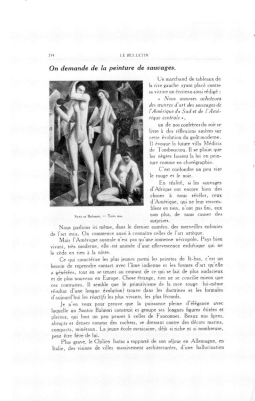

FIG. 136. Francis de Miomandre, "On demande de la peinture de sauvages," *Bulletin de la vie artistique* 7, no. 15 (August 1, 1926): 240.

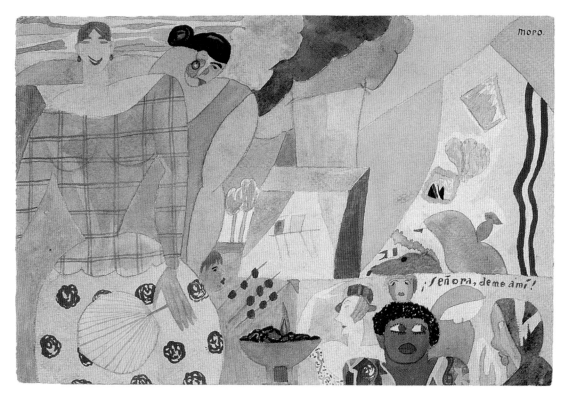

FIG. 137. Alfredo Quízpez Asín (César Moro) (1903–1956), *Senora, Give It to Me!* Tempera on cardboard, 7 × 10⅔ in. (18 × 27 cm). Tenerife Espacio de las Artes.

artists deemed sufficiently innovative, such as Joaquín Torres García and Tarsila do Amaral. *Montparnasse* magazine, too, approached "cultural determinism" with caution. Established in 1914 and run by Paul Husson, Géo-Charles, and Marcel Say, the journal's focus was the vibrant art scene in Paris's Montparnasse neighborhood. With so many Latin American artists living there in the 1920s, these artists were a major presence among its pages beginning as early as 1921.[32] But in the international context of Montparnasse, their work was merely lumped into considerations of the School of Paris. In 1929 Géo-Charles wrote a feature article on the Brazilian artist Vicente do Rego Monteiro in which he asserts: "We find in his work racial traces (here Brazilian), expressed very slightly but deeply felt insofar as one finds them in all true painters, such as the Flemish for example."[33] Géo-Charles's presentation of the impact of race on painting is quite different from the expectation of primitivism so common in other reviews. Rather, he applies racial criterion universally, asserting that race was no more a determinant of style in Brazil than it was in Flanders. This parity, rather than presenting Rego Monteiro as an uncivilized other, established his work as equivalent yet distinct. The following year Géo-Charles invited Rego Monteiro to collaborate with him on the magazine. Together they organized a major exhibition of the "School of Paris" that traveled to three cities in Brazil, which was discussed in Chapter 4.[34] In the context of Montparnasse, at least in the pages of the journal by that name, Latin American artists were perceived as equal contributors to the international mix that made up the School of Paris, rather than as an exotic other.

A SPECIAL CASE: LÉONCE ROSENBERG'S *BULLETIN DE L'EFFORT MODERNE*

Like the vanguard journals mentioned above, Léonce Rosenberg's *Bulletin de l'effort moderne* paid almost no attention to national identity as a factor in artistic production. Compared to these journals, however, the *Bulletin de l'effort moderne* (and the gallery for which it was named) supported and promoted select modern Latin American artists in a much more sustained and discerning manner. Rosenberg had previously taken an interest in the work of Latin American artists between 1916 and 1918, when he served as dealer for the Mexican artists Diego Rivera and Angel Zárraga, Chilean artist Manuel Ortiz de Zárate, and Argentinean artist Emilio Pettoruti, as discussed in Chapter 1. With his promotion of Brazilians Vicente do Rego Monteiro and Tarsila do Amaral, and Ecuadorian artist Manuel Rendón Seminario, in his *Bulletin de l'effort moderne* between 1924 and 1927, however, his support of Latin American modernists surpassed that of other publications.[35]

With the foundation of the *Bulletin de l'effort moderne* in 1924, Rosenberg began to broaden his scope and focus on new talent. The spate of exhibitions and journal coverage of Latin American art—including the first-ever survey exhibition at the Musée Galliéra, which opened in March 1924, the same year that Rosenberg founded his journal—most likely contributed to this wider vision. While the Musée Galliera exhibition presented Latin American heritage as the unifying factor behind the show, Rosenberg never embraced assertion of cultural identity as a marker of modernity, but rather significantly increased his representation of Latin American artists whose work he felt evinced a "modern effort."

In January 1924 Rosenberg printed the first installment of the *Bulletin de l'effort moderne*, which ran until 1927, with a total of forty issues. In the forward he states his intension as "bringing to the attention of those with a curious spirit the most modern production of our time in the fields of architecture, painting, sculpture, printmaking and craft."[36] As can be seen from the cover design featured from 1924 to 1926, the journal promoted a hard-edged modernist aesthetic (fig. 138). The cover design incorporates simple geometric shapes: a decorative border of contrasting orange and blue isosceles triangles frames a centralized rectangle, within which is the title of the journal, written in bold block letters on a white background. The horizontal words *"bulletin de"* balance on the vertical *"l'effort moderne,"* creating a "T" structure that emulates the constructive methods of the artists represented within. Punctuating the rectilinear pattern are several circles and semicircles that serve both a decorative and informational purpose.

Rosenberg intended the journal to be the mouthpiece and public forum for the ideas he promoted at the gallery. In it he featured numerous black and white plates of works by the artists represented at his gallery, many of whom were artists who had previously balked at his strict contracts a few years earlier, including Braque, Gris, Léger, Jean Metzinger, and Picasso.[37] In addition to his core group of cubists, Rosenberg represented lesser-known artists such as the North American sculptor John Storrs, as well as the Australian painter John Joseph Wardell Power and the French artist Georges Valmier, both of whom worked in the cubist style characteristic of the gallery. While throughout its print run the journal consistently promoted and supported artists working in a cubist mode, Rosenberg began to expand his vision of modernism as time passed. Interspersed

FIG. 138. Cover of the *Bulletin de l'effort moderne,* no. 21 (January 1926).

with reproductions of cubist paintings were spreads of landscapes and still lifes painted with an academic clarity consistent with the "call to order" aesthetic. Ironically, these were just the sort of pictures that caused Rivera, Zárraga, and Ortiz de Zárate to leave the dealer around 1918. Moreover, while he never published any writings on surrealism, in 1925 he began reproducing and showing the work of Max Ernst, Giorgio de Chirico, Francis Picabia, and Joan Miró. And in 1927 André Masson signed a contract with the gallery. It seems, therefore, that Rosenberg slowly came to accept other manifestations of modernism concurrent with cubism, without rejecting cubism as a foundational ideal.

In the journal, the plates were interspersed with theoretical texts by leading artists and critics, including Maurice Raynal, Fernand Léger, Theo van Doesburg, Piet Mondrian, and Albert Gleizes. Raynal, in particular, played an important part in shaping the journal's vision because his ideas were very much in line with those of Rosenberg. Raynal made his mark as a critic with his writings on the cubists Braque, Gris, and Picasso when he succeeded Apollinaire at *L'intransigeant* in 1912. Later, like Rosenberg, he focused on purism, contributing various essays to Le Corbusier's and Ozenfant's journal,

L'esprit nouveau. While he embraced a more pluralistic view of art in the 1920s, Raynal, like Rosenberg, regarded cubism as the foundation of modern art. In addition to writing for the *Bulletin de l'effort moderne,* he wrote short monographs on Gris, Léger, and Picasso for Rosenberg's series *Les maîtres du cubisme,* published by Éditions de L'Effort Moderne. He was therefore the ideal partner for Rosenberg's endeavor.

Maurice Raynal most likely brought the Brazilian artist Vicente do Rego Monteiro to Rosenberg's attention in 1925. Rego Monteiro first came to Paris from 1911 to 1914 to study at the open academies of Montparnasse, but he was forced to return to Brazil during the war. He was back again in 1921 and began to make a name for himself, as discussed in Chapter 4, at the Paris salons and at exhibitions sponsored by the Maison de l'Amérique Latine. In addition to exhibitions, Rego Monteiro published two books of prints that brought him to the attention of Parisian critics: *Legendes, croyances et talismans des Indiens de l'Amazone* (1923) and *Quelques visages de Paris* (1925), discussed in the Introduction.

The latter inspired Raynal's first review of the artist in *L'intransigeant,* in which he ranks him among Brazil's most interesting avant-garde artists and praises the book as "extremely intriguing and decorative."[38] Once Raynal "discovered" Rego Monteiro, he supported the artist further by writing the preface for his first one-man exhibition at the Galerie A.-G. Fabre in March and April 1925. In it he asserts: "Rego Monteiro repudiated academic tradition, which generally suffocated young artists from his country, to resurrect the influence of indigenous tradition, which should be the first thing to influence and to inspire all Brazilian artists." Raynal also reviewed the Galerie A.-G. Fabre exhibition for *L'intransigeant,* praising Rego Monteiro's sense of composition, design, and simplicity of color.[39] Similarly, the reviewer for *Comoedia* highlights the artist's knowledge of "cubism from 1912" and praises his schematic designs and sense of geometry.[40] Rego Monteiro's work therefore aligned very much with the aesthetic values promoted by Rosenberg's gallery; but his subject matter was quite different from the typical still lifes, landscapes, and portraits that made up the majority of Rosenberg's earlier cubist acquisitions. While Rosenberg had acquired works by Rivera that incorporated Mexican motifs, he never demonstrated any explicit interest in narrative works or paintings with overt references to national or indigenous themes. His interest in Rego Monteiro

may demonstrate a broadening of his artistic scope in accordance with the new fascination with Latin American art that emerged in Paris around 1924, but the manner in which Rosenberg presented his work suggests that form rather than content still determined his aesthetic choices.

In the October and December 1925 issues of the *Bulletin de l'effort moderne,* Rosenberg featured four paintings by Rego Monteiro. At this point, Rego Monteiro's work had taken a strongly religious turn, with three of the four paintings depicting Christian subjects. These paintings reflect the intense Catholicism of many of Brazil's inhabitants. For Rego Monteiro, however, religious subject matter was not in conflict with modernist technique, but rather represented yet another motif, one with a long history in Brazilian art, with which to experiment. Nor does the subject matter of these paintings seem to have deterred Rosenberg from acquiring them. It seems, rather, that Rosenberg disregarded content altogether and focused entirely on technique. The October issue, in which *Three Nuns* and *Nativity* were reproduced (fig. 139),

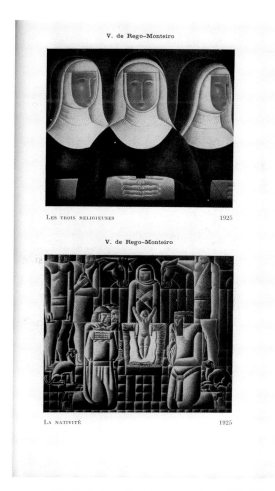

FIG. 139. Vicente do Rego Monteiro, *Three Nuns* and *Nativity,* both 1925. Reproduced in the *Bulletin de l'effort moderne,* no. 18 (October 1925): n.p.

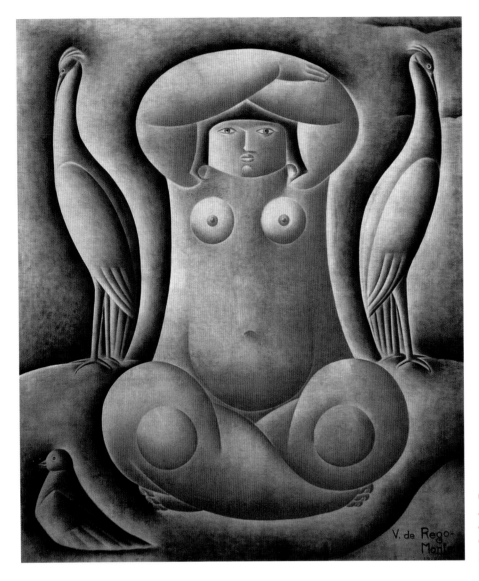

FIG. 140. Vicente do Rego Monteiro, *Nude with Raised Arms*, 1924. Oil on canvas, 63 × 55⅛ in. (160 × 140 cm). Collection of Luís Antônio de Almeida Braga, Rio de Janeiro.

exclusively contained essays on modernist form, including (among others) two essays on color by Metzinger and Auguste Herbin, a discussion of mural painting technique by Severini, and an essay on Léger by Raynal.

Two months later Rosenberg reproduced, side by side, Rego Monteiro's *Mater Dolorosa* and *Nude with Raised Arms* (which is misdated in the journal to 1919, but was actually made in 1924) (fig. 140). *Nude with Raised Arms* had recently been shown in the 1925 Salon des Indépendants. This juxtaposition of a biblical lamentation scene with a painting of a female nude reinforces the idea that Rosenberg identified in Rego Montero an original technique, but was ambivalent about content. *Nude with Raised Arms* displays a strong affinity with paintings by Léger of the period, such as *Woman with a Book* of 1923, which was published in the *Bulletin de l'effort moderne* in April 1924 (fig. 141). This similarity with Léger's machine-like figure helped relate Rego Monteiro's paintings to the general

aesthetic of the journal, but the artist takes his use of color and shading in a different direction from Léger. *Nude with Raised Arms* depicts a seated female nude, with pale eyes, directly facing the viewer. She is positioned in the center of the composition, establishing almost complete bilateral symmetry. While there are subtle differences on each side of the canvas, the only real disruption in the overall symmetry of the composition is the inclusion of a dove in the lower-left corner. Her crossed legs echo her folded arms, which frame her head like a halo. Circular breasts replicate the larger circles of the knees and belly. Like Léger, Rego Monteiro has reduced the body to simple geometric shapes, outlined in clean, precise lines and modeled with highlights and shadows in a restricted palette. Whereas Léger embraced bold primary colors and metallic hues, Rego Monteiro preferred subtle variations of grays and earth tones. Léger shades evenly on all edges of each shape, as if the light were projected directly on the figure. Rego

Monteiro's light source enters from the upper-left-hand corner of the composition. In both cases, however, shading, which follows linear outlines rather than nature, helps delineate the artificial breakdown of the figure into geometric components and, in addition, creates the impression that the entire composition has been rendered in low relief. Light and shadow have been rendered according to a set of very specific rules, but these are not the rules of naturalistic representation; rather, they seem to force the figure to conform to a geometric and chromatic order.

On both sides of the nude, facing away from her, are two slender, long-necked birds whose backs echo the curves of the woman's torso. While this painting is perhaps a simple study of the female nude, in line with the general penchant for monumental female nudes of the period, the presence of the birds suggests an exotic locale or native legend. Rather than referring to Brazil, however, this figure may represent an Egyptian fertility bird goddess, such as the one acquired by the Brooklyn Museum in 1907, with her arms raised over her head (fig. 142). Rego Monteiro began exploring Egyptian hieroglyphics in 1923

when he published his first book of prints, *Légendes, croyances et talismans des Indiens de l'Amazone,* which included a table comparing pictograms from Brazil, Mexico, China, and Egypt (see fig. 168). It is therefore quite possible that this painting stemmed from his fascination with Egypt. This painting thus evokes a generalized notion of the primitive, a construct that emerged in Europe, rather than a specific reference to Rego Monteiro's homeland.

While Rosenberg does not seem to have associated primitivism with a "modern effort," Rego Montero's distinct subject matter and style differentiate his work from that of the other Latin American artists Rosenberg had thus far supported. Rosenberg's willingness to publish new talent indicates that his aesthetic vision was at the very least expanding beyond cubism. In 1925 Rosenberg writes to Rego Monteiro that he will "do everything in his power to place your work in French and international collections." He goes on to advise the artist that prices will be low at first, but to persist: "Matisse's, Derain's, and Picasso's success owes to the fact that for years their work sold cheaply. It was in this way that they created

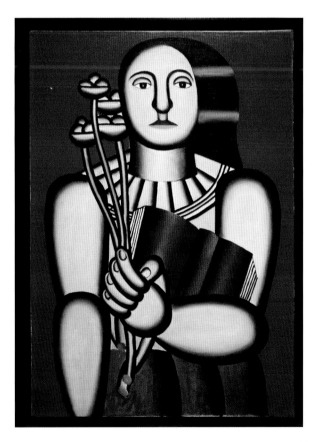

FIG. 141. Fernand Léger, *Woman with a Book,* 1923. Oil on canvas, 45⅔ × 32 in. (116 × 81.4 cm). Museum of Modern Art, New York, Nelson A. Rockefeller Bequest.

FIG. 142. *Female Figure,* ca. 3500–3400 BCE. Painted terracotta, 11½ × 5½ × 2¼ in. (29.2 × 14 × 5.7 cm). Brooklyn Museum, Charles Edwin Wilbour Fund, 07.447.505.

an important nucleus of skilled collectors, all intensely interested in their future. Imitate them, because this is the secret to your commercial success."[41] Despite his initial promises, Rosenberg only reproduced one more painting by Rego Monteiro, *Adoration of the Shepherds*, in the February 1927 issue of the *Bulletin*. While it seems that Rosenberg's interest in selling Rego Monteiro's work declined toward the end of the decade, he remained in epistolary contact with the artist until at least 1930, when he lent several works from his stock to the exhibition of modern art Rego Monteiro was organizing in Brazil.[42] This collaboration was therefore beneficial for both parties and facilitated an unprecedented transatlantic circulation and presentation of modern art.

In addition to Rego Monteiro, Rosenberg also took a brief interest in another Brazilian artist, Tarsila do Amaral, whose work he reproduced in the *Bulletin de l'effort moderne*. Rosenberg's attention to Amaral stemmed from quite different motivations, however. Rosenberg had most likely met Amaral for the first time at a banquet held by Brazilian Ambassador Luis Martins de Souza Dantas several years earlier, in 1923, that he attended with Léger.[43] Amaral then visited Rosenberg's gallery with the wealthy collector Olívia Penteado and purchased works by Delaunay, Lhote, and Léger to decorate her own lush São Paulo home (fig. 143).[44] Rosenberg thus viewed her primarily as an important buyer and commercial contact for potential art sales in South America. And it is perhaps with this ulterior motive in mind that he visited her studio and nominally offered to host an exhibition of her work. As he states in a letter to Léger: "Madame do Amaral in return invited me to visit her studio. . . . Like you, I think

FIG. 143. Tarsila do Amaral's living room in São Paulo. Photograph.

that her publicity in Brazil will bear good fruit . . . and, what's more, after the collapse of Germany and Russia, it is necessary to create new markets."[45] While Rosenberg may have been primarily interested in Amaral's commercial contacts, Amaral wrote home elated with his response to her work: "Good and important news: last week Léonce Rosenberg was here in my studio. He came to look at my work. He is the director of the most important gallery of modern painting in Paris. Showing my work is a difficult and sacred thing for me. But, he liked my art a lot, has been promoting it, and offered me his gallery to hold an exhibition when I am ready. This means that my career is made."[46] Although her assessment of the meeting may have been a bit overly optimistic—perhaps written for the benefit of a dubious family—her opinion of Rosenberg's gallery as "the most important gallery of modern painting in Paris" speaks to Rosenberg's revived reputation by 1923 as well as to the common perception that an exhibition at his gallery would jump-start an artist's career.

Things did not play out exactly as she had planned, however. Amaral was absent from Paris from December 1923 until September 1924, and then only returned for six months to organize her show. Just after her departure, Oswald de Andrade approached Rosenberg again about hosting an exhibition of her paintings, writing to Amaral on March 29, 1925, that the dealer remained committed to showing her work.[47] Despite this assurance, the promised exhibition never materialized, and Amaral ended up exhibiting at the similarly reputable Galerie Percier in June 1926, as discussed in Chapter 6. The reasons for the change in venue are not entirely clear. Rosenberg may simply have lost interest, or had other commitments, but the decision does not seem to have caused any animosity. Amaral invited Rosenberg to the Galerie Percier show, and it was most likely there that he saw *Adoration*, which he reproduced in the *Bulletin de l'effort moderne* in December of that same year.[48] The wealthy collector Jeanne Tachard bought *Adoration*, listed as *Le negre du Saint-Esprit* in the exhibition catalogue, for 5,000 francs at the opening.[49] It was the first painting Amaral sold in Paris. The purchase may therefore have drawn Rosenberg's attention to the painting and prompted him to include it in the *Bulletin*, but Amaral never acquired a formal contract with the dealer.[50]

Despite the subject matter, Rosenberg presents *Adoration* in the same manner he features other works in the *Bulletin*, without comment. He pairs it with Georges Braque's *Still Life* of 1920, a classic cubist composition

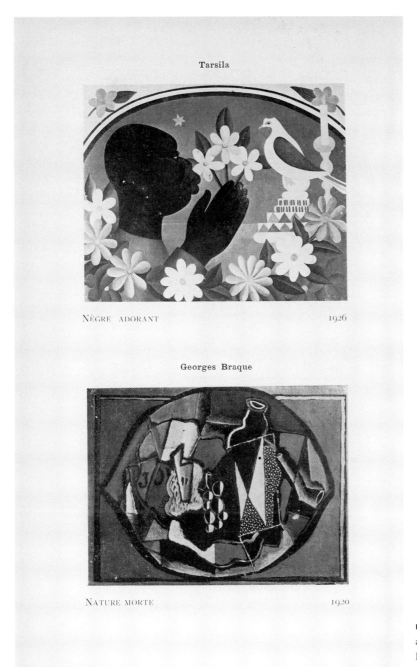

Tarsila

NÈGRE ADORANT 1926

Georges Braque

NATURE MORTE 1920

FIG. 144. Tarsila do Amaral, *Adoration*, ca. 1925, and Georges Braque (1882–1963), *Still Life*, 1920. Reproduced in the *Bulletin de l'effort moderne*, no. 30 (December 1926): n.p.

typical of the paintings Rosenberg usually promoted (fig. 144). While there is some vague similarity in terms of the artists' emphasis on simplified geometries and arrangement of decorative elements on a flat ground, the pairing of the two works is rather jarring. This juxtaposition, as in the case of his presentation of Rego Monteiro's work, suggests that Rosenberg's focus was on form rather than content, and that he was not concerned with issues of national identity or primitivism, as were many other galleries and critics who were beginning to display an interest in Latin American art. Moreover, since Rosenberg only reproduced one painting by Amaral in the *Bulletin*

and never became her dealer or hosted an exhibition of her work, it is hard to determine whether he published her painting out of respect for the artist or as a means to curry her (or Tachard's) favor in hopes of gaining new markets in Brazil.

The one Latin American artist with whom Rosenberg formed a sustained and fruitful arrangement in the 1920s was Ecuadorian Manuel Rendón Seminario. Rendón came from an old colonial family who owned a cacao plantation in Ventanas and a residence in the coastal city of Guayaquil. His father was a diplomat who represented Ecuador in Spain and France, where Rendón was

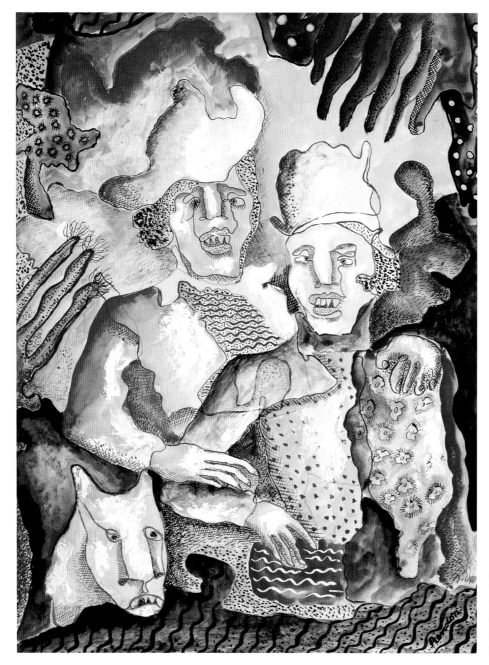

FIG. 145. Manuel Rendón Seminario, *Two Figures and a Dog*, 1924. Watercolor on paper, 25⅔ × 19⅔ in. (65 × 50 cm). Location unknown, formerly Galería Pérez Mac Collum, Guayaquil.

born in 1894. Rendón was a frequent contributor to the Paris salons and held his first solo exhibition in Paris at the Galerie Vildrac in 1918, after which he returned to Ecuador for several years. He arrived back in Paris in 1925, and in June of the following year he held a second one-man show at the Galerie Zborowski (26, rue de la Seine), which included rural landscapes, genre scenes, and images of peasants made during his time in Ventanas and Guayaquil.[51] The show most likely brought him to the attention of Rosenberg.

Paintings such as *Two Figures and a Dog* (1924) most likely exemplify the type of painting in the exhibition (fig. 145). The painting depicts two peasants in what appears to be a tropical landscape. The figures' dark curly hair and colorful garb point to mulatto origin, but these apparent indicators of place and origin almost immediately dissolve into a study of line, color, and form. Jittery, agitated lines animate every section of the image. Tree branches in the shape of fingers encroach on the couple from above and to the left and echo the peasants' nervous hands. Undulating lines at the bottom suggest the fabric of a skirt, but also serve to dissolve the space around the figures, whose faces are drawn with one continuous line. Color, rendered in transparent washes, complements line, taking on a life of its own. Bright shades of yellow, orange, and red are punctuated with areas of blue and

green, not in imitation of nature, but rather in relation to one another, a lesson learned from the fauves. Color and line create interlocking shapes and patterns that cover the surface, suggesting depth, but never allowing the eye to penetrate deep space.

In his review of the exhibition for the *Revue de l'Amérique latine,* Raymond Cogniat describes precisely the quality in Rendón's work that would have appealed to Rosenberg: "It seems at first that we find ourselves in front of a richly colored palette, and then, little by little, the masses find their equilibrium and we see that the subject was merely a pretext. Besides does the subject really matter for an artist who knows so well how to return to the bare essentials? He seems to employ this pretext as a concession for the public, but we feel strongly that his only true preoccupation is with composing, with finding a logical balance among the colored masses, and he often achieves it."[52] As Cogniat points out, subject is simply a pretext for Rendón, at least in the eyes of his French reviewers. Thus, interest in the artist seems to have stemmed more from his approach to art-making than from his "exotic" subject matter, allowing him to construct an identity for himself not based entirely on his nation of origin. His fluency in French and longtime residency in France may also have been important factors in this regard.

Soon after his Zborowski exhibition, Rendón joined Rosenberg's gallery with an exclusive contract, which he held until 1932, when the gallery floundered in the financial crisis. Rosenberg took over control of exhibiting and promoting the artist's work through his journal and gallery. Like Pettoruti, Rendón seems to have been aware of how Rosenberg constructed an aura of importance and exclusivity around the gallery, describing it as "situated in a beautiful residence, where a butler in a tail coat always answers by saying that Mr. Rosenberg is busy or not in."[53] For Rendón, this exclusivity seems to have worked to his advantage, however, since the dealer successfully promoted and sold his work over several years.

When Rendón first joined the gallery, Rosenberg asked him to fill out a questionnaire describing his biographical details and artistic training and to provide an artist's statement. Rendón presents his goal as: "The creation of a new beauty stemming from my inner feelings while continuing the great classical tradition, by means of a meticulously purified visual technique, artistically disciplined and simplified, in the richest material, and incorporating feelings of mystery, emotion, in a universal and logical style."[54] Whether deliberate or not, there are several areas of Rendón's statement that resonate with Rosenberg's aesthetic ideals: his notion of continuing a great classical tradition, as well as his emphasis on discipline, logic, and purified technique. This convergence of Rendón's aesthetic principles with Rosenberg's concept of a "modern effort" may well have facilitated the artist's sustained relationship with the gallery. Within the context of the gallery, Rendón explored the notion of purified technique even further, thereby contributing his own interpretation of Rosenberg's philosophy.

During the course of the *Bulletin*'s print run, Rosenberg promoted Rendón extensively. Rendón's painting *Deep Sea Diver* was the first work to appear in the November 1926 issue, next to Jean Viollier's *Fetish* (fig. 146). The selection of the painting confirms the expansion of Rosenberg's tastes that had started in 1925 with

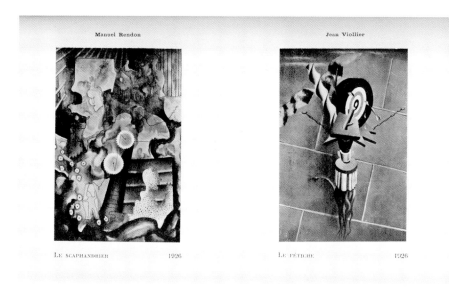

Manuel Rendon Jean Viollier

LE SCAPHANDRIER 1926 LE FÉTICHE 1926

FIG. 146. Manuel Rendón Seminario, *Deep Sea Diver,* 1926, and Jean Viollier (1903–1996), *Fetish,* 1926. Reproduced in the *Bulletin de l'effort moderne,* no. 29 (November 1926).

FIG. 147. Manuel Rendón Seminario, *Rux 32*, 1927. Oil on canvas, 25½ × 19⅔ in. (65 × 50 cm). Costantini Collection, Museo de Arte Latinoamericano de Buenos Aires (MALBA).

his inclusion of several artists who were associated with the surrealist movement or experimenting with surrealist ideas. While Rendón was never a member of Breton's surrealist group, he was clearly aware of the technique of automatism, as can be seen in *Deep Sea Diver*. The painting displays an affinity with the work of André Masson, who also signed an exclusive contract with Rosenberg in 1927 and remained with the dealer, like Rendón, until the gallery floundered in 1932. Rather than a preconceived arrangement of objects in space, the starting point for this painting seems to have been automatic drawing, allowing a free-flowing line to take on a life of its own, sometimes revealing a face, a hand, or a small figure and other times simply animating the space. The small figure in the lower left with the undulating line emerging from its head may have been the inspiration for the title, the *Deep Sea Diver*. The line then connects to a set of gears that suggest a mechanism for returning the figure to the surface. From the title, the viewer interprets the surrounding space as a magical underwater environment replete with floating marine life and gently waving plants. But the linear striations along the top and lower right, which evoke stairs or the wooden paneling in an interior room, disrupt the

illusion: the diver dissolves into a figment of the imagination. The painting has a further liquid quality because of Rendón's use of transparent washes of color that bleed into one another and seem to glow from behind. (This effect can be seen in similar works of the period such as *Rux 32* [fig. 147]). While Rendón tried out various styles during his time with Rosenberg, this painting locates his work firmly among the experimental avant-garde of the time, and reveals a new daring in Rosenberg's promotion of both new styles and emerging artists from Latin America.

Over the course of 1927 Rosenberg reproduced one or two of Rendón's paintings in nearly every issue until the journal folded in December of that year, printing a total of ten paintings and seven poems by the artist. The paintings were executed in a range of styles, from the surrealist automatism described above to an exploration of de Chirico's metaphysical imagery, as seen in paintings such as *Mourners* (fig. 148) (which Rosenberg paired with de Chirico in the *Bulletin*), and the techniques of purism. In June 1927 Rosenberg reproduced *Inca Warrior* in the *Bulletin*, a painting indicating that in the context of Rosenberg's gallery, Rendón began to delve further into the

FIG. 148. Manuel Rendón Seminario, *Mourners*, 1927. Oil on canvas, 23⅔ × 28¾ in. (60 × 73 cm). Private collection.

"purified technique" so admired by his dealer (fig. 149). The painting depicts a bust-length figure with angular features who places his right hand held over his heart. Amorphous shapes in golds, oranges, and blues, some of which are decorated with small blue dots, surround the figure. These dots resemble cubist stippling but are much more regular, suggesting that the looseness of cubist technique has been purified. The shapes in themselves are entirely abstract, but because of their proximity to the figure they coalesce into a crown and elements of costume, which, in combination with the title, evoke an imagined Inca warrior decked out in gold-tinged garments. The warm colors of the shapes contrast with the cold, steely gray tone of the figure's skin and blank eyes, making him appear more like a monument to an ancient past than a living person. Rendón's style here is much more controlled than in *Deep Sea Diver*. Each shape has been carefully delineated and shaded in a manner reminiscent of Léger to create a sense of low relief. There is a clarity of style that makes the image appear frozen in time, rather than animated.

Rendón was one of the most widely promoted and creative Latin American artists presented by Rosenberg. He painted in a variety of styles, interpreting them in new and different ways. By the end of 1927, most of the

FIG. 149. Manuel Rendón Seminario, *Inca Warrior*, 1927. Oil on canvas, 39⅓ × 28¾ in. (100 × 73 cm). Private collection, Paris.

FIG. 150. Manuel Rendón Seminario, *Four Figures*, 1924. Watercolor on poster board, 13¾ × 10⅔ in. (35 × 27 cm). Private collection.

FIG. 151. Francis Picabia (1879–1953), *Dispar*, ca. 1929. Oil on plywood, 59¼ × 37½ in. (150.5 × 95.3 cm). Private collection.

paintings by Rendón in the *Bulletin* demonstrate a preference for this purified technique, suggesting that the ideals of the gallery had an impact on his work. But influence did not just flow one way. Rendón's presence at the gallery and circulation of works such as *Four Figures* of 1924 (fig. 150), with its transparent washes of color and overlapping linear figures rendered in disparate scales, may have been a precedent for Picabia's transparency series, created around 1929. Picabia's *Dispar*, for example, while very different in color palette, demonstrates a strong affinity with Rendón's approach (fig. 151). Since Rosenberg began showing Picabia's work around 1925, it is very likely that

Picabia came across the Ecuadorian's work at the gallery. While Rendón is well known today in Ecuador, his contribution to Rosenberg's "*effort moderne*" has been forgotten in the literature on the interwar period.

Léonce Rosenberg was unique in his promotion and appreciation of Latin American art. He only represented those artists whom he felt displayed a modern attitude or aesthetic in their work. Rather than construing Latin American art as representative of an ethnic or national sensibility, Rosenberg disregarded content almost entirely, instead looking at the structure, color, and arrangement of a composition. Early on, those works that appealed to

him most were clearly aligned with classical or crystal cubism, but by 1924, with the foundation of his *Bulletin de l'effort moderne,* Rosenberg began to expand his aesthetic preferences and incorporate artists whose approach was aligned with surrealism or the more classicizing styles of the call-to-order, although he always maintained a preference for purity of design. Those artists whom Rosenberg brought into the journal and gallery entered into an aesthetic dialogue with a diverse group of artists working in Paris between the wars. The artists from Latin America were not simply following current trends, but rather contributed to the shaping of the gallery's aesthetic. While each artist's experience with the dealer differed in scope and duration, Rosenberg's promotion of their work in the *Bulletin de l'effort moderne* helped establish their reputation in Paris and influenced the future direction of their careers.

LATIN AMERICAN CRITICS

Latin American writers and intellectuals living in Europe often served the additional function of art critic, sending essays home to regional presses about developments in European art and the successes and challenges Latin American artists experienced in Paris. These critics served an essential role of disseminating information across the Atlantic, interpreting and evaluating European artistic movements, and contributing to a transatlantic cultural dialogue. They formed friendships with European critics and often selected key texts for translation in Latin American avant-garde journals or more mainstream newspapers. While many intellectuals and writers, who have been cited throughout, wrote articles on a more irregular basis to promote artists from their home countries, among those who wrote the most extensively about modern art and had the broadest international impact were two Peruvians, José Carlos Mariátegui (1894–1930) and César Vallejo, and the Cuban Alejo Carpentier.[55] Significantly, while they reviewed myriad artists and trends, these three writers all focused on surrealism as the European current with the most impact in the 1920s.

After spending the years from 1919 to 1923 traveling throughout Europe, with extended visits to Rome and Paris, Mariátegui returned to Lima well versed in the most progressive ideas circulating in European intellectual spheres. Intent on stimulating reform in Peru, Mariátegui wrote numerous articles for the local press, pondering issues of Peruvian identity and the terminology appropriate to articulate its relationship to the rest of the world,

and serving as a mouthpiece and interpreter of European movements in Peruvian journals.[56] Mariátegui introduced European avant-garde trends to his Latin American audience, influencing artistic endeavors in Peru and beyond with his aesthetic proclamations. His early articles, mostly published in the Peruvian newspapers *Mundial* and *Variedades,* dealt primarily with European movements. Yet his analysis of these movements reveals an emerging ideological stance.[57] For him, art was a product of its time, rooted in the historical events and social attitudes of the day, rather than an autonomous entity removed from life experience. In "Aspectos viejos y nuevos del futurismo," for example, he states: "The artist who does not feel the agitations, the worries, the anxieties of his city and of his time, is an artist of mediocre quality, with an anemic comprehension."[58] Later, in "Post-Impresionismo y cubismo," he proclaims: "The artistic schools of today are a genuine product of their time and their environment."[59] Mariátegui rejected the notion of "art for art's sake" or art as a personal creative endeavor because he believed that art that spurned referentiality and deliberately disassociated itself from social context could not possibly be relevant in Latin America.[60] In "El artista y la época," Mariátegui developed his critical stance further, contending that artistic production responds to market pressures, and compared the artist to the exploited worker.[61] This expression of Marxist sentiment indicated the approach that would characterize his art criticism in the Peruvian avant-garde journal he founded in 1926, *Amauta.*[62]

Despite his extended consideration of European avant-garde movements, Mariátegui's outlook toward these trends was not particularly favorable. For him, these vanguard movements' "universalist" rhetoric and their competitive attempts to spread their vision around the world simply for the sake of doing something new, were, in effect, another manifestation of European imperialism.[63] He contended that the proliferation of "-isms" that emerged in Europe in the early years of the twentieth century resulted from a culture of decadence and decay. Through his writing, Mariátegui therefore promoted means to counter the impact of Latin America's history of colonialism, and the resulting identity crisis, on artistic production. From his analysis of European movements, Mariátegui began to derive a concept of the avant-garde that could apply to Latin American art, asserting that a spirit of renovation and revolutionary intent, rather than certain formal characteristics, functioned as the common denominator of

vanguard art.[64] Significantly, these qualities could exist in Latin American art without requiring artists to reappropriate European formulas. It was through his knowledge and analysis of European movements that Mariátegui arrived at a comprehensive theory of artistic production.

The one European movement that he deemed worthy of emulation was surrealism. In an article published in *Variedades* in 1926, "El grupo suprarrealista y 'clarte,'" Mariátegui discusses the surrealists' growing political consciousness and condemnation of bourgeoisie decadence.[65] For him, the political stance adopted by these artists and writers distinguished their work from the self-referential "pure" art created by earlier vanguard movements. In a second article on surrealism published in 1930, Mariátegui elaborates further, writing an extensive commentary on the second surrealist manifesto. He praises surrealism's alignment with Marxism and asserts that American (meaning Latin American) artists should emulate the European movement.[66] In surrealism he found not a stylistic model, but rather an archetype of politically engaged vanguardism. Perhaps because he was learning about and assessing the movement from afar, however, he did not see some of the flaws of surrealism that his compatriot César Vallejo identified.

While Mariátegui was one of the first interwar critics to write extensively on European avant-garde tendencies, he left Paris before the major influx of Latin American artists in the mid-1920s. The same year that Maríategui returned to Peru, poet César Vallejo (fig. 152) arrived and remained in Paris until his death in 1938. Like Mariátegui, Vallejo worked as a correspondent for the Lima weeklies *Variedades* and *Mundial,* and he also sent contributions to more than thirty newspapers and magazines in other parts of Latin America, Spain, Italy, and France. He reviewed the Salon d'Automne and Salon des Tuileries, and the 1925 decorative arts exhibition, and wrote articles on individual artists including Picasso, Man Ray, and Picabia, as well as Peruvian Macedonio de la Torre, Argentinean sculptor José Fioravanti (1896–1977; fig. 153), and painter Roberto Ramaugé. Like Mariátegui, his art critical writings have a strongly leftist political bent, and he, too, argued that all art is a product of its time and identified surrealism as an important outcome of the interwar period.[67]

Vallejo did not simply defer to French critics, but rather positioned himself as an authority of equal stature and felt free to criticize their approach. According to Vallejo, prominent art critics André Salmon and Gustave

FIG. 152. José de Creeft (1884–1982), *Vallejo,* ca. 1925. Chased lead. Location unknown. Reproduced in César Vallejo, *Artículos y crónicas completos* (Lima: Pontificia Universidad Católica del Perú, 2002), 151.

Kahn lacked a clear ideological orientation and specific artistic criteria, and he found Waldemar George's tastes too eclectic and incoherent, although he praised his intuition.[68] By bringing French critics to task, Vallejo positioned himself as an authority on modern aesthetic production, rather than a mere reporter of events.

Like many of the French critics in the 1920s, however, Vallejo pondered the existence of a Latin American aesthetic, asking whether "a Latin American spirit" existed. He concludes that America "lacks a cultural home" and that a Latin American spirit did not and would not exist for some time because Latin American culture was hardly distinguishable from that in Spain. Vallejo suggests therefore that the road to self-differentiation lay in tapping into Latin America's Indo-American and pre-Columbian heritage.[69] To address this knowledge gap, he wrote several articles on Incan art that he published in French journals.[70] His intent was not only to educate the French public, but also to provide an historical foundation for contemporary Latin American artists working in Paris.

Like Mariátegui, Vallejo also singled out one European avant-garde movement—surrealism—that he believed could "help us to cleanse our spirit, with the healthy and

invigorating contagion of its pessimism and despair."[71] For Vallejo, surrealism offered the critical inversions and self-deprecating stance necessary to challenge Latin America's dependence on Europe. While Vallejo at first embraced surrealism, especially its alignment with Marxist ideologies, unlike Mariátegui he very quickly became disillusioned with the movement and its founders' unwillingness to truly engage in revolutionary activities. In an article sent to *Variedades*, "Autopsia del superrealismo," Vallejo responds very differently from Mariátegui to the second manifesto, calling surrealism a defunct school and accusing Breton and his followers of opportunism: "The surrealists, mocking the law of continual transformation, became academic during their famous moral and intellectual crisis and were unable to overcome this crisis with truly revolutionary forms, that is to say, destructive-constructive forms. . . . They broke off relations with many members of the [Communist] Party and with their means of publication and proceeded to completely divorce themselves from the great Marxist directives. From a literary point of view, their production continues to be characterized by a bourgeois refinement. . . . Right now, Surrealism—as a Marxist movement—is a cadaver."[72] Despite his eventual rejection of the movement, the amount of ink he spilled first lauding and later refuting it demonstrates the profound impression, be it negative or positive, the surrealists had on Latin American artists and intellectuals in the 1920s.

Surrealism also had a major impact on Cuban novelist, critic, and musicologist Alejo Carpentier. Carpentier had arrived in 1928 in Paris, where he remained until the onset of World War II. Like Mariátegui and Vallejo he served as a correspondent for two journals published in his native country, *Social* and *Carteles,* reporting on all manner of cultural events and developments in Paris, covering music, ballet, literature, theater, opera, cinema, and the visual arts as well as popular entertainers such as Josephine Baker. Among the artists he reviewed were Picasso, Man Ray, Masson, Foujita, Lipchitz, Kisling, and de Chirico; his extensive writings on Cuban artists working in Paris—Eduardo Abela (see figs. 107 and 108), Carlos Enríquez, and Marcelo Pogolotti (see fig. 228)—were essential to the advancement of their careers.

Unlike Vallejo, Carpentier found surrealism to be a movement that effaced skepticism with utter idealism.[73] Whereas Vallejo identified in surrealism a sense of "pessimism and despair," for Carpentier surrealism was not important for its political stance, but rather for its "aversion to skepticism." In "En la extrema avanzada: Algunas actitudes del 'surrealismo'" he contends: "If you read the admirable Surrealist Manifesto by André Breton, you will learn the secrets of a magic art, whose discovery constitutes the most important poetic event to have taken place since Arthur Rimbaud's literary evasion."[74] The fact that two writers could find in surrealism such diametrically opposed sensibilities suggests, perhaps, the movement's success in the deliberate juxtaposition of contrasting images and ideas. It also indicates the adaptability of the surrealist ideology to concerns outside Europe.

Also unlike the Peruvians, while Carpentier was an ardent leftist and strong supporter of revolutionary movements, his political leanings were not as evident in his art criticism. Carpentier's writings, rather, are characterized by astute social commentary. He had a keen eye for cultural prejudice and was quite skeptical of Parisians' growing interest in Latin America. In an essay entitled "Las nuevas ofensivas del cubanismo" he observes: "After having ignored America for hundreds of years, the Gauls have started to become intensely interested in things from our young continent. . . . Continually, in the editing of new magazines, I am asked: 'Translate Latin American things, reveal

FIG. 153. José Fioravanti (1896–1977), *The Homeland,* ca. 1930–34. Stone. Location unknown. Reproduced in José Fioravanti and Musée du Jeu de Paume, *Exposition de sculptures monumentales de José Fioravanti* (Paris: Musée des Écoles Étrangères Contemporaines, 1934), 17.

FIG. 154. Tina Modotti (1896–1942), *Indian Childhood*, 1930. Photograph. As reproduced in *Bifur* 6 (1930): 100.

to us your values, seek out popular poetry by Indians, guajiras and blacks; give us prints, tell us what it is like there.'"[75] Carpentier was appalled at Parisians' distorted expectations, complaining that one French writer, in describing his reasons for an upcoming trip to Latin America, proclaimed: "I want to see if your civilization is comparable to the idea that I have of what a civilization should be."[76] In other words, his expectations of primitivism were so ingrained that he could not possibly believe that Latin America could be a civilized place. Despite his protestations, however, Carpentier did as requested, submitting articles on Afro-Cuban culture to several Parisian publications.

In 1929, the year after Carpentier published his review of surrealism in *Social* discussed above, he wrote an article on Cuban music for the dissident surrealist journal *Documents*. For Carpentier, *Documents* was one of the "three most important modern publications of the day." Ironically, in his essay Carpentier ascribed the same sort of exotic stereotypes to Afro-Cubans that the French so often attributed to Latin America in general and that he

so disdained in the French traveler, asserting: "He ['the black'] needs esoterism, incantations, mystery."[77] Despite his extensive research on the subject, by insisting on the mystical and esoteric nature of Afro-Cuban music, Carpentier aligns it with European primitivist fantasies.[78]

That same year Carpentier also contributed an essay on blacks in the Antilles, "Lettres des Antilles," to the surrealist journal *Bifur*, which was later reprinted on the front page of *Comoedia*. Like *Documents*, *Bifur* included numerous ethnographic photographs juxtaposed with images of modern life and art. Its focus on Latin American themes was unprecedented, however, indicative of the turn toward New World primitivism in the late 1920s. In addition to Carpentier's contribution, during its three-year run the journal included an essay on Ecuador's native population by Henri Michaux, submissions by Latin American writers Vicente Huidobro, Miguel Ángel Asturias, and José E. Rivera, photographs of Mexico by Tina Modotti (fig. 154), and advertisements for the Latin American journals *Nosotros* (Buenos Aires) and *Amauta*

(Lima). Carpentier's involvement and close association with these two alternative surrealist journals provided him with a different perspective from the Peruvians who focused primarily on André Breton's initiatives.

By 1933, however, Carpentier seems to have distanced himself from both groups, lamenting that those associated with *Bifur* and *Documents* got together far from Montparnasse, and the friends of Breton were too preoccupied with preparing "literature" since they became involved with the Communist Party.[79] Once he dissociated himself from surrealism, Carpentier began to rethink Latin America's relationship to the movement, declaring "the marvelous" an innate Latin American characteristic, present long before the surrealists' "discovery" of the region.[80] Such a claim served to assert Latin America's cultural autonomy in the face of foreign influences. While resisting Breton's imperious declarations was certainly warranted, Carpentier's and Vallejos's subsequent negation of surrealism served to obscure the movement's original appeal to and impact on so many Latin American writers and artists. Consequently, the literature on Latin American artists has characteristically avoided determining the particularities of an artist's actual connection to surrealism, a gap that Chapter 9 will address.

As correspondents for various publications at home and abroad, Latin American writers living in Paris played an essential role in disseminating knowledge about European art and culture. They were also instrumental in supporting and furthering the careers of Latin American artists struggling to make a name for themselves in Paris. While they at times were able to challenge the consistent demand for primitivism, they also took advantage of this fascination with the exotic to further their own agendas and promote artists whom they felt deserved recognition. They were not mere reporters, but rather inserted their ideas, opinions, and critiques of what they saw and encountered into transatlantic debates about the nature and direction of modernism. Their voices added much-needed alternative perspectives to the many French journals that were demonstrating a nascent interest in Latin American culture.

8 Joaquín Torres García in Paris

Artist, Innovator, Organizer

In histories of Latin American modernism, Uruguayan artist Joaquín Torres García (1874–1949) is widely acknowledged as a leader in the introduction and promotion of constructivism and abstraction.[1] While his impact in Latin America was certainly significant, the full implications of his presence in Paris in the interwar years have yet to be examined. Prior to returning to Uruguay in 1934, Torres García would live in Europe for forty-three years. These years were primarily in Barcelona, but as Paris began to return to its former glory after World War I, he decided to try his luck in the City of Light, where he spent six highly productive years between 1926 and 1932. One of Torres García's most significant contributions to the Parisian art scene was the foundation, with Michel Seuphor, of the Cercle et Carré group, and the ensuing journal and exhibition. He also organized other artists' groups, wrote art theory, and made a name for himself as an artistic innovator. The objective of this chapter is to examine Torres García's many contributions to Parisian avant-garde art circles as well as to consider the impact his time in Paris had on his own artistic production.

TORRES GARCÍA'S PARIS DEBUT

During his six years in Paris, Torres García held eight one-person exhibitions at various prominent galleries in the city, in addition to participating in numerous group shows. At first, as he laments in his autobiography, he had trouble finding buyers for his work, but by the early 1930s he had established a reputation as a leader and innovator in modernist circles. Important Parisian critics, such as Maurice Raynal and E. Tériade, consistently reviewed his exhibitions in the press, and twice the Parisian critic Waldemar George wrote the text for his exhibition catalogues. Moreover, several influential dealers, including the U.S. dealers George L. K. Morris, James Johnson Sweeney, and Sidney Janis, were purchasing his work.[2]

Torres García held his first individual exhibition in Paris at the Galerie A.-G. Fabre in June 1926, three months prior to settling permanently in the city (see fig. 110). As discussed in Chapter 5, the exhibition was primarily retrospective in nature and highlighted the classicizing frescos he had produced in Barcelona, alongside a few experimental paintings from his New York period. While the exhibition garnered little attention in the press, Torres

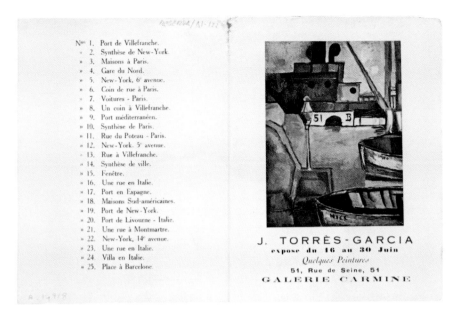

N°. 1. Port de Villefranche.
» 2. Synthèse de New-York.
» 3. Maisons à Paris.
» 4. Gare du Nord.
» 5. New-York, 6° avenue.
» 6. Coin de rue à Paris.
» 7. Voitures - Paris.
» 8. Un coin à Villefranche.
» 9. Port méditerranéen.
» 10. Synthèse de Paris.
» 11. Rue du Poteau - Paris.
» 12. New-York, 5° avenue.
» 13. Rue à Villefranche.
» 14. Synthèse de ville.
» 15. Fenêtre.
» 16. Une rue en Italie.
» 17. Port en Espagne.
» 18. Maisons Sud-américaines.
» 19. Port de New-York.
» 20. Port de Livourne - Italie.
» 21. Une rue à Montmartre.
» 22. New-York, 14° avenue.
» 23. Une rue en Italie.
» 24. Villa en Italie.
» 25. Place à Barcelone.

J. TORRÈS-GARCIA
expose du 16 au 30 Juin
Quelques Peintures
51, Rue de Seine, 51
GALERIE CARMINE

FIG. 155. Cover of Joaquín Torres García and Joseph Milbauer, *J. Torrès-Garcia expose du 16 au 30 juin quelques peintures* (Paris: Galerie Carmine, 1927).

García did earn enough from the sale of his paintings to finance his move to Paris, where he relocated with his family in September 1926.[3] That fall he submitted several fresco fragments to the Salon d'Automne (these may have even been the same works exhibited at the Galerie A.-F. Fabre), maintaining a cautious approach to the Paris art scene. This conservatism did not gain him any followers, however. Art critic Raymond Cogniat, who frequently reviewed Latin American art at the salons, lamented that the incomplete compositions precluded full appreciation of their artistic merits and that it was difficult to judge the frescoes out of context. From these works Cogniat concluded that, while the artist exhibited technical skill, he "had very little personality."[4] In comparison to other Latin American artists exhibiting at the Salon d'Automne that year—such as Elena Cid, Domingos Viegas Toledo Piza, Horacio Butler, Gustavo Cochet (1894–1979), Ana Cortés (1895 or 1903–1998), Carmelo de Arzadun (1888–1968), Rómulo Rozo, and Carmen Saco, many of whom were an established presence at the salons—Cogniat found Torres García's submissions to be unimpressive.

It was his second Paris exhibition—in June 1927 at a new, more experimental venue on the Left Bank, the Galerie Carmine—that established Torres García's reputation as an avant-garde artist in Paris (fig. 155). This time Torres García decided to feature paintings executed in a technique known as *vibracionismo*, alongside several newer works that took the trend in a new direction (fig. 156). Developed in Barcelona around 1917 by Torres García and his compatriot Rafael Barradas, vibracionismo was an artistic movement that fused the aesthetic experiments of cubism and futurism to capture the movement and energy of the modern city. Torres García continued to practice this approach during his time in New York, where he lived from 1920 to 1922, and in Italy, where he lived from 1922 to 1926. At least half of the twenty-five paintings exhibited at the Galerie Carmine were most likely painted before he arrived in Paris (the exhibition included five New York scenes, four of Italy, three of Spain and the Mediterranean, and one of South America). The rest of the pictures featured the houses, ports, railway stations, cars, and streets of Paris. While the Paris pictures expand on his vibracionista experiments of the late 1910s and early 1920s, observation of Paris's urban spaces, replete with different

FIG. 156. Joaquín Torres García, *New York Street Scene*, 1920. Oil on cardboard, 18 × 24 in. (45.7 × 60.8 cm). Costantini Collection, Museo de Arte Latinoamericano de Buenos Aires (MALBA).

FIG. 157. Joaquín Torres García, *Paris Landscape*, 1927. Oil on canvas, 45⅔ × 29⅛ in. (116 × 74 cm). Private collection. I believe this to be the painting exhibited as *Synthesis of Paris*.

sorts of vehicles and architectural styles, inspired Torres García to begin to formulate a new pictorial strategy based on visual rhythms and constructed space that would eventually lead to his signature grid-based compositions.

Reviews of the Galerie Carmine exhibition were more abundant and enthusiastic than his first Paris show and focused on the artist's constructivist approach to painting. In his essay for the exhibition catalogue, Joseph Milbauer describes the artist's process as synonymous to that of an architect: "Constructing a house, a city, a ship, a clock, building structures, drawing routes, erecting columns, executing plans, creating ordinances, in effect, doing the work of an architect."[5] Raymond Sélig, too, in his review

of the exhibition for the *Revue du vrai et du beau*, calls Torres García "a constructor" and refers to the architectural quality of his paintings, illustrating his review with *Street in Italy* as evidence of this approach. Sélig also highlights Torres García's synthesis paintings, a type of composition he had initiated in New York. Three synthesis paintings appeared in the Galerie Carmine show: *Synthesis of New York*, *Synthesis of the City*, and *Synthesis of Paris*. According to Sélig, the synthesis paintings "mix vertiginously cars, advertisements, houses, in a alarming kaleidoscope."[6] A painting from the exhibition reproduced in *L'art vivant* without a label can tentatively be identified as *Synthesis of Paris* (fig. 157).[7] With Paris's iconic Pantheon at

the top and center of the vertical composition, the scene is a chaotic amalgamation of buildings, hotels, clocks, cars, and fragments of advertisements from different parts of the city. Yet within the chaos Torres García has located an overriding rhythm. Right angles pervade the composition, but the round car wheels on the bottom edge of the canvas and the curved forms of the clock and domed roof of the Pantheon on top balance the prevailing angularity. Striated shutters echo the repeating patterns of high-rise and tram windows and rows of classical columns. While grays and browns predominate, Torres García's approach to color emphasized rhythm and balance over observed reality. The red letters UM punctuate the drab palette and are reiterated below in a red street sign and again in the red stripe on the French flag. Yellow is also strategically distributed to create a dynamic surface pattern. Thus, while Torres García clearly references recognizable Parisian monuments, the composition synthesizes the city's rhythms and patterns to capture its vibrant energy.

With a successful Paris exhibition under his belt, Torres García shifted his focus from self-promotion to establishing an artistic network in Paris. Paris in the 1920s attracted artists from around the world, and on more

FIG. 159. Pierre Daura (1896–1976), *Still Life,* ca. 1928. Oil on canvas. Private collection, Barcelona.

than one occasion Torres García took advantage of these circumstances to unite artists of various nationalities to exhibit together. He embarked on his first such endeavor in 1928 because his work was rejected from the Salon d'Automne. As an established artist already in his fifties, Torres García did not accept this rejection as a measure of his artistic ability, but rather as a gauge of the salon's increasing conservatism. Consequently, he assembled four other artists also rejected from the Salon d'Automne (Alfred Aberdam from Poland, Ernest Engel-Rozier from Belgium, Pierre Daura from Barcelona, and Jean Hélion from France) and held an exhibition of their work at the Galerie Marck concurrent with the salon, under the unabashed title *Refusés par le jury du Salon d'Automne 5 peintres* (Rejected by the jury of the Salon d'Automne 5 painters) (fig. 158). One of the paintings in the exhibition, Daura's *Still Life* of ca. 1928, while still recognizable as a figurative work, displays a flattening and stacking of the space and loose expressionist brushwork that characterized the artist's recent formal experiments (fig. 159). Although the work suggests a new approach to structuring a composition, the result is not particularly radical. Thus, the previously innovative Salon d'Automne must have become quite conventional.

Torres García's decision to exhibit in this manner, of course, harks back to the famous Salon des Refusés of 1863 that featured Manet's *Luncheon on the Grass.* By assuming this polemical stance, Torres García strategically aligned himself with France's historical avant-gardes. The announcement for the exhibition explains that these five painters "will exhibit their 'condemned' paintings along

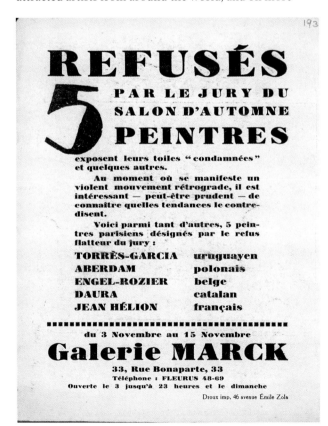

FIG. 158. Galerie Marck, *Refusés par le jury du Salon d'Automne 5 peintres,* November 3–15, 1928. Poster.

FIG. 160. Joaquín Torres García, *Street with House and White Cloud*, 1928. Oil on canvas, 28¾ × 23⅔ in. (73 × 60 cm). Fundación Torres García, Montevideo.

with several others. At a moment when a violent retrograde movement is taking hold, it is interesting—and perhaps even prudent—to know contradictory tendencies."[8] These artists embraced their rejection as a badge of honor, as an indicator of their avant-garde status. And their counter-exhibition had its desired effect. Both critics and the public flocked to the show, and it received significant attention in the press.[9] Louis Léon-Martin writes in *Paris-soir:* "I like that artists protest. If artists didn't have guts, it would be impossible for them. . . . I applaud them, first because it demonstrates that the jury of the Salon d'Automne lacks vision, and then and primarily because their exhibition is very interesting."[10] Paradoxically, in his review of the Salon d'Automne, P. Guétin concludes with a discussion of the exhibition at the Galerie Marck, calling the paintings on display "avant-garde" and noting: "At their head was a master who has already proven himself, the Uruguayan Torres García. Despite his white hair, Torres García had the courage to unlearn everything he had done before and create a personal vision that is expressed through the greatest simplicity. . . . The exhibition is worth seeing; it is the work of gifted and courageous artists."[11] The reviewer for the *Petit journal* writes that the exhibition piqued the public's curiosity: "We now

understand the motive behind their rejection." Alongside his commentary he reproduced five of Torres García's paintings included in the show.[12]

Among these works was *Street with House and White Cloud*, painted in Paris in 1928 (fig. 160). The painting embodies a simplicity of color and form. Torres García limited his palette to gray, white, and brown, overlaid with black lines. It depicts a frontal view of a row of apartment building, with no indication of depth in space. Rendered as simple rectangular forms, individual buildings can only be distinguished by variations in color. In the sky is a single white cloud that is equally lacking in volume. Torres García has overlaid these geometric forms with linear black pictographs. The outline of a pedestrian, a man with a horse and cart, window frames, stairs, antennae, roof lines, and the word "epicerie" all have the same script-like quality. Color, form, and line thus maintain their own distinct properties, but when aligned in the composition coalesce into a recognizable scene.

Another painting made in Paris in 1928 that may have been included in the exhibition is an untitled urban scene (fig. 161). In this work, Torres García adopted a dark palette of grays, browns, and reds. Eliminating almost all evidence of a horizon line, the space seems to be constructed out of

FIG. 161. Joaquín Torres García, *Untitled*, 1928. Oil on canvas, 29¼ × 43½ in. (74.3 × 110.5 cm). Fundación Cisneros, Patricia Phelps de Cisneros Collection, Caracas.

stacked blocks of color. While not yet fully realized, this painting begins to suggest the underlying organizational grid that would come to characterize Torres García's mature work. The blocky, angular figures are roughly drawn, outlined in thick black brushstrokes, their position determined by the rhythms of the composition rather than observation of life. But the painting still references the specificities of the urban Parisian landscape. In this work, Torres García includes the letters "TAB" and "RIE," which suggest the ubiquitous "Tabac" or tobacco stores and patisseries or boulangeries on almost every Parisian street corner. He even includes a street musician playing an accordion, now a stereotypical symbol of Parisian café culture. These paintings are edgy, urban, and contemporary. They make no reference to his Uruguayan heritage, but rather locate his work soundly within the Parisian avant-garde.

DEVELOPING A SIGNATURE STYLE

The Galerie Marck exhibition marked a turning point for Torres García in terms of his approach to painting as well as his recognition in Paris as a member of the avant-garde. At the exhibition he met the Dutch artist Theo van Doesburg, who introduced him to other artists working in abstract modes.[13] Torres García and van Doesburg began an intense friendship that expanded both of their perspectives on art-making. Both wrote articles on the other's work, and it was through their debates that Torres García began to hash out his theory of constructive universalism.

Through van Doesburg, Torres García met Piet Mondrian the following year (fig. 162). Because of his contact with the neoplasticists, his approach to painting underwent a significant shift, leading to what has come to be recognized as his signature style. From the neoplasticists he adopted the aim of representing the universal, but he did not completely reject, as they did, reference to the physical world in his work. After studying van Doesburg's and Mondrian's approach (fig. 163), Torres García began to structure his paintings using asymmetrically arranged horizontal and vertical grids. In *Color Structure* of 1930, for example, these artists' influence is obvious (fig. 164). But several differences persist that differentiate Torres

FIG. 162. Members of Cercle et Carré at Michel Seuphor's house, 1929. Photograph. Joaquín Torres García is at center left and Piet Mondrian is at center right.

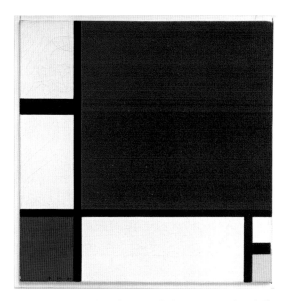

FIG. 163. Piet Mondrian (1872–1944), *Composition with Red, Blue, and Yellow*, 1930. Oil on canvas, 18⅛ × 18⅛ in. (46 × 46 cm). Kunsthaus Zurich.

García from his contemporaries. First, he has drawn his grid freehand, allowing imperfections and inaccuracies to supersede the rigidity of the grid. Also, his palette, while based on Mondrian's reductionist palette of red, yellow, and blue, is muddy and the colors are impure. Rather, the variations in hue in each color field create a sense of texture and volume completely lacking from the flat industrial surfaces of the neoplasticists. The hand of the artist is still adamantly present in Torres García's paintings. Thus, while his compositions are shaped by an acute attention to structure, paint overlaps and spills out of the rigid framework as if executed in a careless or haphazard manner. He thereby deliberately undermines the clean mechanical edges and precision of his colleagues.

At the same time Torres García was incorporating the neoplasticists' grid into his paintings, he was also

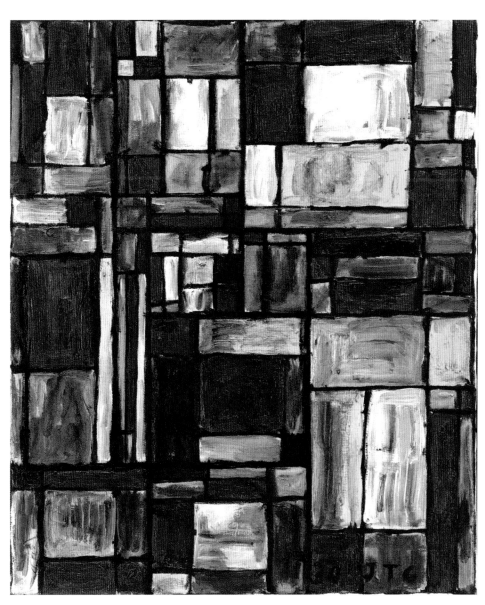

FIG. 164. Joaquín Torres García, *Color Structure*, 1930. Oil on canvas, 24 × 20 in. (61 × 50.8 cm). Museum of Modern Art, New York.

FIG. 165. Joaquín Torres García, *Construction with Curved Forms*, 1931. Oil and nails on wood, 19¼ × 16 × 1⅓ in. (48.8 × 40.5 × 3.4 cm). Private collection, Zurich.

constructing compositions with bits of wood known as *maderas,* a practice he began in Italy in 1924, but that became a primary creative method in Paris.[14] In *Construction with Curved Forms* of 1931, for example, by arranging and rearranging bits of wood, working in a tactile and three-dimensional medium, Torres García intuitively found balance in his compositions before gluing or nailing the pieces in place (fig. 165).[15] The maderas also foreground his preference for impoverished materials: scraps of wood, cracked, worn, or rough edges, and chipping, unevenly applied paint. They function in direct opposition to the clarity and hard edges advocated by the purists and the neoplasticists. Thus, while he employed a similar strategy in structuring pictorial space, his materials ran counter to a modernist machine aesthetic. The rough, unfinished wood showing through "weathered" paint implies the passage of time. In some places one color is painted over another, like the walls of an old house

that have received several coats of paint, but have been neglected over time. The wood is not smooth or highly worked, but rather resembles the coarse, utilitarian boards used in building barns, tool sheds, or the dwellings of the poor. Like Picasso and Kurt Schwitters before him, he is using the impoverished materials of everyday life, materials that undermine the expectations of high art.[16]

Through the maderas and his contact with the neoplasticists, Torres García resolved the underlying structure of his compositions. But from there he took a turn that would significantly differentiate his work from theirs. Despite his associations with these artists, Torres García refused to conform to a singular definition of abstraction. Rather, he insisted on the unification of opposites: the figurative and the nonfigurative, the geometric and the organic. Around 1930 he began to incorporate graphic outlines of recognizable objects such as suns, hearts, anchors, clocks, stars, and vessels within his grids (fig. 166).

FIG. 166. Joaquín Torres García, *Constructive Painting*, 1931. Oil on canvas, 29½ × 21⅔ in. (74.9 × 54.9 cm). Fundación Cisneros, Patricia Phelps de Cisneros Collection, Caracas.

The dramatic simplification and graphic quality of these objects made them function more like linguistic signs than visual replicas of real objects. In each painting he rearranged or recombined these signs to create different associations. Whereas some scholars postulate a positivist meaning associated with each sign, the general consensus is that their meaning is flexible, based on placement and the relationship to other signs in the paintings. His figures were signs, not visual references to objects in the real world, symbols of transcendent connections between divergent cultures and moments in time.

Torres García was certainly not the only artist interested in sign systems as a means to achieve this universality. Discussions about theosophy and metaphysics appeared frequently in modern magazines circulating in Paris, and various avant-garde movements such as suprematism, futurism, and De Stijl shared a fascination with the cosmos and universality. Moreover, Egyptian hieroglyphics had recently come to the attention of the public because of the discovery of King Tutankhamun's tomb in 1922. While Torres García's immediate circle of colleagues—specifically van Doesburg and

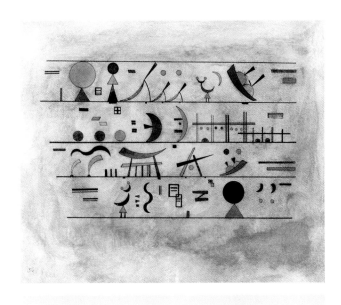

CARACTÈRES SYMBOLIQUES COMPARÉS

FIG. 167. Vassily Kandinsky (1866–1944), *Rows of Signs*, 1931. Tempera and ink on paper, 16⅜ × 19¾ in. (41.7 × 50.3 cm). Kunstmuseum, Basel.

FIG. 168. Vicente do Rego Monteiro, *Symbolic Characters Compared*, 1923. Print from Vicente do Rego Monteiro, *Légendes, croyances et talismans des Indiens de l'Amazone* (Paris: Editions Tolmer, 1923), n.p.

FIG. 169. Joaquín Torres García, *Symbols*, ca. 1930. Pencil drawing on paper, 8⅔ × 5½ in. (22 × 14 cm). Torres García family collection.

Mondrian—rejected outright any hint of figuration, other artists such as Paul Klee and Vassily Kandinsky (fig. 167), as well as the Latin American artist Vicente do Rego Monteiro, incorporated signs into their paintings during this period. By creating signs that often had no identifiable referent or whose referent was malleable, these artists explored the boundary between abstraction and representation. Both Kandinsky and Rego Monteiro participated in group exhibitions with Torres García, so he certainly knew their work. Whereas Klee and Kandinsky invented their own sign systems, Rego Monteiro looked to pictograms from ancient China, Mexico, Brazil, and Egypt for inspiration (fig. 168).[17] In addition to these sources, Torres García drew on symbols from the Hebrew tradition, pre-Columbian America, alchemy, and freemasonry (fig. 169).[18] By employing hieroglyphics or pictograms, these artists created images in a recognizably archaic visual language. Returning to the so-called "primitive" roots of writing, they posited a universal language, which formed links across time and culture and could be understood intuitively, rather than based on linguistic training.

The first major exhibition of pre-Columbian art in Paris, *Les arts anciens de L'Amérique*, organized by the Musée des Arts Décoratifs at the Pavillon de Marsan at the Palais du Louvre in 1928, was probably also a significant source of inspiration for Torres García (fig. 170). The exhibition was a massive undertaking, with 1,246 objects from all over Latin America listed in the catalogue, and it certainly included examples of Mayan pictographic writing. As Margit Rowell recently argued, Torres García's exposure to these objects at the 1928 exhibition as well as at the Musée d'Ethnographie du Trocadéro may have led to his interest in these forms.[19] Moreover, in this moment of intense nationalism, critics often sought national or regional identifiers in an artist's work, especially in the case of foreigners. By employing pictograms, as well as the vertical structure, geometric forms, and earth tones of pre-Columbian art in his paintings, Torres García referenced the regional tradition associated with his homeland, while simultaneously relating that tradition to an imagined universal primitive defined by a propensity for geometric drawing and pictographic writing. This new source material distinguished Torres García's contribution within the ongoing debates about universalism and structure. Thus, by 1930 Torres García had derived a signature style defined by an asymmetrical grid-like format, which stemmed from the debates about abstraction and

FIG. 170. Musée des Arts Décoratifs, Palais du Louvre, Pavillon de Marsan, *Les arts anciens de l'Amérique*, Paris, 1928. Photograph.

structure in Paris between the wars, but remained distinct through the incorporation of pictograms and deliberately naïve technique.

TORRES GARCÍA AND CERCLE ET CARRÉ

While Torres García's artistic practice diverged in many ways from that of the neoplasticists, he still turned to van Doesburg when he decided to establish an artists' group, Cercle et Carré, to counter the increasing popularity of surrealism. According to Torres García: "The aim of the foundation in Paris of 'Cercle et Carré' was the following: At the end of 1930 [correct date is 1929], I had the occasion to visit an exhibition of Dalí's surrealist works, at the Galerie Goemans, rue de Seine. And it displeased me so much, that later, that same afternoon, talking with van Doesburg, I said that we had to do something. . . . Immediately we planned a magazine, names came out."[20] Van Doesburg then wrote to Torres García, saying: "The surrealists are assuming increasing prominence and tremendous propaganda is being created for them, they have managed to find the means of infiltrating the public and infecting them with pseudo-occult images. We lack a periodical, a platform, an official means of defense in the press etc. We must take up a counter position to stop this and unmask the pseudo-Freudian tricks."[21] The two therefore decided to position constructivism as the principal avant-garde alternative to surrealism.

The surrealist exhibition in question was Dalí's Paris debut and included such controversial and overtly sexual works as *The Lugubrious Game* and *The Great Masturbator* (fig. 171), paintings that while executed in a highly academic style deliberately pushed the boundaries

FIG. 171. Salvador Dalí (1904–1989), *The Great Masturbator*, 1929. Oil on canvas, 43⅓ × 59 in. (110 × 150 cm). Museo Nacional Centro de Arte Reina Sofía, Madrid.

of decorum. As Dalí's mouthpiece, André Breton wrote a short essay for the catalogue in which he speaks of the power of Dalí's images to disrupt the status quo in both art (he specifically references abstract painting) and politics (the anti-communist left), and praises Dalí's ability to create "voluntary hallucinations."[22] Breton's dismissal of abstract art and Dalí's status as a representative of Barcelona, the city where Torres García had spent so many years, may have exacerbated the artist's intense reaction to Dalí's work. For Torres García, this affront to propriety was not the direction in which he believed contemporary art should be headed.

What is significant here is that Torres García was not just interested in his own personal creative process; rather, he had a vision for challenging current trends and shaping the entire future of avant-garde artistic production in Paris. Consequently, Torres García proposed the formation of a group with two sections, one comprised of artists operating in a nonfigurative mode, and another that included artists who maintained elements of figuration.[23] For him, the group's strength would be in its heterogeneity. Van Doesburg, however, wanted to eliminate all aspects of figuration. He felt that Torres García's theories did not go far enough because they did not posit pure abstraction as the ultimate end. Because of these ideological differences, Torres García and van Doesburg split ways, and Torres García found a new partner, the Belgian artist and writer Michel Seuphor. Together they founded Cercle et Carré.[24] Van Doesburg formed his own group, called Art Concret, in 1930, comprised of Otto Carlsund, Hélion, Léon Arthur Tutundjian, and Marcel Wantz.[25]

Seuphor and Torres García assembled a group of international artists working in constructivist modes, recruited in Paris as well as Belgium, Germany, Holland, Italy, Poland, and Switzerland, that fluctuated in number from twenty to as high as eighty members. Usually a core group of around twelve people attended meetings because so many of the artists resided outside Paris. Members included such prominent figures as Georges Vantongerloo, Mondrian, Amédée Ozenfant, Kandinsky, Jean Arp, Sophie Taeuber-Arp, Alexandra Exter, Otto van Rees, Joseph Stella, Walter Gropius, and László Moholy-Nagy. Initially group meetings took place at Torres García's home or the Montparnasse café Le Dôme. Later the group met at the Café Voltaire or Café Lipp, where they attempted to hash out the theoretical premise behind their approach to artmaking—a source of constant debate among members.

Torres García and Seuphor also founded the *Cercle et Carré* journal to promote the group's artwork and aesthetic theories.[26] In the first issue, Torres García wrote a manifesto of sorts entitled "Vouloir construire." In it he defines his concept of constructivism:

> [Everything begins] when man abandons the direct copying of nature and forges an image *in his own way*, by not wanting to remember the visual deformation that perspective imposes upon us. In other words, since the *idea* of a thing has been sketched in a contained space more than the thing itself, a certain construction begins. If, in addition, such images were given order in an attempt to harmonize them rhythmically so that they could belong to the totality of the painting more than to what they are trying to express, a higher degree of construction would be achieved. . . . One can go further, until actually considering the unity of the surface. Such a surface will be divided and the divisions will determine spaces that must stand in [mutual] *relation*. Equivalence must exist among them. So that the unity of the whole will remain intact. . . . Representation is the opposite pole of constructivist sensibility. To imitate a thing that already exists is not to create. . . . Construction should be, above all, the *creation of order*. . . . There will no longer be duality between background and images where structure replaces the superimposed images and the painting will have recovered its original identity: *unity*.[27]

Torres García's notion of structure has its origins in the resistance to impressionism's emphasis on opticality in

early twentieth-century modernist movements. But he takes these ideas significantly further by insisting that the artist abandon the idea of figure and ground, instead creating order and imposing structure on the entire canvas. For him, the artist should disregard nature altogether, instead intuitively creating an asymmetrical equilibrium of color, line, and form. While these ideas resemble those of the neoplasticists in some ways, as discussed above, Torres García's vision allowed for a more intuitive or spontaneous approach. He did not call for the complete elimination of the figure; rather, he argued that the form the figure took should be determined by the overall structure of the composition, not visual resemblance. This flexibility caused friction with the more orthodox practitioners of hard-edged abstraction.

While not all the artists in the group subscribed to Torres García's idea of constructivism, they felt a strong enough affinity with his idea to participate in the *ière exposition internationale du Groupe Cercle et Carré* that Torres García organized at Mme Friedberger's modern art gallery, Galerie 23, from April 18 to May 1, 1930 (fig. 172).[28] The gallery space comprised four rooms of paintings and

FIG. 173. Installation view of the *ière exposition internationale du Groupe Cercle et Carré* (which includes Torres-García's *Construction I*, 1930, next to a painting by Amedée Ozenfant), 1930. Photograph.

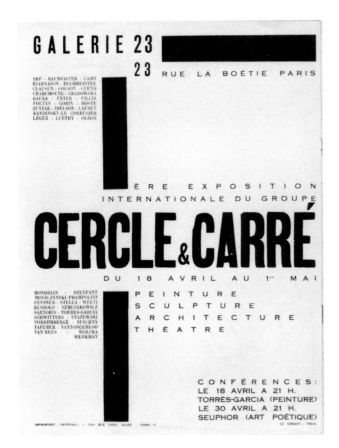

FIG. 172. Galerie 23, *ière exposition internationale du Groupe Cercle et Carré du 18 Avril au ière Mai*, Paris, 1930. Poster.

sculpture on the main floor, with displays of architecture and theatre design in the basement (fig. 173). Among the works were Mondrian's famous *Composition with Red, Blue, and Yellow* of 1930 (see fig. 163); a purist composition by Ozenfant and designs by Le Corbusier; relief sculpture by Arp; works by Willi Baumeister, Schwitters, Kandinsky, and Antoine Pevsner; set designs by Alexandra Exter; various nonfigurative works by artists from Léger's studio; as well as two projects for geometric nonfigurative murals by Léger done in 1923 and 1924. Torres García submitted five pieces, three *maderas* and two constructive universalist paintings (see figs. 164–66 for works comparable to those in the show). The exhibition also included paintings and sculptures by two Latin American artists, Mexican Germán Cueto and Dominican Jaime Colson.

Cueto submitted two masks (fig. 174) that were displayed on thick quadrangular pillars (see fig. 173), and two sculptures shown on pedestals in the center of the room, one of which (fig. 175) appeared in the exhibition catalogue that was printed in the *Cercle et Carré* journal. The sculpture, while vaguely figural in its vertical orientation and segmented shapes, has a mechanical or robotic quality. Layers of sheet metal "cut, beaten, and folded" into geometric shapes were assembled to create a composite form that measured about one meter tall.[29] Cueto rejected the traditional technique of modeling or chipping away to achieve a solid sculptural core, and instead built or constructed the figure from multiple parts. Each part is entirely abstract on its own, but gains significance in association with the pieces that make up the whole. In choosing Cueto's sculpture for reproduction in the journal,

Torres García foregrounded his notion of "construction" as the key procedural link between the pieces on display. He also incorporated a little-known, outside Mexico, Latin American artist into the fold of an emerging international avant-garde community.

The other Latin American artist who participated in the Cercle et Carré exhibition, Jaime Colson, was a bit of an anomaly. Colson had met Torres García in Barcelona in 1918, and it was most likely because of his friendship with Torres García rather than stylistic affinity that he was invited to participate in the Cercle et Carré exhibition. While he had been working in a cubist style inspired by Juan Gris until around 1927 (fig. 176), and these paintings would have aligned with the purist compositions by Ozenfant or Léger in the exhibition, his submission to the 1930 exhibition most likely evidenced his move toward surrealism. Given Torres García's distaste for surrealism, Colson's inclusion may have been more a favor to a friend who was struggling to obtain exhibition opportunities than the result of like-minded artistic production.[30] In 1928 Colson abandoned cubism and began to return to figuration and incorporate aspects of surrealism into his work, a shift that parallels his friend Peruvian artist César Moro's rejection of cubism for surrealism around the same time. While they cannot be definitively identified, the titles of the two paintings Colson submitted, *Memory of Childhood* and *Child's Dream*, reference dream worlds and the metaphysical, and most likely resemble works such as *Metaphysical Figures* made that same year, 1930 (fig. 177). *Metaphysical Figures* depicts several figures in a

FIG. 174. Germán Cueto (1893–1975), *Mask*, 1929–30. Iron, 19⅔ × 13¾ × 8⅔ in. (50 × 35 × 22 cm). Private collection.

FIG. 175. Germán Cueto, *Sculpture*, ca. 1930. Reproduced in "Catalogue de l'exposition organisée par le groupe 'Cercle et Carré' à Paris (Galerie 23) du 18 avril au 1er mai 1930," *Cercle et Carré*, no. 2 (April 15, 1930): n.p.

FIG. 176. Jaime Colson (1901–1975), *Homage to Juan Gris*, 1927. Oil on cardboard, 10 × 8⅔ in. (25.5 × 22 cm). Museo Bellapart, Santo Domingo.

disconcerting space. Colson employed geometric architectural frames to separate and arrange the figures in space. Harsh shadows and a rapidly receding horizon line reminiscent of de Chirico's compositions establish a non-natural space in which size and location contradict the rules of academic perspective. The figures do not interact and seem to be frozen in time and space. Rendered in a clean, highly sculptural style, they seem more like statues than human beings; a severed head floating above its body and several fragments of bodies visible through windows augment the viewer's disorientation. Despite reference to the dream worlds of surrealism, Colson's clean purist lines and geometric structures may have provided enough continuity with the show's premise to facilitate his inclusion, revealing the ambiguous terrain between surrealism and constructivism in 1930.[31]

Two lectures marked the opening and the closing of the exhibition, the former by Torres García and the latter by Seuphor. Torres García's lecture expounded publicly for the first time his theory of constructive universalism, discussed above. But Seuphor's lecture on "La poétique nouvelle" was more like a performance-art piece than an academic lecture, and incorporated recitations of his poems "Tout en roulant les RR" (While rolling RRs) and "Sardaigne o Erreur brièveté" (Sardinia or an error of brevity).[32] Seuphor would later describe the event: "Examples of 'verbal music.' Those who were part of the program spoke through a megaphone in the form of a metal mask that hid the entire face and that the sculptor Germán Cueto had made especially for the occasion [fig. 178]. The mask was placed on a stick, in such a way that I could move it aside with a simple movement of the arm to

FIG. 177. Jaime Colson, *Metaphysical Figures*, 1930. Oil on cardboard, 31½ × 25 in. (80 × 63.5 cm). Museo Bellapart, Santo Domingo.

read my written text. To my right, at around two meters away, Russolo [the futurist musician and artist], seated in front of his Russolophone [fig. 179] that he invented, had as his mission to accentuate the recitations with diverse rhythms and noises; that he did with perfect zeal."[33] The fusion of avant-garde music, poetry, and performance indicate that the organizers embraced a multimedia vision of art-making. Their vision was a nod to dada and futurist performances that assailed the audience with jarring inversions or disavowals of traditional musical, poetic, and visual composition. By closing with this performance, these artists asserted their presence as an avant-garde force in Paris in 1930. Theirs was an alternative to surrealism, continuing the work of the historical avant-gardes, but striking out in a new direction.

The exhibition was not a critical success, however. According to Seuphor, "The Parisian press, with all their frivolity, snobbism, and mind games, was unanimous in condemning us or not taking us seriously."[34] According to the *Journal des débats*, the exhibition purported to be "advanced" but did not actually present anything new.[35] And for the reviewer for *La patrie*, the works on display were essentially variants of cubism.[36] Maurice Raynal, writing for *L'intransigeant*, came closest to identifying the problem. He cites a disconnect between the actual theories of neoplasticism and the paintings on display as well as an inconsistency in approaches that made the exhibition incoherent.[37] While some of the criticisms may have been warranted, especially since the exhibition highlighted purist paintings by Léger and Ozenfant from the early 1920s, what the critics did not seem to appreciate was the new conversation that was taking place. Rather than representing a coherent new movement, Cercle et Carré marked the beginning of a new

FIG. 178. Michel Seuphor with Germán Cueto's mask at the closing of Cercle et Carré, April 30, 1930. Photograph.

approach to abstraction, which did not posit abstraction as an analysis or geometric reduction of an existing reality, but rather as a new creation, guided by the notion of structure. Whereas Torres García found the heterogeneity of the group an asset and a means to a more nuanced debate, critics wanted clarity and consistency. These disagreements over the definition of structure and constructivism led to the eventual dissolution of the group by the summer of 1930. While Cercle et Carré was short-lived, it spawned other avant-garde groups such as Abstraction-Création, and facilitated future international collaborations. According to Seuphor: "It is not without humor that I think, today, that this cascade—Cercle et Carré, Abstraction-Création, Réalités-Nouvelles—that would flush towards Paris the most remarkable that abstract art had in the whole world, had its origin in the

FIG. 179. Luigi Russolo at his Russolophone, 1930. Photograph by Michel Seuphor.

visit that I received, in Vanves, at the end of 1929, from the Uruguayan painter Torres García, and the foundation of Cercle et Carré that followed it."[38]

TORRES GARCÍA AND LATIN AMERICAN ART

While Cercle et Carré was the most celebrated artist's group that Torres García founded in Paris, he was simultaneously organizing in other ways. That same year, 1930, he assembled a group of artists known simply as the Groupe Latino-Américain in Paris for an exhibition at the Galerie Zak (figs. 180 and 181).[39] As discussed in Chapter 5, the Galerie Zak had a history of promoting and exhibiting Latin American art, and Torres García had held his own one-man exhibition there just two years earlier in 1928, thereby establishing a relationship with the gallery.[40] The 1930 group exhibition marked the first time artists from Latin American countries conceived of themselves as a cohesive unit. Artists did not organize the previous survey of Latin American art held in Paris at the Musée Galliéra in 1924, and the sponsors did not embrace a particularly avant-garde outlook. The exhibition organized by Torres García, on the contrary, showcased the work of twenty-one self-identified Latin American artists who were experimenting with vanguard tendencies. While the show did not revolve around a coherent style, the artists included were united in their desire to push the boundaries of traditional art-making. Many of the artists, such as Eduardo Abela, Pedro Figari, Juan del Prete, Manuel Rendón Seminario, Germán and Lola Cueto, Jaime Colson, Raquel Forner (1902–1988), Agustín Lazo, Vicente do Rego Monteiro, and Rómulo Rozo, were living and working in Paris at the time, while others, such as Diego Rivera, José Clemente Orozco, and Carlos Mérida, were not.[41] Among the only identifiable works in the exhibition were del Prete's experimental, yet still highly readable portrait that was reproduced in the journal *Renaissance* and Rendón's *Inca Warrior* (see fig. 149).[42] While most of the other paintings in the exhibition cannot be identified, since they were listed in the catalogue as simply "painting," the artists who painted them formed quite an eclectic group, appropriating aspects of surrealism, abstraction, cubism, and the more figural styles of the School of Paris. Torres García's vision in bringing these artists together was not to showcase a particular style, but rather to unite those who shared a common language, expatriate status, and cultural heritage to increase the possibility of recognition in a highly competitive art market that was already inundated with foreigners.

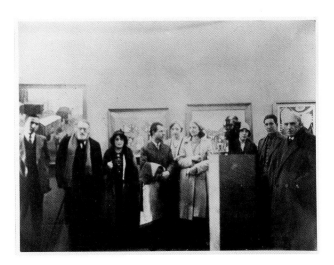

FIG. 180. Galerie Zak, *1ère exposition du Groupe Latino-Américain de Paris du 11 au 24 Avril, 1930*. Photograph. Pedro Figari is second from left; Manolita, Daura, and Torres García are at the far right; and Juan del Prete is in the center.

Because of the stylistic incongruities of the group, Uruguayan author and scholar Hugo David Barbagelata, who wrote the text for the catalogue, suggests that the connection between these very divergent artists was their common link to a pre-Columbian heritage:

> Under the initiative of Mr. J. Torres García, a painter who has already been consecrated by critics, a group of Latin American painters and sculptors has been gathered together.
>
> These artists, from the most distant countries of young America and from the most diverse schools, have, each one, their own personality, some of them influenced by the most elevated and original aspects of pre-Columbian civilization still so little known in Europe and often so whimsically interpreted.
>
> Standing next to these paintings and sculptures, where the perceptive eye discovers many traits of Aztec, Inca, and Maya hieroglyphics as well as a landscape of sweet France or the Spanish motherland, and of Italy, always attractive, will prove to the visitor of the exhibition that there, in Latin America, through the mixing of two civilizations, a group of heralds who have broken rank and want to make themselves known here in the current capital of Latinity are preparing an artistic renewal.[43]

Derived from this eclectic group of artists, Barbagelata's notion of a shared pre-Columbian heritage as being the unifying factor in a Latin American artistic identity is a bit dubious and most likely relates to the popular fascination with the primitive in interwar Paris. This new exhibition format based on geopolitical parameters therefore posed critical challenges. Whereas Barbagelata does note that these artists shared in a quest for artistic renewal, it was the group's identity as citizens of Latin American countries that defined the show. Thus, Torres García's formation of the group, while presenting an additional exhibition opportunity for these artists, also served to reinforce a new classificatory schema, one that has had significant implications for the exhibition and study of Latin American art to this day. Yet, unlike the 1924 survey exhibition, Torres García's show framed their work as avant-garde, positioning these artists as vital contributors to the art scene in Paris between the wars.

Torres García's role as an organizer significantly advanced his reputation in Paris and led to several more exhibition opportunities in the 1930s. In December 1930 he once again joined forces with other artists from Latin America to participate in the group exhibition *Huit artistes du Rio de la Plata*, organized by Adelia de Acevedo at the Galerie Castelucho-Diana in Montparnasse. The exhibition showcased the work of four artists from Uruguay

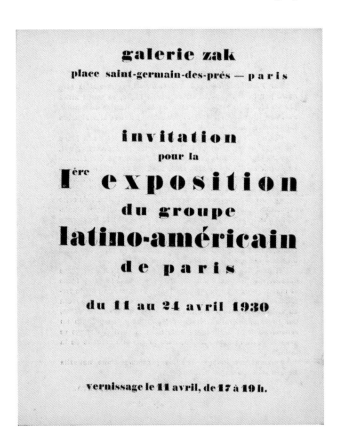

FIG. 181. Invitation to Hugo David Barbagelata and Joaquín Torres García, *1ère exposition du Groupe Latino-Américain de Paris du 11 au 24 Avril, 1930* (Paris: Galerie Zak, 1930).

and four from Argentina: painters Torres García, Rodolfo Alcorta (1876–1963), Horacio Butler, Carlos Alberto Castellanos, Juan del Prete, and Pedro Figari and sculptors Pablo Mañé (1880–1971) and Pablo Curatella Manes. Like the critics of previous exhibitions of Latin American art, reviewers of *Huit artistes du Rio de la Plata* attempted to relate the parameters of the exhibition to its content, seeking an aesthetic trait common to the region. When a common denominator could not be identified, they found the art lacking and suggested that artists should become more national in their expression. French art critic E. Tériade writes: "Without a doubt, we cannot pretend that this exhibition is a manifestation of purely national art, but we will find, among these artists, a few pioneers who will surely prepare the people's spirit to find their own form of visual expression."[44] And Raymond Cogniat writes: "We can say that in general each of the artists represented there certainly has a well defined personality, but not one characterized by his origin; on the contrary it is one that is very directly related to currents in French art."[45]

Cogniat, of course, preferred the work of Castellanos and Figari because of their depiction of non-French subjects. Although Cogniat did support moderate anti-academic modernism, he was not an enthusiast of the extravagances of the extreme avant-garde. Thus, for him, Figari "dominates all the other artists." He goes on to discuss the work of all the artists in the exhibition, with the exception of Juan del Prete. While there is no record of which paintings del Prete submitted, his association with the Cercle et Carré group had led him to begin experimenting with abstraction, eliminating all reference to recognizable objects in his paintings. Cogniat may therefore have discounted the artist because he found his experiments perplexing and inaccessible. Indeed, he also seemed unsure of how to assess Torres García, merely describing his grid-like compositions and referring to his work as "very advanced modernism."[46]

In early 1931 (January 30 to February 14), Torres García held his first individual exhibition of these "very advanced" grid paintings alongside some of his earlier still lifes, city scenes, and wooden toys at the Left Bank's Galerie Jeanne Bucher.[47] French art critic Waldemar George once again wrote the essay for the exhibition catalogue (George also wrote the essay for his Galerie Zak exhibition). For George, the primary appeal of Torres García's paintings was their combination of contemporary technique with a primitivizing aesthetic: "Torres García

reabsorbs and transfigures the key principles of contemporary styles. He applies the laws of constructivism to a strangely harsh primitive vision. . . . His paintings evoke symbols more persuasive than written words." He goes on to praise the earth tones of Torres García's palette, the roughness of his materials, and the childlike quality of his drawing. Interestingly, for George, this primitivism derives from Torres García's time in Spain and Spain's proximity to Africa, not his Latin American heritage; the spectator "rediscovers in front of Torres García's canvases prehistoric man's animist faith (which is the true faith)."[48] While George resorts to some rather stereotypical notions of an imagined primitive, his observations about Torres García's work bring to light the quality that differentiated his paintings from those of many of the other artists working in abstract and constructivist modes: his collapsing of the imagined opposition between the clean lines of the neoplasticist grid and the intuitive quality of handmade objects. Other critics also picked up on Torres García's unique contribution to the Paris art scene, with reviews of his exhibition appearing in *Cahiers d'art, Chantecler,* and *Renaissance.* Charensol, writing for *Chantecler,* sums up the general consensus about the artist's burgeoning reputation in Paris: "Torres García deserves to have the success in Paris that he already obtained in other Latin capitals and in the New World."[49]

Over the next two years Torres García exhibited almost constantly, participating in five group shows, and holding additional individual exhibitions at the Galerie Percier (November 30 to December 12, 1931), the Galerie Jean Charpentier (December 2 to 16, 1931), and the Galerie Pierre (March 4 to 18, 1932). Moreover, art critic E. Tériade become a champion of his work, reviewing several of these exhibitions for *L'intransigeant.*[50] Thus, while at first Torres García struggled to establish a reputation in Paris, in the 1930s he was one of the most successful and influential Latin American artists in the city, promoting a collective Latin American vanguard in Paris as well as shaping notions of international constructivism.

TORRES GARCÍA: THEORETICIAN

In addition to "Vouloir construire," Torres García wrote approximately twenty illustrated manuscripts in Paris, integrating line drawings with his thoughts and convictions about art.[51] With the exception of *Raison et nature: Théorie* (fig. 182), published by Editions Imán in Paris in 1932, most went unpublished until the 1970s. Yet these

FIG. 182. Joaquín Torres García, Cover of *Raison et nature: Théorie* (Paris: Editions Imán, 1932). Fundación Torres García, Montevideo.

manuscripts may have circulated among his friends and confidants in Paris and contributed to a broader dialogue about constructivism. Written in French in a straightforward and accessible style, although replete with spelling and grammatical errors typical of a non-native speaker, these texts aided Torres García in determining his process and approach to art-making. They also reveal, however, that Torres García had formulated some of the most important concepts in twentieth-century art history prior to their appearance in the writings of prominent modern art critics. He articulated a semiotic theory of representation as a treatise for artists well before these ideas emerged as interpretive tools for the work of Picasso and the cubists. He also argued that the flatness of the picture plane was the essential foundation and only true reality for the painter before this idea was made famous by American art critic Clement Greenberg. The fact that Torres García was a central figure in the foundation of artists' groups focusing on abstraction in Paris, and that many of these artists ended up in the United States because of World War II, suggests that the roots of some of these concepts are the result of more complex circulations of ideas than previously thought.

In his essay "Ce que je sais, et ce que je fais par moi même: Cours complet de dessin, et de peinture, et d'autres choses" (That which I know, and that which I make for myself: Complete course in drawing, paintings, and other things) (1930), for example, Torres García postulates a theory of art that parallels a semiotic approach to language. Echoing ideas frequently voiced in avant-garde circles of the period, he argues that artists should emulate primitive art, popular art, and the art of children in order to achieve a state of authentic production unfettered by learned techniques of illusionism.[52] But he was not simply advocating an anti-academic approach to art-making; rather, he argues that art should be a sort of "geometric writing." He goes on: "Words are a convention that we invented to communicate with one another. So too are the letters in the alphabet. As well as drawing. And it should not surpass that function."[53] For him, drawing is not about resemblance or imitation; rather, the idea and the image should be united like language. Drawing should communicate via the inherent graphic and geometric properties of the line on paper.

Later, in *Raison et nature,* Torres García contends that artists must find a balance between reason and nature, logic and instinct, the real and the abstract: "To inscribe NATURE within the structure of thought—establish an order—to create and not to imitate—that is what ART should be." For him, naturalism and imitation err on the side of reason, whereas other stylistic approaches that emphasize deformation or fantasy (the implication here is expressionism and surrealism) rely too much on instinct. Artists should therefore strive for total harmony through an embrace of geometry. He sums up his ideas as follows: "On the subject of painting, the reality on which it must be based—will not include any false representation—the painting must remain on the surface—a third dimension is not real. The two dimensions of the rectangle—LENGTH and WIDTH—which create a RELATIONSHIP—constitute the only real point of departure—the basis for the proportions of that which will be inscribed on the surface afterwards. A line will not have any value other than a line."[54] This emphasis on the physicality of the canvas and the flatness and shape of its structure reveal a leap in thinking about painting's purpose. For Torres García, painting should not incorporate "false representations," by which he means illusionism or academic techniques aimed at making a picture resemble visual reality. Nor should proportions be based on creating the illusion of recession in space, but rather on the size and structure of the canvas. Preempting Greenberg's notion of medium

specificity, Torres García argues that painting should be reduced to its essentials—color, line, form—and that each element should be limited by its own inherent properties.

Torres García's theories did not evolve in isolation, but rather were the result of protracted conversations among a large international group of artists. His articulation of these ideas in writing in Paris in the early 1930s has been left out of discussions of the evolution of modern art theory in Europe and the United States, however. While his 1944 text *Universalismo constructivo* is recognized as the cornerstone of modernist theory and the foundational text on abstract art in Latin American art history, his contribution had a much more global impact than has previously been acknowledged, and Paris was the city where he formulated and initiated the circulation of his ideas.

AFTERMATH OF CERCLE ET CARRÉ

While the Cercle et Carré group began to disintegrate soon after its first and only exhibition at the Galerie 23, many of the artists associated with the group exhibited together at the 1931 Salon des Surindépendants (mentioned in Chapter 4 in the context of national salons), including Latin American artists Domingo Candía (1896–1976), Germán Cueto, Pablo Curatella Manes, Juan del Prete, and Torres García. By this point Torres García was working in his signature style of pictograms positioned in asymmetrical grids that were so influential for the development of abstraction in Latin America. In his review of the Salon des Surindépendants, Tériade declares the significance of Torres García's new vision: "Constructivism with compartments that entail dividing the canvas into numerous units according to the graphic rhythm of an extremely sensitive geometry. This forms discrete mosaic tapestries whose organization, which remains in the best case mysterious, cannot avoid recalling the first cubist constructions. The promoters of this trend are first and foremost Torres García whose impassioned compositions make one think of the façades of Gothic cathedrals or the decoration of Peruvian vases."[55] While Tériade notes a remote link to cubism, he makes clear that Torres García's constructivism represents a new approach. By suggesting that these compositions can simultaneously evoke Gothic cathedrals and Peruvian vases, he avoids the trap of aligning Torres García with a regionalist agenda, however. And indeed, Torres García would himself refer to this approach as the cathedral style. While pre-Columbian cultures were one source

among many from which Torres García drew, he sought cross-cultural affinities and a universalizing vision that did not align aesthetic choices with an essentializing Latin American identity. This approach was instrumental for the other Latin American artists exhibiting at the Salon des Surindépendants.

Mexican artist Germán Cueto also had a major presence at the Salon des Surindépendants in 1931, submitting nine sculptures for display, including one entitled simply *Construction,* which was most likely similar to works such as *Capital 8a Construction* (fig. 183). Although made out of terracotta, *Capital 8a Construction* appears to have been built out of independent interlocking geometric shapes. Curves balance right angles and horizontals complement verticals, establishing a sense of equilibrium. Painted solid ochre, the resulting sculpture bears no resemblance to any object in the natural world, but rather stands on its own as a dynamic constructed form.[56] For Cueto, exhibiting with other artists working in abstract and constructivist modes gave legitimacy to his aesthetic experiments and allowed him to abandon representation altogether.

Another Latin American artist who participated in the Salon des Surindépendants exhibition was Argentinean Juan del Prete. As it did for Cueto, his acquaintance with Torres García and his circle prompted a shift in the artist's style, inspiring him to embrace abstraction as an end in itself. Del Prete had arrived in Paris in 1929 and rapidly secured an individual exhibition at the Galerie Zak (March 14 to April 1930) of paintings he had brought with him from Buenos Aires. The exhibition closed just two weeks before the *Première exposition du Groupe Latino-Americain de Paris* opened, and it was most likely del Prete's presence at the Galerie Zak that led Torres García to invite him to submit a painting for the group show. Reviews of his Galerie Zak exhibition indicate that he was beginning to push the acceptable boundaries of figural representation, distorting and manipulating the figure in unprecedented ways (fig. 184). This approach made the reviewer for *L'amour de l'art* uneasy, and he attributes del Prete's "rash" decision to his ardent Latin character: "This young Argentine has a passionate temperament. I hope he will discover, before it is too late, that taking liberties at twenty years of age that are not permitted to Renoir, Manet or Degas after a long career is terribly dangerous."[57] Despite the critic's admonition, del Prete's work sold relatively well: French and Argentinean collectors purchased five of his paintings.[58] Del Prete subsequently went on

FIG. 183. Germán Cueto, *Capital 8a Construction*, 1928–30. Terracotta, 7.5 in. (19 cm). Private collection.

to become one of the first Latin American artists to fully embrace abstraction as his modus operandi.

Contact with Torres García soon led to other exhibition opportunities for del Prete: the group show *Huit artistes du Rio de la Plata,* a second individual exhibition at the Galerie Vavin-Raspail in 1931, and the group show at the Salon des Surindépendants.[59] In 1932 del Prete joined the newly formed Abstraction-Création: Art Non-Figuratif group, which filled the void left by Cercle et Carré when it disbanded. Founded in February 1931 by Theo van Doesburg, Auguste Herbin, Jean Hélion, and Georges Vantongerloo, the Abstraction-Création group took a hard line on abstraction, rather than allowing for the flexibility that had defined Cercle et Carré and caused the split between Torres García and van Doesburg. In addition to organizing exhibitions, the group founded a journal, which published five issues between 1932 and 1936. The first issue invited artists to submit photographs

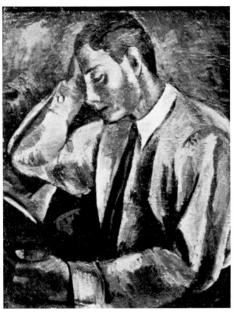

FIG. 184. Juan del Prete (1897–1987), *Figure,* ca. 1930. Reproduced in *L'amour de l'art,* no. 5 (May 1930): 237.

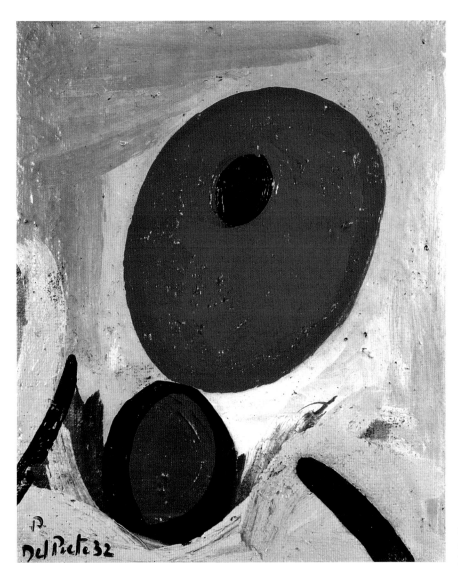

FIG. 185. Juan del Prete, *Abstraction,* 1932. Oil on cardboard, 15⅛ × 12¾ in. (38.5 × 32.3 cm). Private collection, Buenos Aires.

and explanations of their work for publication, but made it clear that artists whose work contained recognizable imagery would not be accepted. Although the group insisted on complete abstraction, it embraced myriad approaches to nonfigurative art. Works that emphasized geometric shapes and flat planes of color dominated, however. As an international organization, membership did not require residence in Paris, but simply a commitment to the group's principals. Thus, at one point the group numbered as many as four hundred, including such prominent figures as Jean Arp, Alexander Calder, Barbara Hepworth, Vassily Kandinsky, Frantisek Kupka, Piet Mondrian, and Kurt Schwitters.

Two of del Prete's paintings appeared in the *Abstraction-Création* journal in 1933, concurrent with works by Calder, Nicholson, Arp, and van Doesburg, among others.[60] Since the current location of these paintings is unknown and the reproductions in the journal are

in black and white, it is difficult to assess adequately their aesthetic properties. It is clear, however, that both are entirely abstract works that emphasize experimentation with color, texture, and form. Two similar paintings from the period, *Abstraction* and *Collage,* both made in 1932, can demonstrate del Prete's radical change in style (figs. 185 and 186). In *Abstraction* the emphasis is on bold color and contrasting approaches to brushwork. Whereas some of the shapes in the composition are clearly delineated, other areas are covered in gestural brushstrokes. Del Prete painted the background primarily dirty white, but then partially painted over the left corner in gray, as if he changed his mind, but left the task of overpainting incomplete. Bright yellow undulating shapes along the bottom, punctuated with two black slashes, anchor the composition. The central elements are two red ovals: a large red one with a black "eye," which balances precariously on a smaller black one with a red center. This dynamic play

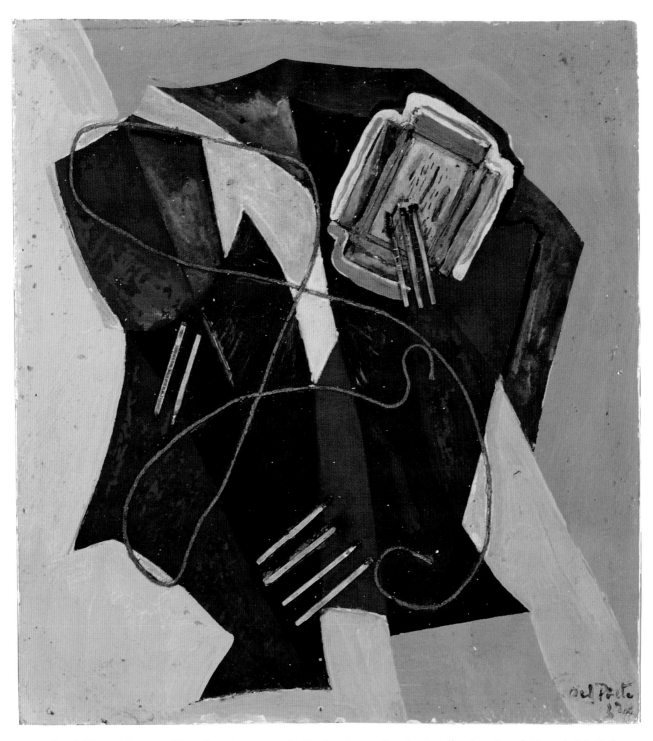

FIG. 186. Juan del Prete, *Collage,* 1932. Oil, cardboard, matches, and cotton thread on cardboard, 12¼ × 11⅛ in. (31 × 28.3 cm). Museo de Arte Moderno de Buenos Aires.

with opposing motifs creates a sense of tension between gesture and form, process and finish, and shape and color.

Painted on a gray and white background, *Collage* exemplifies del Prete's simultaneous interest in collage. Flat, angular geometric shapes intersect with tangential shapes like puzzle pieces. Red, dark blue, and black dominate the color palette, but in some places overlap to form a muddy red or a dark blue/black shape. Like Torres García, del Prete paid close attention to the dynamic placement of color to create a balanced composition. Texture, too, plays an important role in the composition, with smooth areas juxtaposed with patches covered in rough ridges and bumps. Over the painting del Prete glued several collage elements, including a flattened matchbox, three groups of burned matches lined up in even rows, and a piece of curled twine that echoes the linear pattern of the shapes underneath. The matches and the twine play out an additional tension between opposites: the linear versus the curvilinear, and the rigid versus the flexible. These collage elements also serve to emphasize the flat surface of the picture plane from which they project into the viewer's space, denying pictorial illusionism completely.

While del Prete's work looks quite different from that of Torres García, some of the principles of Torres García's theoretical and aesthetic practice, such as his emphasis on balance, harmony, and surface, are clearly present in del Prete's compositions. Moreover, since the nature and expression of abstraction were a constant subject of debate in both the Cercle et Carré group and the subsequent Abstraction-Création group, this broader environment was essential to del Prete's development as an artist. Unfortunately, in 1933, with the economic downturn during the Great Depression, del Prete lost his funding from Argentinean collector Rafael Crespo, who had been backing his residency in Paris, and was forced to return to Argentina.[61] Thus, like so many other Latin American artists residing in Paris between the wars, his presence and contributions have essentially been forgotten.

Despite his many successes in Paris, Torres García was forced to leave the country the previous year (1932) due to the worsening financial climate and increasing xenophobia in the 1930s. At first, he moved back to Spain, but he quickly realized that the situation was no better there. In 1934, already an old man, Torres García returned to Uruguay, where he established the Taller Torres García, which had a major impact on the spread of abstract and constructivist ideas throughout Latin America. During

his six years in Paris, Torres García had not only emerged as an innovative artist, but also as an influential organizer across cultural and national divides. Both the Cercle et Carré group and the Groupe Latino-Américain united artists experimenting with vanguard tendencies to create exhibition and publication opportunities. These groups initiated transnational conversations that shaped the future of twentieth-century art. Torres García was an articulate and prolific theoretician whose ideas contributed significantly to the history of constructivism and abstraction, laying the groundwork for the more spontaneous abstract experiments such as tachisme and art informel after World War II. It is time that Torres García be recognized not just as an innovative Latin American artist, but also as a major contributor to the Parisian art scene between the wars.

9 Exploring Surrealism

For many Latin American artists who arrived in Paris in the 1920s and 1930s, surrealism was the most noteworthy European avant-garde movement. As discussed in Chapter 7, prominent Latin American critics such as José Carlos Mariátegui, César Vallejo, and Alejo Carpentier wrote extensively about surrealism, spreading knowledge of the movement throughout Latin American intellectual circles.[1] With its manifestos, theories, and experimental techniques, surrealism offered a set of criteria or aesthetic attitudes that could be adapted to diverse cultural circumstances. Moreover, the surrealists' antibourgeois stance and alignment with the Communist Party appealed to artists who were beginning to ponder art's social significance and ability to effect change.[2] Surrealism was not just another avant-garde style to master, but rather a model of aesthetic experimentation and social activism that appealed to Latin American artists on various levels.

As they arrived in Paris, Latin American artists attended the various surrealist exhibitions that took place between 1925 and 1930, such as *La peinture surréaliste* and Joan Miró's individual exhibition at the Galerie Pierre in 1925; exhibitions at the Galerie Surréaliste of Man Ray's photographs in 1926 or of Yves Tanguy's paintings presented alongside ancient objects from Peru, Mexico, Colombia, and the northwest coast of the United States from André Breton's collection in 1927; the 1928 de Chirico retrospective; Salvador Dalí's 1929 Paris debut at the Galerie Goemans that so distressed Joaquín Torres García; or Louis Aragon's 1930 exhibition of collage, *La peinture au défi,* at the same location. These exhibitions collapsed traditional categories of display to expound a new, more expansive concept of art that challenged the strictures of bourgeois society.

While some Latin American artists, such as Tarsila do Amaral, Antonio Berni, Raquel Forner, Agustín Lazo, Ismael Nery (1900–1934), and Manuel Rendón Seminario, appropriated the styles and precepts of surrealism from a critical distance, never actually participating in group activities or officially identifying as surrealists, other artists, such as César Moro and later Roberto Matta (1912–2002), and briefly Wifredo Lam, penetrated the surrealists' inner circle, becoming protégées of the poet and founder of the surrealist movement, André Breton. Still others, including María Izquierdo (1902–1956), Frida Kahlo, and Manuel Álvarez Bravo (1902–2002), were deemed "surrealist" by their European colleagues because of perceived

affinities with surrealism, despite minimal engagement with the group's ideas. These diverse and often temporary relationships with surrealism provided the foundation for artistic explorations once these artists returned home. The Latin American artists who experimented with surrealism in Paris were a significant presence, whose direct and indirect contributions shaped the movement both in Paris and the Americas.

Surrealism is a contested topic in studies of Latin American art. Many artists and the scholars who write about them deny any sustained connection to surrealism. Because of Breton's tendency to designate certain Latin American artists as surrealists, an action that denied these artists agency, many Latin American artists and the critics who promoted them downplayed or rejected outright (especially in later historical accounts) any debt to or engagement with surrealism. Writers such as Carpentier, despite his own ties to the movement, declared "the marvelous" to be an innate Latin American characteristic, present long before the surrealists' "discovery" of the region.[3] While such a claim served to assert Latin America's cultural autonomy in the face of foreign influences—and it was certainly warranted to resist Breton's imperious declarations—the literature on Latin American artists has characteristically avoided determining the particularities of an artist's actual connection to surrealism.[4] The goal of this chapter is to examine the myriad ways Latin American artists co-opted, interacted with, or contested the styles and tenets of surrealism in Paris between the wars.

CÉSAR MORO: A TRANSNATIONAL SURREALIST

Born Alfredo Quíspez Asín, Peruvian artist and poet César Moro made the obligatory sojourn to Paris in 1925 to immerse himself in European avant-garde activities.[5] There he cultivated a new persona to match the name he had taken for himself in 1921 and abandoned Spanish as a medium for his poetry, writing exclusively in French.[6] In 1926 he started visiting surrealist exhibitions and most likely met André Breton sometime around 1928.[7] This exposure led him to begin experimenting with surrealist approaches to art-making as a means to push both his painting and his poetry in new directions. He also took up collage, employing the technique to create a personal iconography that oscillated between literary and visual form. The surrealists' embrace of a decentered perspective to critique bourgeois social values and European imperialist

aspirations, and their desire to reshuffle cultural hierarchies, appealed to Moro. For him, surrealism was the ideal language in which to articulate his own marginality or sense of invisibility as a homosexual man negotiating his place in the international art world. For the rest of his life Moro would employ surrealist ideas in his work and promote the movement's premises in Paris, Lima, and Mexico City.

Known now primarily as a poet, Moro was the only Latin American artist to join the surrealist group on his own initiative before Breton began actively recruiting Latin American artists in the late 1930s. His encounter with surrealism allowed him to radically depart from the cultural nationalism that marked his early exhibitions in Paris and Brussels discussed in chapters 3 and 7. While he did not articulate his disdain for this type of work until more than a decade later—in "A proposito de la pintura en el Peru" (About Peruvian Painting), a long diatribe against the dominance of José Sabogal's (1888–1956) brand of indigenism in Peru and passionate plea for the Americas not to rupture their artistic ties with Europe—Moro's ideological shift most likely began in response to expectations of primitivism and nationally specific subject matter that he experienced in Paris.[8] For Moro, surrealism provided the philosophical and artistic basis for a more universal vision.

By the early 1930s Moro was fully integrated into the surrealist group, forming strong friendships with Breton, Paul Éluard, and Benjamin Péret, with whom he remained in epistolary contact even after he left Paris.[9] He was a signatory on various surrealist statements and tracts of poetry in 1932, and in 1933 his poem "Renommé de l'amour" (Renaming of love) appeared in the May 1933 issue of *Surréalisme au service de la révolution.* He also contributed a poem to the surrealists' volume dedicated to Violette Noziére, a young girl on trial in the 1930s for murdering the father who allegedly raped her repeatedly during childhood.[10] Although Moro never published any of his drawings or collages while in Paris, the period of his involvement with the surrealist group was one of intense artistic experimentation in both poetry and the visual arts.

Moro did not conceive of his poetic and artistic practice as separate disciplines; rather, he saw them as integrative activities, locating the poetic in the visual and the visual in the poetic. As Moro delved into surrealism he began to write poems with accompanying collages or pen and ink drawings, gradually developing a personal iconography that manifested in both poetic and visual form.

In one of his earliest surviving attempts at collage made in 1927, Moro surrounds a collaged fragment clipped from a medical journal with free-form automatist drawing (fig. 187). Employing the cutaway image of a human nasal passage, jaw, and throat as a point of departure, Moro extrapolates the rest of the human form in a shaky, sinuous line. In a lighter shade, he echoes the outline of the figure, altering its stance and arm position to create the illusion of movement. An eye on the back of its head suggests that the figure has turned to gaze at and simultaneously reach for the circular floating object in the upper-right corner that resembles a female breast. While not fully developed here, the disembodied eye and the gaze are motifs that Moro built on for the rest of his career. The image also introduces the notion of transparency and vulnerability, themes that reveal Moro's own struggle with marginal social status. The use of collage elements cut from medical journals is also reminiscent of Max Ernst's collage practice, in particular his 1920 collage *Sleepwalking Elevator I,* with its flayed figures represented in profile and from behind (fig. 188).[11] Yet while Moro's image juxtaposes internal and external views of the body as well as movement and stasis, it does not have the jarring quality of surrealist chance juxtapositions. Nor does it disrupt or transform the way the collage element can be read. The addition of the thick scrawling line in the figure's abdomen suggests that we can see through the skin to observe the inner workings of the body. This continuity from collage to drawn form creates a sense of unity that runs counter to the surrealist project of disruption.

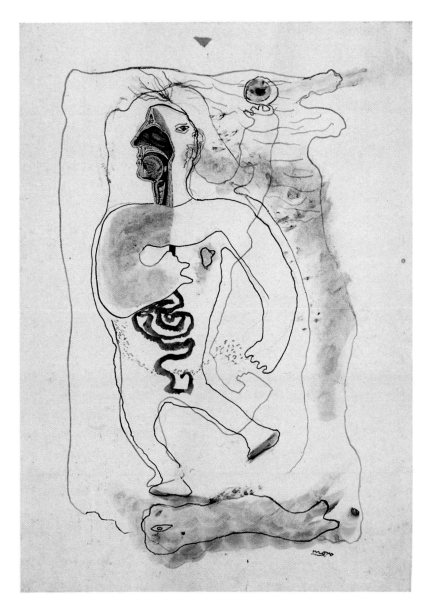

FIG. 187. César Moro (Alfredo Quízpez Asín) (1903–1956), *Untitled,* 1927. Collage, "César Moro Papers," box 1, folder 10, "Artwork by Moro," the Getty Research Institute, Los Angeles (980063).

FIG. 188. Max Ernst (1891–1976), *Sleepwalking Elevator I,* 1920. Gouache, watercolor, pencil on engraving on paper, 7⅔ × 4¾ in. (19.5 × 12.1 cm). Private collection.

FIG. 189. César Moro, *Head,* 1932. Collage on paper, 8½ × 12¼ in. (21.5 × 31 cm). Private collection.

Exposure to and interaction with surrealists working in the collage medium over the next few years pushed Moro to take his collage practice to the next level. In the preface to the 1930 *Peinture au défi* exhibition catalogue, French surrealist poet Louis Aragon elaborates on what he saw as collage's "challenge to painting": "The miracle is an unexpected disorder, a surprising disproportion. And it is in this regard that it is the negation of the real, that, once accepted as a miracle, it becomes the conciliation of the real and the marvelous. The new relationship thus established is surreality. . . . I am talking about what is called for simplicity's sake, collage, although the use of glue is only one of its characteristics and not even an essential one."[12]

In the 1930s Moro began to harness the disruptive and incongruous quality of collage, its "surprising disproportion." In *Head,* for example—one of the few other extant collages known to have been created in Paris—Moro begins to create his own personal iconography: the detached eye (fig. 189). While the eye has held symbolic value in art for centuries, eye portraits are a specific genre that date back to the Georgian period (from around 1790 to 1835), when the aristocracy would exchange miniature portraits of eyes, usually in the form of a small brooch, as tokens of affection that only a lover could identify. By isolating the eye in this manner, Moro's imagery suggests discretion and secret codes of communication between lovers, themes that are particularly relevant to homosexual lovers in a predominantly heterosexual society.

Head is made of textured mauve paper—some torn in a manner reminiscent of Jean Arp's collages in the *Peinture au défi* exhibition, and some cut into rectangular shapes—that overlaps pieces of beige paper cut into curvilinear forms. At the intersection of the abstract cut paper shapes, Moro has shaded the resulting form to create the illusion of transparency. And over the abstract patterns created by the mauve and beige paper, Moro glued two ovoid cutouts from magazines. The cutouts are centered on the beige papers to resemble large eyes peering out at the viewer. The title, *Head,* compels the viewer to make the cognitive leap to unify these disparate elements into a whole face, complete with two eyes, a nose, and a mouth. The collage functions in the manner of a synthetic cubist composition because each individual element is entirely abstract, but in context, or rather because of syntax, they take on meaning as part of a whole. This process closely resembles the semiotics of poetry and the creation of meaning through placement within a sentence or phrase.

What makes this collage enter the realm of surrealism, however, is its questioning of the notion of the gaze. By pasting an image in the center of the eye, Moro creates the illusion of a reflection. But we can only see a fragment or sliver of what is reflected in the eyes: a female face, a decapitated body, a room tilted at a disconcerting angle. Moro thus questions the possibility of shared vision. Can we ever truly see what another person sees? Is anyone's vision complete? Can we share knowledge, poetry, art? Or is communication impossible and each person's experience of the world entirely subjective? The skewed, cubist construction of the head only reinforces this impression that full synthesis is impossible. From this point forward these themes of the obstructed gaze and the impossibility of knowing appear repeatedly in Moro's artwork and poetry. And it is this philosophical questioning that locates this piece firmly in the ranks of surrealist inquiry and relates it to images such as Magritte's photomontage *I do not see the . . . hidden in the forest* (1929), a deliberate probing of the process of vision, speech, and perception in relation to gendered constructs of sexuality.[13]

Moro's artwork represents an original interpretation of and contribution to surrealist practice. His approach to collage—as a form of visual poetry—allowed him to create a personal iconography based on his experience of travel, exile, and sexual difference. These images, which echo in his poetry, deal with the limitations of personal and artistic communication and fragmented or obfuscated vision.

For Moro, surrealism offered the only viable language to express his uniquely modern transnational existence, a language he took with him when he returned to Latin America. In 1933, in the face of the worsening worldwide economic crisis and the intensifying persecution of foreigners in Europe, Moro left Paris for Lima. In Peru, and later in Mexico, he deemed himself a privileged authority on surrealism, promoting exhibitions, writing treatises, and provoking controversy in order to draw attention to the surrealist movement and to proclaim it a counterpoint to the cultural nationalism that dominated Latin American art. His most significant effort in this regard was his collaboration with the Austrian-born artist Wolfgang Paalen and André Breton to organize the famous *Exposición internacional del surrealismo* in Mexico City in 1940, an exhibition that, while controversial, opened up new possibilities for Latin American art.

TARSILA DO AMARAL: A CASE STUDY IN SURREALIST APPROPRIATION

Unlike Moro, Brazilian artist Tarsila do Amaral never joined the surrealist group; rather, she engaged with the group's ideas from a critical distance, selectively appropriating certain surrealist images and strategies.[14] Her engagement was not one of pure emulation, however; instead, she turned the surrealists' penchant for satire and desire to disrupt hierarchical schema back on itself, parodying the images and ideas put forth by the movement to create a counter-modernism that turned European forms into the servants of the Brazilian vanguard.[15] Amaral deliberately and systematically engaged with the tenets and formal languages of surrealism, not to the exclusion of other sources, but much more seriously than has previously been acknowledged. While clearly not manifestations of automatism, Amaral's paintings emulate the branch of surrealism that engaged in carefully constructed, ironic inversions of bourgeois social norms.

As discussed in Chapter 6, Amaral had lived in Paris at various intervals during the 1920s, holding her first solo show there at the Galerie Percier in 1926. While her 1926 exhibition had been well received, critics identified her work closely with that of her teacher, Fernand Léger.[16] For her 1928 show she realized that she needed to do something different to distinguish her work from that of her mentor. As a means to deviate from her obvious affiliation with Léger, Amaral began a selective exploration of surrealism, the most prominent avant-garde movement in

Paris at the time. In Paris, Amaral had various surrealist contacts. She was friendly with Giorgio de Chirico, whom the surrealists greatly admired, and had met the surrealist poets André Breton and Benjamin Péret.[17] In 1927 Rio de Janeiro's *O jornal* published an interview with Blaise Cendrars, an avant-garde poet and Amaral's good friend and confidant, in which he singles out surrealism as the most important European avant-garde movement: "In my opinion the surrealists . . . are the only ones who really count."[18] His proclaimed admiration for surrealism may also have influenced Amaral's decision to explore visual manifestations of the movement as she prepared for her exhibition in Paris in 1928.[19]

Unlike her first exhibition, Amaral spent little time in Paris before the show opened on June 18, 1928. She arrived in March after having spent the previous eighteen months in Brazil preparing, and left soon after the exhibition closed on July 2. This was a moment in Brazil when an emerging bourgeois class began challenging the prerogative of the agrarian aristocracy to which Amaral belonged. In the face of this shifting class structure, rather than continuing to depict urban vitality and rural charm, by co-opting aspects of surrealism's visual lexicon she began to create timeless myths that in their strangeness and indecipherability belie the uncertainty of the moment and question the rigidity of traditional hierarchies of value.[20] The exhibition included only twelve paintings, all of which Amaral completed in 1927 and early 1928, and demonstrated a definitive shift in style.[21] Whereas Amaral composed many of the works in her 1926 exhibition—whether urban scenes or the Brazilian countryside, with densely packed geometric shapes and a smattering of figures—by 1927 she had begun to simplify her compositions. With the exception of *Pastoral* and *Nude* (her famous painting *Abaporu* [fig. 190] was exhibited as *Nude* in Paris; the implications of this will be discussed below), there are no figures present in her paintings. Plants seem to take on an anthropomorphic quality in paintings such as *Manacá* (*Princess Flower*) (fig. 191), *Landscape*, and *Lake*, to make up for the absence of people.[22] She eschewed the urban scene entirely, instead creating otherworldly landscapes such as *Marine* (fig. 192) in lush, contrasting colors. In most of the paintings she focused on a single element, isolated in the center of the composition, as in *The Egg, Sleep, The Columns*, and *The Archway. The Archway*, in particular, seems to be a direct reference to similar archways in early paintings by Giorgio de Chirico,

whose metaphysical paintings were featured in the *Révolution surréaliste.*

The affinity between several works that she painted in early 1928 and images reproduced in the surrealist journal *Révolution surréaliste* in October 1927 provides striking evidence of her exploration of surrealism. While Amaral returned to São Paulo in August 1926 and did not travel to Paris again until March 1928, given all her Parisian contacts and the transatlantic circulation of European publications, it is almost certain that she had access to the journal. In 1925 the surrealist poet Benjamin Péret became chief editor of the *Révolution surréaliste.* Significantly, Péret had a direct connection to the Brazilian expatriate community in Paris. He was married to Elsie Houston, a Brazilian singer who frequently performed the works of the Brazilian avant-garde composer Heitor Villa Lobos. And it was at Villa Lobos's Paris apartment that Amaral and her partner, Oswald de Andrade, first met Péret, and they all frequented the same circles in Paris.[23] Thus, Péret may have sent Amaral or Andrade the *Révolution surréaliste* directly.

In the October issue of the *Révolution surréaliste*, a photograph by American surrealist photographer Man Ray as well as a reproduction of a painting by Spanish surrealist Joan Miró appeared, both of which bear remarkable resemblances to two paintings by Amaral included in her 1928 exhibition. The untitled photograph by Man Ray (fig. 193) in the *Révolution surréaliste* appears as an illustration for Breton's article, continued from previous issues, called "Le surréalisme et le peinture." Although not labeled as such, the photograph is a still from Man Ray's recent film, *Emak bakia* (Leave me alone). While Breton alludes to cinematographic images in his article, he never specifically mentions the film from which the photograph originated. Arranged as a sequence of fantastic non-narrative images, the film employs the devices of moving lights, reflective and shiny surfaces, and variable focus.[24] The still depicts a grouping of wooden geometric forms stacked and lit in such a way that, at first glance, they appear to be resting on a reflective surface. Upon closer examination, it becomes apparent that the objects' base is close to the bottom edge of the frame; Man Ray created the illusion of a reflection by aligning and illuminating the breaklines between the blocks in such a way that the bottom blocks appear to be elongated reflections of the shapes placed on top of them. In the still, these forms, usually used in compositional exercises, become a picture in their own right. The shapes, which in relation to one another

FIG. 190. Tarsila do Amaral, *Abaporu* (originally exhibited as *Nude*), 1928. Oil on canvas, 32⅔ × 28¾ in. (83 × 73 cm). Costantini Collection, Museo de Arte Latinoamericano de Buenos Aires (MALBA).

FIG. 191. Tarsila do Amaral, *Manacá*
(*Princess Flower*), 1927. Oil on canvas,
30 × 25 in. (76 × 63.5 cm). Private
collection, São Paulo.

assume an architectural quality, seem to occupy a bizarre
otherworldly landscape. Interestingly, in the film, the
still image is the culmination of a sequence in which the
blocks are progressively stacked to form towers. Thus it is
quite obvious that they do not rest on a reflective surface.
Nevertheless, double entendre was certainly one of Man
Ray's objectives in his production of *Emak bakia*.[25] It is in
the journal, where the still stands alone out of sequence,
rather than in the film that the photograph becomes more
ambiguous and the illusion of a reflective surface emerges.
This effect is most likely exaggerated in the fuzzy repro-
duction in the *Révolution surréaliste*.[26] Man Ray's uncanny
ability to reframe objects through photography, thereby
freeing them from their intended purpose and allowing
them to assume new meanings and relationships, most
likely appealed to the surrealists and inspired their inclu-
sion of the photograph in the journal.

In 1928 Amaral painted *Calmness I* (exhibited as *Marine*
in Paris; see fig. 192).[27] The visual affinity between Man
Ray's photograph and this painting is so striking that it
is quite likely that the photograph was her source. Since
Emak bakia premiered in Paris in November 1926, Amaral
was probably not familiar with the film because she had
returned to São Paulo in August of that year. Thus, her
exposure to the image could only have been through the
somewhat fuzzy reproduction in the *Révolution surréaliste*.
What remains unclear is whether Amaral was deliberately
making explicit the metamorphosis from stacked blocks
to reflective surface suggested in Man Ray's photograph,
or whether she simply transcribed what she saw into
paint. Whether or not she perceived the shifting possible
readings of the original, her painting no longer embodies
the ambiguity of Man Ray's photograph, but rather makes
concrete the hint of a reflective surface as a depiction of

FIG. 192. Tarsila do Amaral, *Calmness I* (originally exhibited as *Marine*), 1928. Oil on canvas. Location unknown. Reproduced in Maria Eugenia Saturni and Regina Teixeira de Barros, *Tarsila: Catálogo raisonné Tarsila do Amaral = Catalogue raisonné* (São Paulo: Base 7 Projetos Culturais, 2008), n.p.

FIG. 193. May Ray (1890–1976), Film still from *Emak bakia* (Leave me alone), 1926. Reproduced in *Révolution surréaliste* (Paris: Gallimard, 1927), 3:9–10, 42.

an actual body of water, from which protrude massive monoliths in the form of cylinders, pyramids, and obelisks set against a backdrop of solid trapezoidal cliffs. While the regularity of the geometric formations implies that they are machine-made, the environment in Amaral's painting, with its complete lack of animal or vegetal forms, suggests a petrified futuristic city, much like in Man Ray's still. By situating the machine-made elements in a tranquil ocean in *Calmness I,* Amaral has transformed Man Ray's interior still life into an outdoor scene, evocative perhaps of Rio de Janeiro's Guanabara Bay, with its distinctive mountainous geography on a calm day. On its own, *Calmness I* could be understood as a passing fascination with and manipulation of Man Ray's photographed objects. Paired with her interest in a work by Miró in that same issue of the *Révolution surréaliste,* however, Amaral's exploration of Man Ray indicates an intentional probing of surrealist technique.

In her painting *Abaporu* (see fig. 190), Amaral surpasses an exploration and transformation of the formal qualities of the image, as she did with Man Ray's photograph; here she employs some of the surrealists' ideas about classificatory ambiguity and engages more specifically with the surrealists' conceptual project as expressed in Miró's *Person Throwing a Stone at a Bird* (fig. 194). *Abaporu* depicts a colossal seated nude of ambiguous gender. Propped on a bent knee, one arm supports the figure's slightly inclined diminutive head, while the other hangs loosely by its side in a pose reminiscent of Auguste Rodin's *The Thinker* (c. 1880). With its diminutive head, the image subverts Rodin's emphasis on intellectual contemplation, however. By drastically distorting the figure's anatomical proportions, Amaral makes the foot the focal point of the composition instead. As if performing an exaggerated exercise in illusionistic foreshortening, Amaral painted the foot and hand closest to the bottom edge of the canvas much larger than the head and arm near the top of the frame. Instead of creating the illusion of deep space, Amaral offers a disconcerting effect. Since she rendered the figure in profile, parallel to the picture plane, the viewer expects the upper and lower body to be rendered in similar proportion. Reducing the size of the head and upper torso creates the illusion that the figure is of great size and that the viewer is looking up at it from below. In other words, we are compelled to enter the picture at the base, at ground level.

While Amaral executed the painting with extreme painterly clarity, the figure's gender, age, and race are not immediately apparent. This strangely distorted figure sits on a green mound against a cerulean sky, which indicates that the scene is outdoors in a natural setting. No signs of modern life appear to situate the figure in time or place. There are only two other elements in the composition. The first is a large, green anthropomorphic cactus with two outstretched branches painted in the same slick brushwork as the figure. Its erect posture and extended "arms" render it more animated than the languorous seated nude, thereby disrupting a clear delineation between human and vegetal forms. The second element is a luminous yellow circle. While Amaral would later describe the cactus as "exploding with an absurd flower," the circular form is so ambiguously positioned that it remains unclear if it is connected to the cactus or floats in space.[28] Given its central location and placement against a bright blue sky, the perfectly round yellow disk could also be interpreted as a sun. Yet Amaral undermines this reading because she disregards traditional conventions for rendering the directionality of illumination. The yellow circle hangs over the upper-left side of the cactus, but the plant is lit from a source outside the picture plane to the right. The figure, too, appears to be illuminated from the front, rather than in silhouette, as would be the case if the sun were actually shining down on the figure from behind. Its light seems to be circumscribed by its own contour line, unable to permeate the surrounding atmosphere. Thus, the form fluctuates between absurd flower and tropical

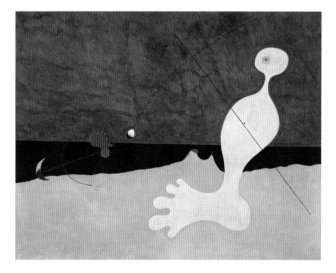

FIG. 194. Joan Miró (1893–1983), *Person Throwing a Stone at a Bird,* 1926. Oil on canvas, 29 × 36 in. (73.7 × 92.1 cm). Museum of Modern Art, New York.

sun, suggesting both possibilities yet not decisively conjuring either.

In *Abaporu* the comical preponderance of phallic forms, the engorged toe (an archetypal Freudian fetish), the small, bulbous head, the smooth, fleshy forms of the figure's limbs, and the erect, three-pronged cactus clearly suggest fetish objects. Yet as the surrealists often did, Amaral deploys the fetish in a playful and satirical manner in *Abaporu,* poking fun at an indiscriminate application of Freud's ideas across cultural and gender divides.[29] Since the gender of the central figure is indecipherable, these phallic forms generate confusion, undermining the clarity of Freud's theory of sexual development. Is *Abaporu* a phallic woman, an emasculated man, or a maternal figure, surrounded by signs of her deficiency? The inert *Abaporu,* like Adam in Michelangelo's *Creation of Adam,* lingers in a state of semi-arousal just before a fervent cultural awakening. Rather than signifying repressed human sexuality, the numerous phallic forms in *Abaporu* seem to suggest the former potency of the indigenous peoples in the pre-colonial world; the associated castration anxiety thus becomes a metaphor for Europe's loss of power over its colonial progeny as the Americas reawaken to their cultural heritage.

The visual affinity between Joan Miró's painting *Person Throwing a Stone at a Bird* and *Abaporu* is immediately apparent. *Person Throwing a Stone at a Bird* was painted in 1926 and reproduced the following year in the *Révolution surréaliste.* About Miró, Breton writes in "Le surréalisme et le peinture": "No one else has the same ability to bring together the incompatible, and to disrupt calmly what we do not dare even hope to see disrupted."[30] In Miró's painting the central figure has been reduced to a continuous outline of a diminutive head, body, and a single bulbous foot. As in *Abaporu,* the foot is oversized in comparison to the rest of the body. Its toes are splayed apart as if rooted in the yellow earth and, oddly, the two largest toes are in the center of the foot rather than in the big toe's typical location. This disconcerting reordering of the toes focuses attention on these swollen appendages and the phallic body they support. The continuous outline suggests that Miró drew the figure in a single stroke, rather than through a laborious working and reworking of form.[31] This strange image is set against a flat green sky, black water, and yellow sand, a color palette very similar to that employed by Amaral in *Abaporu.* Since Miró's painting was reproduced in black and white and was not exhibited

until May 1928 at the Galerie Bernheim-Jeune, four months after Amaral had completed *Abaporu*, she could not have seen Miró's work in person. Her interpretation of color, while clearly her own in this case, perhaps indicates a broader knowledge of Miró's work from her previous trip to Paris in 1925 or 1926.[32] Since Amaral owned a surrealist work by Miró, which was later sold for financial reasons, she clearly had an interest in the artist.[33]

Despite the apparent unpremeditated quality of *Person Throwing a Stone at a Bird*, exaggerated pedal forms appeared in various other works by Miró during this period.[34] This repeated exploration of the exaggerated bulbous foot as a protagonist became Miró's strategy for subverting traditional hierarchies of value, a concern that would preoccupy the surrealists throughout the next decade. It is this aspect of the picture that Amaral appropriated in *Abaporu*. The exaggerated foot and toe in *Abaporu* emulate the primal quality evident in Miró's painting. In its solidity and baseness, the foot in Miró's composition assumes greater importance than the intellect. Without this support, the body would topple over and could never remain upright. By exaggerating its form, Miró ensures that what has been overlooked or typically lies beneath now captures the viewer's attention, thereby subverting expected hierarchies of meaning. This formula most likely appealed to Amaral, an artist grappling with how to both engage in and challenge European constructs of primitivism.

Miró's painting, *Person Throwing a Stone at a Bird*, also had a broad impact on other artists associated with surrealism. Georges Bataille's article "Le gros orteil" (The big toe), Jacques-André Boiffard's photographs of big toes published in *Documents*, and Dalí's 1928 *Bather* series all share an affinity with the same painting that intrigued Amaral. The coalescence of these images around Miró's 1926 picture indicates the power of this painting to instigate further visual dialogues surrounding the issues of cultural hierarchies and norms. Whereas Bataille (via Boiffard) and Dalí chose to underscore the grotesques qualities of the big toe, Amaral transformed the appendage to tap into its subversive potential in a different way. In a moment of prescience, she pre-empts Bataille's and Dalí's delight with the abject and taboo, sanitizing their notion of humanity's baseness through the sleek machine-age aesthetic of purism. Amaral's composition is simple and balanced, her lines are clean and precise, and the surface is highly finished. There is nothing putrid about

Amaral's image, no dirt, no corns, no hair, no perverse sexuality, no signs of labor or even aging. The skin is clean and sleek and the toenails well manicured. One review of the painting when it was exhibited in Paris mockingly referred to it as an advertisement for a pedicure.[35] The enlarged foot becomes a thing of idealized beauty, an icon of the earthbound, antirational, primitive soul. Or as Oswald de Andrade writes in the "Manifesto Antropófago," the figure represents "the permanent transformation of taboo into totem."[36] In other words she reverses the European notion of the abject primitive and, through the action of cleansing and purifying, creates a new vision of the Brazilian primitive—one that collapses the sordid and pure, the primordial and the modern in an image of convulsive beauty.

While none of the critics who reviewed the 1928 exhibition specifically mentioned surrealism, they did comment on Amaral's deliberate avoidance of the real. Georges Charensol calls her an "extremely gifted colorist who would benefit from not avoiding the domain of the real so much."[37] And according to G. J. Gros: "Mme Tarsila had strange visions in her country that stem from, I dare say, an impressive unrealism."[38] Raymond Cogniat goes further in his assessment of Amaral's work: "She offered us, in the decorative way an artist does, a very picturesque place for her fantasy to take place. The evolution of the artist proceeded in this way: promises became certitudes and as her conception became more assured, the author felt more freedom, escaping without hesitation from reality. In this exhibition, most of the paintings are pure imagination; even if a detail is borrowed from reality (a tree, a plant, an animal), it is so stylized, reduced to its most basic shape, that it evokes a creation. All these elements are regrouped in a new order often evocative of a theatrical set and constituting a peculiar world with new connections, and unexpected perspectives."[39] Cogniat's conclusion that Amaral's paintings, through a regrouping or rearrangement of familiar forms, create new, unexpected worlds describes one aspect of the surrealists' project.

Rather than specifically delineating Amaral's European sources, as they did for her 1926 exhibition, other critics rooted their assessment of the artist's work in how they perceived it to relate to her national identity. This critical shift in the interpretation of her work may have contributed to her decision not to acknowledge surrealism as an influence. For example, the critic for the *Cahiers d'art* writes:

Mme Tarsilla [sic] is a young Brazilian. That fact is important. Indeed, ordinarily we maintain that modern art is universal, and that it follows one sole rule, that its forms and expressions should be identical. This assertion is far too absolute. If modern art, whether it be painting, sculpture or architecture, is a phenomenon with universally accepted characteristics, it is no less true that it is characterized by influences specific to each country as well as by the personality of the artist.

Therefore Tarsilla brings to modern painting her sensibility as well as the experiences of her country. Her painting is impregnated with the Indian spirit. . . .

Tarsilla, after having been intoxicated by the impressionist movement, came to Europe to study painting with Léger and Lhote. We wanted to see in her manner of painting what was innate in her and what impressionism threatened to destroy. Thanks to her estrangement from Brazil, Tarsilla was able to better realize the considerable importance that the indigenous element played in her country and that she has introduced in her painting with her own unique sensibility.

We hope that western influences will no longer hinder an effort that seems to us to be fortuitously oriented.[40]

Similarly, in "Tarsila et l'antropophagie," printed in *La presse,* Waldemar George credits Amaral's paintings with revealing aspects of Brazilian thought: "America, that ethnic entity, still holds surprises for us. If Madame Tarsila's exhibition revealed to us an authentic artist, who combined her acute sense of color with a taste for fine technique, this crafted and precise technique of which Léger is the father, she also made known to us certain tendencies in contemporary Brazilian thought. Brazil, following Mexico's example, rebels against the domination of the West in the spiritual realm. After having driven out the invader, they wish to liberate themselves from the spiritual tutelage of Europe."[41] By lauding her "Brazilianness" and "authenticity," this estimation of her work establishes a trajectory from artistic dependence to independence. While she had certainly developed a unique personal style by 1928, the primacy of this reading has precluded a more nuanced discussion of the sources she did engage, such as surrealism, and the manner in which she transformed them.

Amaral, by this point a mature artist with previous experience exhibiting in Paris, was skilled at positioning her own reception and most likely advocated this revised interpretation of her work. Moreover, her Parisian reviewers were not alone in impelling her to renounce foreign influence. Ever since 1923, Mario de Andrade, a Brazilian writer and friend of Amaral's, had been inciting her to abandon Paris for the virgin forests of Brazil: "Tarsila, Tarsila, turn to your true self. Abandon Gris and Lhote, agents of decrepit criticisms and decadent aesthesis! Abandon Paris! Tarsila! Tarsila! Come to the virgin woods, where there is no Negro art, nor gentle brooks. There is Virgin Woods."[42]

By 1928 she began deliberately avoiding acknowledgment of European influence, despite her explicit exploration of surrealism, in a conscious effort to reinforce her "authenticity" in the eyes of the Parisian public. Because she transformed and redeployed her surrealist sources in a more subtle and sophisticated way than her appropriation of Léger's style, however, many Parisian critics also tended to ignore those aspects of her work that referenced Parisian avant-garde forms, because for them conceding influence or artistic dialogue sullied their quest to identify cultural authenticity.

Significantly, the most unfavorable reviews focused on *Abaporu,* which seems to have been a centerpiece to the 1928 exhibition. It was one of three paintings featured in the exhibition brochure and was reproduced twice in different reviews of the show.[43] Critics were rightly perplexed, unable to clearly identify the figure in the painting or make sense of its contradictory signs. The journal *Echos des industries d'art* reproduced *Abaporu* with the caption: "This full-length portrait [this is a deliberate play on words; 'full-length portrait' in French translates literally as 'portrait on foot'], by Tarsila, on view at the Galerie Percier, what a beautiful advertisement for a pedicure."[44] On the one hand, this cursory treatment, which was not even accompanied by a review of the show, mocks the painting by equating its visual strategy with advertising's calculated employment of simple, exaggerated forms. Yet, on the other hand, it recognizes something in the painting that elevates the foot—separates it from common associations of the foot with baseness—through the aesthetic operation of the pedicure. While the author clearly does not take the painting seriously, dismissing it as a joke, he (the writer was most likely male) fails to realize that it is perhaps on the level of satire of European constructs of the primitive that this painting functions best. And with Amaral's painting they got what amounted to a caricature

of their own primitivist fantasies, which like surrealism's reshuffled cultural hierarchies sought a decentred perspective that critiqued European ethnocentrism. While the surrealists frequently deployed parody and uncanny juxtapositions as a means to undermine bourgeois values, Amaral's work appropriates the surrealist penchant for satire to mimic and thereby reformulate conventional constructions of gender, race, and primitivism.[45]

Another review that also reproduced *Abaporu* appeared in the *Journal du peuple.* Here the reviewer expresses his absolute disdain for the painting and avant-garde art in general. The review, entitled "Assez, assez!" (Enough, enough!) proceeds to attack the incomprehensibility of the avant-garde, asking in the caption under *Abaporu* whether the painting was "Art or a practical joke?"[46] Significantly, the author patently categorizes the work as avant-garde, and it is with the subversive and at times sardonic stance assumed by avant-garde artists that he takes offense. For him, avant-garde art is that which dupes the public: "They mock us a little more every day under the pretext of avant-garde art."[47] For him, this art is not worth the effort to try to understand, because it has no substance.[48] Potential buyers are "suckers," and avant-garde art is nothing but "absurdity."[49] He goes on: "The author of the painting reproduced here [Amaral] passes as and attains [avant-garde status] without effort. Why name the author? Except that it is distressing that respectable galleries participate in this game."[50] These negative reviews indicate that critics, perhaps rightly, felt they were somehow the butt of an inside joke that they could not comprehend. While these critics aimed to ridicule the painting, singling out *Abaporu* for negative comment indicates that Amaral had achieved with this image the kind of notoriety and public confusion that marked so much avant-garde production. It was this subversive quality in *Abaporu* that led her husband, Brazilian intellectual Oswald de Andrade, to designate it as the ideal emblem of the anthropophagite movement.

Amaral's exploration of surrealism entailed a critical engagement with the movement's precepts—in particular, its emphasis on overturning traditional hierarchies of value. *Abaporu* is not just a facsimile of surrealist thought; by appropriating and transforming select surrealist images and strategies, Amaral usurped European authority over the notion of the primitive and defined it in her own terms. Whereas the surrealists attempted to transcend European bourgeois culture from within, Amaral

enters into the surrealists' philosophical debates over artistic hierarchies, fetishism, classificatory ambiguity, and cultural primitivism from the point of view of an artist whose culture was increasingly the subject of French primitivist fantasies. Through an astute parody and appropriation of the visual rhetoric of surrealism, combined with a selective mingling and re-signifying of other transatlantic sources, Amaral created *Abaporu,* the painting that would launch the anthropophagite movement.

SAMPLING SURREALISM

Like Tarsila do Amaral, several other Latin American artists engaged with surrealism from a critical distance, incorporating aspects of surrealist aesthetics and methods into their work without fully committing to the movement's ideals. While they did not affiliate directly with Breton's circle, these artists often had contact with members of the group or visited surrealist exhibitions. As mentioned in Chapter 7, Ecuadorian artist Manuel Rendón Seminario experimented with surrealist automatism and integrated bizarre and uncanny objects and spatial configurations into his work, while maintaining his affiliation with Léonce Rosenberg's Galerie de L'Effort Moderne. Jaime Colson, too, painted incongruous spaces and dream worlds in a Léger-inspired purist style (see Chapter 8), but exhibited with Torres García and his circle. Surrealism for them provided a means to expand their stylistic repertoire, but they were not necessarily adherents to the group's directives.

Other innovative but lesser-known artists such as the Brazilian Ismael Nery and Mexican Agustín Lazo absorbed the lessons of surrealism while in Paris but most likely did not integrate these ideas into their compositions until they returned home. Nery, who only spent a few months in Paris in 1927, discovered surrealism and the work of Marc Chagall during his short sojourn.[51] While Chagall had refused to join the surrealist movement, his work evinces a dreamlike quality that appealed to the surrealists and Nery alike. Nery's *Self-Portrait* of 1927, for example, demonstrates a strong affinity with Chagall, with its translucent washes of color, tilting buildings and landscape, and figure that seems to float weightlessly above his chair (fig. 195). The painting addresses an issue that confronted numerous Latin American artists in Paris: their divided artistic identity and the diverse environments in which they worked. On the left side of the painting, Nery depicted the typical tile roofed houses,

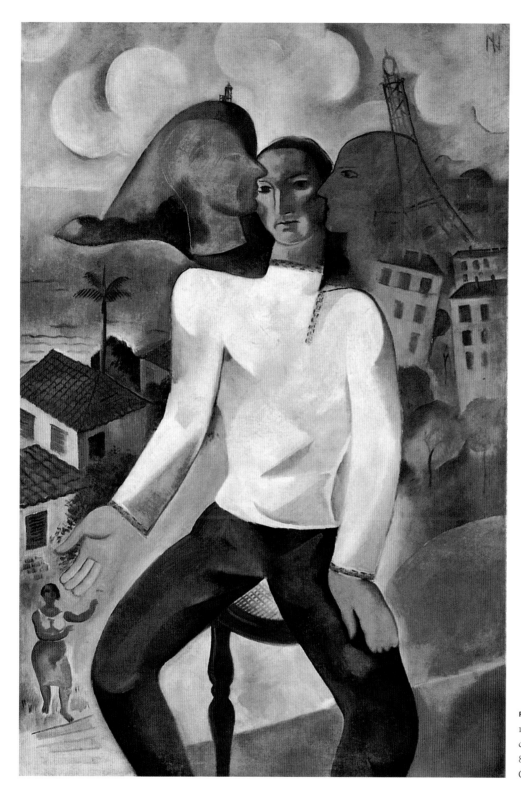

FIG. 195. Ismael Nery (1900–1934), *Self-Portrait*, 1927. Oil on canvas, 50¾ × 33 in. (129 × 84 cm). Collection Domingos Giobbi, São Paulo.

palm trees, and the distinctive mountainous geography of Rio de Janeiro's Guanabara Bay (where Nery studied at the Escola Nacional de Belas Artes), but on the right is a Parisian cityscape complete with the Eiffel Tower, multistory apartment buildings, and gray, cloudy weather. Two decapitated heads in profile emerge from these cityscapes to kiss Nery on the cheek, enticing him to choose between the two cities. But on the Brazilian side a small maternal figure reaches for Nery's outstretched hand, pulling him back toward home and the familiar. The picture articulates the disjointed experience of transnational travel and the negotiation of multiple cultural perspectives experienced by so many international voyagers. It was not their inherent fantastic or primitive nature that brought Latin

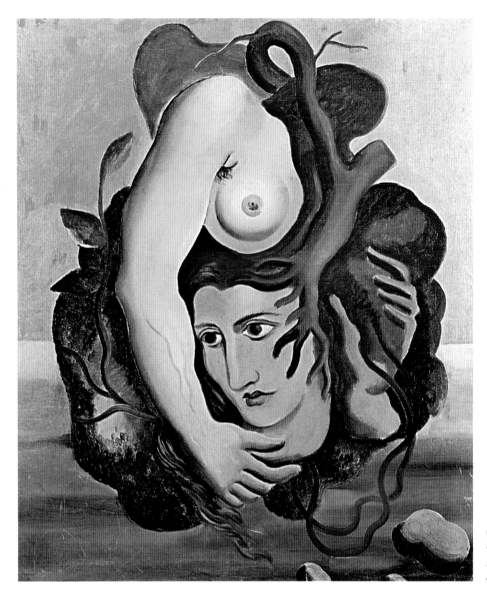

FIG. 196. Ismael Nery, *Surrealist Composition,* 1929. Oil on canvas, 26⅜ × 22¼ in. (67 × 56.5 cm). Private collection, São Paulo.

American artists to surrealism, but rather the surrealists' notion of the uncanny, a state that approximated the feelings of fragmentation and displacement of a foreigner abroad, that appealed to so many artists.

Upon his return to Brazil, Nery became more explicit in his surrealist explorations, painting works such as *Surrealist Composition* of 1929, where he employs the popular surrealist trope of the fragmented body (fig. 196). Floating in a barren landscape, a detached breast and arm encircle a decapitated female head. On the right a severed hand holds an amorphous brown substance that seems to ooze from the body, around which the roots and vines of a plant entwine. While the painting employs a familiar surrealist convention, the consistently warm brown tones and the unblemished body parts establish a cohesiveness that undermines the surrealist project of disorientation.

As with many Latin American artists, surrealism for Nery was more of an academic exercise—a style he tried out for a brief period in the process of developing a personal aesthetic—than an end in itself. It nevertheless informed his future artistic production and introduced artists around him to developments in Europe.

Another artist who encountered surrealism in Paris was Mexican Agustín Lazo.[52] Lazo arrived in Paris in 1927, and while he was aware of surrealism by 1928, like Nery, he most likely did not fully engage with surrealist aesthetics until after his return to Mexico in 1931. In Paris he associated with a group of artists and intellectuals that included Max Jacob, Jean Cocteau, and Sergei Diaghilev, but he did not affiliate with Breton's surrealist circle. James Oles describes his style in Paris as a "weighty stylized classicism," as can be seen in a montage of paintings

by the artist published in *L'art vivant* in 1929 (fig. 197).[53] In a 1928 interview with Febronio Ortego for the Mexican journal the *Universal ilustrado*, however, Lazo expresses his great enthusiasm for what he called in Spanish "suprarealismo": "Superrealism tries to reinvest painting with MEANING, filling it with emotion, with life, with mystery: forcing it to have an object and breaking with pure painting.... This is undoubtedly the movement that offers the most hope, for its lofty intentions, the intelligence of its promoters and, principally, for its desire to maintain and accelerate the state of revolution."[54] What appealed to him about surrealism was that it allowed content to resume precedence in picture-making. He may therefore have started to experiment with surrealist aesthetics in private before his return to Mexico.

Taking his cues from European surrealist paintings, Lazo developed a method of crosshatching in which he composed a series of strangely disconcerting scenes reminiscent of theatrical sets in the early 1930s. In *The Eternal Farewell,* for example, Lazo depicts a bare, unfurnished room, reminiscent of the incongruous spaces in de Chirico's paintings, in which a gentlemen in a bowler hat holding an envelope stands over a woman sprawled on the floor on a flowered sheet with her breasts exposed (fig. 198). The title, *The Eternal Farewell,* leads the viewer to presume that the woman is dead, perhaps at the hands of the man. In the doorway a rider-less white horse, wearing a bridle and saddle, stands calmly waiting for its passenger. The white horse, a motif Lazo frequently incorporated in his oeuvre, has various symbolic connotations in

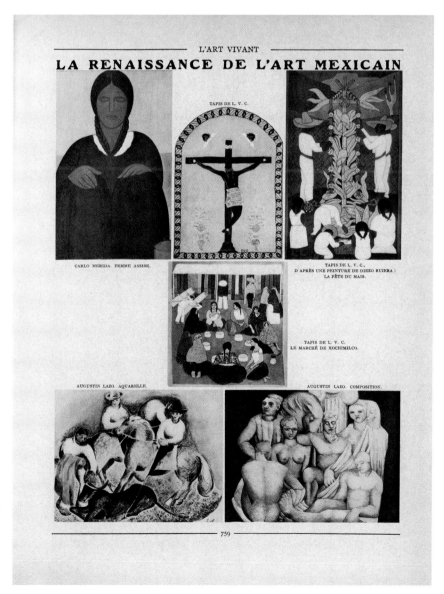

FIG. 197. Page from Jean Cassou, "La renaissance de l'art mexicain," *L'art vivant* 5 (September 30, 1929): 759. This article includes the illustrations *Femme assise* by Carlos Mérida and *Aquarelle* and *Composition* by Agustín Lazo. It also includes three tapestries by Lola Velásquez Cueto: *Fête du mais* (after a painting by Diego Rivera), *Le marché de Xochimilco,* and *Crucifixion.*

FIG. 198. Agustín Lazo (1897–1971), *The Eternal Farewell*, ca. 1930–32. Ink on paper, 9¾ × 12⅔ in. (24.5 × 32 cm). Private collection.

world mythology, ranging from a symbol of fertility to a bearer of heroes. In Lazo's painting, however, its meaning remains nebulous. Did this horse carry the man to the foreboding scene, or is it there to transport the woman to another world? The narrative ambiguity and sharply tilting space create a sense of anxiety and disjunction consistent with surrealist practice, but also convey the dissonance and unpredictability of post-revolutionary Mexico.

Around this same time Lazo also began making collages modeled after Max Ernst's 1929 series *La femme 100 têtes*, which he may have seen in the 1929–30 issues of the *Révolution surréaliste*. In works such as *The Ice of Death*, Lazo appropriates the surrealist notion of the uncanny juxtaposition (fig. 199). A group of five men in formal attire stand behind a decorative curved table. Each man calmly presides over a grouping of what appear to be drinking glasses or ceremonial trophies, ready to serve or present their awards, while an executioner fires a pistol at the central figure. The entire scene takes place atop a glacier in a barren mountainous landscape. Through the combination of cutouts from different sources, Lazo creates a bizarre and disconcerting narrative that juxtaposes the steadfast calm of the five men with the deadly action

of the execution. While these collages were not exhibited publicly in the 1930s, surrealism clearly resonated with Lazo and became the foundation for his artistic practice. By 1940 he specifically aligned himself with the movement, exhibiting two surrealist works (*The Interlocutor*, 1937, and a surrealist drawing) in the *Exposición internacional del surrealismo* in Mexico City organized by Moro, Paalen, and Breton.

The revolutionary nature of surrealism also greatly appealed to renowned Argentinean artist Antonio Berni, recognized now primarily for his socially critical paintings and collages made after his return to Argentina. Berni arrived in 1926 in Paris, where he spent two years studying at the Académie de la Grande Chaumière and the Académie André Lhote, experimenting with cubist and postimpressionist styles. In 1928 he made the acquaintance of the French Marxist philosopher Henri Lefebvre, and the following year he met surrealists Salvador Dalí, Luis Buñuel, Paul Éluard, and Louis Aragon, with whom he formed a lasting friendship.[55] The surrealists' proclaimed embrace of communist ideologies and quest to create images that challenged bourgeois norms were a major draw for Berni.[56] Thus by 1930 he began to

incorporate surrealist motifs into his paintings and to try his hand at collage. His surrealist interlude, while relatively brief, established the groundwork for his later social realist paintings and more experimental collage practice.

For Berni, surrealism introduced a new way of working that was both aesthetically and socially revolutionary. According to Berni, surrealism was "a whole new vision of art and of the world, the current that represents an entire generation of youth, their state of mind, their internal situation after the end of the First World War. It was a dynamic and really representative movement. . . . It was a field of experimentation for me."[57] *Eiffel Tower in the Pampa,* a mixed-media work from this period, exemplifies his incorporation of surrealist elements into his compositions (fig. 200). Using an unconventional combination of tempera and collage on paper over hardboard, Berni emulates de Chirico's manipulation of perspective to create a disconcerting space. In the foreground is a bust-length nude female torso, which resembles his French wife, Paule. While her naturalistic skin tone and bodily proportions suggest that the young woman represents a real person, her missing left arm undermines this reading, recalling

instead de Chirico's trademark mannequins. Next to her on the table is a small round box adorned with an angry face (perhaps a gramophone needle box), and a portable gramophone in a gray crocodile case, on which a record is just starting to play. In the background, on either side of a long, straight highway that runs through an empty plain to a distant horizon, are two buildings: a classicizing building that has been identified as Berni's childhood home in Rosario, Argentina, and the Eiffel Tower depicted in silhouette against a wide-open sky.[58] The juxtaposition of these unrelated elements that do not coexist in the same place creates an unsettling effect evocative of the experience of living abroad and the conflicting pull of different cultural expectations.

Eiffel Tower in the Pampa also incorporates a single collage element, the Eiffel Tower itself, that Berni cut from a lithographic print and superimposed on the surface of the otherwise cohesive painting. While Berni most likely developed an interest in collage through his friendship with Aragon and exposure to the work of Max Ernst, his initial experiments with collage did not take full advantage of the medium's innovatory potential.[59] The varying

FIG. 199. Agustín Lazo, *The Ice of Death,* ca. 1932–36. Collage, 6¾ × 8⅞ in. (17 × 22.5 cm). Fundación Televisa, Mexico City.

FIG. 200. Antonio Berni, *Eiffel Tower in the Pampa*, 1930. Tempera and collage on paper, 19¼ × 21¼ in. (49 × 54 cm). Private collection, Buenos Aires.

sizes of the painted objects in the composition imitate the discontinuous scale of collage elements taken from different sources, yet Berni's early use of collage actually tempers this sense of incongruity. Rather than disrupting the painted surface, Berni incorporates the collage elements almost seamlessly onto the painted surface, only subtly disrupting the illusionistic effect. But this subtle disruption created perhaps an even greater sense of incongruity for the viewer. The same can be said of Berni's other collages of the period, such as *Susanna and the Elder* (1931) or *The Window and the Sea* (1931). It was not until later in his career, after he abandoned the more obvious reference to surrealist aesthetics in his paintings, that collage became a more radical practice in his work. Surrealism, however, provided the foundation for his later development.[60]

In another painting from the period, *Napoleon III* (1930), Berni employs the discrepancies of scale characteristic of collage without the actual collage elements

(fig. 201). In this image, Berni's political consciousness also starts to manifest. The image comprises an uncanny conglomeration of objects assembled as a still life: a key, a lock, half a walnut, an oversized spoon, a French coin, and the decapitated body of a reclining man with an open gash on his side. The objects are all arranged on an inclined plain, as if they will slide off at any moment. A brick wall with an inset window recalls similar motifs in works by Ernst such as *Oedipus Rex* (fig. 202) (as does the walnut). The Napoleon III (Napoleon Bonaparte) coin may be a not-so-veiled reference to the parallels between Napoleon and general José Félix Uriburu, who had usurped the presidency of Argentina through a military coup in September 1930, setting in motion decades of authoritarian rule. Like Uriburu, Napoleon, while initially elected as the first president of the French Republic, hung on to power through a military coup and imposed censorship and extensive repressive measures against his opponents. The precarious arrangement of objects and the violence against the

FIG. 201. Antonio Berni, *Napoleon III*, 1930. Oil on cardboard, 14½ × 17¾ in. (37 × 45 cm). Private collection.

human body denounce the dangers of authoritarian rule and indicate Berni's growing political awareness. Images of violence against the human body repeat in several paintings of the period, such as *Objects in the City I* (1931) and *Landru in the Hotel* (1932), establishing surrealism as a form of pictorial protest against the brutality in Argentina.

While Berni was not in the country at the time of the military coup, the social upheaval in Argentina led to the termination of his grant from the Santa Fe government. Berni managed to remain in Paris for another year, but was finally forced to leave in October 1931. Upon his return he held an exhibition of his surrealist paintings at the Amigos del Arte galleries in Buenos Aires in 1932. Three of the paintings submitted were deemed unfit for public viewing, however, and were removed from the show.[61] Although the titles of the censored works are not known, it seems likely that among them were images with incendiary political implications. This situation reveals the disruptive power of Berni's surrealist experiments and ultimately explains why the exhibition was met with such confusion and rancor, and may also explain in part why he abandoned surrealism so abruptly in 1932.

In the years surrounding Berni's departure from Paris, tensions were mounting between Breton's group and the

French Communist Party, because they held different priorities in regards to creative freedom and how to address the proletarian struggle. Berni continued to follow these developments closely from Argentina and sided with Aragon when he left the surrealist group in 1932 to participate more fully in the activities of the French Communist Party. Berni

FIG. 202. Max Ernst, *Oedipus Rex*, 1922. Oil on canvas, 36⅔ × 40⅛ in. (93 × 102 cm). Private collection.

FIG. 203. Raquel Forner (1902–1988), *The Omen*, 1931. Oil on canvas, 47¼ × 31½ in. (120 × 80 cm). Fundación Forner-Bigatti, Buenos Aires.

would later describe his reasons for aligning with Aragon: "We were not objecting to surrealism's undeniable contributions we were rejecting the merely psychological and individualistic aspects of surrealism where a certain part of it had gotten stuck."[62] Aragon's departure from surrealism corresponded with Berni's decision to abandon his exploration of surrealist aesthetics, turning instead to social realism. For Berni, surrealism, while providing a major creative stimulus, had lost its way in regards to its political objectives, and was no longer a useful tool in combatting social injustice.

While Berni's embrace of surrealism was short-lived, other Argentinean artists took his lead in experimenting with the movement's ideas and aesthetics. Raquel Forner spent just two years in Paris, from 1929 until 1931, but during that period gained enough exposure to incorporate aspects of surrealism into her work. Her painting *Omen* (1931), for example, depicts three women with a large snake entwined around their necks, cowering in fear (fig. 203). Behind the women, whom Forner located in close proximity to the picture plane, three horses run

FIG. 204. Nina Negri (1909–1981), *The View*, 1934. Oil on panel, 87 × 60⅜ in. (221 × 153.5 cm). Private collection.

through what appears to be a watery landscape punctuated with truncated classical columns; a volcano erupts in the background. Like Berni, Forner employs the surrealist aesthetic conventions of psychological tension, incongruous landscapes, and narrative ambiguity to depict an impending natural disaster, which perhaps serves as a metaphor for the social devastation caused by authoritarian regimes. While Berni discarded surrealism soon after his return to Argentina, Forner continued to incorporate certain aspects of surrealism into her work throughout the 1930s, making

uncanny juxtapositions and strange dream-worlds defining characteristics of her style (such as *Moonlight,* 1939).

Argentinean artist Nina Negri, on the contrary, arrived at surrealism from a different direction. After studying in England and Belgium, Negri, an artist who deserves significantly more attention, most likely reached Paris in the early 1930s. By 1934 Negri's paintings evidenced an exploration of surrealist automatism, suggesting that she had come in contact with surrealism before this point. In *The View,* for example, Negri employed automatic

drawing as a point of departure, allowing her mind and brush to wander freely to create undulating biomorphic shapes that intertwine and grow out of one another (fig. 204). Once established, she shaded and modeled these free-form shapes to create a sense of three-dimensionality. By adding three figures that resemble aliens on the left and situating the scene in a strange, otherworldly landscape, the image fluctuates between abstraction and representation, between the real and the imagined, in a manner consistent with the surrealist explorations of artists such as André Masson or Tanguy.

Negri's first known exhibition in Paris was in 1935 at the Salon des Surindépendants, where she submitted some of her prints. Jacques de Laprade, who reviewed the exhibition, writes that her works were "reveries expressed with a brio that is somewhat surprising."[63] While not specifically identified, these prints were most likely created at the printmakers' collective known as Atelier 17, founded by Stanley William Hayter in 1927, where Negri frequently worked.[64] Hayter's workshop catered to artists of all levels of experience who wanted to learn the technique of engraving with a burin. Hayter had developed a technique of printmaking known as simultaneous color printing or viscosity printing, which allowed for the layering of three or more colors on a single plate, and this

brought a wide range of artists to his workshop. While the Atelier 17 was not strictly a surrealist enterprise, many artists affiliated with surrealism, including Victor Brauner, Oscar Domínguez, Ernst, Miró, Wolfgang Paalen, and Tanguy (who exhibited with Negri in a group exhibition at the Galerie de Quatre-Chemins), perfected their printmaking technique at the Atelier 17 and exhibited in their group shows.

In the spring of 1937 Negri exhibited with a group of twenty artists from the Atelier 17 at the Galerie de Quatre-Chemin and was one of four artists singled out by the reviewer, who comments that she "uses the burin in two colors with intelligence."[65] He also chose her print *The Glassblowers* to illustrate the review (fig. 205). *The Glassblowers* consists of swirling, intersecting lines, with several ruled lines transecting the composition. These undulating lines coalesce into a profile head, from which emerges a muscular figure leaning back to exhale into a blowpipe with a bubble of molten glass at the end. Given the nebulous quality of the forms, the subject may have been an afterthought evoked by the billowing shapes. Like her earlier paintings, this print seems to have started as an exercise in automatic drawing that only came to suggest recognizable forms as the process progressed. This technique of working without a preconceived notion of the final image, and deriving titles after completion from the ideas the forms evoked, was common practice among the surrealists.

Contact with the surrealists at the Atelier 17 also led to Negri's inclusion in the 1938 *Exposition internationale du surréalisme* at the Galerie des Beaux-Arts organized by André Breton, Paul Éluard, and Marcel Duchamp, where she exhibited *Spain* (1937) and several untitled prints. Unfortunately, the current location of these prints is unknown and there is very little information, except for the notation of her name in the catalogue, regarding her participation in this exhibition. Nevertheless, Negri seems to have maintained a sustained engagement with surrealist practice, specifically automatism, expressed via the printmaking techniques she learned at the Atelier 17.

All the Latin American artists who dabbled in surrealism—Colson, Rendón, Nery, Lazo, Berni, Forner, and Negri—derived significant intellectual and artistic stimuli from the movement, which in turn informed their subsequent artistic production. Moreover, their presence in Paris and interaction with French and foreign artists expanded the dialogues surrounding surrealism,

FIG. 205. Nina Negri, *The Glassblowers*, ca. 1938. Print. Location unknown. Reproduced in "L'Atelier 17," *Beaux-arts: Chronique des arts et de la curiosité*, April 2, 1937, 6.

allowing for an incorporation of unique viewpoints and approaches. Upon their return home, these artists began to selectively translate those aspects of the surrealist movement that they found relevant or useful to artistic production in their distinct cultural environments. Despite later assertions to the contrary, surrealism, because it was not a definitive style, proved to be one of the most versatile and adaptable European avant-garde trends of the twentieth century and inspired many corollaries in modern Latin American art.

DESIGNATED SURREALISTS: MARÍA IZQUIERDO, FRIDA KAHLO, AND MANUEL ALVÁREZ BRAVO

Despite the many Latin American artists who engaged with surrealism during their sojourns in Paris, the surrealists did not fix their attention on contemporary Latin American art as a "natural" manifestation of surrealism until the late 1930s. César Moro, for example, perhaps because of his fluency in French and deliberate disavowal of national themes in his work, was never singled out by the surrealists as having a special connection to the magical or primitive worlds of an imaginary Peru. It was only after Antonin Artaud and André Breton traveled to Mexico in 1936 and 1938, respectively, that they began to posit a conceptual link between Latin American identity and an inherently surrealist worldview, and to designate those Latin American artists as surrealist whose work fit their imagined construct of the marvelous.

Surrealist poet Antonin Artaud sought to escape the decadence of modern Europe by taking an extended trip to Mexico in 1936, for which he had received a grant to study the Tarahumara people.[66] The trope of the artist's retreat from modern life was, of course, nothing new and echoed famous voyages to "primitive" destinations such as Gauguin's travels to Tahiti.[67] Like Gauguin, Artaud used the journey to confront personal psychological issues, which for him were exacerbated by drug addiction. Once in Mexico, Artaud gave several lectures in which he described European fantasies about the country: "One can almost say that Europe sees the Mexicans of today dressed in the costumes of their ancestors in the act of actually sacrificing to the sun on the steps of the pyramid of Teotihuacan. I assure you that I am scarcely joking. . . . A fantasy of this kind is being circulated in the most advanced intellectual circles of Paris."[68] Yet despite his incredulous tone, Artaud, too, succumbed to the very stereotypes he disclosed, asserting that he came to Mexico in search of "a magic culture" because Europe's promotion of rationalism had failed.[69]

In addition to immersing himself in the life and culture of the Tarahumara people, a culture that he perceived to be the antithesis of European civilization, Artaud made contact with local intellectuals and artists in Mexico City. While there he lived at the residence of Mexican painter María Izquierdo, an innovative modernist celebrated as the first female artist from Mexico to exhibit her work in the United States.[70] And when he returned to Paris he took with him thirty works by Izquierdo for an exhibition at the Galerie Van den Berg that took place in early 1937. While she was most likely aware of the surrealist movement through modernist magazines and journals that circulated in Mexico, Izquierdo had no formal contacts with the group prior to meeting Artaud, nor did she subscribe to the group's theories or methods. Moreover, many of the works Artaud selected were made in the four years prior to his visit.[71] Thus, any perceived correlation with surrealism resulted from Artaud's affiliation with the group, but was not part of the artist's agenda. Indeed, Izquierdo adamantly refused to be classified as a surrealist, asserting in 1939: "Surrealism is worked out in the mind, and I paint emotionally."[72] Her objective for exhibiting in Paris was to gain exposure and to raise money through the sale of her work to help Artaud enter a drug rehabilitation program, not to affiliate with surrealism.[73]

While many of the works in the exhibition cannot be identified definitively and there was no printed catalogue, two paintings, *Consolation* (1933) and *Slaves in a Mythical Landscape* (1936), are known to have been included (figs. 206 and 207). Both are gouache on rice paper and relatively small in size. And both were executed in a deliberately naïve style, using primarily brown and red earth tones. Izquierdo simplified the spaces and figures to basic geometric shapes and ignored the conventions of academic perspective. Common themes in many of the works she sent for the exhibition were tragedy, loss, and ritual mourning in the life of peasant women. In *Consolation*, for example, a nude woman, rendered in a rudimentary style, lies prostrate on the ground with her hands covering her face, while another figure spreads a white cloth over her lower body. In the window a small angel blows a horn, as if announcing a significant event. The room they inhabit is bare except for a truncated red column. While the image lacks narrative clarity, the figures' poses and gestures suggest a stillbirth, miscarriage, or other tragic circumstance

FIG. 206. María Izquierdo (1902–1956), *Consolation*, 1933. Gouache on rice paper, 10⅔ × 8 in. (27 × 20.3 cm). Private collection.

in these women's lives. Similarly, in *Slaves in a Mythical Landscape* a sense of desolation and misfortune prevails. Two women with bound wrists kneel at the foot of a red mountain. One reaches toward the heavens, seemingly imploring for release from bondage, while the other bows her head in submission, as if she has given up hope. In the sky a dark red sun passes behind the mountain, framed on either side by two crescent moons, suggesting the passage of time and the unending torment of their situation. Other paintings in the show repeat these themes of desolation and tragedy, alluding perhaps to Mexico's violent history or the personal trials of women in poverty.

While deliberately anti-academic, these gouaches do not specifically reference Mexico's indigenous traditions. Artaud, however, interpreted Izquierdo's work as a contemporary manifestation of primitivism, channeled directly from the ancient inhabitants of Mexico. To accompany Izquierdo's Paris exhibition, Artaud wrote an article published in *L'amour de l'art* entitled "Le mexique et l'esprit primitive: María Izquierdo." Already from the title, Artaud's single-minded quest to identify art that fit his preconceived notions of the "primitive" is patently apparent. According to Artaud, the primitive mind cannot distinguish the self from the world around it, everything is interrelated, and therefore "primitive" artists create with "unlimited imagination."[74] Artaud understands Izquierdo,

FIG. 207. María Izquierdo, *Slaves in a Mythical Landscape*, 1936. Watercolor on rice paper and board, 8⅛ × 10⅔ in. (20.6 × 27 cm). Private collection.

despite her urban mestizo heritage, as part of his esoteric concept of Mexico, identifying her as "of pure Tarascan race," and suggesting that her art stemmed directly from indigenous tradition.[75] Even though he admits that she sometimes "reproduce[s] images from Europe," he contends that she only chooses those images that are reminiscent of the "pure forms" of her "racial unconscious." For Artaud, Mexican art must remain true to itself and reject the temptation of European influence, and he interprets Izquierdo's work to fit his assertion.[76]

Ironically, Izquierdo's imagery appealed to Artaud because of its resonance with surrealist notions of dream worlds and the uncanny. He proclaims that, in the same spirit as taking peyote, her gouaches "reduce forms to their musical essence, bring the spirit back to its sources, and unite what we thought had been separated."[77] He goes on: "A man, a horse, a color, a crater, in a kind of colorful vibration where their strange forms are submerged, by painting them María Izquierdo reveals to us why these objects are made to go together. And it is because of their differentiation that the properties of these objects attract one another; and they are only artificially separated."[78]

For Artaud, in the primitive worldview, there is no logical order and therefore the juxtaposition of unrelated objects is not disruptive, but rather represents a return to a natural unity. The problem with this interpretation, however, is that it stems from a European—and in its elevation of the primitive to a superior ideal, a specifically surrealist—desire to reverse and disrupt the structure of bourgeois society. As Terri Geis points out, "Artaud's exhibition transformed Izquierdo's paintings into a personal conduit through which he sought to express an alternate reality to European culture."[79] Izquierdo did not have a voice in this interpretation.

Unfortunately, little is known about how the exhibition was received. There are no known reviews of the show, nor was there a published catalogue. While it is possible that André Breton visited the exhibition, since he and Artaud reconciled in 1937, Izquierdo is never mentioned in his writings and she did not participate in the *Exposición internacional del surrealismo* in Mexico City in 1940.[80] Her association with surrealism was therefore one of imagined affinity, rather than deliberate exploration. Artaud's journey did, however, inspire Breton to identify in the

contemporary art of Latin America work that was aligned with the surrealists' concept of the unconstrained primitive mind, analogous to that of children or the insane.

By the mid-1930s, Breton had begun to engage with foreign cultures, women artists, and marginalized groups and individuals as a strategic means of revitalizing surrealism at a moment when the movement was in decline. A spread featured in the journal *Minotaure* of surrealist exhibitions around the world in the winter of 1937 evidenced Breton's more expansive vision.[81] The following year he focused his attention on Mexico, traveling there as a cultural ambassador to the French government. Breton was immediately enchanted with Mexico, famously calling it a surrealist country par excellence.[82] For him, the culture of Mexico was a living manifestation of the surrealists' notion of the reconciliation of opposites. And the country's revolutionary politics resonated with the group's embrace of communist ideologies. While in Mexico, Breton disseminated information about the surrealist movement, giving a lecture entitled "Las transformaciones modernas del arte y el surrealismo" at the National Autonomous University of Mexico. He also sought out communist connections, cowriting the famous "Manifiesto por un arte revolucionario independiente" with the exiled Bolshevik revolutionary Leon Trotsky.[83] And like Artaud, he established connections with prominent contemporary artists including Diego Rivera, Frida Kahlo, and Manuel Álvarez Bravo.

Upon his return to Paris in the fall of 1938, Breton began promoting these artists' work as manifestations of an inherent or naturally occurring surrealism in Latin America. He wrote the catalogue essay for Kahlo's exhibition at the Julien Levy Gallery in New York in November 1938 and invited her to Paris to hold an exhibition before returning to Mexico. For the New York catalogue, Breton articulated just why Mexico appealed so much to him and situated Kahlo within his "fantastic" notion of the country. Breton admits outright that he had already formulated a vision of Mexico before traveling there: "I had long been impatient to go there, to put to the test the idea I had formulated of the kind of art which our own era demanded, an art that would deliberately sacrifice the external model to the internal model, that would resolutely give perception over representation."[84] For him, Kahlo's paintings validated his idea that art should privilege imagination over observation, and he therefore labeled them "pure surrealism." The designation was his, not hers, however, and as

with Izquierdo, served to align the artist with a movement to which she did not subscribe. For Breton, Kahlo was an otherworldly being, a "fairy-tale princess, with magic spells at her finger-tips," whom he wished to claim for surrealism much as Spain laid claim to indigenous territories for its own benefit.[85]

Despite Breton's fantastic declarations, Kahlo, recognizing the magnitude of his international reputation and his ability to promote her career, agreed to participate in the exhibition Breton was planning in Paris for the spring of 1939 and sent eighteen of the twenty-five paintings displayed in New York on to Paris.[86] In January 1939 Kahlo herself set sail for the City of Light, where she stayed with Breton and his wife, Jacqueline, in their apartment on 42, rue Fontaine.[87] From the beginning she loathed the city, the surrealists, and the Parisian art scene in general, writing in a letter to her lover, Hungarian-born American photographer Nickolas Muray:

> You have no idea the kind of bitches these people are. They make me vomit. They are so damn "intellectual" and rotten that I can't stand them any more. It is really too much for my character. I [would] rather sit on the floor in the market of Toluca and sell tortillas, than to have any thing to do with those "artistic" bitches of Paris. They sit for hours on the "cafes" warming their precious behinds, and talk without stopping about "culture" "art" "revolution" and so on and so forth, thinking themselves the gods of the world, dreaming the most fantastic nonsenses, and poisoning the air with theories and theories that never come true. Next morning—they don't have any thing to eat in their houses because *none of them work* and they live as parasites of the bunch of rich bitches who admire their "genius" of "artists." [S]hit and only *shit* is what they are. I [have] never seen Diego or you [Muray], wasting their time on stupid gossip and "intellectual" discussions. [T]hat is why you are real men and not lousy "artists."— Gee weez! It was worthwhile to come here only to see why Europe is rotting, why all [these] people—good for nothing—are the cause of all the Hitlers and Mussolinis. I bet you my life I will hate this place and its people as long as I live. There is something so false and unreal about them that they drive me nuts.[88]

While Kahlo's expression of disgust with the people and environment in Paris may have served to disguise feelings of insecurity about exhibiting in a city so famous for

FIG. 208. Diego Rivera (1886–1957), *Communicating Vessels (Homage to André Breton)*, 1938. Gouache on paper mounted on canvas, 38½ × 47⅔ in. (98 × 121 cm). Musée National d'Art Moderne, Centre Georges Pompidou, Paris.

its avant-garde experiments and her restricted access to theoretical discussions because of her limited French, her reaction also reflects Breton's lack of professional respect for Kahlo as an artist, as evidenced in his lackadaisical treatment of both her time and her artwork. Kahlo's attitude reveals a very real frustration with her inability to control the presentation of her work in Paris and Breton's equation of it with the popular objects he acquired in Mexico, which Kahlo referred to as "all that junk."[89] When she arrived in Paris, Breton had not retrieved the paintings she had sent for the exhibition from customs, nor had he secured a gallery space for the show. And when the Galerie Pierre Colle did finally agree to host the exhibition, the owner initially insisted that only two of Kahlo's paintings could be exhibited because the rest were "too 'shocking' for the public."[90] The "shocking" paintings to which the owner referred were most likely works such as *A Few Small Nips* (exhibited as *Passionately in Love*), *Birth*, and *Suicide* (now known as *The Suicide of Dorothy Hale*), which, with the exception of *Suicide*, were all exhibited in New York.[91] Fortunately, Breton was able to negotiate the inclusion of all of her paintings, but the exhibition was not the solo show she had hoped for.

The exhibition, entitled *Mexique*, which finally opened in mid-March after a month and a half delay, was shaped by Breton's vision of a "fantastic" Mexico, and included more than 144 objects in various media from a vast range of time periods. Among the works on display, in addition to Kahlo's paintings, were pre-Columbian objects primarily from Charles Ratton's collection, and a few from Breton's that he had not sold out of economic necessity; popular objects that Breton had collected in Mexico—masks, dolls, sugar skulls, baskets, ritual objects, nineteenth-century paintings, and retables; more than thirty photographs by Manuel Álvarez Bravo; and a promotional poster by Rivera for Breton's lectures in Mexico entitled *Communicating Vessels* (fig. 208).[92] Kahlo's paintings thus only made up a small fraction of the works on display, and in this context Breton projected onto her work his own fantasies about the exotic "other" and the "myth of the timeless primitive."[93] While the display of both fine and popular art and the juxtaposition of ancient and modern

FIG. 209. Frida Kahlo (1910–1954), *My Nurse and I*, 1937. Oil on metal, 11¾ × 13¾ in. (29.8 × 34.9 cm). Museo Dolores Olmedo Patiño, Mexico City.

objects served the surrealists' objective of collapsing traditional aesthetic categories and setting up unexpected associations, Kahlo rightly felt that this arrangement undermined her status as a modern artist, and the questionable quality of some of the works on display served to downgrade the aesthetic value of her paintings.

The exhibition catalogue opened with a preface by Breton in which he establishes a rhetoric of difference, waxing poetic about his impressions of Mexico: "Its terrain, its climate, its flora, its spirit break with all the laws to which we subscribe in Europe. It inspires an entirely different awareness than that which our limited horizons allow us to experience."[94] To reinforce his presentation of Mexico as an exotic, otherworldly place, Breton claims the works in the show are a "representative collection" of Mexican art from ancient to contemporary. Accordingly, he situates the list of Kahlo's paintings between an inventory of popular objects and a list of the pre-Columbian art in the show, essentially equating her work with indigenous artifacts and crafts. Breton's entry on Kahlo is a slightly modified reprint of the essay he wrote for her

exhibition in New York, discussed previously, in which he portrays her as a fairylike being. Breton was not interested in highlighting Kahlo as a modern Mexican artist, but rather in demonstrating the contextual inevitability of her aesthetic.

Significantly, the only painting by Kahlo reproduced in the catalogue was *My Nurse and I* (fig. 209). (The other works reproduced in the catalogue were a pre-Columbian figurine and two examples of folk art.) While much has been written about this painting from a psychological perspective, in reference to Kahlo's childhood and her fragile bond with her mother, it is Breton's choice of this image to stand in for his ideas about Kahlo and Mexico that is of interest here. For Breton, this painting would have served as a synthesis of the exhibition's themes. By superimposing a Teotihuacán mask on the indigenous wet nurse's face, Kahlo collapses the ancient and the modern, establishing a visual referent for the timeless primitive that so fascinated the surrealists. Moreover, the bizarre juxtaposition of Kahlo's adult head on her infant body and the milk-rain falling from the sky would have appealed to

the surrealists' sense of the uncanny. Thus, for Breton, it proved his theory that surrealism occurred spontaneously in what he perceived to be "primitive" places.

The exhibition also featured *What the Water Gave Me*, one of the paintings that first brought Kahlo to Breton's attention when he saw it unfinished in Mexico (fig. 210). *What the Water Gave Me* is a self-portrait of sorts, depicting incoherent images from the artist's meandering mind while she soaks in the bathtub. Visible beneath the water are her outstretched legs, with her toes breaking the surface near the center of the composition. The toe of her right foot trails blood along the tub wall, alluding to her perpetual pain from a previous injury. On the surface of the water a bizarre, dreamlike scene unfolds: a dead bird is propped in the branches of a miniature tree, a skyscraper erupts from the mouth of a volcano, two female lovers float on a sponge, a corpse hangs from a noose around its neck, and Kahlo's Tehuana dress floats nearby. While this image has often been interpreted according to Kahlo's biography, the extreme juxtapositions of scale and the incoherent narrative rendered in meticulous detail resonated with a surrealist sensibility. It was this image that inspired Breton's promotion of the artist and subsequent invitation to Paris, and as one of the larger paintings in the exhibition, it most likely featured prominently in the gallery. Breton also singled it out for reproduction

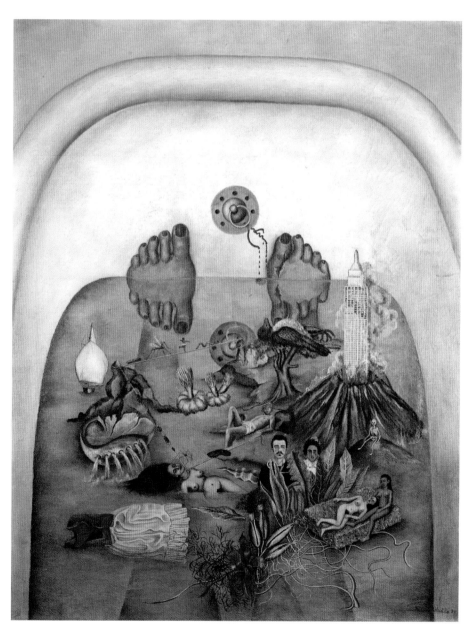

FIG. 210. Frida Kahlo, *What the Water Gave Me*, 1938. Oil on canvas, 35½ × 28 in. (90 × 71 cm). Private collection.

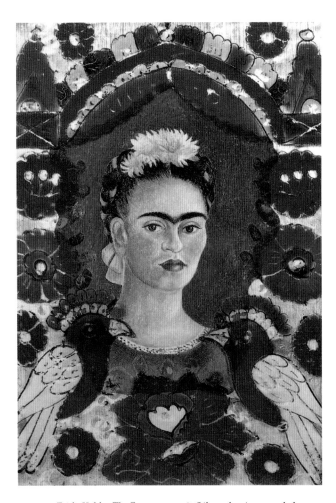

FIG. 211. Frida Kahlo, *The Frame*, ca. 1938. Oil on aluminum and glass, 11⅜ × 8⅔ in. (29 × 22 cm). Musée National d'Art Moderne, Centre Georges Pompidou, Paris.

in *Minotaure* in the May 1939 issue amidst paintings by Tanguy, Paalen, Brauner, Domínguez, and Matta, among others, under the heading "Des tendances les plus récentes de la peinture surréaliste" (The most recent tendencies in surrealist painting), reinforcing his designation of Kahlo as a surrealist.[95]

Despite her irritation with the circumstances of her visit and presentation of her work, Kahlo, in the end, deemed the exhibition a success, not in terms of sales—because, as she proclaimed, "People in general are scared to death of war and all the exhibitions have been a failure, because the rich bitches don't want to buy anything"—but rather in terms of art world exposure.[96] Describing the opening in her characteristically insolent manner, Kahlo writes: "There were a lot of people on the day of the opening, great congratulations to the 'chicua,' amongst them a big hug from *Juan Miró* and great praises for my painting from *Kandinsky,* congratulations from *Picasso* and *Tanguy,*

from Paalen and from other 'big cacas' of Surrealism. In sum I can say that it was a success, and taking into account the quality of the taffy (that is to say the crowd of congratulators) I believe that the thing went well enough."[97] Thus for Kahlo, recognition and validation from the Parisian art world served as a greater indicator of achievement than commercial reward. And while reviews and purchases were few, the French government did buy her painting on aluminum and glass entitled *The Frame,* one of her most colorful and outwardly "folkloric" works in the show (fig. 211).[98] This choice speaks to Parisian museums' preference for foreign art that was decorative and nonthreatening, yet suggested ethnic and cultural difference.

In addition to Kahlo, Breton's *Mexique* exhibition also featured the work of Mexican photographer Manuel Álvarez Bravo. Unlike Kahlo, Bravo did not travel to Paris for the exhibition and therefore maintained even less control over the presentation of his work than she did. Since Breton did not enumerate the works by Bravo in the catalogue, but rather simply listed them as photographs, it is impossible to know exactly which images were displayed. It is nevertheless likely that many of the photographs Breton published with his article "Souvenir du Mexique" in *Minotaure* in May 1939 were among the photographs in the exhibition. Breton chose the photograph *Girl Looking at Birds* of 1931 for the cover of the *Mexique* catalogue (fig. 212). The photograph depicts a young girl in tattered garments sitting on a brick ledge, leaning against the wooden door of a colonial church decorated with ornate circular metal knobs. The knobs form a pattern around three edges of the composition, with the girl occupying the fourth side. Bravo photographed the girl looking intently at the sky, with her arm shading her eyes so that she can look directly into the bright light. The shadow creates a stark contrast between her eyes, which are barely discernable in the darkness, and the lower portion of her face, which is captured in acute detail. Without the title, it would be impossible to know what she was looking at, and it was in this way, without context or label, that Breton reproduced the photograph against a backdrop of deep magenta on the cover of the catalogue. The photograph thus becomes a metaphor for looking at the objects of another culture, as if squinting into the bright sun, trying to discern fleeting shapes without grasping their true form.

For Breton, Bravo's photographs demonstrated a new and revolutionary approach to capturing Mexican

life. Breton was not interested in stock images of the country's local culture and landmarks, and in his short essay on Bravo for the *Mexique* catalogue, laments the current tendency in Mexican photography to employ the simplistic device of "surprise" at local difference to garner the foreigner's attention. For him, this type of photography could not possibly encapsulate the "soul of the country." But Bravo, with his "passionate investigation" of Mexico, has achieved what Breton calls "an admirable synthetic realism" that reveals "everything that is wretched about Mexico." He goes on to laud his "infallible technique" and "unique discernment." For Breton, it

was Bravo's willingness to focus on the abject, the underbelly of Mexican society, that distinguished him from his contemporaries and aligned his work with surrealist sensibilities.[99]

Breton mentions one photograph by name in his tribute to Bravo in the catalogue, singling out *Worker Killed in a Brawl* as having achieved what Baudelaire deemed "*eternal style.*"[100] The photograph he is referring to is most likely the same as the image labeled as *After the Riot (Tehuantepec)* and now known as *Striking Worker, Assassinated* (fig. 213), which Breton chose to open his essay "Souvenir du Mexique." What is interesting here

FIG. 212. Cover of André Breton, *Mexique* (Paris: Renou et Colle, 1939), with a photograph by Manuel Álvarez Bravo (1902–2002), *Girl Looking at Birds,* 1931.

FIG. 213. Manuel Álvarez Bravo, *Striking Worker, Assassinated,* 1934. Photograph.

is that when Breton first honed in on this image, he did so not for its political significance—since he understood it as a worker killed in a brawl—but rather because it exemplified "the power of conciliation of life and death [which] is no doubt Mexico's primary allure."[101] The photograph is a close-up shot of a slain man with blood streaming from his eyes and nose and pooling in the dirt around his head. His shirt and trousers are spattered in blood. The camera angle is not from above, but rather directly level with the prone body, giving the image a sense of immediacy and repulsion that would not have been possible from another vantage point. While the quantity of blood indicates the man's demise, his smooth skin and everyday clothing make him seem alive. In capturing this moment between life and death, Bravo created an image that approximated a surrealist sensibility in both its subject matter and brazen style. Once again, it was Breton, not Bravo, who made this connection, however.

Following the *Mexique* exhibition, Breton decided to feature prominently Mexican artists in an issue of *Minotaure* published in May 1939. He asked Rivera to create a special frontispiece and back cover for his essay, creating a sort of journal within a journal (fig. 214). Rivera's frontispiece depicted the dead minotaur, slain by Theseus, at the center of the labyrinth. Rivera twisted and distorted its proportions to present the bull's oversized head, spurting stylized streams of blood, from directly above. The minotaur's human limbs create a spiral around the head, in a manner reminiscent of the famous Aztec Coyolxauhqui Stone, which is continued in the brick walls of the labyrinth; these spirals are united visually by the uniform coloring that carries over from body to walls. The minotaur's yellow horns point down, directing the reader's gaze toward the journal's title, printed below in letters that resemble Mayan glyphs. Surrounding the minotaur are human skulls and bones, suggesting the

FIG. 214. Diego Rivera, Graphic design for frontispiece of "Souvenir de Mexique," *Minotaure* 6, nos. 12–13 (May 1939). Museo Nacional de Arte, Biblioteca de Arte Mexicano Ricardo Pérez Escamilla, Mexico City.

savage deaths of those condemned to walk the labyrinth. These motifs simultaneously refer to the Maya and Aztec traditions of sacrificial death, making Rivera's print the type of dual image so esteemed by the surrealists, and affirming Mexico as an integral part of Breton's notion of a universal primitive and a font of surrealist energy.

The issue featured Breton's famous essay "Souvenir du Mexique" illustrated with ten photographs by Bravo, in addition to photographs of Mexico by Fritz Bach, including one of Rivera, Trotsky, and Breton; photographs by Raoul Ubac of the popular objects Breton acquired in Mexico; two paintings by Diego Rivera (*The Couple* and *Casahuatl* [*Guerrero-Taxco*]); several examples of retables and popular art; and a print of Zapata by José Guadalupe Posada.[102] In other words, the spread presented a conglomeration of unrelated images chosen by Breton to construct a vision of Mexico in line with a surrealist sensibility. In his essay, Breton discusses several of the photographs by Bravo. He describes in detail the formal rhythms in a photograph now known as *Ruin* (1931), calling the placement of a phonograph on top of a coffin in the lower-left corner "poetically shocking" (1939; fig. 215). He also describes the "mysterious relationship" between "daisies flowering amid rubbish" and "arches of white feathers" in a Native American cemetery in *Recent Grave*

FIG. 215. Manuel Álvarez Bravo, *Recent Grave*, 1939. Photograph.

(1939), labeled in *Minotaure* as "Ixtapalapa."[103] Significantly, the photographs that most intrigued Breton and which he singled out as examples of Bravo's surrealist sensibility were those that presented death as an arbitrary event in daily life, an understanding of death that conflicted with a European bourgeois desire to isolate it from the quotidian.

While Breton's essay extols the sheer poetry of his experience in Mexico, in particular his visit to Guadalajara with Rivera, it is steeped in clichés about the "desire and danger" of the country and the timelessness of Mexican culture. For him, Mexico was the only place in the world where popular traditions persisted and where art was therefore "made by everyone, for everyone."[104] He goes on to proclaim that place, the Mexican soil, and its "millennial roots" manage to "transcend the progression of time," thereby collapsing past, present, and future into a "mental landscape of surrealism."[105] For him, the experience of traveling around Mexico parallels that of automatic writing: "Mexican roads rush into the very regions where automatic writing revels and lingers."[106]

While the designation of the artists Izquierdo, Kahlo, and Bravo as surrealists conflicted with how they conceived of their own work, Artaud's and Breton's attention to and promotion of these artists brought recognition to their work in and outside Mexico and positioned it as part of a transnational avant-garde sensibility. The downside, however, was that it became difficult to extricate an understanding of their production from the surrealist identity imposed upon them. The surrealist lens through which Breton viewed their work, while Eurocentric in some regards, did allow for the beginnings of a transatlantic dialogue and a new means of approaching the contemporary art of non-European cultures. This association with surrealism was thus a double-edged sword; it expanded the circulation and knowledge of Mexican art, while simultaneously reinforcing Eurocentric and paternalistic assumptions about the nature and impetus behind the art produced there.

Breton's fascination with Mexico did not end with his promotion of Mexican artists in Paris. In 1940 he helped coordinate from afar, with Moro and Paalen, the *Exposición internacional del surrealismo* at the Galería de Arte Mexicano in Mexico City. This exhibition, while beyond the scope of this book, initiated a new phase of transatlantic surrealism that continued to inspire both explorations and contestations of the movement in Latin America for decades to come.[107]

BRETON'S NEW RECRUITS:
ROBERTO MATTA AND WIFREDO LAM

In the same issue of *Minotaure* that featured "Souvenir du Mexique," Breton reproduced the work of another now world-renowned Latin American artist, the Chilean Roberto Matta. Unlike the Mexicans, Matta came to surrealism on his own accord and actively embraced the movement's precepts. Since Matta never explored issues of cultural identity in his work, and instead took an interest in the surrealist practice of automatism, Breton did not single him out as a representative of a global surrealism. Rather, he included him as part of a second generation of surrealists who Breton anticipated would regenerate the movement. Matta made several unique contributions to surrealism that served to invigorate theoretical discussions and surrealist experimentation in the years just prior to World War II. First, he introduced architecture as a surrealist space and incorporated principles of architectural design in his conceptualization of visual environments. Second, like Torres García, Matta was a prolific theoretician, frequently articulating his ideas in writing, thereby expanding notions of surrealism and challenging some of its key principles.

Salvador Dalí introduced Matta to Breton in the fall of 1937. Prior to this meeting, Matta, who had trained as an architect, had been an apprentice to Le Corbusier from 1934 until 1936.[108] His exposure to surrealism inspired Matta to reconsider a career as an architect, and he soon took up painting. But it was his architectural training and foundation in high-level mathematics that informed his unique approach to surrealism and gave him a facility in rendering complex spatial systems.[109] For Breton, Matta's fresh interpretation of surrealist methodologies provided the new energy that the movement needed.

Before his contact with the surrealists, Matta regarded his drawing practice as a "casual hobby."[110] It was his friend the British-American surrealist Gordon Onslow Ford who recognized the significance of his drawings: "He invited me to his room, where, to my astonishment, amidst the banal *chinoiserie* of our hostess, were pinned his most exciting drawings, made with coloured pencils—the most extraordinary landscapes, full of maltreated nudes, strange architecture, and vegetation. . . . I left that room a different person. . . . When we did see each other again, a conception of a new art crystallized."[111] Soon after, when Breton saw Matta's drawings for the first time, he had a similar reaction and invited him to join

the surrealist group. Describing that early meeting with Breton, Matta writes: "That evening [December 31, 1937] Breton, with his enormous love for everything, and with all his ferocity, revealed to me the sub-reality of my everyday life, and gave me the weapons with which to fight so that my reality could be a super-reality, more humane, more just, and more beautiful."[112] Not only did Breton find in Matta a new protégée, but Matta also felt that contact with Breton opened up new possibilities for the way he approached his art and his life. The relationship was thus one of mutual benefit.

Matta's first official collaboration with the surrealists was his participation in the *Exposition internationale du surréalisme* organized by Breton and surrealist poet Paul Éluard at the Galerie des Beaux-Arts in January and February 1938. For the exhibition, Breton and Éluard created a surrealist street lined with mannequins posed as prostitutes and dressed by artists Arp, Dalí, Ernst, Duchamp, Man Ray, Miró, and Tanguy, among others. While Matta was listed in the catalogue among those who dressed a mannequin, there is no photographic record or description of his contribution. In another room Duchamp covered the floor with moss and dead leaves and hung sacks of coal from the ceiling, among which were displayed the works of art hung on revolving doors. The exhibition featured 229 objects by sixty different artists from all over the world. In accordance with Breton's interest in globalizing surrealism, the catalogue records the countries represented in a separate list underneath the artists' names. But strangely, neither Chile (Matta) nor Argentina (Negri) appear among the fourteen countries named, excluding Latin America from the surrealist world.[113] This exclusion reflected the surrealists'

FIG. 216. Anonymous, *Surrealist Map of the World.* Reproduced in *Variétés* (Brussels), June 1929, 25.

conception of Latin America as portrayed in the 1929 surrealist map of the world that exaggerated Mexico, but reduced South America to a tiny island and labeled Peru and Mexico as the only countries of relevance (fig. 216). For the surrealists, only the archaeological sites of ancient America merited recognition, not the loci of contemporary artistic production. Since Matta was fluent in French and, like Moro, did not acknowledge cultural heritage in his work, he was not singled out as "other" by the surrealists.

Matta's contributions to the exhibition included four drawings all made in 1937 labeled *Scenario no. 1* to *Scenario no. 4*. *Scenario no. 1,* a pencil drawing subtitled *Sun's Suction Panic,* is an entirely abstract intricate web of lines and undulating biomorphic forms (fig. 217). The shapes twist and turn, creating a sense of depth and volume with no reference to human scale. The image therefore simultaneously suggests a microcosm and a macrocosm, the magnification of a cell and the fluctuations of a galaxy. The title, however, alludes to the latter—the powerful gravitational pull of the sun on everything around it. In the lower-left-hand corner is a menacing vagina dentata, a popular motif among the surrealists, with red-orange teeth and a bright yellow center that seems to be consuming or sucking its extremities into itself. The drawing thus evokes an overall sense of tension and peril. While Matta completed these drawings before coming into direct contact with the surrealists, their free-flowing format and rippling organic shapes resemble the works of artists who engaged in automatist experiments such as Masson, Arp, and Domínguez.

In addition to inviting Matta to participate in the international surrealist exhibition, Breton asked him to create an illustration for an edition of the *Oeuvres complètes d'Isidore Ducasse Comte de Lautréamont,* and to submit an essay to the surrealist journal *Minotaure* about the confluence of architecture and surrealism. Written in French and adapted for publication by Georges Hugnet, the resulting essay, "Mathématique sensible—Architecture du temps," which was illustrated with Matta's collage *Project for an Apartment,* appeared in the spring 1938 issue (fig. 218).[114] In it Matta envisions an apartment as a malleable, womb-like space, the antithesis of Le Corbusier's rigid modernist aesthetic, proclaiming, "We need to cry against the digestions of right angles in the midst of which one allows oneself to be brutalized."[115] Instead Matta advocates spaces that would "cybernetically adapt themselves

FIG. 217. Roberto Sebastián Matta Echaurren (1911–2002), *Scenario No. 1: Sun's Suction Panic*, 1937. Colored pencil and lead pencil on paper, 19⅔ × 25⅔ in. (50 × 65 cm). Private collection.

to the occupant."[116] He calls for "walls like damp sheets" and "furniture which rolls out from unexpected spaces, receding, folding up, filling out like a walk in the water. . . . This furniture . . . would open itself to the elbow, to the nape of the neck."[117] Not only would the space adapt to the occupant's physical contours, it would also morph to accommodate the inhabitant's mood and conform to each individual's disposition.

Matta's collage *Project for an Apartment* illustrates precisely his vision for such a space. The caption next to the image reads: "A pure space to make one aware of human verticality. Different plans, a staircase without banisters to master the void. Psychological ionic column. Flexible pneumatic seating."[118] It goes on to list the proposed materials: "Inflated rubber, cork, various papers, concrete, plaster, a rational architectural framework."[119] Despite the specificity of the list, this was not a space that could actually be built, but rather it was a psychological environment with ever-changing dimensions and surfaces. The collage depicts an open living area that unfolds to reveal levels

above and below. In the center-left a trapezoidal section of the floor is simply removed to reveal a lower level replete with strange organic furnishings. But there is no obvious means to descend into this space, nor is there a rail to protect the inhabitants from falling. A strange cross-like totem pole projects from below, connecting the various levels while projecting an ominous shadow on the floor. On the right, a backless staircase winds precariously up to a skylight, indicated by a photo-collage of trees and sky, but there is no corresponding upper level. Several other cutouts of outdoor scenes act as windows along an undulating back wall, along which warped planes create alcoves almost at whim. A man and a woman, cut from a magazine or newspaper, occupy the apartment. The woman reclines in the foreground in a chair that seems to meld to her body, while the man has just entered along a narrow entryway that appears to have extended out to meet him. He wears a coat and hat as if he were just returning home from work. The seeming normalcy of the couple contradicts the extreme strangeness of the space that, if

it functions as Matta describes in his essay, reveals in its twists, turns, and transformations a psychological profile of the occupants. Thus, what Matta contributed to surrealism was a new vision of architecture, one that rejected the concrete and the logical and instead responded to the inner desires and needs of its occupants.

From this point forward, Matta became more and more integrated into surrealist group activities. In the spring of 1938 Matta and his wife, Anne, visited Onslow Ford in Switzerland, and it was there that he tried his hand at painting.[120] Onslow Ford describes Matta's process: "He squeezes little dollops of yellow, red, green and blue along the edge of a palette knife—then, without hesitation, he made a rapid gesture on a white canvas and, as he did not wish to use the clean brushes, he worked the paint with his fingers, one finger for yellow, one for red, etc. In this way the paint was spread out, and the colours were mixed on the canvas. This technique remained the basis of his oil paintings for many years."[121] The two couples went on to spend the summer in Trévignon on the coast of France, where Matta completed his first six oil paintings and began to elaborate his theory of "psychological morphology":

"Psychological morphologies": inventing visual equivalences to various states of consciousness. I refuse to agree that a juxtaposition of "received" images, however striking the effect of certain rapprochements—collages—can really testify to what we feel in a given situation. I want a morphology that does not stop at the outline, at the epidermis of people and things. The image of a tree is not the greenery gathered around its trunk, standing out with varying sharpness and grace from a colored background. The image is actually the sum total of all we know of seed and germination, the sudden blossoming of buds, the shadow cast by the tree, the image of the infinite sadness it evokes when laid bare on a winter's day. Rather more, it is everything the word "tree" can bring into our field of consciousness as emotive images, many of which have nothing to do with the image of a tree, but nevertheless require the presence of this image in order to exist.[122]

What is significant in this explanation is that Matta specifically challenges the surrealists' embrace of collage, calling the individual pieces of a collage merely "received images." For Matta, these "received images," while they

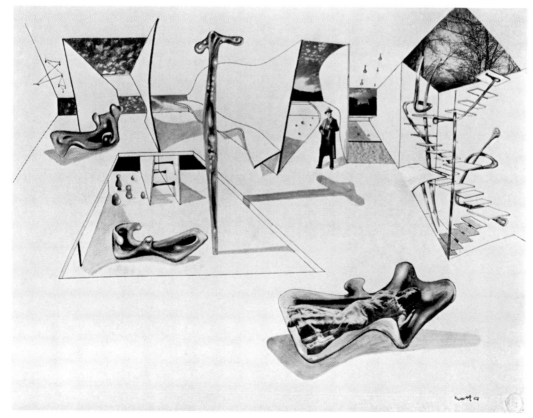

FIG. 218. Roberto Sebastián Matta Echaurren, *Project for an Apartment.* Illustration for Matta Echaurren, "Mathématique sensible–Architecture du temps," *Minotaure,* no. 11 (Spring 1938): 43.

may create a stimulating or surprising visual effect, only represent an external reality. He proposes instead a new theory of representation that takes into account emotive or internal responses to any given visual stimulus, what he calls "inscapes."

When Matta returned to Paris in the fall of 1938, he attended a surrealist meeting at the café Deux Magots, where he attempted to explain his theory of psychological morphology to Breton. Breton, in turn, requested that he articulate his theory in writing.[123] The resulting essay, while not published until much later, laid out a unique approach to art-making that went beyond the surrealists' attempts to tap into unconscious desires and impulses via automatism and collage to propose a means of visualizing alternative or changing temporal and physical states. For Matta, "The conception of a psychological temporal medium in which objects are continually being transformed leads one to compare it with a Euclidean space in rotary and pulsatory transformation." In other words, he sought to transcend the single system of spatial measurement elaborated in Euclidean geometry to reveal parallel dimensions. A morphology was, according to Matta, the graphic representation of an object's "absorption and emission of energies" in time and space, not just an expression of optical virtuosity. This time his target is not collage, but rather Dalí's paranoic-critical method: "The attempts of the symbolists, the so-called critical paranoiacs, are based on a transformation of optical images in a caricatural sense, and the same applies for the forms of so-called abstract art."[124] He tacks on a critique of abstract art for its similar lack of emotional depth and emphasis on the optical. For Matta, art must penetrate the inner workings of the mind, revealing unseen connections and states of flux.

The corresponding paintings also greatly pleased Breton. As Matta recalls: "When we [Matta and Onslow Ford] arrived in Paris and showed them to Breton, he found them incredible, formidable. He published a color reproduction of one in the following edition of *Minotaure*. That never happened to anyone in that epoch!"[125] Breton's support led Matta to submit two of his paintings, *Optical Pneumatic* and *Psychology Morphology,* to the Salon des Indépendants in the spring of 1939. Since Matta made various drawings and paintings between 1938 and 1939 that he titled *Psychological Morphology,* it is impossible to determine exactly which one was exhibited at the salon. But it may have been the same painting Breton published

in *Minotaure,* known today as *Morphology of Desire* but labeled in *Minotaure* as *Psychological Morphology* (fig. 219). Composed mostly of bright primary colors, the painting captures a sense of energy and movement. Amorphous shapes swirl around one another and seem to fade in and out of focus. In the lower center a group of intersecting triangles and trapezoids emerge that seem to be pulled or sucked in opposite directions by a red form in the upper left and an ominous black and red blob in the lower right. In the upper right a jagged yellow and black form, with smaller daubs of red and blue, seems to be swooping in from above. While there is a certain optical virtuosity to Matta's composition, the shifting focus, rendered by contrasting sharp edges with blurred contours, and bold color with muted tones suggests the flux between physical and temporal states that Matta describes in his essay.

On the eve of World War II, Matta once again joined the surrealist group for a period of intense artistic activity. Onslow Ford had rented a château in Chemillieu in the Rhône Valley near the border of Switzerland, where many of the surrealists congregated for their summer holiday to paint and write. Among the group were Breton and his wife and daughter, Esteban Francés (Spain), Ithell Colquhoun (Britain), Kay Sage (United States), Yves Tanguy (France), as well as Matta and his wife. Onslow Ford describes the scene: "After dinner in the evenings, when it was too cold to work in our studios, or too wet to venture out of doors, we gathered round the fire and André Breton read us passages from the German Romantics and Baudelaire, Rimbaud, Lautréamont, Apollinaire, Jarry and others, illuminating them for me for the first time with his poetic vision. He told us of the twenties and early thirties in Paris, of poems, pictures, books, struggles and adventures. What a joy it was to feel the roots of the family tree, to feel that it was alive, had many branches and was growing!"[126] In this context of creative interchange, Matta solidified his approach to painting. His time with the surrealists provided the foundation for his future artistic production, imparting the intellectual stimulation and aesthetic tools he needed to establish himself as an artist. The flow of benefit was not just one way, however. While Matta joined the movement after it had been in existence for more than a decade, he formed part of a new generation of artists whose theories and aesthetic approaches revitalized surrealism, taking it in new directions even as war began to disperse its members. By the fall of 1939, with the outbreak of war, Matta

FIG. 219. Roberto Sebastián Matta Echaurren, *Morphology of Desire*, 1938. Oil on canvas, 28¾ × 36¼ in. (73 × 92.1 cm). Private collection.

was on a boat headed for New York, where he would join up with many of his former surrealist colleagues, inaugurating a new phase of the movement on the other side of the Atlantic.[127]

After Matta left the country, Breton and several other members of the surrealist group held on in France as long a possible, hoping the situation would improve. But by the summer of 1940 most of those who remained, including Breton, Pierre Mabille, René Char, Ernst, Brauner, Domínguez, Masson, and Benjamin Péret, were forced to escape to Marseilles, where they stayed at the Villa Air-Bel, the official headquarters for the "Defense of Intellectuals Menaced by Nazism" run by Varian Fry, until they could obtain passage out of the country.[128] It was in Marseilles, during surrealism's last European interlude until after World War II, that the Cuban artist Wifredo Lam, who will be discussed further in the next chapter, first came in contact with the surrealists.

During his visits to Air-Bel, Lam, who was also trying to leave the country, participated in surrealist games organized by Breton, leading Breton to ask Lam to illustrate his poem *Fata Morgana*.[129] Lam made numerous preparatory drawings for Breton's poem and eventually chose six for the final publication (fig. 220). The dynamic line drawings Lam created, inspired by automatism and the exquisite corpse game, mark a transition from his exploration of Picasso to his signature style. Inspired by the surrealists, Lam began to invent horse-headed females, horned hybrid creatures, and visual puns involving sexual organs that later became distinguishing features of his paintings.[130] While his engagement with the surrealists was quite short-lived, as it was for Matta, this contact marked an important transitional moment in his work. Yet, unlike Matta, because of his Afro-Cuban heritage Lam was subject to the primitivizing assumptions that marked Breton's assessment of Mexico. As Breton writes in 1941: "Lam started off with a great fund of the marvelous and the primitive within him."[131] In other words, Breton believed that through his race and culture, Lam had an inherent connection to the nebulous concept of the primitive defined by European minds, and that he was merely a conduit for the expression of his innate ethnic identity.

Thus, Breton's recruitment of Latin American artists fell into two categories: those whom he felt contributed

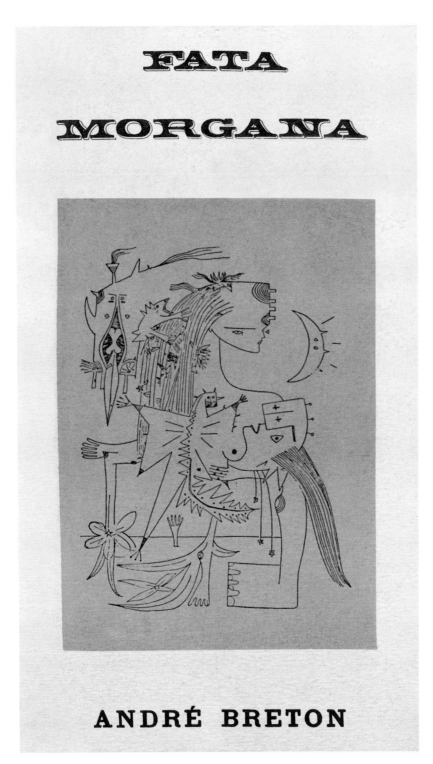

FIG. 220. Wifredo Lam (1902–1982), Cover of André Breton, *Fata Morgana*, trans. Clark Mills (Chicago: Black Swan, 1941).

intellectually to the movement and those whom be believed embodied an innate primitivism that was inherently surrealist. Breton's preconceptions and prejudices stemmed from an ingrained Eurocentrism that, despite the surrealists' anti-colonialist stance and attempts at reversing traditional cultural hierarchies, he was unable to transcend. By reaching out to Latin American artists, however, he expanded the movement's reach and incorporated a diverse range of artists into a transnational dialogue about surrealist practice. Moreover, outside Breton's immediate circle, many artists incorporated, challenged, and transformed surrealist ideas in myriad ways in their work. Latin American artists' engagement with surrealism in Paris between the wars was thus a sustained and significant exploration of the movement's theories and approaches on every level.

10 A Pre–World War II Resurgence

By the 1930s conditions had changed dramatically in Paris. The stock market crash severely affected the art market, and exhibition opportunities quickly dried up. Moreover, the xenophobia spurred by the inundation of foreigners into France and the increasing fascist presence in Spain, Italy, and Germany made Paris quite a different city from what it had been in the previous decade. French poet Maurice Henry writes in a letter to César Moro, who had already left Paris for Peru: "And I assure you that in France foreigners are getting really bad press—according to bourgeois journals, foreigners are responsible for everything and several thousand workers have been driven back to the borders—if they are foreigners, they are like the Jews in Germany or blacks in the USA.[1] Pedro Figari also expresses anxiety about the situation in a letter to Manuel Güiraldes: "Every day I feel more and more like leaving, so much more so because for some time now the environment here, besides getting darker and darker, does not allow any hope of feedback, especially for painters. . . . South Americans don't stay here anymore except in homeopathic doses."[2] Fortunately for Figari, in November 1933 he obtained a post as the advisor to the minister of public education and was able to return to Uruguay in May 1934.

While most of the Latin American artists who had arrived in Paris in the mid- to late 1920s had returned home by the early 1930s because of economic challenges and increasing xenophobia, those who had put down roots in Paris, such as Angel Zárraga, Vicente do Rego Monteiro, Carlos Alberto Castellanos, Manuel Ortiz de Zárate, and Pablo Curatella Manes, remained in Europe throughout the decade. Almost no new artists were arriving, however, and the possibilities for exhibitions were few and far between. Sales declined drastically at Parisian galleries, and some venues went out of business.[3] Castellaños writes in 1932 about how desperate the situation had become: "I have not painted for this whole time—and the money isn't coming in either, I live the life of a poor person and am deprived of many things—I have to make the bed and clean the studio which I would be happy to do if only I could keep the studio that I have rented in the same house on the first floor."[4] Despite his efforts, Castellanos soon lost his studio and his belongings, which the landlord kept as payment. He left Paris for a time, traveling to Mallorca, Algeria, and Spain until the Spanish Civil War forced him to return to Paris in 1936. Cuban artist Marcelo Pogolotti writes: "Every day I went on foot

from the outskirts to the center of Montparnasse to try to sell a drawing or to earn some money. It was the worst period in France."[5] Moreover, according to Pogolotti, by the late 1930s Montparnasse had fallen into decadence and there were no Latin American artists of importance left there: "Once a week Montparnasse was inundated with a wave of petit-bourgeois vacationers . . . the atmosphere had completely changed. . . . Montparnasse was increasingly alien to me and even came to depress me."[6] Despite the circumstances, these artists hung on in their adopted country, but Paris no longer sustained artists, as it had in the previous decade. Even when circumstances began to improve slightly, toward the end of the decade, exhibitions tended to highlight presentations of cultural nationalism rather than experimental or alternative artistic approaches. There were, however, a few voices of resistance, both politically and aesthetically, that provide a point of contrast to the widespread desire to pin down national aesthetic identities.

EXPOSITION INTERNATIONALE DES ARTS ET TECHNIQUES DANS LA VIE MODERNE

The situation began to improve somewhat in 1937 with the *Exposition internationale des arts et techniques dans la vie moderne.* The exposition refocused attention on the arts and world cultures with the opening of the Musée de l'Homme and the Palais de Tokyo, which housed the Musée d'Art Modern de la Ville de Paris. The Jeu de Paume also hosted an exhibition of its holdings of foreign art, *Origines et développement de la peinture internationale*

FIG. 221. Marcelo Martinez de Hoz, Argentina pavilion at the *Exposition internationale des arts et techniques dans la vie moderne*, Paris, 1937. Reproduced in Jacques Laprade, "La peinture et la sculpture. Exp. Internationale," *Beaux-arts: Chronique des arts et de la curiosité*, September 24, 1937, 3.

contemporaine, in conjunction with the exposition.[7] Unlike the 1925 fair, where Latin American contributions were minimal,[8] six Latin American countries—Argentina, Brazil, Mexico, Peru, Uruguay, and Venezuela—constructed pavilions for the exposition.[9] The exposition thus provided a rare opportunity for the presentation of Latin American art in Paris in the late 1930s.

The pavilions of Argentina and Uruguay were featured prominently in the French press. The Argentine pavilion, in particular, foregrounded the importance of art and architecture to the country. Designed by engineer Marcelo Martínez de Hoz, the austere modernist pavilion consisted of a tall, blocky tower—disturbingly similar to that of the German pavilion—with a simplified classical facade (fig. 221).[10] Inside was a Spanish-style courtyard, which also served as a sculpture garden. Sculptor Pablo Curatella Manes was commissioned to create an enormous bas-relief map of Argentina, which French critic Maurice Raynal praised for allowing "geographic accuracy" to "yield to the lyrical figuration of the country," evoking "the no less real poetry of ancient world maps."[11] While there were rooms dedicated to industry, tourism, public services, and social and economic developments, the display of fine arts dominated the presentation of Argentine culture, since artist Rodolfo Alcorta was the commissary general of the republic of Argentina and Curatella Manes acted as jury. The exhibition was expansive, featuring works by several dozen painters and sculptors, including such members of the Grupo de París as Alfredo Bigatti, Lino Spilimbergo, Hector Basaldúa, Raquel Forner, and Horacio Butler, as well as other artists with experience in Paris, José Fioravanti, Alberto Lagos, Gonzalo Leguizamón Pondal (1890–1994), and Hilda Ainscough.[12] The exhibition did not include the work of more radical artists working in abstract modes such as Juan del Prete, however, indicating a deliberate choice on the part of organizers to present a more moderate view of Argentina's artistic production.

The conservative journal *Beaux-arts: Chronique des arts et de la curiosité* ran a full-page spread on the exhibition with numerous illustrations of the pavilion, highlighting the significance of Argentina's artistic presence in Paris. Several sculptures by Alfredo Bigatti, a painting by Raquel Forner, furniture designed by Nordiska Kompaniet, as well as an installation view of the exhibition of painting and sculpture accompanied the article written by Jacques de Laprade. Yet Laprade asserts that there was no

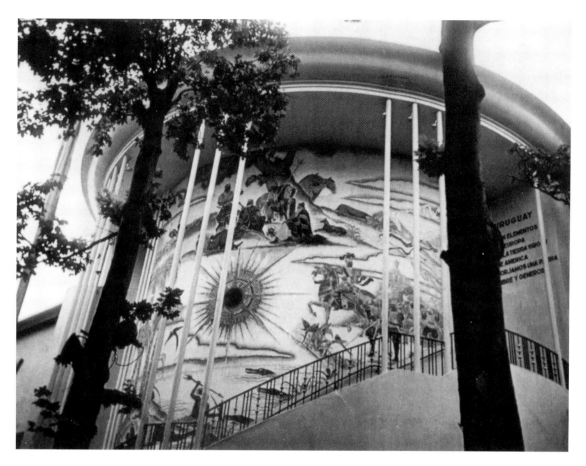

FIG. 222. Carlos Alberto Castellanos, Mural for the Uruguay pavilion, at the *Exposition internationale des arts et techniques dans la vie moderne,* Paris, 1937.

evidence of a national tradition in Argentine art because it "is still in the process of formation."[13] Thus, at the end of the 1930s, Latin American countries continued to confront the assumption that the art produced there was derivative of European tendencies, when it should have been based on national differentiation. According to Laprade, only those nations close to Central America "have retained elements of a sumptuous past," whereas Argentina maintained its ties to Europe.[14] Despite his criticisms, Laprade does praise the "artistic freedom" that differentiated the work sent for the 1937 exposition from that of previous presentations of Argentine art in Paris.[15] Unlike Laprade, other reviewers identified specifically national characteristics in the art. Gilles de la Tourette, for example, writes of the "genius of a race that has the tendency to present itself in lyrical and sentimental ways, with strong dense materials, like the rich Argentine soil."[16] While most of the artists represented did not travel to Paris for the exhibition, the fair served to reassert Argentina's cultural alliance with France and the importance of intellectual exchange that had been absent for the past few years.

It also pushed a highly nationalistic agenda, however, that stifled the voices of artists who wished to resist such formulas.

The other country to present artistic identity prominently in its pavilion was Uruguay. The Uruguay pavilion was a massive rotunda with an illuminated map of the country on one facade, a mural depicting Uruguay's tourism industry on another, and on the wall above the main exterior staircase, a mural by Carlos Alberto Castellanos entitled *With European Elements, in the Virgin Earth of America, We Forge a Free and Generous Homeland* (fig. 222).[17] As discussed previously, Castellanos was a known entity in Paris; he was a significant presence at the salons, and the Galerie Durand-Ruel held a major retrospective of his work in 1927, but he struggled financially in the 1930s.[18] Executed in a clear, naturalistic style, Castellanos's mural measured over one hundred square meters and depicted the principle periods and figures of Uruguayan history, including its indigenous heritage, the Spanish conquest, the gaucho, the worker, soldiers for independence, and the modern city, surrounding a vibrant South American

sun. The mural brought Castellanos back into the spotlight and won him a painting prize at the *Exposition internationale* as well as the Legion of Honor from the French government.[19] Uruguayan artists featured inside the pavilion included José Cuneo (1887–1977) (who also had a solo show at the Galerie Jeanne Castel in 1938), Milo Beretta (1875–1935), Gilberto Bellini (1908–1935), and Germán Cabrera (1903–1990). Again, notably absent were more experimental artists, such as Pedro Figari and Joaquín Torres García, whose work did not fit the vision of the country promoted by organizers. While the political climate and general format of the exposition perhaps deterred the presentation of avant-garde art, the absence of important artists from both Argentina and Uruguay indicates the intensely conservative and highly nationalistic environment, especially in official contexts, of the prewar years. The exhibition, did, however, bring Latin American art back into the public eye in Paris, where it had virtually disappeared since 1933.

TWO BRAZILIANS EXHIBIT IN PARIS

Since Brazil occupied a pavilion donated by the French government, rather than designing its own building, large murals and sculptural decor were not part of the plan. The French-Brazilian Coffee Company did, however, commission Brazilian artist Emiliano di Cavalcanti to paint murals for its pavilion. Now lost, these murals earned di Cavalcanti a gold medal for his achievement and brought him recognition in the Paris art scene. Simultaneously, his work was featured in a solo exhibition at the Galerie Rive Gauche. The gallery had planned a series of exhibitions of contemporary painters from Latin America in conjunction with the *Exposition internationale*.[20] Founded in 1935, the Galerie Rive Gauche was a relatively new establishment trying to get on its feet in a difficult economic climate. The fact that an independent gallery took as a project a series of exhibitions of Latin American art indicates the changing landscape and acknowledgment of "Latin America" as an aesthetic category worthy of recognition in Paris. This was the first time, with the exception of the Galerie Zak, when a gallery that did not promote Latin American culture as part of its official mission—as did the Cercle Paris-Amérique Latine, which organized exhibitions of Latin American art in the 1920s—decided to focus on Latin American art on its own initiative.

Despite the Galerie Rive Gauche's intentions, the series did not materialize. The wording of an invitation sent to Brazilian artist Cícero Dias (1907–2003) suggests that the gallery made a broad call for participation, but the only Latin American artist to actually exhibit with the gallery was di Cavalcanti.[21] Di Cavalcanti had spent several years in Paris between 1923 and 1925, working as a correspondent for the journal *Correio da manhã* in Rio de Janeiro and studying briefly at the Académie Ranson, but did not exhibit during this earlier visit. He returned in 1936 to Paris, where he worked for the radio station Diffusion Française while continuing to paint. The Galerie Rive Gauche sponsored the first solo exhibition of di Cavalcanti's work in Paris in June 1937 in conjunction with the *Exposition internationale* and later held a second show in December 1938.[22]

While there is very little record of these shows, among the works exhibited were most likely paintings such as *Girls with Guitars* of 1937 (fig. 223). The scene depicts three rather corpulent mulatta women as three Brazilian graces. The two with guitars squeeze onto a small sofa and a third, in a luminous orange dress, sits rather awkwardly in the space behind them. The women are not playing their instruments, but rather staring with melancholy at the viewer, perhaps reflecting di Cavalcanti's nostalgia for his homeland. The room in which they sit opens onto a balcony overlooking the sea, and a vase of tropical flowers, in the same shade of orange as the third woman's dress, decorates the table. On the wall behind them is a Brazilian flag. While the image is entirely readable, di Cavalcanti has appropriated the modernist technique of tipping the space sharply upward and stacking and compressing the figures to emphasize the flatness of the picture plane. The corpulence of his figures resonates with the general trend in France in the 1930s of monumentalizing the female form, linking her to the land and notions of fertility.[23] Pictures such as this one, while highlighting Brazilian national identity, employed modernist visual languages familiar to Parisian audiences as a means to communicate a sense of unity across cultural boundaries, as well as a common embrace of tradition and regionalism.

With the heightened emphasis on national character in the context of the *Exposition internationale*, di Cavalcanti's work perfectly matched Parisian expectations. The review of his June 1937 exhibition in *Beaux-arts: Chronique des arts et de la curiosité* proclaims that "his works sing of the customs and ports of Brazil." While highly laudatory, the reviewer's language is steeped in prejudice about the Latin American character, however, calling di Cavalcanti's style

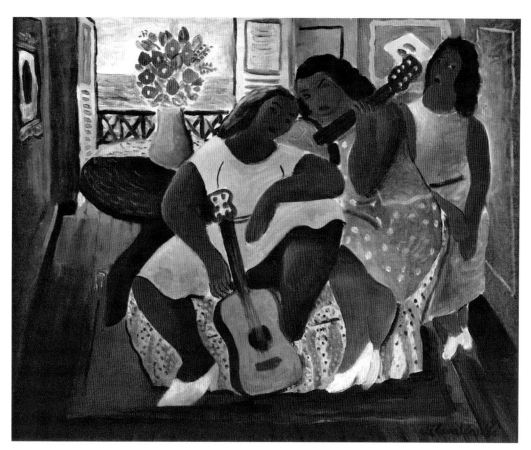

FIG. 223. Emiliano di
Cavalcanti (1897–1976),
Girls with Guitars, 1937.
Oil on canvas, 19⅔ × 24 in.
(49.8 × 60.8 cm). Gilberto
Chateaubriand Collection,
Museu de Arte Moderna,
Rio de Janeiro.

"ardent," "sensual," and "passionate."[24] The essentializing
assumptions about Latin American art had only increased
in the context of the intense nationalism just prior to
the war.

Although the Galerie Rive Gauche's plans for an
exhibition series on Latin American art did not come to
fruition, interest in art from the region by other galleries
picked up during this period. While Cícero Dias did not
end up exhibiting at the Galerie Rive Gauche following
his invitation, he did come to Paris in 1937 at the encour-
agement of di Cavalcanti, who writes to his friend in
November 1936: "My dear Cícero, I write to you from the
Montparnasse Post Office to tell you that you must leave
for Paris immediately. I admit I am going through difficult
moments at this point in time because money is short, but
even so this is the ideal place to be. Life is picking up again,
little by little, with no intellectual disturbances."[25] He goes
on to suggest that they share a studio space to save money,
but insists that the situation in Paris is improving.

Once in Paris, Dias held two exhibitions in 1938:
one, *Peintures de Cícero Dias,* at the Galerie Jeanne Castel
(where Uruguayan artist José Cuneo also exhibited that
year) with the support of Ambassador Luis Martins de
Souza Dantas, and another at the Galerie Billiet.[26] While
there is no known record of the paintings shown, André
Salmon's assertion that they would appeal to the surreal-
ists indicates that the images at the Galerie Jeanne Castel
may have included works on paper executed in Brazil
during the previous decade, such as an untitled work
of a strange, disconcerting landscape in watercolor and
India ink (fig. 224).[27] In the center is a plaster portrait
bust with an arm holding a lightbulb protruding from
the bust's mouth. The bust floats above a long, low build-
ing with multiple barred windows. On the roof is a col-
umn with a decorative railing of intricate iron grillwork
spiraling up to its capital. Strange hybrid birds, insects,
and vegetation also hover in the space, and a vehicle
entwined in vines drives up the right side of the composi-
tion. Space, scale, and narrative follow no logical order,
but rather suggest a strange world of dreams and unfet-
tered imagination.

Salmon, in his review of Dias's exhibition at the
Galerie Jeanne Castel, presents the artist as if he were a
native from an undiscovered land. Likening the role of
art critic to that of colonial explorer, he asserts, "Another
discovery is twofold: a new artist and an unknown world,"

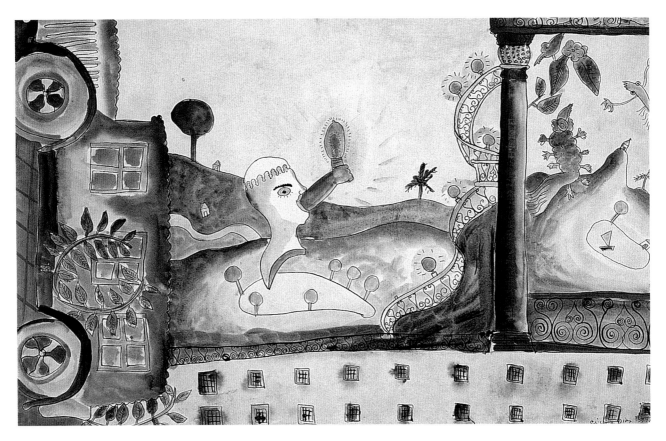

FIG. 224. Cícero Dias (1907–2003), *Untitled,* 1928. Watercolor and India ink on paper, 13¾ × 21⅔ in. (35 × 55 cm). Private collection, Paris.

and he goes on to deem Dias a "splendidly civilized savage."[28] For Salmon, Dias's paintings are poetic responses to "national folklore" and would certainly have appealed to the surrealists. Interestingly, in his discussion of Dias's use of color, Salmon mentions that the artist was "anxious about an extravaganza of colors" and therefore employed a limited palette.[29] Ironically, Dias's perceived anxiety about color most likely stemmed from a desire to stave off the very sorts of exoticizing interpretations of his work that Salmon wrote. Thus, although Salmon's review was exceedingly positive, noting that selection by the prestigious Galerie Jeanne Castel was consecration in itself, his interpretation of Dias as a conduit for the savage instinct that emanated from an unexplored virgin land undermines the artist's agency and simplifies his work, forcing it into a European construct of the primitive.

Several of Dias's paintings sold to prominent buyers such as France's former prime minister Albert Sarraut and Madame Paul Guillaume. These sales and positive reviews such as Salmon's gave Dias the confidence to engage in new forms of artistic experimentation. Around this time Dias befriended Picasso and the surrealist poet Paul Éluard, leading him to start working in abstract

modes that drew on the biomorphic forms of surrealist automatism. *Life* (1940s), for example, consists of swirling patterns and vibrant colors (fig. 225). Set against a blue-gray background, a green stem punctuated with red "eyes" with black spikes emerges from a fiery orange pedal form. From the stem protrude hand-like shapes in a range of bright colors that seem to be grasping for something beyond the frame. While slightly ominous, the whole configuration pulsates with life. His exposure to abstraction in Paris inspired Dias to make the leap from the dreamlike watercolors that dominated his oeuvre in the 1930s to the bolder, fully abstract compositions that became his signature style in the 1940s and distinguished him from those artists foregrounding national themes in their work.

To avoid the repressive Estado Novo government in Brazil, Dias decided to remain in Paris during World War II, unlike many of his contemporaries. Unfortunately, in 1942 he was captured by the Nazis and sent to prison in Baden-Baden, in hopes that he could be exchanged for German prisoners in Brazil. He managed to return to France clandestinely in 1942, but left as soon as possible for Lisbon, where he remained until the war was over. In

1945 he returned to Paris, where he lived for many years, becoming involved with new currents in abstraction.

A VOICE OF RESISTANCE: MARCELO POGOLOTTI

Cuban artist Marcelo Pogolotti also held his first solo show in Paris in 1938.[30] Pogolotti's art and political affiliations stood in direct contrast to the picturesque nationalism that dominated official exhibitions, however. Pogolotti had arrived in Paris in 1928 and settled on the outskirts of the city. In the late 1920s and early 1930s he spent time in Italy, where he came in contact with the Italian futurists, returning to Paris to participate in several group shows with his Italian colleagues. As the political and economic situation deteriorated in Paris, he became involved with a group of artists with communist sympathies founded in 1932 known as the Association des Écrivains et Artistes Révolutionnaires (AEAR), whose primary objective was to resist fascism.[31] Organizations modeled after the AEAR were founded throughout Latin America in the 1930s, establishing a united transatlantic front of artists and intellectuals fighting for a common cause.[32] Yet, of the few Latin American artists to remain in Paris during the 1930s, Pogolotti was the only one to express overtly leftist politics in his work and to become directly involved with the group in France. He exhibited with them in 1933, 1934, and 1935 and maintained his ties to the AEAR throughout the decade.

The AEAR believed that artists, no matter what their stylistic approach, must become involved in the fight against fascism. As Georges Henry writes in his review of

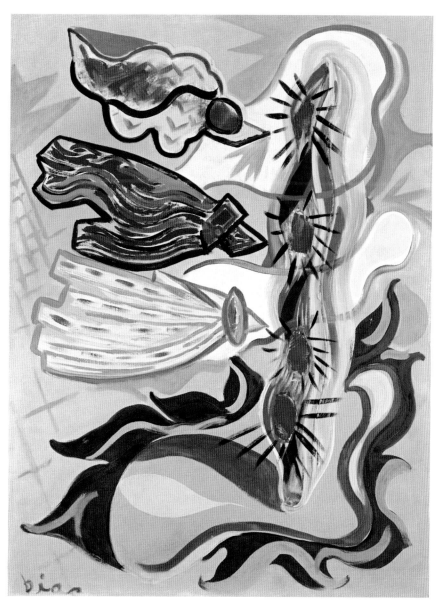

FIG. 225. Cícero Dias, *Life,* 1940s. Oil on canvas, 31⅞ × 23⅔ in. (81 × 60 cm). Private collection, Paris.

the 1934 AEAR exhibition at the Porte de Versailles, which showcased the work of more than one hundred painters, printmakers, and sculptors, including such renowned figures as André Lhote, Fernand Léger, and Jacques Lipchitz: "Why should it matter to us that this 'nude' or this abstract composition or this 'landscape' or 'still life' is unrivaled? In such a tumultuous time as the one that we are going through, when workers are fighting in the street, there is not a man, whatever his situation may be, who can remain outside of the fight. . . . Painters, like all others, must take a stand."[33] Henry goes on to single out Pogolotti's contribution to the exhibition because it evinced "class consciousness" and "effectiveness in the fight," and provided a "living example" of resistance.[34]

The painting in question, *Cuban Landscape,* was one of Pogolotti's only works throughout his career to refer to his Cuban heritage (fig. 226). According to Pogolotti, the painting depicts soldiers from Gerardo Machado's army standing guard over workers in the sugarcane fields to make sure that the sugar gets to the ships that will take it north. Unemployed workers watch from the sidelines, waiting for a task. A cutaway view of a city building in the upper right reveals two businessmen speculating on the sugar market, while on the left, a row of U.S. canons points toward the island, to make sure that Cuba complies with its demands.[35] The narrative that unfolds is one of subjugation and suffering at the hands of an imperialist superpower and a repressive dictatorship. It depicts the harsh realities of 1930s Cuba rather than a picturesque vision of a tropical island, as suggested by the title *Cuban Landscape.* Indeed, with this painting Pogolotti deliberately and strategically positioned himself against his contemporaries who had so recently exhibited in Paris: "I resisted creating a picture of my country that satisfied the taste for the exotic of the French, the Anglo-Saxons and other foreigners, either as a savage Antillean island given to frenetic public displays on public holidays, as Abela painted it three years ago, or as a remote dreamland,

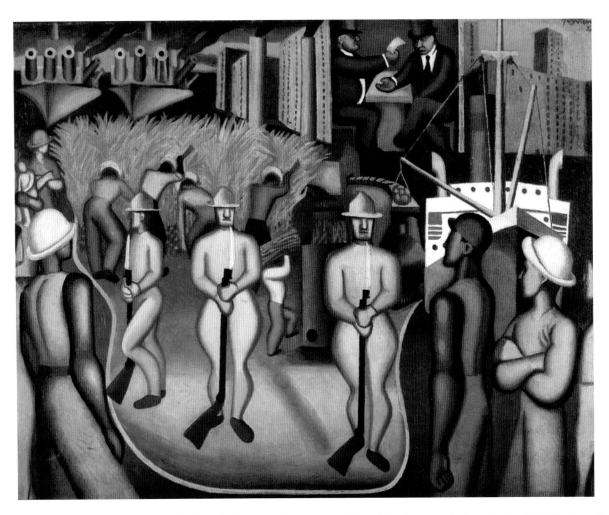

FIG. 226. Marcelo Pogolotti (1902–1988), *Cuban Landscape,* 1933. Oil on canvas, 28¾ × 36¼ in. (73 × 92 cm). Museo Nacional de Bellas Artes, Havana.

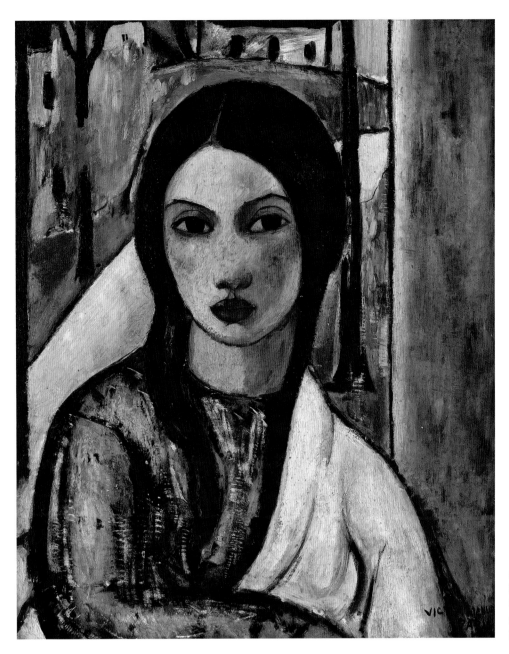

FIG. 227. Victor Manuel García (1897–1969), *Tropical Gypsy*, 1929. Oil on wood, 18⅓ × 15 in. (46.5 × 38 cm). Museo Nacional de Bellas Artes, Havana.

idealized by Victor Manuel [García] in his *Tropical Gypsy* [fig. 227], during his several month stay in Paris in 1929. My goal was paint human reality in a social landscape."[36] Social realism thus served as a way to resist the exoticizing expectations to which so many Latin American artists who exhibited in Paris succumbed, as well as a means of aligning himself with an international Marxist ideology.

It was Pogolotti's association with the AEAR that led to his individual exhibition *Tableaux abstraits et figuratifs* at the Galerie Carrefour from February 25 to March 15, 1938. Through the AEAR, Pogolotti met Pierre Vérité, a dealer of African and Oceanic art, who made the arrangements with the gallery.[37] While the exhibition did not focus on Pogolotti's politically motivated paintings exclusively, also

featuring some of his early experiments with abstraction such as *Hieroglyph* of 1931 (fig. 228), it presented the political paintings as a dominant trend in his work. On the cover of the exhibition catalogue was *Silence* (fig. 229).[38] Executed in a clear, linear style, reminiscent of Léger's or Ozenfant's approach, the painting depicts a group of iconic symbols of the arts: a violin, a palette, theatrical masks, a classical column and sculpture, a guitar, and an open book. Yet these items are set in a landscape of dark, craggy rocks that seems to close in from above. A page from the book is torn and the column is toppling over onto the objects beside it. As its title suggests, the image alludes to the curtailing of artistic freedoms and silencing of creative voices. Referring to the political situation

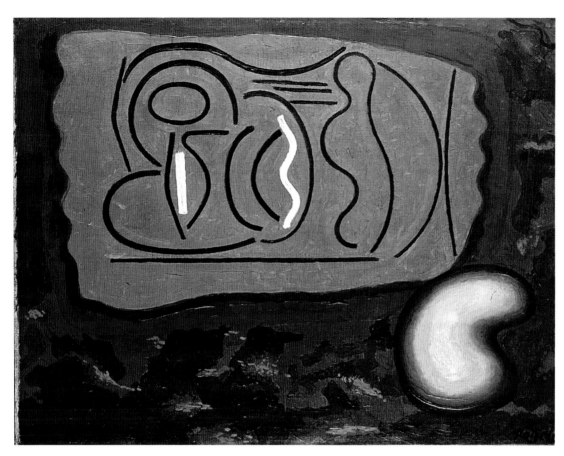

FIG. 228. Marcelo Pogolotti, *Hieroglyph*, 1931. Oil on canvas, 18⅓ × 18⅓ in. (46.5 × 62.5 cm). Museo Nacional de Bellas Artes, Havana.

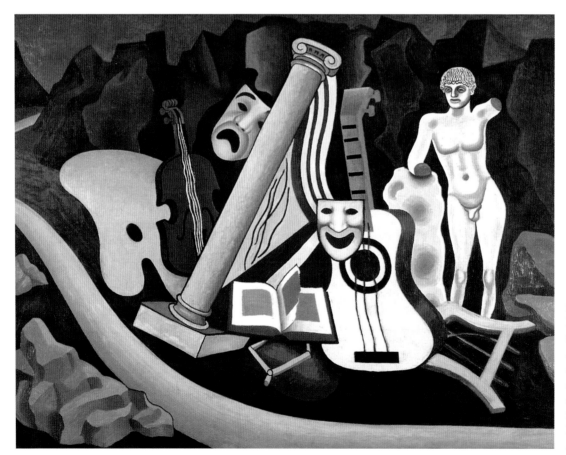

FIG. 229. Marcelo Pogolotti, *Silence* (*Scoria* or *Instruments*), ca. 1937. Oil on canvas, 35 × 45⅔ in. (89 × 116 cm). Museo Nacional de Bellas Artes, Havana.

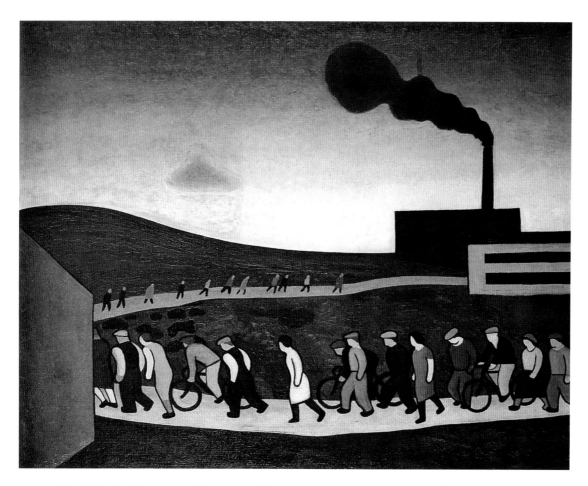

FIG. 230. Marcelo Pogolotti, *Dawn*, 1937. Oil on canvas, 31⅞ × 39½ in. (81 × 100.5 cm). Museo Nacional de Bellas Artes, Havana.

in France in 1937, Pogolotti writes in his autobiography: "Circumstances increasingly confined the conscious intellectual, who even in France was rapidly losing all freedom of expression, after having been gagged in almost all the rest of Europe. There are fewer and fewer magazines and newspapers where it was reasonable to express one's views. In such publications it seemed like there was little or no remuneration, whereas the reactionary ones paid exorbitant amounts to their collaborators."[39] *Silence* expresses this feeling of censorship and political frustration.

Hanging in the window of the gallery was a painting entitled *Dawn* that also foregrounded the political focus of Pogolotti's most recent work (fig. 230). Like *Cuban Landscape,* the title, *Dawn,* primes the audience for an idyllic scene of natural beauty. Instead, the viewer is confronted by a long line of anonymous workers trudging toward a factory along a winding path. The workers arrive on foot or bicycle, their shoulders hunched and heads bowed in anticipation of an arduous day's work. The factory in the distance, a dark, foreboding building,

churns black smoke into the morning sky. The landscape is entirely barren, taking its cue perhaps from the empty landscapes of surrealism, with no trees or greenery of any sort. These are the exploited masses upon whose labor the capitalist economy depends. By choosing this image for the gallery window, Pogolotti deliberately highlighted the social aspect of his work for visitors to the exhibition.

Also included in the exhibition was *The Intellectual* of 1937 (fig. 231). This work depicts a man seated at his desk in front of his typewriter, leaning on a book propped open with his elbow. To his left is a shelf containing more books that appear to lean on his head. The man's face, simplified to eliminate all his features, is turned to the viewer, but is completely impenetrable, as if he were lost in thought. Those thoughts manifest in the specter that emerges behind him, which Pogolotti describes as a "large ugly bird with a scythe that represents hunger, persecution, and death." Pogolotti painted the man's body in a robust manner in order "to belie the vulgar notion of the tenuousness of thinkers." His image presents the intellectual with the weight of the world on his shoulders, pondering

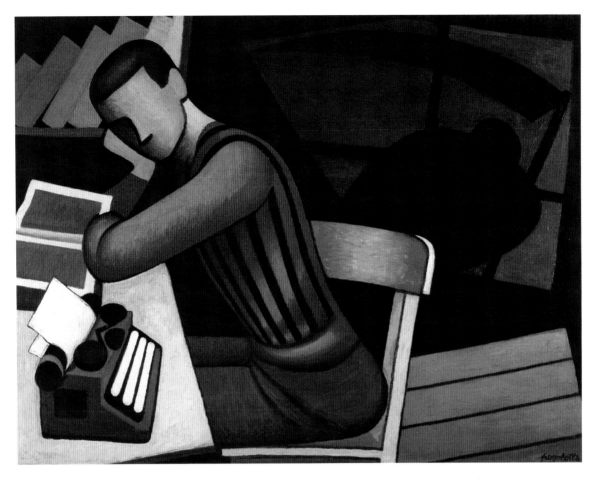

FIG. 231. Marcelo Pogolotti, *The Intellectual* (or *Young Intellectual*), 1937. Oil on canvas, 35 × 45⅔ in. (89 × 116 cm). Museo Nacional de Bellas Artes, Havana.

the future direction of society. For Pogolotti, it was up to the intellectual to find an "adequate interpretation" for the problems of the world.[40] His role, while agonizing, was essential to the political process.

In his short essay for the exhibition catalogue, Jean Cassou situates Pogolotti within the current debates among artists and intellectuals about abstraction and figuration, debates that were taking place on both sides of the Atlantic. He attributes the artist's politics to his cultural identity, however. Cassou's assumption is that outside Europe, the "theoretical and speculative" character of abstraction is entirely irrelevant because countries such as Cuba and Mexico, where social and political upheaval have been much more intensely felt than in Europe, require art that relates directly to "a real and present drama." Drawing on his knowledge of Mexican art, which was discussed in Chapter 7, Cassou relates Pogolotti's trajectory to Diego Rivera's move from cubism to muralism, suggesting that the Cuban followed in Rivera's footsteps. The problem with Cassou's interpretation, however, is

that Pogolotti made the transition from abstraction to social realism in Paris and did not necessarily see the two modes as mutually exclusive. Moreover, since he had not lived in Cuba for more than a decade, his subjects have almost nothing to do with the situation in Cuba. Thus, while Cassou at least recognizes Pogolotti's embrace of political activism in his work, he mistakenly attributes this shift to the artist's Latin American heritage.[41]

Despite Cassou's introduction and the prominent placement of the socially critical paintings in the exhibition, the reviews of the show were as divided in their focus as the French art world was in recognizing social realism as an important artistic trend. The mid-1930s was a moment of intense discussion in Paris regarding the role of art in relation to society and what it meant to be a realist painter. The arguments were so heated that writers Louis Aragon and Léon Moussinac organized a series of debates—the debates on painting took place in May 1936—that were later published as the "Querelle du realism" (Realism quarrel). Each participant, among whom

were many prominent artists such as Lhote, Léger, Le Corbusier, and Marcel Gromaire, was invited to defend his or her concept of realism. As one of the organizers of the debates, Aragon foregrounded his contention that the realism of the Popular Front must be "socialist realism," and that any other manifestation was merely decadence.[42]

Despite the strong arguments for social realism as the way forward for a socially engaged modern art in the 1930s and Pogolotti's clear embrace of this proposal, several of the reviews of Pogolotti's exhibition simply ignored the politically motivated content of the artist's production. F. H. Lem, writing for *Marianne,* for example, sought first to identify Pogolotti's work with his Cuban heritage, commenting that he "kept the memory of calm horizons and even light from his country." Lem only remarks in the most oblique way on Pogolotti's recent work, noting the artist's representation of "the unified strength that emerges from the human melee."[43] And in *Nouvelles littéraires, artistiques et scientifiques,* Maximilien Gauthier lauds Pogolotti's energetic style, graceful design, charming color, and ardent sensibility, with no mention whatsoever of the artist's Marxist politics.[44] Roger Lesbats, writing for *L'oeuvre,* embraces the stereotype of Cubans as passionate and carnal: "When the artist has ardent blood in his veins, he manages to give abstraction flesh and passion."[45] Only the socialist journal the *Populaire de Paris organe central du Parti Socialiste* articulated fully Pogolotti's evolution as an artist and recent turn to social realism. Identifying him as a Cuban painter in exile, which was not entirely accurate and perhaps mentioned to increase his political appeal, the reviewer proclaims that Pogolotti paints "human tragedy," making the scenes "more poignant in his use of dark colors." For this reviewer, "The culmination of [Pogolotti's] evolution from abstraction to figuration is certainly the painting entitled 'Dawn' which represents, in a sordid landscape, despite the soft morning light, a long queue of workers traveling to the factory."[46] By singling out *Dawn* for comment, and highlighting Pogolotti's politically motivated work, the reviewer not only aligns the artist's outlook with that of the journal, but foregrounds an aesthetic stance that engaged directly with the challenges and tensions of a precarious political moment.

THREE CARIBBEAN ARTISTS EXHIBIT AT THE GALERIE BERNHEIM-JEUNE

While Pogolotti embraced social realism, most other Latin American artists exhibiting in Paris in the late 1930s eschewed this trend entirely. In 1939 several other galleries renewed their interest in Latin American art. The famous Galerie Bernheim-Jeune had previously featured Latin American artists such as Angel Zárraga (1920, 1921, and 1926), José Clemente Orozco (1925), and Vicente do Rego Monteiro (1928). In the spring of 1939 it held three simultaneous individual exhibitions of two Caribbean artists and one Costa Rican artist: Mario Carreño (1913–1956), Jaime Colson, and Max Jiménez. (It was essentially a group exhibition of ten paintings by each artist, each with a separate catalogue.)[47] Carreño and Colson had just arrived in Paris from Mexico, where they had been in contact with the Mexican muralists. They did not, however, incorporate the muralists' political voice into any of the work they exhibited in Paris. Ironically, contrary to Cassou's assumptions about Pogolotti's sources, there was much more of a link between Carreño and Colson and the Mexican muralists than there was between Pogolotti and the Mexicans. Yet the paintings they exhibited differed drastically from those of Pogolotti in terms of content. Carreño, Colson, and Jiménez embraced a monumental figurative aesthetic that entirely eschewed reference to contemporary events on the eve of World War II, and that reflected instead the tendency toward classicism on both sides of the Atlantic in the 1930s.

Colson and Jiménez were both veteran Parisian residents. As discussed previously, Jiménez had made a name for himself as an experimental sculptor at the 1924 *Exposition d'art Américain-Latin* at the Musée Galliera and held a solo show that same year at the Galerie Percier. With the stock market crash in 1929, he left Paris, spending the next decade in Spain, Costa Rica, the United States, Chile, and Cuba, where he came in contact with numerous Latin American artists and intellectuals. Around 1938 he took up oil painting, producing a body of work that he brought with him to Paris when he returned in 1939.[48] At the Galerie Bernheim-Jeune he exhibited ten of these paintings, most of which were monumental female nudes, such as *Anita* (fig. 232). This work depicts a seated, dark-skinned nude with a crimson blanket draped over her shoulders. Her enormous inflated form fills the pictorial space, with her diminutive head slightly inclined to fit into the frame. Her hands and breasts are swollen to almost grotesque proportions and her claw-like fingernails and pointed nipples contrast with the soft, fleshy form of her body, alluding to a dangerous or forbidden sexuality. Behind her on the wall is a small painting of a woman

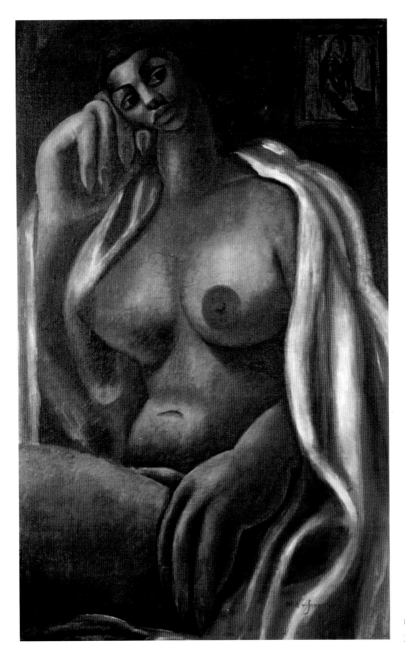

FIG. 232. Max Jiménez, *Anita,* ca. 1939. Oil on canvas, 38⅓ × 24¼ in. (97.5 × 61.5 cm). Jiménez-Beeche Collection.

in a blue robe, perhaps the Virgin Mary, suggesting that *Anita* has turned her back on the strictures of religion and has instead embraced her unbridled sexuality, most likely as a prostitute. This image would have appealed directly to entrenched European fantasies about the libidinous nature of exotic African women.

As discussed in Chapter 4, in 1931 French critic Waldemar George, who wrote the introduction to Jiménez's catalogue and reviewed the show, became a staunch advocate for nationalism in art.[49] While his emphasis was primarily on French artists, whom he urged to look to their own heritage for inspiration and to resurrect classical forms, he held artists of different nationalities to the same standard, seeking evidence of ethnic difference and national character in every aspect of their work. He therefore championed those artists whom he believed derived their artistic inspiration from their cultural identity.

In his introduction to Jiménez's exhibition catalogue, George locates the artist's work within a grand narrative of artistic independence: "Perhaps we will experience soon a glorious and terrible awakening of the [Latin American] Republics which, after having shaken off the political yoke of a decadent Spain, attempt to break down the spiritual bonds that still unite them to the West."[50] Despite the clear resonance of Jiménez's images with the penchant for monumental nudes in France between the wars, in his persistent quest for native authenticity (he

made similar assessments in earlier reviews of Amaral's and Torres García's work), George attributes the artist's proclivity for figural distortion to his cultural heritage: "But, while the deformations of European painters remain purely arbitrary, those of Jiménez seem controlled by an occult spiritual inclination, by a vision and by a will to express artistically, that which tends toward the unreal and which departs from classical humanism. Jiménez is haunted by the static colossal forms of divinities, of which pre-Columbian art provides us with so many examples."[51] George suggests that when European artists created such distortions they did so by choice, but when Latin American artists did so, they stemmed from a repressed cultural impulse or "occult spiritual inclination"; he thus restricts the agency of the artist to an imagined primitive impulse. And his reference to pre-Columbian art as Jiménez's source is a stretch at best, perpetuating a European desire for authentic connections rather than actual exposure to such objects.

Writing for *L'art vivant*, Maximilien Gauthier makes a similar assessment of Jiménez's inspiration: "Max Jiménez, born in 1900, painter from Central America, presents for our enjoyment an art that is definitely from the country of fissured isthmuses, of hallucinatory mountains, volcanoes whose awakening shakes the earth and seems to spread torrents of flame, ashes and blood on the sea. A fierce sensuality is the basis of Max Jiménez's inspiration. His female nudes, with monumental deformations, attractive and appalling at the same time. And the drama happens in an orgy of truly tropical colors."[52] For Gauthier, Jiménez's nudes are the result of an inherent tropical sensuality that emanates from a sexualized landscape of erupting volcanoes and orgies of color. This geographic determinism served as an interpretive mechanism for European critics who wished to classify art according to a system of difference.

Exhibiting at the same time as Jiménez was Dominican artist Jaime Colson. Colson too had previously made a name for himself in Paris, exhibiting at the Association Paris-Amérique Latine with César Moro in 1927 as well as with Torres García's Groupe Latino-Américain and Cercle et Carré group in 1930. While Colson remained in Paris longer than Jiménez, he too left in 1934, spending time in Mexico, Cuba, and the Dominican Republic before returning to Paris in 1938. Colson also adopted a monumental figural style in the 1930s, bringing a selection of paintings made in Mexico with him to Paris for his exhibition at the

Bernheim-Jeune. Like Jiménez, he exhibited ten paintings; among them were works such as *Maternity* of 1936, which evidences his exposure to the work of Rufino Tamayo, David Alfaro Siqueiros, and Diego Rivera in Mexico (fig. 233). The painting depicts a mother and son painted in a highly sculptural style. Their faces are simplified and painstakingly modeled as if they were carved in stone. Yet the background consists of flat geometric shapes, undermining the volumetric quality of the figures. In his review of the painting, George notes briefly that it is painted with great facility and "elemental force." This was his only mention of Colson's work. Despite his previous experience in Paris, Colson was essentially ignored in reviews of the exhibition, with attention instead focused on his younger protégé, Mario Carreño. While none of the three artists exhibiting at the Galerie Bernheim-Jeune presented subject matter specific to their country of origin, Colson may have been the easiest to dismiss because of the relative moderation of his portraits. Whereas Jiménez and Carreño painted monumental figures in inexplicable poses and situations, bursting from the confines of the frame, Colson's more tempered approach lacked the exuberance expected of Latin American artists.[53]

The youngest of the three artists to exhibit at the Bernheim-Jeane was the Cuban Carreño. Carreño arrived in Paris in 1937, after having spent the previous year in Mexico, where he met and came under the tutelage of Colson. It was Colson who introduced him to Picasso's Ingres-inspired classicism. Once in Paris, Carreño took classes at the Académie Julian with Jean Souverbie and studied mural technique at the École des Arts Appliqués.[54] He socialized at Le Dôme, where he met Spanish surrealist Oscar Domínguez. Domínguez encouraged him to incorporate aspects of surrealism in his work, which manifested as otherworldly landscapes and odd combinations of figures in several of the paintings exhibited at the Galerie Bernheim-Jeune.[55]

The reviews of the exhibition in both *Beaux-arts: Chronique des arts et de la curiosité* and *L'art vivant* singled out Carreño as the most significant artist in the show, serving as an important marker of success in the career of the younger artist. *Beaux-art* reproduced Carreño's painting *Women by the Seashore* (fig. 234) alongside the review, as did *L'art vivant*, which also featured two other paintings by Carreño, but only one by Jiménez and none by Colson.[56] Former Prime Minister Albert Sarraut, who had recently acquired a painting by Cícero Dias, purchased one of

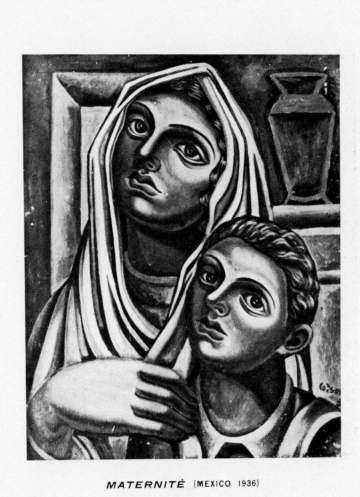

MATERNITÉ (MEXICO 1936)

FIG. 233. Jaime Colson, *Maternity*, 1936. Oil on canvas. Private collection. Reproduced in Jaime Antonio Colson and Galerie Bernheim-Jeune, *Exposition Jaime Colson: Peintre Dominicain* (Paris: MM. Bernheim Jeune, 1939), n.p.

Carreño's other paintings featured in the journal. In accordance with the penchant for neoclassicism in France between the wars, *Women by the Seashore* draws on the iconography and style of Renaissance paintings of the Virgin and Child and Saint John. Inexplicably, Carreño replaced the figure of Saint John with that of a nude prepubescent girl. His figures are voluptuous and monumental, painted in a highly sculptural style. The young mother, covered from the waist down in wet drapery, lifts her infant son so that he may play with a white dove on a string. The light of the setting sun illuminates his head, creating a halo of sorts. While the small group of figures is standing on the seashore, there is nothing specifically Caribbean about the image; rather, the classicism of the figures suggests a Mediterranean landscape.

Despite the blatant lack of referents to Carreño's Cuban heritage in the painting, Waldemar George tries rather arbitrarily to align it with the artist's national identity, and goes on to assign every other aspect of the painting to a national category as well: "His rhythm and the lines in his compositions are Italian, French or Spanish. The atmosphere that emanates from his work is not; it comes from the harsh perfume of the islands, the fire of greatness, the cruelty, the obscure mysticism that cannot be found elsewhere. The Indian soul is just a day behind the frail facade of the visual constructions borrowed from the artists of Paris who play, in the twentieth century, the role that the painters of Rome and Florence once played."[57] George's notion of Cuban culture and landscape draws directly on prevalent stereotypes of the savage primitive

in his characterization of the country as "harsh," "cruel," and steeped in "mysticism." His assertion that the "Indian soul" was the hidden impetus behind the image has grounding in neither the painting nor Carreño's background, but rather stems from George's desire to categorize artists according to national criteria.

Gauthier's review of Carreño's exhibition in *L'art vivant* took a more tempered approach. Whereas Gauthier, in a general assessment of the artists as a group, contends that their work "corresponds to the character of a land, of a climate and a society," his discussion of Carreño's submissions focuses on the artist's style. Gauthier comments on the "grace" of the artist's figures and the "tender

harmony of colors," comparing Carreño to Bartolomé Esteban Murillo and André Derain.[58] Unlike George, Gauthier is not as adamant in his attempt to explain Carreño's artistic traits as a product of his cultural identity.

The selection of these three artists to exhibit at the prestigious Galerie Bernheim-Jeune and the extensive reviews of their work in two prominent yet increasingly conservative art journals indicates a resurging interest in a certain type of Latin American art, which aligned with the classicizing aesthetic so prevalent in French art between the wars. Despite these artists' avoidance of subjects that referenced their cultural identity, the tendency on the part of critics to interpret their work according to

FIG. 234. Mario Carreño (1913–1956), *Women by the Seashore*, ca. 1939. Location unknown. Reproduced in Mario Carreño, *Exposition Carreno: Peintre cubain* (Paris: MM. Bernheim-Jeune, 1939), n.p.

national or ethnic heritage, made explicit for the first time in response to the survey exhibition of Latin American art in 1924, only intensified in the late 1930s. Indeed, even the counterpart to these exhibitions, the surrealist shows that Breton organized in 1938 and 1939 discussed in the previous chapter, tended to understand the work of Latin American artists according to imagined assumptions—albeit different ones—about their national identity. Yet the joint exhibition of these three artists from different countries, and their decision to travel around Latin America during their time away from Paris, also indicates that a much greater sense of Latin American artistic identity had evolved since the 1920s, an identity that would continue to develop throughout the century.

WIFREDO LAM AT THE GALERIE PIERRE

The very last exhibition by a Latin American artist to take place before the outbreak of World War II was that of Cuban Wifredo Lam at the Galerie Pierre from June 30 to July 14, 1939.[59] Lam had arrived in Paris a year earlier, with a letter of introduction to Picasso. Picasso, in turn, introduced him to numerous members of the Parisian avant-garde, including Braque, Matisse, Léger, Éluard, Ernst, Tzara, and Breton, and arranged for Pierre Loeb to become his dealer.[60] Although Lam was only one quarter black (his father was Chinese and his mother a mulatta of Spanish and African descent), because he physically appeared more African than Asian, these European artists and critics tended to align their visual perception of the man with their interpretation of African societies. Describing his first impression of Lam, Loeb exclaims, "Your African face drawn by a refined and subtle Chinese, your pin of a head topped with a smooth matted helmet of black cotton wool."[61] For Loeb, the perceived connection between Lam's art and his race was of primary significance and influenced the presentation and reading of his work.

While Loeb's gallery did not focus exclusively on surrealism, it did have strong connections to the movement. The gallery had hosted an exhibition of surrealist painting in November 1925 and maintained affiliations with many of the surrealists (Arp, Brauner, Paalen, Artaud) over the next decade. While Lam had previously experimented with surrealist motifs while in Spain, he most likely came in contact with the Parisian surrealists for the first time via the gallery. His exhibition, however, did not reflect his knowledge of the movement, but instead evidenced

Lam's sustained and deliberate investigation of Picasso's encounter with the African. As discussed in the previous chapter, it was not until he left Paris that Lam briefly incorporated surrealist practices into his work.

During his time in Paris, Lam did not employ Africanizing forms as a reflection of his Afro-Cuban heritage, but rather he engaged these forms as a means of emulating the modernity of the Parisian avant-garde, and in so doing, definitively breaking with his academic training. Lam was attracted to Picasso's incorporation of primitive forms to invent visually new and challenging images.[62] Initially, the formal characteristics of African art were as foreign to him as they were to his European colleagues. Yet, as Lam began to realize that his counterparts and critics aligned their conception of him as a person with the Africanizing elements in his work, he decided to explore new means of imbuing these primitivizing forms with meaning relevant to his heritage, a meaning that differed fundamentally from that imposed upon him by the Parisian avant-garde and blossomed after his return to Cuba in 1941.[63] It was through critical and very conscious evaluation of Picasso's art that Lam explored means of achieving modernism through African forms.

The paintings in his Paris exhibition exemplified this exploration of Picasso's early cubist experiments from around 1907. In these works, Lam severely simplified his forms and reduced three-dimensional figures to basic geometries in a way comparable to Picasso, as seen in a comparison between Picasso's *Head of a Woman* of 1907 and Lam's *Self-Portrait* of 1938 (figs. 235 and 236). Despite similarities, Lam's work displays a penchant for geometric shapes, right angles, and bilateral symmetry, whereas Picasso's forms are more fluid and asymmetrical. Like Picasso, Lam's self-portrait appropriates the modernists' vision of the primitive, and thus seems to acknowledge the primitivist perception of him by his Parisian colleagues. But his use of a mask, which acts as a hiding or transforming mechanism, actually serves to negate the validity of the identity imposed upon Lam. His decision to paint a self-portrait as a mask indicates that this particular representation is neither a depiction of his true appearance nor his real identity. Rather, by using a mask, he has presented a self that is both invented and malleable. Although Picasso frequently used the African mask as a motif in his work, he never associated the mask with the self, but rather as a reference to something outside the European tradition. The leap from mask to painted

FIG. 235. Pablo Picasso (1881–1973), *Head of a Woman*, 1907. Oil on canvas, 18⅛ × 13 in. (46 × 33 cm). Barnes Foundation, Philadelphia.

FIG. 236. Wifredo Lam, *Self Portrait*, 1938. Oil on cardboard, 18⅛ × 15 in. (46 × 38 cm). Private collection, Paris.

self-portrait is therefore unique to Lam. This work appears to be a reaction to the primitivizing identities imposed on him, a response that he did not fully develop until after he returned to Cuba.

Other paintings in the exhibition often comprised an individual or a pair of female figures, such as *Woman with Long Hair I* of 1938 (fig. 237). Lam's figures from this period are characterized by their flat, geometricized bodies, teardrop-shaped heads, long, angular noses, flat, linear eyes, extremely long hair or no hair at all, oversized, expressive hands, and bold, black outlines that define essential forms. In *Woman with Long Hair I,* the woman stands at a slight angle, with her head almost touching the ceiling. Her blue dress echoes the blue of the walls and her striped bodice repeats the striated pattern in the ceiling, making the figure meld with her surroundings. Her exceedingly long hair frames a mask-like face that prevents any reading of emotion. Instead, the entire composition—the tilted body, crossed arms, and cold palette—conveys a sense of unease. The flat geometric design, graphic rhythms, and figural

distortion indicate Lam's acute investigation of a specific moment in Picasso's artistic development.

Lam's exhibition in Pierre Loeb's gallery was well-received and attended by various members of the Parisian avant-garde, including Le Corbusier and Marc Chagall.[64] Yet since the gallery had a history of hosting exhibitions of non-Western art, those who visited made the same assumptions about Lam's art as had Loeb. For example, in a review of the show published in *Marianne,* Charles Théophile explores the relationship between Lam's paintings and pre-Columbian sculpture. He comments that Lam painted with the "force of primitive peoples" without "false ingenuity" or "false archaism," since he was "liberating the atavistic meaning of the forms."[65] This reading of Lam clearly stems from Europeans' preconceived notions of primitivism rather than from an objective assessment of Lam's newfound interest in the Africanizing elements of Picasso's style. The comparison of Lam's work to pre-Columbian forms resulted from the author's awareness of Lam's Latin American origin rather than any actual

FIG. 237. Wifredo Lam, *Woman with Long Hair I,* 1938. Gouache on paper, 39⅓ × 26 in. (100 × 66 cm). Collection of Ramon and Nercys Cernuda, Miami

relationship, since Lam had never traveled to other regions of Latin America before living in Europe, and no monumental pre-Columbian art was ever produced in Cuba. While Lam may have become familiar with pre-Columbian art through books or in Parisian museums, he would have had no more access to it than the reviewer of the exhibition. By stating that Lam's connection to primitive forms was genuine, as opposed to European artists' false engagement with the primitive, the author perpetuates the idea that, through his race and culture, Lam had an inherent connection to this nebulous concept of primitive society defined by European minds.

Lam had arrived in France in the late 1930s, a time of increasing political and social turmoil. In this period of national insecurity, race served as a visible determinant of the "other." The French were both intrigued and wary of people from non-European cultures and thus invented an understanding of these people in opposition to their

conception of Frenchness. Although Lam was readily accepted into the ranks of the Parisian avant-garde, their perception of him was directly linked to his race. In spite of this distorted vision, he was never the passive victim of primitivist speculations. Lam certainly benefited from his relationship with Picasso in Paris and the surrealist group in Marseilles. Through their creative intensity and revolutionary spirit, as well as in response to their primitivist vision, Lam, like so many Latin American artists before him, was able to engage and transform his European sources to create a unique approach to art-making.

CONCLUSION

While there was a brief resurgence between 1937 and 1939, the Latin American artistic presence in Paris was almost entirely curtailed by World War II. In August 1939 most of the museums and galleries in Paris closed and evacuation procedures, which had been in planning stages for several years, were implemented.[66] Artists left the city in droves, either returning home or heading to New York, one of the next great capitals of modern art. In a letter to Mario Carreño written on September 7, 1939, Jaime Colson describes the end of an era: "There is nothing to do here, because in addition to the state of agitation that stems from the current situation, from the artistic point of view everything is in ruins: the Louvre is closed as a precaution, the art galleries are deserted. By chance I saw the Salon de 'Surindépendants' before it opened: disastrous. They are still playing the eternal game of 'abstraction.' In such conditions, I believe it is best not to think any more about it and go work in America."[67] Ironically, the exodus from Paris under the threat of war felt more like exile for many Latin American artists—especially figures such as Zárraga and Lam, who did not leave until the threat of Nazi persecution made life in Paris impossible—than did their original departure from their home countries. Paris represented an obligatory rite of passage, where artists came of age, made new international contacts, and established themselves on the world stage. While many Latin American artists returned to Paris or traveled there for the first time after World War II, in the postwar period Paris become just one of many options, with cities such as New York, San Francisco, Mexico City, Bogotá, Buenos Aires, São Paulo, and Rio de Janeiro emerging as equally viable artistic centers.[68] Between the wars, Paris was unique because of its singular draw for artists around the world, its infrastructure that could accommodate these shifting

demographics, and its general openness, despite opposi-
tional forces, to the presence of foreign artists.

It was in Paris, in the period between the wars, that
Latin American artists began to formulate a sense of
artistic identity as a group. With the first survey of Latin
American art at the Musée Galliera in 1924, artists and
critics alike began to ask themselves what it meant to be
an artist from Latin America. In responding to Parisian
expectations of primitivism or native content, these art-
ists gained a sense of agency and clarified their artistic
identity. The cultural perspective they achieved from liv-
ing abroad allowed them to formulate unique strategies
to contribute to, oppose, or modify European modern-
ist trends and to make them relevant upon their return
home. This is not to say that Latin American artists ever
embraced a common aesthetic or philosophical out-
look, but rather that a bond between artists of distinct
nationalities formed because they experienced certain
situational similarities or came to acknowledge cultural
affinities while living in Paris. Indeed, it was the voyage,
the distance from home, and the global metropolis itself
that facilitated the creation of this identity. These art-
ists participated in nearly every avant-garde movement
in Paris as well as the more academic and traditional
modes still prevalent at the official salons. By detailing
the specific circumstances of their participation, the work
they produced, and the subsequent critical debates it pro-
voked, this study expands notions of modernism in Paris
between the wars to incorporate the many contributions
of these artists from Latin America.

Notes

INTRODUCTION

1. Vicente do Rego Monteiro, *Quelques visages de Paris* (Paris: Imprimerie Juan Dura, 1925), n.p. All translations are my own, unless otherwise noted. For an in-depth discussion of the book in relation to the Brazilian context, see Edith Wolfe, "Paris as Periphery: Vicente do Rego Monteiro and Brazil's Discrepant Cosmopolitanism," *Art Bulletin* 46, no. 1 (March 2014): 98–119.

2. His style drew on Brazilian art from Marajoara culture that had become a source for Brazilian art deco design in the 1920s. See Márcio Alves Roiter, "A influência Marajoara no art déco brasileiro," *Revista UFG* 13 (July 2010): 21–27. Art deco proved to be a particularly suitable style for Rego Monteiro because its formal references to non-Western artistic traditions mollified Parisian audiences' desire to comprehend his work in terms of the artist's national identity. Art deco was also a modernist style, which allowed Rego Monteiro to participate in the Parisian art scene and to engage and challenge his Parisian audience.

3. Kathryn Porter Aichele, *Paul Klee's Pictorial Writing* (Cambridge: Cambridge University Press, 2002), 131–32.

4. Rego Monteiro, *Quelques visages de Paris,* n.p.

5. Ibid.

6. Ibid.

7. Ibid., preface.

8. André Warnod, "Beaux-arts: Quelques visages de Paris," *Comoedia*, February 4, 1925, 3.

9. Sérgio Milliet, "Brésiliens: Quelques visages de Paris," *Revue de l'Amérique latine* 9, no. 40 (April 1925): 356.

10. See, for example, Romy Golan, *Modernity and Nostalgia: Art and Politics in France between the Wars* (New Haven: Yale University Press, 1995); Christopher Green, *Art in France: 1900–1940* (New Haven: Yale University Press, 2000); Kenneth E. Silver, *Esprit de Corps: The Art of the Parisian Avant-Garde and the First World War, 1914–1925* (Princeton, N.J.: Princeton University Press, 1989). One recent exception is a book that deals specifically with Brazilian artists: Marta Rossetti Batista, *Os artistas brasileiros na Escola de Paris: Anos 1920* (São Paulo: Editora 34, 2012).

11. J. Gerald Kennedy makes this assertion in his discussion of Hemingway's sojourn to Paris: J. Gerald Kennedy, *Imagining Paris: Exile, Writing, and American Identity* (New Haven: Yale University Press, 1993), 26.

12. James Clifford, *Routes: Travel and Translation in the Late Twentieth Century* (Cambridge, Mass.: Harvard University Press, 1997), 30.

13. Kennedy, *Imagining Paris,* 28–29.

14. Kobena Mercer, ed., *Exiles, Diasporas and Strangers* (London: Iniva, 2008), 7.

15. Mary Louise Pratt, *Imperial Eyes: Travel Writing and Transculturation* (London: Routledge, 1992), 4.

16. Helen Carr, "Modernism and Travel," in *The Cambridge Companion to Travel Writing,* ed. Peter Hulme (Cambridge: Cambridge University Press, 2002), 81.

17. The idea of Pan-Americanism—the belief in shared cultural, economic, and historical bonds between South American nations— originated with the South American statesman and revolutionary Simón Bolívar (1783–1830). Upon his death, French intellectual Saint-Simonian Michel Chevalier identified the peoples of the region as a "Latin race," which led to the coining of the term "Latin America" under Napoleon III. See Walter Mignolo, *The Idea of Latin America* (Malden, Mass.: Blackwell, 2005); and John Lynch, *Simón Bolívar: A Life* (New Haven: Yale University Press, 2006). For an in-depth discussion of the topic, see Arturo Ardao, *América Latina y la latinidad* (Mexico City: Universidad Nacional Autónoma de México, 1993).

18. For a discussion of influence, see Harold Bloom, *The Anxiety of Influence: A Theory of Poetry,* 2nd ed. (New York: Oxford University Press, 1997).

19. Gerardo Mosquera and Jean Fisher, eds., *Over Here: International Perspectives on Art and Culture* (New York: New Museum of Contemporary Art, 2004), 7.

20. Kobena Mercer, "Erase and Rewind: When Does Art History in the Black Diaspora Actually Begin?" in Mercer, *Exiles, Diasporas and Strangers,* 22.

21. In the seventeenth century, France colonized French Guiana on the South American continent. France also laid claim to various Caribbean islands, including Saint-Domingue (Haiti) and much of the Lesser Antilles.

22. In the last twenty years of the nineteenth century, France made significant colonial gains in the so-called "scramble for Africa," and after World War I continued to make forays into colonialism, claiming the former Turkish territories of the Ottoman Empire (now Syria and Lebanon) as well as Togo and Cameroon in West Africa.

23. Ramón Vasconcelos, *Montparnasse, impresiones de arte* (Havana: Cultural, 1938), 160.

24. Emiliano di Cavalcanti, *Viagem da minha vida; Memórias* (Rio de Janeiro: Editora Civilização Brasileira, 1955), 130.

25. Mosquera and Fisher, *Over Here,* 3.

26. Carlos Vidal, "Globalization or Endless Fragmentation? Through the Shadow of Contradictions," in Mosquera and Fisher, *Over Here*, 26.

27. Alejo Carpentier, *Crónicas* (Havana: Editorial Arte y Literatura, 1975), 257. Originally published as Alejo Carpentier, "La obra reciente de Carlos Enríquez," *Social* 17, no. 5 (May 1932).

28. Saloni Mathur, introduction to *Migrant's Time: Rethinking Art History and Diaspora* (Williamstown, Mass.: Clark Art Institute, 2011), viiin2, xiii.

29. According to Carole Sweeney, the notion of the primitive denotes the untamed, the savage, or the prerational, whereas discourses of the exotic allude to a "geographical otherness characterized by plenitude and harmony." Critics, however, often conflated the two, interpreting geographical otherness as intrinsically primitive. See Carole Sweeney, *From Fetish to Subject: Race, Modernism, and Primitivism, 1919–1935* (Westport, Conn.: Praeger, 2004), 8.

30. Mosquera and Fisher, *Over Here*, 2. Ideas also come from the "Global Art History and the Peripheries" conference at the École Normale Supérieure, Paris; Institut National d'Histoire de l'Art; Terra Foundation for American Art, June 12–14, 2013.

31. Sweeney, *From Fetish to Subject*, 7. Sweeney is quoting Hal Foster, "The 'Primitive' Unconscious of Modern Art," *October* 34 (1985): 200.

32. Mosquera and Fisher, *Over Here*, 3.

33. Marcelo Pogolotti, *Del barro y las voces* (Havana: Contemporáneos, 1968), 182.

34. It was only after this exhibition in Paris that the survey show, with representative examples of artwork from each country, became an accepted format for the display of Latin American art. No such exhibition had ever been held in Latin America or the United States prior to this date. The first survey exhibition of Latin American art in the United States was held in 1939 at the Riverside Museum, New York, in conjunction with the New York World's Fair.

CHAPTER 1. AMONG THE CUBISTS

1. 1. I have documented fewer than ten residing in Paris during this period, but since exhibition opportunities were rare, it is hard to determine whether some remained in the city, biding time until conditions improved.

2. MoMA.org, "Paul Rosenberg and Company: From France to America," http://www .moma.org/interactives/exhibitions/2010 /paulrosenberg/.

3. Thank you to Jay Oles for this observation.

4. The original contracts are in the Bibliothèque Kandinsky, Fonds Léonce Rosenberg, Paris.

5. For more information, see Michael C. FitzGerald, *Making Modernism: Picasso and the Creation of the Market for Twentieth-Century Art* (Berkeley: University of California Press, 1996), 48.

6. In 1925 André Warnod included Ortiz de Zárate among his list of important young painters. André Warnod, *Les berceaux de la jeune peinture: Montmartre, Montparnasse* (Paris: A. Michel, 1925), 192. Ortiz de Zárate was also listed in René Édouard-Joseph, *Dictionnaire biographique des artistes contemporains, 1910–1930* (Paris: Art et Édition, 1930).

7. Ramón Favela, *Diego Rivera: The Cubist Years* (Phoenix: Phoenix Art Museum, 1984), 35.

8. Juan Carlos Palenzuela, "Les artistes vénézuéliens à Paris, 1920–1939" (Ph.D. diss., Université de Paris VIII-Vincennes à Saint-Denis, 1986). In his dissertation, Palenzuela offers a useful account of many Latin American artists' sales in Paris between the wars.

9. For more on Ortiz de Zárate and Modigliani, see Valérie Bougault, *Paris Montparnasse: The Heyday of Modern Art, 1910–1940* (Paris: Terrail, 1997), 68, 103; John Crombie, *Rue de la Grande Chaumière: The Cradle of Montparnasse* (Paris: Kickshaws, 1998), 62–65; and Jean-Paul Crespelle, *La vie quotidienne à Montparnasse à la Grande Époque, 1905–1930* (Paris: Hachette, 1976), 62.

10. Excerpts from this discussion of Rivera were published in Michele Greet, "Rivera and the Language of Classicism," in *Picasso and Rivera: Conversations across Time*, ed. Michael Govan et al. (Los Angles: Los Angeles County Museum of Art, 2016).

11. The date of this work is unknown. Some sources date the image to 1915, meaning it could have been included in the Lyre et Palette exhibition. The Musée Picasso, however, has dated the image to 1920–25, making it a later tribute to cubism. Given that Ortiz de Zárate had renounced cubism by around 1918, I am inclined to believe that it was painted earlier.

12. Thank you to Jay Oles for this information.

13. There is no record of exclusive contracts with Zárraga and Ortiz de Zárate in the Bibliothèque Kandinsky, Fonds Léonce Rosenberg.

14. Letter from Angel Zárraga to his family, November 1919, cited in Antonio Luna Arroyo, *Zárraga* (Mexico City: Salvat Ciencia y Cultura Latinoamérica, 1993), 49.

15. Jean-Gabriel Lemoine, "Une exposition d'art Américain-Latin," *Beaux-arts: Chronique des arts et de la curiosité* 2, no. 8 (April 15, 1924): 117.

16. Favela, *Diego Rivera*, 121.

17. Alex Danchev, *Georges Braque: A Life* (New York: Arcade, 2005), 130.

18. Correspondence between Léonce Rosenberg and Diego Rivera, Fonds Leonce Rosenberg B15, Diego Rivera reserved communication; contract signed between Léonce Rosenberg and Diego Rivera, April 20, 1916 (3 sheets); first amendment to contract, November 5, 1917, signed by both parties (1 sheet); contract signed by both parties, October 15, 1918 (2 sheets), all in Bibliothèque Kandinsky, Fonds Léonce Rosenberg. Quote from Bertram David Wolfe, *The Fabulous Life of Diego Rivera* (New York: Stein and Day, 1969), 86, 89.

19. Favela, *Diego Rivera*, 108. While in Rosenberg's possession this painting was most likely simply known as *Paysage*. It was not renamed *Zapatista Landscape* until the 1930s (information from Jay Oles).

20. In correspondence between Léonce Rosenberg and Diego Rivera, a letter dated March 8, 1916, mentions "Bouquet of Flowers" (Rivera number 286 8.3.16 [1 sheet, 1 envelope]); a letter dated April 2, 1916, mentions "Still Life of ?" and "Bottle of Oil" (Rivera numéro 288 2.4.16 [1 sheet, 1 envelope]). Both in Bibliothèque Kandinsky, Fonds Léonce Rosenberg.

21. See Favela, *Diego Rivera*; Olivier Debroise, *Diego de Montparnasse* (Mexico City: Secretaría de Educación Pública, Cultura SEP, 1985); Sylvia Navarrete, Serge Fauchereau, Anna Indych-López, and Joanne Klaar Walker, *Diego Rivera: The Cubist Portraits, 1913–1917* (London: Philip Wilson, 2009); and Françoise Garcia, *Diego Rivera: Les années cubistes* (Bordeaux: Musée des Beaux-Arts Bordeaux, 2011).

22. Jacques Lipchitz, introduction to Marlborough Gallery, *Jacques Lipchitz: The Cubist Period, 1913–1930* (New York: Marlborough Gallery, 1987).

23. Lhote describes his process in Maurice Raynal, *Modern French Painters* (New York: Brentano's, 1928), 117.

24. Letter from André Lhote to G. Pauli, July 26, 1917, cited in Garcia, *Diego Rivera: Les années cubistes*, 142.

25. While Lhote and Rivera would drift apart, Lhote became an important teacher for numerous Latin American artists who arrived in Paris in the 1920s.

26. Pierre Reverdy, "Sur le cubisme," *Nord-sud* 1 (March 15, 1917): 5–7.

27. Patrick Marnham, *Dreaming with His Eyes Open: A Life of Diego Rivera* (Berkeley:

University of California Press, 2000), 136.

28. Garcia, *Diego Rivera: Les années cubistes*, 144.

29. Lhote would later write about the importance of Cézanne: "It is this orderly, intelligible and visual fusion of forms, this overlap of lively planes, this loving entanglement of objects that henceforth could never live without one another and that we cannot cut out with the brush, or separate without killing them, it is this sensitive fusion that Cézanne reconstituted in his paintings, in which it matters little that they represent a glass container filled with potatoes, a landscape from here or elsewhere, or a figure. The material object, here, no longer counts, or rather there is no longer one object on view: it is emotion born of sensation." André Lhote, "L'enseignement de Cézanne," *Nouvelle revue française; Revue mensuelle de littérature et de critique,* November 1920, 663. In 1920 an important Cézanne retrospective was also held at the Galerie Bernheim-Jeune: Galerie Bernheim-Jeune, *Exposition Cézanne,* December 1–18, 1920.

30. Galerie Blot, *Exposition de peinture, aquarelles et dessins de Eugène Corneau, André Favory, Gabriel Fournier, André Lhote et Diego Rivera,* October 28–November 19, 1918.

31. Salmon coined the term in his editorials of August and September 1918. Marnham, *Dreaming with His Eyes Open,* 137.

32. For views on Vauxcelles, see Marie-Claude Chaudonneret, *Les artistes étrangers à Paris: De la fin du Moyen âge aux années 1920* (Bern: Peter Lang, 2007), 248.

33. "Andre Lhote and Diego Rivera, who were taken to task by Mr. Léonce Rosenberg and reproached for not being cubists anymore, have addressed two letters to us. They replied with a blinding clarity that they can paint however they please, and that their evolution as artists depends only on themselves." Louis Vauxcelles, "Carnet des ateliers: Au pays du cube," *Carnet de la semaine, gazette illustrée, littéraire, politique, économique et satirique,* October 6 and 27, 1918, 7.

34. Ibid.

35. Ibid.

36. Favela, *Diego Rivera,* 151. Favela cites Adam Fischer, "Moderne klassik kunst i Paris," *Klingen* (Copenhagen) 2, no. 3 (1919).

37. André Salmon, "La semaine artistique: Selon Cézanne (Galerie Blot)," *L'Europe nouvelle* 4, no. 43 (November 2, 1918): 2069. See also a discussion of Rivera's views in André Salmon, "La semaine artistique: Exposition André Lhote," *L'Europe nouvelle* 4, no. 48 (December 7, 1918): 2309.

38. The sale took place on April 28, 1921. The letter from Léonce Rosenberg advising Diego Rivera that his works were put up for auction was dated February 14, 1921, but the letter was returned to sender. Bibliothèque Kandinsky, Fonds Léonce Rosenberg.

39. André Salmon, *L'art vivant* (Paris: Crès, 1920), 157–58.

40. "Les arts: Au parnasse: Quarante sept artistes exposent au Café du Parnasse," *Montparnasse,* July 1, 1921, 4.

41. Galerie Bernheim-Jeune, *Exposition Ortiz de Zárate* (Paris: Bernheim-Jeune, 1927).

42. Angel Zárraga, "Chez les cubistes: M. Angel Zárraga," *Bulletin de la vie artistique* 5, no. 21 (November 1, 1924): 482–83. Jacques Villon, Robert Delaunay, and Georges Braque also responded.

43. In the introduction to Zárraga's piece, the author states that he hasn't made a cubist painting in seven years. Ibid.

44. Whereas Cendrars would later take a distinct interest in Latin American artists and intellectuals, forming strong friendships with Brazilian artist Tarsila do Amaral and her partner, Oswald de Andrade, his collaboration with Zárraga was his first of this nature.

45. Marjorie Perloff, *The Futurist Moment: Avant-Garde, Avant Guerre, and the Language of Rupture* (Chicago: University of Chicago Press, 1986), 39.

46. Cendrars cited in ibid., 40–41.

47. Like Rivera, Zárraga revered Cézanne, writing in 1921: "With Paul Cézanne began a new type of painter: the painter whose workshop is no longer, strictly speaking, a workshop, but a laboratory. . . . With Cézanne, despite harsh cerebral constraint, each canvas was a beautiful adventure, that risked perpetual departure for the discovery of a new world." Angel Zárraga, "Confidences d'artistes," *Bulletin de la vie artistique* 2, no. 21 (November 1, 1921): 554.

48. Malcolm Gee, *Dealers, Critics, and Collectors of Modern Painting: Aspects of the Parisian Art Market between 1910 and 1930* (New York: Garland, 1981), 136.

49. Louis Vauxcelles, "Quarante tableaux par Angel Zárraga," in Galerie Bernheim-Jeune, *Exposition Angel Zárraga* (Paris: Bernheim-Jeune, 1920).

50. Ibid.

51. Ibid.

52. Félix Fénéon and René Delange, *2me exposition Angel Zárraga* (Paris: Bernheim-Jeune, 1921).

53. R. D. [René Delange], "Angel Zárraga," *Excelsior,* October 26, 1921, 4.

54. Raynal, *Modern French Painters,* 23.

55. For a more extensive discussion of Zárraga's time in Paris, see Michele Greet, "Del cubismo al muralismo: Angel Zárraga en Paris," in *Ángel Zárraga: El sentido de la creación,* ed. Evelyn Useda Miranda (Mexico City: Museo de Palacio de Bellas Artes, 2014).

56. Christopher Green, *Art in France: 1900–1940* (New Haven: Yale University Press, 2000), 216. These ideas were further elaborated in his 1921 essay: Léonce Rosenberg, *Cubisme et empirisme* (Paris: Editions de l'Effort moderne, 1921).

57. Emilio Pettoruti, *Un pintor ante el espejo* (Buenos Aires: Libreria Histórica, 2004), 167. Since Rosenberg had represented Severini, Marinetti must have known that Pettoruti's aesthetic coincided with Rosenberg's vision. Pettoruti would later vehemently deny a connection to Severini, but there are undoubtedly affinities in their aesthetic. See Emilio Pettoruti, "Letter from Emilio Pettoruti to José Gómez Sicre," September 30, 1965, José Gómez Sicre Papers, Art Museum of the Americas, Washington, D.C.

58. Pettoruti, *Pintor ante el espejo,* 167.

59. Pettoruti, "Letter from Pettoruti to Gómez Sicre." This defensive argument has to be taken in context, however. It was written in response to a text by Gómez Sicre that essentially deemed him a follower of Severini and the cubists.

60. Pettoruti, *Pintor ante el espejo,* 169.

CHAPTER 2. LATIN AMERICAN ARTISTS IN MONTPARNASSE

Epigraph. Alejo Carpentier, *Crónicas, arte y sociedad* (Havana: Editorial Arte y Literatura, 1975), 332. Originally published as Alejo Carpentier, "Montparnasse, república internacional de artistas," *Carteles,* June 24, 1928.

1. Ramón Vasconcelos, *Montparnasse, impresiones de arte* (Havana: Cultural, 1938), 8.

2. Jason Weiss, *The Lights of Home: A Century of Latin American Writers in Paris* (London: Routledge, 2002), 5.

3. Paulette Patout, "La cultura latinoamericana en París entre 1910 y 1936," in *1899/1999: Vida, obra y herencia de Miguel Ángel Asturias: La riqueza de la diversidad* (Nanterre: Université Paris X, ALLCA XX, 1999), 210.

4. Mathilde Pomès, "L'Amérique latine et les études en France," *La renaissance de l'art français et des industries de luxe* 9, no. 8 (special issue on Latin America) (August 1926): 488–90.

5. Ibid.

6. Patout, "Cultura latinoamericana," 210.

7. There were also nation-specific organizations such as the Institut des Universités Argentines en France and the Institut d'Etudes Françaises à Buenos-Aires.

8. Carpentier, *Crónicas*, 334. This is also confirmed by Christopher Green, *Art in France: 1900–1940* (New Haven: Yale University Press, 2000), 61.

9. For a discussion of immigration statistics, see Suzanne Pagé et al., *L'École de Paris, 1904–1929: La part de l'autre* (Paris: Paris Musées, 2000), 141; Green, *Art in France*, 206; and Ralph Schor, "Le Paris des libertés," in *Le Paris des étrangers depuis un siècle*, ed. André Kaspi and Antoine Marès (Paris: Imprimerie Nationale, 1989), 14–15.

10. Vincent Bouvet, *Paris between the Wars, 1919–1939: Art, Life and Culture* (New York: Vendome, 2010), 21.

11. For a description of the voyage, see Marguerite Moreno, "Recuerdos et saudades: De Bordeaux à Buenos-Aires," *Paris Sud et Centre Amérique* 2, no. 63 (October 30, 1926): 20.

12. Lorraine Coons and Alexander Varias, *Tourist Third Cabin: Steamship Travel in the Interwar Years* (New York: Palgrave Macmillan, 2003), xxi.

13. Ibid., 25–26.

14. Mariana Ravenet Ramírez, *Ravenet revela a Ravenet* (Havana: Letras Cubanas, 2005), 73.

15. Musée Galliéra, La Maison de l'Amérique Latine, and L'Académie Internationale des Beaux-Arts, *Exposition d'art Américain-Latin, 15 mars–15 avril 1924* (Paris: Musée Galliéra, 1924).

16. Armando Maribona, *El arte y el amor en Montparnasse: Documental novelado, París, 1923–1930* (Mexico City: Ediciones Botas, 1950), 61.

17. Ibid., 62.

18. Manuel Rendón Seminario and Miguel de Ycaza Gomez, *Rendon* (Guayaquil, Ecuador: Cromos, 1985), n.p.

19. Ravenet Ramírez, *Ravenet revela a Ravenet*, 111.

20. Jaime Bestard, *La ciudad Florida (Memorias de un bohemio)* (Buenos Aires: Fanetti, 1951), 122.

21. Juan Carlos Palenzuela, "Les artistes vénézueliens à Paris, 1920–1939" (Ph.D. diss., Université de Paris VIII-Vincennes à Saint-Denis, 1986), 292.

22. Pedro da Cruz, "Torres García and Cercle et Carré: The Creation of Constructive Universalism, Paris 1927–1932" (PhD diss., Lund University, Sweden, 1994), 35.

23. Aracy A. Amaral, *Tarsila: Sua obra e seu tempo* (São Paulo: Editora 34; Editora da Universidade de São Paulo, 2003), 103.

24. Julio María Sanguinetti, *El doctor Figari* (Montevideo: Fundación BankBoston, 2002), 238. See also "L'atelier de Pedro Figari," *Revue de l'Amérique latine*, ill. suppl. (April 1, 1927): liv.

25. Maribona, *Arte y amor*, 237.

26. André Warnod, *Les berceaux de la jeune peinture: Montmartre, Montparnasse* (Paris: A. Michel, 1925), 162.

27. Ibid., 166.

28. Emiliano di Cavalcanti, *Viagem da minha vida; Memórias* (Rio de Janeiro: Editora Civilização Brasileira, 1955), 134.

29. Interestingly, La Coupole, the luxurious dance hall and restaurant that opened in late 1927, rarely figured in the discussions or correspondence of Latin American artists.

30. Carpentier, *Crónicas*, 335.

31. The woman in question may perhaps be Aicha, a woman from Martinique, who was painted by many artists who spent time at La Rotonde. See ibid., 336.

32. Warnod, *Berceaux de la jeune peinture*, 206–7.

33. "The Brazilian colony takes their meals at Gismondi. We find there Mugnaini, Cavalliero, Pinheiro, Dutra, Rego, Monteiro [*sic*], Reanne Simon, sculptors Bruheret [*sic*], Tuni, Joaquim de Rego-Monteiro [*sic*]." There are numerous mistakes in Warnod's spelling of artists' names. Ibid., 204.

34. For more on the Grupo de París, see María Elena Babino, *El Grupo de París* (Buenos Aires: Buenos Aires Ministerio de Cultura, 2010); and María Elena Babino, *El Grupo de Paris* (Buenos Aires: Museo de Artes Plásticas Eduardo Sívori, 2015).

35. Jeu de Paume and Universidad de La Plata, *Exposition d'art Argentin*, April 1926. This included work by Héctor Basaldúa, Alfredo Bigatti, Horacio Butler, Pablo Curatella Manes, Raquel Forner, Juan Manuel Gavazzo Buchardo, Alfredo Guttero, Alberto Lagos, Benito Quinquela Martin, Emilio Pettoruti, Lino Spilimbergo, and José Antonio Terry.

36. Guillermo Whitelow, *Héctor Basaldúa* (Buenos Aires: Academia Nacional de Bellas Artes, Fondo Nacional de las Artes, 1980), 47. He is quoting Horacio Butler in Horacio Butler, *La pintura y mi tiempo* (Buenos Aires, Editorial Sudamericana, 1966), n.p.

37. Carpentier, *Crónicas*, 381. Originally published as Alejo Carpentier, "El encanto cosmopolita del barrio latino," *Carteles*, June 30, 1929.

38. For information on individual artist's grants, see Michele Greet, "Transatlantic Encounters: Latin American Artists in Interwar Paris," http://chnm.gmu.edu/transatlanticencounters.

39. Cited in Patricia Artundo, *Artistas modernos Rioplatenses en Europa 1911–1924: La experiencia de la vanguardia* (Buenos Aires: MALBA, Colección Costantini, 2002), 142.

40. Whitelow, *Héctor Basaldúa*, 20.

41. Elvira Vernaschi, *Gomide* (São Paulo: Indústria Freios KNORR; MWM Motores Diesel; Universidade de São Paulo, 1989), 40.

42. Rendón Seminario and Ycaza Gomez, *Rendon*, n.p.

43. Ravenet Ramírez, *Ravenet revela a Ravenet*, 101.

44. Juan Emilio Hernández Giró, *El arte nacional: Estudio-programa seguido del proytecto de reglamento de pensiones* (Havana: Carasa, 1926), n.p.

45. Ibid.

46. For more on Gattorno, see Sean M. Poole, *Gattorno: A Cuban Painter for the World/ Un pintor cubano para el mundo* (Miami: American Art, 2004), 31.

47. Ramón Vázquez Díaz, *Víctor Manuel* (Madrid: Vanguardia Cubana, 2010), 204, 213. He cites Alejo Carpentier's introductory words to the catalogue for the Asociación de Pintores y Escultores, Havana, *Exposición de Pintura/Gattorno*, March 5–20, 1927.

48. For a list of artists who trained at the École nationale supérieure des Beaux-Arts, see Greet, "Transatlantic Encounters," http://chnm.gmu.edu/transatlanticencounters (Subjects: École nationale des Beaux-Arts).

49. María Esther Vázquez and Horacio Butler, *Horacio Butler: Conversaciones con María Esther Vázquez* (Buenos Aires: Ediciones de Arte Gaglianone, 1982), 71–73.

50. Emar had worked for the Chilean embassy in Paris until 1923. When he returned to Santiago he published a series of articles in *La nación* on European modernist movements and individual artists such as Matisse, Vlaminck, and Cézanne, reflecting on his experience abroad. Juan Emar, *Jean Emar: Escritos de arte (1923–1925)* (Santiago: Dirección de Bibliotecas, Archivos y Museos, Centro de Investigaciones Diego Barros Arana, 1992), 14–16.

51. Among the artists sent to Paris were Tótila Albert, Julio Ortiz de Zárate, Isaías Cabezón, Julio Antonio Vásquez, Luis Vargas Rosas, Héctor Banderas, Gustavo Carrasco, Héctor Cáceres, Laura Rodig, Armando Lira, Laureano Guevara, Abelardo "Paschín" Bustamante, Inés Puyó, Augusto Eguiluz, Marcial Lema, Rafael Alberto López, Roberto Humeres, and Camilo Mori. Ricardo Bindis, *Camilo Mori: Su vida y su obra* (Santiago: Museo Nacional de Bellas Artes, 1974), n.p.

52. Héctor Fuenzalida, *El pintor Isaías Cabezón* (Santiago: Universidad de Chile, Facultad de Bellas Artes, 1960), 42–44.

53. Museo Nacional de Bellas Artes, *José Perotti: 28 Agosto–28 Septiembre 2003* (Santiago: Museo Nacional de Bellas Artes, 2003), 21.

54. Banco del Estado de Chile and Instituto

Cultural, *Grupo Montparnasse y la renovación* (Santiago: Instituto Cultural del Banco del Estado de Chile, 1990), 5–7.

55. Julio E. Payró, *Bigatti* (Buenos Aires: Academia Nacional de Bellas Artes, 1966), 119.

56. Carlos Arturo Fernández Urbide, "Eladio frente a Pedro Nel," in *Eladio Vélez, 1897–1967: Paisaje, frutas, retrato*, ed. Eladio Vélez and Alberto Sierra Maya (Bogotá: Banco de la República, Biblioteca Luis Angel Arango, 2002), 14–15.

57. A 1926 essay by Maurice Raynal is quoted in *Victor Brecheret Retrospectiva* (São Paulo: Museu de Arte Brasileira; Fundação Armando Alvares Penteado, 1969), 16.

58. Carpentier, *Crónicas*, 337.

59. For a discussion of the Académie Julian in the nineteenth century, see Maya A. Jiménez, "Colombian Artists in Paris, 1865–1905" (PhD diss., City University of New York Graduate Center, 2010), 82. In relation to Brazil, see also Arthur Valle, "Pensionnaires de l'École National des Beaux-Arts à l'Académie Julian (Paris durant la iière République [1890–1930])," *19&20* (Rio de Janeiro) 1, no. 3 (November 2006).

60. Jiménez, "Colombian Artists in Paris."

61. Martine Hérold, *L'Académie Julian a cent ans* (Paris: 6e: 31, rue du Dragon, n.d.).

62. Without this sort of detailed record from other academies, it is difficult to compare enrollment. See Greet, "Transatlantic Encounters," http://chnm.gmu.edu/transatlanticencounters (Subjects: Académie Julian).

63. Information from "L'Académie Julian, 1890–1928: Sous-série 63 AS," Archives Nationales, France.

64. For a description of the Académie Colarossi, see John Crombie, *Rue de la Grande Chaumière: The Cradle of Montparnasse* (Paris: Kickshaws, 1998), 23.

65. This count stems from mentions of having studied at the school in secondary source monographs.

66. Maribona, *Arte y amor*, 53.

67. Crombie give the date of 1902, but the date inscribed on the current door plaque indicates that the academy was founded in 1904. Crombie, *Rue de la Grande Chaumière*, 41.

68. Ibid., 42.

69. Rendón Seminario and Ycaza Gomez, *Rendon*, n.p.

70. Bestard, *Ciudad florida*, 102.

71. Emilio Pettoruti, *Un pintor ante el espejo* (Buenos Aires: Libreria Histórica, 2004), 157–58.

72. Vázquez and Butler, *Horacio Butler: Conversaciones*, 71–73.

73. Maribona, *Arte y amor*, 63. For a more extensive description of the Académie de la Grande Chaumière, see Crombie, *Rue de la Grande Chaumière*, 41–43, 74–75.

74. Pettoruti, *Pintor ante el espejo*, 161.

75. Crombie, *Rue de la Grande Chaumière*, 74–75.

76. In 1924 Léger opened a school at 86, rue Notre-Dame-des-Champs, with Ozenfant. Christopher Green, *Léger and the Avant-Garde* (New Haven: Yale University Press, 1976), 243. Latin American artists who studied with him included Tarsila do Amaral (Brazil), Amelia Peláez (Cuba), Lydia Cabrera (Cuba), Delia del Carril (Argentina), Hernán Gazmuri (Chile), Ricardo Grau (Peru), Nina Negri (Argentina), and Carlos Prevosti (Uruguay).

77. Maribona quotes Bourdelle in Maribona, *Arte y amor*, 62. Other Latin American artists who mention having studied with or been influenced by Bourdelle include Luis Alberto Acuña, Santos Balmori, Alfredo Bigatti, Germán Cabrera, Juan José Calandria, Pablo Curatella Manes, Lorenzo Domínguez, Francisco Narváez, Antonio Pena, José Perotti, Henriette Petit, Rómulo Rozo, Juan José Sicre, Marco Tobón Mejía, Macedonio de la Torre, Sesostris Vitullo, Gastão Worms, and José Luis Zorrilla de San Martín.

78. Cited in Universidad de Chile and Instituto de Extension de Artes Plasticas, *M. A. Bontá* (Santiago: Editorial Universitaria, 1955), 15.

79. See, for example, Kenneth E. Silver, *Chaos and Classicism: Art in France, Italy, and Germany, 1918–1936* (New York: Guggenheim Museum, 2010); and Romy Golan, *Modernity and Nostalgia: Art and Politics in France between the Wars* (New Haven: Yale University Press, 1995).

80. For an example of some of Lhote's theoretical writings, see André Lhote, "A First Visit to the Louvre," *Athenaeum*, August 22, 1919, 787–88; André Lhote, "The Paris Salon," *Athenaeum*, July 16, 1920, 87, 88, 118; André Lhote, "L'enseignement de Cézanne," *Nouvelle revue française; Revue mensuelle de littérature et de critique*, November 1920, 649–72; André Lhote, "La vie des lettres: Peinture d'un cubisme 'sensible,'" *La vie des lettres et des arts* 15 (April 2, 1924): 1–6; and André Lhote, "De l'utilisation plastique du coup de foudre," *Nouvelle revue française; revue mensuelle de littérature et de critique*, March 1924, 289–302.

81. Hélène Moulin, *André Lhote, 1885–1962* (Paris: Réunion des Musées Nationaux, 2003), 102.

82. Jacques Guenne, "Portraits d'artistes André Lhote," *L'art vivant* 2 (March 1926): 181.

83. Moulin, *André Lhote*, 106–7. For a discussion of Lhote's theories and techniques, see also Gordon William Snelgrove, "An Investigation of the Present Developments from Cubism as Exemplified by the Work and Theories of Andre Lhote" (master's thesis, University of Chicago, 1933); and Daniel Robbins, *André Lhote, 1885–1962, Cubism: October 16 through December 18, 1976* (New York: Leonard Hutton Galleries, 1976).

84. Lhote starts by discussing the flaws in the teaching at the École des Beaux-Arts and then goes on to discuss works by Rembrandt, van Gogh, and Bonnat. For the unpublished document, see André Lhote, "Premier discours à mes élèves," André Lhote archives, Raincy, France.

85. Moulin, *André Lhote*, 102. Lhote taught at the Académie Montparnasse from 1917–25, at the Académie Moderne from 1918–20, at the Atelier d'Études from 1920–21, and the Académie de la rue du Départ from 1921–25. In 1927 he also started a summer program in the small village of Mirmande (near Valence), where he took students to teach *plein-air* painting.

86. Warnod, *Berceaux de la jeune peinture*, 219.

87. Serge Lemoine, "L'atelier d'André Lhote: Entretien avec Aurelie Nemours," interview, March 16, 2003, in Moulin, *André Lhote*, 113–16.

88. Snelgrove, "Investigation," 69; Guenne, "Portraits d'artistes André Lhote," 181.

89. Moulin, *André Lhote*, 116.

90. Juan Manuel Bonet, ed., *Tarsila do Amaral* (Madrid: Fundación Juan March, 2009), 205–6. Originally published as Tarsila do Amaral, "A Escola de Lhote," *Diário de São Paulo*, April 8, 1936. Lhote's work was first shown in Brazil in 1930 in the exhibition *L'École de Paris au Brésil* organized by the French journal *Montparnasse*, for which Rego Monteiro was editor. The exhibition included about sixty paintings, watercolors, and drawings by artists such as Blanchard, Braque, Derain, Dufy, Foujita, Gleizes, Gris, Gromaire, Herbin, Laurens, Le Fauconnier, Léger, Lhote, Masson, Matisse, Rego Monteiro, Picasso, Rendon, Severini, Vlaminck, and Zak; *Montparnasse* 16, no. 58 (January 1930) served as a catalogue. Lhote's paintings were also included in André Lhote and Mário de Andrade, *SPAM: Primeira exposição de arte moderna, pintura, escultura, arquitetura* (São Paulo: SPAM, 1933). This exhibition of painting, sculpture, and architecture was held from May to April 1933 in São Paulo and included one hundred works by André Lhote, Anita Malfatti, Arnaldo Barbosa,

Constantin Brancusi, Victor Brecheret, Giorgio de Chirico, Le Corbusier, [?] Csako, Robert Delaunay, Raoul Dufy, Esther Bessel, Tsuguharu Foujita, Albert Gleizes, [?] Gobbis, Antonio Gomide, Hugo Adami, Jenny K. Segall, John Graz, Juan Gris, Marie Laurencin, Lasar Segall, Fernand Léger, Jacques Lipschitz, Mussia Pinto Alves, Pablo Picasso, François Pompon, Regina Graz, Rossi Osir, Sará Affonso, Tarsila do Amaral, Edouard Vuillard, Gregori Warchavchik, and Wasth Rodrigues. In the introduction, Mario Andrade called Lhote one of three world-renowned artists in the show. The other two were Picasso and Lasar Segall.

91. Jorge López Anaya, *Historia del arte argentino* (Buenos Aires: Emecé Editores, 1997), 146. This group, which exhibited together at Amigos del Arte after their return from Paris in 1928, included Horacio Butler, Aquiles Badi, Alfredo Bigatti, Lino Spilimbergo, Hector Basaldúa, Victor Pissarro, Alberto Morera, and Antonio Berni, and Raquel Forner joined the group in 1929. Furthermore, Berni still remembered Lhote fondly in a newspaper interview conducted in 1962: M.-T. Maugis, "Un quart d'heure avec Antonio Berni," *Les lettres françaises*, August 30, 1962. Archivo Berni, Fundación Espigas.

92. On Figari, see André Lhote, "Galerie Druet, 1923," *Nouvelle revue française*, December 1, 1923, 772. Pedro León Donoso, *Ideas acerca de la pintura moderna; Conferencia dictada en el curso de capacitación del personal del Museo Único y del [Archivo] Nacional de Historia* (Quito: Talleres del Ministerio de Educación, 1938).

93. La Sociedad de Embellesimiento, *Exposition de peinture moderne* (Bogota: La Sociedad de Embellesimiento, 1922). Amigos del Arte, *Exposición de pintura moderna Europea* (Montevideo: Amigos del Arte, 1935). (These two catalogues are in the André Lhote archives.) For more on the exhibition in Venezuela, see Mariano Picón-Salas and Juan Carlos Palenzuela, *Las formas y las visiones: Ensayos sobre arte* (Caracas: Universidad Católica Andrés Bello, 2007), 121–23. A full list of the thirty-five paintings by Lhote sent to Venezuela are in the André Lhote archives.

94. The history of this academy is a bit unclear. According to Warnod, it seems that Lhote ran the Académie de la rue du Départ and moved to the 18, rue Odessa, location in 1925, turning the Départ location over to Kisling and Metzinger: "This academy was still, last year [1924], installed in a court of

la rue du Départ; to get there it was necessary to climb a steep staircase like a ladder in a henhouse; but now a new location, on rue d'Odessa, is much more comfortable." Warnod, *Berceaux de la jeune peinture*, 219.

95. Amaral, *Tarsila: Sua obra e seu tempo*, 207.

96. Bonet, *Tarsila do Amaral*, 48–49, translates Tarsila do Amaral, "Recordações de Paris," *Habitat* (São Paulo), no. 6 (1951): 17–26.

97. She also purchased another unspecified painting of Lhote's choosing in 1924.

98. Tarsila do Amaral, "Letter to André Lhote," January 25, 1924, André Lhote archives.

99. Even in 1928, Raynal, an affiliate of Léonce Rosenberg, continued his attack on Lhote, writing that his painting lacked style and personality: "André Lhote, despite his real intelligence, is the leading culprit of this too hasty movement, which he called *le cubisme sensible*. Once more the *subject* reappears, manipulated by scientific geometric deformations, clever and nimble, but coldly impersonal, because of the absence of all authentic style. Hayden, Herbin, Survage, Ortiz, Zarraga, Pruna and Gimmi embraced this tendency, and their ability was such that they often made it very attractive." Maurice Raynal, *Modern French Painters* (New York: Brentano's, 1928), 23.

100. Bonet, *Tarsila do Amaral*, 205. Originally published as Amaral, "A Escola de Lhote."

101. Letter from Héctor Basaldúa to his friends, Paris, 1923, cited in Whitelow, *Héctor Basaldúa*, 46.

102. While not noted in Vázquez and Butler, *Horacio Butler: Conversaciones*, his name appears on the rosters at the Académie Lhote, so he must have returned to take classes at the new academy.

103. Romy Golan discusses the characteristic monumentality of the period; see Golan, *Modernity and Nostalgia*, 18–21.

104. Letter from Horacio Butler to his siblings, 1923, cited in Vázquez and Butler, *Horacio Butler: Conversaciones*, 71.

105. Pettoruti, *Pintor ante el espejo*, 160.

106. Marcelo Pogolotti, *Del barro y las voces* (Havana: Contemporáneos, 1968), 226.

CHAPTER 3. PARIS

1. The first two sections of this chapter were published as Michele Greet, "Occupying Paris: The First Survey Exhibition of Latin American Art," *Journal of Curatorial Studies* 3, nos. 2–3 (June–October 2014): 212–37.

2. "Les arts: L'Académie International des Beaux-Arts," *Revue de l'Amérique latine* 4, no. 15 (March 1, 1923): 286–87.

3. "Manifestations artistiques," *Revue de l'Amérique latine* 5, no. 17 (May 1, 1923): 95.

4. Delegates included Mme Dampt, Alípio

Dutra, and Manoel Madruga (Brazil); Horacio Butler and Juan Manuel Gavazzo Buchardo (Argentina); Angel Zárraga and George de Zayas (Mexico); Juan Emilio Hernández Giro (Cuba); Luis Alberto de Sangroniz (Chile); Carlos Otero (Venezuela); and Pierre Montalvo de Matheu (El Salvador). "À l'Académie Internationale des Beaux-Arts," *Revue de l'Amérique latine* 6, no. 21 (September 1, 1923): 94.

5. Ibid.

6. The concert included Brazilian pianist Souza Lima; Argentinean composer Carlos Pedrell; and Mexican violoncellist Rubén Montiel. I have not been able to determine where this concert and exhibition were held.

7. Artists in the exhibition included Alfredo Bernier, Juan Manuel Gavazzo Buchardo, José A. Merediz, Tito Saubidet, and Manuel Villarubia-Nory (Argentina); Tarsila do Amaral, Victor Brecheret, [?] Duara, Alipio Dutra, Gaston Infante, Manoël Madruga, Anita Malfatti, Vicente do Rego Monteiro, and Domingos Viegas Toledo Piza (Brazil); Luis Alberto de Sangroniz (Chile); Marco Tobón Mejía (Colombia); Max Jiménez (Costa Rica); Juan Emilio Hernández Giro (Cuba); Manuel Rendón Seminario (Ecuador); José Felix (Peru); Pierre Matheu de Montalvo (El Salvador); Manuel Cabré and Carlos Otero (Venezuela); Servando del Pilar (Spain); and Manuel Reinoso and [?] Arriaran (unidentified). This list comes from two sources: Magellan, "La maison de l'Amérique latine," *Revue de l'Amérique latine* 5, no. 19 (July 1, 1923): 288; and Raymond Cogniat, "Les artistes de l'Amérique latine: À la Galerie G.-L. Manuel et à la 'Maison de l'Amérique latine,'" *Revue de l'Amérique latine* 5, no. 20 (August 1, 1923): 365.

8. Magellan, "Maison de l'Amérique latine," 288.

9. Cogniat, "Artistes de l'Amérique latine," 365.

10. Ville de Paris Direction des Beaux-Arts et des Musées and Musée Galliéra, "Letter to 'Maison de l'Amérique Latine' and Académie International des Beaux-Arts," January 1, 1924, press release, Musée Galliera archives, Paris. The press release then detailed the process for submitting work: artists had to send a list of works by January 15, works had to be received between March 5 and 8, and each piece had to be labeled with the address of the exhibitor.

11. Suzanne Pagé et al., *L'École de Paris, 1904–1929: La part de l'autre* (Paris: Paris Musées, 2000), 31.

12. "L'exposition d'art Américain-latin," *Revue de l'Amérique latine* 7, no. 26 (February 1, 1924): 189–90.

13. Cited in "La maison de l'Amérique latine," *Revue de l'Amérique latine* 7, no. 28 (April 1, 1924): 380.

14. This rhetoric of Paris as the capital of Latin America soon took hold across the Parisian art world. The text for Argentine artist Roberto Ramaugé's exhibition at the Galerie Georges Petit in 1927, for example, reads: "Paris, thanks to its inexhaustible resources, its justified prestige, as well as to the freedom that it offers for education and research of any kind, has truly become the Capital of these exchanges previously deemed quixotic." Roberto Ramaugé, *Roberto Ramaugé* (Paris: Galerie Georges Petit, 1927), n.p.

15. Cited in "Maison de l'Amérique Latine," 381.

16. For a full list of all the artists who participated in the exhibition, see Michele Greet, "Transatlantic Encounters: Latin American Artists in Interwar Paris," http://chnm.gmu.edu/transatlanticencounters (Subjects: 1924 Exposition d'Art Américain-Latin).

17. On March 21 the program featured a lecture on Latin American literature, followed by Cuban dance, poetry, and music. On April 4 there occurred "Causerie sur l'art Américain latin par M. Louis Hourticq, professeur à l'École des Beaux-Arts," followed by a musical program. On April 11 a lecture on Latin American poetry was accompanied by a musical program. The musical concert of April 15 showcased Inca music followed by a concert by Gabriel Fauré (including a translation into French of Inca lyrics). These programs are all in the Musée Galliera archives.

18. Henri Clouzot, "Les arts: La première exposition de l'Amérique latine," *L'Europe nouvelle*, April 24, 1924, 447.

19. Argentina had seventeen artists; Bolivia had one artist; Brazil had thirteen artists; Chile had seven artists; Colombia had one artist; Costa Rica had one artist; Cuba had seventeen artists (including many from the retrospective); Ecuador had two artists; Honduras had one artist; Mexico had two artists; Peru had two artists (one from the retrospective); El Salvador had one artist; Uruguay had seven artists; and Venezuela had three artists.

20. Raymond Cogniat, "La vie artistique: Exposition d'art Américain-latin au Musée Galliéra," *Revue de l'Amérique latine* 7, no. 29 (May 1, 1924): 436.

21. P. V., "Les petites expositions," *Journal des débats*, April 5, 1924, 4.

22. José Frías, "La exposición latinoamericana en el Museo Galliera," *Revista de revistas* (Mexico) 15, no. 733 (May 25, 1924): 36.

23. The legend of the feathered serpent refers to the Mesoamerican deity known as Quetzalcoatl, worshipped in various forms by different ethnic groups since around the first century BCE.

24. Cogniat, "Vie artistique: Exposition d'art Américain-latin," 436.

25. Phil Sawyer, "In Color and Clay," *Chicago Tribune* and the *Daily News* (New York), March 23, 1924 (European edition), 4, writes: "[Xul Solar] also uses these principles [Pettoruti's] in an amusing fashion."

26. Ibid.

27. Frías, "Exposición latinoamericana," 35–36.

28. Cogniat, "Vie artistique: Exposition d'art américain-latin," 436.

29. *Candombe* is a traditional Afro-Uruguayan dance, while *pericón* is a folk dance.

30. Cogniat, "Vie artistique: Exposition d'art américain-latin," 436.

31. Clouzot, "Arts: La première exposition de l'Amérique latine," 447–48.

32. "Le monde des arts," *New York Herald*, March 16, 1924, 3.

33. Sawyer, "In Color and Clay," 4.

34. Ibid.

35. Clouzot, "Arts: La première exposition de l'Amérique latine," 447–48; Cogniat, "Vie artistique: Exposition d'art américain-latin," 436.

36. Michele Greet, *Beyond National Identity: Pictorial Indigenism as a Modernist Strategy in Andean Art, 1920–1960* (University Park: Pennsylvania State University Press, 2009), 44–45.

37. Raymond Cogniat, "La vie artistique: Les américains au Salon des Indépendants," *Revue de l'Amérique latine* 7, no. 29 (May 1, 1924): 433–34. The exhibition was organized by the Maison de l'Amérique Latine and the Académie Internationale des Beaux-Arts.

38. Armando Maribona, *El arte y el amor en Montparnasse: Documental novelado, París, 1923–1930* (Mexico: Ediciones Botas, 1950), 241–42.

39. "Mr. Paul Léon [director of fine arts] informed the members of the Director's Committee that the French State just acquired a bronze head by the Argentine sculptor Alberto Lagos"; "Les beaux arts: Expositions d'art américain latin," *Comoedia*, March 28, 1924, 3.

40. Sawyer, "In Color and Clay," 4. Frías, "Exposición latinoamericana en el Museo Galliera," 35.

41. Cogniat, "Vie artistique: Exposition d'art américain-latin," 435.

42. Ibid.

43. Henri Simoni, "Les artistes de l'Amérique latine au Musée Galliera," *L'oeuvre*, March 16, 1924, 5.

44. Sawyer, "In Color and Clay," 4.

45. Cogniat, "Vie artistique: Exposition d'art américain-latin," 435.

46. Frías, "Exposición latinoamericana en el Museo Galliera," 35. The daring of Jiménez's work was also highlighted in the text for his 1924 exhibition: "Max Jiménez approaches difficult art with audacious logic. The development of a curious spirit and skillful execution excludes all banality from his art." Max Jiménez, *Celso Lagar, peintre, Max Jiménez, sculpteur* (Paris: Galerie Percier, 1924), n.p.

47. Frías, "Exposición latinoamericana en el Museo Galliera," 36.

48. Sawyer, "In Color and Clay," 4.

49. This painting sold for 3,500 francs in 1926.

50. Jean-Gabriel Lemoine, "Une exposition d'art Américain-latin," *Beaux-arts: Chronique des arts et de la curiosité* 2, no. 8 (April 15, 1924): 117.

51. Clouzot, "Arts: La première exposition de l'Amérique latine," 447.

52. Sawyer, "In Color and Clay," 4.

53. Cogniat, "Vie artistique: Exposition d'art américain-latin," 434.

54. Clouzot, "Arts: La première exposition de l'Amérique latine," 447–48.

55. Frías, "Exposición latinoamericana en el Museo Galliera," 35.

56. Ibid.

57. "Maison de l'Amérique Latine," 380–82. There is little mention of the bureau in the press after this proposal, so it is likely that it never came to fruition.

58. "Inauguration de l'Association Paris-Amérique latine," *Petit Parisien*, June 4, 1925, 3. The association was founded on March 19, 1925, but the inauguration did not take place until several months later.

59. "Au cercle 'Paris-Amérique latine,'" *Revue de l'Amérique latine* 10, no. 45 (September 1, 1925): 284–85.

60. Paulette Patout, "La cultura latinoamericana en París entre 1910 y 1936," in *1899/1999: Vida, obra y herencia de Miguel Ángel Asturias: La riqueza de la diversidad* (Nanterre: Université Paris X, ALLCA XX, 1999), 218.

61. These exhibitions included 1925 (October), Armando Maribona and Jiménez Armongol, Cuba; 1926 (June), Enrique Riverón, Cuba; 1926 (July), Carmen Saco, Peru; 1927 (March), César Moro, Peru, and Jaime Colson, Dominican Republic; 1927 (June), group show of Argentine art (eighteen artists living and working in Paris); 1927 (November), Francisco Olazo and Manuel Domingo Pantigoso, Peru; 1927 (December), Elena del Carpio, Bolivia; 1928 (January), Andrés

Nogueira, Domingo Ravenet, and Alberto Sabas, Cuba; 1928 (June), Rómulo Rozo, Colombia.

62. "Les arts: Au cercle Paris-Amérique latine," *Revue de l'Amérique latine,* ill. suppl. (January 1, 1928): viii–x.

63. Raymond Cogniat, "La vie artistique: Mme Carmen Saco, sculpteur péruvien," *Revue de l'Amérique latine* 12, no. 58 (October 1, 1926): 368; "Les arts: L'exposition de Mme Carmen Saco," *Revue de l'Amérique latine,* ill. suppl. (October 1, 1926): lv–lvii. The latter reproduced *Project for a Fountain.*

64. "Exposition des quelques oeuvres de sculpture Péruviennes et des pastels et dessins de Madame Carmen Saco au cercle Paris-Amérique-latine," *Paris Sud et Centre Amérique* 2, no. 57 (August 30, 1926): 9.

65. Gustave Kahn, "Quelques sculpteurs de l'Amérique latine," *La renaissance de l'art français et des industries de luxe* 9, no. 8 (special issue on Latin America) (1926): 487.

66. Felipe Cossío del Pomar, introduction to *Hommage au génial artiste Franco-Péruvien Gauguin* (Paris: Association "Paris-Amérique latine," 1926).

67. Société Paris-Amérique Latine, *Tableaux de Jaime A. Colson et César Moro, du 10 au 16 mars 1927* (Paris: Société Paris-Amérique Latine, 1927). The catalogue was reproduced in Fernando Villegas Torres, "Vínculos Artísticas entre España y Perú (1892–1929): Elementos para la construcción del imaginario nacional peruano" (PhD diss., Universidad Complutense de Madrid, 2013), 672.

68. José Carlos Mariátegui, Luis Alberto Sánchez, and Manuel Aquézolo Castro, *La polémica del indigenismo* (Lima: Mosca Azul Editores, 1976), 33, cites José Carlos Mariátegui, "El indigenismo en la literatura nacional," *Mundial* (Lima) 345 (January 21, 1927): n.p.

69. For a discussion of the exhibition, see Villegas Torres, "Vínculos artísticas entre España y Perú," 221. The catalogue is reproduced in ibid., 690.

70. "Arts: Au cercle Paris-Amérique latine," viii–x.

71. "L'Amérique latine: Arts et lettres," *New York Herald,* December 4, 1927, 5.

72. The academy seems to have died out before it really began, since there is no documentation of any artists having studied there.

73. Information from a publicity brochure from the current Maison de l'Amérique Latine, 217 boulevard Saint-Germain, 75007 Paris.

CHAPTER 4. AT THE SALONS

1. For a discussion of the French salons, see Claire Maingon, *L'âge critique des salons 1914–1925: L'École française, la tradition et l'art moderne* (Mont-Saint-Aignan: Presses universitaires de Rouen et du Havre, 2014).

2. Christopher Green, *Art in France: 1900–1940* (New Haven: Yale University Press, 2000), 132.

3. By counting those artists listed in the *Revue de l'Amérique latine* between 1923 and 1932 and those who self-reported participation in secondary sources, I have identified sixty-four Latin American artists who participated in the Société des Artistes Français and thirty-five who participated in the Société Nationale des Beaux-Arts salons in the 1920s and 1930s, but there were most likely many more. I also reviewed annals for the Société des Artistes Français between 1927 and 1930, but was unable to obtain the years prior to 1927. For a complete list, see Michele Greet, "Transatlantic Encounters: Latin American Artists in Interwar Paris," http://chnm.gmu.edu/transatlanticencounters (Subjects: Société des Artistes Français; Société Nationale des Beaux-Arts; Salon d'automne; Salon des Tuileries; Salon des Indépendants).

4. Napoleon Bonaparte established the Legion of Honor, the highest decoration in France, in 1802. The Order is divided into five levels: *chevalier* (knight), *officier* (officer), *commandeur* (commander), *grand officier* (grand officer), and *grand croix* (grand cross). It may be awarded to foreign nationals who have served France or the ideals it upholds. Latin American artists awarded the French Legion of Honor included Juan Emilio Hernández Giro (1924), Alberto Valenzuela Llanos (1924[?]), Angel Zárraga (1927), Marco Tobón Mejía (1928), Gaston de Fonseca (1929), Tito Salas (1932), Victor Brecheret (1933), Pablo Mañé (1934), Carlos Alberto Castellanos (1937), and Pablo Curatella Manes (1939).

5. Raymond Cogniat, "La vie artistique: Les salons, Société Nationale des Beaux-Arts," *Revue de l'Amérique latine* 12, no. 55 (July 1, 1926): 67.

6. Raymond Cogniat, "Les salons," *Revue de l'Amérique latine* 15, no. 78 (June 1, 1928): 553.

7. Raymond Cogniat, "La vie artistique: Le salon," *Revue de l'Amérique latine* 19, no. 102 (June 1, 1930): 548.

8. Cogniat, "Vie artistique: Les salons," 68.

9. Ibid.

10. An example of a work that appeared in several manifestations was Zorrilla de San Martín's *The Fountain of Athletes.*

11. Cogniat, "Vie artistique: Les salons," 68.

12. "Une oeuvre de M. Tobón Mejia," *Revue de l'Amérique latine,* ill. suppl. (July 1, 1930): viii.

13. Cogniat, "Vie artistique: Les salons," 68.

14. Anecdote recounted in Jorge Cárdenas, *Vida y obra de Marco Tobón Mejía* (Medellín: Museo de Antioquia, 1987), 30.

15. The Salon des Indépendants, Salon d'Automne, and Salon des Tuileries all took place at the Palais de Bois, creating an even greater divide with the official salons that exhibited at the Grand Palais. Béatrice Joyeux-Prunel, *Géopolitique des avant-gardes: Une histoire socioculturelle de la scène avant-gardiste européenne, 1848–1968* (Paris: Gallimard, forthcoming), 133.

16. César Vallejo, *Artículos y crónicas completos* (Lima: Pontificia Universidad Católica del Perú, 2002), 76. Originally published as César Vallejo, "Salón de las tullerías de París," *Alfar* (La Coruña), no. 44 (November 1924).

17. For a complete list, see Greet, "Transatlantic Encounters," http://chnm.gmu.edu/transatlanticencounters (Subjects: Salon d'automne).

18. The Tuileries accepted only five hundred paintings per year, as compared to the twelve hundred shown at the Salon d'Automne.

19. Raquel Pereda, *Carlos Alberto Castellanos: Imaginación y realidad* (Montevideo: Fundación Banco de Boston, 1997), 96.

20. Carlos Alberto Castellanos, *Exposition Carlos A. Castellanos tableaux et tapisseries* (Paris: Galeries Durand-Ruel, 1927).

21. "Les peintres sud-américains," *New York Herald* (Paris edition), December 29, 1920.

22. "Au Salon," *Le crapouillot,* November 1, 1924, 29, reproduces Malfatti's painting under the title *Egliseà venise.* Raymond Cogniat, "La vie artistique: Les artistes américains au Salon d'Automne," *Revue de l'Amérique latine* 9, no. 37 (January 1, 1925): 64.

23. Raymond Cogniat, "La vie artistique: Les artistes américains au Salon d'Automne," *Revue de l'Amérique latine* 10, no. 48 (December 1, 1925): 545.

24. With *Tropical,* Malfatti achieved enough recognition to secure a solo show the following year, which will be discussed in Chapter 6.

25. Cogniat, "La vie artistique: Les artistes américains au Salon d'Automne" (January 25, 1925), 551.

26. For a further discussion of Malfatti, see Chapter 6.

27. For a further discussion of Zárraga's mural commissions in Paris, see Michele Greet, "Del cubismo al muralismo: Angel Zárraga

en Paris," in *Ángel Zárraga: El sentido de la creación*, ed. Evelyn Useda Miranda (Mexico City: Museo de Palacio de Bellas Artes, 2014).

28. Vincent Bouvet, *Paris between the Wars, 1919–1939: Art, Life and Culture* (New York: Vendome, 2010), 54.

29. Previously, Milliat was president of the Fédération des Sociétés Féminines Sportives de France (FSFSF), officially founded on January 18, 1918.

30. A trompe l'oeil certificate in the lower-left corner of the painting reads "From left to right Jeanne Zarraga, Henriette Comte, Thérèse Renaut of the Sports Club of Paris, Champion of France in Women's Soccer in 1922."

31. *Soccer Players* was reproduced as *Footballeuses* in Louise Hervieu, "Zarraga," *La renaissance de l'art français et des industries de luxe* 9, no. 6 (June 1926): 339–45. René Édouard-Joseph, *Dictionnaire biographique des artistes contemporains, 1910–1930* (Paris: Art et Édition, 1930), 457.

32. Zárraga's exhibitions in the mid-1920s include 1925, Galerie Bernheim-Jeune (group show); 1925, Galerie Devambez (group show); 1926, *Exposition Angel Zarraga*, Galerie Bernheim-Jeune; 1926, Salon du France, Musée Galliera.

33. Antonio Luna Arroyo, *Zárraga* (Mexico City: Salvat Ciencia y Cultura Latinoamérica, 1993), 131, cites *Miroir des Sports* (Paris), January 1925.

34. The homoeroticism of these images makes it tempting to speculate that Zárraga struggled with a latent homosexuality, and that his turn to religion in the 1920s was a subterfuge for these repressed desires that only revealed themselves in his paintings of young male athletes. There is, however, no direct evidence of this conjecture.

35. Cited in Paulette Patout, "Le chemin de croix de Saint-Martin de Meudon: Une oeuvre majeure du peintre Angel Zarraga (1886–1946)," *Bulletin des Amis de Meudon* 60, no. 206 (April 1996): 145.

36. Kenneth E. Silver, *Chaos and Classicism: Art in France, Italy, and Germany 1918–1936* (New York: Guggenheim Museum, 2010). Zarraga's work would have fit perfectly into the conceptualization of this show, but it was not included.

37. Angel Zárraga, *Aprendizaje* (Mexico City: Secretaria de Educación Pública, 1942), 26–27.

38. Luna Arroyo, *Zárraga*, 33. Arroyo mentions this review in *Excelsior* dated October 30, 1931, but I have been unable to locate the original.

39. Cogniat, "Vie artistique: Les artistes américains au Salon d'Automne," 545.

40. Bernard Gineste, "The Neoceltic Monument of Étampes," http://www.corpusetampois.com/cae-20-doucefrance1925monument.html.

41. Waldemar George, "Le Salon des Tuileries," *L'amour de l'art*, n.d., 235. Maurice Raynal, "Le Salon des Tuileries," *L'intransigeant*, May 29, 1925, 5.

42. André Lhote, "La obra de Pablo Curatella Manes," *El hogar*, January 15, 1926, 38.

43. Brecheret's *Mise au tombeau* was reproduced in *Le crapouillot* on November 15, 1923, and reviewed in Raymond Cogniat, "La vie artistique: Les artistes américains au Salon d'Automne," *Revue de l'Amérique latine* 6, no. 24 (December 1, 1923): 356–58.

44. The version reproduced here is plaster painted gold; it seems that the version submitted to the salon was white plaster. Perhaps the gold was added at a later date or this is a different version.

45. *Porteuse de parfums* by Brecheret was reproduced in "Le Salon d'Automne," *Montparnasse* 10, no. 36 (November 1, 1924). It was also reviewed in Géo-Charles, "Le Salon d'Automne," *Montparnasse* 10, no. 37 (December 1, 1924). Raynal's review was most likely first printed in his column for *L'intransigeant*, but I have been unable to locate the original. It was reprinted in the 1926 exhibition catalogue *Victor Brecheret, São Paulo*, cited in Daisy V. M Peccinini de Alvarado, *Brecheret: A linguagem das formas*, trans. Charles Richard Castleberry (São Paulo: Instituto Victor Brecheret, 2004), 273. Cogniat discussed the sculpture in Cogniat, "La vie artistique: Les artistes américains au Salon d'Automne" (January 1, 1925), 63.

46. Peccinini de Alvarado, *Brecheret: A linguagem das formas*, 272, cites and translates Louis Hautecoeur, *Gazette des beaux-arts*, December 1924.

47. André Warnod, "La danseuse de Brechéret," *Comoedia*, October 18, 1925.

48. Peccinini de Alvarado, *Brecheret: A linguagem das formas*, 280.

49. For an explanation of the Bachué myth, see Alvaro Medina, "Rómulo Rozo: El arte de su tiempo en América Latina," in *Rómulo Rozo: Sincretismo* (Mexico City: Instituto Nacional de Bellas Artes, 1999), 27–30.

50. "Romulo Rozo," *Revue du vrai et du beau* 6, no. 98 (March 10, 1927): 12.

51. "La vie artistique: Salon de 1926," *Revue moderne des arts et de la vie*, June 15, 1926, 17. The chronology of these events is a bit unclear. Raymond Cogniat only mentions that Rozo submitted the *Head of a Woman*

to the national salon, and Cogniat almost always commented on the unique contributions of Latin American artists to the salons for his reviews in the *Revue de l'Amérique latine*. But since the *Revue moderne* article was published over the summer, it came out before the Salon d'Automne. So either Rozo had submitted his indigenous works to the national salon or the Salon des Tuileries in the spring of 1926 with no comment by Cogniat (if it was the national salon, my contention that he reserved his more experimental work for the Salon d'Automne is of course negated) or the reviewer visited Rozo's studio to see what he was preparing for the Salon d'Automne.

52. "Romulo Rozo," 12.

53. José Frías quoted in Armando Maribona, *El arte y el amor en Montparnasse: Documental novelado, París, 1923–1930* (Mexico: Ediciones Botas, 1950), 78.

54. Suzanne Pagé et al., *L'École de Paris, 1904–1929: La part de l'autre* (Paris: Paris Musées, 2000), 31.

55. Unfortunately, it is impossible to tell from the catalogue where each artist's work was hung, but Cogniat commented on how the new organization made it so much easier to identify Latin American artists. Raymond Cogniat, "La vie artistique: Les américains au Salon des Indépendants," *Revue de l'Amérique latine* 7, no. 29 (May 1, 1924): 432–34.

56. Ibid., 433.

57. Maribona, *Arte y amor*, 115.

58. Quoted in ibid., 112.

59. Cited in ibid., 113, 115.

60. Some noteworthy Latin American artists at the Salon des Indépendants included Rodolfo Alcorta, Victor Brecheret, Manuel Cabré, Carlos Alberto Castellaños, Jaime Colson, Vicente do Rego Monteiro, Anita Malfatti, Pablo Curatella Manes, Manuel Rendón Seminario, and Rómulo Rozo. For a complete list, see Greet, "Transatlantic Encounters," http://chnm.gmu.edu/transatlanticencounters (Subjects: Salon des Indépendants).

61. Maribona, *Arte y amor*, 117.

62. "Beaux-arts: Le 35e salon des artistes indépendants," *Comoedia*, February 10, 1924.

63. That year he also published a book of prints: *Legendes, croyances et talismans des Indiens de l'Amazone* (Paris: Folmer, 1923).

64. For a discussion of the Brazilian sources present in *The Hunt*, see Edith Wolfe, "Paris as Periphery: Vicente Do Rego Monteiro and Brazil's Discrepant Cosmopolitanism," *Art Bulletin* 96, no. 1 (March 2014): 102–3.

65. Ibid., 102.

66. Cogniat, "La vie artistique: Les américains au Salon des Indépendants," 433–34.

67. See discussion in the introduction of Vicente do Rego Monteiro, *Quelques visages de Paris* (Paris: Imprimerie Juan Dura, 1925).

68. André Warnod, *Les berceaux de la jeune peinture: Montmartre, Montparnasse* (Paris: A. Michel, 1925), 7–8. See also Pagé et al., *École de Paris*, 88, which cites André Warnod, *Comoedia*, January 27, 1925.

69. For an extensive discussion of the School of Paris, see Pagé et al., *École de Paris*.

70. Juan Fride, *Luis Alberto Acuña: Pintor colombiano* (Bogotá: Editorial Amerindia, n.d.), 20, quotes *Paris-midi*, October 22, 1926.

71. Ibid.

72. Romy Golan, *Modernity and Nostalgia: Art and Politics in France between the Wars* (New Haven: Yale University Press, 1995), 139. It is hard to determine where these pieces ended up because it seems that throughout the 1920s the annex was still referred to as part of the Musée du Luxembourg, so even works hung at the Jeu de Paume were reportedly acquired by the Luxembourg. Latin American artists whose work was acquired by the Musée du Luxembourg included Carlos Alberto Castellanos (three works acquired in 1919), Alberto Valenzuela Llanos (*Romeros en flor* acquired in 1924), José Antonio Terry (*La enana chepa* and *Sac ruche* acquired in 1924), Luis Alberto Acuña (*Nessus séduisant Déjanire* acquired in 1926), and Rómulo Rozo (sculpture acquired in 1928). The museum also acquired works by Benito Quinquela Martin (*Tormenta en el astillero*), Samson Flexor, and Alberto Lagos. It was not until the 1930s that artists reported that their works were purchased by the Jeu de Paume, which acquired Victor Brecheret's *O grupo* in 1934 and a work by Mario Carreño in ca. 1939.

73. "Art-Lovers Flock to Salon du France," *New York Herald*, October 23, 1926, 5.

74. [?] Vanderpyl, "Le Salon du France," *Petit Parisien*, October 21, 1926, 7.

75. "L'Amérique latine: Arts et lettres," *New York Herald*, October 31, 1926, 5. While the number printed in the paper was indeed 67,000 francs, that seems to be an astronomical amount. While I have no evidence to confirm this, I wonder if it is perhaps a typo and the actual amount should have been 6,700 francs.

76. Georges Charensol, "Les expositions," *L'art vivant* 2 (November 5, 1926): 831–32.

77. Maurice Lautreuil, "L'École de Paris au Brésil: Expositions et conférences organisées par la revue 'Montparnasse,'" *Montparnasse*, no. 58 (January 1930): 1–3.

This exhibition set the precedent for a similar exhibition that took place in 1933. André Lhote and Mário de Andrade, *SPAM: Primeira exposição de arte moderna, pintura, escultura, arquitetura* (São Paulo: SPAM, 1933). SPAM also featured a mix of European and Brazilian artists. See Chapter 2, n90, for a complete list.

78. Walter Zanini, *Vicente do Rego Monteiro: Artista e poeta* (São Paulo: Empresa das Artes, Marigo Editora, 1997), 265–66.

79. In a letter from Léonce Rosenberg to Rego Monteiro, dated December 10, 1929, Rosenberg agrees to lend works by Rendón, Gleizes, Joseph Csáky, Auguste Herbin, Léopold Survage, Georges Valmier, Laurens, and Severini to the exhibition for a period of four months. Ibid., 131.

80. Golan, *Modernity and Nostalgia*, 153n50. Golan cites and translates Waldemar George, "École Française ou École de Paris," *Formes*, pt. 1 (June 1931): 92–93; pt. 2 (July 1931): 110–11.

81. George writes: "The École de Paris is a neologism, a new accession. This term, which dominates the world art market, is a conscious example of premeditated conspiracy against the notion of a School of France. It not only takes into consideration foreign contributions; it ratifies them and grants them a leading position. It is a rather subtle, hypocritical sign of the spirit of Francophobia. It allows any artist to pretend he is French. . . . It has no legitimacy. It refers to French tradition but it in fact annihilates it. . . . Shouldn't France repudiate the works that weaken her genius? . . . The École de Paris is a house of cards build in Montparnasse. . . . Its ideology is oriented against that of the French School. . . . The moment has come for France to turn in upon herself and to find in her own soil the seeds of her salvation." Ibid.

82. Pagé et al., *École de Paris*, 38. *Peintres italiens de Paris* (Salon de l'Escalier), 1928; *Un groupe d'Italiens de Paris* (Galerie Zak, 1929); *Exposition d'art polonais moderne*; *Les artistes juifs de Paris* (Galerie Billiet, Zurich, 1929); *Artistes américains de Paris* (Galerie de la Renaissance, 1932). This emphasis on national artistic traditions persisted in the 1930s with exhibitions at the Jeu de Paume of *Modern Italian Art* (1935), *Contemporary Spanish Art* (1936), *Catalan Art* (1937), *Three Centuries of Art from the USA* (1938 with MoMA), and *Art in Latvia* (1939). See Bouvet, *Paris between the Wars*, 226.

83. For a discussion of performing the self as an emigré artist, see Kenneth E. Silver, "Made in Paris," in Pagé et al., *École de Paris*, 41.

84. André Fage, *Le collectionneur de peintures modernes: Comment acheter, comment vendre* (Paris: Éditions Pittoresques, 1930), 241.

85. Louis Leon-Martin, "Aujourd'hui s'ouvre l'exposition des 'vrais indépendants' les novateurs paraissent se soucier surtout de l'effet décoratif," *Paris-soir*, October 27, 1928. André Warnod, "Beaux-arts ce qu'on verra au salon des 'vrais indépendants,'" *Comoedia*, October 24, 1928. Warnod describes the division of the salon into avant-grade, impressionist, and traditional rooms.

86. Of the independent salons (true or false, international or French), we know of three already. Warnod, "Beaux-arts ce qu'on verra," 1–2.

87. Raymond Cogniat, "La vie artistique: Le Salon des Surindépendants," *Revue de l'Amérique latine* 20, no. 105 (September 1, 1930): 263.

88. André Warnod, "Deux salons 'indépendants' s'ouvrent aujourd'jui: Les Surindépendants ou le petit salon plus riches qu'un grand/ Les Vrais Indépendants continuent les traditions des peintres du dimanche," *Comoedia*, October 23, 1931, 1–2.

89. Cogniat, "Vie artistique: Le Salon des Surindépendants," 263.

90. "Le Salon des Vrais Indépendants," *Eve*, November 18, 1928, 3. I have not been able to identify which painting she submitted.

91. Cogniat, "Vie artistique: Le Salon des Surindépendants," 263.

92. Paul Fierens, "L'Exposition des Surindépendants," *Journal des débats*, November 18, 1930, 3.

93. Cogniat, "Vie artistique: Le Salon des Surindépendants," 263. Italics are mine.

CHAPTER 5. AT THE GALLERIES

1. Louis Vauxcelles, "La semaine artistique," *L'ère nouvelle*, November 8, 1923, 2.

2. César Vallejo, *Artículos y crónicas completos* (Lima: Pontificia Universidad Católica del Perú, 2002), 689. Originally published as César Vallejo, "La juventud de América en Europa" *Mundial* (Lima), February 1, 1929.

3. Béatrice Joyeux-Prunel, *Géopolitique des avant-gardes: Une histoire socioculturelle de la scène avant-gardiste européenne, 1848–1968* (Paris: Gallimard, forthcoming), 158–59.

4. Ibid., 160.

5. Ibid., 138.

6. Malcolm Gee, *Dealers, Critics, and Collectors of Modern Painting: Aspects of the Parisian Art Market between 1910 and 1930* (New York: Garland, 1981), 67–69.

7. Ibid., 41.

8. Armando Maribona, *El arte y el amor en Montparnasse: Documental novelado, Paris,*

1923–1930 (Mexico City: Ediciones Botas, 1950), 273.

9. Ibid., 58, 256.

10. For more on Paris galleries, see Joyeux-Prunel, *Géopolitique des avant-gardes*, 154–56.

11. André Fage, *Le collectionneur de peintures modernes: Comment acheter, comment vendre* (Paris: Éditions pittoresques, 1930), 124.

12. Orozco was not in Paris at the time of the exhibition and it received very little critical attention, with only one known review. Raymond Cogniat, "Les expositions: M. José Clemente Orozco," *Revue de l'Amérique latine*, ill. suppl. (February 1, 1926): xxviii–xxix.

13. Joyeux-Prunel, *Géopolitique des avant-garde*, 145.

14. André Salmon and Carlos Mérida, *Images de Guatemala* (Paris: Éditions de Quatre-Chemins, 1927).

15. Julio María Sanguinetti, *El doctor Figari* (Montevideo: Fundación BankBoston, 2002), 157.

16. Patricia Artundo, *Artistas modernos rio-platenses en Europa 1911–1924: La experiencia de la vanguardia* (Buenos Aires: MALBA, Colección Costantini, 2002), 145.

17. Cited in Charles Lesca, "Pedro Figari, peintre uruguayen," *Revue de l'Amérique latine* 5, no. 17 (May 1, 1923): 166–67. For the full text of the lecture, see Fernando Laroche, *El arte de Figari: Conferencia pronunciada por el senõr Fernando Laroche, en la universidad, bajo el patrocino del Comité France-Amérique de Montevideo* (Montevideo: Renacimiento, 1923), 1–30.

18. Gee, *Dealers, Critics, and Collectors*, 170.

19. Jules Supervielle, *Exposition Pedro Figari: Scènes de la vie sud-américaine* (Paris: Galerie E. Druet, 1923). Supervielle also published a promotional article on the artist and the exhibition, which included reproductions of three paintings. Jules Supervielle, "À propos d'une exposition de Pedro Figari," *Revue de l'Amérique latine* 6, no. 24 (December 1, 1923): 287–90.

20. Supervielle, *Exposition Pedro Figari*.

21. Gabriel Peluffo Linari, "The Construction of a 'rioplatina' Legend," in *Pedro Figari: Mito y Memoria Rioplatenses*, ed. Gabriel Peluffo Linari et al. (Caracas: Museo de Bellas Artes, n.d.), 24.

22. Vauxcelles, "Semaine artistique," 2.

23. Raymond Cogniat, "La vie artistique: Exposition Pedro Figari à la Galerie Druet," *Revue de l'Amérique latine* 6, no. 24 (December 1, 1923): 357. The rest of Cogniat's review of Figari's 1923 exhibition focused almost entirely on form, praising the artist's ability as a colorist, while criticizing his lack of attention to composition and ordering of volumes.

24. "To save such a beautiful legend and give so much value as it is there in the Río de la Plata, and so forgotten and unknown, and having succeeded in interesting Europe's high intelligentsia"; Sanguinetti, *Doctor Figari*, 256. Sanguinetti cites letters to don Manuel Güiraldes, August 27, 1927, and November 26, 1928. Archivo Figari, Archivo General de la Nación, Montevideo.

25. Sanguinetti, *Doctor Figari*, 229, 275. Among the collectors of Figari's work in the 1920s were the Musée de Luxembourg, Jos Gesselt, Georges Bernheim, A. Athis, Georges Bénard, Emile Shreiber, Georges Lhoucq, M. Nougayrol, Hubert de Ganay, Maurice Khan, and Pierre Barthélemy. Figari made this list of collectors on July 23, 1929.

26. Salmon had reviewed Figari's 1923 exhibition and was therefore familiar with the artist. André Salmon, "Les arts et la vie," *Revue de France* 4, no. 14 (July 15, 1924): 381–84.

27. Pedro Figari and André Salmon, *Exposition Pedro Figari* (Paris: Galerie E. Druet, 1925).

28. Ibid.

29. See Sergio Piñero, "Exposicion Pedro Figari," *Martín Fierro*, July 19, 1925, 3. Gervasio Guillot Muñoz, "La peinture de Pedro Figari," *Revue de l'Amérique latine* 10, no. 47 (November 1, 1925): 403–6.

30. Raymond Cogniat, "La vie artistique: Exposition Pedro Figari," *Revue de l'Amérique latine* 10, no. 48 (December 1, 1925): 546; André Warnod, "Exposition Pedro Figari," *Comoedia*, October 18, 1925.

31. Guillot Muñoz, "Peinture de Pedro Figari," 404.

32. Ibid., 405.

33. Cogniat, "Vie artistique: Exposition Pedro Figari," 546.

34. Warnod, "Exposition Pedro Figari."

35. Guillot Muñoz, "Peinture de Pedro Figari," 405.

36. Warnod, "Exposition Pedro Figari."

37. Jean Cassou, "L'art de Pedro Figari," *Revue de l'Amérique latine* 11, no. 51 (March 1, 1926): 260.

38. Guillot Muñoz, "Peinture de Pedro Figari," 406.

39. Waldemar George, "Le mois artistique," *L'amour de l'art*, November 1, 1925, 453.

40. Sanguinetti, *Doctor Figari*, 245. He cites a letter from Pedro Figari to Federico Fleurquin ("miembro del Consejo Nacional de Administración") from Paris, July 17, 1927. Archivo Figari, Museo Histórico Nacional, Montevideo, tomo 2648.

41. "Les arts: Pour Pedro Figari," *Revue de l'Amérique latine*, ill. suppl. (May 1, 1927): lxix.

42. Georges Pillement, *Pedro Figari* (Paris: Crès, 1930), 4.

43. Ibid., 6.

44. Raymond Ronze, "Pedro Figari homme curieux et grand artiste," *Revue de l'Amérique latine* 21, no. 113 (May 1931): 352.

45. Sanguinetti, *Doctor Figari*, 284. He cites a letter from Figari to Manuel Güiraldes, Paris, May 17, 1930, Archivo Faget Montero.

46. "Un grand prix à Pedro Figari," *Revue de l'Amérique latine*, ill. suppl. (April 1931): xxxviii.

47. Pedro Figari, *Exposición Figari octubre 1933* (Montevideo: Sociedad Amigos del Arte Montevideo, 1933).

48. Cited in Gee, *Dealers, Critics, and Collectors*, 120.

49. "El pintor Camilo Egas triunfa en París," *El Guante* (Guayaquil), 1925, Archivo de Camilo Egas, Quito, clipping file, property of Trinidad Pérez. The exhibition was entitled *Exposition peintures de Camilo Egas* and was held in September and October 1925 at the Galerie Carmine 51, rue de Seine. Reproductions of *Raza India*, *Caravane "Otavalo," Desnudo* (may be the same as *Zambiza* in the exhibition), *Nu de femme "Catacachi,"* and *Insidieuse* exist in the archives. The discussion of Egas's Paris exhibition has been published previously in slightly modified form in Michele Greet, *Beyond National Identity: Pictorial Indigenism as a Modernist Strategy in Andean Art, 1920–1960* (University Park: Pennsylvania State University Press, 2009), 38–48.

50. Another version of *Raza India*, also painted while Egas was in Paris, was later reproduced in his journal, *Hélice*. It is therefore unclear which version was included in the exhibition.

51. García Calderón is quoted in Gonzalo Zaldumbide, "Le peintre Camilo Egas," *Revue du bureau de propagande de l'association Paris-Amérique latine*, ca. 1925, 34, Archivo de Camilo Egas, clipping file, property of Trinidad Pérez.

52. Ventura García Calderon, "Un peintre Équatorien: Camilo Egas," *Paris Times*, ca. 1925, Archivo de Camilo Egas, clippings file, property of Trinidad Pérez.

53. Reviews of the exhibition at the Galerie Carmine from September to October 1925 appeared in the *Petit journal, Paris Times, Lanterne, Semaine à Paris, Paris-midi, Action française, Carnet del semaine, Paris-Sud América, Comedia, L'art et les artistes, Renaissance, Journal des arts,* and *Charivari*. This list was taken from "Breves noticias criticas sobre la obra realizada por Egas, en Paris," n.d., Archivo de Camilo Egas,

clipping file, property of Trinidad Pérez.

54. All three quotes were reproduced in "Camilo Egas: Algunos comentarios de la crítica francesa, sobre la obra del pintor Egas," *Hélice: Revista quincenal de arte* 1, no. 1 (April 26, 1926): 17. The quote is by [?] Breaj, "Une faune humaine d'une horrible beauté," *L'action française*, October 31, 1925. The quote by Yves Mar was selected from the *Semaine à Paris* (date not listed), and the quote from Vauxcelles from *Volunté*, October 11, 1925. The original articles are in the Archivo de Camilo Egas, clipping file, except for the article by Vauxcelles. Property of Trinidad Pérez.

55. Galerie Carmine and René-Jean, *Exposition H. Garavito (Quelques types du Guatemala)* (Paris: Galerie Carmine, 1925).

56. Ibid.

57. "L'exposition du jeune peintre H. Garavito," *Paris Sud et Centre Amérique* 1, no. 30 (November 30, 1925): 15.

58. Miguel Angel Asturias, *El Imparcial* (Guatemala), December 1925.

59. Galerie Carmine and Louis Vauxcelles, *Toledo-Piza expose quelques paysages du Brésil et de l'Île-de-France* (Paris: Galerie Carmine, 1926).

60. Alejo Carpentier, *Crónicas, arte y sociedad* (Havana: Editorial Arte y Literatura, 1975), 112. Originally published as Alejo Carpentier, "Abela en la Galería Zak," *Social* 14, no. 1 (January 1929).

61. Cuneo's and Michelena's show—which was sponsored by the minister of Uruguay and organized by "L'Office de Propaganda de la Legation de l'Uruguay" at the Galerie Zak and featured impressionist-style landscapes and academic sculpture—not only fell flat financially, but also failed to achieve critical recognition. *L'amour de l'art,* for example, described the show as the type of exhibition that one "forgets completely five minutes after leaving." "Chroniques. J. Cuneo et B. Michelena (Zak)," *L'amour de l'art*, no. 5 (May 1930): 234.

62. Vincent Bouvet, *Paris between the Wars, 1919–1939: Art, Life and Culture* (New York: Vendome, 2010), 374–75.

63. Cited in José Seoane Gallo, *Eduardo Abela cerca del cerco* (Havana: Editorial Letras Cubanas, 1986), 187, based on an interview with Abela in 1963.

64. Ibid., 190–91.

65. For more on negrophilia, see Petrine Archer-Straw, *Negrophilia: Avant-Garde Paris and Black Culture in the 1920s* (New York: Thames and Hudson, 2000).

66. Carpentier, *Crónicas*, 115. Originally published as "Abela en la Galería Zak."

67. Ibid., 114.

68. All these reviews are cited in Seoane Gallo, *Eduardo Abela cerca del cerco*, 241–44.

69. Adolfo Zamora, "Eduardo Abela: Cuban Painter," *Revista de Avance* 3, no. 30 (January 15, 1929): 18–19. Reproduced in Mari Carmen Ramírez and Héctor Olea, *Inverted Utopias: Avant-Garde Art in Latin America* (New Haven: Yale University Press, 2004), 467–68.

70. Raymond Cogniat, "La vie artistique: Abela," *Revue de l'Amérique latine* 17, no. 85 (January 1, 1929): 73–74.

71. Carpentier, *Crónicas,* 89. Originally published as Alejo Carpentier, "Las nuevas ofensivas del cubanismo," *Carteles,* December 15, 1929.

72. Cogniat, "La vie artistique: Abela," 73–74.

73. Seoane Gallo, *Eduardo Abela cerca del cerco*, 242. Seoane quotes the *New York Herald*, but does not provide a citation for the article. I have been unable to locate the original. Maribona, *Arte y amor*, 382.

74. Joaquín Torres García and Juan de Gary, *Exposition Torrès Garcia du 7 au 20 Juin 1926* (Paris: Galerie A.-G. Fabre, 1926).

CHAPTER 6. "EXHILARATING EXILE"

1. Linda Nochlin, "Art and the Conditions of Exile: Men/Women, Emigration/Expatriation," *Poetics Today* 17, no. 3 (Autumn 1996): 318, 329.

2. This chapter has been published previously as Michele Greet, "'Exhilarating Exile': Four Latin American Women Exhibit in Paris," *Artelogie: Revue de recherches sur les arts, le patrimoine et la littérature de l'Amérique latine* (Fall 2013).

3. Other women artists who held individual exhibitions include Enriqueta Bonco (Argentina), Mme. Bourières-Giraud [?], Rosario Cabrera (Mexico), Carolina de Chávez (Peru, sculptor), Elena del Carpio (Bolivia), Eva González [?], Antonia Matos (Guatemala, sculptor), Carmen Saco (Peru, sculptor), and Léonor Villanueva (Ecuador). There is almost no available information on these exhibitions. Mention of these exhibitions stems almost entirely from the *Revue de l'Amérique latine.*

4. Cited in Briony Fer, *Realism, Rationalism, Surrealism: Art between the Wars* (New Haven: Yale University Press, 1993), 155.

5. The Galerie Percier was owned by André Level, a colleague of Daniel-Henry Kahnweiler. Other artists who exhibited at the Galerie Percier included Naum Gabo, Joaquín Torres-García, and Alexander Calder.

6. Malcolm Gee, *Dealers, Critics, and Collectors of Modern Painting: Aspects of the Parisian Art Market between 1910 and 1930* (New York: Garland, 1981), 175.

7. The only other exception might be Vicente do Rego Monteiro's 1925 exhibition at the Galerie Fabre.

8. Amaral was in Paris from June 1920–June 1922; February–December 1923; September 1924–March 1925; December 1925–August 1926; and March–July 1928; and several months in 1931. Oswald de Andrade was also in Paris for an extended stay in 1923 and in 1925–26. For more on Tarsila do Amaral, see Aracy A. Amaral, *Tarsila: Sua obra e seu tempo* (São Paulo: Editora 34; Editora da Universidade de São Paulo, 2003). For an excellent discussion of Amaral's visits to Paris, see Paulo Herkenhoff, "Tarsila: Deux et unique," in *Tarsila do Amaral: Peintre Brésilienne à Paris 1923–1929*, ed. Elza Ajzenberg et al. (Rio de Janero: Imago Escritório de Arte, 2005), 12–51.

9. According to Mário Carelli: "In Tarsila's studio on the rue Hégésippe Moreau in Montmartre, not only Brazilians got together, but also all the artistic avant-garde of Paris for typical Brazilian meals: Feijoada, made of bacuri, pinga, corn husk cigarettes were available to provide an exotic feeling. . . . The first echelon: Cendrars, Fernand Léger, Jules Supervielle, Brancusi, Robert Delaunay, Vollard, Rolf de Maré, Darius Milhaud, the black prince Kojo Tovalou (Cendrars les Nègres) . . . the ravishing Tarsila dressed by Poiret, heiress of an agricultural dynasty, gives a monkey to Léger, assuming without a complex, her 'Brazilianness.'" Alain Sayag, *Art d'Amérique latine, 1911–1968* (Paris: Musée National d'Art Moderne, Centre Georges Pompidou, 1992), 94–99.

10. Letter from Blaise Cendrars to Tarsila do Amaral, Tremblay-sur-Mauldre, February 13, 1925, cited in Amaral, *Tarsila: Sua obra e seu tempo*, 185.

11. Letter from Blaise Cendrars to Oswald de Andrade, February 11, 1925, cited in ibid., 186.

12. Based on *L'anthologie nègre*, Cendrars wrote a scenario for the Swedish Ballet directed by Rolf de Maré called *La création du monde*, an African version of the creation of the world that was presented October 25, 1923, at the Théâtre Champs Elysées with music by Darius Milhaud, choreography by Jean Borlin, and costumes and stage design by Fernand Léger.

13. Andrade introduced him to the modern artists and writers of São Paulo. The group then embarked on a trip to Brazil's historic colonial towns in the state of Minas Gerais.

Cendrars was enchanted by Brazil and, according to Amaral, constantly referred to the exoticism of the country's tropical land-scape, virgin forests, and wildlife. Aracy A. Amaral, *Tarsila viajante viajera* (São Paulo: Pinacoteca do Estado, 2008), 155. His time in Brazil inspired the poems in *Feuilles de route I, le formose* (Paris: Au sans pareil, 1924), which he published in September with a cover illustration by Amaral.

14. Tarsila do Amaral, "Pau-Brasil and Anthropophagite Paintings," in *Tarsila do Amaral*, ed. Juan Manuel Bonet (Madrid: Fundación Juan March, 2009), 31. Originally published in *Revista annual do Salão de Maio* (São Paulo), 1939, 31–35.

15. Letter from Blaise Cendrars to Oswald de Andrade, April 1, 1926, cited in Amaral, *Tarsila: Sua obra e seu tempo*, 230.

16. Amaral would later choose *A cuca* to donate to the Musée de Grenoble, one of the first art museums in Paris to collect contempo-rary art.

17. It was perhaps through her connection to the fashion industry that Amaral came in contact with Legrain and asked him to col-laborate on her exhibitions. Lydia Puccinelli, ed., *African Forms in the Furniture of Pierre Legrain* (Washington, D.C.: National Museum of African Art, 1998), 5.

18. Aracy Amaral, "Tarsila Revisited," in Bonet, *Tarsila do Amaral*, 63.

19. "Chronique de l'Amérique latine," *New York Herald*, June 21, 1926, 3.

20. Letter from Tarsila do Amaral to her family, April 19, 1923, reproduced in Amaral, *Tarsila: Sua obra e seu tempo*, 20.

21. As Paulo Herkenhoff suggests, "The Black provides a new service to the rural aristocracy: his/her legitimacy at the Sorbonne and in the Parisian environ-ment." Herkenhoff calls this "second hand primitivism." Herkenhoff, "Tarsila: Deux et unique," 24, 27. Other authors have attempted to deem Amaral's primitivism "authentic" because of her acquaintance with black servants in her youth, but this assertion ignores the social distance her upper-class status would have established. Maria José Justino, *O banquete canibal: A modernidade em Tarsila do Amaral (1886–1973)/The Cannibal Feast: Modernity in Tarsila do Amaral* (Curitiba, Brazil: Editora UFPR, 2002), 133.

22. G. de Pawlowski, "Les petites expositions 'Tarsila,' 38, rue La Boétie," *Journal des débats*, June 20, 1926, 3.

23. For a discussion of race and cultural primitivism in Paris, see Carole Sweeney, *From Fetish to Subject: Race, Modernism, and Primitivism, 1919–1935* (Westport, Conn.: Praeger, 2004), 4: "I argue that interwar cultural primitivism developed from an initial modish interest in black cultural difference that simply inverted essentialist racial typologies into a more heterogeneous text of cultural difference that gradually opened up debates on race, colonialism, and representation of blackness."

24. Amaral's first sale of a painting in Paris was *Nègre adorant* to Mme Tachard for 5,000 francs. Amaral, *Tarsila: Sua obra e seu tempo*, 247.

25. Tarsila do Amaral, "Pintura pau-brasil e antropofagia," *RASM: Revista anual do Salão de Maio*, no. 1 (1939), includes a cata-logue of the III Salão de Maio (May Salon), São Paulo.

26. "Exposition Tarsila (Galerie Percier)," *Paris Sud et Centre Amérique* 2, no. 50 (June 20, 1926): 16.

27. Raymond Cogniat, "Les peintres de l'Amérique latine," *La renaissance de l'art français et des industries de luxe* 9, no. 8 (August 1926): 470–77.

28. De Pawlowski, "Petites expositions 'Tarsila,'" 3.

29. "Mme Tarsila, who did not bother to put her easel on the bank of the Tamanduatchy river and who has not looked for in the landscapes plays of shadow, has composed in a bright studio, on themes that are her own, all sorts of images"; "Peinture exo-tique," *Paris-midi*, June 10, 1926.

30. Maurice Raynal, "Les arts," *L'intransigeant*, June 13, 1926, 2.

31. "Peinture exotique."

32. Georges Charensol, "Les expositions," *L'art vivant* 2 (June 15, 1926): 475–77.

33. Raynal, "Arts," 2.

34. De Pawlowski, "Petites Expositions 'Tarsila,'" 3.

35. Letter from Mario de Andrade to Anita Malfatti, São Paulo, July 24, 1926, cited in Nádia Battella Gotlib, *Tarsila do Amaral: A modernista* (São Paulo: Editora SENAC, 1998), 132.

36. Galerie André, *Exposition (peintures, aquarelles, dessins) d'Annita Malfatti à la Galerie André*, November 20–December 5, 1926.

37. Marta Rossetti Batista, *Anita Malfatti: No tempo e no espaço* (São Paulo: Editora 34; Editora da Universidade de São Paulo, 2006), 345.

38. "La vie artistique: Les artistes vus aux récen-tes expositions, Salon des Indépendants: Mlle Annita Malfatti," *Revue moderne des arts et de la vie*, May 15, 1926, 3–4. M. Molé, "Annita Malfatti," *Les artistes d'aujourd'hui*, April 15, 1926, cited in Batista, *Anita Malfatti*, 335.

39. Molé, "Annita Malfatti," in Batista, *Anita Malfatti*, 335.

40. "L'exposition des oeuvres de Mlle Annita Malfatti," *Paris Times*, December 1, 1926, 4.

41. André Warnod, "Au Salon des Indépendants," *Comoedia*, May 28, 1926.

42. "L'exposition des oeuvres de Mlle Annita Malfatti," 4.

43. "La vie artistique: Les artistes vus aux récen-tes expositions, Salon des Indépendants: Mlle Annita Malfatti," *Revue moderne des arts et de la vie*, February 28, 1927, 4.

44. "L'exposition des oeuvres de Mlle Annita Malfatti," 4.

45. Museo Casa Estudio Diego Rivera y Frida Kahlo and Museo Mural Diego Rivera, *Lola Cueto: Trascendencia mágica, 1897–1978* (Mexico City: Instituto Nacional de Bellas Artes, 2009), 89.

46. André Salmon, "La obra de Velásquez Cueto, mexicana," *Ilustrado*, February 21, 1929, 47.

47. Ibid., 47, 54.

48. [?] Ortega, "América en Europa: Tapicería mexicana en París," *El universal ilustrado* 551 (December 10, 1927): 29, 62.

49. Salmon, "Obra de Velásquez Cueto," 54.

50. Ibid., 47. Whereas all things African had been the rage since before World War I, the first major exhibition of pre-Columbian art in Paris did not take place until 1928, at the Musée des Arts Décoratifs.

51. Reviews are listed in Museo Casa Estudio Diego Rivera y Frida Kahlo and Museo Mural Diego Rivera, *Lola Cueto*. I have not been able to locate the originals of all these reviews.

52. Jean Cassou, "La renaissance de l'art mexic-ain," *L'art vivant* 5 (1929): 758–60.

53. Ibid., 758.

54. Museo Casa Estudio Diego Rivera y Frida Kahlo and Museo Mural Diego Rivera, *Lola Cueto*, 164–65.

55. Pedro da Cruz, "Torres García and Cercle et Carré: The Creation of Constructive Universalism, Paris 1927–1932" (PhD diss., Lund University, Sweden, 1994), 87.

56. José Gómez Sicre, "Amelia Peláez . . . The First Lady of Cuban Painting," *Metropolitan*, August 1978, 11. In 1924, Léger, with Ozenfant, founded the Académie de l'Art Moderne at Léger's studio at 86, rue Notre-Dame-des-Champs in Montparnasse. Othon Friesz was the third member of the original teaching staff; later Alexandra Exter and Marie Laurencin joined the faculty. Ozenfant left the school in 1929, but Léger continued as its director until

1939. He renamed it the Académie d'Art Contemporain in 1929.

57. José Seoane Gallo, *Palmas reales en el sena* (Havana: Editorial Letras Cubanas, 1987), 37.

58. Letter from Alexandra Exter, December 31, 1936, Giulio V. Blanc Papers, Archives of American Art, Smithsonian Institution, Washington, D.C.

59. This argument is made in Cuban Museum of Arts and Culture, *Amelia Peláez, 1896–1968: A Retrospective/Una retrospectiva* (Miami: Cuban Museum of Arts and Culture, 1988), 25.

60. Elliott also makes this argument in Ingrid Elliott, "Domestic Arts: Amelia Peláez and the Cuban Vanguard, 1935–1945" (PhD diss., University of Chicago, 2010), 21. She suggests that, possibly inspired by Lydia Cabrera, Peláez was perhaps mocking the European tendency to simplify African cultures through their construct of the primitive.

61. Most of the still lifes were listed in the catalogue simply as *Still Life*, so it is virtually impossible to pin down which paintings were exhibited. Galerie Zak, *Exposition Amelia Peláez del Casal: 28 avril au 12 mai 1933* (Paris: Galerie Zak, 1933).

62. Francis de Miomandre, preface to Galerie Zak, *Exposition Amelia Peláez del Casal*, translated in Cuban Museum of Arts and Culture, *Amelia Peláez*, 27.

63. The *Germinal* review is cited in Cuban Museum of Arts and Culture, *Amelia Peláez*, 27.

64. Ibid., 27, cites M. Gros, *Journal des beaux-arts*, May 7, 1933.

65. Ibid.

66. Simon Lissim, "Amelia Pelaez," *Mobilier et décoration*, 1933, 334–36.

67. Ibid., 336.

68. "Triunfo de una cubana en Francia," *El mundo*, May 7, 1933. "Vibraciones del cable: Triunfa una cubana," *El pais*, May 8, 1933, Giulio V. Blanc Papers, Archives of American Art, Smithsonian Institution.

69. The exhibition, *Exposition de livres manuscrits par Guido*, was held from December 22–January 6, 1934, at the Galerie Myrbor, 17, rue Vignon. Guido "Gio" Colucci was a master calligrapher who copied poems by poets such as Paul Valéry, André Gide, Paul Claudel, and Léon-Paul Fargue (whose poems Peláez illustrated in gouache), among others. Other artists who contributed illustrations included André Derain, Alexandra Exter, André Lhote, Gio Colucci, P. de Francisco, Lydia Cabrera, Simon Lissim, Amelia Peláez, Nicolas Poliakoff, and Clément Serveau.

CHAPTER 7. IN THE PRESS

1. See Christopher Green, *Art in France: 1900–1940* (New Haven: Yale University Press, 2000), 51–52.

2. Other journals that covered Latin American art were *L'amour de l'art*, founded by Louis Vauxcelles, which reproduced work by Argentine sculptor Pablo Curatella Manes and painter Juan del Prete, and *Beaux-arts: Chronique des arts et de la curiosité*, which followed Angel Zárraga's career. Many of the critics who wrote about Latin American art also served as translators of Latin American literature, such as Jean Cassou, Francis de Miomandre, Georges Pillement, and Jules Supervielle. See Paulette Patout, "La cultura latinoamericana en París entre 1910 y 1936," in *1899/1999: Vida, obra y herencia de Miguel Ángel Asturias: La riqueza de la diversidad* (Nanterre: Université Paris X, ALLCA XX, 1999), 219.

3. There were a few other journals that focused on Latin America—*France-Amérique*, 1910–40s, and *La vie latine*, which began in 1924—but none had an art column like the *Revue de l'Amérique latine*.

4. Mathilde Pomès, "L'Amérique latine et les études en France," *La renaissance de l'art français et des industries de luxe* 9, no. 8 (special issue on Latin America) (1926): 488–90.

5. Galerie Drouant, *Histoire de la France et École de Paris* (Paris: Galerie Drouant, 1962), n.p. Information about Cogniat's career derives from this source.

6. Raymond Cogniat, "La vie artistique: Pedro Figari d'aprés Georges Pillement," *Revue de l'Amérique latine* 20, no. 106 (October 1, 1930): 353.

7. It is possible that he traveled there from New York briefly during World War I, but travel to the Caribbean does not seem to have had any impact on his work.

8. Francis Picabia, "À Madame Rachilde, femme de lettres et bonne patriote," in *Cannibale* (Paris: Au Sans Pareil, 1920), 1:4.

9. The term "aesthetic of figurative pastiche" stems from George Thomas Baker, "Lost Objects: Francis Picabia and Dada in Paris, 1919–1924" (PhD diss., Columbia University, 2001), 12.

10. Francis Picabia, "Les arts: Ou Picabia fait de la peinture et de la politique," *Revue de l'Amérique latine*, ill. suppl. (March 1, 1927): xxxv–xxxvi. Raymond Cogniat, "La vie artistique: Exposition Picabia," *Revue de l'Amérique latine* 15, no. 73 (January 1, 1928): 74–75.

11. Cogniat, "La vie artistique: Exposition Picabia," 75.

12. Alejo Carpentier, *Crónicas, arte y sociedad*

(Havana: Editorial Arte y Literatura, 1975), 278. Originally published as "El cubano Picabia," *Social* 18, no. 2 (February 1933). In his novel about Latin American artists in Paris, the Cuban artist Armando Maribona would make a similar assertion: "Cuban Francis Picabia was one of the supreme priests [of dadaism]." Armando Maribona, *El arte y el amor en Montparnasse: Documental novelado, París, 1923–1930* (Mexico City: Ediciones Botas, 1950), 390.

13. Pomès, "Amérique latine," 488. The *Renaissance*'s first such effort was a feature article on the Mexican artist Angel Zárraga published in June 1926, which, while providing a glowing overview of the artist's career, interpreted his style as a product of his racial makeup: his "beautiful thousand-year-old blood of the Spanish conquerors," which was balanced by a "tender calmness" that stemmed from his mother's French origins. Louise Hervieu, "Zarraga," *La renaissance de l'art français et des industries de luxe* 9, no. 6 (June 1926): 339. That same issue printed a short review of Tarsila do Amaral's 1926 exhibition at the Galerie Percier and reproduced two of her paintings, *Lagoa santa* and *Paysage*, indicating the journal's concerted effort to turn its attention to Latin American art.

14. The essay on sculpture attempts to identify the most remarkable and "characteristic" works from Latin America. The essay devolves quickly into a list of artists and what they've done at the salons. The author does not try to define aesthetic unity or tradition, but does note that most artists drew on the Greco-Latin tradition. Gustave Kahn, "Quelques sculpteurs de l'Amérique latine," *La renaissance de l'art français et des industries de luxe* 9 (special issue on Latin America) (1926): 478–87.

15. Raymond Cogniat, "Les peintres de l'Amérique latine," *La renaissance de l'art français et des industries de luxe* 9, no. 8 (August 1926): 466.

16. "The worst eccentricities which under pretext of innovation, were so largely accommodated on our premises, thanks to their exotic character, could only inspire mistrust in our Latin brothers." Ibid., 467.

17. Ibid.

18. Ibid., 466–67.

19. Ibid., 475.

20. Anita Brenner, "Une renaissance mexicaine," *La renaissance de l'art français et des industries de luxe* 11, no. 2 (February 1928): 60–68. Published in the United States as Anita Brenner, "A Mexican Renascence," *Arts* 8, no. 3 (September 1925): 127–50. Sections

of this discussion of the promotion of the Mexican Renaissance in the French press appeared previously in Michele Greet, "Rivera and the Language of Classicism," in *Picasso and Rivera: Conversations Across Time*, ed. Michael Govan et al. (Los Angeles: Los Angeles County Museum of Art, 2016).

21. Brenner, "Renaissance mexicaine," 60–68.

22. Silvestre Arqueles Vela, "Nuestras encuestas ¿Existe un renacimiento literario en México?" *El universal ilustrado* 5, no. 249 (February 9, 1922): 24; Silvestre Arqueles Vela, "La influencia francesa en el renacimiento de nuestra literaria," *El universal ilustrado* 6, no. 277 (August 24, 1922): 2; José Juan Tablada, "Mexican Painting of To-Day," *International Studio* 76, no. 308 (January 1923): 267–76; Dr. Atl, "Colaboración artística—u—¿Renacimiento artístico?" *El universal*, July 13, 1923. Thank you to Lynda Klich for providing these sources.

23. Jean Cassou, "La renaissance de l'art mexicain," *L'art vivant* 5 (1929): 758–60. Although *L'art vivant* reviewed many individual Latin American artists, including Zárraga, Figari, Rendón Seminario, Curatella Manes, Amaral, Toledo-Piza, Castellanos, Torres García, Ortiz de Zarate, and Rego Monteiro, Cassou's was the first article to examine the artistic production of a specific country. Another review of Mexican art appeared in *Le monde* magazine in 1929: "Artistes et poetes mexicains," *Le monde*, May 18, 1929, 8–9.

24. Cassou, "Renaissance de l'art mexicain," 758.

25. E. Gomez Maillefert, "La peinture mexicaine contemporaine," *L'art vivant* 6 (June 15, 1930): 83.

26. Ibid.

27. Francis Miomandre, "On demande de la peinture de sauvages," *Bulletin de la vie artistique* 7, no. 15 (August 1, 1926): 234–35. The article does not specifically reference the Brussels exhibition. It is possible, therefore, that the exhibition traveled to Paris in the summer of 1926, especially since all the artists were living in Paris at the time. Unfortunately, I have found no documentation of an exhibition in Paris prior to that in 1927 at the Société Paris-Amérique Latine.

28. *Le carrosse du saint-sacrement* is a comedy in one act published in Paris in 1829. It was inspired by the historical figure Micaela Villegas, a well-known Peruvian comedian of the seventeenth century.

29. Miomandre, "On demande de la peinture de sauvages," 234–35. The reference to Moro as "delicious" is curious. Is it perhaps meant to be flirtatious? I have not come across any evidence of a relationship between

Miomandre and Moro, but that does not preclude the possibility. A *quena* is a traditional wooden or bamboo flute from the Andes.

30. *Señora Give It to Me* was made during the same period as The *"Cholos"* but was not in the exhibition. Moro's contributions included five paintings, four watercolors, and fifteen drawings. The exhibition brochure was reproduced in Fernando Villegas Torres, "Vínculos Artísticas entre España y Perú (1892–1929): Elementos para la construcción del imaginario nacional peruano" (PhD diss., Universidad Complutense de Madrid, 2013), 671.

31. Miomandre, "On demande de la peinture de sauvages," 235.

32. Reviews of Brecheret, Cabré, Curatella Manes, Egas, Mané, Ortiz de Zarate, Otero, Rego Monteiro, Rendón Seminario, Toledo-Piza, and Zorrilla de San Martín appeared in the journal.

33. Géo-Charles, "Monteiro," *Montparnasse*, no. 57 (November–December 1929): 8.

34. The exhibition opened in Rego Monteiro's hometown of Pernambuco at the state museum and then traveled to São Paulo and Rio de Janeiro.

35. Rosenberg also initiated dealings with Uruguayan artist Joaquin Torres García, but this relationship never came to fruition. Joaquín Torres García, *Historia de mi vida* (Barcelona: Paidós, 1990), 223. According to Torres García, Léonce Rosenberg was very interested in his work but did not become his dealer.

36. Léonce Rosenberg, "Avant-propos," *Bulletin de l'effort moderne*, no. 1 (January 1924): 1.

37. It seems, therefore, that by 1924 Rosenberg had revised his approach to dealing with artists, allowing for more informal and less rigid arrangements. It is also possible, however, that the works he included in the journal by artists who had left his ranks were paintings he had obtained prior to the split, and in continuing to exhibit their work Rosenberg was attempting to maintain a semblance of control in the cubist market.

38. Maurice Raynal, "Les petites expositions," *L'intransigeant*, February 6, 1925, 4.

39. Walter Zanini, *Vicente do Rego Monteiro: artista e poeta* (São Paulo: Empresa das Artes: Marigo Editora, 1997), 206. Zanini quotes Raynal's preface to Rego Monteiro's 1925 exhibition catalogue: Maurice Raynal, "Les Arts," *L'intransigeant*, April 7, 1925, 2.

40. "Parmi les petites expositions," *Comoedia*, April 12, 1925.

41. Letter from Léonce Rosenberg to Vicente do Rego Monteiro, July 22, 1925, cited in

Walter Zanini, *Vicente do Rego Monteiro: Artista e poeta/Monteiro, Vicente do Rego, 1899–1970* (São Paulo: Empresa das Artes, Marigo Editora, 1997), 129.

42. Maria Luiza Guarnieri Atik, *Vicente do Rego Monteiro: Um brasileiro de França* (São Paulo: Editora Mackenzie, 2003), 25. Atik mentions that Rego Monteiro had difficulty selling his work in Paris.

43. Paulo Herkenhoff, "'Tarsila: Deux et unique,'" in *Tarsila do Amaral: Peintre Brésilienne à Paris 1923–1929*, ed. Elza Ajzenberg et al. (Rio de Janero: Imago Escritório de Arte, 2005), 16.

44. Ibid., 19.

45. Cited in ibid.

46. Letter from Tarsila do Amaral to her family, October 31, 1923, cited in Aracy A. Amaral, *Tarsila: Sua obra e seu tempo* (São Paulo: Editora 34; Editora da Universidade de São Paulo, 2003), 130.

47. Ibid., 192.

48. Ibid., 231. *Bulletin de l'effort moderne*, no. 30 (December 1926), reproduces *Nègre adorant* (1926) by Tarsila do Amaral.

49. Amaral, *Tarsila: Sua obra e seu tempo*, 247.

50. It is also possible that he facilitated the sale, but there are no records to corroborate this idea. As a frequent collaborator with Rosenberg, Raynal's positive appraisal of Amaral's work may also have contributed to his choice to include one of her paintings in the journal, but his emphasis on primitivism contrasted with that of the dealer.

51. The Galerie Zborowski also represented Modigliani, Soutine, and Foujita.

52. Raymond Cogniat, "La vie artistique: Exposition Manuel Rendón," *Revue de l'Amérique latine* 12, no. 56 (August 1926): 160.

53. Miguel de Ycaza Gómez, "Manuel Rendón," in *Rendon* (Guayaquil, Ecuador: Cromos, 1985), n.p.

54. Manuel Rendón Seminario, "Reponses au questionnaire," Bibliothèque Kandinsky, Fonds Léonce Rosenberg, Paris.

55. See, for example, the writings of Gonzalo Zaldumbide (Ecuador), Jean Emar (Chile), José Frías (Mexico), Luis Cardoza y Aragón (Mexico), Jules Supervielle (Uruguay), Charles Lesca (Argentina), Ventura García Calderón (Peru), Adolfo Zamora (Cuba), Oswald de Andrade (Brazil), and Vicente Huidobro (Chile).

56. This discussion of Mariátegui was published in modified form in Michele Greet, *Beyond National Identity: Pictorial Indigenism as a Modernist Strategy in Andean Art, 1920–1960* (University Park: Pennsylvania State University Press, 2009), 16, 69–70.

57. Mariátegui's articles on art include "El

artista y la epoca," *Mundial* (Lima), October 14, 1925; "El grupo suprarrealista y 'clarté,'" *Variedades* (Lima), July 24, 1926; "El balance del suprarrealismo," *Variedades* (Lima), February 19 and March 5, 1930; "Aspectos viejos y nuevos del futurismo," *Tiempo* (Lima), August 3, 1921; "Post-impressionismo y cubismo," *Variedades* (Lima), January 26, 1924; "El expresionismo y el dadaismo," *Variedades* (Lima), February 2, 1924; and "El pintor Pettoruti," *Variedades* (Lima), December 12, 1925, among many others. These articles were all reproduced in José Carlos Mariátegui, *El artista y la época* (Lima: Empresa Editora Amauta, 1959).

58. Mariátegui, *Artista y época*, 58. Originally published as Mariátegui, "Aspectos viejos y nuevos del futurismo."

59. Mariátegui, *Artista y época*, 62. Originally published as Mariátegui, "Post-impressionismo y cubismo."

60. Mariátegui, *Artista y época*, 67, 60. These ideas are expressed in his articles originally published as Mariátegui, "Expresionismo y el dadaismo" and "Post-impresionismo y cubismo."

61. Mariátegui, *Artista y época*, 13–14. Originally published as Mariátegui, "Artista y la epoca."

62. Greet, *Beyond National Identity*, 81.

63. Mariátegui, *Artista y época*, 57. Originally published as Mariátegui, "Aspectos viejos y nuevos del futurismo."

64. "But they are united by the finality of renovation, by the flag of revolution, all those artistic factions are fused under the common denominator of vanguard art"; Mariátegui, *Artista y época*, 57. Originally published as Mariátegui, "Aspectos viejos y nuevos del futurismo."

65. Mariátegui, *Artista y época*, 44. Originally published as Mariátegui, "Grupo suprarrealista y 'clarte.'" In 1928 Mariátegui printed three of Moro's surrealist poems in *Amauta*.

66. Mariátegui, "Balance del suprarrealismo."

67. César Vallejo, *Artículos y crónicas completos* (Lima: Pontificia Universidad Católica del Perú, 2002), 736. Originally published as César Vallejo, "La obra de arte y la vida del artista," *Comercio* (Lima), May 6, 1929.

68. Vallejo, *Artículos y crónicas completos*, 75. Originally pubished as César Vallejo, "Salón de las tullerías de París" *Alfar* (La Coruña), no. 44 (November 1924).

69. "The version that it is necessary to make derives from rigorously indo-American and pre-Columbian remains." Vallejo, *Artículos y crónicas completos*, 398–99. Originally published as César Vallejo, "Una gran reunion latinoamericana," *Mundial* (Lima), March 18, 1927.

70. Vallejo, *Artículos y crónicas completos*, 945–48. Originally published as César Vallejo, "Recientes descubrimientos en el país de los Incas," *Beaux-arts: Chronique des arts et de la curiosité*, no. 165 (February 28, 1936) (trans. Georgette Philippart). *Artículos* does not list the original French title. Vallejo, *Artículos y crónicas completos*, 952–55. Originally published as César Vallejo, "L'homme et dieu dans la sculpture Inca," *Beaux-arts: Chronique des arts et de la curiosité*, September 11, 1936 (trans. Georgette Philippart).

71. Vallejo, *Artículos y crónicas completos*, 689. Originally published as César Vallejo, "La juventud de América en Europa," *Mundial* (Lima), no. 450 (February 1, 1929).

72. Vallejo, *Artículos y crónicas completos*, 828–33. Originally published as César Vallejo, "Autopsia del superrealismo," *Variedades*, March 1930; also reprinted in *Nosotros* (Buenos Aires), March 1930, and *Amauta*, April–May 1930.

73. "No attitude could better define the eminently idealist spirit of the new generations than the attitude adopted by the surrealists" and "One of the primary characteristics of the surrealist spirit is its aversion to skepticism"; Carpentier, *Crónicas*, 107. Originally published as Alejo Carpentier, "En la extrema avanzada: Algunas actitudes del 'surrealismo,'" *Social* 13, no. 12 (December 1928).

74. Carpentier, *Crónicas*, 106.

75. Carpentier, *Crónicas*, 89. Originally published as Alejo Carpentier, "Las nuevas ofensivas del cubanismo" *Carteles*, December 15, 1929.

76. Carpentier, *Crónicas*, 491. Originally published as Alejo Carpentier, "México, según una película europea," *Carteles*, September 6, 1931.

77. Alejo Carpentier, "La musique cubaine," *Documents* 6 (November 1929): 327.

78. For a much more in-depth discussion of this topic, see Amy Fass Emery, "The Anthropological Flâneur in Paris *Documents, Bifur*, and Collage Culture in Carpentier's ¡Ecué-Yamba-O!," in *The Anthropological Imagination in Latin American Literature* (Columbia: University of Missouri Press, 1996).

79. Carpentier, *Crónicas*, 532. Originally published as Alejo Carpentier, "La agonía de Montparnasse," *Carteles*, June 25, 1933.

80. Luis M. Castañeda, "Surrealism and National Identity in Mexico: Changing Perceptions, 1940–1968," *Journal of Surrealism and the Americas* 3, no. 1 (2009): 23. Castañeda cites Alejo Carpentier, *El reino de este mundo* (Mexico City: Edición

y Distribución Ibero Americana de Publicaciones, 1949).

CHAPTER 8. JOAQUÍN TORRES GARCÍA IN PARIS

1. Mari Carmen Ramírez's seminal book traces the impact of his school and artistic philosophies in Latin America. Mari Carmen Ramírez, *El Taller Torres-García: The School of the South and Its Legacy* (Austin: Archer M. Huntington Art Gallery, University of Texas Press, 1992).

2. Mary Kate O'Hare, *Constructive Spirit: Abstract Art in South and North America, 1920s–50s* (Newark: Newark Museum; San Francisco: Pomegranate, 2010), 53–59.

3. Torres García's friend Pierre Daura was instrumental in organizing the Galerie Fabre exhibition. For more on Torres García's and Daura's friendship, see Teresa Daura Macià, *Pierre Daura, 1896–1976* (Barcelona: Ambit, 1999), 37–43.

4. Raymond Cogniat, "La vie artistique: Les artistes américains au Salon d'Automne," *Revue de l'Amérique latine*, ill. suppl. (January 1, 1927): xii.

5. Joaquín Torres García and Joseph Milbauer, *J. Torrès-Garcia expose du 16 au 30 juin quelques peintures* (Paris: Galerie Carmine, 1927), n.p.

6. Raymond Sélig, "Les oeuvres de J. Torrès-Garcia à la Galerie Carmine," *Revue du vrai et du beau* 6, no. 105 (July 25, 1927): 3.

7. The painting is referred to as *Paisaje de Paris* in Mario H. Gradowczyk, *Torres-García: Utopía y transgresión* (Montevideo: Museo Torres García, 2007), 132.

8. Joaquín Torres García, Poster for *Refusés par le jury du Salon d'Automne 5 peintres*, 1928.

9. According to Torres García, nearly five thousand people attended the exhibition. Joaquín Torres-García, *Historia de mi vida* (Barcelona: Paidós, 1990), 202.

10. Louis Léon-Martin, "Les refusés," *Paris-soir*, November 14, 1928, 5.

11. P. Guétin, "Le Salon d'Automne," *Carnet des arts*, November 1928, 202.

12. "Un nouveau 'Salon de Refusés,'" *Petit journal*, November 14, 1928.

13. Guétin, "Salon d'Automne," 202.

14. A recent exhibition of Torres García's *maderas* organized by the Menil Collection has demonstrated the importance of these works in formulating his theory of constructive universalism. Mari Carmen Ramírez, Margit Rowell, and Cecilia de Torres, *Joaquín Torres-García: Constructing Abstraction with Wood* (Houston: Menil Collection, in association with The Museum of Fine Arts; New Haven: Yale University Press, 2010).

15. Margit Rowell, "Torres García and

'Primitivism' in Paris," in Ramírez, Rowell, and de Torres, *Constructing Abstraction with Wood*, 121.

16. Pablo Picasso, *Glass, Newspaper, and Dice* (1914), or Kurt Schwitters, *Merz Constructions* (1921), are examples.

17. Rego Monteiro began exploring hieroglyphics in 1923 when he published his first book of prints: Pierre Louis Duchartre and Vicente do Rego Monteiro, *Legendes, croyances et talismans des Indiens de l'Amazone* (Paris: Folmer, 1923). The book included a table comparing pictograms from Brazil, Mexico, China, and Egypt.

18. See Pedro da Cruz, "Torres García and Cercle et Carré: The Creation of Constructive Universalism, Paris 1927–1932" (PhD diss., Lund University, Sweden, 1994), 124. Angel Kalenberg, "Joaquin Torres García-Introducción," in *Seis maestros de la pintura uruguaya*, ed. Juan Manuel Blanes (Buenos Aires: Museu Nacional de Bella Artes, 1987), 114.

19. Rowell, "Torres García and 'Primitivism' in Paris," 123–27.

20. Cruz, "Torres García and Cercle et Carré," 38, cites Joaquín Torres García, "La presente revista," *Círculo y cuadrado*, no. 1 (May 1936).

21. Letter from van Doesburg to Torres García, n.d., probably November 1929, cited in Jorge Castillo, *The Antagonistic Link: Joaquín Torres-Garcia, Theo van Doesburg* (Amsterdam: Institute of Contemporary Art, 1991), 87.

22. Salvador Dalí and André Breton, *Dalí* (Paris: Galerie Goemans, 1929).

23. The divide also had to do with conflicting personalities and ideological tensions. Pierre Daura, who was also instrumental in the group's formation, wrote in his diary: "In order to avoid disagreeable relations, we thought it necessary to divide the group in two sections." Daura diary, November 24, 1929, Pierre Daura Archives, Georgia Museum of Art, Athens, cited in Macià, *Pierre Daura*, 40.

24. For an excellent consideration of the larger context of Cercle et Carré, see Lynn Boland, *Cercle et Carré and the International Spirit of Abstract Art* (Athens: Georgia Museum of Art, University of Georgia, 2013).

25. Dalí and Breton, *Dalí*.

26. Three issues of *Cercle et Carré* were published on March 15, April 15, and June 30, 1930.

27. Joaquín Torres García, "Vouloir construire," *Cercle et Carré*, no. 1 (March 15, 1930): 3–4. Translated in Museum of Modern Art, Artist File, Joaquín Torres García.

28. According to Marie-Aline Prat, on the eve of the first exhibition, there were fifty-five artists listed as members, all of whom paid 25 francs for membership. Marie-Aline Prat, *Peinture et avant-garde au seuil des années 30* (Lausanne: Age d'homme, 1984), 63. The exhibition was organized and paid for by the participants. Malcolm Gee, *Dealers, Critics, and Collectors of Modern Painting: Aspects of the Parisian Art Market between 1910 and 1930* (New York: Garland, 1981), 279.

29. Serge Fauchereau, *Germán Cueto* (Madrid: Museo Nacional Centro de Arte Reina Sofia, RM Verlag, 2004), 47.

30. Colson struggled financially in Paris and worked as a bookbinder to make ends meet. While he had exhibited at the Salon des Indépendants and in groups shows with César Moro in Brussels and at the Association Paris-Amérique Latine, he had not managed to hold an individual exhibition because of the cost of renting gallery space. Fundación Colson, *Jaime Colson: Memorias de un pintor trashumante: París, 1924/Santo Domingo, 1968* (Barcelona: Artes Gráficas Manuel Pareja, 1978), 34, 103.

31. Jean Arp, too, tread a fine line between surrealist automatism and constructivism.

32. Fauchereau, *Germán Cueto*, 47.

33. Michel Seuphor, *Cercle et Carré* (Paris: P. Belfond, 1971), 22.

34. Prat, *Peinture et avant-garde*, 80, cites Michel Seuphor "À propos de l'exposition," *Cercle et Carré*, no. 3.

35. "Les expositions," *Journal des débats*, May 8, 1930.

36. Prat, *Peinture et avant-garde*, 83n86, cites Jacques-Louis Touttain, *La patrie*, April 26, 1930.

37. Maurice Raynal, "On expose—Cercle et Carré (Galerie 23, rue La Boëtie, 23)," *L'intransigeant*, April 29, 1930, 7.

38. Cruz, "Torres García and Cercle et Carré," 73–74, cites Michel Seuphor, *Dictionnaire de la peinture abstraite: Précédé d'une histoire de la peinture abstraite* (Paris: F. Hazan, 1957), 50.

39. The *Première exposition du Groupe Latino-Americain de Paris* took place April 11–24, 1930. Apparently, the group held two more exhibitions together over the next few years, but I have not been able to locate any records on these exhibitions except a single mention of the *Troisième exposition du Groupe Latino-Américain*, Galerie Zak, June 27–July 10, 1932.

40. Perhaps because Torres Garcia's exhibition was held simultaneously with that of Cuban artist Eduardo Abela's at the Galerie Zak (December 1–7), Waldemar George, who wrote the catalogue essay, attempts to align the artist's work with prevalent notions of primitivism in Paris at the time. He describes Torres García's pictures as depicting a "barbarous universe," with an ambiance of a "magic tropical forest." Further on he refers to his figures as "grotesque," "macabre," and "fantastic," and compares the artist's approach to "witchcraft." While Torres García was exploring certain aspects of primitivism in 1928 such as a rough, unrefined approach to brushwork, and occasionally incorporated African figures in his work, his subject matter and formal explorations were diametrically opposed to those of Abela and made no reference to his culture of origin. Waldemar George's essay thus stands out for its bizarre interpretation of the artist. Joaquín Torres García and Waldemar George, *À la Galerie Zak quelques peintures récentes et rétrospectives de Torrès-Garcia du 1er au 7 décembre* (Paris: Galerie Zak, 1928), n.p.

41. Germán Cueto, Torres García's friend and a member of Cercle et Carré, most likely brought their work to Paris for exhibition.

42. The portrait was reproduced in *La renaissance de l'art français et des industries de luxe* 13, no. 5 (May 1930): 120.

43. Hugo David Barbagelata and Joaquín Torres García, *Exposition du Groupe Latino-Américain de Paris* (Paris: Galerie Zak, 1930).

44. E. Tériade, "On expose—Huit artistes du Rio de la Plata," *L'intransigeant*, December 9, 1930, 5.

45. Raymond Cogniat, "La vie artistique: Huit artistes argentins et urugayens," *Revue de l'Amérique latine* 21, nos. 109–10 (January–February 1931): 111–12.

46. Ibid., 112.

47. A complete list of paintings and objects exhibited does not exist, but the review by Georges Charensol mentions scenes of ports, houses, boats, tabacs, and still lifes among the works on display. Georges Charensol, "Galerie Jane Bucher," *La renaissance* 4, no. 2 (February 1931).

48. Joaquín Torres García and Waldemar George, *Peintures de Torrès-Garcia du 30 janvier au 14 février 1931* (Paris: Galerie Jeanne Bucher, 1931).

49. Charensol, "Galerie Jane Bucher." Fernand Demeure, "Torres-García," *Chantecler*, February 7, 1931. "Torres-García," *Cahiers d'art* 6, nos. 9–10 (1931): 451.

50. E. Tériade, "On expose," *L'intransigeant*, October 26, 1931; E. Tériade, "Expositions-Torrès-Garcia," *L'intransigeant*, March 8, 1932.

51. For an analysis of many of these texts, see Mari Carmen Ramírez, "A Constructed Precariousness: Abstraction against the

Grain," in Ramírez, Rowell, and de Torres, *Constructing Abstraction with Wood*.

52. Joaquín Torres-García, *Ce que je sais, et ce que je fais par moi même: Cours complet de dessin, et de peinture, et d'autres choses* (Montevideo: Fundación Torres García, 1974).

53. Ibid. The text is handwritten and unpaginated.

54. Joaquín Torres-García, *Raison et nature: Théorie* (Montevideo: Ministerio de Educación y Cultura, 1974), n.p.

55. E. Tériade, "A travers les salons—Tendances de la surindépendance," *L'intransigeant*, October 26, 1931, 5.

56. *El monje, El arquitecto, El mecánico, La guerra, Cabeza, Cometa, Objeto barroco, Equilibrio inestable*, and *Construcción;* Faucherau, *Germán Cueto*, 50. An extensive review of the exhibition appeared in *El nacional* in Mexico: Arqueles Vela, "Asteriscos de la vida Mexicana en Europa: Esculturas de Germán Cueto en la exposición de Surindependientes," *El nacional*, October 1931, reproduced in ibid., 150–51.

57. "Chroniques: Del Prete (Zak)," *L'amour de l'art* 5 (May 1930): 237.

58. Rafael F. Squirru, *Juan del Prete* (Buenos Aires: Ediciones de Arte Gaglianone, 1984), 20.

59. I have not been able to locate the catalogue or any reviews of the Galerie Vavin-Raspail exhibition, so it is hard to know whether he made the leap to abstraction at this point or the following year.

60. *Abstraction, création, art non-figuratif* (New York: Arno, 1932). Issue no. 2 (1933) reproduces two pictures by del Prete, with no text on pages 7 and 9.

61. Squirru, *Juan del Prete*, 20.

CHAPTER 9. EXPLORING SURREALISM

1. In addition to the writers discussed in Chapter 7, surrealism had a significant presence in Mexican journals. See, for example, José María González de Mendoza, "El suprarrealismo y sus escándalos" *Revista de revistas*, February 6, 1927, 18–47. *Contemporaneos* also published works by Miró, Dalí, Picasso, and de Chirico in its magazine as well as essays: "La posía de Paul Eluard," *Contemporaneos* 4, no. 12 (1929): 130–33; "Robert Desnos y el sobrer-realismo," *Contemporaneos* 5, no. 18 (1929). These examples were cited in Alicia Azuela, "Surrealism in Mexico: An Alternative?" in *Surréalisme périphérique: Actes du colloque Portugal, Québec, Amérique latine, un surréal-isme périphérique?* ed. Luís de Moura Sobral (Montreal: Université de Montréal, 1984), 204, 295.

2. Henri Barbusse and his journal, *Clarté*, were particularly influential in this regard, and reprints or references to many of the articles therein appeared in Latin American journals.

3. Luis M. Castañeda, "Surrealism and National Identity in Mexico: Changing Perceptions, 1940–1968," *Journal of Surrealism and the Americas* 3, no. 1 (2009): 23. Castañeda cites the prologue to Alejo Carpentier, *El reino de este mundo* (Mexico City: Edición y Distribución Ibero Americana de Publicaciones, 1949).

4. Even as recently as 2010 at the "Surrealism and the Americas" conference in Houston, the internationally renowned curator Mari Carmen Ramírez insisted that surrealism was not a useful lens under which to exam-ine Latin American art. Ramírez's argument stemmed from her 1996 essay written in response to the *Art of the Fantastic* exhibi-tion in 1987 at the Indianapolis Museum of Art that proclaimed an essentializing notion of the "fantastic" as a defining characteristic of Latin American art. While in 1996 hers was a poignant critique of the prevailing tendency in the United States of exhibiting Latin American art under the aegis of the irrational, the primitive, and the fantastic, the continued assertion of this stance has prevented nuanced scholarly analysis of Latin American artists' conflicted engage-ment with the surrealist movement. For an excellent discussion of the reasons why surrealism in Latin America is a neglected subject, see the introduction to Graciela Speranza and Dawn Ades, eds., *Surrealism in Latin America: Vivísimo Muerto* (Los Angeles: Getty Research Institute, 2012), 9. One exception, however, is the chapter "Surrealismo no Brasil? Décadas de 1920 e 1930" in Jorge Schwartz, *Fervor das vanguar-das: Arte e literatura na América Latina* (São Paulo: Companhia das Letras, 2013), 47–64.

5. This section was published as Michele Greet, "César Moro's Transnational Surrealism," *Journal for Surrealism and the Americas* 7, no. 1 (2013): 19–51, https://jsa.hida.asu.edu. The article further traces Moro's surrealist activities to Peru and Mexico. Moro had difficulty maintaining his artistic activities because he suffered health and economic problems, which forced him to drop out of the ballet acad-emy where he was studying. In a letter to his brother Carlos he writes: "For a while now I haven't been drawing because I don't have materials. The same thing with paint-ing, my economic state is abysmal. . . . When you come to Paris you will be surprised to

find instead of the boxer you left behind, a skinny man, something that greatly upsets me because I love plumpness." André Coyné, "El arte empieza donde termina la tranquili-dad," in *Con los anteojos de azufre: César Moro, artista plastic*, ed. Rodrigo Quijano (Lima: Centro Cultural de España, 2000), 12.

6. Moro changed his name from Alfredo Quispez Asín around 1921. The new name, based on a character in a story by Spanish novelist Ramon Gómez de la Serna and chosen for its pleasing combination of sounds, suggests a very different iden-tity. While Moro's father was a relatively wealthy physician, the name "Quispez" indicates indigenous heritage. The choice of the name "Moro," however, inverts the class hierarchy that an indigenous name suggested in early twentieth-century Peru. Moro translates as "Moor"—the North African group that occupied the Iberian peninsula for nearly eight hundred years. In Spanish, the word "Moro" often has nega-tive connotations and can be used to refer to all dark or black peoples. "César Moro," however, implies "Black Caesar," or the imperial leader of the dark race. Thank you to Alison de Lima Greene, curator of con-temporary art and special projects, Museum of Fine Arts, Houston, for suggesting the notion of "Black Caesar."

7. Ricardo Silva-Santisteban, "André Breton en el Perú," in *Avatares del surrealismo en el Perú y en América Latina*, ed. Joseph Alonso, Daniel Lefort, and Josée Rodríguez Garrido (Lima: Institut Français d'Études Andines, 1992), 93. Silva-Santisteban cites 1928 as the date Moro met Breton, but as far as I know there is no direct evidence to corroborate this date. The Moro Archives at the Getty Research Institute contain an invitation for an opening at the Galerie Surréaliste of works by Man Ray and "Objets des Îles" in March 1926 as well as an exhibi-tion brochure for Tanguy's exhibition at the Galerie Surréaliste in May 1927, which included Peruvian, Mexican, Colombian, and Northwest Coast objects. If Moro attended these events, he may have met Breton or other surrealists even earlier than 1928. Once Moro became involved with the surrealists, he visited exhibitions by Picabia, Dalí, and Ernst. Brochures from all the exhibitions he attended are among César Moro's papers at the Getty Research Institute, Los Angeles. The Moro Archives also contain catalogues from two de Chirico exhibitions from the same period.

8. César Moro, "A proposito de la pintura en el Peru" (1939), reprinted in César Moro,

La Tortuga ecuestre y otros textos (Caracas: Monte Avila, 1977). The essay was originally published in the journal Moro started with Westphalen, *El uso e la palabra*, in December 1939.

9. Many of these letters are among César Moro's papers at the Getty Research Institute.

10. André Breton, *Violette Noziére* (Brussels: Nicolas Flamel, 1933).

11. According to Dawn Ades, "Max Ernst was one of the first artists systematically to explore the disorienting power of combined photographic images, and the possibilities of marvelous transformations of objects, bodies, landscapes and even substance itself down to the tiniest detail." Dawn Ades, *Photomontage* (London: Thames and Hudson, 1986), 111.

12. Cited in Lucy R. Lippard, *Surrealists on Art* (Englewood Cliffs, N.J.: Prentice-Hall, 1970), 38–39.

13. For an in-depth discussion of this work, see Robin Greeley, "Image, Text and the Female Body: Rene Magritte and the Surrealist Publications," *Oxford Art Journal* 15, no. 2 (1992): 48–57.

14. A greatly expanded version of this section has been published previously as Michele Greet, "Devouring Surrealism: Tarsila do Amaral's *Abaporu*," *Papers of Surrealism*, no. 11 (Spring 2015): 1–39, http://www.surrealismcentre.ac.uk/papersofsurrealism/journal11/index.htm.

15. Madureira makes this claim in relation to the "Manifesto Antropófago," but it applies equally to *Abaporu*. Luís Madureira, *Cannibal Modernities: Postcoloniality and the Avant-Garde in Caribbean and Brazilian Literature* (Charlottesville: University of Virginia Press, 2005), 51.

16. Amaral briefly studied with Léger in 1923. That fall she and Oswald attended the Ballet Suédois's performance of *La création du monde*, a piece inspired by Blaise Cendrars's *Anthologie nègre* (1921), with costumes by Léger. Aracy A. Amaral, "Oswald de Andrade and Brazilian Modernism: An Interdisciplinary Approach to Avant-Garde Visual Arts in the Twenties," in *One Hundred Years of Invention: Centenário de Oswald de Andrade*, ed. K. David Jackson (Austin: Abaporu, 1992), 161. Amaral gives the date of November 1924, but the ballet actually opened in October 1923. For more about the ballet, see Sylvie Forestier, *Fernand Léger et le spectacle* (Paris: Réunion des Musées Nationaux, 1995), 21.

17. Aracy A. Amaral, "O surreal em Tarsila," *Mirante das artes, Sao Paulo: Perspectiva*,

June 1967, 24. She owned two paintings by de Chirico, one of which was *L'énigme d'une journée*, now in the Museu de Arts Contemporâneo de São Paulo. Juan Manuel Bonet, "A 'Quest' for Tarsila," in *Tarsila do Amaral*, ed. Juan Manuel Bonet (Madrid: Fundación Juan March, 2009), 84. From October 1924 until April 1925 (Amaral was in Paris from September 1924 until February 1925), the surrealists ran the Bureau Central de Recherches Surréalistes on the rue de Grenelle, where the public could go to find out about surrealism. While she never mentions visiting the bureau, she was most likely aware of its existence.

18. Interview with Blaise Cendrars and Sérgio Buarque de Holanda, "Conversando con Blaise Cendrars," *O jornal* (Rio de Janeiro), September 23, 1927, cited in Aracy A. Amaral, *Tarsila: Sua obra e seu tempo* (São Paulo: Editora 34; Editora da Universidade de São Paulo, 2003), 273. Monique Chefdor claims that Cendrars went to Brazil because he was disgruntled with the "dictatorial turn that literature took in Paris with emerging surrealism"; see her introduction to Blaise Cendrars, *Complete Postcards from the Americas: Poems of Road and Sea* (Berkeley: University of California Press, 1976), 17. This is not at all the tone of his interview in Brazil, however. I am inclined to believe that Cendrars's disenchantment with surrealism emerged closer to 1929 and the publication of the second manifesto, with its thinning of the ranks, rather than before his trip to Brazil.

19. Later, according to Amaral, the surrealists would attack Cendrars, which may have influenced her decision to disavow any relationship to the trend, out of loyalty to her friend. Tarsila do Amaral, "Blaise Cendrars," *Diário de São Paulo*, July 28, 1943, translated in Bonet, *Tarsila do Amaral*, 37–38.

20. For a discussion of class structure in Brazil, see Icleia Maria Borsa Cattani, "Antropofagia y mitos: la pintura de Tarsila do Amaral/Myths and Anthropophagy: The Painting of Tarsila do Amaral," in *History and (in) movement; Historia y (en) movimiento*, ed. Annateresa Fabris, Felipe Chaimovich, Lisette Lagnado, and Luiz Camillo Osorio (São Paulo: Museu de Arte Moderna, 2008), 2:64.

21. Paintings in the exhibition included *Paysage, Manacá, Les bateaux, Pastorale, Sommeil, Le parc, La voûte, Nu, Marine, L'oeuf, Les colonnes*, and *Lac*. Galerie Percier, *Tarsila "du 18 juin au 2 juillet 1928"* (Paris: Galerie Percier, 1928).

22. I have included all the original French titles

here for reference. *L'oeuf* (The egg), *Sommeil* (Sleep), *Les colonnes* (The columns), and *La voûte* (The archway).

23. In early 1929, Péret moved with Houston to Brazil and lived there until 1931.

24. Edward A. Aiken, "'Emak Bakia' Reconsidered," *Art Journal* 43, no. 3 (Autumn 1983): 240.

25. According to Aiken, "*Emak Bakia* is carefully crafted to present a series of images that intentionally lend themselves to multiple readings." Ibid.

26. For more on Man Ray and photography, see Jane Livingston, "Man Ray and Surrealist Photography," in *L'Amour Fou: Photography and Surrealism*, ed. Rosalind E. Krauss and Jane Livingston (Washington, D.C.: Corcoran Gallery of Art, 1985), 128.

27. Amaral painted a second version of the painting, *Calmness II*, the following year.

28. Amaral, "O surreal em Tarsila," 24.

29. See Dawn Ades, "Fetishism: Surrealism's Job," in *Fetishism: Visualising Power and Desire*, ed. Anthony Shelton (London: South Bank Centre, 1995).

30. André Breton, *Surrealism and Painting*, trans. Simon Watson Taylor (1928; repr., Boston: Museum of Fine Arts, 2002), 38–40.

31. While Miró most likely drew the contour of the figure as a continuous line, he was known to make preliminary drawings. So, this painting is probably not a true example of what the surrealists deemed automatism. Yet, in his discussion of Miró in *Surrealism and Painting*, Breton refers specifically to the "pure automatism" of Miró's paintings, which may have led to later misinterpretations of his work. Ibid., 36.

32. Miró made *Person Throwing a Stone at a Bird* in Montroig between August and December 1926. Carolyn Lanchner, *Joan Miró* (New York: Museum of Modern Art, 1993), 56–57. Amaral left Paris for Brazil in August 1926, so it is impossible for her to have seen the picture in person. Miró's work was included in one exhibition in late 1925 that Amaral could have visited: Galerie de la Ville l'Évêque, *L'art d'aujourd'hui*, November 30–December 1925. She may also have visited the artist's studio in Paris.

33. Amaral owned a "painting from Picasso's hermetic phase, a famous Eiffel Tower by Delaunay, a Dadaist painting by Picabia, a surrealist painting by Miró, a constructivist painting by Kabatze (Russian), a wooden *Carlito* by Fernand Léger, and a painting by Léger"; Amaral, *Tarsila: Sua obra e seu tempo*, 328, cites "Exposição Tarsila do Amaral," *Correio Paulistano*, September 25, 1929.

34. In 1925 Miró painted *The Statue*, which

included a toenail and knife-like leg hairs. In 1928 he illustrated a book of poems by Lise Hirtz titled *Il était une petite pie* (There once was a little foot). For the December 1929 issue of *La révolution surréaliste* he submitted another drawing of a foot-person, this time with a bulbous hand that reaches for its floating, ribbon-like companion. As Rosalind Krauss points out, around 1930 Miró filled entire notebooks with images of this part of the body. For more on Bataille and Miró, see Rosalind Krauss, "Michel, Bataille et Moi," *October* 68 (Spring 1994): 18.

35. "Echos et nouvelles," *Echos des industries d'art*, June 1928, 37.

36. Oswald de Andrade and Leslie Bary, "Cannibalist Manifesto," *Latin American Literary Review* 19, no. 38 (December 1991): 40.

37. Georges Charensol, "Les expositions," *L'art vivant* 4 (July 1, 1928): 526.

38. Amaral, *Tarsila: Sua obra e seu tempo*, 293, cites (in Portuguese) G. J. Gros, *Paris-midi*, June 27, 1928.

39. Raymond Cogniat, "La vie artistique: Deux peintres brésiliens: Mme Tarsila, M. Monteiro," *Revue de l'Amérique latine* 16, no. 80 (August 1, 1928): 158. An article on the Tupi-Guarani Indians of Brazil directly preceded Cogniat's review.

40. Italics are mine. "Les expositions: Tarsila (Galerie Percier)," *Cahiers d'art* 3, no. 5–6 (1928): 262.

41. Waldemar George, "Tarsila et l'anthropophagie," *La presse*, July 5, 1928, 2.

42. Letter from Mário de Andrade to Tarsila do Amaral, November 15, 1923, cited in Aracy A. Amaral, ed., *Correspondência Mário de Andrade y Tarsila do Amaral* (São Paulo: Edusp: IEB, 1999), 79. This passage was translated in Maria José Justino, *O banquete canibal: A modernidade em Tarsila do Amaral (1886–1973)/The Cannibal Feast: Modernity in Tarsila do Amaral* (Curitiba, Brazil: Editora UFPR, 2002), 148.

43. Only one other review of the exhibition included an illustration other than *Abaporu*. André Warnod, "Les expositions: Tarsilla–Sculpture–?" *Comoedia*, June 24, 1928; Warnod reproduced *Paysage*.

44. "Echos et nouvelles," 37.

45. Madureira points out: "The copy is now the adulterated hypothesis that the periphery theatricalizes in order to ridicule the dominant European belief in the integrity of the model"; Madureira, *Cannibal Modernities*, 4.

46. A. B., "Les arts: Assez, Assez!" *Journal du Peuple*, June 24, 1928, 3.

47. Ibid.

48. "But we should not waste much of our time trying to understand that which is incomprehensible." Ibid.

49. A. B. employs the colloquialisms "*gobeurs*" and "*loufoquerie*" in his description. Ibid.

50. Ibid.

51. Nery had also spent the years 1920–21 in Paris studying at the Académie Julian.

52. For a much more comprehensive discussion of Lazo's time in Paris, see James Oles, *Agustín Lazo: The Ashes Remain (Las Cenizas Quedan)* (Mexico City: UNAM, 2009).

53. Ibid., 46. Jean Cassou, "La renaissance de l'art mexicain," *L'art vivant* 5 (1929): 758–60. In 1930 he contributed two paintings to Torres García's Galerie Zak exhibition (*Le petit valet* and *Mère avec son enfant*), most likely rendered in a similar style.

54. Cited and translated in Oles, *Agustín Lazo*, 49.

55. Jorge Glusberg, *Antonio Berni* (Buenos Aires: Museo Nacional de Bellas Artes, 1997), 30.

56. I would like to cite a graduate student here for her excellent paper on Berni written for my class on "Transatlantic Encounters" at the Phillips Collection, Center for the Study of Modern Art: Miriam Kienle, "Antonio Berni and Surrealism" (2009).

57. Cited in Glusberg, *Antonio Berni*, 34.

58. Fernando García, *Los ojos: Vida y pasión de Antonio Berni* (Buenos Aires: Planeta, 2005), 71. García identifies the location as Berni's childhood home.

59. Berni brought a copy of *La femme 100 têtes* by Ernst with him to Argentina. Ibid., 87.

60. As Elisa Vargas points out: "The way that Berni suddenly ceased to use the sort of imagery of the paintings of 1930 to 1932 seems to prove the point made by his daughter, that these paintings were an exploration of style. Nevertheless, some works made at a later date bear the imprint of his brief encounter with Surrealism; moreover, in those produced from 1961 onwards the real weight of his surrealist adventure becomes evident, lurking behind his bizarre images and bold collages, transformed and in the service of powerful social messages." Elisa Vargas, "Surrealism and Painting within the Context of the Argentine Avant-Garde: 1921–1987" (PhD diss., University of Essex, 1991), 119.

61. Adriana Lauria et al., *Berni y sus contemporáneos* (Buenos Aires: MALBA–Colección Costantini, 2005), 174, cites "Otras exposiciones," *La nación* (Buenos Aires), July 4, 1932, 7, Archivo José León Pagano (MAMBA), Buenos Aires, folder 57, no. 14.

62. Lauria et al., *Berni y sus contemporaneous*, 174, cites José Viñals, *Berni, Palabra e Imagen* (Buenos Aires: Imagen Galería de Arte, 1976), 59.

63. Jacques de Laprade, "Les surindépendants," *Beaux-arts: Revue d'information artistique*, no. 147 (October 25, 1935): 1.

64. When the workshop moved to 17, rue Campagne-Première, in 1933 it became known as Atelier 17.

65. "L'atelier 17," *Beaux-arts: Chronique des arts et de la curiosité*, April 2, 1937, 17.

66. For a discussion of Artaud in Mexico, see Renée Riese Hubert, "Antonin Artaud's Itinerary through Exile and Insanity," in *Borders, Exiles, Diasporas*, ed. Elazar Barkan and Marie-Denise Shelton (Stanford: Stanford University Press, 1998), 178–94.

67. Recently, other poets associated with the surrealists, Blaise Cendrars and Benjamin Péret, had taken extended trips to Brazil, returning with stories of strange lands and native traditions that provided rich fodder for their literary endeavors.

68. Keith Jordan, "Surrealist Visions of Pre-Columbian Mesoamerica and the Legacy of Colonialism: The Good, the (Revalued) Bad, and the Ugly," *Journal of Surrealism and the Americas* 2, no. 1 (2008): 42, cites one of Artaud's lectures given in Mexico.

69. "The culture of rationalism in Europe has failed and I have come to Mexico to search for the roots of a magic culture that I believe it is still possible to find in indigenous soil"; Azuela, "Surréalisme Périphérique," 205–6, cites Antonin Artaud, *El teatro y su doble* (Buenos Aires: Editorial Sudamericana, 1964), 174.

70. For more discussion of Izquierdo and Artaud, see Terri Geis, "The Voyaging Reality: María Izquierdo and Antonin Artaud, Mexico and Paris," *Papers of Surrealism*, no. 4 (Winter 2005): 1–11.

71. Ibid., 5

72. Cited in ibid., 8n23.

73. Ibid., 8–9.

74. Antonin Artaud, "Le mexique et l'esprit primitif: Maria Izquierdo," *L'amour de l'art* 18, no. 8 (October 1937): 44–46.

75. Ibid. See also Geis, "Voyaging Reality," 6.

76. Artaud, "Mexique et l'esprit primitif," 44–46.

77. Ibid.

78. Ibid.

79. Geis, "Voyaging Reality," 9.

80. Ibid.

81. "Le surréalisme autour du monde," *Minotaure* 4, no. 10 (Winter 1937): 60–62.

82. "Is there a surrealist Mexico? If you believe there is, where is it encountered? Outside of everything I said, Mexico is the Surrealist place par excellence. I encounter Surrealist Mexico in its mountains, in its flowers,

in the dynamism which confers on it the mixture of its races, as in its highest aspirations"; Amy H. Winter, *Wolfgang Paalen: Artist and Theorist of the Avant-Garde* (Westport, Conn.: Praeger, 2003), 72n6. Winter cites André Breton, interview by Rafael Heliodoro Valle, University of Mexico, June 1938, INBA Archives, Mexico City.

83. For more on the manifesto, see Robin Greeley, "For an Independent Revolutionary Art: Breton, Trotsky and Cárdenas's Mexico," in *Surrealism, Politics and Culture* (Aldershot, UK: Ashgate, 2003), 204–25. Collaboration between Breton and Trotsky continued through 1939. The February 1939 issue of *Clé: Bulletin mensuel de la FIARI* (Féderation Internationale de l'Art Révolutionnaire Indépendant), on whose national committee Breton served, published Trotsky's article "Pour la liberté de l'art" that he sent from Coyoacán.

84. Féderation Internationale de l'Art Révolutionnaire Indépendant, *Clé: Bulletin Mensuel de la FIARI* (Paris: F.I.A.R.I., 1939), translated in Breton, *Surrealism and Painting*, 141.

85. Both Jordan and Winter make this point: Jordan, "Surrealist Visions of Pre-Columbian Mesoamerica," 46; Winter, *Wolfgang Paalen*, 80–81.

86. The works not sent to Paris may have been sold in New York or simply been eliminated from the Paris show. These were not the most controversial images, though, so their exclusion from the Paris show was most likely not related to content.

87. Hayden Herrera, *Frida: A Biography of Frida Kahlo* (New York: Harper and Row, 1983), 241. Most of the details of Kahlo's time in Paris stem from Herrera's book.

88. Letter from Frida Kahlo to Nicholas Muray, February 16, 1939, cited in ibid., 245–46.

89. Herrera, *Frida*, 241–42.

90. Ibid.

91. *Suicide of Dorothy Hale* was the only work not included in the New York show, since it was made after the exhibition at the Julien Levy Gallery. Works in the Paris exhibition included *The Square Is Theirs, I with My Nurse, They Ask for Planes and Only Get Straw Wings, The Heart, My Dress Was There Hanging, What the Water Gave Me, Pitahayas, Tunas, Food from the Earth, The Lost Desire, Birth, Dressed up for Paradise, She Plays Alone, Passionately in Love, Burbank—American Fruit Maker, Xochitl,* and *The Frame.* I am using the English titles as printed in the Julien Levy catalogue. The titles were translated into French for exhibition in *Mexique.*

92. Because of the stock market crash, Breton had been forced to sell off most of his collection of pre-Columbian (as well as Native American and Oceanic) art in 1931.

93. See Jordan, "Surrealist Visions of Pre-Columbian Mesoamerica," 40, 46. Manuel Álvarez Bravo's photographs were listed simply as "photographs" and not numbered as individual items in the checklist, but according to Kahlo there were around thirty-two. Herrera, *Frida,* 241–42.

94. André Breton, *Mexique* (Paris: Renou et Colle, 1939).

95. André Breton, "Des tendances les plus récentes de la peinture surréaliste," *Minotaure* 6, nos. 12–13 (May 1939): 19.

96. Letter from Frida Kahlo to Nicholas Muray, February 27, 1939, cited in Herrera, *Frida,* 250.

97. Letter from Frida Kahlo to Ella and Bertram Wolfe, March 17, 1939, cited in ibid., 251.

98. One of the few reviews of the show appeared in L. P. Foucaud, "L'exposition de Frida Kahlo," *La flèche,* March 1939, cited in ibid., 251. This article praised Kahlo's authenticity and sincerity. Herrera asserts that the Louvre bought Kahlo's painting, but the painting was actually never in the Louvre collection. It is more likely that it was purchased by the Jeu de Paume. Ibid., 251.

99. André Breton, "Photographies de Manuel Alvarez Bravo," *Mexique,* n.p. The essay reads as follows:

> The photograph in general has confined itself to revealing Mexico to us from the simple angle of surprise, as experienced by the foreign eye at each turn in the path. The result is the most eclectic and disappointing documentation that I know of, at the primary expense of Mexico's panoramic sites, indigenous dances and colonial baroque architecture. A look through these bundles of fugitive impressions allows one to experience without moving the continuous, mechanical, profoundly detached clicks, there is no doubt that by such means the soul of the country could never be penetrated. It is essential to have participated in the culture since childhood and from that point forward to continue with a passionate investigation in order to be able to reveal the whole. That is what Manual Alvarez Bravo has achieved in his compositions that evidence an admirable synthetic realism, of which I do not know of an equivalent here. Everything that is wretched about Mexico he puts at our disposal: where Alvarez Bravo stopped, where he made a concentrated effort to capture a light, a sign, a silence, it is not only where the heart of Mexico beats but where the artist was still able to sense, with a unique discernment, the fully objective value of his emotions. Served in his great moments of inspiration by the most rare sense of quality and at the same time by an infallible technique, Manuel Alvarez Bravo, with his "Worker killed in a brawl," has achieved what Baudelaire called *eternal style.*

100. Breton, *Mexique,* n.p.

101. André Breton, "Souvenir du Mexique," *Minotaure* 6, nos. 12–13 (May 1939): 31–52. In André Breton, "Memory of Mexico," trans. Geoffrey Mac Adam, *Latin American Literature and Arts* 51 (Fall 1995): 9–16.

102. Breton had featured Posada's prints in *Minotaure* previously; André Breton, "Bois de Posada," *Minotaure* 4, no. 10 (Winter 1937): 18–19.

103. Breton, "Memory of Mexico," 11.

104. "Unlike us, you [Rivera] have the advantage of participating in the popular tradition, which to my knowledge has stayed alive only in your country. You possess the last secret—which we Europeans desperately seek—of this innate sense of poetry and art as it should be, as it must be: made by everyone, for everyone." Ibid., 12.

105. Ibid., 12, 14.

106. Ibid., 14.

107. See, for example, Castañeda, "Surrealism and National Identity in Mexico"; Michele Greet, "César Moro's Transnational Surrealism," *Journal of Surrealism and the Americas* 7, no. 1 (2013): 19–51; Winter, *Wolfgang Paalen;* Ilona Katzew, "Proselytizing Surrealism: André Breton and Mexico," *Review: Latin American Literature and Arts* 51 (Fall 1995): 21–33.

108. There were no actual construction projects underway because of the economic downturn, but Matta did collaborate on illustrations for La Ville Radieuse. Roberto Matta, *Matta* (Buenos Aires: Der Brücke, 1990), 108–10. Some sources give the dates 1935–37.

109. He was interested in the three-dimensional algebraic models constructed by Jules Henri Poincare and was influenced by the writings of Russian esotericist P. D. Ouspensky, who challenged the limitations of three-dimensional geometry. Mary Schneider Enriquez, "Roberto Matta: International Provocateur," in *Matta: Making the Invisible Visible,* ed. Elizabeth T. Goizueta (Chicago: University of Chicago Press, 2004), 30.

110. Germana Matta Ferrari, ed., *Entretiens morphologiques: Notebook No. 1, 1936–1944* (London: Sistan, 1987), 23.

111. Ibid.

112. Quoted in Perrine Le Blan, ed., *Matta, 1936–1944: Début d'un nouveau monde* (Paris: Malingue, 2004), 151.

113. Indeed, James Herbert has suggested that the 1938 exhibition published the list of nationalities separate from the list of artists as a parody of the 1937 *Exposition internationale*'s emphasis on nationalism. James D. Herbert, *Paris 1937: Worlds on Exhibition* (Ithaca, N.Y.: Cornell University Press, 1998), 134.

114. Roberto Sebastián Matta Echaurren, "Mathématique sensible—Architecture du temps," *Minotaure* 5, no. 11 (Spring 1938): 43. Translated in Lippard, *Surrealists on Art*, 167–69.

115. Lippard, *Surrealists on Art*, 169.

116. Ibid., 167.

117. Ibid., 169.

118. Matta Echaurren, "Mathématique sensible," 43.

119. Ibid.

120. Matta Ferrari, ed., *Entretiens morphologiques*, 23. Ferrari quotes Gordon Onslow-Ford, "Torward a New Subject in Painting," San Francisco Museum of Art, 1948/Notebook, 1956. Ford says they were in Switzerland in the spring of 1938 and then in Trévignon over the summer.

121. Ferrari, *Entretiens morphologiques*, 23.

122. Roberto Matta, "Inscape," unpublished notes from the summer 1938 in Trévignon, reproduced in ibid., 72.

123. Ibid., 24.

124. Roberto Matta, "Morphologie Psychologique," unpublished notes from fall 1938, translated by Gordon Onslow-Ford, reproduced in ibid., 70.

125. Eduardo Carrasco, ed., *Matta: Conversaciones* (Santiago: CENECA: CESOC, 1987), 63. *Minotaure* 6, nos. 12–13 (May 1939): 22, reproduced *Morphologie psychologique* (1937) by Matta in color.

126. Matta Ferrari, *Entretiens morphologiques*, 81.

127. For more on the surrealists in New York, see Martica Sawin, *Surrealism in Exile and the Beginning of the New York School* (Cambridge, Mass.: MIT Press, 1995). Other articles on the subject can be found in the *Journal of Surrealism and the Americas*.

128. The American Emergency Rescue Committee (founded by Eleanor Roosevelt), the American Federation of Labor, and the Museum of Modern Art (New York) facilitated passage out of the country for many of the artists and intellectuals trapped in Marseilles. Lam, Breton, and Levi-Strauss finally left Marseilles on a boat bound for Martinique on March 24, 1941.

129. Lam also contributed to the creation of a new card game, designing the "Genius: Lautréamont card" to replace the king, and the "Mermaid: Alice in Wonderland" to replace the queen. *Fata Morgana* was banned by the Vichy government in 1941. Helena Benitez, *Wifredo Lam: Interlude Marseille* (Copenhagen: Edition Bløndal, 1993), 16, 21.

130. Lowery Stokes Sims, "Wifredo Lam: From Spain back to Cuba," in *Wifredo Lam and His Contemporaries, 1938–1952,* ed. Maria R. Balderrama (New York: Studio Museum in Harlem; Abrams, 1992), 23.

131. André Breton, "The Long Nostalgia of Poets" (1941), reprinted in Breton, *Surrealism and Painting*, 171.

CHAPTER 10. A PRE–WORLD WAR II RESURGENCE

1. Henry goes on to recount the worsening political situation in France and how the surrealists could no longer participate in Communist Party activities. Letter from Maurice Henry to César Moro, November 25, 1934, in César Moro Papers, Getty Research Institute, Los Angeles, box 1, correspondence 1930–34.

2. Letter from Pedro Figari to Don Manuel Güiraldes, September 23, 1933, in Archivo Figari, Archivo General de la Nación, Montevideo, cited in Julio María Sanguinetti, *El doctor Figari* (Montevideo: Fundación BankBoston, 2002), 299.

3. Vincent Bouvet, *Paris between the Wars, 1919–1939: Art, Life and Culture* (New York: Vendome, 2010), 222.

4. Raquel Pereda, *Carlos Alberto Castellanos: Imaginación y realidad* (Montevideo, Uruguay: Fundación BankBoston, 1997), 109. Pereda quotes from his diary entry of November 22, 1932.

5. Marcelo Pogolotti, *Del barro y las voces* (Havana: Contemporáneos, 1968), 209.

6. Ibid., 252.

7. Christopher Green, *Art in France: 1900–1940* (New Haven: Yale University Press, 2000), 61.

8. Those who did participate exhibited in the Spanish section (Rafael Barradas, Rómulo Rozo) or as individuals (Pablo Curatella Manes, Ivan da Silva-Bruhns).

9. The Venezuela pavilion was designed by Venezuelan architects Carlos Raúl Villanueva and Luis Malaussena and included artworks by Armando Reverón, César Prieto, Rafael Monasterios, and Héctor Poleo. As far as I know, there were no reviews in the press of its content. Mexico chose to construct a cosmopolitan building with a giant sculpture of a peasant holding a sickle in front of it. For more on the Mexico pavilion, see Mauricio Tenorio-Trillo, *Mexico at the World's Fairs: Crafting a Modern Nation* (Berkeley: University of California Press, 1996), 237. Brazil did not actually build a pavilion, but rather occupied a building that was given as a gift from the French government. See Zilah Quezado Deckker, *Brazil Built: The Architecture of the Modern Movement in Brazil* (London: Spon, 2001), 55.

10. While Argentina remained neutral during most of World War II, the country harbored a significant population of ethnic Germans toward whom the Nazis directed pro-Nazi propaganda.

11. Maurice Raynal, *Pablo Curatella Manés* (Oslo: Merkur Boktrykkeri Nyt, 1948), 41–42.

12. For more on the exhibition, see Diana B. Wechsler, "1937: Argentina en la Exposición Internacional de París," in *Spilimbergo*, ed. Guillermo Whitelow at al. (Buenos Aires: Fondo Nacional de las Artes, 1999), 203–5. See also "Los plásticos argentinos en la exposición internacional de Paris," *Forma: Organo de la sociedad Argentina de artistas plásticos*, no. 5 (January 1938): 3.

13. Jacques de Laprade, "La peinture et la sculpture. Exp. Internationale," *Beaux-arts: Chronique des arts et de la curiosité* (September 24, 1937): 3.

14. "The nations closest to Central America have retained elements of a sumptuous past." Ibid.

15. Ibid.

16. Excerpt of a review by French critic Gilles de la Tourette in Wechsler, "1937: Argentina," 205. Originally published as Gilles de la Tourette, "El arte en el Pabellón Argentino de la Exposición de París," *La nación*, December 26, 1937.

17. Pereda, *Carlos Alberto Castellanos*, 116, 118.

18. The exhibition included sixty works from his *América tropical* series, mythological themed paintings, and eleven tapestries. Ibid., 96.

19. Ibid., 118.

20. Cícero Dias, *Rive Gauche*, invitation to exhibit at the Galerie Rive Gauche, March 3, 1937.

21. I have not been able to locate any further invitations or a list of artists invited.

22. The exhibition took place from December 13–31, 1938. Invitation in the Bibliothèque Kandinsky archives, Paris. "E. di Cavalcanti," *Beaux-arts: Chronique des arts et de la curiosité* (June 25, 1937): 7.

23. See Romy Golan, *Modernity and Nostalgia: Art and Politics in France between the Wars*

(New Haven: Yale University Press, 1995), 18–21.

24. "E. di Cavalcanti," 7.

25. Letter from Emiliano di Cavalcanti to Cícero Dias, November 17, 1936, reproduced and translated in Josué Montello et al., *Cícero Dias: Uma vida pela pintura* (Curitiba, Brazil: Simões de Assis Galeria de Arte, 2002), 131.

26. I have not been able to locate any further information about the second exhibition.

27. André Salmon, "Plaisir de la découverte," *Aux écoutes,* May 28, 1938.

28. Ibid.

29. Ibid.

30. Susanna Temkin is working on a dissertation at the Institute of Fine Arts, New York University, on Pogolotti entitled "Un arte social y revolucionario: Marcelo Pogolotti and the International Avant-Garde."

31. AEAR was modeled after the International Union of Revolutionary Writers (UIER), which was founded in Moscow in 1927.

32. These organizations included Mexico's Sindicato de Obreros Técnicos, Pintores y Escultores and Liga de Escritores y Artistas Revolucionarios (LEAR); Peru's Asociación de Escritores, Artistas e Intelectuales del Perú; Ecuador's Sociedad de Artistas y Escritores Independientes (Guayaquil) and the Sindicato de Escritores y Artistas (SEA) (Quito); and Argentina's Asociación de Intelectuales, Artistas, Periodistas y Escritores (AIAPE).

33. Georges Henry, "Expositions: Vers un art revolutionnaire," *Commune: Revue littéraire pour la defense de la culture* 1, pt. 2, no. 10 (1934): 1146–47.

34. Ibid.

35. Pogolotti describes the painting in Pogolotti, *Del barro y las voces,* 221–22.

36. Ibid., 221.

37. Susanna Temkin, "International Intersection: Marcelo Pogolotti at the Galerie Carrefour" (paper presented at "Passages à Paris: Artistes étrangers à Paris de la fin du XIXe siècle à nos jours," Institut National d'Histoire de l'Art, Paris, 2013).

38. *Hieroglyph* could very likely have been in dialogue with works by Torres García or Rego Monteiro of the period that focused on pictographic languages, as discussed in Chapter 8. But Pogolotti does not seem to have been associated in any way with Torres García's group. Pogolotti also mentions experimenting with surrealist automatism during this period. Pogolotti, *Del barro y las voces,* 183. Paintings in the exhibition included: *Hieroglyphe, Tourbillon, Paysage aérien, Blanc et noir, Le plan, Marine,*

Dockers, Aube, Evasion, Jeane intellectuel, Silence, and *Groupe,* as well as a group of drawings and watercolors.

39. Ibid., 259.

40. Ibid.

41. I say "Latin American" here because of Cassou's conflation of the Mexican and the Cuban. Marcelo Pogolotti and Jean Cassou, *Tableaux abstraits et figuratifs, du 25 février au 15 mars* (Paris: Galerie Carrefour, 1938). The full text of the catalogue reads: "Far from us, the strictly theoretical and speculative character of our formal debates is lost. Our abstract inventions, we immediately want to give them meaning, content, relate them to a real and present drama. The fact is that far from us this drama is externalized right away: there, in Cuba, the people are intensely aware, the human being cries out. And the abstract shapes that we produce here, in our laboratories at the end of a long intellectual tradition, in these bloody tropics, become flesh and bones. Party to this in the epoch of cubism, Rivera becomes in his home, in Mexico, the eloquent fresco painter of the Revolution. This kind of adventure might well happen to the Cuban Marcel Pogolotti if his country's fights help to shift lamentably from abstraction to figuration. Visual forms become humanized, pure rhythms become a body in action. And all of the artist's being engages in this action of the painting, which is a universal action."

42. Bouvet, *Paris between the Wars,* 276.

43. F. H. Lem, "Les expositions: Pogolotti (Galerie 'Carrefour')," *Marianne,* March 23, 1938, 11.

44. Maximilien Gauthier, "Exposition," *Nouvelles littéraires, artistiques et scientifiques,* May 1938, 49–51.

45. Roger Lesbats, *L'oeuvre,* incomplete citation, Giulio V. Blanc Papers, Archives of American Art, Smithsonian Institution, Washington, D.C.

46. A. D., "Marcel Pogolotti à la galerie du Carrefour," *Le populaire de Paris organe central du Parti Socialiste,* March 11, 1938.

47. Jaime Antonio Colson and Galerie Bernheim Jeune, *Exposition Jaime Colson: Peintre Dominicain* (Paris: Bernheim Jeune, 1939); Mario Carreño, *Exposition Carreno: Peintre cubain du lundi 24 avril au vendredi 5 mai 1939* (Paris: Bernheim Jeune, 1939); Max Jiménez and Waldemar George, *Dix toiles de Max Jiménez* (Paris: Bernheim Jeune, 1939).

48. The date he returned is not entirely certain. He may have returned as early as 1937.

49. Golan, *Modernity and Nostalgia,* 152–53. See also Bouvet, *Paris between the Wars,* 222–23.

50. Jiménez and George, *Dix toiles de Max Jiménez.*

51. Ibid.

52. Maximilien Gauthier, "Les expositions: Max Jiménez et Mario Carreño," *L'art vivant* 15 (June 1939): 54–55.

53. Gautier specifically calls Cuba an exuberant place, an assessment that can be extended to the Dominican Republic. Gauthier, "Les expositions," 54–55.

54. Mario Carreño Morales, *Mario Carreño: Cronología del recuerdo* (Santiago: Antártica, 1991), 31–32.

55. Domínguez encouraged him to work with the surrealists, and Carreño made a drawing for *Minotaure* that was never published. Ibid., 38, 43.

56. Waldemar George, "Les expositions: Amica America," *Beaux-arts: Chronique des arts et de la curiosité,* no. 330 (April 28, 1939): 4; Gauthier, "Les expositions," 54–55.

57. George, "Les expositions," 4.

58. Gauthier, "Les expositions," 54–55.

59. Parts of this section were published as Michele Greet, "Inventing Wifredo Lam: The Parisian Avant-Garde's Primitivist Fixation," *Invisible Culture: An Electronic Journal for Visual Culture,* January 2003, http://www.rochester.edu/in_visible _culture/ivchome.html. Pierre Loeb's exhibition of Lam's work was the last held before Loeb was forced to close the gallery and move his family to escape the Nazis. He then traveled to Cuba, where he stayed with Lam for a while. Wifredo Lam and Galerie Albert Loeb, *Wifredo Lam, Oeuvres de 1938 à 1946: En hommage à Pierre Loeb* (Paris: Galerie Albert Loeb, 1974), n.p. The only other time Lam exhibited in Paris before World War II was as part of a group show entitled *Art représentatif de notre temps* at the Mai Gallery. Lou Laurin-Lam, *Wifredo Lam: Catalogue Raisonné of the Painted Work* (Lausanne: Acatos, 1996), 183.

60. Wifredo Lam and Sebastián Gasch, *Wifredo Lam a París* (Barcelona: Polígrafa, 1976), 43.

61. Pierre Loeb's statement was originally written in 1942 and published in 1943 in *Tropiques.* It was reprinted in Lam and Galerie Albert Loeb, *Wifredo Lam,* n.p.

62. Gerardo Mosquera maintains that even though Lam employed the geometry of African masks, he derived his ideas mainly from Picasso. Gerardo Mosquera, "Modernidad y africanía: Wifredo Lam en su isla," in *Wifredo Lam* (Madrid: Museo Nacional Centro de Arte Reina Sofía, Ministerio de Cultura, 1992), 31.

63. Juan A. Martínez, *Cuban Art and National Identity: The Vanguardia Painters, 1927–1950*

(Gainesville: University Press of Florida, 1994), 140.

64. Antonio Núñez Jiménez, *Wifredo Lam* (Havana: Editorial Letras Cubanas, 1982), 143.

65. Charles Théophile, "Wifredo Lam: Peintures et dessins," *Marianne*, July 12, 1939.

66. Lam and Galerie Albert Loeb, *Wifredo Lam*, 285.

67. Letter from Jaime Colson to Mario Carreño, September 7, 1939, cited in María de la Luz Ortiz de Rozas Ojeda, *Historia de un sueño fragmentado: Biografía de Mario Carreño* (Santiago: Aguilar Chilena de ediciones, El Mercurio, C y C Impresores, 2007), 53.

68. See, for example, Isabel Plante, *Argentinos de París: Arte y viajes culturales durante los años sesenta* (Buenos Aires: Edhasa, 2013); Estrellita Bograd Brodsky, *Latin American Artists in Postwar Paris: Jesus Rafael Soto and Julio Le Parc, 1950–1970* (New York: New York University Press, 2010); and Estrellita Brodsky, ed., *Soto: Paris and Beyond, 1950–1970* (New York: Grey Art Gallery, New York University, 2012).

Full searchable online bibliography is available here: https://www.zotero.org/mgreet1 /items/collectionskey/86knnpks

Illustration Credits

Unless noted, images are the author's own photographs or scans from the best available source. Scans of archival documents and images were created with the assistance of Sherrie Rook, George Mason University, visual resources curator.

René-Gabriel Ojéda © RMN-Grand Palais/Art Resource, NY: fig. 5

Sotheby's New York: figs. 6, 10, 11, 15, 29, 37, 52, 87, 148, 206, 207

Courtesy of Pierre Moos: fig. 7

Museo Nacional de Arte, CONACULTA, INBA, Mexico City: fig. 9

Carlton Lake Art Collection, Harry Ransom Humanities Research Center—The University of Texas at Austin: fig. 13

Pascal Pia Collection at the W. T. Bandy Center for Baudelaire and Modern French Studies, Vanderbilt University: figs. 19, 20

Christie's New York: figs. 22, 89

Caldarella & Banchero and José Cristelli: figs. 23, 60

Courtesy of Alberto Minujín: fig. 25

© MOURON.CASSANDRE Lic 2015-20-05-03 www.cassandre.fr: fig. 27

Rômulo Fialdini and Milene Rinaldi: fig. 47

Pinacoteca do Estado de São Paulo: figs. 56, 90

Acervo Artístico-Cultural dos Palácios do Governo do Estado de São Paulo: fig. 57

Museo Xul Solar: fig. 62

Bertrand Prévost, Musée National d'Art Moderne, Centre Georges Pompidou, Paris, France. © CNAC/MNAM/Dist. RMN-Grand Palais/Art Resource, NY: fig. 63

Courtesy of Fernando Saavedra Faget: fig. 64

Courtesy of Nicolás Svistoonoff: figs. 65, 66

Courtesy of Dora Escobar: fig. 67

Museo Nacional de Bellas Artes, Buenos Aires: figs. 69, 102

Francisco Kochen: figs. 86, 88, 122

Courtesy of Sandra Brecheret Pellegrini: fig. 91

Courtesy of José Darío Gutiérrez: fig. 93

© CNAC/MNAM/Dist. RMN-Grand Palais/Art Resource, NY: fig. 95

Wilson Special Collections Library, UNC Chapel Hill: fig. 101

Christoph Hirtz: fig. 105

Museo Nacional de Bellas Artes, Havana: figs. 107, 108, 124–26, 129, 226–31

Rômulo Fialdini: figs. 111, 112, 114, 115, 191

Musée National Fernand Léger, Biot, France: fig. 116

National Gallery of Art, Washington, D.C.: fig. 118

Carlos Contreras de Oteiza: fig. 123

Tenerife Espacio de las Artes: fig. 137

Digital Image © The Museum of Modern Art/ Licensed by SCALA/Art Resource, NY: fig. 141

Creative Commons-BY: fig. 142

Museo de Arte Latinoamericano de Buenos Aires (MALBA): figs. 147, 156, 190

Courtesy of Martha Daura: fig. 159

Fundación Torres García: fig. 160

Fundación Cisneros: figs. 161, 166

Kunsthaus Zürich: fig. 163

Kunstmuseum, Basel: fig. 167

Museo Nacional Centro de Arte Reina Sofía, Madrid: fig. 171

Museo Bellapart, Santo Domingo: figs. 176, 177

Michel Seuphor: fig. 179

Cecilia de Torres Ltd.: figs. 180, 181

Museo de Arte Moderno de Buenos Aires: fig. 186

The Getty Research Institute, Los Angeles (980063): fig. 187

Fundación Televisa: fig. 199

Fundación Forner-Bigatti: fig. 203

Boisgirard: fig. 204

Museo Dolores Olmedo Patiño, Mexico City: fig. 209

Javier Hinojosa: fig. 214

Museu de Arte Moderna, Rio de Janeiro: fig. 223

Barnes Foundation, Philadelphia: fig. 235

Courtesy of Eskil Lam: fig. 236

Courtesy of Ramón and Nercys Cernuda: fig. 237

Index

propagande (journal), 75

Buñuel, Luis, 212

Bureau Central de Recherches Surréalistes, 276n17

Bureau des Nations de l'Amérique Latine, 74, 264n57

Bustamante, Abelardo "Paschín," 261n51

Butler, Horacio, 38–39, *38*, 42, 46, 50, 52, 172, 189, 238, 261n35, 263n91

Cabezón, Isaías, 42, 151, 261n51; *Portrait of Victor Valdés Alfonso, 42, 43*

Cabinet Maldoror, Brussels, 151

Cabré, Manuel, 62, 65; *The Seine, 62*

Cabrera, Germán, 240, 262n77

Cabrera, Lydia, 138, 262n76; *Contes Cubains,* 141

Cabrera, Rosario, 106, 150, 269n3

Cáceres, Héctor, 261n51

Café du Parnasse, 23

Café Lipp, 182

cafés, 37–40

Café Voltaire, 182

Cahiers d'art (journal), 10, 145, 152–53

Calandria, Juan José, 262n77

Calder, Alexander, 193

"call to order" movement, 47, 66, 154

Candía, Domingo, 191

Candombe (dance), 107–9

Carlsund, Otto, 182

Carnet de la semaine (journal), 21, 105

Carpentier, Alejo, 7, 32, 33, *38*, 40, 41, 116–17, 119, 147, 166, 168–70, 196

Carpio, Elena del, 77, 269n3

Carrasco, Gustavo, 261n51

Carreño, Mario, 106, 249, 251–53, 256; *Women by the Seashore, 251–52, 253*

Carril, Delia del, 262n76

carte de séjour, 33

Cassou, Jean, 107, 111, 137, 248, 271n2; "La renaissance de l'art mexicain," 150, *151, 211*

Castellanos, Carlos Alberto, 72, 83, 98, 106, 146, 150, 189, 237, 239, 265n4; mural for the Uruguay pavilion at *Exposition internationale des arts et techniques dans la vie moderne, 239–40, 239; Spaniards Surprised by Indians, 72, 73; Water Carrier, 83–84, 84*

Castellanos, Julio, letter from, *48*

Catholicism, 155

Cavalcanti, Emiliano di, 7, 37, 240–41; *Girls with Guitars, 240, 241*

Cazenave, Paule, 46

Cendrars, Blaise, 24, 124–25, 201, 260n44, 269n13, 276nn18–19, 277n67; *L'anthologie nègre,* 124, 269n12; *Feuilles de route,* 126; *Profond aujourd'hui, 24, 25;* scenario for *La création du monde,* 269n12, 276n16

Cercle de l'Amérique Latine, 74

Cercle et Carré (artists' group), 101, 106, 121, 138, 171, *176,* 181–87, 189, 191–95, 251

Cercle et Carré (journal), 182, *183*

Cercle Paris-Amérique Latine, 75, 240

Cézanne, Paul, 18, 20–21, 25, 26, 43, 48, 62, 65, 107, 260n29, 260n47; *Bathers,* 53

Chagall, Marc, 36, 98, 116, 124, 208, 255

Char, René, 235

Charensol, Georges, 99, 129, 189, 206

Chávez, Carolina de, 269n3

Chevalier, Michel, 258n17

Chez Gismondi (café), 38

Chile, 5, 42–43, 261n51

Círculo de Bellas Artes, Venezuela, 79

Clifford, James, 5

Clouzot, Henri, 61, 73–74

Cochet, Gustavo, 106, 172

Cocteau, Jean, 20, 124, 210

Codex Borbonicus, 24

Cogniat, Raymond, 59, 63, 67–68, 70–71, 74, 76, 79–82, 85, 90, 92, 95, 97, 101, 109–10, 120, 129, 146–47, 161, 172, 189, 206, 266n51; "Les peintres de l'Amérique latine," 149–50, *149*

Colarossi, Filippo, 44, 45

collage, 195, 197–200, 212–14, 233–34

Collin, Raphael, 44

colonialism: and artistic influence, 6; France and, 1–4, 7, 258n21, 258n22; Latin America and, 6–7

Colquhoun, Ithell, 234

Colson, Jaime, 4, 76–77, 106, 151, 183–85, 187, 208, 218, 249, 251–52, *252,* 256, 274n30; *Homage to Juan Gris, 184, 185; Metaphysical Figures, 184–85, 186*

Colucci, Guido "Gio," 271n69

Columbus, Christopher, 41

Comité France-Amérique, 33

Communist Party, 168, 170, 196, 215

Comœdia (journal), 95–96, 105

constructive universalism, 176, 183, 185

constructivism, 4, 101–2, 138, 181–84, 191

contracts, artists', 17, 18, 20, 22, 105

Coons, Lorraine, 34

Corneau, Eugène, 21

Correio da manhã (journal), 240

Cortés, Ana, 172

Cossío del Pomar, Felipe, 76, 80; *Descendants of the Incas, 80, 80*

costumbrismo, 115

Courbet, Gustave, 26, 111

Courtois, Gustave, 44

Creation (journal), 95

Creeft, José de, *Vallejo, 167*

Crespo, Rafael, 195

criticism, prominent themes of: Abela's work and, 116–20; cubism, 63–64; derivative/academic character of Latin American art, 43, 47, 59, 68, 71–74, 81, 95; dilution of French art, 7, 60, 95, 98, 100; Figari's work and, 108–12, 146; native/primitive content and Latin American identity, 7, 9, 59, 63–64, 66–68, 72–74, 76–78, 94, 96, 107, 110–21, 125, 132–33, 141–42, 146–53, 167, 188–89, 240–41, 250–56. *See also* exoticism; primitivism; the press

Crombie, John, 44, 45

Crussol, marquise de, 75

crystal/classical cubism, 17

Cuba, 41, 61, 116–20, 141, 143–44, 147, 244, 248–49, 252

cubism: crystal/classical, 17; decline of, 32; as foundation of modern art, 155; Latin American practice of, 4, 11–31, 54–55, 63–64; Lhote and, 18–20, 47, 50, 52–55; and portraiture, 18–20; rejection of, 20–27; Rosenberg and, 11–20, 31, 154; synthetic, 17, 19, 141

Cueto, Germán, 4, 106, 134, 183, 187, 191; *Capital 8a Construction, 191, 192; Mask, 183, 184;* metal mask, 185, *187; Sculpture, 183, 184*

cultural hybridity, 8

cultural misunderstanding, 1–4

Cuneo, José, 116, 240, 241, 269n61

Curatella Manes, Pablo, 40, 57, 69, 90–91, 96, 101, 189, 191, 237, 238, 261n35, 262n77, 265n4, 271n2; *Group of Acrobats, 101, 102; Lancelot of the Lake and Queen Guinevere, 90, 91; Woman in a Heavy Overcoat, 70–71, 71*

Dalí, Salvador, 181–82, 196, 212, 230, 231, 234; *Bather* series, 206; *The Great Masturbator, 181, 182*

Daura, Pierre, 174, 273n3, 274n23; *Still Life, 174, 174*

David, Jacques-Louis, 48

De Chirico, Giorgio, 154, 163, 168, 185, 196, 201, 211, 213, 276n17

the decorative, 123, 131, 134, 136, 138, 143, 144

Defense of Intellectuals Menaced by Nazis, 235

Degas, Edgar, 107

De Gaulle, Charles, 78

Delacroix, Henri, 107

Delange, René, 26

De las Casas, Carmen, 49

Delaunay, Robert, 50, 124, *158*

Delaunay, Sonia, 134

Denis, Maurice, 57, 111

Derain, André, 13, 100, 116, 157, 253

Despiau, Charles, 60

De Stijl, 180

Deux Magots (café), 234

Diaghilev, Sergei, 210

Dias, Cícero, 240–43, 251; *Life, 242, 243; Untitled, 241, 242*

Diffusion Française (radio station), 240

Divoire, Fernand, 4

Documents (journal), 169–70, 206

Domínguez, Lorenzo, 262n77

Domínguez, Oscar, 218, 226, 231, 235, 251

Domínguez Neira, Pedro, 50

Douairière D'Uzès, Duchesse, 75

Doucet, Jacques, 126

Doumer, Paul, 82–83

Duchamp, Marcel, 218, 231

Duchartre, P.-L., 111

Dufy, Raoul, 100, 116

Dunoyer de Segonzac, André, 57